VICTORIAN PAINTING

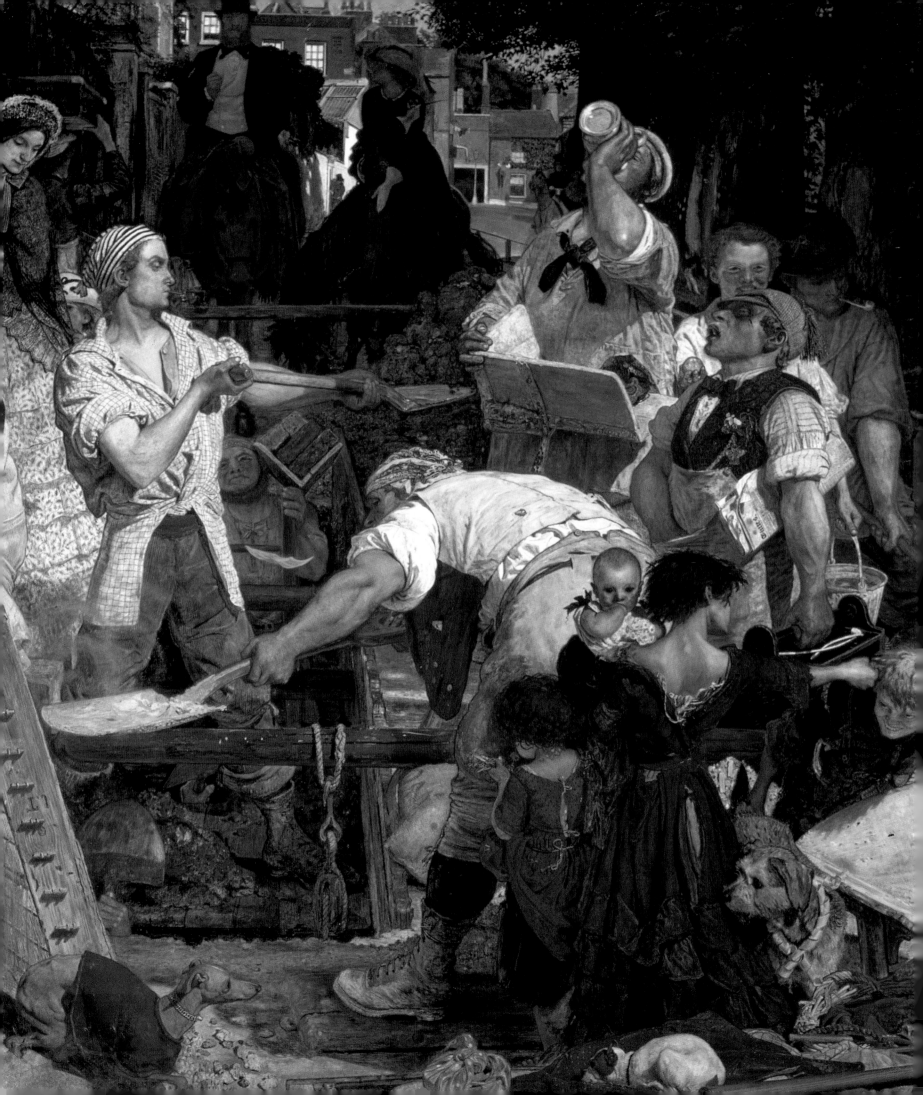

VICTORIAN PAINTING

Lionel Lambourne

To those artists whom space has compelled me to omit

Phaidon Press Limited
Regent's Wharf
All Saints Street
London N1 9PA

First published 1999
© 1999 Phaidon Press Limited

ISBN 0 7148 3776 8

A CIP catalogue record for this book is available from the British Library

Library of Congress Cataloging in Publication Data available

Printed in Hong Kong

Frontispiece:
Ford Madox Brown
Work
(detail of Pl. 291)

Author's Acknowledgements

Roger Sears, formerly of Phaidon Press, first conceived the wide scope of this book, which has been turned into a reality by Bernard Dod, the most patient of editors. He was a pleasure to work with, as was Sam Wythe his deputy. Deirdre O'Day's picture research was of immense help to the project. My son Patrick Lambourne helped me, although computer illiterate, to deliver the text in presentable condition. My wife Maureen coped with both me and the manuscript at every stage, checking with immense care the endless pages of proofs which would have defeated me.

Many people have helped me with this book, among them Chris Beetles, Nita Budd, Annabel Cassidy, Katherine Coombs, Richard Dennis, Julia Collieu, Amanda Jane Doran, Betty Elzea, Cathie Haill, Simon Houfe, Peter Johnson, Rupert Maas, Mrs Jeanne Mackenzie, Ronald Parkinson, David Robinson, Peyton Skipwith, Brian Stuart and Mrs Virginia Surtees.

A book of this type is very much a collaborative effort and without the help of the above people this work would never have reached publication stage. To them I extend my thanks while myself remaining responsible for all errors.

Photographic Acknowledgements

Phaidon would like to thank all those private owners, and museums, galleries, and institutions credited in each caption who have kindly provided material for publication. Additional credits and providers of images are as follows:

Art Gallery of New South Wales. Watson Bequest Fund: 588; Art Gallery of South Australia. Elder Bequest Fund: 532, South Australian Government Grant with the assistance of Bond Corporation Holdings Ltd through the Art Gallery of South Australia Foundation to mark the Gallery's Centenary (1981): 535; Art Gallery of Windsor, Ontario. Memorial bequest of Mr & Mrs G Hudson Strickland: 540; The Art Institute of Chicago. Friends of the American Art Collection: 274, 607; Art Resource, New York: 78, 489; Arthotek, Peissenberg: 559; Arthur Ackermann & Peter Johnson Ltd, London: 255; Auckland Art Gallery, Toi o Tamaki: 528, Mackelvie Trust Collection: 433; Baltimore Museum of Art. Private collection, on extended loan: 500; Beaverbrook Art Gallery. Beaverbrook Canadian Foundation: 538; Bridgeman Art Library, London: 26, 27, 32, 79, 80, 106, 113, 120, 123, 124, 126, 127, 133, 138, 158, 168, 171, 174, 181, 182, 201, 210, 211, 218, 219, 223, 227, 233, 239, 241, 247, 249, 264, 275, 277, 280, 284, 295, 297, 301, 304, 319, 321, 324, 344, 358, 362, 368, 378, 382, 389, 396, 407, 412, 417, 428, 429, 434, 442, 444, 470, 472, 483, 504, 515, 543, 546, 549, 555, 564, 566, 568, 593, 597, 599, 603, 609, 623; British Architectural Library, RIBA, London: 42; British Library, London: 544; Cadw: Welsh Historic Monuments, Cardiff: 54; Carnegie Museum of Art, Pittsburgh. Acquired through the generosity of the Sarah Mellon Scaife family: 506; by permission of the Duke of Devonshire and the Chatsworth Settlement Trustees: 256; Richard Cheek, Belmont, Mass.: 59; Chris Beetles Ltd, London: 145; Christie's Images, London: 104, 111, 350, 351, 353, 359, 380, 517; Cleveland Museum of Art. Bequest of John L Severance: 18; Collection of Pre-Raphaelite Inc, by courtesy of Julian Hartnoll, London: 376; David Messum Fine Art, London: 589; Delaware Art Museum. Samuel & Mary R Bancroft Memorial: 471; Detroit Institute of Arts. Bequest of Henry Glover Stevens in memory of Ellen P Stevens and Mary M Stevens: 87, gift of Dexter M Ferry Jr: 585; Dundee City Council Arts & Heritage Department: 411, 558; English Heritage, London: 156, photo Jonathan Bailey: 34, 69; ET Archive, London: 529; Faringdon Collection Trust, Buscot Park: 343, 346; Fine Art Museums of San Francisco. Gift of Mr & Mrs John D Rockefeller 3rd: 505, Museum purchase, Whitney Warren Jr Fund, in memory of Mrs Adolph B Spreckels: 190; Ford & Etal, Northumberland: 381; Frederick Warne & Co, London, courtesy of the National Trust: 391; Giraudon, Paris: 582; Hatfield House, courtesy of the Marquess of Salisbury: 75; Honolulu Academy of Arts. Purchase, special Academy funds and donations from the community: 88; Image Library, State Library of New South Wales: 192; Trustees of the Leeds Castle Foundation, photo Barry Duffield: 475; Leicestershire Museums, Arts & Records Service: 262; courtesy of the Treasurer and Masters of the Bench, Lincoln's Inn: 41; Lord Lloyd-Webber Collection, London: 242; Maas Gallery, London, photo Glynn Clarkson: 240; Manchester City Art Galleries: 52; Metropolitan Museum of Art. Bequest of Miss Adelaide Milton de Groot: 512, Arthur Hoppock Hearn Fund: 93, George A Hearn Fund: 508, Morris K Jesup Fund: 495, gift of John Stewart Kennedy: 497, purchase, Charles Allen Munn Collection, bequest of Charles Allen Munn, by exchange: 493, gift of Mrs Russell Sage: 486, gift of the Senate House Association, Kingston, New York: 197, gift of Mr & Mrs Carl Stoeckel: 496, gift of Erving Wolf Foundation and Mr & Mrs Erving Wolf: 498; Montreal Museum of Fine Arts. Gift of Lord Strathcona and Family: 479, purchase, acquisition funds for Canadian works of art donated by Mr Maurice Corbeil, Mrs Howard W Pillow, Mr & Mrs A Murray Vaughan, anonymous gift and Horsley & Annie Townsend Bequest: 537; Museum of Fine Arts, Boston. Emily L Ainsley Fund: 586, gift of James Lawrence: 300, given by Janet Hubbard Stevens in memory of her mother, Janet Watson Hubbard: 600; National Gallery of Art, Washington DC. Chester Dale Collection: 511, gift of Mr & Mrs Cornelius Vanderbilt Whitney: 501, John Hay Whitney Collection: 503, Harris Whittemore Collection: 581; National Gallery of Canada. Gift of the Massey Collection of English Painting: 590, transfer from the Canadian War Memorials, gift of the 2nd Duke of Westminster: 4; National Graphic Center, Falls Church: 48; National Park Service, Gettysburg: 196; National Trust. East Midlands Regional Office, photo Don Godfrey: 261, Knighthayes Court, photo Chris Vile: 53, London, photo John Bethell: 573, A C Cooper: 50, Derek Witty: 51, 81; National Trust for Scotland, Edinburgh: 267; Art Collection of NationsBank, St Louis: 494; reproduced by permission of the librarian of the Oxford Union Society, photo Cyril Band: 44; Parliamentary Works Directorate, London, reproduced by kind permission of the Palace of Westminster: 35–40, 58; reproduced by permission of Perth and Kinross Council, Scotland: 469; RMN, Paris: 90, 583; Royal Academy of Arts, London. Pope Family Trust: 32, private collection: 237; Royal Botanic Gardens, Kew: 392; The Royal Collection: all works are © Her Majesty Queen Elizabeth II; Royal Commission on the Ancient and Historical Monuments of Scotland, Edinburgh: 57; reproduced with the permission of the Governors of the Royal Shakespeare Theatre: 232; Scala, Florence: 601; Science & Society Picture Library, London: 325; Sheffield Galleries & Museums Trust, by permission of the Ruskin Gallery, Collection of the Guild of St George: 19; Sotheby's Picture Library, London: 467; reproduced with kind permission of the Special Trustees of Guy's and St Thomas's Hospitals, London: 43; courtesy of Sir John Sykes, Bt: 70; © Tate Gallery, London: 228; Toledo Museum of Art, purchased with funds from the Florence Scott Libb Bequest in memory of her father, Maurice A Scott: 487; Unilever Historical Archives, Port Sunlight, reproduced with kind permission of Elida Fabergé Ltd: 214; V&A Picture Library, London: 9, 61; reproduced by permission of the Trustees of the Wallace Collection, London: 485.

Preface 6

1 **INTRODUCTION** *8*

2 **THE VICTORIAN ART ESTABLISHMENT** *24*

3 **THE FRESCO REVIVAL: MURAL PAINTING** *42*

4 **THE GOOD AND THE GREAT: PORTRAIT PAINTING** *64*

5 **OILS VERSUS WATERCOLOURS: LANDSCAPE PAINTING** *92*

6 **THE NARRATIVE IMPULSE: GENRE PAINTING** *126*

7 **'VIRTUAL REALITY': THE PANORAMA** *150*

8 **CHILDHOOD AND SENTIMENT** *168*

9 **FAIRY PAINTING** *190*

10 **SPORTING AND ANIMAL PAINTING** *208*

11 **THE PRE-RAPHAELITES** *230*

12 **'ALL HUMAN LIFE IS HERE': CROSS-SECTIONS OF SOCIETY** *256*

13 **THE NUDE AND CLASSICISM** *278*

14 **WOMEN ARTISTS** *304*

15 **SOMBRE SCHOOLS OF ART: SOCIAL REALISM** *326*

16 **PARTING: EMIGRATION AND WAR** *348*

17 **THE FRAILER SEX AND THE FALLEN WOMAN** *366*

18 **A TRANSATLANTIC EXCHANGE** *390*

19 **COLONIAL TIES: PAINTERS IN A WIDER WORLD** *412*

20 **AESTHETES AND SYMBOLISTS: THE LAST ROMANTICS** *438*

21 **IMPRESSIONISM IN BRITAIN** *462*

22 **THE END OF AN ERA** *486*

Select Bibliography 504

Index 506

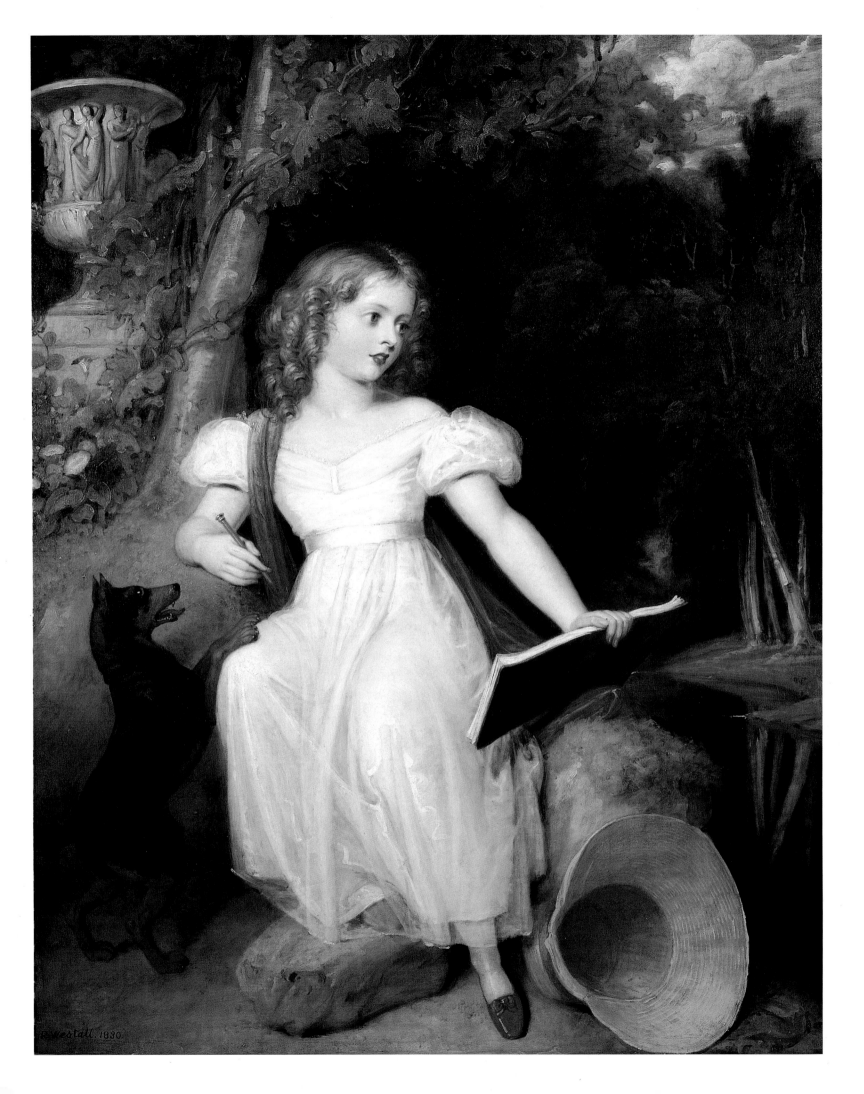

'When *I* use a word,' Humpty Dumpty said in rather a scornful tone, 'it means just what I choose it to mean – neither more nor less.'

'The question is,' said Alice, 'whether you *can* make words mean so many different things.'

In Lewis Carroll's *Alice in Wonderland* (1865) Alice is querying Humpty Dumpty's use of the word *glory* but they could usefully be discussing the word *Victorian*. Except for Napoleon the name of no other nineteenth-century ruler has become more widely used as a stylistic term. The future Queen Victoria was born in 1819, ascended the throne in 1837 and died in 1901. She reigned for 63 years, longer than any previous monarch, and gave her name to a great period of English history, social life and artistic endeavours. As decorative art terms the words *Early, Mid, High* or *Late* Victorian are readily understood from Kansas to Karachi and Canberra to Canada. The convenient brevity of these phrases makes them more useful than the cumbersome alternatives of 'third quarter of the nineteenth century', or 'during the second Presidency of Grover Cleveland (1892–6)'.

Until quite recent years the term 'Victorian' was used, when describing paintings, as a dismissive and pejorative term, frequently coupled with the word 'sentimental'. Today, although convenient, the word is still frowned on by the academic fine art world, for most serious art historians prefer to use date-specific or stylistic terminology such as Romantic Realist, Realist, or Symbolist, although the sale rooms continue to hold regular sales of 'Fine Victorian Pictures'.

No great consistency is claimed for the present book's use of the term beyond a rough rule of thumb that works mentioned should on the whole have been painted during the Queen's *lifetime*, not reign, i.e. 1819–1901. This arises from the fact that reigns, like artistic movements, do not begin in a neat and tidy manner but haphazardly. The Queen's own connection with the arts is of great interest, and can serve as a useful paradigm for the taste of the time. As a little girl from the age of four she is revealed as a determined young lady with views of her own, while a watercolour by Richard Westall (1765–1836) of her sketching outdoors at the age of 11 shows her holding out her sketchbook professionally to gauge perspective (Pl. 1). Westall was her first teacher, and by copying his narrative works she acquired a love of genre painting, the universal passion of the time. Yet although her own taste was for popular works telling a story, Victoria's artistic horizon would be widened by her marriage to her beloved Albert, whose art-historical knowledge was highly sophisticated. His influence on British art was profound, for he brought with him German artistic theories which greatly influenced the course of subsequent British art.

This book will also examine paintings produced during the Victorian era not only in the United Kingdom, but also across the wider English-speaking world. Inevitably this attempt could be described as superficial, but nevertheless is worth making to establish both similarities and discrepancies of theme and the British ability to assimilate immigrants and their cultures while simultaneously sending its citizens away to colonize and spread British ideas abroad.

The artists discussed include major foreign painters as diverse as Winslow Homer and Vincent Van Gogh whose stay in Great Britain marked a crucial turning-point in their lives. Many surveys of nineteenth-century art give the impression of it being an artistic football match in which the French Impressionists playing away against the British Pre-Raphaelites always win by a large margin. Both artistic movements have not always been popular, although they are immensely admired today and supported by enthusiastic fans. But like the Premier Division they are usually seen in isolation from other paintings of their time. It is rewarding to place both movements in wider contexts, although before doing so it is first necessary to look at the central role played in the arts by such institutions as the Royal Academy.

1 Richard Westall, **Queen Victoria as a Girl,** 1830, watercolour, 144.8 × 133.7cm (57 × 44⅔in). Royal Collection

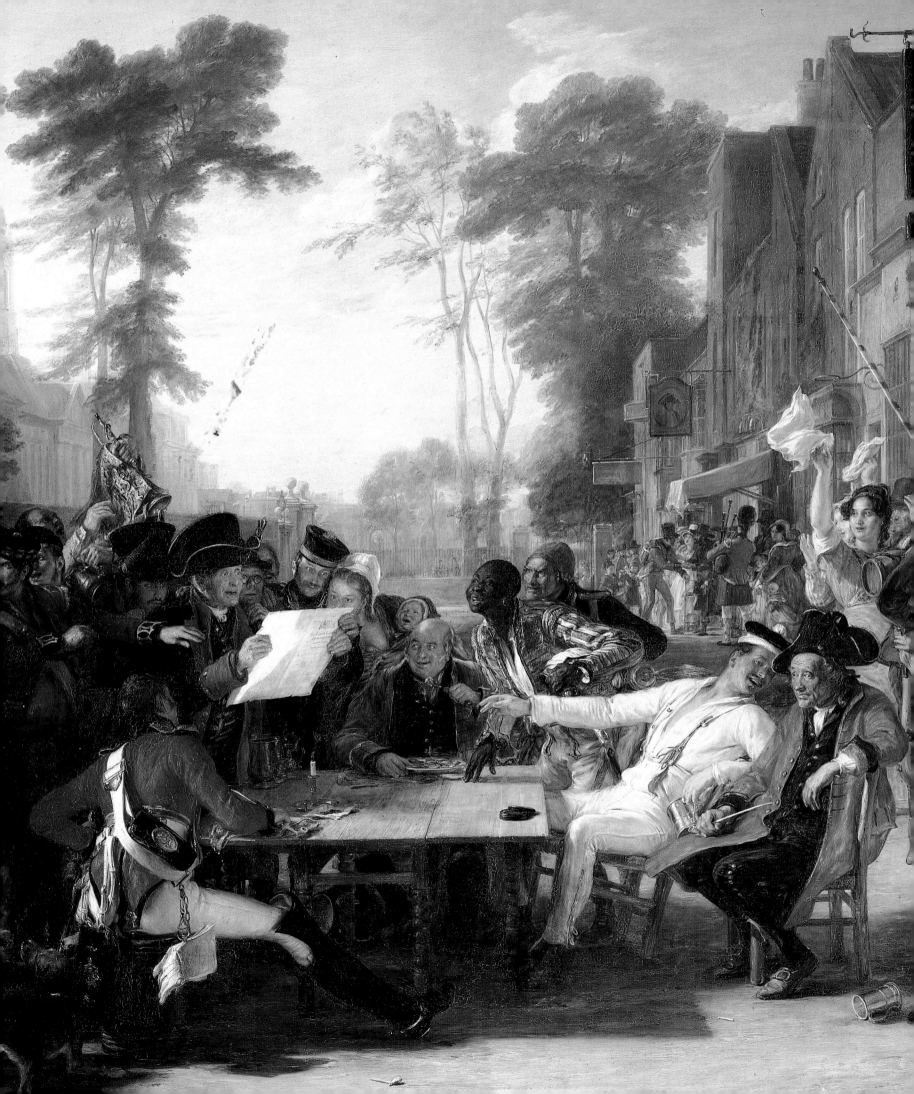

To begin at a beginning let us turn back to the eighteenth century and the foundation of the Royal Academy. Its founder was the imposing figure of Sir Joshua Reynolds (Pl. 3), who remained its President until his death in 1792. When it began in 1768, membership was open to 40 practising Academicians, who had to be artists by profession. Interestingly, two women, Angelica Kauffmann (1741–1807) and the flower painter Mary Moser (1744–1819), were among the original 36 members, but no further women were elected for more than 150 years. Reynolds's motive in founding the Academy was to raise the status of the profession by training and by arranging a free exhibition of works of a high standard of excellence, thus fostering the emergence of a national school of painting. In 1769 a new class of Associate Members was instituted from which Academicians were elected.

2 David Wilkie, **Chelsea Pensioners Reading the Gazette of the Battle of Waterloo** (detail of Pl. 9)

For Sir Joshua, landscape painting was not among the most exalted forms of art; it lacked man. In his *Discourses* (1769–90), which established a 'pecking order' of types of painting, 'History painting' – grand historical or religious subjects of an ennobling character – ranked first. Landscape, rather surprisingly, ranked below domestic scenes and portraiture, and only above the painting of animals, still life and flowers.

Reynolds's categories were very much at variance with the views and achievement of the most important British artist of the first half of the eighteenth century, William Hogarth. Of his work Reynolds wrote:

> The painters who have applied themselves more particularly to low and vulgar
> characters, and who express with precision the various shades of passion, as they
> are exhibited by vulgar minds (such as we see in the works of Hogarth) deserve
> great praise; but as their genius has been employed on low and confined subjects,
> the praise which we give must be as limited as its object.

Reynolds goes on to list among this class of subjects the depiction of the merry-making or quarrelling of peasants and boors by the Dutch painters David Teniers

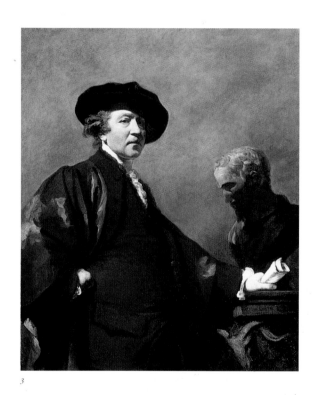

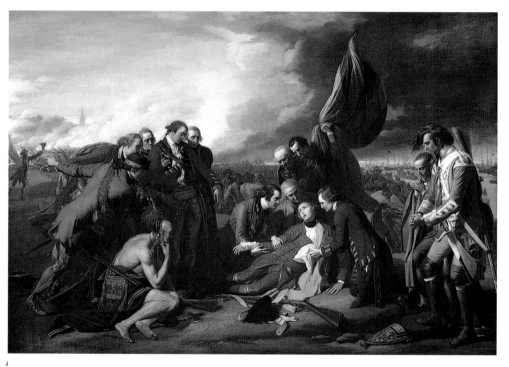

3

4

(1610–90), Adriaen Brouwer (*c.*1605–38) and Adriaen van Ostade (1610–84), and the 'French Gallantries' of Antoine Watteau (1684–1721).

Reynolds elaborated still further on his theories in his third and fourth discourses (1770 and 1771), advocating that History painting should be interpreted in the lofty and rhetorical 'Grand Manner', the *gusto grande* of the Italians. The general aim was to transcend nature. The subject itself must be of an elevating character. Ample and noble draperies for the people portrayed were *de rigueur* and fashionable contemporary costumes inadmissible. Alternatively the figures should be portrayed nude.

Theoretically these rules were to remain in force throughout the early decades of the Romantic era, but in practice they became greatly modified, especially in the work of Reynolds's successor, the American Benjamin West (1738–1820), who became President of the Royal Academy in 1792.

West had begun his career as a portraitist in New York before studying in Rome and settling in London, where he was appointed History Painter to George III. He painted in an assured Neoclassical manner such subjects as *Agrippina Landing at*

Brundisium with the Ashes of Germanicus (1768). In 1770 he really made his mark with his famous *Death of General Wolfe* (Pl. 4), which depicted the figures not in classical dress or 'heroic nudity' but in contemporary costume, a radical innovation which led to attacks for breaking the conventions of the Grand Manner. The practice was, however, emulated by his fellow American long resident in England, the Bostonian John Singleton Copley (1738–1815), in his *Death of the Earl of Chatham* (Pl. 5).

Despite Reynolds's advocacy of History painting, it never really caught on in England. There was an unquenchable demand for portraits, a natural corollary of the British obsession with the individual human face. As a great portrait painter himself,

5
John Singleton Copley
**The Death of the Earl
of Chatham**
1779–81
oil on canvas, 228·6 × 307·3cm
(90 × 121in)
Tate Gallery, London

5

Reynolds excelled in posing his sitters in 'Grand Manner' attitudes derived from classical sculpture. This convention was adopted by Reynolds, West and their worthy successor Sir Thomas Lawrence (1769–1830). Lawrence became an internationally known artist, whose portrait formula of a standing figure sensitively posed in a wild or desolate landscape (Pl. 6) was echoed in the work not only of his British followers but also French artists as various as Delacroix, Ingres, Gérard and Gros. Under the presidency of Lawrence and his pupil and successor Sir Martin Archer Shee (1770–1850), portraiture flourished, and indeed was to remain throughout the century the most lucrative form of painting.

6
Thomas Lawrence
**George Gordon, 5th Duke
of Gordon**
c.1825
oil on canvas, 274·8 × 177·8cm
(108 × 70in)
City of Aberdeen Town House
Collection

7
David Wilkie
Blind Man's Buff
1812
oil on canvas, 63.2 × 91.8cm
(25 × 36¼in)
Royal Collection

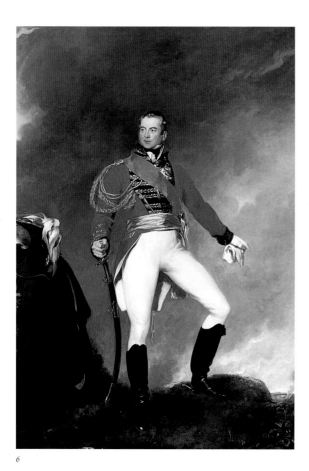

6

Running portraiture very close was the practice of painting 'genre' subjects – narrative pictures of people in scenes from ordinary life, often with an anecdotal content. Genre painting in England saw its first great flowering on the walls of the Royal Academy during the reigns of George IV and William IV long before Victoria ascended the throne. Most of the genre artists whom we think of as typically Victorian – William Mulready, Sir Edwin Landseer, Thomas Webster, and the American Charles Robert Leslie – had established their reputations many years before 1837.

Their range of subject-matter was very diverse. Mulready and Webster favoured child genre, Landseer both Scottish and anthropomorphic animal scenes, while Leslie revelled in literary subjects taken from Shakespeare, Molière and Laurence Sterne's *Tristram Shandy*. But the greatest genre painter of them all was Sir David Wilkie (1785–1841), who drew extensively on scenes from the everyday life of the Scottish lowlands. Although much admired during his own lifetime, Wilkie today is sadly neglected, perhaps the least known and appreciated of major nineteenth-century artists.

Wilkie was born at Cutts, Fife, in 1785, the son of a Presbyterian minister. As a boy he diligently studied prints after Van Ostade and Teniers, and their influence can be seen in much of his precociously brilliant early work: cross-sections of rural life full of anecdote and humour such as *Pitlessie Fair* (1804) and *Village Politicians* (1806, a contemporary variation on a seventeenth-century Dutch theme). The Prince Regent himself purchased two important works, *The Penny Wedding* (1819) and *Blind Man's Buff* (Pl. 7). The latter is indebted to Van Ostade in composition and handling, and also to the French narrative tradition.

In his *Remarks on Painting* (published posthumously in 1843), Wilkie wrote, 'the taste for art in our isle is of domestic rather than a historical character. A fine picture is one of our household gods, and kept for private worship: it is an everyday companion.' These words provide an ideal point of departure for discussing the small-scale cabinet-sized pictures at which he excelled, such as *The Refusal* (Pl. 8). This painting was inspired by Robert Burns's poem about the wooing by Duncan Gray of the 'Haughty Hizzie Meg … deaf as Ailsa Crag'. Wilkie's sister sat as the model for Meg, his friend William Mulready for Duncan Gray and Mulready's parents as Meg's mother and father.

The culmination of Wilkie's early success was marked in 1816 by a commission from the Duke of Wellington for the painting *Chelsea Pensioners Reading the Gazette of the Battle of Waterloo* (Pl. 9). The Duke had originally suggested a small picture on the theme of 'British Soldiers Regaling at Chelsea', and it was Wilkie's idea to introduce the dramatic event of the arrival of the news of the great British victory. Wilkie took immense pains with the crowded scene, constructing a box within which he experimented with small model figures in order to resolve the composition. The work took five years to complete, and Wilkie asked the then huge price of 1,200 guineas for it, to the chagrin of the Duke, who insisted on paying in bank notes rather than by cheque, in order that the clerk at his bank, Coutts, should not think him 'a damn fool for paying so much for a picture'.

When the painting was shown at the Royal Academy in 1822 it was an immense success: high and low flocked to see it, enraptured by its patriotic subject. So great were the crowds that for the first time in the history of the Academy, a barrier had to be erected in order to protect the work. (This barrier was not to reappear until Frith's equally great success with *Derby Day* (Pl. 320) in 1858.)

Wilkie later visited Spain in search of new picturesque genre themes, where he became greatly influenced by the paintings of Velázquez. He died at sea from a fever contracted while researching material for biblical paintings in the Holy Land. His immense early success as a painter was to establish firmly the popularity of genre painting, and set the pace for further developments in the field throughout the century.

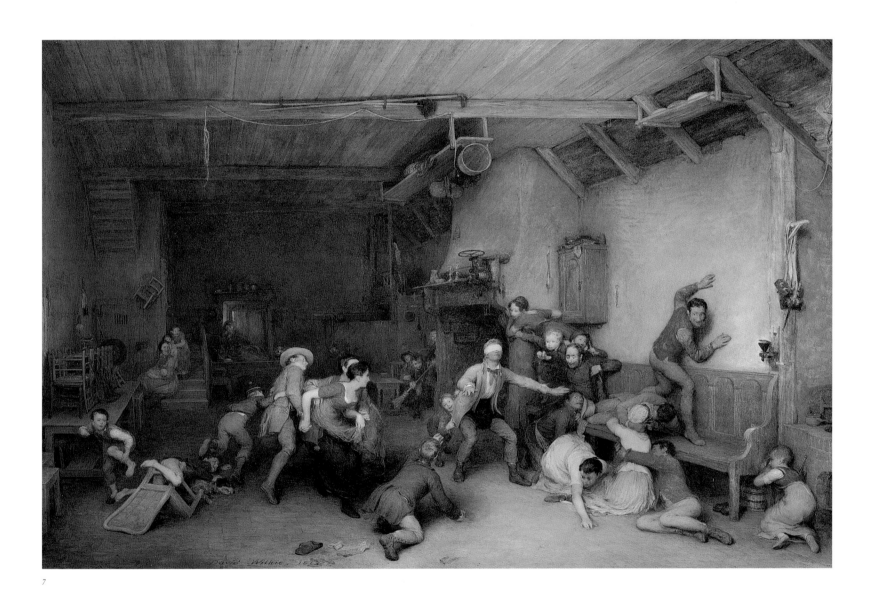

7

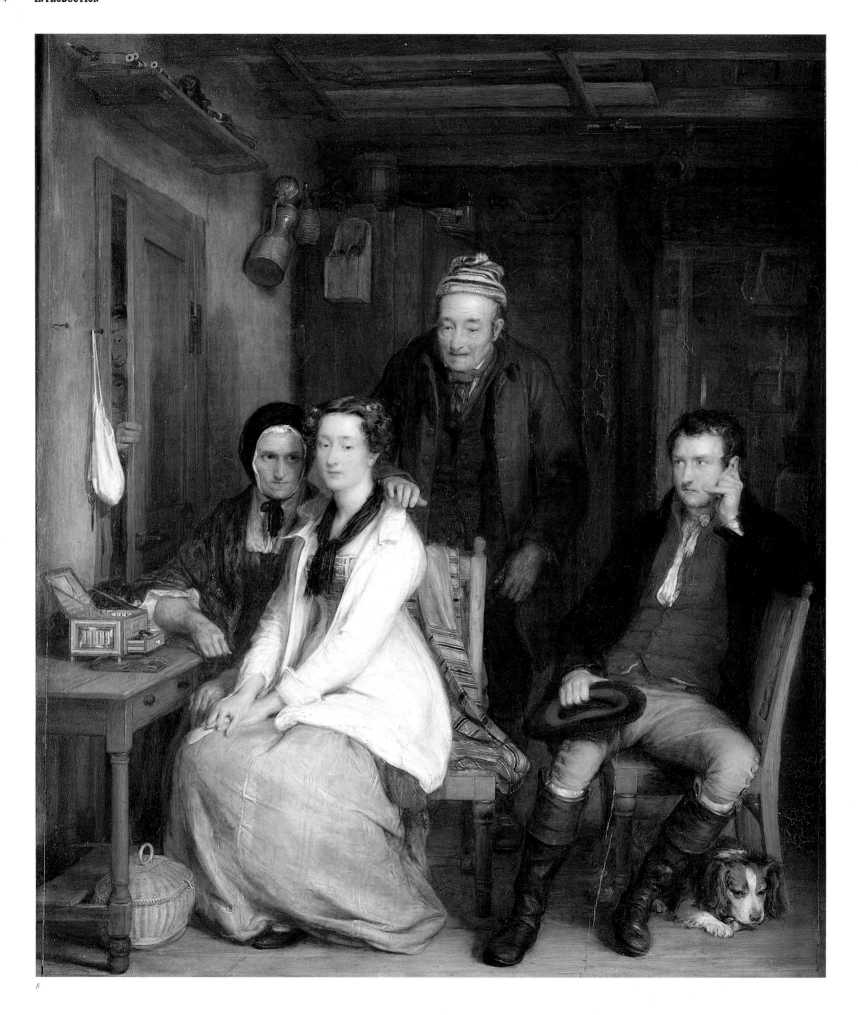

8

Not everyone, however, approved of the ascendancy of genre subjects in the public's affections. On 6 February 1824, Wilkie's one-time friend Benjamin Robert Haydon (1786–1846) wrote in his journal:

> Wilkie by his talent has done great injury to the taste of the Nation. Nothing
> bold or masculine or grand or powerful touches an English Connoisseur – it must
> be small and highly wrought, and vulgar & humorous & broad & palpable. I
> question whether Reynolds would now make the impression he did, so com-
> pletely is the taste ebbing to a Dutch one.

Haydon's career, a tragi-comedy of high endeavour and High Art, vividly encompasses many of the artistic problems which emerge just prior to the Victorian era. One of the great eccentrics of British art, he was consumed, in his own words, by an 'irresistible, perpetual and continual urging of future greatness … like a man with air balloons under his armpits and ether in his soul'. Haydon like Sir Joshua Reynolds was a Devonian, and attended the same grammar school at Plympton where he read his predecessor's *Discourses*, which later inspired him to write: 'I felt my destiny fixed. The spark which had for years lain struggling to blaze, now burst out for ever.' Haydon came to believe fervently that he possessed a divine mission: to found a great British School of History Painting and a system of public art education. 'I must believe myself destined for a great purpose; I feel it; I ever felt it; I know it.'

Haydon's enthusiasm touched a sensitive nerve in the English body politic. As early as 1811 he argued for the commercial benefits of art education: 'Why is France superior in manufacture at Lyons? Because by State Support she educates youth to design.' Again in 1815 he advocated 'the establishment of a system of Public Schools of Design for the benefit of the art and manufactures of the country'. Haydon's

8
David Wilkie
**The Refusal from Burns's
Song of 'Duncan Gray'**
1814
oil on wood, 62.8 × 51.7cm
(24¾ × 20⅜ in)
Victoria and Albert Museum,
London

9
David Wilkie
**Chelsea Pensioners Reading
the Gazette of the Battle of
Waterloo**
1818–22
oil on canvas, 97 × 158cm
(38¼ × 62¼ in)
Wellington Museum,
Apsley House, London

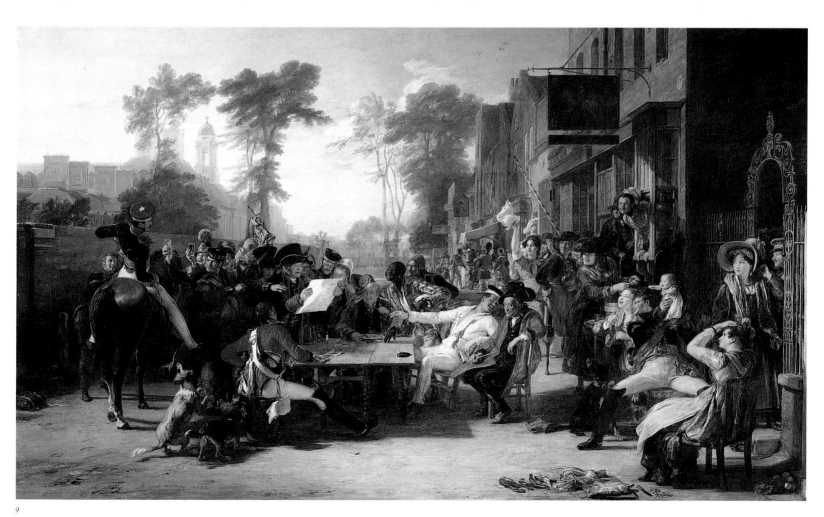

9

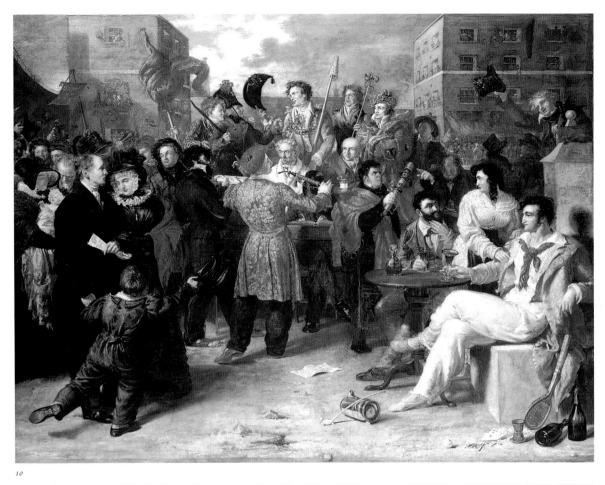

10

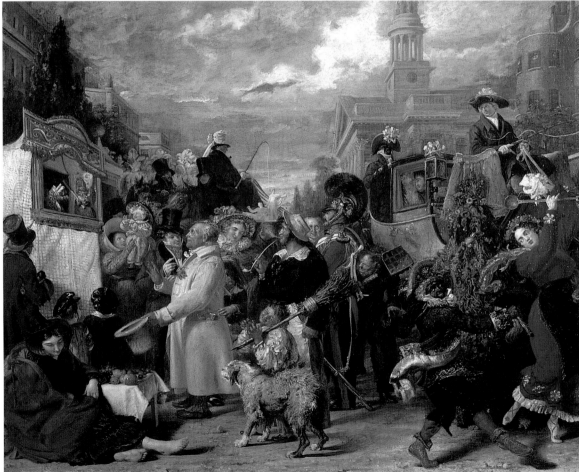

11

dreams of Ancient Greece and Rome were realized in the heavily pillared porticos of buildings in industrial towns which house public museums and institutions. His journeys to those towns to lecture did much to bring about their creation. But although the first of several Government Schools of Design was indeed to be inaugurated in Somerset House in 1837, Haydon received no recognition for his role in galvanizing radical support to achieve this end.

Haydon indeed achieved greatness, but not as a result of his History painting, which was described by Dickens, who liked him, as 'quite marvellous in its badness'. Ironically, his lasting fame has come from his genre scenes, and posthumously from the 26 volumes of his amazingly dramatic journal which brings vividly to life his friends, who included Wordsworth, Keats, Charles Lamb and William Hazlitt.

He painted several works recording the growing power of the middle classes, such as *The Reform Banquet* (1834), and was keenly interested in the burning issue of the day, political reform, reflected in *The Meeting of the Unions on Newhall Hill, Birmingham* (1832). An improvident businessman, he was first incarcerated for debt in the King's Bench Prison in July 1827, which was the immediate inspiration for his painting *The Mock Election* (Pl. 10), an ironic reference to Hogarth's famous *Election* series. The scene depicted shows the exercise yard of a London debtor's prison, where the inmates are participating in a cheerful mimicry of the political process. The chief candidate, sporting a large red rosette on his hat, is confidently canvassing his fellows' support, while lobbyists proffer their petitions and the rabble quaff wine. Any sense of a real election is far away: so much so that George IV, no lover of democracy, added the work to the Royal Collection for the rewarding price of 500 guineas. Its Hogarthian details and humour delighted the young Princess Victoria.

Haydon's genre masterpiece was yet another Hogarthian exercise, *Punch, or May Day* (Pl. 11). The central point of the complex composition is the almost hidden face of an 'Image Seller' who carries on his head a board bearing plaster casts of classical figures for sale. A sailor smoking a long clay pipe puffs clouds of smoke which partially hide two of the plaster casts, the Apollo Belvedere, and the Ilissos from the Elgin Marbles, which the artist greatly admired. The pipe smoke is an ironic reference to Hogarth's famous engraving *Time Smoking an Old Master*. The figure of Apollo points right to a handsome young guardsman, two lovers in a coach and a young lady being molested by the carnival May Day figure of a Jack in the Green – symbols of youth and vitality. The Ilissos points left at a pickpocket, the eternal drama of Punch and Judy, and a hearse, symbolic of death and disaster.

Haydon's genre scenes, full of such fascinating details, anticipate the great cross-sections of human life by Frith, among the most valuable of all visual documentary records of the Victorian era. Haydon, however, continued to dream of success as a history painter. His paintings of the real heroes of his time were much in demand, and he produced no fewer than 23 versions of a portrait of the lonely brooding figure of *Napoleon on St Helena*, and 25 variants on the theme of *Wellington Musing on the Field of Waterloo*. One of these variants was *The Hero and his Horse on the Field of Waterloo*, which inspired a poem by his friend Wordsworth. In 1842 Haydon painted *Wordsworth on Helvellyn* (Pl. 12) showing the great poet in old age brooding over the landscape which had inspired so much of his finest poetry. While Wordsworth sat for him, Haydon discovered that the poet conformed to 'ideal' dimensions: 'I found him, to my wonder, eight heads high, or 5 feet 9¾ inches, and of very fine heroic proportions.'

There is something comic in Haydon's delight at these ideal dimensions, but it was such enthusiasm for the 'nuts and bolts' of the ideal that made Haydon an inspiring teacher. One of his pupils was the young Edwin Landseer (1802–73), whom in

10
Benjamin Robert Haydon
The Mock Election
1828
oil on canvas, 142 × 183cm
(56 × 72in)
Royal Collection

11
Benjamin Robert Haydon
Punch, or May Day
1829
oil on canvas, 150.5 × 185.1cm
(59¼ × 72½in)
Tate Gallery, London

12
Benjamin Robert Haydon
Wordsworth on Helvellyn
1842
oil on canvas, 124.5 × 99.1cm
(49 × 39in)
National Portrait Gallery,
London

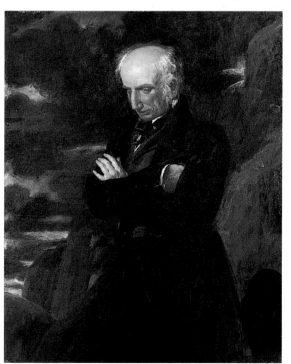

12

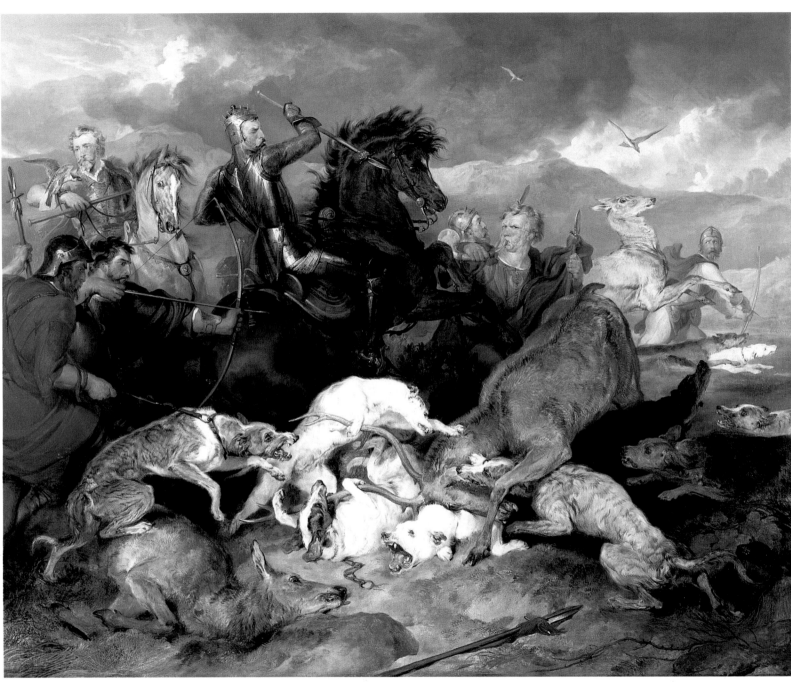

13

1815 he encouraged to study anatomy, lending him sketches of lions to copy. Haydon described how Landseer 'had dissected animals under my eye, copied my anatomical drawings, and carried my principles of study into animal painting. His genius thus tutored, has produced solid and satisfactory results.' The contact with a mind of such a grandiose nature as Haydon's must indeed have enlarged the young Landseer's imagination, and made him resolve to raise animal painting to heights unimagined by Reynolds when formulating his 'pecking order'. But before he devoted his energies solely to animal painting, Landseer created several successful history and genre paintings.

In 1824 he first visited Scotland, and fell in love with the Highlands. He met Sir Walter Scott at Abbotsford, and may have stayed at Chillingham Castle in Northumberland, close to the scene described in the famous Border *Ballad of Chevy Chase*, a theme which inspired one of Landseer's finest early works, *The Hunting of Chevy Chase* (Pl. 13), which is permeated by the romantic imagery of Scott's novels

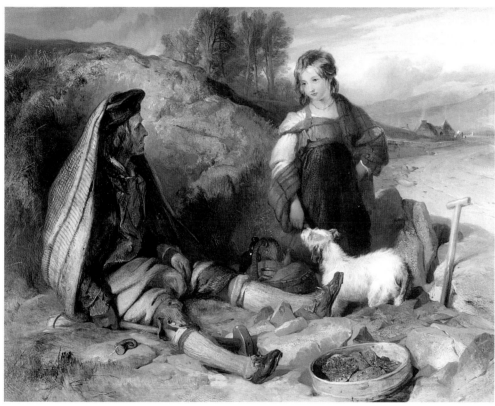

14

and poems. A History painting on a grand scale, it pays handsome tribute to his seventeenth-century Flemish predecessors, notably Frans Snyders (1579–1657). Landseer also embarked upon a number of contemporary genre scenes in which he explored the lives of Scottish crofters.

Ever since the late eighteenth century the road system of the country had been dramatically improved by the surveying and engineering work of Thomas Telford and John McAdam, accomplished not with sophisticated modern earth-moving techniques but by the physical labour of stonebreakers and navvies. The key early proto-realist painting *The Stonebreaker and his Daughter* (Pl. 14) contrasts the physical exhaustion of the old man slumped on the ground, his ram's horn full of snuff beside him, with the youth of his pretty daughter. She has brought him his lunch in a basket, and looks down at her father compassionately while the rough-haired terrier muzzles her hand. In the distance the smoking chimneys of the crofter's cottage hint

15
Samuel Palmer
**Coming from Evening
Church**
1830
tempera on paper, 30 × 20cm
(11¼ × 7⅞ in)
Tate Gallery, London

16
John Constable
**The Cenotaph to the
Memory of Sir Joshua
Reynolds, Erected in the
Grounds of Coleorton Hall,
Leicestershire, by the Late
Sir George Beaumont, Bart.**
1836
oil on canvas, 132·1 × 108·6cm
(52 × 42¾ in)
National Gallery, London

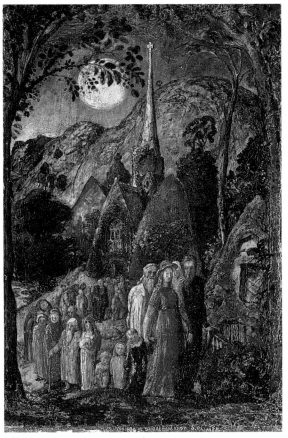

15

at the favourite early nineteenth-century sentiment of happy domesticity in rural poverty, extolled by Robert Burns in such lines as:

> The honest man, though e'er sae poor
> Is king o'men for a' that.

This presentation of manual labour of the most physically demanding type takes on an unusual significance when later treatments of the subject are recalled. It was used as a pictorial theme in 1857 by two artists of the Pre-Raphaelite School, Henry Wallis (Pl. 357) and John Brett (Pl. 112), and most notably in 1849 in France by Gustave Courbet (Pl. 388).

The seven brief years of William IV's reign (1830–7) before Victoria was crowned possessed qualities as individual as the nine-year reign of her son Edward VII (1901–10), which followed her 63 years upon the throne. While the Edwardian era can be described as the last golden, autumnal days before the the cataclysm of the First World War, the reign of William IV was more akin to spring. It was a time which saw radical changes of gear, both politically, with the Reform Bill of 1832, and artistically. On the walls of the Royal Academy genre painting was in the ascendant, but romantic landscape painting still flourished. Although Reynolds had castigated landscape for being merely topographical, 'a representation of a particular spot', some landscape painters mixed their paints with prayer to produce very remarkable results.

The most notable visionary painter was Samuel Palmer (1805–81), who from 1827 to 1832 settled amidst the hilly scenery of the Shoreham valley in Kent, the 'garden of England'. There he painted small, 'ideal', jewel-like landscapes, works which combine a medieval primitivism with a passionate love of nature, portraying moonlit harvesters, congregations leaving church on starry nights with a full moon (Pl. 15), or trees in full blossom. Palmer's landscapes had deeply religious overtones, for he described nature as 'the gate into the world of vision', and believed that 'bits of nature are generally much improved for being received into the soul'. He wrote of the vision he strove to achieve: 'One must try behind the hills to bring up a mystic glimmer like that which lights our dreams. And these same hills (hard task) should give us promise that the country beyond them is Paradise.'

Palmer's paintings provide one of the last clear Romantic statements of identification with nature before the onset of a materialistic and mundane age. Another very different farewell to old values can be found in two of the last exhibited works of John Constable (1776–1837).

In 1836 Constable exhibited *The Cenotaph to the Memory of Sir Joshua Reynolds, Erected in the Grounds of Coleorton Hall, Leicestershire, by the Late Sir George Beaumont, Bart.* (Pl. 16) at the last Royal Academy exhibition in Somerset House, before the move to new premises in Trafalgar Square which it shared with the National Gallery until 1868. Sir George Beaumont had been one of the chief founders of the National Gallery, and was a friend and patron of Constable and Wordsworth. Constable nostalgically paid tribute to both men in this memorial painting, which brought 'Sir Joshua Reynolds's name and Sir George Beaumont's once more in the catalogue, for the last time at the old house'. The painting, Constable's own valedictory assertion of the old values expressed by Reynolds, depicts the cenotaph at Beaumont's home, Coleorton Hall, inscribed with a poem by Wordsworth:

> Ye lime trees ranged before this hallowed urn …
> Where REYNOLDS 'mid our countrey's noblest dead,
> In the last sanctity of fame is laid.

Reynolds's admiration for the great masters of the Renaissance led Constable to flank the cenotaph in his painting with busts of Michelangelo and Raphael.

Constable also loved to paint watercolours, but these were rarely exhibited. An

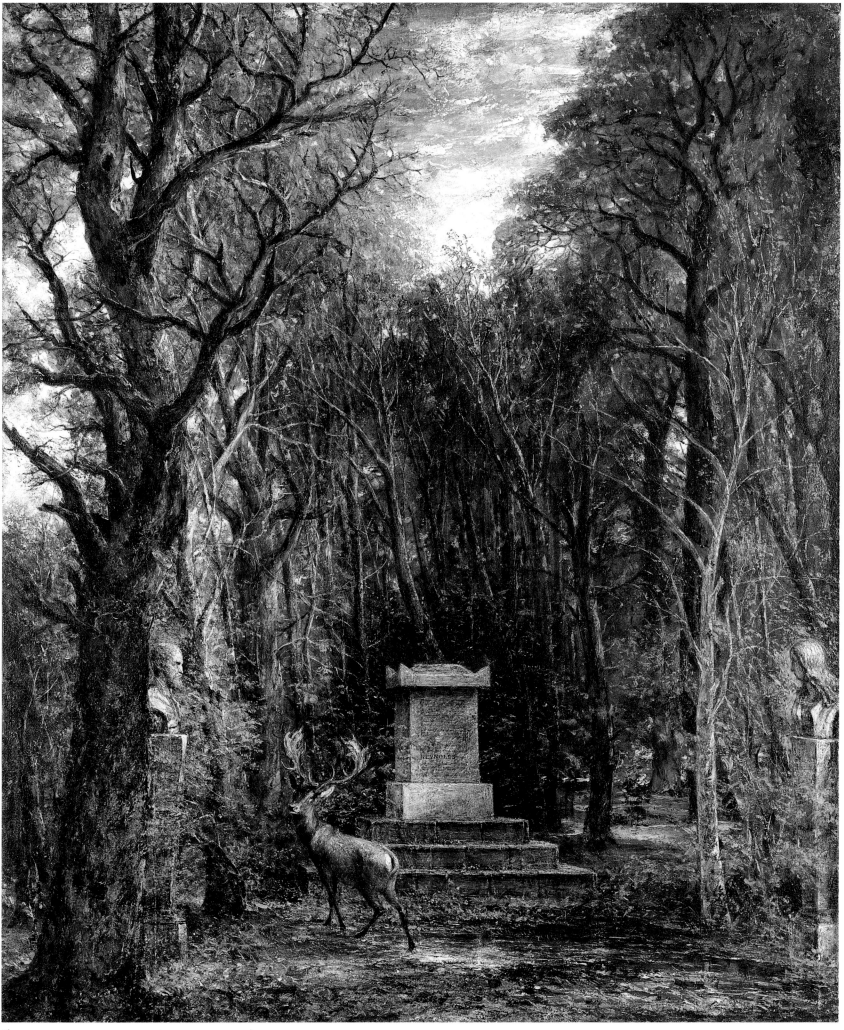

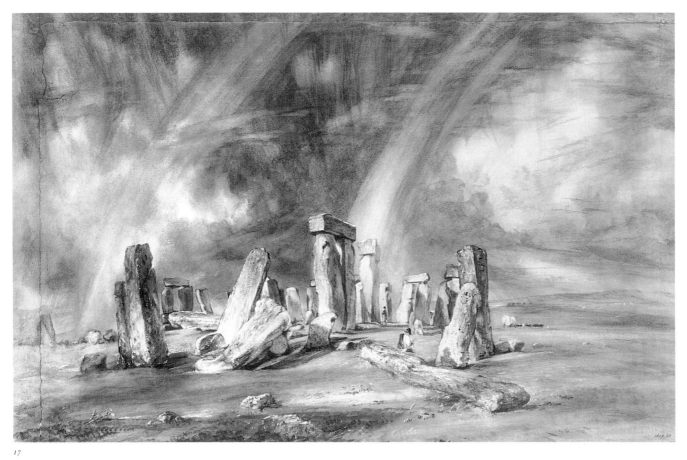

17

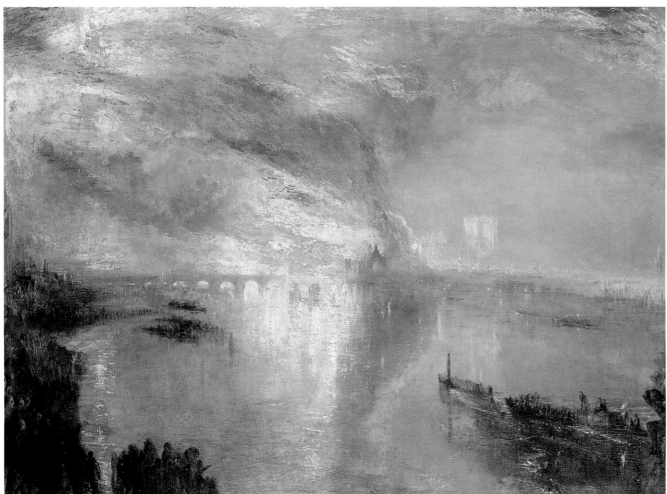

18

exception was his view of *Stonehenge* (Pl. 17), depicted with a double rainbow. This landscape, also exhibited in the Royal Academy in 1836, is one of the greatest of all British watercolours. The shadow of an old man on one of the great stones symbolizes the fleeting nature of life, as does the hare scuttling along at the bottom left of the sheet. Constable cut the animal out and collaged it on the sheet to give a feeling of spontaneity. This was a quality which he prized, once explaining that he was prepared to sit, no matter how long, 'till I see some living thing; because if any such appears, it is sure to be appropriate to the place'. (He once sat so still that he discovered a field mouse in his pocket!) Constable died on 1 April 1837, shortly before the accession of the young Queen.

During the Victorian era this quality of spontaneity was to become one of the least-valued aspects of a work of art. Constable's hare, like Turner's studies of fireworks on the lagoon at Venice, would provide one of the last bursts of energy of this type. Turner once remarked to his young admirer John Ruskin, 'I never lose an accident', a phrase which reveals the secret of the vibrancy of many of his watercolours. This love of spontaneity was recorded by the painter William Parrott (1813–89) in a small oil study of Turner on a 'varnishing day' (Pl. 19), one of the three days when exhibitors were allowed to make last-minute adjustments to their work. Turner is shown transforming his paintings like 'a magician performing his incantations in public', producing what Constable jealously described as 'airy visions, painted with tinted steam'. He is armed with a palette and an arsenal of brushes in his hand, scumbling glazes on a painting, while other artists look on in admiration.

Turner was greatly interested in a balloon flight that took place on 7 November 1836 from Vauxhall to Germany, writing to one of the balloonists saying, 'Your excursion so occupied my mind that I dreamt of it.' Although he himself was never to experience flight, his vivid visual imagination enabled him to paint as though from viewpoints high in the sky. This illusion occurs in his watercolour sketches of the great fire at the Palace of Westminster in 1834, which he later used as the inspiration for two powerful oils, which portray the blaze at its height (Pl. 18). This view is taken from above the Surrey end of Waterloo Bridge, looking towards Westminster and Westminster Bridge. As with his other oil paintings of the 1830s, these were made not for commission but to please himself. In his final years, which overlapped with the beginning of the new reign, he produced many of his most famous works.

The fire in the Palace of Westminster was a crucial historical event, for it marked a watershed in the political and social life of Great Britain. Only two years previously the new middle classes had been swept to power by the Reform Bill of 1832. Before the passage of the emancipating legislation that made this shift of power possible, the country had been on the verge of revolution. Afterwards, a horrified Duke of Wellington looked down at a House of Commons packed with newly emancipated middle-class industrialists and remarked that he had never seen so many 'bad hats' in his life. By 'bad hats', he implied that the new MPs were *nouveau riche* arrivistes who lacked the qualifications of gentlemen, notably by not owing their status to inherited land, but deriving their wealth from the new industrial heart of England in the Midlands and the North. Yet from this class was to emerge an important new phenomenon – the self-made man eager to show that culture was not solely the prerogative of the aristocracy.

What sort of works were artists to create to provide the visual pabulum for these eager collectors? Would they follow the advice of Sir Walter Scott, who wrote, 'It is the proper business of the fine arts to delight the world at large by their popular effect rather than to puzzle and confound them by depth of learning'? These questions will find an answer in a survey of the Victorian art establishment.

17
John Constable
Stonehenge
1836
watercolour, 38.7 × 59.1cm
(15¼ × 23¼in)
Victoria and Albert Museum,
London

18
J.M.W. Turner
**The Burning of the Houses
of Parliament**
1835
oil on canvas, 92·7 × 123·2cm
(36½ × 48½in)
Cleveland Museum of Art

19
William Parrott
**J.M.W. Turner at the Royal
Academy, Varnishing Day**
1846
oil on wood, 25 × 22.8cm
(9¾ × 9in)
Ruskin Gallery, Collection
of the Guild of St George,
Sheffield

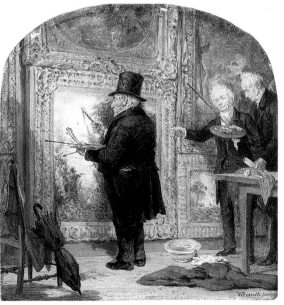

19

In December 1822, when the idea of a National Gallery was still under discussion, Constable wrote: 'Should there be a National Gallery, which is talked of, there will be an end of the art in poor old England, and she will become in all that relates to painting as much a nonentity as every other country that has one. The reason is plain: the manufacturers of pictures are then made the criterion of perfection, instead of nature.' What worried Constable were the vast numbers of dubious Old Masters on the market, the direct result of the perfectly innocent practice of artists copying masterpieces as part of their training. This could take place at several different places, one being the British Institution in Pall Mall. This organization had been founded in 1805 with the object to 'encourage and reward the talents of the artists of the United Kingdom, and to open an exhibition for the sale of

21
Frederick Mackenzie
**The National Gallery when
at Mr J.J. Angerstein's
House, Pall Mall**
1824
oil on wood, 46.7 × 62.2cm
(18⅜ × 24½in)
Victoria and Albert Museum,
London

21

their productions', thus breaking the virtual monopoly of the Royal Academy.

At the British Institution a series of annual exhibitions was held, at which collector members could show their latest acquisitions. The first show, held in 1815, was of Flemish and Dutch paintings, drawn from private collections. The event reflected a growing taste for Dutch genre which had developed in England. Even Reynolds, supreme champion of History painting, had paradoxically both enjoyed and collected Dutch genre. The Prince Regent, later George IV, bought with enthusiasm and flair both individual masterpieces and *en bloc*, purchasing 86 canvases from Sir Thomas Baring in 1816. The future Prime Minister, Sir Robert Peel, followed suit, his collection of 77 works being eventually purchased by the National Gallery in 1871. Their example was followed by such major figures of the time as the Duke of Wellington and Thomas Hope, the great arbiter of Neoclassical taste.

Besides the enthusiasm for Dutch genre there was also an interest in the work of contemporary French artists. By introducing lofty sentiments, it was felt that genre painting could be infused with the concept of 'Natural Man' expounded by Jean-Jacques Rousseau. Diderot praised the work of Jean-Baptiste Greuze (1725–1805) as 'morality in paint', referring to his success at the 1755 Salon with *Father Reading the Bible to his Children*. Greuze worked within conventions of gesture and expression that were readily understood by an international audience. In England his works contributed to the romantic idealization of the labouring poor in the paintings of artists such as Francis Wheatley (1747–1801), who was famed for his print series *The Cries of London* (1792–5), the precursor of many paintings of itinerant street traders. Such subjects were also used by William Redmore Bigg (1755–1828), Edward Penny (1714–91), George Morland (1762/3–1804) and Thomas Gainsborough (1727–88), whose 'fancy pictures' of maids with brooms at cottage doors or guarding pigs have an engaging charm. So popular was Morland's work that it was extensively faked in his own lifetime. These forgeries led to a lively demand for new paintings, for why buy a dud Morland when you could buy an original William Collins, or Thomas Webster?

Despite Constable's fears, the National Gallery was founded in 1824 when the government purchased 38 paintings from the collection of John Julius Angerstein, a merchant who had died in 1823. They were first displayed in his former home at 100 Pall Mall. A watercolour by Frederick Mackenzie (1787–1854) depicts the principal room as it was first shown to the public in 1824 (Pl. 21). The large painting on the right is *The Raising of Lazarus* by Sebastiano del Piombo, which is No. 1 in the National Gallery Catalogue. Here also the Old Masters could be copied, a process which increased after William Wilkins's new building opened in Trafalgar Square in 1838. The 'National Pepper Pot', as it soon became known because of its shape,

provided shared premises for both the National Gallery and the Royal Academy from 1838 to 1868.

Copying facilities at both institutions were often shamelessly abused by unscrupulous dealers who commissioned artists to counterfeit old paintings. Fraudulent auctions and doubtful dealers abounded. Smoke-filled 'ovens' were kept busy in which paintings were kippered and 'distressed' into antiquity. As many as 12,000 foreign paintings also found their way into the country each year, and onto the art market. Faced with such dubious works it is not surprising that many discriminating eyes sought the reassurance of buying direct from a live artist.

After the passage of the Reform Bill in 1832 there was a pronounced and continuing shift in patronage of the arts. The role of patron ceased to be the prerogative of members of the professional classes such as architects like Sir John Soane (1753–1837), who willed his house and its collection to the country in 1833. Patronage was increasingly practised by *nouveau riche* businessmen who had made their money by the methods described in the best-selling book *Self Help* (1859) by Samuel Smiles. The vocations of these self-made men were very various. As the early Victorian painter Thomas Uwins put it: 'The old nobility and land proprietors are gone out. Their place is supplied by railroad speculators, iron mine men, and

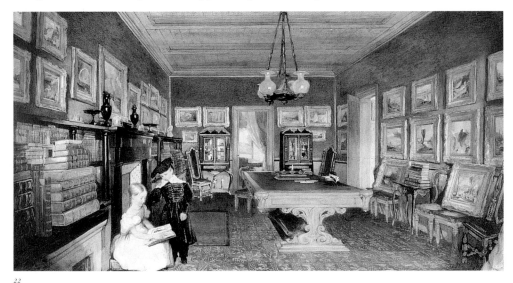

22
John Scarlett Davies
**The Library of Benjamin
Godfrey Windus**
1835
watercolour, 28.8 × 55.1cm
(11¼ × 21¾in)
British Museum, London

22

grinders from Sheffield, Liverpool and Manchester merchants and traders.'

Robert Vernon (1774–1849), for example, was an army contractor who had built on the success of his father's carriage hire firm. His major art collection was left to the National Gallery in 1847, an action which was held up as an example to other collectors. There were two wine merchants, John Allnut (1773–1863), an amateur art dealer and archaeologist, and John James Ruskin (1785–1864) the famous critic's father, whose son spurred him on as a collector by saying that 'a room without pictures is like a face without eyes'. There was Benjamin Godfrey Windus (1790–1867), a pill manufacturer and property speculator, a 'hard-nosed' dealer whose speculations on the art market included such tricks as submitting two Turners for sale at Christie's and bidding the price up twice so that they reached a new inflated saleroom record. We gain a glimpse of Windus's collection in a watercolour of his library in 1835 by John Scarlett Davies (1804–45; Pl. 22). In this room, built without windows to protect watercolours from the light, the young John Ruskin spent hours studying Turners while writing *Modern Painters*.

On the sale of Windus's collection much was made of the fact that it had been formed by 'a man engaged at one time in mere trade … simply and absolutely a

23
William Mulready
**An Interior Including
a Portrait of John
Sheepshanks at his
Residence in Old Bond
Street**
1832
oil on wood, 50.8 × 40cm
(20 × 15⅞in)
Victoria and Albert Museum,
London

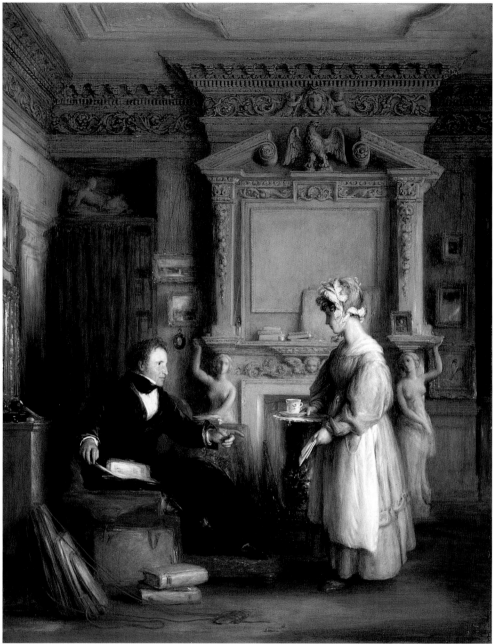

23

Londoner of the middle-class, actively occupied in business'. Later in the century another pill manufacturer, Thomas Holloway (1800–83), was also to form one of the key collections of Victorian paintings, which he left to Royal Holloway College, Egham – the educational institution for women which he founded in memory of his wife. The collection of 77 paintings was formed at the top of the market in two years in the early 1880s, and included major works by Landseer, Frith (Pl. 321), Briton Rivière (Pl. 280) and Edwin Long (Pl. 358).

Lady Eastlake, a distinguished art historian whose husband was both Director of the National Gallery and President of the Royal Academy, looked back to the decade 1830–40, when writing thirty years later in 1870:

A change which has proved of great importance to British art dates from these
years. The patronage which had been almost exclusively the privilege of the
nobility and higher gentry, was now shared (to be subsequently almost engrossed)
by a wealthy and intelligent class, chiefly enriched by commerce and trade; the
note book of the painter, while it exhibited lowlier names, showing henceforth

higher prices. To this gradual transfer of patronage another advantage very important to the painter was owing; namely that collections, entirely of modern and sometimes only of living artists, began to be formed. For one sign of the good sense of the *nouveau riche* collector consisted in a consciousness of his ignorance upon matters of connoisseurship. This led him to seek an article fresh from the painter's loom, in preference to any hazardous attempts at the discrimination of older fabrics.

One of the most interesting of all these early collector patrons was John Sheepshanks (1787–1863; Pl. 23), who came from a family enriched by the great expansion of the cloth industry at the end of the eighteenth century. Until middle age he remained a partner in the family business in Leeds, but after his father's death he sold up and moved to London. He first showed a fine sense of discrimination in creating a scholarly collection of Old Master etchings which he presented to the British Museum, and he also bought copies of Italian paintings. The foundation of the National Gallery in 1824 probably made him realize that there was little he could contribute to the Old Master field, but much, on the other hand, to contemporary British art. He developed a keen interest in acquiring works by living artists of the British School and decided to found a National Gallery of British Art; this was put into effect in 1857 by his gift of 233 oils and 298 drawings and watercolours to the new museum at South Kensington. Sheepshanks's achievement was a major one, and his collection today provides us with a microcosm of early Victorian taste. The gallery thus founded retained this function until the opening of the Tate Gallery in 1897, which then took over responsibility for the representation of the British School.

The Royal Family would play a central role in determining the course of art in the new reign. Queen Victoria was only eighteen when she came to the throne in June 1837, and was crowned Queen a year later on 28 June 1838. In 1840 she married her cousin, Prince Albert of Saxe-Coburg Gotha, who for her was a paragon of a husband, and who brought to his duties as Prince Consort a keen interest in the arts of music, painting and design. Prince Albert was passionately interested in art and a great collector of early Renaissance paintings of the Italian, German and Flemish schools. A natural proselytizer, he shared this enthusiasm with Sir Charles Eastlake (1793–1865), the Director of the National Gallery.

As an art historian the Prince Consort was decades ahead of his time. In 1853, with the help of Dr Carl Ruland, his librarian, he began the task of putting into order the Raphael drawings in the Royal Collection, and of gathering a monumental corpus of both engravings and photographic reproductions of all known works by or connected with Raphael. In its thoroughness and in the use of photography, the work set a new standard in art-historical studies.

Unusually for someone of his rank, Prince Albert also had a keen interest in contemporary art, an area in which his activities would be deeply influential. These interests were recognized early by the Prime Minister, the perspicacious Sir Robert Peel, who in 1841 appointed the Prince Chairman of the Royal Commission which was set up 'to take into consideration the Promotion of the Fine Arts of this Country, in connection with the Rebuilding of the Houses of Parliament'. The young Prince, aged only 22, and despite opposition, expertly steered the Commission to its famous recommendation that prizes should be offered for designs for frescos in the new buildings (see below, pp. 44–9).

In the seventeenth century Prince Albert's ancestor, Ernest (the Pious; 1601–75), had introduced compulsory education until the age of 16 in the Duchy of which he was the founder. Prince Albert also believed implicitly in the value of art and educa-

24
Henry Courtnay Selous
**The Opening Ceremony
of the Great Exhibition,
1 May 1851**
1851–2
oil on canvas,
169.3 × 241.6cm
(66¾ × 95¼in)
Victoria and Albert
Museum, London

tion as a moral cement for society. He may well have read with interest the report of a committee set up in 1835 to examine the connections of the arts and manufactures. The report reflected a dissatisfaction with the limitations of art education, which was restricted to fine art, although industry had an ever-expanding need for designers. The committee began to bring about the establishment of schools of design with the purpose of gaining closer collaboration between art and industry.

The Prince adopted such ideas with enthusiasm. In the energetic figure of Sir Henry Cole (1808–82), a maverick civil servant of great vision, he found the ideal man to effect the major enterprise of the Great Exhibition of 1851, which was designed to 'improve standards of design and manufacture in industry and the applied

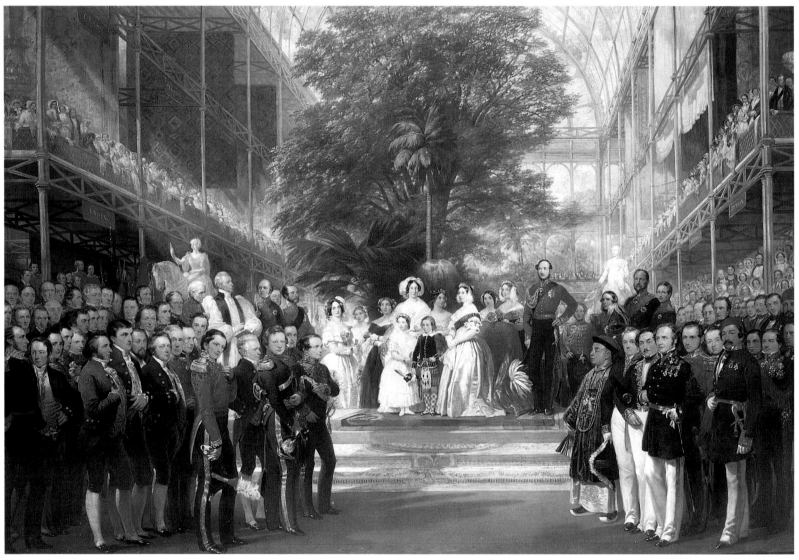

24

and decorative arts'. We have a memorable glimpse of the opening ceremony on 1 May 1851 by Henry Courtnay Selous (1803–90; Pl. 24). (The Chinese man on the right named Hee Sing, who had 'gate-crashed' the V.I.P. enclosure, had a junk selling Chinese goods in the Pool of London.) The exhibition was held in Hyde Park in the Crystal Palace, a vast building of glass and iron, the design of which influenced the construction of similar structures at International exhibitions in New York in 1853, Paris in 1855 and Vienna in 1873. The Crystal Palace remained open in central London for over five months, before being re-erected at Sydenham in 1852, where it stood until it was destroyed by fire in 1936.

The Great Exhibition attracted 6,170,000 people, making £505,000 of which

£150,000 was profit. This money was invested in the purchase of an estate at South Kensington on which numerous national institutions have been built, making the name South Kensington almost synonymous with museums. But the Great Exhibition had concentrated exclusively upon the decorative arts and contained no paintings. This situation was remedied in Manchester, for not to be outdone by London, the city sought the Prince Consort's advice about an event to rival the Great Exhibition. Albert suggested that on this occasion the theme should be art rather than industry.

The Art Treasures Exhibition held at Manchester in 1857 contained 1,079 works by Old Masters, 689 'paintings by modern masters' (which included names as varied as Hogarth and Landseer), 386 British portraits, nearly 1,000 watercolours, 59 miniatures and 44 paintings lent by the Marquis of Hertford from what would become the Wallace Collection. It was claimed that it was the greatest assemblage of Old Masters ever brought together, and it included major loans from both the Royal Collection and the personal collection of the Prince.

There were also wonderful collections of the applied arts, including suits of armour labelled DO NOT TOUCH which alarmed some little girls, a scene which the *Punch* artist Richard (Dicky) Doyle (1824–83) could not resist sketching in his personal copy of the catalogue (Pl. 25). This impressive three-volume work was largely the creation of Gustav Friedrich Waagen (1794–1868), the amazingly energetic German art historian whose descriptions of important but inaccessible country house art collections are still invaluable.

On 5 July 1841, Thomas Cook, an enterprising Leicester temperance worker, had the brainwave of organizing the first ever railway excursion from Leicester to Loughborough for a temperance rally. From these humble beginnings developed a thriving enterprise, which led in 1851 to trains from all over the country making the wonders of the Great Exhibition available to a vast cross-section of the British public. Trains also took the public in large numbers to the Art Treasures Exhibition in Manchester, where attendance averaged 9,000 a day. The *Art Treasures Examiner*, a weekly newspaper run during the exhibition, waxed lyrical about a textile factory's outing to this event:

> These visitors, all attired in their Sunday best, were brought to Manchester in three special trains, the first train consisting of 37 carriages. The fine brass band belonging to the establishment accompanied the first two trains, and the Saltaire fife and drum band the last. The work people entered the Exhibition in an orderly manner, with the bands playing 'The Fine Old English Gentleman' ... accompanied by their generous employer, Mr Titus Salt, who paid all the expenses ... The 2,500 partook of dinner in the large refreshment tent ... After dinner, the drum and fife band took up a commanding position ... and played some of their most popular pieces.

Although it all sounds very jolly there were sadly no labels or lecturers to explain the pictures. This omission was criticized by Charles Dickens, who found the exhibition 'too lifeless and dull for working people', who 'want more amusement, and particularly something in motion, though it were only a twisting fountain. The thing is too still after their lives of machinery; the art flows over their heads in consequence.'

These events reflected the optimism and self-confidence which permeated British society. The future would go on getting better and better thanks to the expansion of British industry and commerce, which, combined with missionary zeal, would spread the certainties of religious faith, the Pax Britannica and the English language across the world from the subcontinent of India to the 'dark continent' of Africa.

Tragically, the second London International Exhibition of 1862 was marred by

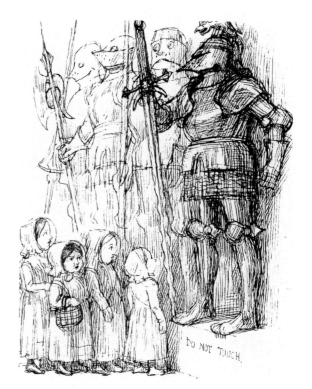

25
Richard Doyle
'Do Not Touch'
1857
sketch in margin of artist's
copy of the Art Treasures
Exhibition catalogue
Victoria and Albert Museum,
London

25

26
George Bernard O'Neill
Public Opinion
1863
oil on canvas, 53.3 × 78.6cm
(21 × 31in)
Leeds City Art Gallery

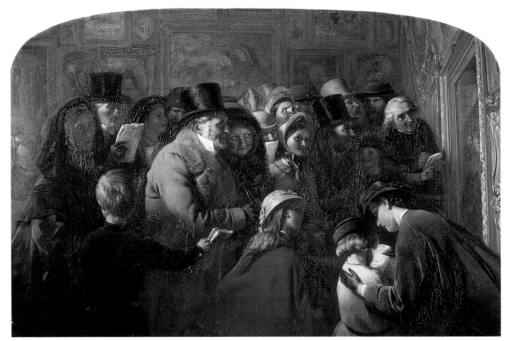

26

Prince Albert's death. The Queen was desolated by his loss, and later by the break-up of her immediate family, as one by one her daughters left home to make advantageous royal marriages abroad. For many years a miasma of mourning surrounded the court, and the Queen lost popularity with the nation at large. But the passing of the years saw her return to popularity and she became known as 'the Grandmother of Europe'. The public enjoyed such major events as her proclamation as Empress of India in 1877, followed ten years later by her Golden Jubilee and in 1897 by her Diamond Jubilee. This last period of her life was a sort of apotheosis, in which she was accepted as the living and apparently immortal symbol of British greatness and the Empire.

For much of the Queen's reign, the pattern of many of the 11,000 Victorian painters' lives listed in Christopher Wood's *Dictionary of Victorian Painters* may be compared in some respects to the progress of a club upwards through the tables of the Football League. Many successful artists advanced steadily up the promotion ladder having started in the humble role of exhibiting their works annually and helping to fill the vast walls of the Royal Academy with between one and two thousand exhibits. If fortunate they might paint the 'picture of the year', a work which particularly tickled the fancy of visitors. Large crowds would gather in front of such a painting, often producing quite a dangerous crush, as depicted in *Public Opinion* (Pl. 26) by George Bernard O'Neill (1828–1917). Such a success would help them to progress further up the promotion ladder to become elected Associate Royal Academicians and finally Royal Academicians, thus arriving at guaranteed financial success in the Premier League. Posthumous fame is unpredictable, however, and some artists' work, once greatly admired, is now for one reason or another often relegated to the lower 'second, third and fourth divisions' of art, normally condemned to remain unseen in reserve collections, although many such pictures are of considerable interest. Indeed, without this more mundane work it is difficult to place greater achievements in a proper context. When Royal Academicians were elected they had to deposit a 'Diploma work' which over the years led to the Academy housing an important collection of British art.

The financial rewards of becoming an 'RA' could be very great indeed, and were often accompanied by a knighthood and lavish studio accommodation. The

painter John Ballantyne (1815–97) specialized in depicting successful Royal Academicians happily working in their vast studios, painting no fewer than 15 works of this type, one of them (Pl. 27) showing Frith at work upon his vast painting of the marriage of the Prince of Wales (Pl. 455). Among other painters depicted by Ballantyne were Holman Hunt, Landseer, Sir Francis Grant, Clarkson Stanfield, Thomas Faed, Sir Noel Paton, and Daniel Maclise at work on the frescos in the House of Lords. Several of the artists' magnificent studios survive near Holland Park, notably the palatial home of Lord Leighton, now open to the public as Leighton House.

From the early nineteenth century there was a feeling that artists required a groundwork of technical knowledge. The first step to becoming a Royal Academican often involved tuition at one of two famous schools of drawing, Sass's Academy or Heatherley's School of Art. The satiric novelist Samuel Butler (1835–1902) began his career as a painter, and his *Mr Heatherley's Holiday: an Incident in Studio Life* (Pl. 28) provides us with a glimpse of Heatherley's School, referred to again and again in the biographies of Victorian artists, which acted almost in the role of a preparatory school before artists attained a place at the Royal Academy schools. 'Heatherley's' in Newman Street had the same props as the Academy – casts from antique sculpture, and skeletons for the study of anatomy. The skeleton 'was always getting knocked about and no wonder, the students used to dress it up, and dance with it – Mr Heatherley never went away on holiday; he employed the time at home repairing the skeleton.'

A painting by Charles West Cope (1811–90) of *The Council of the Royal Academy Selecting Pictures for the Exhibition* (Pl. 29) gives a vivid glimpse of the selection process

27
John Ballantyne
**William Powell Frith
Painting the Princess
of Wales**
1863
oil on canvas, 76 × 63cm
(29¾ × 24¾in)
Private collection

28
Samuel Butler
**Mr Heatherley's Holiday:
an Incident in Studio Life**
1874
oil on canvas, 92·1 × 70·8cm
(36¼ × 28in)
Tate Gallery, London

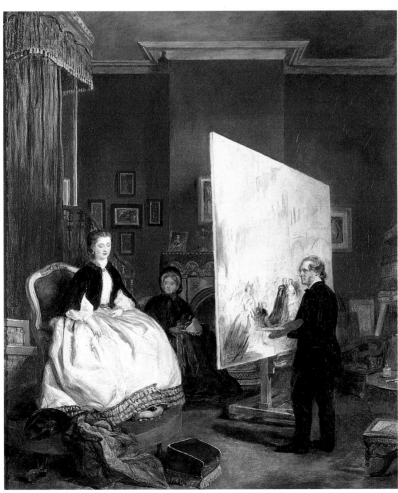

27

28

29
Charles West Cope
**The Council of the Royal
Academy Selecting Pictures
for the Exhibition**
1876
oil on canvas, 145 × 220cm
(57¼ × 86⅝in)
Royal Academy, London

for the Royal Academy's summer show which was then, as it remains, highly controversial. When this painting was first exhibited the catalogue entry read: 'The selection is made by the council of the year; all works sent in are brought before them, and are accepted, rejected, or made doubtful, the decision in every case being determined by a majority of votes, the President having the casting vote.' The President, Sir Francis Grant, is seated on the left holding a gavel. Just behind him is Cope himself, and next to him, in a brown jacket, Thomas Faed. Prominent in the centre, with his top hat on the floor, is the figure of Sir John Everett Millais (1829–96). He was to describe his career in a speech at the 1895 banquet at which he deputized for Lord Leighton as President, the post he was himself to occupy for a short while the following year. Millais said:

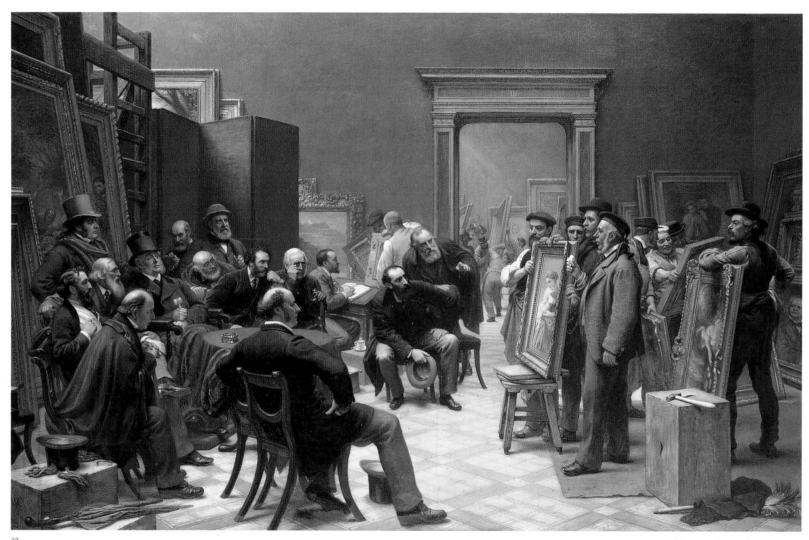

29

I must tell you briefly my connections with the Academy. I entered the antique school as a probationer, when I was eleven years of age; then I became a student in the Life School; and I have risen from stage to stage until I reached the position I now hold of Royal Academician: so that man and boy, I have been intimately connected with this Academy for more than half a century. I have received here a free education as an artist … and I owe the Academy a debt of gratitude I can never repay …

The Council was exclusively composed of members of the Royal Academy, which inevitably led some artists to question the fairness of the whole procedure. These criticisms were voiced in a satirical poem, 'A Rap at the RA', written in 1875 by the artist John Soden, which laments the way in which:

The toil of months, experience of years
Before the dreaded Council now appears–
It's left their view almost as soon as in it–
They damn them at the rate of three a minute
Scarce time for even faults to be detected,
The cross is chalked; 'tis flung aside 'Rejected'.

Soden also grumbled about the works which did succeed in finding a place on the walls and made fun of artists who:

… scenes of babydom immortalise
'Dear Baby's bath' 'Dear Baby – well!' – 'at meals,'
'Baby's first lollipop' – 'its little toes',
'First ittle toof' and 'Blowing Baby's nose'.

We can put both painting and poem in perspective when we learn that in the year 1875, 4,638 works were entered for the Summer Exhibition, of which 561 were accepted, 995 marked 'doubtful' and 3,082 rejected. Cope's painting brings this selection process vividly to life, making us realize what the screening process involved. Members and associates had the right to exhibit up to eight works automatically, although only portrait painters regularly took advantage of this privilege.

There were far more complaints from artists about being badly hung, rather than outright rejection. It was very important to the achievement of critical recognition to be hung 'on the line' instead of being 'skied' or hung very low on the crowded walls (see Pl. 19). The line was a ledge 2 inches deep which ran round the walls of the Academy at Somerset House and Trafalgar Square, at a height of 8 feet from the floor. All large pictures and full-length portraits were placed 'above the line', the heavy frames of the largest being supported by the ledge. The best position was 'on the line', that is below the ledge at, or just above, eye level. This was a contributory factor to the smaller average size of paintings in the early years of the Victorian era. When the Academy moved to its present home, Burlington House, in 1869, the line was abolished and larger paintings again became fashionable. This was fine for painters in oil, but what about watercolour painters?

Watercolour is a particularly British art form, eminently suitable for capturing vagaries of climate and depicting landscapes, and also well adapted for detailed depictions of architecture. Yet its very delicacy as a medium meant that from the first foundation of the Royal Academy in 1768, watercolour painters had to struggle to vie with the more spectacular effects attained by oil paint. This led a group of artists to found in 1804 a Society of Painters in Water Colours which had its premises in Pall Mall.

The Society, soon known as the Old Water Colour Society, fulfilled an important role and attracted a large following. But no institution remains unchanged, and by 1832 the Society had itself become an over-exclusive and conservative body, and a rival New Society of Painters in Water Colours was established, which changed its name to the Institute of Painters in Water Colours in 1863. Today, when you come out of the Royal Academy and look up at the first floor opposite, you can see the busts of Turner, Thomas Girtin, David Cox and George Barret gazing down rather forlornly on the bustle of Piccadilly from the palatial premises the Society occupied from 1843, now used for film previews.

A watercolour by George Scharf (1788–1860) gives a vivid impression of the New Society in 1834 (Pl. 30), with a fire burning brightly in the grate while visitors look at sketchbooks, or gaze at walls lined five-deep with watercolours in rich gold mounts and large frames. By 1850, fierce rivalries raged between all three institutions, which intensified after 1865 with the runaway success of still another institution, the

30
George Scharf
**Interior of the Gallery of the
New Society of Painters in
Water Colours, Old Bond
Street**
1834
watercolour, 29.6 × 36.9cm
(11⅝ × 14½ in)
Victoria and Albert Museum,
London

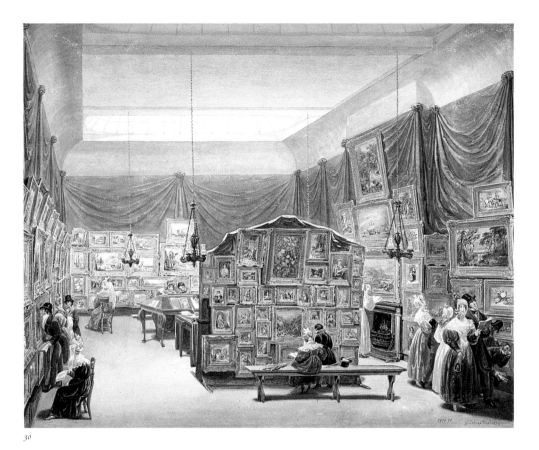

30

Dudley Gallery, which was given over to more aesthetic and daring works in water-colours. Distinct styles and themes were also associated with the older societies. The *Art Journal* tried to sum it up in 1861: 'The Old Water Colour Society was originally a body of landscape painters, and the New began life as a company of figure painters, by way of broad distinction from the senior body, but neither society has been able to sustain the character it assumed, and which was originally given to it.' The opening of the Dudley Gallery in 1865 at the Egyptian Hall, opposite the Royal Academy, created a new and much needed venue for artists whose 'aesthetic' works were shunned by more conservative institutions (see below, pp. 441–2).

All this rivalry was extremely good for business. Contemporary connoisseurs such as the Reverend Richard Ellison formed their collections by buying direct from the walls of exhibitions such as the one recorded by George Scharf. Ellison left his complete collection to what is now the Victoria and Albert Museum, where it forms the nucleus of the national collection of watercolours.

But there was a condition. Ellison was a strict Sabbatarian and these watercolours, some given in 1860, others bequeathed to the Museum by his widow in 1873, were only presented on the understanding that they would never be shown on Sundays. (Right up to the outbreak of the Second World War the last duty of an attendant on a Saturday night was to draw the curtains over the Ellison pictures to prevent the public seeing them on Sundays.) Public opening of museums on Sunday was a highly controversial issue. In the first few months after the opening of the Mappin Art Gallery in Sheffield in July 1877, 6,000 visitors would pass through in the three hours it was open on a Sunday afternoon. But Sunday opening was still quite unusual, for battle was joined between the Lord's Day Observance Society and the pro-opening National Sunday League who gradually won the argument. At long last most public galleries were opened on Sundays in 1896. The pro-opening lobby's memorial even today is to be seen in the fact that in many national and regional galleries attendance on Sunday is higher than on any other day of the week.

The actual hours when a gallery was open related closely to the audience it was aimed to attract. At South Kensington today visitors to fashionable private views lit by electric light are the descendants of artisans who paid 6d. to visit galleries illuminated by gas light up to 9 pm after a hard day's work. Throughout the Victorian era there was an ongoing concern for the education of 'the intelligent artisan class'. A leading figure in this process was the artist and administrator Richard Redgrave, who in 1858, at the opening of the new Cambridge School of Art, recalled how in 1841 a system of schools of design was initiated:

> for the purpose of instructing artisans – and artisans alone, for all others were carefully excluded – in designs for patterns; the prices charged being low, to suit the persons instructed. But it was found that after good designs were obtained, they were of no use; there was no public to adopt them; and it then became necessary to found schools for the improvement of public taste. Schools were opened for the admission of all classes of the community ... That movement was inaugurated in 1851.

As so often happens in the educational field, Scotland was far ahead of England in its practices, for the first government-funded art school in Britain was the Edinburgh Trustees' Academy, founded in 1760. It lasted just under a hundred years, for in 1858 it was taken over by a central government department. Its final years, under the directorship of the inspired teacher Robert Scott Lauder (1803–69), were of great importance for Scottish art. From Lauder's classes emerged such major figures as William McTaggart and William Quiller Orchardson.

Many schools of design were established all over the country. They enjoyed government funding administered for the Board of Trade by Sir Henry Cole. By 1856 it was claimed that there were 27,239 art students in training throughout the country. By 1894 Kensington controlled 285 provincial schools of art which gave instruction to 150,000 students. It was always intended that these schools should include museums of casts and specimens for study, in particular the London School at Somerset House, whose collections were much enlarged by decorative art exhibits from the Great Exhibition. At first housed in Marlborough House, these collections formed the nucleus of the Victoria and Albert Museum, where Richard Redgrave right from the start made sure that paintings also played a central role, in part because of his friendship with John Sheepshanks.

One of the attractions of South Kensington over Trafalgar Square was the relative purity of its air. The smoke of central London was so bad that it was said to blacken 'the clothing of sheep as far as Eltham, and to put the sparrows of London streets into perpetual mourning'. There were many attempts to move the National Gallery away from such insalubrious surroundings. The relative cleanliness of Kensington was a contributory factor to Isabel Constable leaving so many of her father's paintings to the South Kensington Museum in 1888. Other institutions founded in these years were a National Portrait Gallery, tentatively begun in 1856 with a government grant of £2,000, although the present premises were not opened until 1896, and the Slade School of Fine Art, opened in 1871.

Felix Slade (1790–1868) was an art collector and philanthropist who left funds to endow chairs of Fine Art at Oxford, Cambridge and University College, London. Both the professorships at Oxford and Cambridge only involved giving lectures, intended for a general audience. John Ruskin held the first Oxford appointment from 1870 to 1879, founding there the Ruskin School of Drawing. In London the Slade School of Fine Art from the beginning built up a great tradition of drawing from the nude inaugurated by Sir Edward Poynter (1836–1919), who held the chair from 1871 to 1875. Two other great teachers were Alphonse Legros (1837–1911),

who was appointed Professor in 1876, and Henry Tonks (1862–1937), under whom the School enjoyed its heyday from 1895 to the outbreak of the First World War. The Slade School rapidly superseded the Royal Academy Schools, where teaching methods were arid and academic.

In 1857 a Society of Women Artists was founded, a leading member being Mrs E.M. Ward (see Pl. 372). This marked the beginning of the long process of emancipation of women in art in the nineteenth century. Outside London there were major rivals to the Royal Academy: the Liverpool Academy, the Royal Manchester Institute and the Scottish Academy.

The success or failure of Victorian artists depended a great deal upon the critical responses to exhibited works in the press. Much of the comment was anonymous, or signed with a 'pen name' following the custom of the day, which positively encouraged savage criticism. The first important critical name was, rather surprisingly, that of the novelist William Makepeace Thackeray (1811–63) who had studied in a London art school and a Paris atelier before becoming a journalist and working for several periodicals, notably *Punch* and *Fraser's*. He wrote under the assumed name of Michael Angelo Titmarsh, a typically ironic reference to his own broken nose (which he had in common with Michelangelo) and his personal aspirations to be an artist. Trenchant and witty, his reviews of genre paintings at the Royal Academy form a great contrast to the cloudy rhetoric of the one name which dominated public opinion more than any other, that of John Ruskin (1819–1900). He was the subject of what has become almost a Pre-Raphaelite icon, the portrait of him by Millais standing on a rock in the middle of a waterfall in Glenfinlas (Pl. 31). The rock on which he stands, gneiss (Pl. 298), had particular associations for Ruskin, who described it in Volume IV of *Modern Painters* as 'the symbol of a perpetual fear'. The strata in petrified motion and the turbulent waterfall mirror the tensions between sitter, artist and the sitter's wife, caught in perhaps the most famous of all Victorian 'eternal triangles' (see below, p. 247).

Ruskin's most important work of art criticism is *Modern Painters* (5 volumes, 1843–60; epilogue, 1888), which began as a defence of Turner, and expanded to become a general survey of art. His admiration for the naturalistic and architectural qualities of the Gothic style is the theme of *The Seven Lamps of Architecture* (1849) and *The Stones of Venice* (3 volumes, 1851–3). Maddeningly inconsistent, he wrote at his best some of the most inspiring of all prose descriptions of works of art. At his worst, his dithyrambic adulation of 'doggies' by Landseer or 'girlies' by Kate Greenaway, coupled with his famous libel on Whistler, reveals the mental problems which ended in his complete breakdown in 1889. He remains one of the great pillars of the Victorian establishment, whose critical judgement was awaited with nervous apprehension by many artists, for Ruskin's opinions expressed in *Modern Painters* could make or break the reputation of an artist. As early as 1856 *Punch* carried this verse written by 'A Perfectly Furious Academician':

I takes and paints,

Hears no complaints,

And sells before I'm dry;

Till savage Ruskin,

He sticks his tusk in,

Then nobody will buy.

NB. Confound Ruskin; only that won't come into poetry – but it's true.

Burne-Jones's work in particular was regarded with suspicion by the critics. In 1869 the *Art Journal* condemned his work as 'supremely disagreeable', 'studiously offensive', and the product of 'a diseased imagination'. Two years later Rossetti,

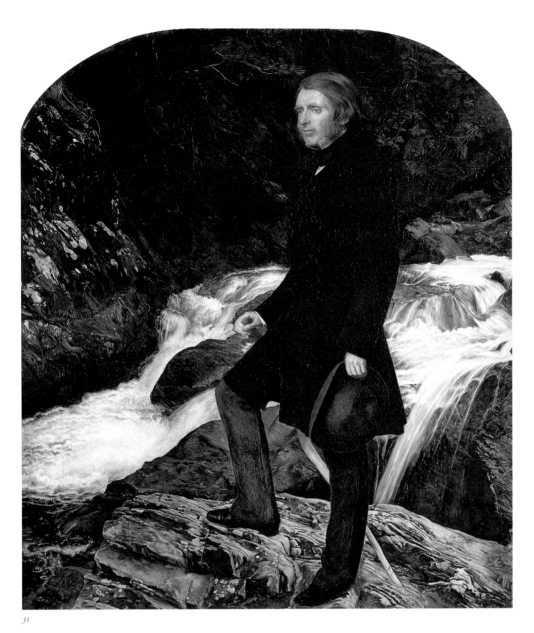

31
John Everett Millais
John Ruskin
1853–4
oil on canvas, 79 × 68cm
(31 × 26¾in)
Private collection

31

Simeon Solomon and other Pre-Raphaelites were attacked in 'The Fleshly School of Poetry', an essay which appeared in *The Contemporary Review* by Robert Buchanan, writing under the pseudonym of 'Thomas Maitland'. Such attacks were the reason why Rossetti never exhibited his work, and why Burne-Jones ceased to exhibit until the Grosvenor Gallery opened in 1877, when his work brought praise from Ruskin in the same article in which he attacked Whistler. Ruskin's clout as a critic was now even more formidable as he held the prestigious post of Slade Professor of Art at Oxford. His famous libel on Whistler, discussed below (pp. 470–4), was to mark a turning point in the history of art, the beginnings of theories as various as aestheticism, conceptualism and abstraction.

The apostle of aestheticism was an Oxford don, Walter Pater (1839–94), whose uneventful life was enlivened by his friendships with the artist Simeon Solomon and the poet Algernon Charles Swinburne (1837–1909). (Swinburne's own powers of criticism were considerable, providing unique insights into the aesthetics of his time.) Pater's *Studies in the History of the Renaissance* (1873), with its pioneering appreciations of Botticelli and Leonardo's *Mona Lisa*, was hailed by his disciple Oscar Wilde as the 'Holy Writ of Beauty'.

In his last major work, a record of the *Private View of the Royal Academy, 1881* (Pl. 32), Frith portrayed a cross-section of the 'good and the great' (see below,

p. 277) whose presence is testimony to the continuing social cachet of the Royal Academy. But change was in the air, for on 1 May 1877, at 135 New Bond Street, a new privately run gallery, the Grosvenor, had opened its doors (see below, pp. 450–4). This new venue enabled high society to enjoy art in its most extreme form. A glamorous private view was attended by every section of the Victorian establishment from politicians to the Royal Family. Indeed, as Oscar Wilde put it in the words of Lord Henry Wotton to the artist Basil Hallward concerning *The Picture of Dorian Gray* (1891):

> It is your best work, Basil, the best thing you have ever done … You must certainly
> send it next year to the Grosvenor. The Academy is too large and too vulgar.
> Whenever I have gone there, there have either been so many people that I have
> not been able to see the pictures, which was dreadful, or so many pictures that I
> have not been able to see the people, which was worse. The Grosvenor is really
> the only place.

Despite Wilde's words there were, of course, several other important and influential dealers who mounted exhibitions, such as the Fine Art Society, which in 1881 opened new premises in Bond Street designed by E.W. Godwin, still one of the most delightful spaces in London in which to look at paintings. Here Whistler was to stage some of the most original exhibitions of the Victorian era (see below, p. 474).

Art dealing often runs in families, notably in the famous firm of Thomas Agnew and Sons, which first began business in 1817 in Manchester, a Liverpool branch following in 1859. The most flamboyant member of the family was William Agnew (1825–1910), who played a leading role in forming the collections of Sir Henry Tate (1819–99), both initially in Liverpool and later in London where premises were opened in 1877. The firm of Agnews also sold many works to three great patrons of Birmingham Art Gallery, which although opened in 1867 did not have an official purchase grant until 1946. Without the Pre-Raphaelite paintings and works by David

32

Cox given and bequeathed by Sir John Middlemore, J.H. Nettlefold, and Sir William Kenrick, there would have been little to see in 1886, when the new building was opened. Yet within a year Birmingham Art Gallery was visited by 1,165,000 people, at a time when the population of the city was only half a million.

The belief in the function of museums as an important educational resource – an escape route to higher things for the intelligent artisan – led to the growth of museums as 'palaces for the people' all over the country and not only in London. The industrialization of the Midlands and the North of England, and the rapid increase in the size of cities such as Bradford and Leicester, produced a new breed of philanthropic captains of industry. Their local patriotism led them to wish that their home towns should boast all the trappings of civilization and, through the building of galleries, provide entertainment and instruction for their employees.

During the last three decades of the nineteenth century, despite its commercial rivals, the Royal Academy remained a powerful establishment. The supporters and officials of new art galleries opening in the Midlands and the North made frequent annual purchases from the summer exhibitions, which were regarded as a benchmark of orthodox attainment. But the downside of this process was that the Academy began to be seen as the bulwark of orthodox mediocrity, increasingly hostile to innovation and opposed to modern creative art. Particularly bitter arguments arose over the administration of the Chantrey Bequest.

When the sculptor Sir Francis Chantrey died in 1841, he left a magnificent financial bequest 'for the encouragement of British Fine Art in Painting and Sculpture only' which came into effect on the death of his widow in 1875. Under its terms the President and Council of the Royal Academy could purchase 'Works of Fine Art of the highest merit in painting and sculpture' for the nation.

By 1890 the Chantrey purchases numbered 52, many of them very large canvases. They were stored at South Kensington, an arrangement which led predictably to fierce territorial battles, all too familiar to any museum curator of a national institution. In 1891 an offer of £80,000 from Sir Henry Tate, the sugar magnate, to build a gallery was accepted by the Government, and the site of the old prison at Millbank selected. The Tate Gallery opened on 21 July 1897, the nucleus being the Chantrey pictures, Sir Henry Tate's collection, and 18 pictures presented by G.F. Watts.

By 1900 battle was joined with the 'moderns' who wished to encourage the acquisition of more adventurous works. The avant-garde critic Dugald Sutherland MacColl challenged the acquisition of yet another work by Frank Dicksee (1853–1928): 'If the Chantrey Trustees are of the opinion that their recent performance in the purchase of Mr Dicksee's *Two Crowns* fulfils the Bequest's conditions, the view is shared by no critic with a reputation to lose.' Despite these criticisms the Royal Academy continued to uphold Victorian pictorial values far into the twentieth century. This attitude was held by the President, Sir Edward Poynter, who was elected in 1896, and clung to office in his eighties until a few months before his death in 1919. He was then followed by the architect of the Victoria and Albert Museum, Sir Aston Webb, until 1924, and then by an ironic twist of fate by Sir Frank Dicksee, who until his death in 1928 maintained a gallant rearguard action against all aspects of modernism in art. His ghost must recently have been pleased by the return of his painting *Two Crowns* to exhibition on the walls of the Tate Gallery.

In 1949, soon after the Second World War, the whole Chantrey collection was exhibited at the Royal Academy to much critical comment. With hindsight this event can now be seen as the beginning of a revival of interest in Victorian painting, which has continued until today.

It was P.G. Wodehouse who remarked that if there was one thing universally recognized about the Victorians, it was that they were not to be trusted with a pile of bricks and some mortar. Throughout the Queen's reign buildings multiplied with frightening rapidity, and once up and running, lunatic asylums, hospitals, law courts, libraries, cemeteries, schools, memorials and especially town halls were often embellished with extensive wall decorations and mural paintings. Controversy raged not only over the subjects to be depicted but also over the techniques used to actually *paint* the pictures. The merits were discussed of *buon fresco* versus *fresco secco*, tempera versus oil paint, and new experimental methods such as 'spirit fresco'. As so often in Great Britain many problems arose from the variable climate. True fresco (*buon fresco),* the Italian word for 'fresh', as practised in Italy from the fourteenth century, was one of

33 Daniel Maclise, **The Meeting of Wellington and Blücher at Waterloo** (detail of Pl. 40)

the most permanent forms of wall decoration known. The wall was first plastered and the cartoon traced, then an area sufficient for a day's work was covered with a final fine layer of damp plaster and the pigments applied to it mixed with water. Because the plaster was still damp a chemical reaction took place and the colours became integrated with the wall itself as it slowly dried out. This process worked magically in Italy for artists as varied as Gozzoli and Raphael, but when used in the damp and fog of mid-Victorian England disaster often struck – the plaster never dried out! Some artists preferred to use the technique of *fresco secco* which involved painting on dry plaster, but this also had its disadvantages, for the effect was not unlike working on an ordinary distempered wall and the paint was liable to scale off. Because of these problems many artists opted to use the more manageable medium of painting in oil on canvases which, when completed, were mounted flush upon the walls, and thus incorporated within the architectural setting.

The story leading to the revival of British mural painting begins on 16 October 1834, when a disastrous fire destroyed the old Palace of Westminster. As the news of the conflagration spread, many artists came into central London to record the event, most notably Turner (Pl. 18).

The fire was to have far-reaching effects which, like the advent of photography, would threaten the supremacy of landscape painting, and afford a new importance to History painting in the form of frescos. The new Palace was rebuilt by Sir Charles Barry and Augustus Welby Northmore Pugin, whose decorative genius still permeates the building. But while Pugin's passionate belief in the revival of the Gothic style determined the ornamentation of the building, its effects were enhanced by the presence on the walls of an extensive pictorial record of great moments in British history. For these, paradoxically, we are largely indebted to the young German, Prince Albert, who at the age of 22 became Chairman of the Royal Commission set up in 1841 to promote the fine arts in connection with the rebuilding of the Houses of Parliament.

It is important to recall the Germanic background of Prince Albert, who in his youth had come in contact with the work of the Nazarenes, a group of idealistic German painters who believed that art should serve a moral or religious purpose and strove to return to the spirit of the Middle Ages. The name Nazarene was applied to them derisively to mock their biblical dress and hairstyles. In 1809 they moved to Rome where they lived and worked together in a disused monastery. They broke up as a group in the 1820s but their ideas continued to be influential, particularly on the large number of students who surrounded the charismatic teacher Peter von Cornelius (1783–1867) in Munich. The group provided a close prototype for the beliefs and preferences of the later British Pre-Raphaelite Brotherhood. The passionate contempt of the Nazarenes for prevailing academic styles was only surpassed by their admiration for the purity, piety and honesty of art before Raphael, whether north or south of the Alps. One of their most cherished aims was the revival of monumental fresco.

In 1841 Cornelius, who had become Director of the Academies of Düsseldorf and Munich, visited London to give advice on the projected new scheme at Westminster. He was extensively interviewed by Charles Eastlake (1793–1865), artist, art historian and administrator, whose role as Secretary to the Royal Commission was the first step in a career which led him to become President of the Royal Academy and Director of the National Gallery. In that post his love of early Italian painting had full scope, enabling him to make many major acquisitions.

Another admirer of the Nazarene school and its aims was the artist William Dyce (1806–64), a typical Victorian polymath with wide talents also as musician and

scientist. Born in Aberdeen, he studied in Rome where he had been profoundly impressed by the frescos of Raphael and the work of the Nazarenes, whose Christian primitivism appealed to his Scottish pietism. In 1828 he returned to England and exhibited two works at the Royal Academy painted on Nazarene principles, *The Madonna* and *Jacob and Laban*. Dyce was also a mural painter and his *Neptune Resigning to Britannia the Empire of the Sea* (Pl. 34), commissioned by the Prince Consort for Osborne House on the Isle of Wight, is one of the best-preserved of all Victorian frescos. From 1840 to 1843 Dyce was Director of the Government School of Design. Given two such enthusiastic advocates of the Nazarene style it is hardly surprising that the Commission decided that the new Houses of Parliament should be decorat-

34
William Dyce
Neptune Resigning to Britannia the Empire of the Sea
1847
fresco, 3.5 × 5.1m
(11ft 5in × 16ft 10in)
Osborne House, Isle of Wight

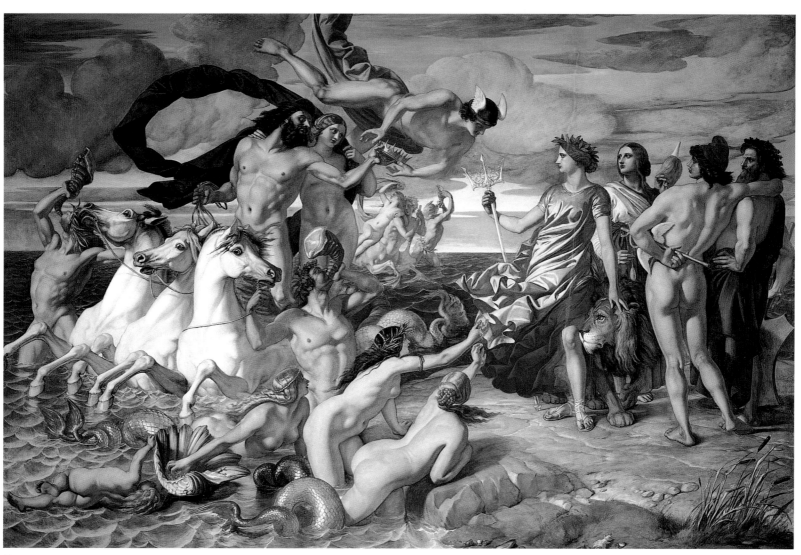

34

ed with monumental frescos, which would bring the history of the British nation to life on the walls of the great interiors of the House of Lords and the House of Commons. The Commissioners announced a competition for large rough designs, or cartoons, 'executed in chalk or charcoal, not less than ten nor more than fifteen feet in their largest dimensions, the figures to be not less than the size of life, illustrating subjects from British History or from the works of Spenser, Shakespeare or Milton'.

Meanwhile, shortly before the artists were selected to paint the frescos in the new Houses of Parliament, Prince Albert had commissioned a kind of trial run. This was a series of frescos in the lunettes of the octagonal central room of a garden pavilion in the grounds of Buckingham Palace; the subjects were to be taken from

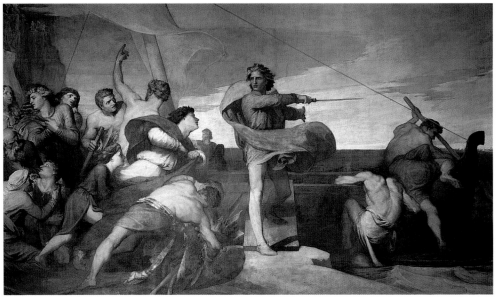

35

Milton's *Comus*, but with each artist illustrating a scene of his own choice. The men chosen were a cross-section of the leading artists of the day, including Sir William Ross, Clarkson Stanfield, Thomas Uwins, Sir Charles Eastlake, Charles Robert Leslie, Daniel Maclise, Sir Edwin Landseer, William Etty and William Edward Frost. Etty was unable to cope with the medium of fresco, and in 1844, amidst considerable bitterness, his commission was taken away and given to William Dyce. The garden pavilion was demolished in 1928, but the frescos were recorded in *The Decoration of the Garden Pavilion in the Grounds of Buckingham Palace* by Ludwig Gruner and Mrs Anna Jameson, published in 1846.

In 1843, a vast exhibition of the cartoons was held in St George's Hall, Westminster. The exhibition created enormous interest, and the caricaturist John Leech saw the opportunity for a series of biting satires, which he called 'Cartoons' and published in the new comic journal *Punch*. The new usage of the word 'cartoon' has stuck to this day. The closing day on 2 September saw huge crowds, partly due to the fact that one of the cartoons, *Saint George after the Death of the Dragon*, was the work of a promising young artist, Richard Dadd, who had sensationally murdered his father only days before (see below, p. 202).

Tragedy would also overtake another competitor, Benjamin Robert Haydon. He had been delighted by the Westminster competition, which at last seemed to realize the aims of his long campaign for government-funded murals in the new buildings. But sadly this great opportunity for history painters had come too late for him, for neither of his designs, *The Curse of Adam and Eve* or *The Black Prince Entering London in Triumph*, was accepted. He wrote bitterly that the authorities had 'resolved to employ none but those of German tendency'. Like the hero of his painting *Marcus Curtius Leaping into the Gulf*, exhibited and derided in 1843 at the British Institution, Haydon was to leap into the next life 'a comet to death and ruin'. He was distraught because another design, *The Banishment of Aristides*, which illustrated the evils of popular government, had been 'hooted by the populace'. They preferred to rush past the Egyptian Hall where it was on exhibition, to see the famous dwarf General Tom Thumb who was on show next door. In the first week Haydon took £7 13s. 0d., and Tom Thumb £600! Heartbroken, he ended his own life at the age of 60 in June 1846. Characteristically, Haydon's suicide was a hideously bungled affair. In his journal, found by his side, he had attempted to give his death a tragic grandeur by paraphrasing Shakespeare's *King Lear*: 'Stretch me no more on this rough world!' But

having selected a pistol of too small a calibre to kill himself efficiently, he was oblig-
ed to finish the job by cutting his throat with a razor.

Happily there were many successful competitors. Among those who won the
first prizes of £300 each were Edward Armitage (1817–96), a pupil of Delaroche, for
Caesar's Invasion of Britain, Charles West Cope for *The First Trial by Jury* and George
Frederic Watts for *Caractacus Led in Triumph through the Streets of Rome*. With the prize
money Watts went to Italy where he painted *Alfred Inciting the Saxons to Encounter the
Danes at Sea* (Pl. 35) in oils. It was shown at the 1846 exhibition 'for artists skilled in
oil painting' and purchased for a committee room. Looking at it today it is easy to
see its debt to Renaissance masters, and why Watts was nicknamed 'England's
Michelangelo'.

The first fresco to be painted actually in situ was *The Baptism of King Ethelbert* by
William Dyce, commissioned in 1845 and finished a year later (Pl. 36). By 1847 suit-

36
William Dyce
**The Baptism of
King Ethelbert**
1846
fresco, 5 × 2.9m
(16ft 4in × 9ft 4in)
House of Lords, Palace
of Westminster, London

37
Charles West Cope
**The Embarkation of the
Pilgrim Fathers for New
England, 1620**
1856
fresco, 2.2 × 2.9m
(7ft 3in × 9ft 5in)
Palace of Westminster, London

36

37

able subjects had been proposed for over 100 wall compartments in the new Palace.
Many subjects were chosen by the Commissioners, some of whom were prominent
historians. New attitudes to the stormy historical events of the seventeenth century
were reflected in such paintings as *The Embarkation of the Pilgrim Fathers for New
England, 1620* (Pl. 37) by Cope and a series of eight murals by Edward Matthew
Ward, which dealt with the restoration of Charles II after the Commonwealth and
the Glorious Revolution that ended the reign of James II. In the words of the
Commission, 'the subjects [were] selected on the principle of parallelism … an
attempt has been made to do justice to the heroic virtues which were displayed on
both sides'.

Echoing both Boydell's Shakespeare Gallery (see below, p. 192) and the Prince's
experimental garden pavilion, was a series of eight subjects taken from Shakespeare,
Milton and other British poets by artists as various as Watts, Cope and John Tenniel

38
John Tenniel
**A Song for Saint Cecilia's
Day**
1850
fresco, 2.5 × 1.8m
(8ft 1in × 5ft 9in)
Upper Waiting Hall, Palace
of Westminster, London

39
William Dyce
**Hospitality: The Admission
of Sir Tristram to the
Fellowship of the Round
Table**
1849–52
fresco, 3.4 × 6.6m
(11ft 3in × 21ft 9in)
Royal Robing Room, Palace
of Westminster, London

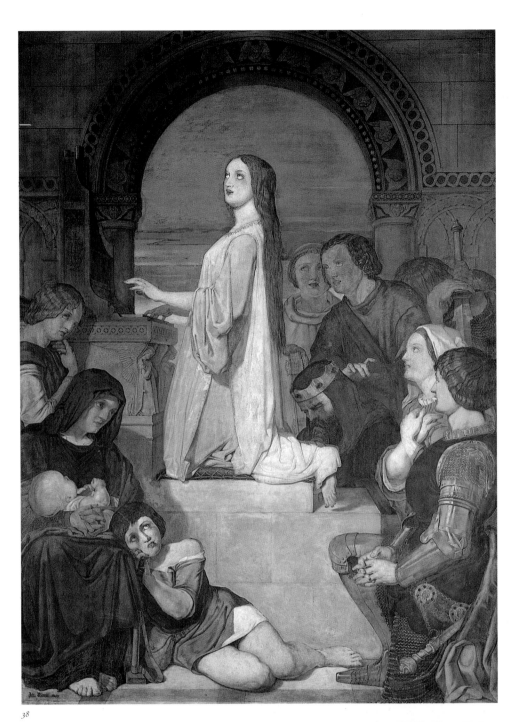

38

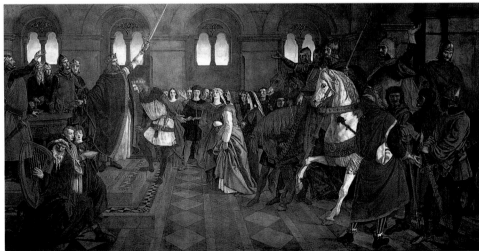

39

(1820–1914). In 1850 Tenniel painted Dryden's *A Song for Saint Cecilia's Day* in the Upper Waiting Hall (Pl. 38), which has survived better than other works as the artist painted very thinly on the plaster. Tenniel, however, was not to continue to work as a painter, but every week for more than half a century provided *Punch* with its 'lead' cartoon, in many of which a statuesque Britannia shook a disapproving finger at Germania or Erin. Today, he is chiefly remembered for his illustrations for Lewis Carroll's *Alice in Wonderland* and *Through the Looking Glass*.

Dyce's frescos for the Queen's Robing Room in the Palace of Westminster were commissioned in 1847 and painted between 1849 and 1852, but sadly owing to Dyce's death only five of the seven works were completed. Among the most spectacular are the Belliniesque *Religion: The Vision of Sir Galahad and his Company* and *Hospitality: The Admission of Sir Tristram to the Fellowship of the Round Table* (Pl. 39), the first of several treatments of the Arthurian cycle as murals.

The most impressive frescos were also the largest: Daniel Maclise's *The Meeting of Wellington and Blücher at Waterloo* (Pl. 40) and *The Death of Nelson at Trafalgar* (completed in 1865) in the Royal Gallery of the House of Lords. This commemoration of two great British heroes provides the most stirring examples of Maclise's powers of large-scale composition. Vast numbers of figures are depicted in these noble rep-

40
Daniel Maclise
The Meeting of Wellington and Blücher at Waterloo
1859–61
waterglass on plaster,
3.7 × 13.9m (12ft × 45ft 8in)
Royal Gallery, Palace of
Westminster, London

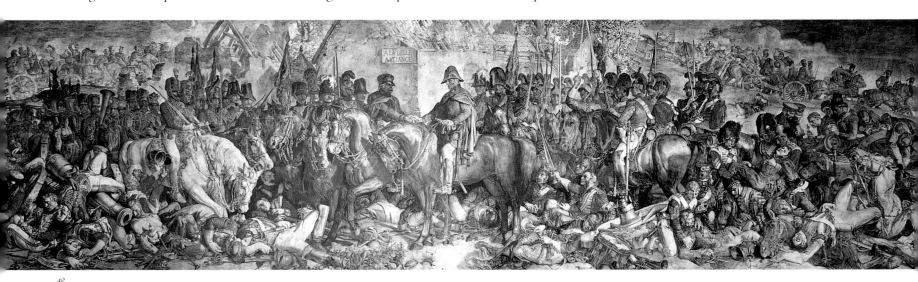

40

resentations of the horror and pathos of war. Wellington is shown, unlike his triumphant officers, as concerned and compassionate, reflecting his well-known words about the loss of human life on the battlefield. The Prince Consort was greatly impressed by the figures of Wellington and Blücher, which were sensitively evaluated by Dante Gabriel Rossetti who wrote of Maclise:

> His two supreme works – the 'Waterloo' and 'Trafalgar' in the House of Lords –
> unite the value of almost any contemporary record with that wild legendary fire
> and contagious heart-pulse of hero-worship which are essential to the transmis-
> sion of epic events through art ... only in the field of poetry, and not of painting,
> can the world match them as realized chronicles of heroic beauty.

In the wake of the Westminster designs a number of frescos were also painted in public buildings, among them Dyce's murals at All Saints, Margaret Street, the major church of the High Anglican movement, and Watts's *The School of Lawgivers* (Pl. 41) at Lincoln's Inn, London, a vast semicircular work executed single-handed in true fresco on a wet ground, 45 feet long and 40 feet high in the middle. Encouraged by its success, Watts offered to paint *The Progress of Cosmos* for the vast spaces of the Great Booking Hall of Euston Station at his own expense. A watercolour by the

41
George Frederic Watts
The School of Lawgivers
1853–9
fresco, 12.2 × 13.7m (40 × 45ft)
Lincoln's Inn, London

42
Philip Charles Hardwick
**The Booking Hall,
Euston Station**
1846–9
watercolour, 72.5 × 61cm
(28½ × 24in)
Royal Institute of British
Architects, London

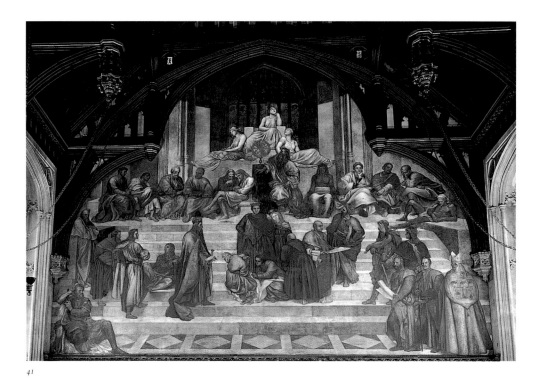

41

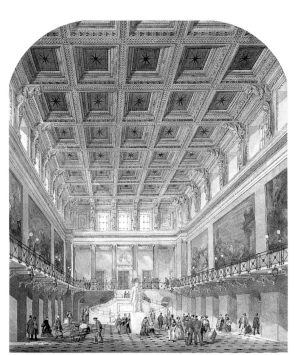

42

architect Philip Charles Hardwick (1822–92) gives a vivid idea of what the project would have looked like had it been realized (Pl. 42).

Gulley Jimpson, the hero of Joyce Cary's novel *The Horse's Mouth* (1944), has an overwhelming urge to paint large murals whenever he is seated near or passes a blank wall of any size, with extremely amusing results. A similar type of enthusiasm in Victorian times led to many surprising schemes being projected which were never realized. Watts, for example, not only wanted murals in railway stations and town halls, but also advocated painting large reproductions of John Flaxman's classical designs on the walls of Eton College, so the boys would 'grow up under the influence of works of beauty of the highest excellence'. The follower of Dyce, John Rogers Herbert (1810–90), who painted nine frescos from the Old Testament on the theme of Human Justice at Westminster, believed that British gaols could be painted with subjects which would convey to criminals the importance of a good life. He exhorted artists to 'Paint your courts of justice so as to impress witnesses with the abhorrence of falsehood … Paint your hospitals for the sick with great subjects of miraculous cures from the Gospels.' The latter idea was to be realized, although using not the Gospels but fairy stories, and executed not in fresco but by ceramic artists in the less elevated mural form of Doulton wall-tile decorations; these were introduced into many children's wards, notably at St Thomas's Hospital, where they can still be seen (Pl. 43).

Fairy tales and legends frequently provided the themes for Victorian mural paintings, especially the Arthurian stories made so familiar by Malory and retold by the Poet Laureate Alfred Tennyson in his *Idylls of the King* (1859). These epic tales featured in one of the most remarkable ventures of the Pre-Raphaelite movement, the Oxford Union fresco series (Pl. 44).

In June 1857 Dante Gabriel Rossetti (1828–82) visited Oxford to see the new Union Society Debating Hall, now the Library, built by the architect Benjamin Woodward with whom he had been friendly for some years. Rossetti had already missed a commission to paint a mural in the new Oxford Museum, which Woodward was building, despite being swamped by copious advice from Ruskin. On seeing the walls in the Union building Rossetti was determined not to miss a

second chance, and persuaded the Building Committee of the Oxford Union that they needed murals in their new Debating Hall. Interest in fresco and mural painting was widespread because of the competitions for Westminster, and the Committee agreed that the scheme should be carried out by Rossetti and his friends for no fee but their costs of material and maintenance. The incredibly awkward ten bays of bare walls round the top of the room, pierced with 26 round windows, set off a train of thought in Rossetti's mind, a dream of illustrating ten scenes from the *Morte d'Arthur* by Malory. He rapidly gathered a team of enthusiasts around him, among them two earnest young men who had both originally intended to go into the Church, William Morris (1834–96) and his life-long friend, Edward Burne-Jones (1833–98). They had met while undergraduates at Exeter College and were both trying to become artists, guided as they were by an admiration for the charismatic Rossetti.

Other recruits to 'the jovial campaign' (so described by Rossetti) included Arthur Hughes, Val Prinsep (1838–1904) and John Roddam Spencer Stanhope, disciples of Watts, who was currently painting his vast mural at Lincoln's Inn. 'What fun we had at the Union,' wrote Val Prinsep years later, 'what jokes, what roars of laughter.' The story of the magical summer is itself a legend. Morris, who both as a boy and as an undergraduate loved the arts of the Middle Ages, felt strongly that he could not hope to paint knights unless he experienced what it was like to wear armour, and had a helmet and suit of chain mail 'run up' to his own design by a doubtless surprised Oxford blacksmith. To the delight of his friends, 'Topsy' (Morris's nickname) succeeded in getting his head stuck in the helmet at a dinner party. With characteristic energy he finished his own fresco first, and then filled in time by painting the great beams and roof.

It is not known whether the redoubtable figure of the Vice Chancellor Benjamin Jowett ever looked in, but it is quite probable, as he liked to be aware of new events in the University. If he did, he might well have asked the famous question immortalized in the caption to Max Beerbohm's cartoon: 'And what were they going to *do* with the Holy Grail when they found it, Mr Rossetti?'

Although the Oxford Union frescos have set many problems for restorers over the years they remain hauntingly beautiful today, a sonorous golden echo of what Ruskin described as 'the finest piece of colour in the world'. Some of the Westminster murals also suffered from rapid deterioration. One artist wrote despairingly: 'I feel how much has been wasted in, as it were, writing in the sand. Time's effacing finger had begun to obliterate at one end while we were painfully working at the other.'

These technical problems and the death of the Prince Consort in 1861 caused a loss of patronage and momentum which dealt a blow to the progress of the Westminster fresco scheme from which it was not to fully recover for another fifty years. But just as the Westminster project began to wane new opportunities for mural painting emerged in the new 'Museumopolis' at South Kensington under the energetic leadership of Sir Henry Cole.

Excited by seeing mosaics in Italy, Cole in 1862 began to enlist his colleagues Richard Redgrave and Richard Burchett, and friends such as Frederic Leighton, Tenniel, Watts and Poynter, to embark upon a series of decorations which would be transformed into ceramic mosaic by W.B. Simpson and Sons, or Italian glass mosaic by Salviati. The series would take the form of portraits of leading figures in the Fine and Decorative Arts through history, although the majority were to be drawn from Italian Renaissance times. All these portraits, which became known as 'the Kensington Valhalla', were painted life-size on panels of uniform dimensions. Redgrave contributed the Florentine sculptor Donatello (Pl. 46), Burchett the

43
Margaret Thompson
and William Rowe
Puss in Boots
1899–1901
wall decoration in Doulton
tiles, 168 × 117cm (66 × 64in)
St Thomas's Hospital, London

43

medieval goldsmith William Torrell and architect William of Wykeham. Poynter painted the figures of the Greek sculptor Phidias and painter Apelles, while Leighton contributed a distinguished full-length portrait of Cimabue and another of Nicola Pisano.

At Henry Cole's suggestion Poynter visited Venice to study mosaic before executing a design for the apse of the Lecture Theatre which was not carried out. The knowledge was not wasted, for Poynter did contribute to the classical frieze which encircles the Royal Albert Hall – his subject being *The Four Quarters of the Globe Bringing Offerings to Britain*. Poynter's most memorable mural decoration is the Dutch Kitchen or Grill Room in the Victoria and Albert Museum, consisting of a frieze of peacocks (Pl. 45) surmounting two series of the *Months* and the *Seasons*; it was designed in 1866 and painted by ladies of the South Kensington School of Art on Minton blank tiles. But perhaps the most important mural decorations at South Kensington are the frescos begun by Leighton in 1868 entitled *The Arts of Industry as Applied to War* and *The Arts of Industry as Applied to Peace* (Pl. 47), the latter being reproduced here from the oil sketch as the original fresco, now in a narrow corridor, is impossible to photograph. The Prince Consort had originally discussed with Leighton the idea for these works as a memorial to the Crimean War. Leighton conceived them in classical terms, *Peace* being strictly Hellenic while *War* was set in fourteenth-century Italy with youths trying on armour and testing crossbows.

In all these works neither the horrors of modern war nor reflections of contemporary life made their appearance. This was to become the province of the recently invented camera; Roger Fenton (1819–69) pioneered the taking of war photographs

44
Dante Gabriel Rossetti
and others
**Scenes from Malory's
'Morte d'Arthur'**
1857
fresco
Library, Oxford Union Society

45
Edward John Poynter
Peacock Frieze (detail)
1866
paint on Minton blank tiles,
111.75 × 63.5cm (44 × 25in)
Grill Room, Victoria and
Albert Museum, London

46
Richard Redgrave
Donatello
1867
oil on canvas, 264.2 × 87.6cm
(104 × 34½in)
Victoria and Albert Museum,
London

45

46

47
Frederic Leighton
Study for The Arts of
Industry as Applied to Peace
*c.*1872–3
oil on canvas, 40.7 × 91.4cm
(16 × 36in)
Victoria and Albert Museum,
London

48
Emanuel Leutze
Westward the Course of
Empire Takes its Way
(Westward Ho!)
1861–2
stereochromed mural,
4.5 × 8.9m (14ft 9in × 29ft 4in)
Capitol Building, Washington
DC

49
George A. Reid
Hail to the Pioneers
1897–9
fresco, 2.2 × 5.2m (7 × 17ft)
Old City Hall, Toronto

in the Crimea in the 1850s, and across the Atlantic in the 1860s Matthew Brady (1823–96) recorded the carnage of the titanic struggle between North and South. With the advent of photography the visual reporting of war would never be the same. But the mural painter still had an important role to play, in projecting what might be described as the heroic dimension. This task was ideally suited to the talents of Emanuel Leutze (1816–68), born in Baden-Württemberg in Germany. He came to America aged 9, and trained in Philadelphia before returning to Düsseldorf in 1841 to become a prolific painter and active liberal during the period leading to the March 1848 revolution. In 1851 he painted *Washington Crossing the Delaware* (Pl. 497).

Leutze believed passionately in the principles of individual freedom, which he perceived as fundamental to the American political system. His fame steadily increased as a result of his History paintings devoted to Christopher Columbus. He returned to America in 1859, and in 1861 the Federal government invited him to paint a large mural at the top of the west stairway in the US Capitol, Washington, DC. There he painted the theme *Westward the Course of Empire Takes its Way (Westward Ho!)* (Pl. 48), a motto taken from a verse by Bishop Berkeley of 1752. The equation in the popular mind of 'west' with 'freedom and liberty' is deeply entrenched in the American language. The apex of the composition showing the Stars and Stripes being passed to the young pioneer symbolized the North's confidence in the future, secure in the belief that the Southern Confederate troops could never take Washington.

Leutze settled permanently in Washington to paint the mural in the Capitol, and portraits of Abraham Lincoln and various Union army officers. Appropriately he was working on a cartoon for a mural entitled *Emancipation of the Slaves* when he died. Such works possess striking and curious parallels with similar decorative schemes in the parliament buildings of many countries. Throughout the Victorian era newly emergent nations and regions celebrated heroic incidents in their past with narrative History paintings on the walls of governmental centres. Examples include the panoramic paintings created in 1858 by Cornelius Krieghoff for the Provincial Parliament buildings in Quebec City (later burnt), and the ambitious murals in

47

48

49

50
William Bell Scott
**The Romans Cause a
Wall to be Built for the
Protection of the South**
1857
oil on canvas, 182 × 182cm
(71⅝ × 71⅝in)
Wallington House,
Northumberland

51
William Bell Scott
Iron and Coal
1861
oil on canvas, 186.6 × 187.9cm
(73¼ × 74in)
Wallington House,
Northumberland

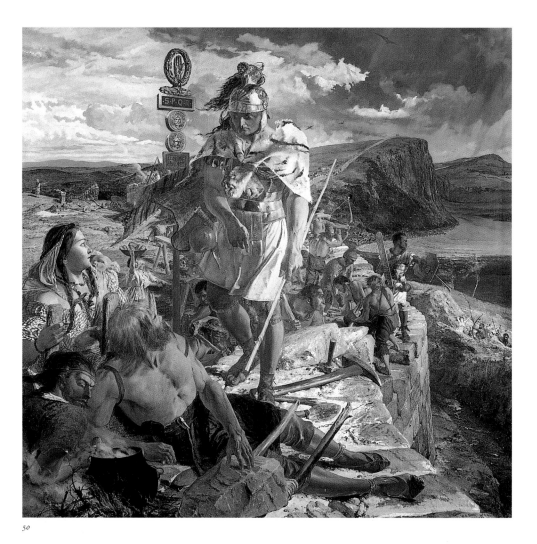

50

Toronto by George Reid (1860–1947) painted between 1897 and 1899 for the City Hall (Pl. 49).

Two major Pre-Raphaelite celebrations of particular regions in the north of England (Northumberland and Manchester) provide remarkable examples of such narrative history sequences. The Northumberland series was painted by William Bell Scott (1811–90), a close friend of Rossetti. In 1842 William and his brother David were both disappointed when neither achieved success in their entries of cartoons for the Westminster competition. William had pinned his hopes on *The Free North Britons Surprising the Roman Wall between the Tyne and Solway*. Although unlucky at Westminster, the experience was to prove valuable in 1855, when Bell Scott was invited by Sir Walter and Lady Pauline Trevelyan (a friend of Swinburne, Rossetti and Ruskin) to make a cycle of paintings depicting the history of Northumberland at their home, Wallington House, Northumberland. The open courtyard of the house was being converted into a central hall with spaces ideal for murals. Eight historical scenes were chosen for the main areas, and the Northumbrian ballad *Chevy Chase* was decided on for the spandrels of the arcading at first-floor level. The pilasters were to be painted with flowers and foliage by Lady Trevelyan and her intellectual idol John Ruskin, who had thrown his weight behind the whole venture. In executing the murals Bell Scott shunned fresco and chose to work in oil paints. The subjects ranged through the centuries and included *The Romans Cause a Wall to be Built* (Pl. 50), *A Descent of the Danes*, *The Death of the Venerable Bede, AD 735*, and *Grace Darling and her Father Saving the Shipwrecked Crew, 7 September, 1838*.

But by far the most famous painting in the series was *Iron and Coal: The Industry*

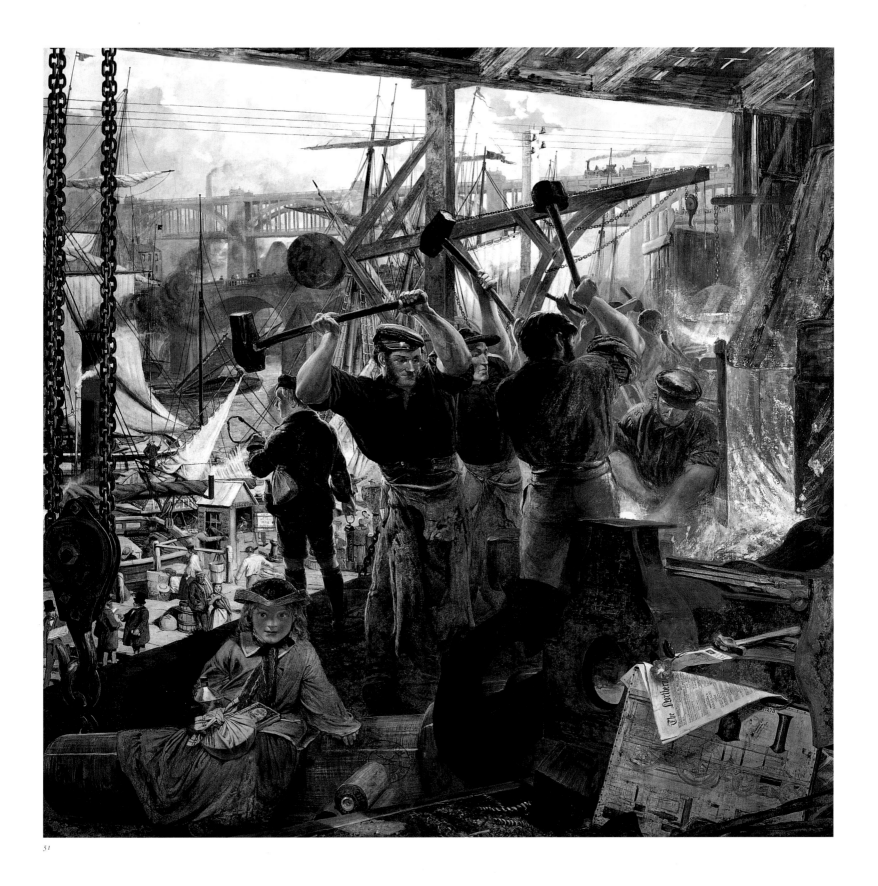

51

52
Ford Madox Brown
**The Expulsion of the Danes
from Manchester, 910 AD**
1879–93
fresco, 145.9 × 317.1cm
(57¼ × 125in)
Great Hall,
Manchester Town Hall

of the Tyne (Pl. 51), proudly subtitled *In the Nineteenth Century the Northumbrians Show the World What Can be Done with Iron and Coal.* The wealth of detail in this painting has led to it becoming known as one of the best illustrations of the Industrial Revolution. The scene is set in the factory shed of the railway works of Robert Stephenson and Co., Engineers. At the bottom right can be seen a blueprint for one of Stephenson's steam engines, an example of which is crossing Stephenson's High Level Bridge in the distance. Such engines were built by the three muscular men or 'strikers' seen hammering out molten iron. The little girl seated on the Armstrong gun case to the left has brought her father's hot lunch done up in cloth, and also carries a school arithmetic book. A coal barge passes on the river and the scene abounds with significant detail. A newspaper carrying the precise date, 11 March 1861, advertises a panorama of Garibaldi's campaigns in Italy, and a photographer. An actual photographer can also be seen at work in the background of the painting, perhaps a prophetic comment from the artist that photography, rather than painting, was the emerging medium with which to record such contemporary scenes.

52

The last major Pre-Raphaelite mural scheme began in 1877, when the architect Alfred Waterhouse's new and richly decorated Gothic Town Hall at Manchester was completed. The commission for the decoration of the Great Hall was first agreed in principle in 1876. Among the artists suggested by Waterhouse were the three Royal Academicians Leighton, Watts and Poynter, as well as Albert Moore and William Blake Richmond, but they all declined. Eventually the project was entrusted by Manchester Corporation to the minor Pre-Raphaelite Frederic Shields, who persuaded them to commission Ford Madox Brown (1821–93) to paint twelve large wall decorations illustrating the history of Manchester.

Brown, a socialist, originally proposed several subjects such as *The Peterloo Massacre, 1819* and *The Cotton Famine,* the latter showing the first bales of cotton arriving in Lancashire after the American Civil War, but these were rejected as being too politically sensitive. Safer themes were substituted, such as *The Expulsion of the Danes from Manchester, 910 AD* (Pl. 52), and *The Opening of the Bridgewater Canal, 1761.* The rapid deterioration of some of the Westminster murals had shown the dangers

of using the true water-based fresco technique in damp English buildings. To prepare himself technically Brown visited Antwerp to examine Baron Leys's recent wall paintings in the Hotel de Ville, and looked at Leighton and Poynter's work in South Kensington. On the architect G.E. Street's advice he also travelled to Gloucester to meet Thomas Gambier-Parry (1816–88) and discuss the new 'spirit fresco' technique with its inventor.

Gambier–Parry's technique was also used by Leighton in his *Industrial Arts* murals in South Kensington (see above), and in an altarpiece at St Michael, Lyndhust in Hampshire. The widely varied artistic interests of Gambier Parry included the formation of one of the most distinguished collections of early Italian paintings in Great Britain, which played a key role in the British revival of fresco painting. He himself used his 'spirit fresco' technique in his paintings at Ely and Gloucester Cathedral and elsewhere. In 1880 he published an account of the technique, which involved heating a mixture of the appropriate pigments, oils and resin and using this medium to paint on plaster coated with whiting and white lead. The technique was used extensively by both Leighton and Madox Brown, the resultant frescos sharing a strange 'chalkiness' of colour.

Madox Brown's first seven pictures were carried out directly on the walls by this 'spirit fresco' process, which was thought to be more durable than true fresco, and were painted while the artist lived chiefly in Manchester. The remainder were painted in oils on canvas between 1886 and 1893 in London and cemented upon the walls. Such a scheme gave the ageing disciple of the Nazarenes his last great opportunity to paint a heroic series of murals.

After Pugin and Waterhouse the most remarkable architect of the Gothic Revival was William Burges (1827–81), who created some of the most elaborate of all buildings in the Gothic style, which like the Palace of Westminster were also extensively painted with murals and wall decoration. Burges's association with his patron, the 3rd Marquis of Bute, began in 1865 when the Marquis was only 18 and the heir to vast fortunes derived from the docks of Cardiff and estates in Wales and Scotland. Architect and patron were perfectly matched, for the Marquis had the money to indulge Burges's fantasies. At Cardiff Castle, Castel Coch, and his own house in Kensington, William Burges's love of elaborate Gothic decoration led him to devise what *The Architect* described as:

53
Axel Haig
**View of the Winter
Smoking Room with
Medieval Figures**
1870
watercolour, 40.6 × 35.6cm
(16 × 14in)
Knighthayes Court, Tiverton,
Devon

53

> flat surfaces being treated with figure decoration, brilliant in colour and clever in
> design, although wanting in repose and harmony – reminiscent almost of a mid–
> summer night's dream, with all its gorgeousness of gilding and colour, and yet
> withal stamping the artist as one of the most talented and original of modern
> designers.

Less sympathetically the *Building News* commented: 'Mr Burges evidently labours under the extraordinary impression that the main purpose of architecture is to serve as the basis for the display of colour.'

Today, when we visit Cardiff Castle and climb the Clock Tower we are struck

54
William Burges
Scenes from Aesop's Fables
designed before 1881;
completed 1887
details of ceiling fresco
Drawing Room,
Castel Coch, Cardiff

55
Harold Speed
Autumn
1898
oil on canvas, 255 × 537cm
(100⅜ × 211⅝in)
Refreshment Room,
Royal Academy, London

56
James Abbott McNeill Whistler
The Peacock Room
1877
oil and gold leaf on leather
and wood, central panel
approx. 188 × 427cm
(74 × 168in)
Freer Gallery of Art,
Washington DC

 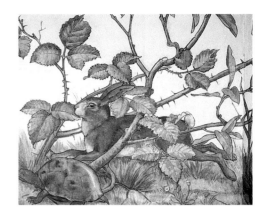

54

by the sumptuousness of the Winter Smoking Room, richly decorated with stained glass and paintings. The vaulted ceiling displays signs of the zodiac and occupations of the seasons, while the decoration of the Summer Smoking Room is even more elaborate. It extends through two storeys with a clerestory and not an inch of wall or ceiling is left undecorated. Elsewhere in the castle are other strange towers with remarkable rooms, such as the Arab Room and the Chaucer Room. We gain a vivid idea of these rich interiors in the striking watercolours of Axel Haig (1835–1921), in which he has been unable to resist the temptation to insert figures in medieval costume, as in *View of the Winter Smoking Room with Medieval Figures* (Pl. 53), a fanciful view of the room richly decorated with frescos and two gentlemen before a blazing fire anachronistically smoking pipes.

In the 1870s, a few miles north of Cardiff, Burges built Castel Coch for the Marquis, a fantasy fort with portcullis, drawbridge and real slits through which to pour boiling oil on unwanted guests. The main rooms are elaborately decorated with intricate patterns and figures, and the effect is much like entering the margins of a medieval Book of Hours. In the octagonal high-vaulted room on the first and second floor of the keep are panels of flowers and illustrations from *Aesop's Fables*: the Fox and the Stork, the Hare and the Tortoise and other familiar tales (Pl. 54). Viewed from below the roof is alive with animals, birds and butterflies.

In 1876 and 1877 the flamboyant American artist, James Abbott McNeill Whistler (1834–1903), whose signature was a butterfly, painted the most controversial of all murals created in the Victorian era, now known as *The Peacock Room* (Pl. 55). The subject arose from a commission to decorate a dining-room for the millionaire shipping magnate, Frederick Leyland. Lined with red sixteenth-century Spanish leather, the room was designed to show off a collection of blue and white Chinese porcelain and Whistler's own paintings *Rose and Silver: La Princesse du Pays de la Porcelaine* (1864/5) and, facing it, *The Three Girls* (1867). Starting with such good intentions, everything, from the client's point of view, went wrong when Whistler painted a lush pattern on the leather based on peacock's feathers, a theme which rapidly took over the concept of the whole room, culminating in a portrayal of a proud artist peacock shrieking at a mean patron peacock scraping up silver shillings. This was a reference to Leyland paying Whistler not in guineas (twenty-one shillings) but pounds (twenty shillings). Gentlemen and artists were paid in guineas, tradesmen in pounds, and Whistler chose to see this as an insult. After many vicissitudes the whole room is now on permanent display in Washington's Freer Gallery of Art.

In 1890 the Royal Academy held a competition to encourage mural painting, offering a commission to paint a series of frescos on the theme of the Four Seasons on the walls of the Refreshment Room. The winners were Fred Appleyard (1874–1963) with a design showing *Spring Driving Out Winter*, Harold Speed

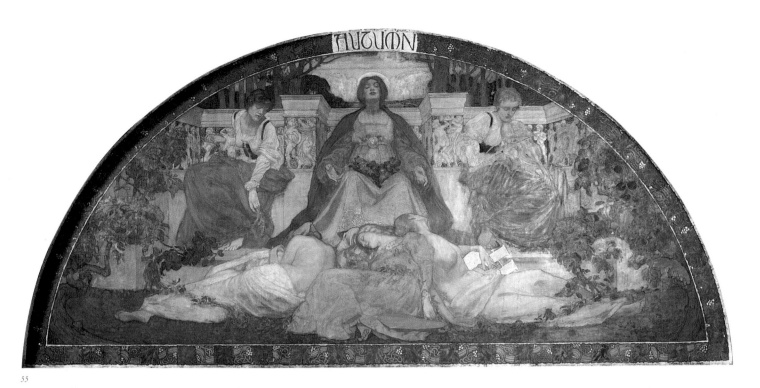

55

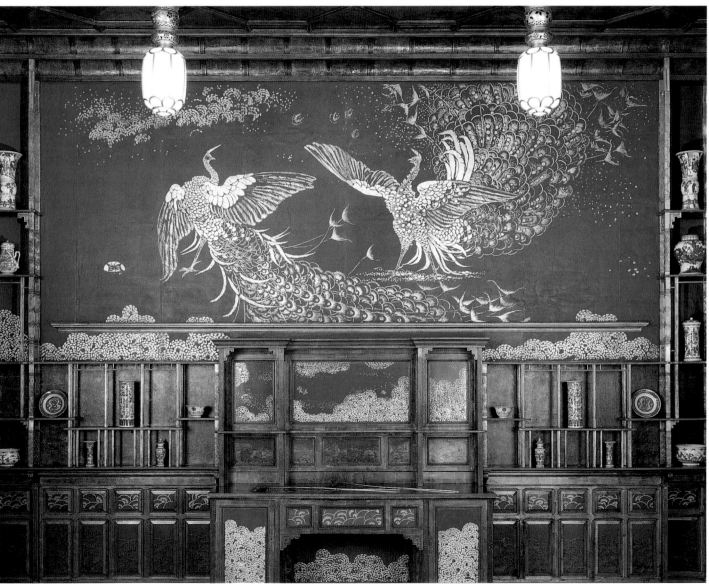

56

57
Phoebe Traquair
Suffer the Little Children
1885–6
oil and beeswax on plaster,
3 × 5.2m (10ft × 17ft)
Mortuary Chapel, Royal
Hospital for Sick Children,
Edinburgh

58
Henry Arthur Payne
**Plucking the Red and White
Roses in the Old Temple
Gardens**
*c.*1907
fresco, 2 × 2.1m
(6ft 9in × 6ft 11in)
Peers' Corridor, Palace
of Westminster, London

(1872–1957) with a design for *Autumn*, and William Reynolds-Stephens (1862–1943), better known later as an architect and sculptor, who submitted a design for *Summer*. No one seems to have been attracted to the subject of *Winter*. As the years passed Reynolds-Stephens's *Summer* became very dirty, and with the artist's agreement was painted over in the 1920s. But Appleyard's and Speed's frescos survive, the latter (Pl. 55) providing a fine variation on the theme of sleeping beauties so popular in late Victorian times.

Another large mural scheme worthy of note was Burne-Jones's designs for mosaics in the American Church of St Paul's Within-the-Walls in the Via Nazionale, Rome, executed between 1872 and 1876, the most extensive ecclesiastical decoration completed in the city in the nineteenth century. A further boost to mural painting was the decision in 1892 to decorate the walls of the Royal Exchange with a series of paintings of the history of London. When Madox Brown's Manchester Town Hall frescos are recalled, this proves the truth of the old adage: 'What Manchester thinks today, London thinks tomorrow.' Both Liverpool and Glasgow also celebrated their civic pride by commissioning local talents to illustrate their respective histories in appropriate municipal buildings. One of the most unusual mural painters, the

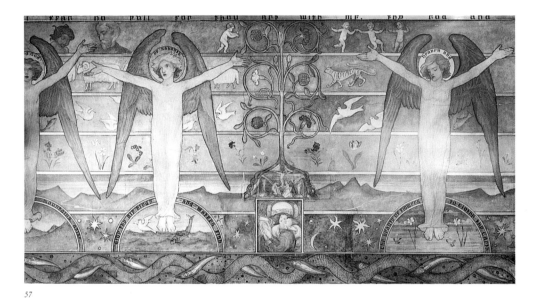

57

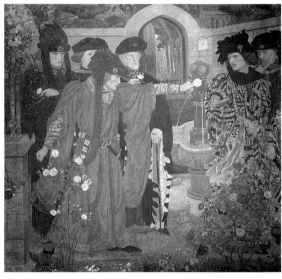

58

remarkably versatile graphic artist Phoebe Traquair (1852–1936), worked in Edinburgh and executed the murals in the mortuary chapel in the Royal Hospital for Sick Children (Pl. 57). In 1884, and later in 1893, she painted the decorations of the Catholic Apostolic Church, London Street, Edinburgh, which were a strange and disturbing mixture of Celtic-influenced fantasy and symbolism.

One artist who took part in the Royal Exchange scheme during the 1890s was the American Edwin Austin Abbey (1852–1911), who like Sargent and Whistler worked in England. All three expatriate Americans, together with Puvis de Chavannes and Augustus St-Gaudens, were asked early in the 1880s to collaborate in decorating the Boston Public Library in the United States. The initial plan for the library called for dividing the books into separate collections grouped according to subject. Sargent chose the large vaulted corridor at the head of the principal staircase, an area which appealed to him because it was completely detached from other works in the scheme. After toying with idea of Spanish literature as a theme, he finally settled upon the Bible, and like a latter-day Holman Hunt set off in 1891 to Egypt, the Holy Land, Greece and Constantinople.

Back in London, as Sargent began to sift through the sketches made on his

travels, the architect Charles McKim and Samuel Abbott, Chairman of the Trustees of Boston Public Library, came over to discuss Whistler's proposed contribution to the scheme. Sargent warned McKim that Whistler's mood was unpredictable: 'One of three things will happen, and I don't know which. Either he will be as silent as the grave, or outrageously vituperative, or the most charming dinner companion you've ever met.' In the event, after a convivial evening, when the table was cleared Whistler bubbled with enthusiasm and drew on the white tablecloth a tentative idea of a great peacock 15 feet high. Whistler's companions left in great spirits, but … the tablecloth went to wash, and this alternative Peacock Room never materialized.

Abbey specialized in historical and Shakespearian scenes, but for the Boston Public Library he turned to the familiar theme of *The Quest for the Holy Grail*, proving that the old Arthurian dreams featured at Westminster and in the Oxford Union frescos had still not lost their power to inspire. For Abbey, who kept the Library context of the paintings firmly in mind, the Grail series symbolized the shared literary traditions of England, Europe and America; he therefore created a composite style for

59
Edwin Austin Abbey
Scenes from 'The Quest for the Holy Grail'
1890–1901
oil and gold leaf on canvas
Boston Public Library

59

Boston evolved from every possible Arthurian source, both ancient and modern, including the poetic versions of Malory, Beardsley's illustrations, Tennyson and Richard Wagner's *Parsifal* (1882). The total effect is most impressive, as can be seen in the general view of the Delivery Room (Pl. 59). At the end of the room can be seen panel 5, depicting the *Castle of the Grail*, while on the right above the fireplace is panel 9, the very Wagnerian *Castle of the Maidens*.

The Boston Library project, which occupied much of Abbey's time between 1890 and 1900, led in 1907 to his becoming technical supervisor of several new murals for the Peers' Corridor in the Houses of Parliament. A notable example of these new frescos was *Plucking the Red and White Roses in the Old Temple Gardens* (Pl. 58) by Henry Arthur Payne (1868–1940), which shows both the continuing vitality of the Pre-Raphaelite tradition and the greater technical virtuosity of mural painters in the Edwardian era. And so our story ends, as it began, at Westminster.

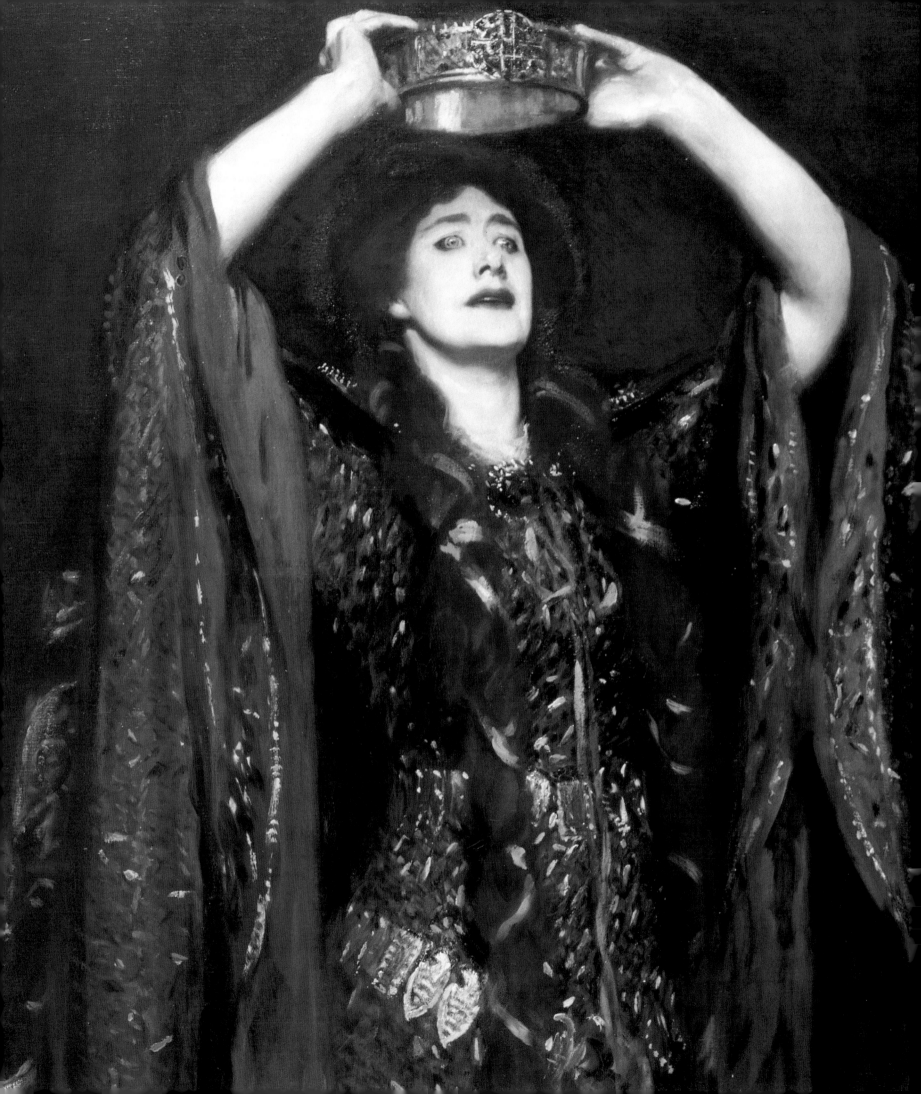

From the era of Hilliard and Van Dyck to that of Reynolds and Gainsborough, the British nation has always been fascinated by the face of the individual, and by artists' attempts to capture a likeness on vellum, ivory, paper or canvas. With the death in 1830 of Sir Thomas Lawrence, the recorder of the great personalities of the struggle against Napoleon, a major force departed. He was succeeded as President of the Royal Academy by another portrait painter, Martin Archer Shee, few of whose works are memorable. Royalty, so dependent on the portrait painter to communicate the awe of majesty, lacked a major interpreter, although Sir David Wilkie's swaggering yet sympathetic state portrait of William IV wearing the uniform of the Grenadier Guards provides us with an engaging likeness of that amiable if dim monarch (Pl. 61). Sadly, Wilkie was never to paint the young Queen Victoria, and in the early years of her

60 John Singer Sargent, **Ellen Terry as Lady Macbeth** (detail of Pl. 94)

61
David Wilkie
William IV
1833
oil on canvas, 267 × 173cm
(105¼ × 68⅛ in)
Wellington Museum,
Apsley House, London

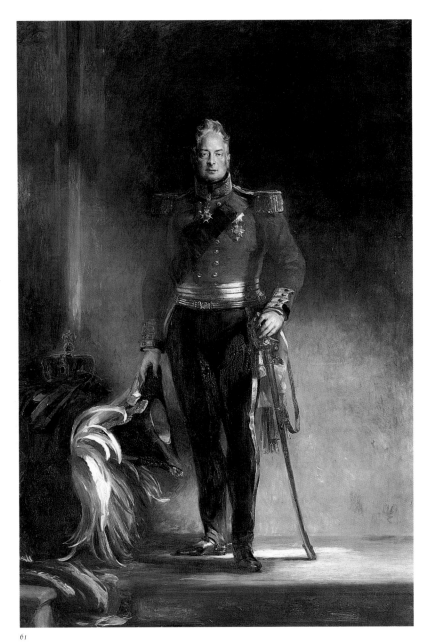

61

reign there was a real lack of recorders of the good and the great, although demand for portraiture soared.

There was a continuing demand for portrait miniatures, the most intensely British form of art. One of the most productive practitioners of this discipline was Sir William Charles Ross (1794–1860), who is said to have painted no fewer than 22,000 miniatures before a stroke brought his career to an end. Ross particularly excelled at capturing happy, cheerful likenesses, and his miniatures of Lord Melbourne, the exiled King Louis Philippe, and royal children such as *Prince Ernest and Prince Edward of Leiningen*, the sons of Queen Victoria's half-brother, playing with a macaw and the Queen's dog Islay (Pl. 62) are among the finest portraits of his time

John Linnell (1792–1882), the father-in-law of Samuel Palmer and friend and admirer of William Blake, was best known for his landscapes, which he much preferred to painting miniatures. Yet his work in the miniature medium is very distinctive, whether he is depicting his teacher, the watercolourist John Varley, or *George Rennie* (Pl. 63), a civil engineer and son of John Rennie, famous for his construction of London Bridge, Waterloo Bridge and Southwark Bridge.

There was also, of course, a demand for chroniclers of the society scene. In this field there was one very enjoyable light-weight artist, Alfred Edouard Chalon (1780–1860). Today his work is usually overlooked, but one of the first acts of the young Queen was to appoint him as Portrait Painter in Watercolour to the Queen. Chalon specialized in small full-length portraits, about 12 inches high, such as the great ballerina Taglioni as La Sylphide (Pl. 233). One of the Queen in the National Gallery of Scotland, Edinburgh, makes her look like a very elegant doll. He also painted delightful miniatures of fashionable women, such as the captivating portrait of Mrs Peter De Wint (Pl. 64), very much the wife of a successful regional artist up in London for a smart private view at the Royal Watercolour Society, wearing an entrancing new bonnet bedecked with ribbons.

When Queen Victoria asked Chalon whether he was worried by the new invention of photography, he replied, 'Ah non, Madame, photography can't flatter!' While Chalon made light of the advent of photography, his sentiments were not shared by Ross, who is said to have remarked on his deathbed that it was 'all up with future miniature painting'. Such pessimism was not entirely justified, for the art lingered on and other miniaturists of great ability continued to practise.

No one would be in a better position to answer the question as to whether photography or portrait painters flattered the most than the young Queen, who was to become one of the most famous faces of her time, an experience which left her, as she observed in old age, with no delusions about her appearance. To study the iconography of the Queen not only provides us with a succinct survey of her life and interests, but also an interesting cross-section of the most fashionable portrait painters of her reign.

The first grand portrait of the Queen was by Sir George Hayter (1792–1871), whom the Queen considered 'out and out the best portrait painter in my opinion'. Yet his portrait of her seated on the throne (Pl. 65), while regal, does not provide the

same insight into her character as Charles Robert Leslie's moving impression of the young Queen approaching the central mystery of the Coronation service, the act of Holy Communion (Pl. 449). Another great moment in her emotional life was her marriage to her Fairy Prince, her handsome German cousin Albert of Saxe-Coburg Gotha. He was ideally suited to perform the difficult role of Prince Consort, being fluent in four languages, methodical and hard-working, and keenly interested in architecture and design. He was also musical – both as an instrumentalist and as a composer – and was a close friend of Mendelssohn. He was a most considerate husband, a good example of this being when he arranged for Millais's *Christ in the House of His Parents* (Pl. 286), which had created such hostile criticism at the Royal Academy from Dickens and others, to be sent down to Windsor for the Queen to see as she convalesced following the birth of her third son.

While the Prince composed music the Queen enjoyed practising the art of watercolour, painting many charming portraits of members of her growing family (Pl. 66). From an early age she had the privilege of being taught by several leading watercolour painters. One of the most engaging was Edward Lear, to whom on one

62
William Charles Ross
Prince Ernest and Prince Edward of Leiningen
1839
miniature on ivory,
18.5 × 14.3cm (7¼ × 5¾ in)
Royal Collection

63
John Linnell
George Rennie
1824
miniature on ivory,
12.1 × 8.9cm (4¾ × 3½ in)
National Portrait Gallery, London

64
Alfred Edouard Chalon
Mrs De Wint
*c.*1830
watercolour, 10.3 × 8.3cm
(4 × 3¼ in)
Victoria and Albert Museum,
London

62

63

64

occasion the Queen showed the Royal miniature collection, to which he responded excitedly, exclaiming, 'Oh! Where *did* you get all these beautiful things?' and receiving the cool reply, 'I inherited them, Mr Lear.'

Both the Queen and Prince Consort loved painting and patronized contemporary artists. Even before her marriage the Queen had purchased and been given works by Landseer, and she continued to patronize him throughout his life. On 2 October 1845 she wrote of his *Windsor Castle in Modern Times* (Pl. 67): 'Landseer's game picture (begun in 1840!) … is at last hung up in our sitting room here, and is a very beautiful picture, and altogether very cheerful and pleasing.' In it the Prince Consort's thigh-length boots give him something of the appearance of the hero of Weber's opera *Der Freischütz*, accentuated by the highly finished Germanic surface of the painting, probably achieved to satisfy the dictates of Albert himself.

The Prince Consort greatly admired the work of another favourite painter of the Royal Family, Franz Xaver Winterhalter (1805–73), a German whose mission in life was to record all the crowned heads and royal families of Europe. In the years 1842 to 1871 Winterhalter was to paint more than a hundred works for the British Royal

66

67

65
George Hayter
Queen Victoria
1840
oil on canvas, 269.2 × 185.6cm
(106 × 73in)
Royal Collection

66
Queen Victoria
**The Royal Family
at Osborne House**
1850
watercolour, 20.7 × 24.8cm
(8⅛ × 9¾in)
Royal Collection

67
Edwin Landseer
**Windsor Castle in Modern
Times**
1840–5
oil on canvas, 113.3 × 144.5cm
(44⅝ × 56⅞in)
Royal Collection

68

69

Family, one of the most memorable being the moving portrayal of the Duke of Wellington on his 82nd birthday making a presentation to his one-year-old godson, Prince Arthur, who shared the same birthday, 1 May (Pl. 68). That morning the Great Exhibition had been opened by the Queen, and the Crystal Palace can be seen in the background. On Winterhalter's death Queen Victoria wrote to one of her daughters, 'His works will in time rank with Van Dyck. He painted you all from your birth. There was not another portrait painter like him in the world.' While the Queen's prediction has not quite been realized, Winterhalter's glittering and romantic records of the European royalty of his time will always be valued.

As we will see (below, p. 218), the Queen was not a great admirer of Sir Francis Grant (1803–78), who nevertheless painted some of the best portraits of her on horseback (Pl. 69). Although he had no formal training, by studying the works of Velázquez he had learnt when young what a good portrait should look like. After he had painted the Queen on horseback the demand for similar equestrian portraits grew rapidly, keeping him always busy.

The leading history painter of the period, Daniel Maclise (1806–70), also excelled as a caricaturist and portrait painter. As a young man in Cork he made drawings of the famous people he encountered, enjoying a great success with his portrait of Sir Walter Scott, who visited Ireland in 1825. After he settled in London in 1828, Maclise became aware of the portrait drawings of Ingres, and successfully grafted Ingres's incisive delicacy of line on to the British tradition of small-scale, full-length watercolour portraits. In the next twenty years he was to produce nearly a thousand highly individual portraits before restricting himself to oil portraits of friends such as Charles Dickens.

Occasionally Maclise ventured on spectacular large exhibition watercolour portraits, as in the case of *Sir Francis Sykes and Family* (Pl. 70), which depicts a Tory baronet and his family romantically dressed in medieval costume on a winding staircase. Sir Francis, carrying a lance, rather significantly has both eyes firmly closed. Was this perhaps because he was bored with sitting, or rather standing, for the portrait wearing heavy armour? Or may Sir Francis's closed eyes have been wish-fulfilment on the part of the artist Maclise, who had just succeeded Disraeli as Lady Sykes's lover? They were eventually discovered *in flagrante* by the irate Sir Francis, who began well-publicized divorce proceedings.

The novels of Sir Walter Scott and the romantic interest in medievalism had many curious effects on early Victorian life. The enterprising Samuel Pratt found it lucrative to run a shop in Lower Grosvenor Street where armour could be bought or hired for wear in spectacular pageants and tilting parties. The armour worn by Sir Francis Sykes in Maclise's painting may well have come from Pratt's, who made much of the armour worn at the Eglinton Tournament, the most renowned event of nineteenth-century chivalry, which aroused almost worldwide interest. Although the actual event held at Eglinton in Ayrshire, Scotland, in August 1839 was marred by pouring rain, this did not dampen the romance of the Middle Ages for high society, as is revealed in Landseer's double portrait of Queen Victoria and Prince Albert in costumes of the period of Edward III worn at a fancy dress ball given at Buckingham Palace in 1842; the painting was completed two years later (Pl. 71).

Maclise's portrait certainly provides an escape from the dilemma once lamented by Millais: 'Artists have to wrestle today with the horrid antagonism of modern dress; no wonder, therefore, that few recent portraits look really dignified. Just imagine Vandyck's "*Charles 1st*" in a pair of check trousers!' We are reminded of Sir Francis Grant's Academy *Discourse* of 1873, in which he advised: 'I need hardly add how absolutely essential it is that, in the department of portrait painting, truth to nature

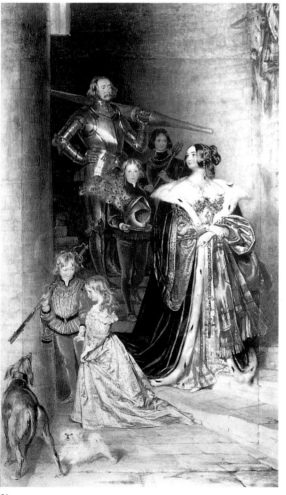

70

68
Franz Xaver Winterhalter
The First of May, 1851
1851
oil on canvas, 106.7 × 129.5cm
(42 × 51in)
Royal Collection

69
Francis Grant
**Queen Victoria Riding
out with her Gentlemen**
1839–40
oil on canvas, 99.3 × 136.6cm
(39¼ × 54in)
Royal Collection

70
Daniel Maclise
**Sir Francis Sykes
and Family**
1837
watercolour, 112.3 × 64.7cm
(44½ × 25½in)
Private collection

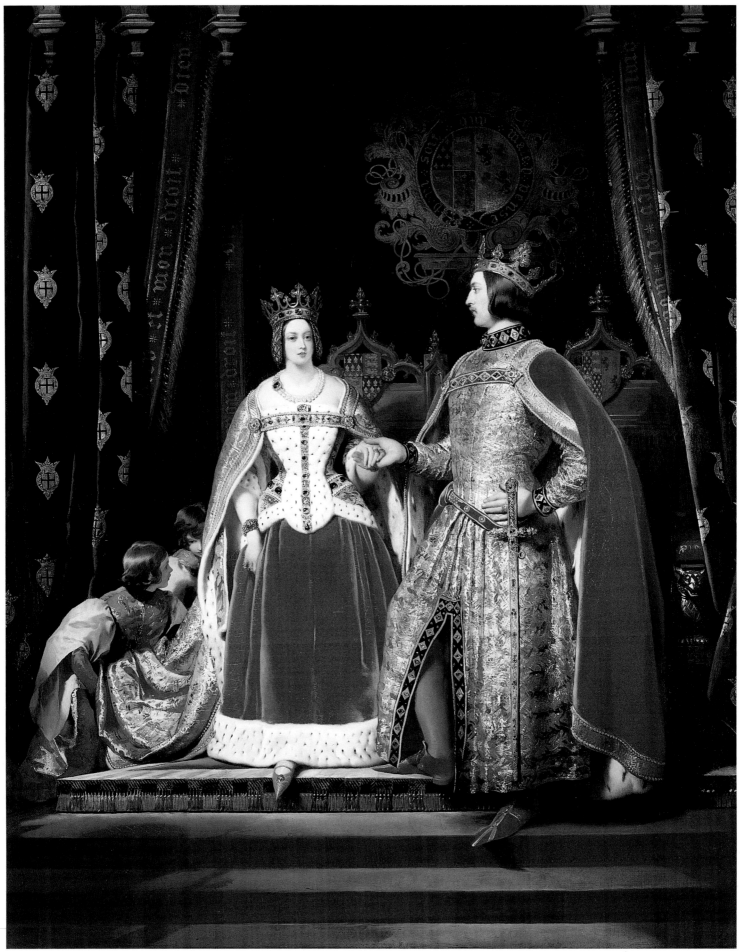

should be combined with taste and refinement. A portrait which may be a strong resemblance, and yet replete with vulgarity, is simply an abomination.'

During his lifetime Charles Dickens (1812–70) had many artist friends who painted his portrait. Maclise caught him at the beginning of his career, just after the publication of *The Pickwick Papers*. This book first appeared in 1836–7 as a serial in 20 paperback monthly parts, selling at a shilling a copy. The binder's order of 400 copies for the first issue rose to 40,000 for the 15th, a triumphant success from which Dickens, then aged 24, never looked back. Maclise portrays an attractive young man in a hurry – handsome, dashing and brimming with energy (Pl. 72). Frith painted him 'in mid-whisker', as it were, at the height of his fame and creativity, urged on by Dickens's friend and biographer John Forster who was fearful that Dickens would grow a really large beard, which would possess, so Forster believed, just the vulgarity which Grant decried. But the work which perhaps captures the rich variety of Dickens's teeming imagination most vividly is entitled *Dickens's Dream* (Pl. 73) by the little-known artist Robert William Buss (1804–75). The great Victorian novelist sits musing in his study surrounded by the myriad creations of his stories.

Another great bewhiskered novelist of the Victorian era was Anthony Trollope (1815–82). While there are 'respectable' portraits of him, they do not capture his personality so vividly as the caricature by the 22-year-old 'Spy', Leslie Ward (1851–1922), of the choleric old gentleman ensconced in the depths of the Garrick Club, cigar in hand, which was published in the *Men of the Day* series in the journal *Vanity Fair* on 5 April 1873. The original art work seen here (Pl. 74) possesses a vitality smoothed over in the intermediary processes of reproduction by multiple lithographic stones. Although it was Carlo Pellegrini ('Ape') who established the house style of full-length caricatured figures in *Vanity Fair*, it was 'Spy' who was its main exponent and who in over one thousand caricatures captured the 'good and the great' of the late Victorian era. Ward believed that a caricaturist needed to combine a 'profound sense of character with humour' in order to 'translate into terms of comedy a psychological knowledge unsuspected by those who uncritically perceive and delight in the finished caricature'.

71
Edwin Landseer
Queen Victoria and Prince Albert at the Bal Costumé of 12 May 1842
1844
oil on canvas, 142.6 × 111.8cm (56¼ × 44in)
Royal Collection

72
Daniel Maclise
Charles Dickens
1839
oil on canvas, 91.4 × 71.4cm (36 × 28⅛in)
National Portrait Gallery, London

73
Robert William Buss
Dickens's Dream
1875
watercolour and pencil, 70 × 89cm (27½ × 35in)
Dickens House, London

72

73

74
Leslie Ward (Spy)
Anthony Trollope
1873
watercolour, 29.5 × 18.4cm
(11⅝ × 7¼in)
National Portrait Gallery,
London

75
George Richmond
Lord Salisbury
1870–2
oil on canvas, 236.2 × 144.8cm
(93 × 57in)
Hatfield House, Hertfordshire

76
Alfred Stevens
Mrs Mary Ann Collmann
1854
oil on canvas, 70.4 × 55.2cm
(27¼ × 21¾in)
Tate Gallery, London

74

75

The sheer energy of many Victorian portrait painters is amazing. George
Richmond (1809–96) began his career as a member of the Ancients, a group of
young artists who gathered round Samuel Palmer and were inspired by William
Blake's work. Marriage and family responsibilities led him to concentrate exclusive-
ly on portraiture after 1831, and his sitter book contains 2,500 entries of members of
the aristocracy, the clergy and the literary world, such as John Ruskin, Charlotte
Brontë and George Eliot. He did not begin painting in oils until he was 35, before
that having worked almost exclusively in crayon and watercolour, but for the next
thirty-five years he painted oil portraits of one prominent person after another. A fine
example at Hatfield House shows the Prime Minister Lord Salisbury (Pl. 75), an aris-
tocrat to the tips of his fingers who led the Conservative Party after the death of
Disraeli.

While some artists produced literally thousands of portraits, others produced
only a few isolated works of great quality. One such was Alfred Stevens (1818–75),
the great sculptor and hopeless businessman whose major monument is the
Wellington Memorial in St Paul's Cathedral. His 'one-off' portrait of *Mrs Mary Ann
Collmann* (Pl. 76) has an intensity of vision which reminds us of the contribution
made to the art of portraiture by the Pre-Raphaelites and their prophet John Ruskin.
Ruskin's rhetoric, like the Bible, can be quoted both pro and con on virtually all
artistic topics, justifying Tolstoy's judgement of him as someone who thought with
his heart. Tolstoy's description comes to mind when we look either at Ruskin's own
watercolour self-portrait (Pl. 78), or his portrait by Millais where he is shown stand-
ing on a rock in a highland burn at Brig o'Turk, Glenfinlas, in 1853, one of the most
famous of all Victorian images (Pl. 31).

Both works reveal one of the great men of the Victorian era, torn by self-doubt.
When we look at Millais's painting we are reminded of the private turmoil of both
sitter and artist, and the oft-told story of Millais's relationship with Ruskin's wife
Effie, with whom he fell in love while painting this portrait. Effie's loveless and
unconsummated marriage with Ruskin was subsequently ended and she married

77
John Everett Millais
**Mrs James Wyatt Jnr and
her Daughter**
*c.*1850
oil on wood, 35.6 × 45.1cm
(14 × 17¾in)
Tate Gallery, London

78
John Ruskin
Self-Portrait
1873
watercolour, 35.3 × 25.3cm
(13¾ × 10in)
Pierpont Morgan Library,
New York

Millais. Millais began his long and busy career as a portrait painter, an interesting example being *Mrs James Wyatt Jnr and her Daughter* (Pl. 77), which wittily juxtaposes prints after Leonardo and Raphael's Madonnas with the engaging gawkiness of the mother whose daughter stands precariously upright on her knee. Millais's career was also to end with portraiture, and the depiction of such famous sitters as Cardinal Newman, Gladstone and Disraeli, a few days before the great politician's death.

The choice of sitter or model was immensely important to all the Pre-Raphaelites and their associates. In their early work their commitment to depict what they saw with absolute fidelity led to the creation of powerful small-scale portraits which are charged with something of the intensity of portrait miniatures. On 12 April 1853 the Pre-Raphaelite Brotherhood all made portraits of each other to send to their fellow member Thomas Woolner in Australia. William Holman Hunt's *Dante Gabriel Rossetti* (Pl. 79), done on this occasion, captures something of the brooding sensuality of the man who was to paint some of the most beautiful of all

77

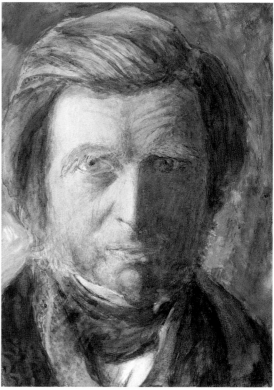

78

portraits of women. All Rossetti's depictions of women have individual merits but the most haunting are his series of drawings of his wife Elizabeth Siddal, while the most voluptuous are the small-scale paintings of his mistress Fanny Cornforth (for example, Pl. 301), and the most sinuous the three-quarter and full-length paintings of Jane Morris (Pls. 552, 561), the professional model Alexa Wilding and the actress Ruth Herbert. In a parallel with Picasso in the twentieth century, one model could merge into the next as each relationship altered and the artist's preoccupations changed. In the 1870s Rossetti perfected a highly individual idealized type of female beauty, which retrospectively can be related to the eighteenth-century allegorical portrait tradition, associated with such glamorous models as Lady Hamilton, who often posed as a Greek goddess.

A fine example of this type of painting is a portrayal of the beautiful Alexa Wilding as *La Ghirlandata* (Pl. 80). It was painted at Kelmscott Manor in 1873 with the young May Morris modelling for the two angels at the top of the painting.

William Michael Rossetti, the historian of the group, wrote 'of the underlying significance of this picture … he [his brother Dante Gabriel] purposes to indicate, more or less, youth, beauty, and the faculty for art worthy of a celestial audience, all shadowed by mortal doom.' William Michael Rossetti was himself to become the subject of an important portrait by Madox Brown (Pl. 81), one of the first ever painted by gaslight, for the sitter worked in the Inland Revenue, and could only visit the artist in the evening after work.

One of the most important events in the development of Victorian portrait painting took place in 1856 with the founding of the National Portrait Gallery. Its major aim, revealingly, was not primarily artistic, but historical and inspirational. Lord Palmerston put it succinctly when putting the motion for its financial support: 'There cannot be a greater incentive to mental exertion, to noble actions, to good conduct on the part of the living, than for them to see before them the features of those who have done things which are worthy of our admiration and whose example we are more induced to imitate when they are brought before us in the visible and tangible shape of portraits.'

Similar thoughts must surely have animated one of the great portrait painters of the age, George Frederic Watts (1817–1904), in about 1860 when he devised the project of a Victorian 'Valhalla' of the good and the great painted in oil to a standard size – approximately 25 by 20 inches – dimensions ideal for close-up studies of the face. It must surely be more than coincidental that Watts was at this time the permanent house guest at Little Holland House, where it was said of him, 'He came to stay 3 days; he stayed 30 years.' At Little Holland House Sara Prinsep had created London's leading salon. She was the oldest of the seven formidable Pattle sisters (known collectively as 'Pattledom'), and their 'open house' every Sunday afternoon was described irreverently by the cartoonist George Du Maurier: 'It's a nest of præraphaelites, where Hunt, Millais, Rossetti, Watts, Leighton etc. Tennyson, the Brownings and Thackeray etc. and *tutti quanti* receive dinners and incense, and cups of tea handed to them by these women almost kneeling.'

The oldest of the Pattle sisters was Julia Margaret Cameron (1815–79), whose life was passed in India with her husband, an administrator, until she returned aged nearly 50 in 1863 to take up, with passionate enthusiasm, the new art of photography, writing: 'From the first moment I handled my lens with a tender ardour.' At Little Holland House she met virtually all the leading intellectual figures of the day, most

79
William Holman Hunt
Dante Gabriel Rossetti
1853
oil on wood, 29.2 × 21.5cm
(11⅞ × 8½in)
Birmingham City Museum
and Art Gallery

79

of whom she managed to lure before her camera either in Kensington or at her home at Freshwater on the Isle of Wight, to the lasting benefit of posterity. Du Maurier recalled meeting Watts there, and how they talked about 'the beauty of the Elgin Marbles and the desirability of growing as like them as possible'.

Mrs Cameron virtually invented the 'close-up', taking a series of soft-focused portraits of remarkable sensitivity of such figures as Charles Darwin, Robert Browning and Thomas Carlyle. 'When I have had such men before my camera,' she wrote in *Annals of my Glass House* (1874), 'my whole soul has endeavoured to do its duty towards them in recording faithfully the greatness of the inner as well as the features of the outer man.' The poet Alfred Tennyson (who lived near her on the Isle of Wight at Farringford House) was a frequent, if reluctant, sitter, who protested mildly that one portrait made him look like 'a Dirty Monk'! (Pl. 82). History does not divulge what Tennyson thought of a series of photographs Mrs Cameron made illustrating his poem *The Idylls of the King*, which dealt with the legendary story of King Arthur of Avalon and the Knights of the Round Table, also a favourite theme of Rossetti, Morris and Burne-Jones. The new art of photography and Pre-Raphaelite principles thus proved mutually inspirational.

Poor Tennyson was constantly in demand as a sitter, and when not posing for Mrs Cameron he was commandeered for several portraits by Watts, the most notable being that of 1863–4, the troubled face of the writer of *In Memoriam* (Pl. 83). Two of the most important portraits of the Victorian era are the hauntingly beautiful portrait of Watts's child bride Ellen Terry, *Choosing* (Pl. 85), and the later three-quarter-length portrait of *Cardinal Manning* (Pl. 84), a penetrating character study. In these two works Watts placed himself firmly in the front rank of British portrait painters. When Tennyson sat for Watts in 1859 the poet asked him what he wished to achieve

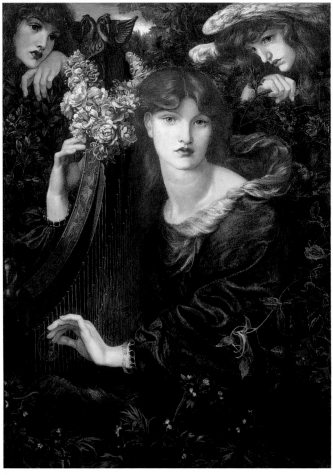

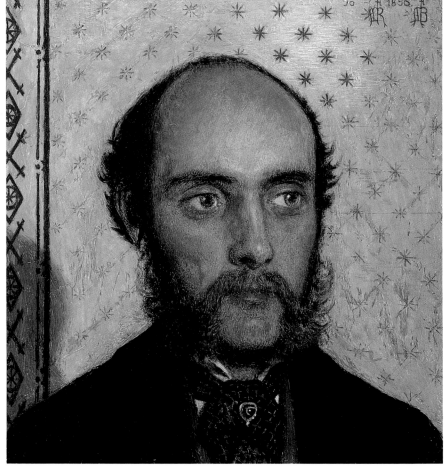

80 *81*

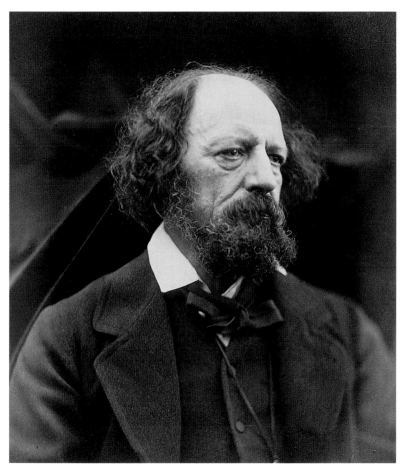

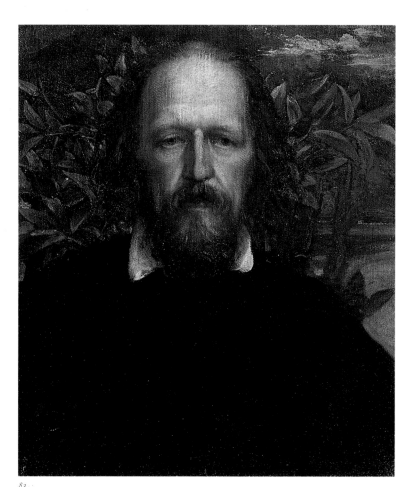

82

83

84
George Frederic Watts
Cardinal Manning
1882
oil on canvas, 90.2 × 69.9cm
(35½ × 27½in)
National Portrait Gallery,
London

85
George Frederic Watts
Choosing (Ellen Terry)
1864
oil on canvas, 46.3 × 35.5cm
(18¼ × 14in)
National Portrait Gallery,
London

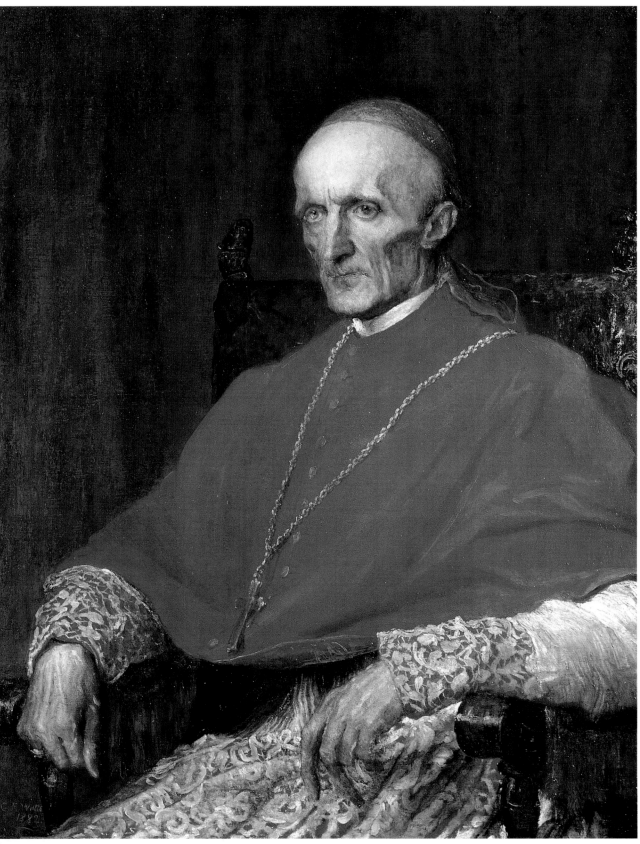

84

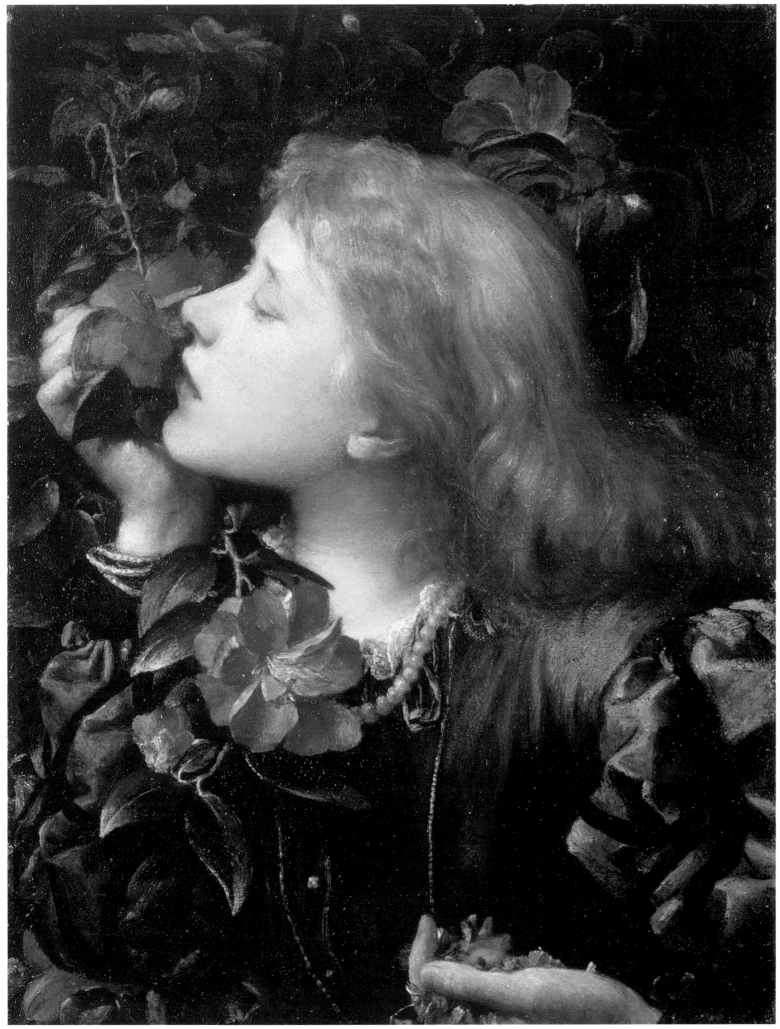

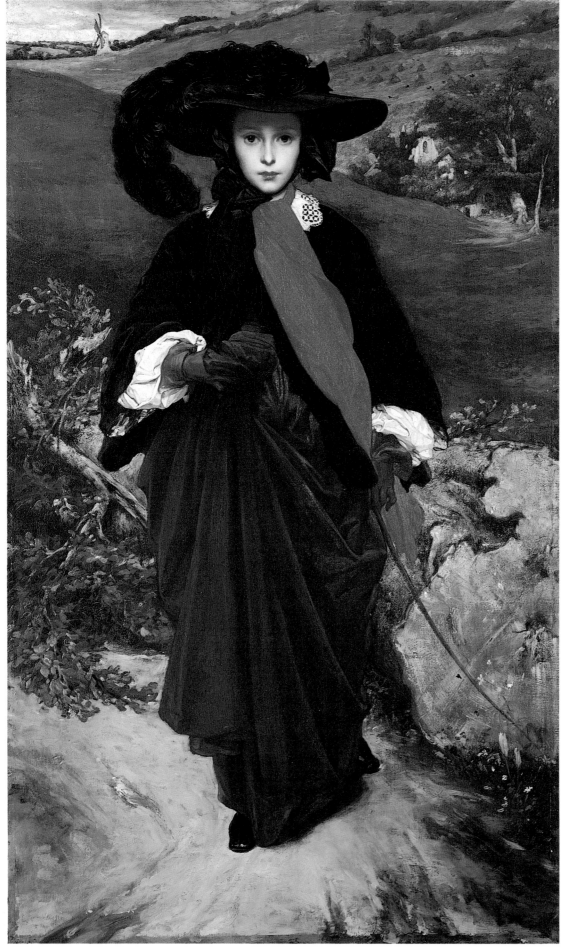

when he painted a portrait, and Watts's answer is said to have inspired these lines in *Lancelot and Elaine*:

As when a painter, poring on a face,
Divinely thro' all hindrance finds the man
Behind it, and so paints him that his face,
The shape and colour of a mind and life,
Lives for his children, ever at its best
And fullest …

For Watts's great friend Frederic Leighton (1830–96), portraiture was not a full-time pursuit, but several of his paintings must rank among the most striking of Victorian likenesses, a notable example being his portrait of *May Sartoris* (Pl. 86). This engaging study of a 16-year-old girl, the daughter of one of Leighton's most intimate friends Adelaide Sartoris, possesses an almost disturbing directness as the sitter walks towards us along a dusty path past a felled tree-trunk in a russet autumnal landscape. The black riding habit, relieved by touches of white at wrist and neck and a bright scarlet sash, make this a remarkable exercise even for a great colourist like Leighton.

To paint a self-portrait is an act of self-analysis which needs courage, even if you are one of the great portrait painters of your time, like James Abbott McNeill Whistler (Pl. 87). Indeed, all Whistler's sitters needed courage, for when exhibited their likenesses would be transformed not into gods, goddesses, saints or muses as in

86
Frederic Leighton
May Sartoris
c.1860
oil on canvas, 152.1 × 90.2cm
(59⅞ × 35½ in)
Kimbell Art Museum,
Fort Worth

87
James Abbott McNeill Whistler
**Arrangement in Grey:
Portrait of the Painter**
1872
oil on canvas, 74.9 × 53.3cm
(29½ × 21in)
Detroit Institute of Arts

88
James Abbot McNeill Whistler
**Arrangement in Black
No. 5: Lady Meux**
1881
oil on canvas, 194.3 × 130.2cm
(76½ × 51¼ in)
Honolulu Academy of Arts

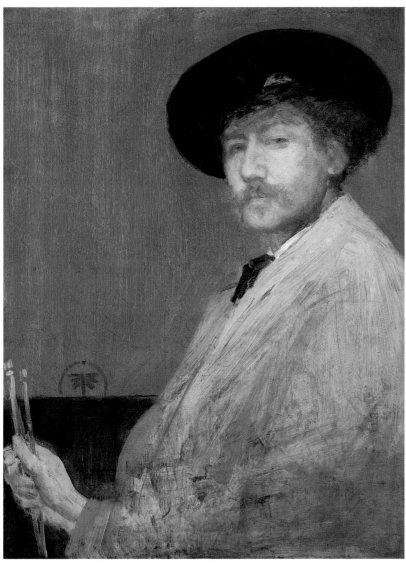

87

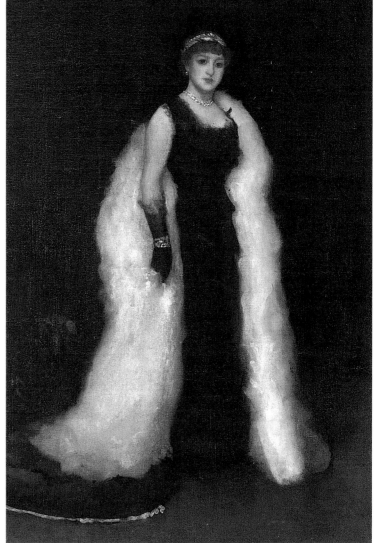

88

eighteenth-century portraits, but into 'Symphonies', 'Harmonies', or 'Arrangements' to emphasize their purely 'formal values'. The adventuress Lady Meux, categorized by Whistler as *Arrangement in Black No. 5* (Pl. 88), possessed courage in abundance, having clawed her way up the society ladder from working as a prostitute at the Casino de Venise in Holborn to marrying the scion of a wealthy family of brewers, despite strenuous efforts by the Meux family to discourage the match. Dressed to kill in a low-cut, figure-hugging, black velvet evening gown ablaze with diamonds and relieved by a full-length white sable stole, she embodies not the stuffy age of Queen Victoria but the more daring world of the Prince of Wales, the future Edward VII. Artist and sitter both deserved and fully understood each other, in a definitive demonstration of the 'swagger' portrait.

Whistler's most famous portrait must surely be his *Arrangement in Grey and Black No. 1: The Artist's Mother* (Pl. 90), purchased by the French government twenty years after it was painted. J.-K. Huysmans wrote of it in *La Révue Indépendante* in 1884: 'It

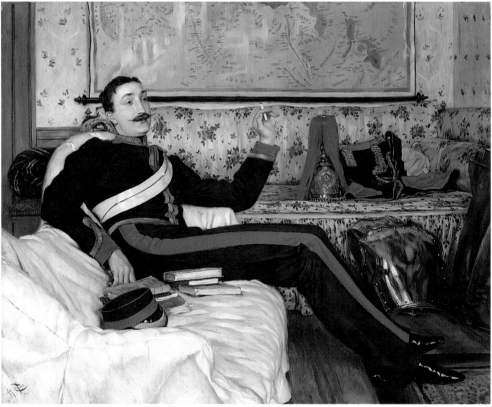

89

was disturbing, mysterious, of a different colour from those we are accustomed to seeing. Also the canvas was scarcely covered, its grain almost invisible; the compatibility of the grey and the truly inky black was a joy to the eye, surprised by these unusual harmonies; it was, perhaps, English painting Baudelairized, lunar, real painting.'

James Tissot (1836–1902) was so successful at painting endless portrait variations of his beloved mistress Kathleen Newton (Pl. 479) that his abilities as an interpreter of men are often forgotten. But surely one of his most memorable portraits is of Colonel Frederick Gustavus Burnaby (Pl. 89) enjoying a cigarette, the quintessence of indolent charm, very different from the heroic poses in which soldiers are depicted in more conventional portraits. Yet Tissot does succeed in suggesting that the sitter was more than a military dandy with a waxed moustache. His height, 6 feet 4 inches, is subtly indicated, and it is not surprising to learn that he was a master-

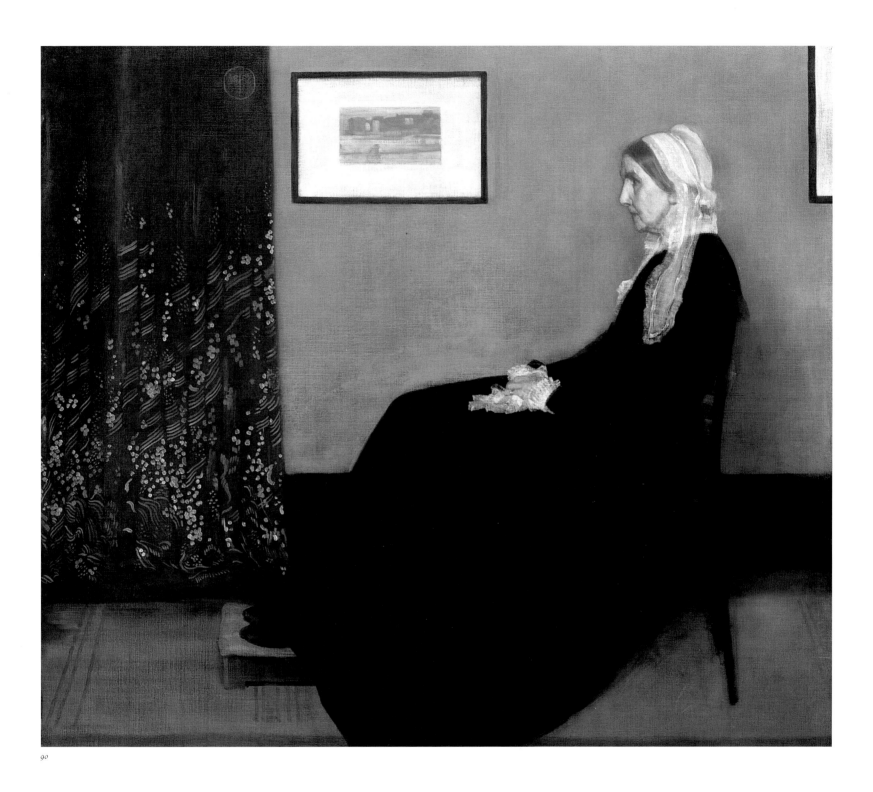

91
Hubert von Herkomer
Cecil Gordon Lawson
1877
watercolour, 49.5 × 34.3cm
(19½ × 13½in)
National Portrait Gallery,
London

92
Frank Holl
John Everett Millais
1886
oil on canvas, 130.8 × 116.8cm
(51½ × 46in)
Royal Academy, London

93
John Singer Sargent
Madame Gautreau
1884
oil on canvas, 209.3 × 109.7cm
(82½ × 43½in)
Metropolitan Museum of Art,
New York

balloonist, and so strong that he could carry a small pony under his arm. A frequent traveller in the Middle East, Burnaby was to die in 1885 with a dervish's spear through his throat.

In the 1870s a curious fate united the three great painters of subjects of social concern – Luke Fildes, Frank Holl, and Hubert von Herkomer (see below, pp. 336–42) – for all of them turned to portraiture to make their fortunes. Fildes in later years painted the state portraits of both Edward VII and George V, while Herkomer created wonderful watercolour portraits of John Ruskin, Richard Wagner and the short-lived landscape artist Cecil Gordon Lawson (Pl. 91). From 1871 Herkomer was resident in both England and Germany where he held frequent exhibitions of his work, which became greatly admired, gaining him the Order of Merit from the Kaiser, Wilhelm II.

Painting portraits was hard work, and it was by no means all plain sailing. In 1888 Millais wrote a letter to Frank Holl, who had spoken of his aim as being 'to drag upon the canvas the identity of the man himself'. In it Millais gives a vivid

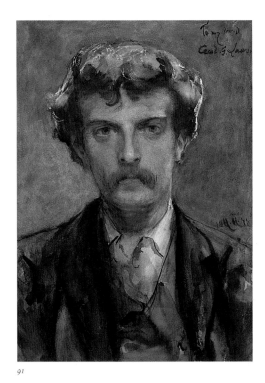

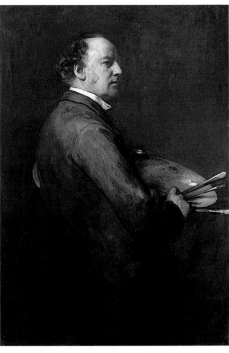

91 *92*

account of the tedium of the Victorian portrait painter's lot: 'you have been ill, and I don't wonder at it, with the quantity of work you have done this year. Portrait-painting is *killing work* to an artist who is sensitive, and he must be so to be success-ful, and I well understand that you are prostrated by it. Everyone must have his say, and however good the performance may be, there is some fault to find.' Millais's words were prophetic, for Holl's success as a portrait painter was so great that the pressure of commissions certainly contributed to his early death at 43, a few months after Millais's warning about overwork. In the last decade of his life Holl painted 198 portraits, only two of women. One of the most memorable of all Holl's portraits is his Diploma painting of 1886, a sensitive likeness of his friend Millais, palette and brushes in hand. (Pl. 92)

Sir Osbert Sitwell once said of John Singer Sargent (1856–1925) that his clients went to him because he made them appreciate just how rich they really were. Born in Florence the son of a wealthy Bostonian doctor, Sargent has been described as 'an American born in Italy, educated in France, who looks like a German, speaks like an

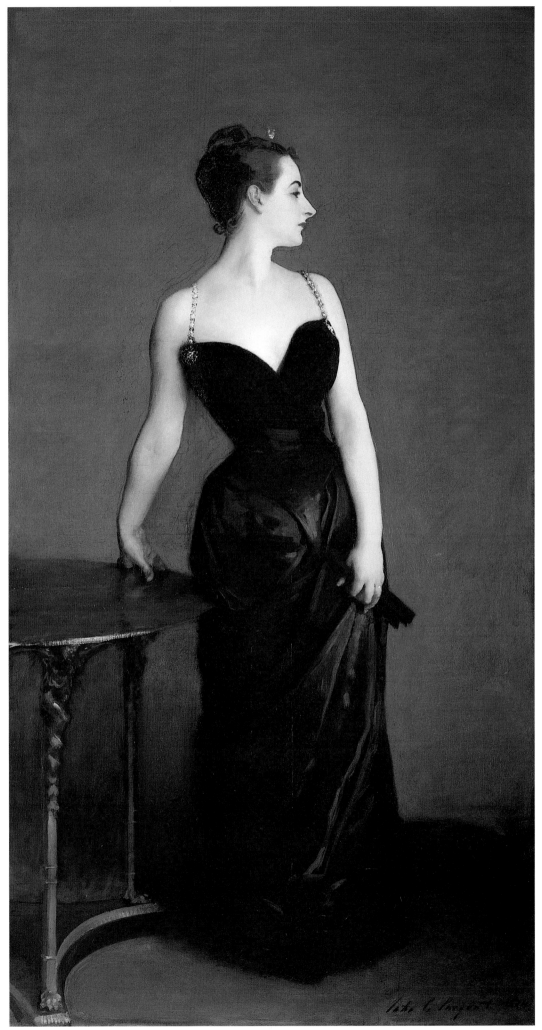

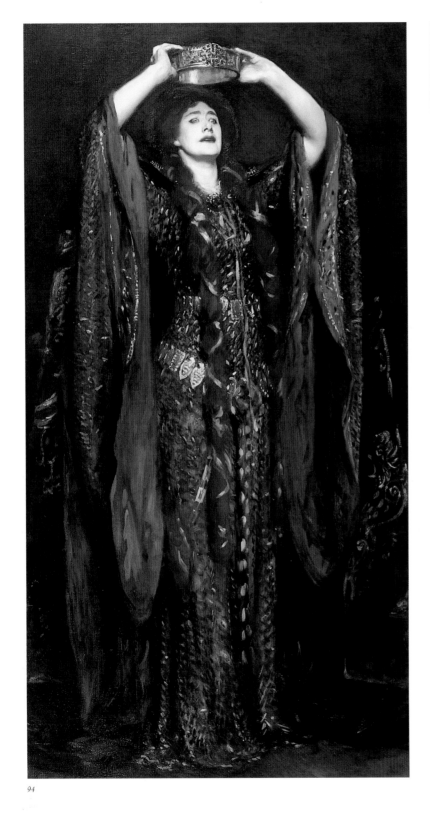

94

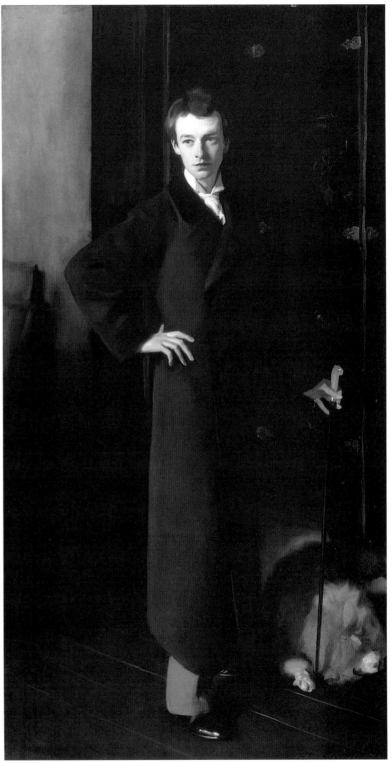

95

Englishman, and paints like a Spaniard'. This last point refers to his veneration for Velázquez, whose work he studied in Madrid in 1879. The following year he visited Haarlem to look at the work of Frans Hals, whom he also greatly admired. After studying art in Florence he moved to Paris to work at first under Carolus Duran, and then on his own from 1880 to 1884, when he left after a scandal caused by the exhibition of a daring portrait of Madame Gautreau at the Salon (Pl. 93), an event which marked a turning point in his career. Madame Gautreau, an American born in Louisiana, came to Paris after the American Civil War and married a successful banker, despite being a member of the *beau-monde*. Sargent's friend Ralph Curtis described the scene at the opening of the Salon: 'The coy reference to the sitter as Mme XXX in the catalogue fooled no one. "Ah voilà la belle!" "Oh quelle horreur!" etc. … Mme Gautreau and mère came to his [Sargent's] studio bathed in tears.' The portrait remained in Sargent's possession until 1916, as it had never been commissioned by the sitter. He considered it the finest portrait he ever painted.

Sargent settled in London, describing himself as 'an Impressionist'. At first the public was nervous, it being regarded as 'positively dangerous to sit to him – it's taking your face in your hands'. But confidence began to increase with the purchase for the nation by the Chantrey Bequest of *Carnation, Lily, Lily, Rose* (Pl. 225) and his portrait of the actress *Ellen Terry as Lady Macbeth* (Pl. 94), and commissions flooded in.

Although painting fashionable women and aristocratic family groups occupied Sargent more and more, one of his most delightful portraits is that of the young artist and writer *Walford Graham Robertson* (1866–1948), painted in 1894 (Pl. 95). Robertson's engaging memoirs *Time Was* (1931) contain some of the most enjoyable non-malicious gossip concerning the major artistic figures of the late Victorian age committed to paper. In them he describes sitting for the portrait:

> It was hot summer and I feebly rebelled against the thick overcoat. 'But the coat
> is the picture,' said Sargent. 'You must wear it.' 'Then I can't wear anything else,'
> I cried in despair, and with the sacrifice of most of my wardrobe I became thinner and thinner, much to the satisfaction of the artist, who used to pull and drag
> the unfortunate coat more and more closely round me until it might have been
> draping a lamp-post.

Just visible in the background is Robertson's elderly poodle Mouton, 'well stricken in years and almost toothless, who claimed rather unusual privileges and was always allowed one bite by Sargent, whom he unaccountably disliked, before work began. "He has bitten me now," Sargent would remark mildly, "so we can go ahead."'

Inevitably there emerged other portrait painters who followed Sargent's methods – most notably Sir John Lavery (1856–1941) a member of a little group who came to be known as 'The Slashing School'. A fine example of a portrait by Lavery is provided by *The Rocking Chair* (Pl. 97), a reminder that the exciting manipulation of black, white and grey in the 1890s was not solely the prerogative of great illustrators such as Beardsley and Phil May. The Slashing School would in turn be overtaken by foreign painters who worked in London in the 1890s and the Edwardian era, notably Antonio Mancini (1850–1930) and Giovanni Boldini (1845–1931), the latter being hailed by Sickert as the 'non pareil parent of the wriggle and chiffon school'. This phrase provides a perfect description of Boldini's portrait of *Lady Colin Campbell* (Pl. 96), a fencer, swimmer, horsewoman, art critic and the central figure in a notorious divorce case, in which no fewer than three co-respondents were named. Such works were anathematized by George Moore as 'white satin Duchesses', and further decried by Sickert in *The New Age* (1910), who attacked the way in which 'the place that is filled in works of art by the obscenity called the body, is replaced by a

94
John Singer Sargent
Ellen Terry as Lady Macbeth
1889
oil on canvas, 221 × 114.3cm
(87 × 45in)
Tate Gallery, London

95
John Singer Sargent
Walford Graham Robertson
1894
oil on canvas, 230.5 × 118.7cm
(90¾ × 46¾)
Tate Gallery, London

96
Giovanni Boldini
Lady Colin Campbell
1897
oil on canvas, 182.2 × 117.5cm
(71¾ × 46¼in)
National Portrait Gallery,
London

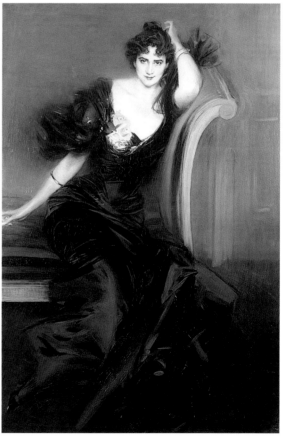
96

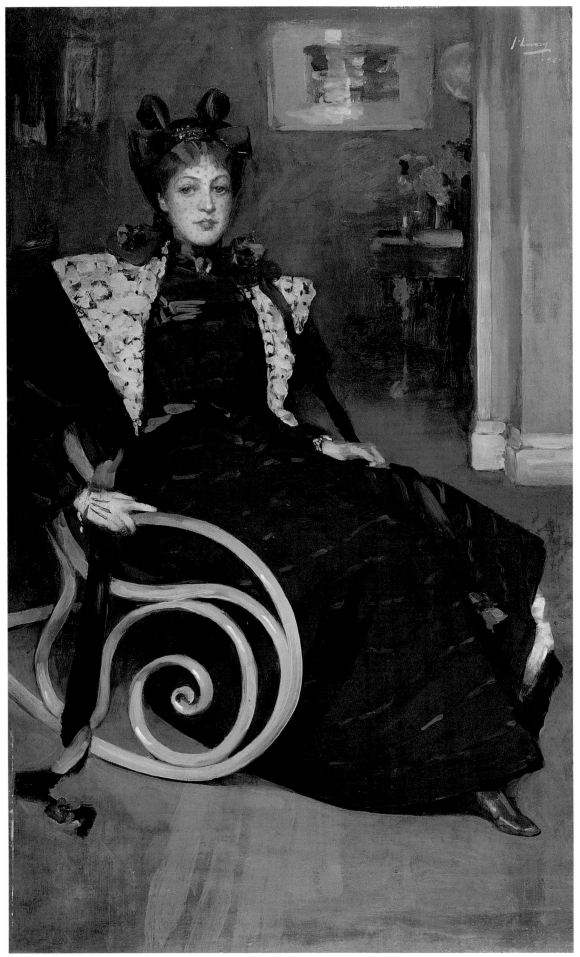

perpendicular cascade of chiffon on which gleams the occasional gem, and always *de rigueur* an oscillating chain. In this chain are twisted delicate fingers without nails. Their well-bred contortions suggest a soul slightly misunderstood.'

Sickert himself was not lacking in courage, and in 1891 boldly decided to accept the challenging problem presented by George Moore's luminous nose (Pl. 98). Moore, an intimate friend of Manet and the Impressionists, had himself studied painting in Paris for some years. The problem of painting his likeness had challenged Manet, Degas and Forain. Sickert's straightforward head-and-shoulders composition, shown at the Royal Academy in 1891, struck terror in the eye of the beholder and was denounced at the Academy banquet as the portrait of an intoxicated mummy. What strikes us now is the way in which the portrait points both backwards to the close-up technique of Watts and Mrs Cameron, and forwards to the work of Ruskin Spear (1911–90).

A more spontaneous portrait by Sickert was inspired by an event which took place on 16 July 1894 in Hampstead Church: the unveiling of a bust of the poet John Keats (Pl. 99). After the service Aubrey Beardsley, the great draughtsman of the decadent 1890s, was observed walking off through the graveyard making clumsy efforts to avoid the graves and, as Sickert wrote, 'falling over the embarrassing mounds that tripped his feet'. He had been overcome by a fit of coughing. Beardsley, like Keats, was to die of tuberculosis in his twenties, a fact which gives this painting by Sickert, a master of the immediate moment, a tragic irony. The picture demonstrates the continuing importance of portraiture at the end of the Victorian age, in the artist's ability to capture the subject in a manner very different from both the society portrait painter and the lens of the camera.

97
John Lavery
The Rocking Chair
1895
oil on canvas, 126·9 × 76cm
(50 × 30in)
Diploma Collection, Royal
Scottish Academy, Edinburgh

98
Walter Richard Sickert
George Moore
1891
oil on canvas, 60.3 × 50.2cm
(23¾ × 19¾in)
Tate Gallery, London

99
Walter Richard Sickert
Aubrey Beardsley
1894
oil on canvas, 76.1 × 31cm
(30 × 12¼in)
Tate Gallery, London

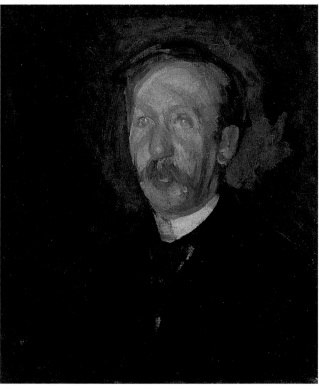

98 *99*

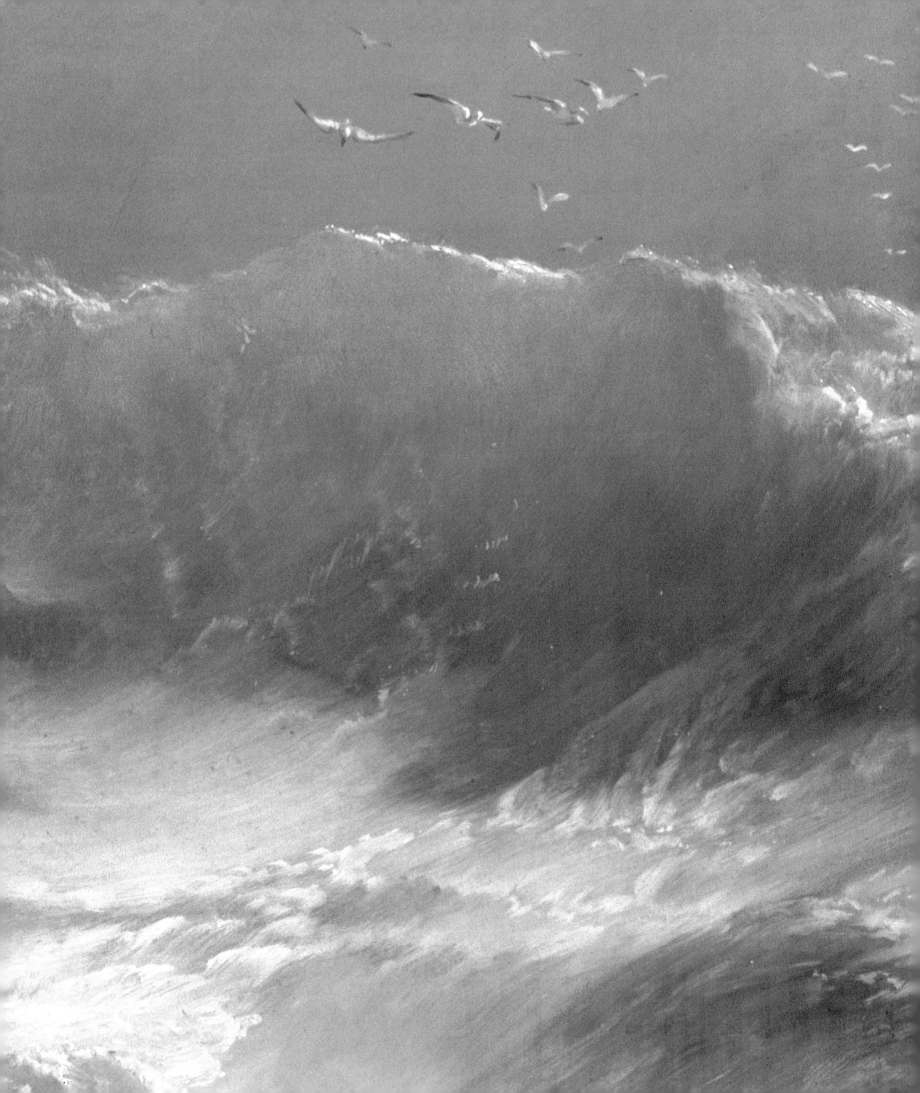

When aged 16 John Ruskin began to take lessons with the President of the Old Water Colour Society, Anthony Vandyke Copley Fielding. In a rhyming letter to his father, Ruskin described how he enjoyed the lessons and his physical aversion to the very smell of oil paint:

> I cannot bear to paint in oil,
>
> C. Fielding's tints alone for me!
>
> The other costs me double toil
>
> And wants some fifty coats to be
>
> Splashed on each spot successively.
>
> Faugh, *wie es stinckt!* I can't bring out,
>
> With all, a picture fit to see
>
> My bladders burst, my oils all out –
>
> And then, what's all the work about?

In these amusing lines Ruskin, a great practitioner of the watercolour medium, vividly contrasts its relative ease and cleanliness with the smelly business of using

100 Clarkson Stanfield, **On the Dogger Bank** (detail of Pl. 109)

101
J.M.W. Turner
**The Fighting Temeraire
Tugged to her Last Berth
to be Broken up**
1838
oil on canvas, 90·8 × 121·9cm
(35¼ × 48in)
National Gallery, London

102
J.M.W. Turner
**Snowstorm – Steam-Boat
off a Harbour's Mouth
Making Signals in Shallow
Water, and Going by the
Lead**
1842
oil on canvas, 91·4 × 121·9cm
(36 × 48in)
Tate Gallery, London

103
J.M.W. Turner
**Rain, Steam and Speed –
the Great Western Railway**
1844
oil on canvas, 90·8 × 121·9cm
(35¼ × 48in)
National Gallery, London

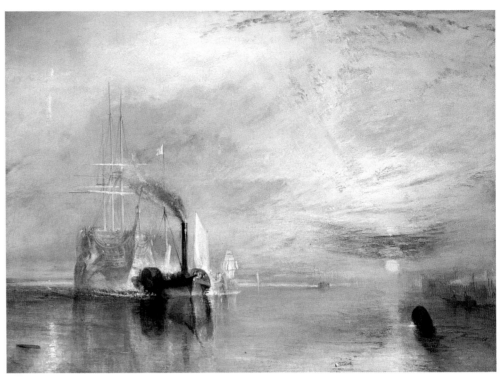

101

turpentine and oil colours (then stored in pigs' bladders). Ruskin's preferred medium, translucent watercolour paints, flourished in the mid-Victorian age, partly because of his own skilful advocacy. Ironically the oil medium, in the clever hands of Whistler, would itself eventually take on the fluid, wash-like qualities of watercolour in the controversial form of the 'Nocturnes'. In this survey of landscape painting it will be convenient to look first at paintings in oils, and then at watercolours.

In the very year of the Queen's accession one of the 'twin peaks' of English landscape painters, John Constable, died. John Ruskin, the impassioned champion of Turner, had a blind spot about the work of Constable, which he dismissed in slighting terms: 'Constable perceives in a landscape that the grass is wet, the meadows flat, and the boughs shady; that is to say, about as much, I suppose, as might in general be apprehended, between them, by an intelligent faun and a skylark.' These disdainful words imply that Constable was not an intellectual artist but only a simple, indeed naïve, recorder of nature. This was very far from the truth, for Constable himself asserted that painting was a science and 'should be pursued as an inquiry into the laws of nature'. He also said, and how Victorian the statement seems: 'In an age such as this, painting should be understood, not looked on with blind wonder, nor considered only as a poetic inspiration, but as a pursuit, *legitimate, scientific* and *mechanical*.'

Although Constable died in 1837, he was survived by Joseph Mallord William Turner (1775–1851), who produced some of his greatest paintings in the decade before his death at the age of 76. Some of these works reflect the sentiment of the new Victorian age, such as *The Fighting Temeraire Tugged to her Last Berth to be Broken up* (Pl. 101), a nostagic look back at the glories of the days of sail and a welcome to the age of steam. This was Turner's own personal favourite painting which he used to refer to as 'My Darling'.

Far more radical was another work, exhibited in 1842, which attempted to render light at the expense of form: *Snowstorm* (Pl. 102), of which Turner wrote: 'I only painted it because I wished to show what such a scene was like; I got the sailors to lash me to the mast to observe it; I was lashed for four hours and did not expect to escape, but I felt bound to record it if I did …'

102

103

104
James Baker Pyne
Isola Bella, Lago Maggiore
1857
oil on canvas, 95.2 × 130.8cm
(37½ × 51½in)
Private collection

104

Two years later, in *Rain, Steam and Speed – the Great Western Railway* (Pl. 103), Turner produced his salutation to the new railway age, his most remarkable celebration of the new technical wonders of steam, trains, viaducts and bridges. In the painting rural life is represented by the distant ploughman and the hare leaping frantically forward to escape the oncoming wheels of the train.

Turner made his last visit to Italy in 1840, and exhibited Italian subjects until 1846 (Pl. 132). The eighteenth-century concept of the sublime in landscape survived almost only in Turner's solitary genius, and with his death the awesome summits of the Alps were supplanted by the more placid beauty of the Italian lakes and the charms of the Tuscan countryside. Many artists, inspired by Turner's example, studied, travelled and painted in Italy. The work of James Baker Pyne (1800–70) has often been confused with that of Turner, but at its best displays real originality, as in his dramatic views of the Bay of Naples and more peaceful scenes such as *Isola Bella, Lago Maggiore* (Pl. 104).

Even more than Turner, Constable had his rivals and imitators whose less exalted views of landscape flourished. Ironically, the vacancy at the Royal Academy caused by Constable's death was filled by Frederick Richard Lee (?1798–1879), who has been described as 'the quintessence of the second-rate school of greenery'. According to his collaborator the animal painter Thomas Sidney Cooper, who regularly painted the cows in Lee's landscapes, Lee saw painting as 'more of a business than as a pastime, and he always gave me the impression that he considered the profession beneath him'. Both Constable and David Cox, the great watercolour painter, loathed Lee, whose commonplace vision they felt heralded the decline of landscape painting. One of the more memorable of Constable's imitators was Frederick Waters Watts (1800–62), whose prolific work was often confused with Constable's even in their lifetimes, especially his 'Jumping Horses', feeble echoes of leaping horses by Constable.

The quiet and unassuming art of William Shayer (1788–1865) was very different, owing its appeal to the rural genre tradition of George Morland. His picturesque landscapes, many set in the New Forest, still have great charm. Shayer had a great

interest in gypsies whose bivouacs, made of bent saplings, often appear in his works, and he also loved to depict timber waggons. His masterpiece, *The Village Festival* (Pl. 105), reveals his warm affection for the rural life he portrays.

The same quality is to be found in the marine landscapes of Edward William Cooke (1811–80). His Dutch and Belgian coastal scenes, such as *Scheveningen Beach* (Pl. 106), capture the charm of children playing on seashores liberally strewn with lobster pots and fishing nets. The early Victorian public loved marine landscape paintings, which could take many varying forms, and Cooke's tranquil beaches form an interesting contrast to the cool objectivity which distinguishes *Land's End, Cornwall* (Pl. 107) by Thomas Creswick (1811–69), with its unusual aerial viewpoint.

The marine paintings of Clarkson Stanfield (1793–1867) were greatly admired by John Ruskin. He considered him to be Turner's nearest rival as a delineator of cloud forms. In a famous passage he lavished praise on Stanfield's *On the Dogger Bank* (Pl. 109): 'He will carry a mighty wave up against the sky and make its whole body

105
William Shayer
The Village Festival
1842
oil on canvas, 90 × 108cm
(35½ × 42½in)
Tate Gallery, London

106
Edward William Cooke
Scheveningen Beach
1839
oil on canvas, 45.7 × 91.4cm
(18 × 36in)
Royal Holloway College,
University of London, Egham,
Surrey

105

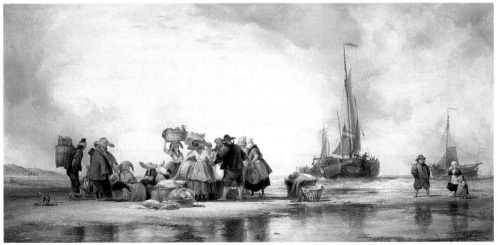

106

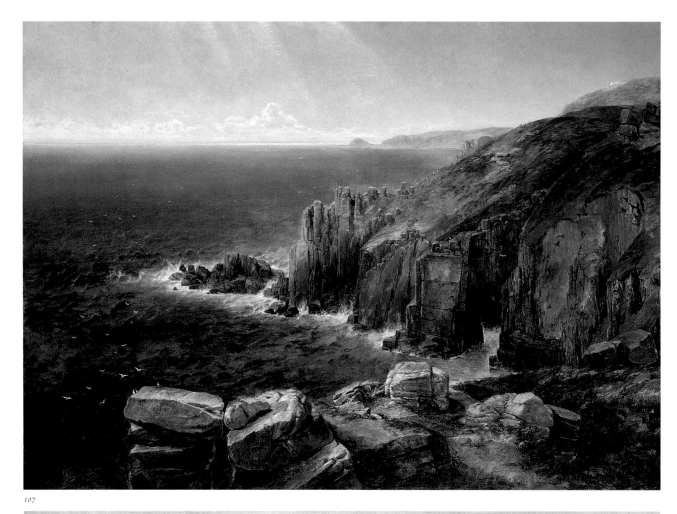

107

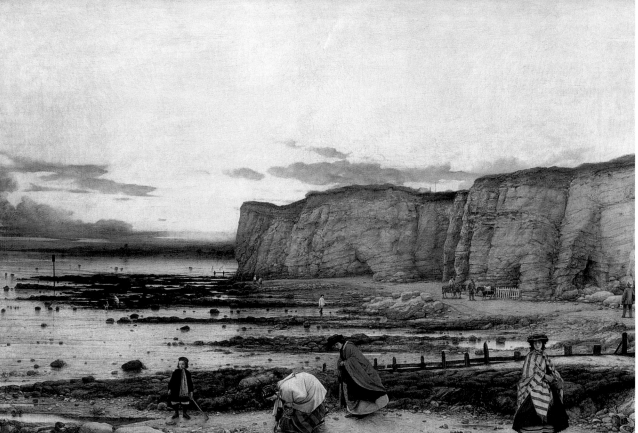

108

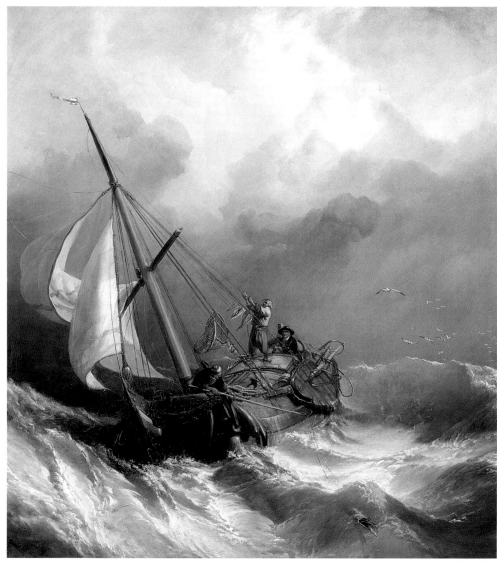

109

107
Thomas Creswick
Land's End, Cornwall
1842
oil on canvas, 92.1 × 130.2cm
(36¼ × 51¼in)
Victoria and Albert Museum,
London

108
William Dyce
**Pegwell Bay: A Recollection
of October 5th, 1858**
1858–60
oil on canvas, 63.5 × 88.9cm
(25 × 35in)
Tate Gallery, London

109
Clarkson Stanfield
On the Dogger Bank
1846
oil on canvas, 76.1 × 69.8cm
(30 × 27½in)
Victoria and Albert Museum,
London

dark and substantial against the distant light using all the while nothing more than chaste and unexaggerated colour to gain the relief. His surface is at once lustrous, transparent and accurate to a hair's breadth in every curve.'

One of the most remarkable of all marine landscape paintings is by William Dyce, more renowned as a mural painter (see above, pp. 44–9). His *Pegwell Bay: A Recollection of October 5th, 1858* (Pl. 108) was a new departure and is a work which can be viewed at several intellectual levels. Pegwell Bay is on the Kent coast between Ramsgate and Sandwich, bordered by chalk cliffs rich in fossils. At first sight the painting would appear to be a happy record of the Dyce family enjoying a day at the seaside collecting seashells. Across the foreground, from right to left, are Dyce's wife Jane, her sisters Grace and Isabella, and one of his sons, while the artist himself with his painting equipment is in the middle distance on the right. Closer inspection reveals that it is low tide, and that far out across the bay many other people are also searching – for what? Surely not seashells, but fossils. Immense public interest was aroused in 1859, the year when this picture was painted, by the publication of Charles Darwin's *The Origin of Species*, which upset received ideas on the creation of the universe, causing religious arguments of the type recorded in Edmund Gosse's autobiographical narrative *Father and Son* (1907). The painting takes on another deeper dimension when we look up and see, high in the lowering sky, Donati's Comet which had appeared three months earlier and was now at its brightest. As comets

110
John William Inchbold
The Lake of Lucerne, Mont Pilatus in the Distance
1857
oil on wood, 35.5 × 48.8cm
(14 × 19¼ in)
Victoria and Albert Museum,
London

111
John Brett
Val d'Aosta
1858
oil on canvas, 87.6 × 68cm
(34½ × 26¾ in)
Private collection

112
John Brett
The Stonebreaker
1857–8
oil on canvas, 50 × 68cm
(19¼ × 26¾ in)
Walker Art Gallery, Liverpool

were considered bad omens, was Dyce, in painting this work, reflecting the religious concerns of his time?

In his writings on geology and mountain landscape in Volume 4 of *Modern Painters*, entitled *Of Mountain Beauty*, Ruskin had championed the Pre-Raphaelite precept of 'fidelity to nature'. These articles were greatly admired by the young artist John Brett (1831–1902), who was directly inspired to visit Switzerland and paint *The Glacier of Rosenlaui* (1856), detailing the surface of every pebble in the foreground with the care demanded by Ruskin when he described small stones as pearls or 'mountains in miniature'. Ruskin's stern dictum in *Modern Painters* was that 'from young artists nothing might be tolerated but simple *bona fide* imitation of nature', and that they should 'go to Nature in all singleness of heart, and walk with her laboriously and trustingly, having no other thought but how best to penetrate her meaning, and remember her instruction; rejecting nothing, selecting nothing, and scorning nothing. Then, when their memories are stored, and their imagination fed, and

110

their hands firm, let them take up the scarlet and gold, give the reins to their fancy, and show us what their heads are made of.' This ideal was powerfully reinforced by Brett's willingness to accept Ruskin's passionate advocacy of detail.

While in Switzerland Brett met John William Inchbold (1830–88), an artist whose landscapes such as *The Lake of Lucerne, Mont Pilatus in the Distance* (Pl. 110) also possess the true Ruskinian blend of sharply observed rocks and misty distances. Intriguingly, Inchbold's method of allowing the white ground to show through in places, and the extreme thinness of paint, led to this work being catalogued for many years as a watercolour. Inchbold and Brett were both bullied and praised by Ruskin with endless criticism of their works. Ruskin crowed: 'Brett wanted some lecturing like Inchbold … He is much tougher and stronger than Inchbold, and takes more hammering, but I think he looks more miserable every day, and have good hope of making him completely wretched in a day or two more!'

On his return to England Brett painted a boy knapping flints on Box Hill,

111

112

113
William James Müller
**The Ramesseum at Thebes,
Sunset**
1840
oil on canvas, 74.3 × 135.9cm
(29¼ × 53½in)
Bristol Museum and Art
Gallery

114
John Frederick Lewis
**A Frank Encampment in
the Desert of Mount Sinai,
1842 – the Convent of Saint
Catherine in the Distance**
1856
watercolour and bodycolour
over pencil, 64.8 × 134.3cm
(25½ × 52⅞in)
Yale Center for British Art,
Paul Mellon Collection, New
Haven, CT

Surrey, entitled *The Stonebreaker* (Pl. 112), which made his reputation and greatly impressed Ruskin. His review in *Academy Notes* ended with the words, 'If he can paint so lovely a distance from the Surrey downs and railway-traversed vales, what would he not make of the chestnut groves of the Val d'Aosta!' Within a few days Brett left to carry out Ruskin's exhortation, and the resultant work, *Val d'Aosta* (Pl. 111), more than any other Pre-Raphaelite landscape, bears the mark of Ruskin's overpowering emphasis on the importance of detail.

While Italy and Rome had long been a magnet for artists, the Middle East was an even more tempting artistic location throughout the High Victorian era. In 1837, quite independently of each other, John Frederick Lewis (1805–76), William James Müller (1812–1845) and David Roberts (1796–1864) all set off to paint in the Middle East – Lewis to Italy, Greece, and the Levant; Müller to Egypt and Turkey; and Roberts to Egypt. Equally skilled in both oil and watercolour, they used the latter medium for sketches which would later be worked up into oil paintings. All were motivated by an awareness of the potential public demand for virtually any composition with a Bedouin encampment, a palm tree, a pyramid and an oasis.

The situation was summed up shrewdly in the autumn of 1844 by the novelist and art critic W.M. Thackeray, enjoying what would now be described as a 'freebie' at the expense of the P&O Company during which he visited Athens, Constantinople, Jerusalem and Cairo. Thackeray considered that: 'There is a fortune to be made for painters in Cairo, and materials for a whole Academy of them. I never saw such a variety of architecture, of life, of picturesqueness, of brilliant colour, and light and shade. There is a picture in every street, and at every bazaar stall.'

Müller's journal gives a vivid account of his journey and enthusiasms. He arrived in Alexandria in November 1838, and shortly afterwards noted in his journal: 'Egypt is full of scriptural subjects, and a Holy Family is found in every Arab village.' He travelled to Cairo via the new Mahmoudia canal, and spent two weeks sketching the slave market, and inevitably the pyramids. Then he travelled up the Nile to Luxor, recording the temples of Dendera and Karnak and the impressive avenue of sphinxes. When visiting *The Ramesseum at Thebes* (Pl. 113) – the mortuary temple of Rameses II on the west bank of the Nile – to sketch the fallen remains of one of the colossal statues of the pharaoh, Müller witnessed a thunderstorm which he described as being quite different from 'those prints and pictures, with endless rows of pillars and skies of flames, with moons and stars, and God knows what else, which Mr Martin and his school are pleased to indulge in'.

113

114

Of all Victorian images of Egypt the most familiar are surely the published views of *The Holy Land, Idumea, Arabia, Egypt and Nubia* (1842–9) by David Roberts. Between October and December 1838 he travelled up the Nile to Abu Simbel, sketching as he went, awed and astonished by the monuments of ancient Egypt. Back in Cairo he obtained a permit to sketch in the mosques, on the condition that he wore Turkish dress, shaved his whiskers and did not use hog's-hair brushes, conditions to which he willingly agreed since he believed himself to be the first professional artist to gain this opportunity.

In February he set off across Sinai to Palestine, and after a brief visit to Alexandria, returned to England in May 1839 with 272 drawings, a panorama of Cairo and three full sketchbooks, which was, as he said, 'one of the richest folios that ever left the east'. Elected a Royal Academician in 1841, he spent the rest of his life reinterpreting these notes as major oil paintings such as *The Gate of Metwaley, Cairo* (Pl. 115), exhibited at the Royal Academy in 1843. Although impressed by the architecture of the old gate, built in 1092, Roberts found working very difficult: 'I have stood in the crowded streets of Cairo jostled and stared at until I came home quite sick. No one in looking over my sketches will ever think of the pain and trouble I had to contend with in collecting them.' With such works, and even more with the great books of coloured lithographs made after his return, Roberts satisfied a vast demand for accurate topographical depictions of Egypt and the Holy Land.

Although Roberts was the supreme view-taker, John Frederick Lewis, who lived in Cairo for many years, got closest to the pulse of Egyptian life. Lewis was primarily a subject painter but used sun-bleached landscape backgrounds to great effect, as in one of the most famous of his works, *A Frank Encampment in the Desert of Mount Sinai, 1842 – the Convent of Saint Catherine in the Distance* (Pl. 114). Lewis's sheer technique was eulogized by Ruskin in pages of lyrical rhapsody, for he considered this watercolour one of 'the most *wonderful* pictures in the world', praising particularly Lewis's 'refinements of handling which escape the naked eye altogether. If the reader will examine … with a good lens, the eyes of the camels … he will find there is

as much painting beneath their drooping fringes as would, with most painters, be thought enough for the whole head.'

Ruskin was worried that the watercolour would eventually fade and wrote to Lewis in 1856: 'Are you sure of your material – if one of those bits of white hair-stroke fade – where are you? – *Why* don't you paint in oil only, now?' At Ruskin's urging, and upon his own realization that he could not sell his watercolours for as much as his oils, Lewis resumed painting in oils in 1856. Since he used the two media in an almost identical manner, this was an easy change to make, but an ill-advised one, since his oils, brilliant though they are, lack the sheer virtuosity of his great exhibition watercolours, technical *tours de force*.

Another great traveller was Edward Lear (1812–88), even more remembered for his nonsense verse. Lear earned his living as a landscape artist and produced several amusing books of travel recollections. They contain sometimes hair-raising accounts of his experiences in search of picturesque subjects, which he first drew in water-colours and then worked up into oils when at home in England, Corfu or San Remo. Individual foreground details and studies of foliage were often painted from local sources. A remarkable example of this process is provided by a large painting with a long title, *The Temple of Bassae or Phigaleia, in Arcadia from the Oakwoods of Mount Cotylium. The Hills of Sparta, Ithome and Navarino in the Distance* (Pl. 116). This was a spot in mainland Greece where, amid solitary oaks, Apollo was worshipped as the god of health. On his return to England with watercolour sketches for the picture, Lear travelled to Leicestershire in order to paint the oak tree and rocks in the fore-ground directly from nature on the seven-foot canvas.

Lear may well have discussed the problems of painting direct from nature with his 'PRB Daddy', his nickname for his great friend William Holman Hunt (1827–1910), who, motivated by Pre-Raphaelite principles, believed in absolute fidelity to nature. In 1854–6 Holman Hunt journeyed to the Dead Sea and what he believed to be the site of Sodom to paint *The Scapegoat* (Pl. 297). He wrote to Rossetti: 'I don't know I should have thought of the subject demanding immediate illustration had I not had the opportunity of painting this extraordinary spot as back-ground from Nature.' The arid landscape of the Holy Land drew Holman Hunt back on several occasions. One of his best landscapes produced there was *The Plain of Esdraelon from the Heights above Nazareth* (Pl. 117), a scene rich in religious associations.

116

115
David Roberts
**The Gate of Metwaley,
Cairo**
1843
oil on wood, 76.2 × 62.2cm
(30 × 24½in)
Victoria and Albert Museum,
London

116
Edward Lear
**The Temple of Bassae
or Phigaleia, in Arcadia
from the Oakwoods of
Mount Cotylium. The Hills
of Sparta, Ithome and
Navarino in the Distance**
1854
oil on canvas, 146.4 × 229.5cm
(57¾ × 90½in)
Fitzwilliam Museum,
Cambridge

117
William Holman Hunt
**The Plain of Esdraelon from
the Heights above Nazareth**
1877
oil on canvas, 41 × 75cm
(16¼ × 29½in)
Ashmolean Museum, Oxford

118
Ford Madox Brown
**An English Autumn
Afternoon, Hampstead –
Scenery in 1853**
1852–3, 1855
oil on canvas, 71.7 × 134.6cm
(28¼ × 53in)
Birmingham City Museum
and Art Gallery

This work reminds us of Holman Hunt's continuing advocacy of painting out of doors: 'directly and frankly not merely for the charm of minute finish, but as a means of studying more deeply Nature's principles of design, and to escape the conventional treatment of landscape backgrounds'.

The 'charm of minute finish' cannot alter the fact that for mid-Victorian artists, public and clients, the choice of subject was all-important. Exotic Eastern subjects scored for their obvious novelty. The more prosaic choice of subject depicted in Ford Madox Brown's *An English Autumn Afternoon, Hampstead – Scenery in 1853* (Pl. 118) was puzzling. It would have been more acceptable if it had contained some narrative element, but Brown abjured this, remarking, 'The figures are peculiarly English – they are hardly lovers … more boy and girl, neighbours and friends.' When Ruskin obtusely asked, 'What made you take such a very ugly subject, it was a pity because there was some *nice* painting in it?', Brown replied, 'Because it lay out of a back win-

117

dow.' This response reminds us that the artist was a friend of the photographer Roger Fenton. Both photographer and painter would surely have agreed that, for them, 'nature' indeed lay outside the back window.

Another painting by Brown reflects his deep personal involvement with landscape as a subject, as it contains a self-portrait. On the right of *Walton-on-the-Naze* (Pl. 119) we see the artist as, to use his own words, he 'descants learnedly on the beauty of the scene' while gesturing to the broad landscape of the estuary, above which arches a rainbow. Both works, while displaying all the necessary 'truth to nature', show a large and sympathetic vision, very different from the strict adherence to Ruskinian principles to be observed in the work of Brett.

An artist whose work shares something of the same mood as that found in Brown's landscapes was the busy art administrator Richard Redgrave (1804–88). In his summer vacations he put his concerns for social problems to one side, and on

119

120

119
Ford Madox Brown
Walton-on-the-Naze
1859–60
oil on canvas, 31.7 × 42cm
(12¼ × 16½in)
Birmingham City Museum
and Art Gallery

120
Richard Redgrave
**The Valleys also Stand
Thick with Corn:
Psalm LXV**
1864
oil on canvas, 71.1 × 96.5cm
(28 × 38in)
Birmingham City Museum
and Art Gallery

121
Richard Burchett
**View across Sandown Bay,
Isle of Wight**
c.1855
oil on canvas, 34.3 × 57.2cm
(13½ × 22½in)
Victoria and Albert Museum,
London

holiday at Abinger painted some memorable landscapes, amongst them *The Valleys also Stand Thick with Corn: Psalm LXV* (Pl. 120). In his *Memoirs* Redgrave had written about the beauty of harvest as a possible background for landscape painters, and in this work follows his own advice with great success, for it visually conveys the mood of the psalm: 'The pastures are clothed with flocks, the valleys also are covered over with corn, they shout for joy, they also sing.' Cerulean skies also arch above a golden cornfield alight with cornflowers and scarlet poppies in *View across Sandown Bay, Isle of Wight* (Pl. 121) by Richard Burchett (1815–75), another fugitive from the art-administrative straitjacket of South Kensington.

There were indeed two paths which lay before mid-Victorian landscape painters. On the one hand they could follow the Pre-Raphaelite belief that by taking infinite pains the artist can succeed in pinning down nature. On the other hand they could supply a ready market for less intense full-scale exhibition pieces of the type discussed in a criticism of 1865: 'The painting of the present day, is the light reading of art, and light reading has ever been the most popular form both of art and literature.' The critic was reviewing a work by George Vicat Cole (1833–93), *Winter Scene* (Pl. 122), a celebration of many elements of the legendary Victorian Christmas – extremely cold weather, and with it the desire to retreat into the warmth of indoors, and deck

121

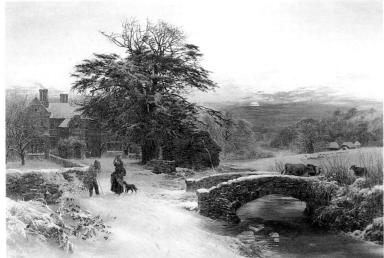

122

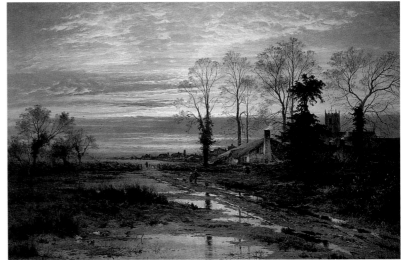

123

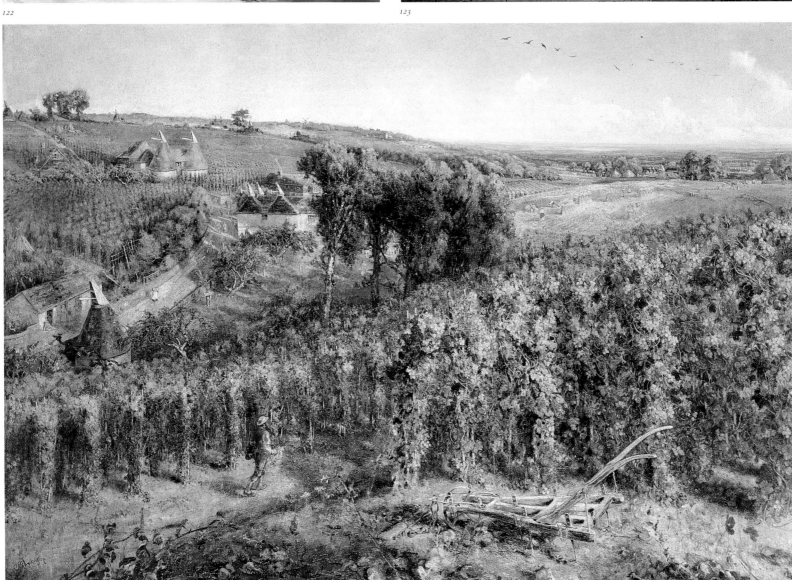

124

the walls with holly and ivy. Cole was fond of unobtrusively illustrating passages of poetry in his paintings, and this work relates to the song from Shakespeare's *Love's Labour's Lost*, Act V, Scene ii:

> When icicles hang by the wall,
> And Dick the shepherd blows his nail,
> And Tom bears logs into the hall,
> And milk comes frozen home in pail …

Cole's friend Benjamin Williams Leader (1831–1923) chose an even more recondite quotation from the sixteenth-century writer Thomas Tusser for the title of his most famous painting, *February Fill Dyke* (Pl. 123). Rather unfairly, Leader is often dismissed as being merely a feeble imitator of John Constable, with whom his family had been friendly. Leader's pictures of his native Worcestershire came to typify the landscape paintings which younger British Impressionist artists rejected. Although they remain out of favour with intellectual critics, they nevertheless obtain high prices in the saleroom.

Landscape artists played an important role in the fashionable Grosvenor Gallery, particularly the director Sir Coutts Lindsay's 'discovery', Cecil Gordon Lawson (1851–82), sadly neglected today, who painted large and remarkably evocative English landscapes. Lawson admired Rubens and Constable, both names long out of favour in an artistic world dominated by Ruskin, who as recently as 1871 had dismissed the work of Constable (and David Cox) as 'wholly disorderly, slovenly and licentious … the mere blundering of clever peasants'. When *A Hymn to Spring* was submitted for exhibition at the Royal Academy in 1873, it was rejected, but he was more successful with the lyrical *Hop Gardens of England* (Pl. 124), which was accepted. But the real significance of Lawson's work would not be realized by the public until the Grosvenor Gallery's retrospective exhibition held in 1883 after his early death at the age of 31.

An interesting group of artists who were also closely associated with the Grosvenor became known as the Etruscan School, united as they were by affection for the countryside outside Rome. Their style was characterized by a breadth of handling and fondness for the subdued tonalities of the distant mountains of the *Campagna* near Rome. One of the most interesting members of the group was George Heming Mason (1818–72), who settled in Italy in 1843 and painted sunlit Italian landscapes such as *Ploughing in the Campagna* (1857), a rural variation on the

122
George Vicat Cole
Winter Scene
1865
oil on canvas, 81.9 × 119.7cm
(32¼ × 41¼in)
Victoria and Albert Museum,
London

123
Benjamin Williams Leader
February Fill Dyke
1881
oil on canvas, 121.9 × 183cm
(48 × 72in)
Birmingham City Museum
and Art Gallery

124
Cecil Gordon Lawson
**The Hop Gardens
of England**
1873
oil on canvas, 148.6 × 212cm
(58½ × 83½in)
Private collection

125
George Heming Mason
Harvest Moon
1872
oil on canvas, 86.3 × 230.9cm
(34 × 91in)
Tate Gallery, London

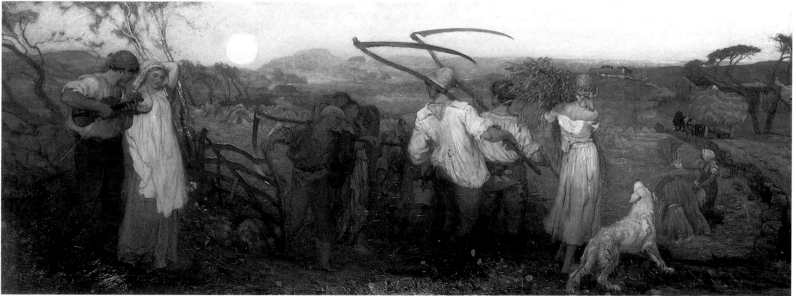

125

126
John Atkinson Grimshaw
Nightfall down the Thames
1880
oil on canvas, 38.7 × 61.6cm
(15¼ × 28¼in)
Leeds City Art Gallery

127
John Atkinson Grimshaw
**Tree Shadows on the Park
Wall, Roundhay, Leeds**
*c.*1872
oil on canvas, 52.7 × 45.1cm
(20¾ × 17¾in)
Leeds City Art Gallery

picturesque Victorian vision of Italian mountains, lakes and ruins. In 1858 Mason returned to England where, urged on by Leighton, he began to paint local scenes and attempted to 'classicize' English rural life. A fine example of this process is provided by his last painting, *Harvest Moon* (Pl. 125), with its procession of harvesters returning at dusk through the fields, carrying their scythes, sheaves and musical instruments.

Dusk and moonlight were also vital elements in the creation of Whistler's Nocturnes, those unique studies of water at night, in places as various as London, Southampton Water and Venice (Pl. 586). Whistler owed the title to his patron F.R. Leyland, a keen amateur musician, a fact he acknowledged in a letter written in November 1872: 'I can't thank you too much for the name nocturne as a title for my moonlights. You have no idea what an irritation it proves to the critics and constant pleasure to me – besides it is really charming and does so poetically say all I want to say and *no more* than I wish.' In the Nocturnes Whistler painted with lavish use of his 'sauce' – highly diluted oil paint used to establish the prevailing tone of colour. In the 1880s the Yorkshire painter John Atkinson Grimshaw (1836–93) had a studio in Manresa Road, Chelsea, not far from Whistler. He was visited by Whistler, who remarked with uncharacteristic modesty: 'I considered myself the inventor of Nocturnes until I saw Grimmy's moonlit pictures.'

Whistler was referring to works such as Grimshaw's *Nightfall down the Thames* (Pl. 126). His remarkable townscapes, created at dusk or at night, record the rain and mist, the puddles and smoky fog of late Victorian industrial England with great poetry. Some of Grimshaw's finest works are of his home town, Leeds, but he also painted Glasgow, Liverpool, Scarborough, Whitby and London. *Tree Shadows on the Park*

126

128
Anthony Van Dyke Copley
Fielding
Ben Lomond
1850
watercolour, 17.8 × 26cm
(7 × 10¼in)
Victoria and Albert Museum,
London

129
William Henry Hunt
Primroses and Bird's Nests
*c.*1850
watercolour, 34.3 × 35.3cm
(13½ × 13⅞in)
Victoria and Albert Museum,
London

130
John Ruskin
Coast Scene near Dunbar
1857
watercolour, 32.5 × 47.5cm
(12¾ × 18¾in)
Birmingham City Museum
and Art Gallery

Wall (Pl. 127), one of several paintings of Roundhay Park, Leeds, was probably painted near Old Park Road, a view little different today. Although they evoke the Victorian suburban night vividly, Grimshaw's pictures, unlike Whistler's, are sharply focused, almost photographic, and clearly delineated in their careful application of oil paint. The effect is very different from the Nocturnes of the greater artist, for they belong to a far older tradition of moonlit landscapes. Yet as the first explorations of the beauty of the urban landscape, rather than rural idylls, they have a welcome originality. They also form an appropriate point at which to turn from oil painting to the world of the full-scale exhibition watercolour, where works in the medium could be judged as major works of art in their own right.

On the crowded walls of the Royal Academy annual exhibition, the main selling outlet for all artists, the narrow frames and pretty washline mounts which watercolourists used to complement their work could not hold their own against the richly encrusted gilt frames of oil paintings. Watercolour painters began to use the device of gilt mounts in order to compete, but these were ill suited to the relatively small scale and delicate colouring of many watercolours. Their visual impact was not enhanced, and they were still lost on the packed walls of the Academy's rooms at Somerset House, hung from floor to ceiling and vying for attention with vividly coloured oils.

This led artists to develop the technique of painting not only with the translucent washes of pure watercolour, but in gouache – rather like our modern 'poster' paint – to give greater body to their work. But even this technique did not solve the problem of the Academy's unwelcoming attitude to the watercolour medium, and as a result groups of artists founded their own Societies of Painters in Water Colours (see above, pp. 35–6). This kept business thriving, and connoisseurs competed for landscapes, which fell in the main into two categories, the idyllic and the topographical. Among the regular visitors at both the watercolour societies and the Academy were John Ruskin and his father, a wealthy wine merchant. Years later Ruskin looked back on those visits with nostalgic pleasure and reminisced:

> I cannot but recall with with feelings of considerable refreshment, in these days of
> the deep, the lofty, and the mysterious, what a simple company of connoisseurs
> we were, who crowded into happy meeting, on the first Mondays in Mays of

128

129

130

long ago, in the bright large room of the Old Water-Colour Society; and dis-
cussed, with holiday gaiety, the unimposing merits of the favourites, from whose
pencils we knew precisely what to expect, and by whom we were never either
disappointed or surprised.

These visits laid the foundations of Ruskin's life-long involvement with watercolour,
which, even more than oil painting, was part of the very fibre of his being. His opin-
ion was respected whether assessing, praising or condemning works of art. Although
in his own time he was never thought of as an artist, his writing on watercolours con-
tinues to command respect simply because he was himself a great practitioner of the
medium.

As we have seen, Ruskin had painting lessons from Anthony Van Dyke Copley
Fielding (1787–1855), who in a long career exhibited literally thousands of works and
specialized in rapidly painted landscapes with rich sonorous colour such as *Ben
Lomond* (Pl. 128). Fielding was a professional teacher who passed on to him a series
of mannerisms and visual clichés for picture making. Ruskin wrote that Fielding
taught him 'to wash colour smoothly in successive tints … to use a broken scraggy
touch for the tops of mountains' and 'to produce dark clouds and rain with twelve
or twenty successive washes'.

Another important influence was William Henry (Bird's Nest) Hunt
(1790–1864), so nicknamed to acknowledge his favourite subject: still-life studies of
bird's nests such as *Primroses and Bird's Nests* (Pl. 129). Gifted with an almost photo-
graphic intensity of vision, Hunt once observed: 'I feel really frightened when I sit
down to paint a flower.' His works gave Ruskin bench-marks at which to aim as an
artist, and he developed a remarkable facility for handling the watercolour medium.
No one has ever excelled him in painting geological specimens and rocks, as in *Coast
Scene near Dunbar* (Pl. 130).

Both Ruskin and his father were keen collectors, and from the 1830s their home
began to fill up with works by Samuel Prout (1783–1852), David Roberts and, of
course, Turner. From looking at Prout's works such as the *C'a d'Oro, Venice* (Pl. 131),
Ruskin was to learn how to draw architecture, one of the consuming interests of his
life. But his supreme passion was to be the work of Turner, who became Ruskin's
idol.

The two men met in 1840, at the beginning of the decade which saw the

131
Samuel Prout
C'a d'Oro, Venice
*c.*1830
watercolour, 43.2 × 30.5cm
(17 × 12in)
Victoria and Albert Museum,
London

132
J.M.W. Turner
The Dark Rigi
1842
watercolour, 30.2 × 46.3cm
(11¾ × 18¼in)
Laing Art Gallery,
Newcastle-upon-Tyne

131

fruition of Turner's lifelong experiments with watercolour. He turned back through his sketchbooks and relied upon his prodigious visual memory to create some of his most wonderful watercolours, working up small sketches made on the spot into larger and more finished works. Very early in his career Turner had said that he drove the colours about till he had expressed the idea in his mind. It was Ruskin's privilege to understand Turner's mind intuitively, and he leapt to the defence of Turner when his more daring works were criticized, writing a book which became the first volume of *Modern Painters* (1843).

The stimulus of being in Italy and Switzerland was always of great importance to Turner. According to Ruskin, a trip to the Alps in 1841 completely rejuvenated the artist: 'The faculties of imagination and execution appeared in renewed strength; all conventionality being done away by the force of the impression which he had received from the Alps, after his long separation from them.' As Turner travelled he made countless sketches from which he worked out a 'blueprint' master-sketch. He made these into a series from which prospective clients could order finished watercolours. The paintings produced from this series have come to be regarded as some of his very finest, notably the variations on the Rigi mountains of the mid-1840s worked up from sketches made in 1840 or 1841. Like Hokusai's views of Mount Fuji, these come in different 'colour ways'. One of the most impressive is *The Dark Rigi* (Pl. 132).

After Turner's death in 1851, Ruskin's preoccupation with the Pre-Raphaelite movement and his disastrous marriage turned his thoughts elsewhere for a while, but he still retained his concern for his old love, landscape watercolours. His criticism, so often unintentionally comic, could also be deliberately funny. In his *Academy Notes* for 1857, for example, he accused the Society of Painters in Water Colours of supplying the demand of the British public for 'a kind of Potted Art, of an agreeable flavour, suppliable and taxable as a patented commodity, but in no wise to be thought of or criticised as *Living Art'*.

He only made one exception – the work of David Cox (1783–1859), which he had come to value and of which he wrote: 'There is not any other landscape which comes near these works of David Cox in simplicity or seriousness.' Like Clarkson Stanfield and David Roberts, David Cox began his career by painting scenery, in his case at the Theatre Royal, Birmingham, before moving to London to study watercolour painting with its great exponent John Varley (1778–1842). In 1841 he settled in Harbourne, near Birmingham, making frequent sketching trips to North Wales.

At his best Cox broke new ground in the sheer violence with which he attacked the sheet with his brush, capturing the gloomier aspects of British weather in a unique manner which owes little to either Constable or Turner. Cox often depicted landscapes lashed by strong winds and driving rain, with man or animals reacting to the elements, such as *Rhyl Sands* (Pl. 133). One of his most impressive works is *The Night Train* (Pl. 134), which shows a lurid evening sky glowering over a dark moorland. In the distance can be seen the flashing lights of a night express, startling a group of horses into a wild gallop. A few years later in 1853 Cox painted *The Challenge*, a solitary bull bellowing his defiance to the elements. *The Challenge* and *The Night Train* may have been the two watercolours which hung in 1856 on either side of an elaborate, highly wrought Eastern scene by John Frederick Lewis, forming a contrast which led Ruskin to comment on Cox's 'excessive darkness and boldness … the English moors gain in gloom and power by opposition to the Arabian sunlight, and Lewis's finish is well set off by the impatient breadth of Cox'.

Cox's love of the moorland of North Wales is an example of a phenomenon present throughout the history of British art, in which individual landscape artists have

132

133

134

135

often become enthralled by a particular locality. Certain artists' names have indeed become inseparably linked with specific areas, so that Peter De Wint (1784–1849) has become as inextricably associated with Lincolnshire as Constable with Suffolk. His *Harvest Field* (Pl. 135) is one of many similar studies made near the Lincolnshire Wolds to the north of the county. Of such works the poet John Clare wrote lyrically: 'those rough sketches, taken in the fields, that breathe the living freshness of the open air and sunshine, where the harmony of earth, air and sky form such a happy unison of greens and greys, that a flat piece of scenery on a few inches of paper appears so many miles'. De Wint, at his best when capturing the vast skyscapes of the Lincolnshire fens, also excelled at architectural drawings, making many fine studies of Lincoln Cathedral.

The watercolour medium was not limited to pastoral and topographical subjects, but also lent itself to linear, sharply observed yet grand architectural studies of great cathedrals and country houses. Joseph Nash (1808–78) was an architectural draughtsman of note, who had studied with the older Pugin. Nash specialized in portraits of old English mansions such as *The Porch at Montacute House, Somerset* (Pl. 136). He reinterpreted many of these watercolours as lithographic plates in his profusely illustrated book *The Mansions of England in the Olden Time*, published between 1839 and 1849. When exhibited, works of this type gained immensely from their elaborate frames; the one shown here is a superb example of what has been facetiously called the 'Jacobethan' style. The artist chose the frame in a successful attempt to emulate the architectural details of the depicted house.

Turner's death in 1851 left the way clear for other painters to venture at painting Venetian views. Ever since the days of the Grand Tour in the eighteenth century a huge appetite for views of Venice had developed, for visitors to Italy tend to long for a pictorial souvenir, a wish now usually satisfied by their own cameras. Vast 'coffee-table' books of prints by Joseph Nash and William Lake Price entitled *Interiors and Exteriors in Venice* were published, so large that two people are needed to lift them on to a reading lectern. Watercolours such as *The Hospital of the Pietà* (Pl. 139) by James Holland (1800–70) and *San Giorgio Maggiore* (Pl. 140) by Myles Birket Foster (1825–99) vied for public attention.

A poetic recorder of other attractions in Italy was Samuel Palmer (1805–81), more often remembered for his famous visionary years at Shoreham in Kent, where he painted lyrical pastoral landscapes – moonlit harvesters and trees aflame with blossom. Three years after his return to London in 1834 he married the painter John Linnell's daughter and spent his honeymoon in Rome. His two watercolours of *Ancient Rome* and *Modern Rome* are especially skilful examples of the use of gouache. After his return to England Palmer was to try and recapture the intense vision of his Shoreham years, but contemporary pressures intervened, and a work such as *Going to Sea (Going to India – The Father's Blessing and the Mother's Prayer)* (Pl. 137), shows Palmer reflecting the widespread public unease at the departure of troops for the suppression of the Indian Mutiny, a far cry from the dream-like Virgilian idylls of his earlier works.

Competing with Venice and the attractions of the Eternal City for the affections of the mid-Victorian public were romantic landscapes of the Italian Lakes and the Scottish Highlands. The enthusiastic adoption of Balmoral as a Scottish retreat by Queen Victoria and Prince Albert, and the popularity of the romantic novels of Sir Walter Scott (1771–1832), led to a keen demand for depictions of such subjects as *The Pass of Glencoe from Rannoch Moor* (Pl. 138), *Ben Muich-Dhui* and *The Entrance to the Pass of the Awe, Argyllshire* by Thomas Miles Richardson junior (1813–90). Richardson was criticized by Ruskin in his *Academy Notes* of 1857, who wrote that the artist:

136

137
Samuel Palmer
Going to Sea (Going to India – The Father's Blessing and the Mother's Prayer)
1858
watercolour, 19.4 × 42.9cm
(7⅝ × 16⅞in)
Victoria and Albert Museum, London

138
Thomas Miles Richardson jnr
The Pass of Glencoe from Rannoch Moor
1884
watercolour, 76·2 × 127cm
(30 × 50in)
Guildhall Art Gallery, London

139
James Holland
The Hospital of the Pietà
1844
watercolour, 38.4 × 25cm
(15¼ × 9⅞in)
Victoria and Albert Museum, London

140
Myles Birket Foster
San Giorgio Maggiore
*c.*1855
watercolour, 18.5 × 25.7cm
(7¼ × 10⅛in)
Victoria and Albert Museum, London

137

138

seems always to conceive a Highland landscape only as a rich medley of the same materials – a rocky bank blue at one place and brown at another; some contorted Scottish firs; some ferns; some dogs, and some sportsmen: the whole contemplated under the cheering influence of champagne, and considered in every way delightful.

Samuel Prout's painstaking depictions of picturesque cities such as Venice, Würzburg and Dresden also sold well. Immensely popular, Prout shares with Myles Birket Foster the somewhat dubious distinction of being the most forged of all Victorian artists. This is partly because Prout produced several instructional illustrated volumes of the 'How to Draw Picturesque Scenery' type, which inevitably led to the creation of many extremely close copies of Prout compositions. A century later these are still capable of deceiving inexperienced eyes. Copies of Birket Foster also abound, often with glaringly obvious fake monograms, which nevertheless fool untrained eyes, since many derive from the chromo-lithographed colour reproductions in a book, *Songs of the Poets*.

Several artists on the fringes of the Pre-Raphaelite movement created sensitive and memorable watercolours. Alfred William Hunt (1830–96) depicted a strange moon-like landscape with surrealist sharpness of detail in the depiction of rocks in his *A November Rainbow – Dolwyddelan Valley* (Pl. 141). The son of a landscape painter, Hunt vacillated between an academic and artistic career, until Ruskin's praise for some of his early watercolours persuaded him to be an artist. For several years he

139

140

141
Alfred William Hunt
**A November Rainbow –
Dolwyddelan Valley**
1865
watercolour, 50.3 × 75.5cm
(19¾ × 29¾ in)
Ashmolean Museum, Oxford

pursued a dual career as oil and watercolour painter, before becoming a member of the Old Water Colour Society in 1862 and concentrating increasingly on the effects of light.

Much of the considerable charm of the small delicate landscapes by George Price Boyce (1826–97) resides in the details of cats, birds, dogs and children playing in peaceful, sun-drenched gardens surrounding red-brick homes in the calm of early morning or peaceful afternoon. He also visited Egypt, bringing home, like Hunt before him, a view of *The Great Sphinx of Gizeh* of which Rossetti remarked caustically to Boyce on 14 April 1862 that he 'did not like what I had done in the East. Said that all the things artists brought from the East were always all alike and equal-

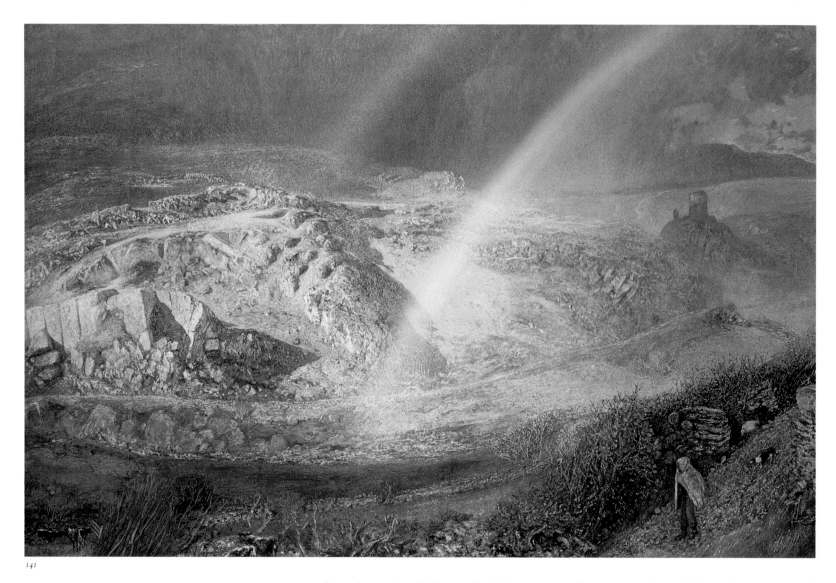

141

ly uninteresting.' Rossetti's judgement was in a way to be vindicated, since a work such as Boyce's *Night Sketch of the Thames near Hungerford Bridge* (Pl. 142) anticipates his friend Whistler's first Nocturne by a decade! If such original inspiration comes by looking out of your window in London, why travel?

From the 1860s Ruskin gradually abandoned active encouragement of his contemporaries, preferring younger disciples who could produce the sort of work he really wanted. An ideal figure of this type was Albert Goodwin (1845–1932), who was taught in London by Madox Brown and Arthur Hughes. Following a three-month visit to Italy with Ruskin in 1872 he made many further visits abroad as far afield as the South Seas and India. His townscapes are now the most sought-after of

142
George Price Boyce
**Night Sketch of the Thames
near Hungerford Bridge**
*c.*1866
watercolour, 22.2 × 33.6cm
(8¾ × 13¼in)
Tate Gallery, London

142

143
Frederick Walker
Spring
1864
watercolour, 62.2 × 50.2cm
(24½ × 19¾in)
Victoria and Albert Museum,
London

144
George John Pinwell
King Pippin
1866
watercolour, 13.3 × 16.8cm
(5¼ × 6⅝in)
British Museum, London

143

144

late Victorian landscapes. At his best, and Goodwin was remarkably consistent, he excels at catching the essence of a famous view of a city, such as *Ponte Vecchio, Florence* (Pl. 145), in a style which, while it looks back to Turner's great series of cities, ports and rivers, has its own integrity.

The evocations of rural life by Frederick Walker (1840–75) were greatly admired for their successful blend of simplicity, sentiment and pathos. For example, his *Spring* (Pl. 143) depends for its naturalism on the artist's ability to paint in what Ruskin described as his 'semi miniature, quarter fresco, quarter wash manner', a technique also described as 'working up a painting to a stage of extreme elaboration of drawing, to be afterwards carefully worn away, so that a suggestiveness and softness resulted – not emptiness, but veiled detail'. When adversely criticized by the *Art Journal* in 1869 for 'using bodycolour like mortar', Walker drew a caricature of himself squeezing paint out of a giant tube of Chinese White and asking: 'What *would* "the Society" say if it could only see me?'

Today we are inclined to regard works like *Spring* as only narrowly escaping sentimentality, but in his day they were greatly admired. Van Gogh said of Walker and George John Pinwell in a letter of 1885: 'They did in England exactly what Maris,

145
Albert Goodwin
Ponte Vecchio, Florence
*c.*1890
watercolour, 24.1 × 34.2cm
(9½ × 13½in)
Private collection

146
John William North
A Gypsy Encampment
1873
watercolour, 64 × 92.6cm
(25¼ × 36½in)
Victoria and Albert Museum,
London

145

146

Israels, Mauve, have done in Holland, namely restored nature over convention; sentiment and impression over academic platitudes and dullness …'

Before his early death Walker became known as the leader of a group which in the 1890s was retrospectively named the Idyllic School. It consisted primarily of illustrators who occasionally created watercolours, usually figurative subjects in landscape settings or domestic scenes such as *King Pippin* (Pl. 144) by George John Pinwell (1842–75). Another member was John William North (1842–1924), whose *A Gypsy Encampment* (Pl. 146) takes us into the world of social concern discussed below (Pls. 406, 409). The concerns of the group were summarized in another of Van Gogh's comments on Pinwell: 'He was such a poet that he saw the sublime in the most ordinary, commonplace things.'

The most ordinary and commonplace things would indeed excite a new generation of landscape artists, the British Impressionists of the 1880s.

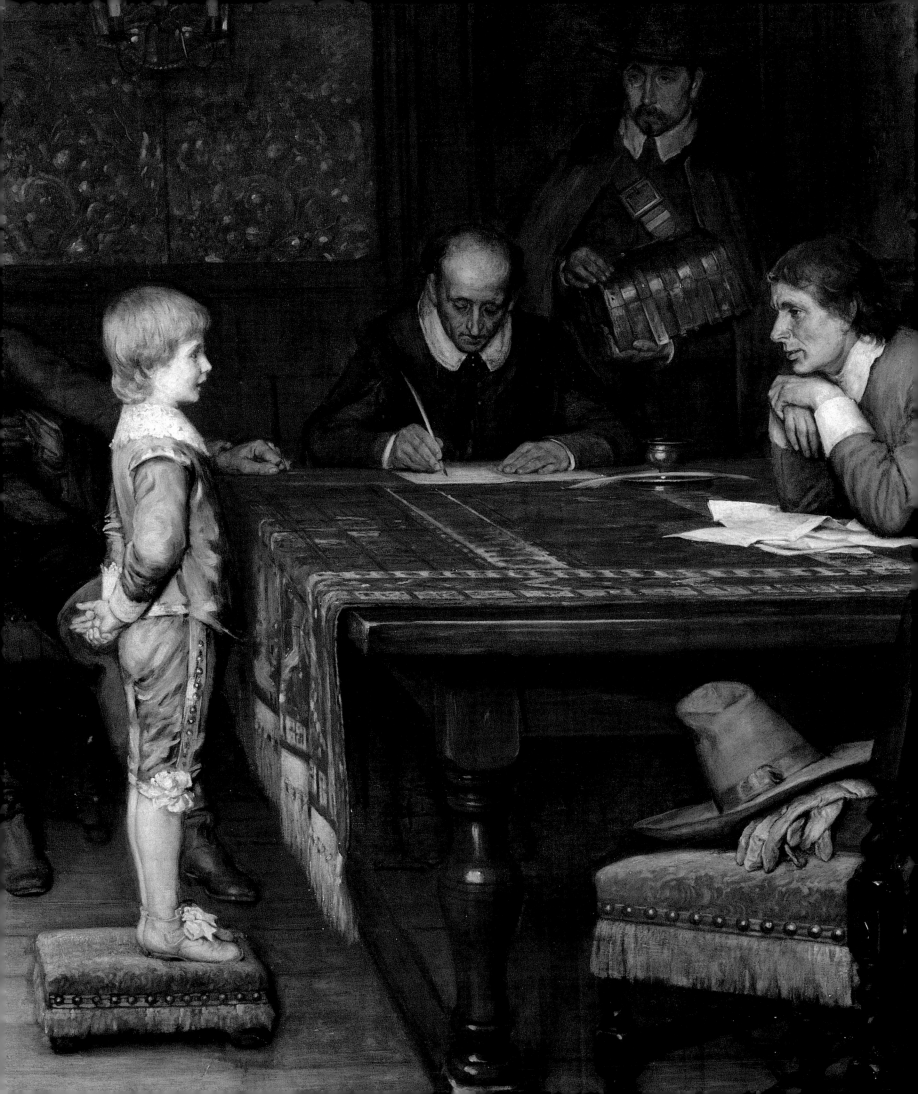

The novelist George Eliot loved seventeenth-century Dutch paintings. For her the simple stories and convivial scenes of Jan Steen (1626–79) and David Teniers, and the daily tragicomedies of the master–servant relationship in the work of Pieter de Hooch (1629–84), possessed great appeal. In *Adam Bede* (1859) she writes:

It is for this rare, precious quality of truthfulness that I delight in many Dutch paintings, which lofty minded people despise. I find a source of delicious sympathy in these faithful pictures of a montonous homely existence, which has been the fate of so many more among my fellow-mortals than a life of pomp or … of world-stirring actions. I turn, without shrinking from cloud-borne angels, from prophets, sibyls and heroic warriors, to an old woman bending over her pot, or eating her solitary dinner while the

noonday light … falls on her mob-cap, and just touches the rim of her spinning-wheel, and her stone jug, and all those cheap common things which are the precious necessaries of life to her … Do not impose on us any aesthetic rules which shall banish from the region of Art those old women scraping carrots with their work-worn hands … let Art always remind us of them …

George Eliot's words remind us that the inclination to see and hear such anecdotes lies deep in human nature, although different ages satisfy it in various artistic ways. Today we like to listen to and watch radio and television 'soap operas' which present 'everyday stories of country folk' or of the people who live in city streets or suburban housing estates. Year after year we share vicariously in the joys and sorrows of the characters, identifying with their lives and loves, celebrations and tribulations. Our enjoyment of programmes about drug-related crimes and criminals on the safe medium of television are parallels of the realistic glimpses of 'boors' smoking and carousing in the powerful small-scale panels of Adriaen Brouwer and Adriaen van Ostade.

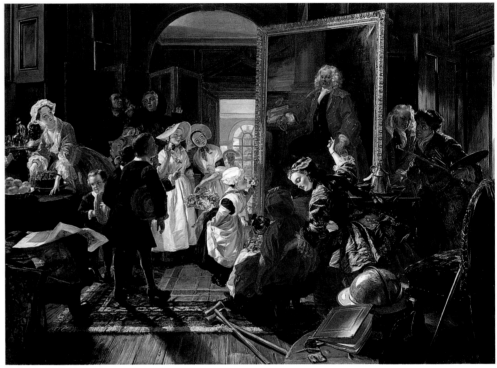

148

William Hogarth (1697–1764), loved to satirize what we would describe as the 'highbrow' aspiration of British painters to achieve the 'Grand Manner' of Italian art, which he held in contempt. Hogarth's aim was to elevate everyday subjects to the moral seriousness of History painting, and he lamented that 'painters and writers never mention, in the historical way, any intermediate species of subject between the sublime and the grotesque'.

Many Victorian genre painters acknowledged their debt to Hogarth, but none in a more graceful manner than Edward Matthew Ward (1816–79) in his imaginative reconstruction of *Hogarth's Studio in 1739 – Holiday Visit of the Foundlings to View the Portrait of Captain Coram*, exhibited in 1863 (Pl. 148). The painting may well have been inspired by the fact that Hogarth's distinguished portrait of his old friend Captain Coram had been lent by the Foundling Hospital, which Coram had founded, to the Manchester Art Treasures Exhibition of 1857. Ward would have seen it there since he had works of his own in the show.

In Ward's painting Hogarth and Coram hide behind the portrait while Hogarth's

149
Charles Robert Leslie
**My Uncle Toby and
the Widow Wadman**
1841
oil on canvas, 60.9 × 97.7cm
(24 × 38½in)
Victoria and Albert Museum,
London

pug-dog Trump sits on a crippled child's lap. The pose of the couple by the screen comes from one of the scenes in Hogarth's *Marriage à la Mode*, while on the table on the left can be seen drawings and prints. These two details remind us that via the medium of engravings Hogarth's great series of paintings from the 1730s – *The Harlot's Progress*, *The Rake's Progress*, *Marriage à la Mode* and *The Idle and Industrious Apprentices* – had became an unconscious part of the British public's visual vocabulary, as familiar as the novels of Henry Fielding and Tobias Smollett which they resemble so closely. Indeed, Hogarth's pictures were likened by his contemporaries to such works by his friend Fielding as *Tom Jones* (1749), and described as 'novels in paint'. Hogarth's 'modern moral subjects' ventured on themes which many Victorian painters would imitate and study, as they would the engravings of the Dutch school and the work of Greuze. These sources would fuse with the quintessentially English work of William Hogarth to form a rich visual narrative language.

In 1843, at the beginning of the Victorian era, William Makepeace Thackeray, in his capacity as art critic, discussed the motivation of contemporary artists:

> They do not aim at such great subjects as heretofore, or at subjects which the
> world is pleased to call great, viz. tales from Hume or Gibbon or royal personages
> under various circumstances of battle, murder, and sudden death. Lemprière is
> justly neglected, and Milton has quite given place to *Gil Blas* and *The Vicar of
> Wakefield*. The heroic, and peace be with it! has been deposed; and our artists, in
> its place, cultivate the pathetic and the familiar. The younger painters are content
> to exercise their talents on subjects far less exalted: a gentle sentiment, an agree-
> able, quiet incident, a tea-table tragedy, or a bread and butter idyll, suffices for the
> most part their gentle powers.

Thackeray's words accurately describe the way in which novels and plays rich in strong dramatic situations inspired the early Victorian genre painters, and notably Charles Robert Leslie (1794–1859). He was in temperament and ability ideally suited to excel at literary subject painting, of which he was the greatest exponent. Born in London, Leslie spent his early youth in Philadelphia, and always seems to have retained a good measure of easy-going American charm, for without it he could hardly have achieved close personal friendships with figures as diverse as the Redgrave brothers (the art historians) and the touchy John Constable. This later friendship enabled him to write the famous *Memoirs* of the great landscape artist for which now he is now chiefly remembered.

Leslie, as the Redgraves shrewdly remarked, realized early in life that the true bent of his genius was for comedy. Humour in paintings can often have the exaggeration of frozen tableaux depicting the 'banana skins' of social embarrassment. It is always liable to date more quickly than any other quality in a work of art, and for that reason some of his works are difficult to appreciate today. His most successful work, of which he painted several versions, was entitled *My Uncle Toby and the Widow Wadman* (Pl. 149); it illustrated the scene in Laurence Sterne's ironic masterpiece *Tristram Shandy* (1760–7) in which the flirtatious Widow Wadman captivates the old soldier Uncle Toby, seated in his sentry box, by pretending to have something in her eye. The model for Uncle Toby was the much-loved, versatile actor Jack Bannister, and his familiar features helped to create the painting's popularity.

The most popular British authors for pictorial treatment were, in a rough order of descending popularity, Shakespeare, Goldsmith, Sterne, Scott, Pepys, Burns and later Dickens, with Cervantes, Molière and Le Sage being the most favoured foreign authors. These names now strike us as presenting a rather curious 'top ten'. Shakespeare, Cervantes and Molière we can understand, but who now, outside a university, reads the picaresque adventures of Le Sage's *Gil Blas* (1715–35)?

149

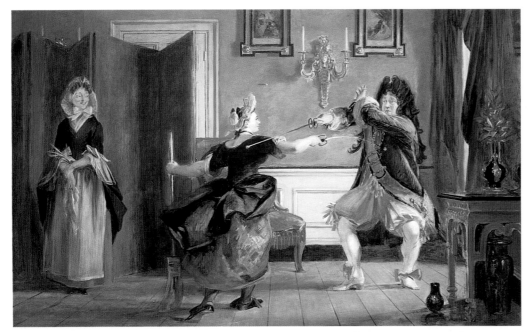

150

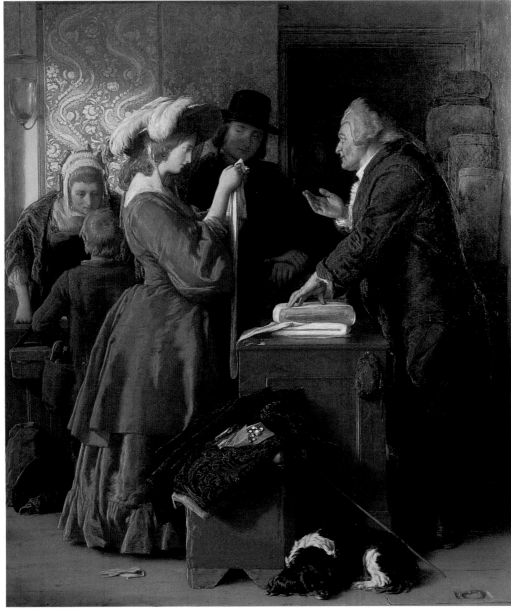

151

A far more understandable favourite was Molière's play *Le Bourgeois Gentilhomme* (1670), which was immensely popular as an artistic subject in the 1830s and 1840s. Molière's Monsieur Jourdain, the quintessential *nouveau riche* figure, could be readily appreciated in an age which saw the emergence of a large new middle class of successful manufacturers, not to mention such flamboyant characters as the railway entrepreneur and bankrupt George Hudson, the 'Railway King' of York. It is therefore not surprising to find Molière's hero appearing in some of the liveliest of Leslie's works. In *Le Bourgeois Gentilhomme* (Pl. 150) Jourdain demonstrates his new skills at fencing to his maid Nicole, who without even dropping her broom strikes him several times with her foil, while his wife looks on with amusement.

Today Oliver Goldsmith would certainly not feature as the second most popular British writer, but for the early Victorian public his play *She Stoops to Conquer* (1773) was eminently suitable for the favourite pastime of reading aloud in the domestic circle of the family. Goldsmith's works became so popular as a pictorial source for narrative painters that Thackeray threatened to refuse to review any more paintings with such themes. This resolution was broken when he saw and admired at the Royal Academy in 1846 one of the greatest successes achieved by William Mulready (1786–1863), *Choosing the Wedding Gown* (Pl. 151). The painting illustrates the opening sentences of Goldsmith's novel *The Vicar of Wakefield* (1766): 'I ... chose my wife, as she did her wedding gown, not for a fine glossy surface, but for such qualities as would wear well.' Thackeray described the painting in glowing terms: 'a blaze of fireworks is not more intensely brilliant: it must illuminate the whole room at night, when everybody is gone.' The work had been commissioned from Mulready by John Sheepshanks for £1,050. For Mulready, with his painstakingly slow method of working, such a commission was providential, for it enabled him to take his time and concentrate, as he loved to do, on perfecting the subtle richness of his colouring, painted over a white ground, a technique which would be adopted by the Pre-Raphaelites.

As a boy the young William Powell Frith (1819–1909), born in Harrogate in Yorkshire, wanted to be an auctioneer rather than an artist, and he was always keenly aware of the commercial possibilities of his works. His early career as a painter was devoted to literary subjects which illustrated the foibles of human nature, and he turned his hand with equal facility to Sterne, Scott and, inevitably, Goldsmith, first succeeding in 1841 with yet another subject from *The Vicar of Wakefield* entitled *Measuring Heights*. The same year he painted a scene from *A Sentimental Journey* in which Laurence Sterne himself is caught flirting with a little French milliner by 'taking her pulse' (Pl. 152).

Today illustration is almost a pejorative word, but in the nineteenth century the partnership of the illustrator with the novelist was of incalculable importance. The talents of Dickens's illustrators such as 'Phiz' (Hablot K. Browne), John Leech and George Cruikshank established the visual appearance of figures such as Mr Pickwick, Ebeneezer Scrooge and Fagin. But artists also liked to depict dramatic moments from the novels, *The Old Curiosity Shop* (1840–1) being a particular favourite. The Pre-Raphaelite William Holman Hunt painted *Little Nell and her Grandfather* looking back on London during their escape, and his pupil Robert Braithwaite Martineau (1826–69) portrayed *Kit's First Writing Lesson* (1851–2; Pl. 307).

William Maw Egley (1826–1916), after a stint painting Molière subjects, also turned to Dickens for inspiration, choosing *Dombey and Son* (1848). In *Florence Dombey in Captain Cuttle's Parlour* (Pl. 153) Florence is shown taking refuge from her father's cold-hearted neglect and cruelty with the colourful old sailor Captain Cuttle.

150
Charles Robert Leslie
Molière, *Le Bourgeois Gentilhomme*, Act III, Scene ii
1841
oil on canvas, 60.9 × 97.7cm
(24 × 38�2 in)
Victoria and Albert Museum, London

151
William Mulready
Choosing the Wedding Gown
1846
oil on wood, 53.3 × 45cm
(21 × 17¾ in)
Victoria and Albert Museum, London

152
William Powell Frith
A Scene from Sterne's *A Sentimental Journey*
1841
oil on canvas, 90.8 × 69.9cm
(35¼ × 27½ in)
Victoria and Albert Museum, London

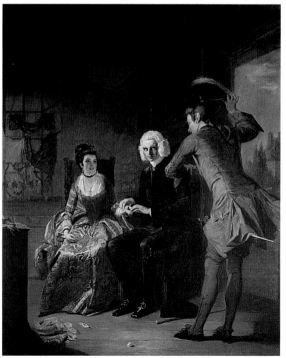

152

153
William Maw Egley
**Florence Dombey in
Captain Cuttle's Parlour**
1888
oil on canvas, 60.9 × 45.7cm
(24 × 18in)
Victoria and Albert Museum,
London

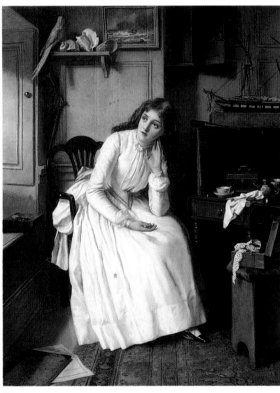

153

Paintings illustrating literary themes from bygone eras were often described as Costume Pictures, and many artists' studios had prop boxes full of period costumes and accessories. When exhibited they were often conveniently supplied with long and detailed captions describing the incident portrayed. Works of this type certainly gave the middle-class patron value for money, since their mere presence upon the walls of his dining room guaranteed that the host was a man of wide erudition and good taste. As the critic Francis Palgrave wrote in the 1862 London International Exhibition catalogue: 'The growth of the Incident style in painting runs parallel with the great outburst of novel writing from about 1790 onwards, with social change that gives the patronage of art rather to the mercantile than to the educated classes.'

These literary works prepared the way for 'modern-life' subjects taken direct from life. An interesting and relatively little-known Pre-Raphaelite example of such a subject is provided by *The Rescue* (Pl. 154) by Millais, his only major venture at a 'modern-life' painting, other than *The Blind Girl* (Pl. 299). The work depicts a fireman going to the rescue of three children in a burning building. He carries one on his back and one under each arm and is about to deliver them into the arms of the waiting mother. It was inspired by a fire he had witnessed in the Tottenham Court Road. He declared: 'Soldiers and sailors have been praised on canvas a thousand times. My next picture shall be of the fireman.' The painting was executed with the usual meticulous Pre-Raphaelite attention to detail. To gain the right light effects the studio was filled with smoke and coloured glass placed over the windows.

In many Victorian genre subjects, there was an important family element. The cycle of family life was reflected again and again in its ups and downs, its disasters and triumphs: birth, christenings, the joys of childhood, birthdays, the terrors of the schoolroom, courtship, marriage, old age, death, funerals and the festivals of Christmas and Easter, many of which occasions were celebrated by attending church.

Thomas Webster (1800–86), before he began his lifelong task as the depictor of childhood (see p. 174), had been a Chapel Royal choirboy, and this experience must have helped him when in 1847 he painted the most famous treatment of this theme, *A Village Choir* (Pl. 155), commissioned by John Sheepshanks. It was inspired by Washington Irving's *The Sketchbook*, published in 1820, in which the author recounts how he was taken to a local church by the village squire, who describes the various characters in the village choir and band.

Today, when we look at *A Village Choir*, we are reminded of Thomas Hardy's first successful novel, *Under the Greenwood Tree* (1872), and his later *The Return of the Native* (1878) which deals with the same theme – the close-knit bands of village musicians who gave way in mid-Victorian times to the new-fangled church organs and harmoniums. The painting was set in the old west gallery of the church of All Saints, Bow Brickhill, near Bletchley, Buckinghamshire, and many local characters can be identified from Webster's sketches, for example the clarinettist 'Old Tooth', possibly a blacksmith. British critics revelled in this attention to detail, but when it was exhibited in Paris in 1855 French critics were fascinated by different qualities, finding in the painting 'a quiet, almost serious aspect of caricature … a life-like reality'.

This life-like quality is of particular interest today as we seek to understand and visualize the Victorian age, so like and so different from our own times. There are very few visual parallels to match the graphic verbal interviews recorded by Henry Mayhew (1812 87) in his monumental *London Labour and the London Poor* (1851). Mayhew broke new ground in the illustrations for the book, which were engravings after daguerreotypes of the people whom he interviewed, making it one of the first books illustrated by photography. These illustrations can be usefully supplemented by only a very few paintings, for on the whole Victorian artists shunned the direct

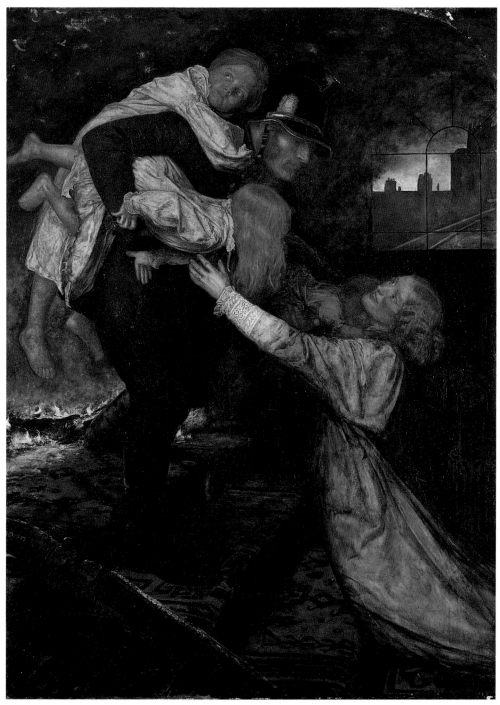

154

154
John Everett Millais
The Rescue
1855
oil on canvas, 119.4 × 83.8cm
(47 × 33in)
National Gallery of Victoria,
Melbourne

reportage of urban realities. An exception was Arthur Boyd Houghton (1836–75), who in a series of small, slightly disturbing works, such as *Volunteers Marching Out* (Pl. 156), captured on canvas the crowded bustle of the London streets. The Volunteer soldiers depicted were part of a movement which had arisen in 1859 out of widespread patriotic fears of war with France. Even unlikely artistic figures such as Leighton, Millais, Poynter and Simeon Solomon joined what was a Victorian version of 'Dad's Army', and reviews were held up and down the country.

Street scenes were also painted by Charles Hunt (*fl.*1870–96), whose *A Coffee Stall, Westminster* (Pl. 157) enables us to visualize the one described by George Gissing in his novel *New Grub Street* (1891) at which his hero slakes his thirst on his way to and from 'the valley of the shadow of books' in the British Museum Reading Room.

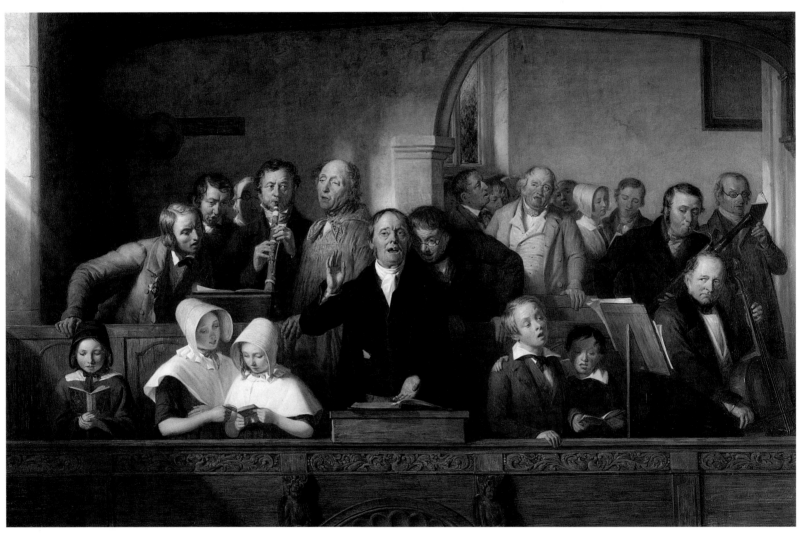

155

The misuse of alcohol was one of the great social problems of the age, and the cause of temperance was enthusiastically advocated by George Cruikshank (1792–1878). In the original watercolour for Plate V of the print series *The Bottle*, entitled *Cold, Misery and Want Destroy their Youngest Child* (Pl. 397), Cruikshank's melodramatic powers are seen at their most extreme, giving a stark warning on the evils of drink. He was to repeat this message in huge paintings and prints in which he traced two paths through life, one for those who drink, and another for those who don't, the former ending up on the gallows.

But water – 'Adam's ale' – was not always readily available for converts to the teetotal cause. The heat of London in high summer always caused shortages of water in the parks, sun-parched streets and suburban gardens. In the summer of 1854 London society of all classes was threatened by a terrible outbreak of cholera caused by contaminated water coming from old pumps, and seeping sewage pipes, causing the death of over 500 people. Its source was traced to the pump handle in Broad Street, Soho, where a few years earlier 'the comers and goers to the pump' were watched by an observant little girl, the daughter of John Gould the ornithologist. Years later she described how:

> There was always *something* going on at the pump, the water was considered very
> good then and people sent jugs to be filled from all round. Then a man with
> cocoa nuts nicely quartered, would thrust his barrow under the spout and pump
> well on the fruit, until it looked quite fresh; of a morning the watercress women
> would pump on their cresses, and then sit down on the curb, and shake each
> bunch and re-arrange them in their baskets, and all day long children were play-
> ing round the pump, making drinking cups of their hands, or caps, sending the
> handle high up and riding down on it and all sorts of tricks.

We are reminded of this vivid description when we look at *The First Public Drinking Fountain* (Pl. 160), by W.A. Atkinson (*fl.*1849–67). Founded in 1859, the Metropolitan Drinking Fountain and Cattle Trough Association's aims were not only to combat cholera but also to further the work of the temperance movement. Samuel Gurney MP paid for this, the first fountain, erected against the wall of St Sepulchre's church, Holborn (no longer extant in its original form). The group using the fountain provides a good cross-section of Victorian society, as it includes five errand boys, a smartly dressed middle-class mother helping her daughter to drink from a chained mug, a porter with the curious headgear known as a 'porter's knot' for carrying heavy loads at nearby Smithfield Market, and the statuesque figure of a flower-seller with her basket.

155
Thomas Webster
A Village Choir
1847
oil on wood, 37.4 × 56.4cm
(14¾ × 22¼in)
Victoria and Albert Museum,
London

156
Arthur Boyd Houghton
Volunteers Marching Out
*c.*1860
oil on canvas, 34 × 24cm
(13¾ × 9½in)
Kenwood House, London

157
Charles Hunt
A Coffee Stall, Westminster
1881
oil on canvas, 60 × 89.7cm
(23¾ × 35¼in)
Museum of London

156

157

158
John Henry Henshall
Behind the Bar
1882
oil on canvas, 62.2 × 111.1cm
(24⅛ × 43¾ in)
Private collection

159
Myles Birket Foster
The Milkmaid
1860
watercolour, 29.7 × 44.5cm
(11¾ × 17½ in)
Victoria and Albert Museum,
London

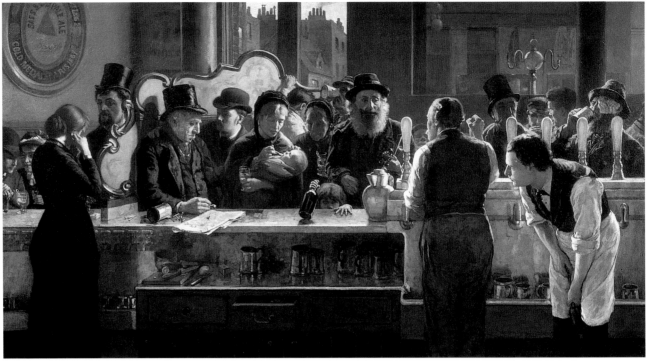

158

159

Both the temperance propaganda of the 'sell no more drink to my father' type, and the early chapters of Charlie Chaplin's autobiography have built up in our minds a lurid picture of the Victorian pub. A direct and straightforward visual record of just such a place is by John Henry Henshall (1856–1928). His painting *Behind the Bar* (Pl. 158) is a memorable image of a little child waiting to have an empty bottle in his hand refilled to take home, standing next to the nursing mother who seems to be feeding her baby with some stout from her glass, while on the right a busy barman draws a cork from a bottle. Such direct records of the urban scene have a bold directness rare in Victorian art, and form an interesting contrast with more romanticized rural scenes.

Itinerant tradesmen and showmen were always good subjects for 'modern-life' painters; *The Peepshow* (Pl. 161) by John Burr (1834–93) shows a form of street entertainment which appealed to the deep-seated human instinct to peer through a hole. On the walls and back of the peepshow are painted scenes of a type vividly described in one of Mayhew's interviews: 'People is werry fond of the battles in the country, but a murder wot is well known is worth more than all the fights … I've "*Napoleon's Return from Helba*", "*Napoleon at Waterloo*", "*The Death of Lord Nelson –*" and also "*The Queen embarking to start for Scotland, from the Dockyard at Voolwich*" [sic].'

While topography and landscapes filled the bulk of the space on the walls of the watercolour societies, there were also always a number of genre scenes. Myles Birket Foster in particular loved to paint such subjects. His most famous work, *The Milkmaid* (Pl. 159), is an idealized Victorian version of an eighteenth-century 'fancy picture', depicting comely working-class women who are given more than a frisson of sexual appeal. Some engaging works of this type were painted by Joshua Cristall (1767–1847), who had a particular fondness for portraying women or girls engaged on close needlework or embroidery, themes which recur again and again in his work, an attractive example being *A Scottish Peasant Girl Embroidering Muslin at Luss, Loch Lomond* (Pl. 162).

In early Victorian times the more enjoyable aspects of rural life were often featured in such works as the watercolour *Haymakers at Dinner* (Pl. 163) by Thomas Uwins (1782–1857), an arcadian idyll of happy workers enjoying their noonday food and drink, very different from the dour Social Realist treatments of such rural subjects later in the century (see below, pp. 331ff.).

Letters were a favourite device of genre artists, for they gave another dimension to a painting, linking it with the conventions of epistolary novels such as Samuel Richardson's *Pamela* (1740) or Laclos's *Les Liaisons dangereuses* (1782). The very appearance of a letter implies a past and invites us to construct a future. The device probably arose from the convention in classical drama of all action taking place upon one day, at one location. This led to the introduction of the theatrical mechanism of a messenger to provide information about life outside the confines of the immediate stage, a convention adopted with enthusiasm by Victorian artists in whose canvases stolen, discovered, lost or intercepted communications suggest a life outside the picture frame, just as later a telephone call would in plays and films.

The arrival of the postman was therefore frequently a moment of high drama, as demonstrated in Charles West Cope's *Palpitation* (Pl. 164), a work of fascinating complexity. Is the woman listening to the maid and postman waiting for a letter from an illicit lover? The whip hanging from the antlers and the hat suggest that a man is already in the household, the antlers being a traditional symbol of cuckoldry. The glove lying on the ground may signify that she is in danger of being cast off like the proverbial old glove.

Many artists like Cope excelled at painting a narrow strip of open door through

160
W.A. Atkinson
The First Public Drinking Fountain
1859
oil on canvas, 128.9 × 103.3cm
(50¾ × 40¾in)
Geffrye Museum, London

161
John Burr
The Peepshow
1864
oil on canvas, 76.1 × 63.4cm
(30 × 25in)
Forbes Magazine Collection, New York

160

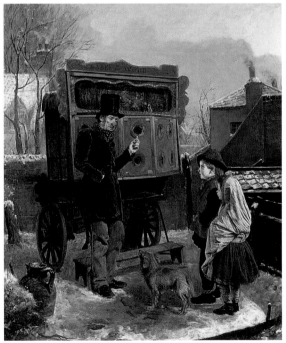

161

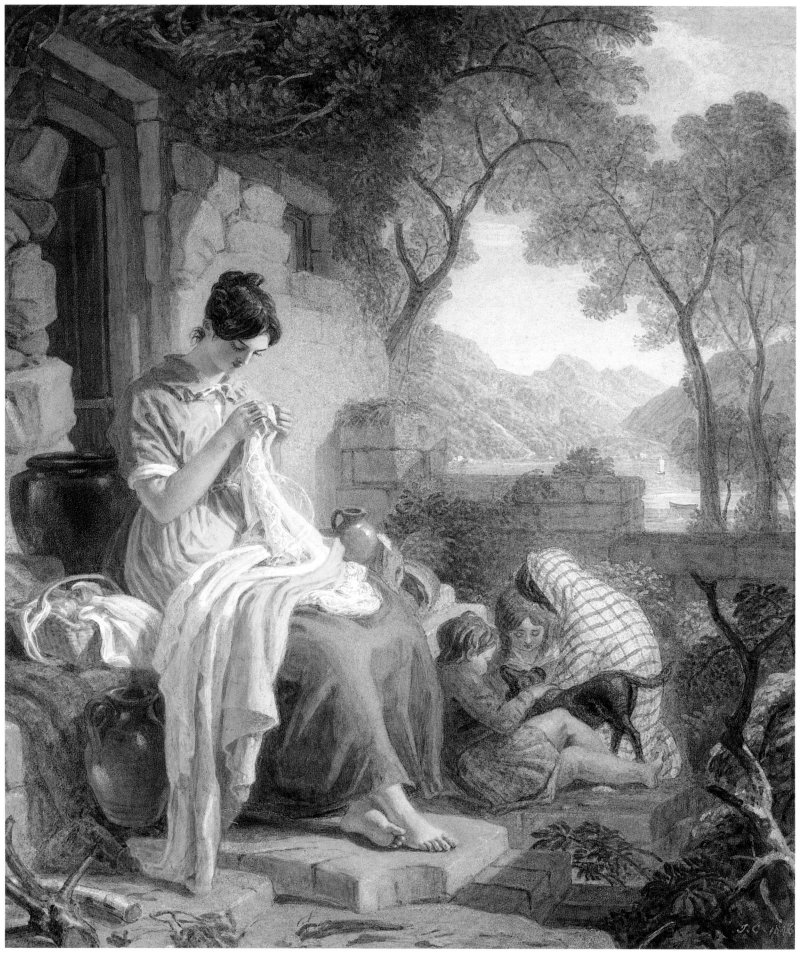

162

162
Joshua Cristall
**A Scottish Peasant Girl
Embroidering Muslin at
Luss, Loch Lomond**
1846
watercolour, 55.9 × 47.9cm
(22 × 18⅞in)
Victoria and Albert Museum,
London

163
Thomas Uwins
Haymakers at Dinner
*c.*1822
watercolour, 47.9 × 70.2cm
(22 × 27⅛in)
Victoria and Albert Museum,
London

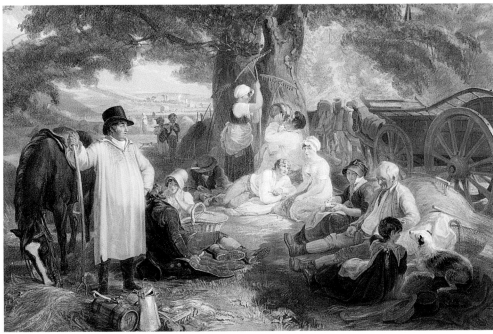

163

which action can be glimpsed, a particularly fine example being provided by the
eavesdroppers on the left of David Wilkie's *The Refusal* (Pl. 8). In Cope's picture the
lock and bolts on the door look very substantial. What are we meant to infer from
this? The situation depicted is ambiguous, for the girl may be awaiting a letter from
a legitimate suitor. She holds a phial of smelling salts, which with the umbrella, bag
and gloves dropped on the floor heighten the tension of the scene. The painting's
ambiguity makes it a fine cover for a love story, a use it has been put to several times
in paperback editions of Victorian novels.

Another method of extending the parameters of a dramatic situation was to con-
ceive paintings in pairs. In 1854 Abraham Solomon (1823–62) exhibited two works
which successfully united some potent themes. In *First Class – The Meeting: 'And at
First Meeting Loved'* (Pl. 165) railway travel and flirtation are observed in a portrayal
of a first-class compartment in which an attractive young lady loses her heart to a
handsome young man while her father slumbers. Critics were outraged at the cou-
ple's familiarity and the picture was criticized for its impropriety; in a second version
the young lady is moved to the corner seat while her father chats animatedly to the
young man, who has ceased to be a mere civilian and become a dashing naval officer.
There were no complaints about the painting's pendant, *Second Class – the Parting*
(Pl. 429).

In 1857 Solomon followed his success with *Waiting for the Verdict* (Pl. 166),
depicting an intensely worried family circle waiting in the lobby of a courtroom for
the verdict on the unseen father of the family. It was followed two years later by its
sequel *Acquitted*, showing the released father happily reunited with his family.
Solomon exhibited *Waiting for the Verdict* at the Liverpool Academy in 1857 as well
as at the Royal Academy, and the public supported the award of Liverpool's annual
prize of £50 to the picture, preferring it to the actual winner, Millais's *Blind Girl*
(Pl. 299), which was supported by Ruskin; he admired Solomon's work, but
described it as: 'very full of power; but rather a subject for engraving than painting.
It is too painful to invest with the charm of colour.'

How strange these words sound today. For the Victorians black and white, the
print medium, was suitable for news reportage, but not esteemed as an artistic medi-
um. Today colour television enables half the world to 'wait for the verdict' on the

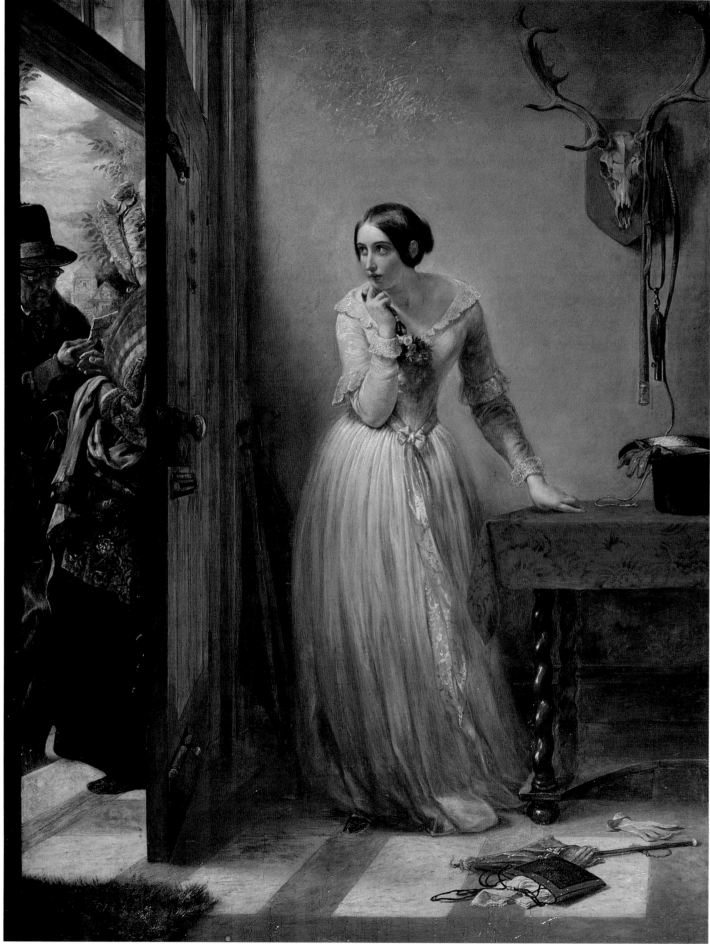

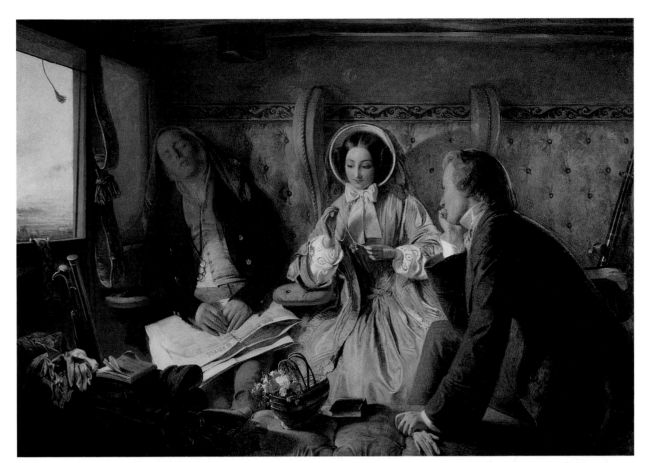

164
Charles West Cope
Palpitation
1844
oil on wood, 76.2 × 57.8cm
(30 × 22¾in)
Victoria and Albert Museum,
London

165
Abraham Solomon
**First Class – The Meeting:
'And at First Meeting Loved'**
1854
oil on canvas, 69.2 × 96.8cm
(27¼ × 31⅛in)
National Gallery of Canada,
Ottawa

166
Abraham Solomon
Waiting for the Verdict
1857
oil on canvas, 110.3 × 124.5cm
(43½ × 49¼in)
Tate Gallery, London

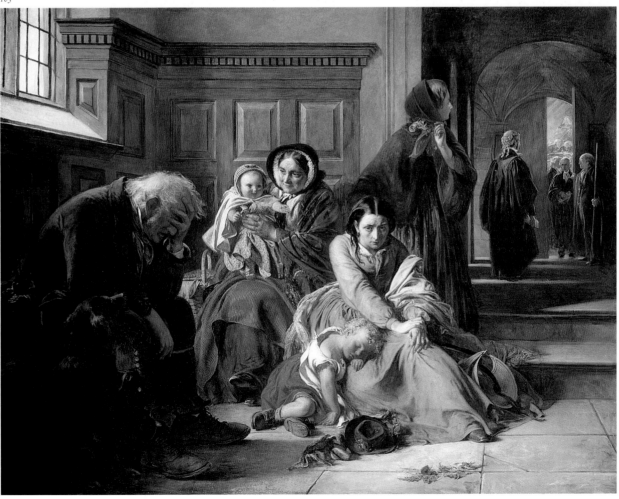

167
William Dyce
**Titian's First Experiments
with Colour**
1856–7
oil on canvas, 91 × 70 cm
(36 × 27½ in)
Aberdeen Art Gallery
and Museum

168
Henry Nelson O'Neil
**The Last Moments
of Raphael**
1876
oil on canvas, 121 × 182.7cm
(47¾ × 72in)
Bristol Museum and Art
Gallery

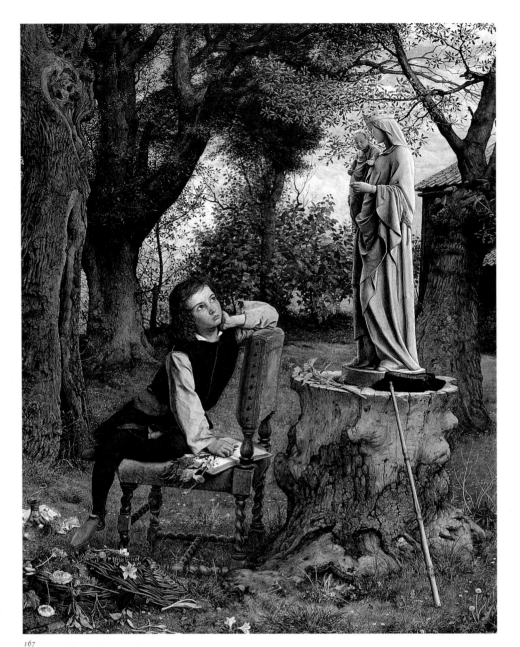

167

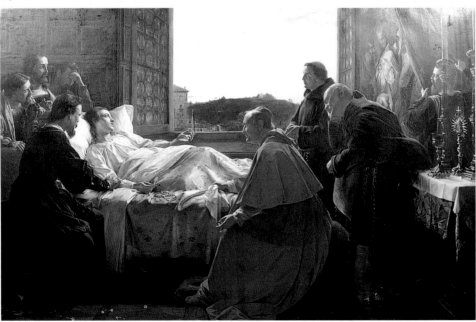

168

result of sensational murder cases presented in lurid detail. In the Victorian age paintings of such incidents were of immense public interest, both when they first appeared on the walls of the Royal Academy and in reproductive form. Steel engraving introduced in the 1820s made very large editions of such prints possible, and by 1840 editions of 20,000 or 30,000 prints after a popular painting were being produced.

As the century progressed the parameters of genre painting and History painting overlapped and enlarged. Popular themes included scenes from the early lives of great leaders, composers, writers and painters, a notable example of the latter being provided by William Dyce's *Titian's First Experiments with Colour* (Pl. 167). Death scenes were if anything even more popular, such as Leighton's *Death of Brunelleschi* (1852) and *The Last Moments of Raphael* (Pl. 168) by Henry Nelson O'Neil (1817–80).

Unlike their predecessors, nineteenth-century painters visiting Italy were just as interested in scenes of contemporary life as in studying the Old Masters. Writing home from Naples in 1825, Thomas Uwins wrote of the inspiration that Italy provided him as an artist:

> There is one point in which Italy in an artist's eye must always
> have the preference – I mean the school it provides for study;
> and in this I do not refer merely to the pictures, statues and
> works of art in which it abounds, but to the simplicity of the
> manners of the people … and the historic character of their fea-
> tures and dress … In England a painter must invent everything

… In Italy on the contrary, the thing is half made up to his hand. One of Uwins's Italian works, *An Italian Mother Teaching her Child the Tarantella* (Pl. 169), was so popular that it was made into a design for a wallpaper, and six repetitions from his hand are recorded. Intriguingly, the initial idea for this painting came to him not from actual observation in Italy but at one of the meetings of the Sketching Society to which he belonged. Uwins came to specialize professionally in Italian genre subjects such as *A Neapolitan Saint Manufactory* and the perennially popular titles *Brigands Capturing English Travellers*, *Nuns Taking the Veil* and *A Neapolitan Boy Decorating the Head of his Inamorata*. When he was elected RA in 1838 he wrote: 'The public have chalked out a course for me; because I have done some Italian subjects suc-

169

cessfully, no one will have anything else from my hands, and they who "live to please, must please to live".'

Uwins's testimony could be echoed by many other British artists for whom Italian themes offered a fruitful field throughout the nineteenth century. Even Luke Fildes, after winning his early reputation with the gloomy realism of paupers queuing for night shelter (Pl. 407), turned to make his fortune with portraits and the jollier theme of Venetian gondoliers and their sweethearts. There were dangers in this process, and David Wilkie had already warned in 1836 that 'the beaten track of costumes, views and imitations of others, was the rock all young visitors to Italy split upon'. An exception to Wilkie's dictum was Sir Charles Lock Eastlake, who as a young artist in Italy painted scenes in the Roman Campagna such as *The Salutation to the Aged Friar* (Pl. 170), and also acquired the deep knowledge of the Italian Renaissance which made him a most distinguished Director of the National Gallery.

When the Royal Academy moved to its new home in 1869, the abolition of the 'line' (see above, p. 35) proved popular with artists, and larger paintings became fashionable. William Logsdail (1859–1944) took advantage of the change to produce

170
Charles Lock Eastlake
**The Salutation to the Aged
Friar**
*c.*1840
oil on canvas, 94.5 × 112.9cm
(37¼ × 44½in)
Forbes Magazine Collection,
New York

171
William Logsdail
Piazza of St Mark's, Venice
1883
oil on canvas, 126.2 × 222.3cm
(49¾ × 87½in)
Birmingham City Museum and
Art Gallery

172
Walter Dendy Sadler
Friday
1882
oil on canvas, 108 × 217cm
(42½ × 85½in)
Walker Art Gallery, Liverpool

170

a large canvas of the hustle and bustle of the *Piazza of St Mark's, Venice* in 1883 (Pl. 171), followed by *St Martin-in-the-Fields* (Pl. 621) and other London landmarks.

A curious phenomenon in Protestant England was the amazing popularity in Victorian times of what are now known in the art trade as 'Merry Cardinal' pictures. These were a speciality of three artists who sound for all the world like key members of an Italy football squad. Their names, in decreasing order of scarlet birettas scored, were François Bruneri, Andrea Landini and Alexandre Rizzoni. They all created works with such excruciating titles as *The Cardinal's Breakfast*, *The Bad Cigar* and *His Eminence's Monkey*. In a penalty shoot-out, however, their total score would be surpassed by the prolific output of the French painter Jean-François Vibert (1840–1907). The English response to such works was provided by two paintings by Walter Dendy Sadler (1854–1923), entitled *Thursday* (1880), showing a group of jovial monks fishing, and *Friday* (Pl. 172), showing the catch being consumed on the following day with immense enjoyment.

A literary phenomenon of the Victorian era which led to the creation of a new genre theme was a popular form of writing for children pioneered by Captain Marryat (1792–1848), whose *Children of the New Forest* (1847) is an exciting story of Roundheads and Cavaliers. These themes were developed in the 35 'stirring tales of boyish pluck' written by George Henty (1832–1902), which told historical tales with child heroes and heroines. All these themes inspired new paintings, works which were greatly in demand all over the world, for they provided, in a readily assimilated form, a broad-brush history both of national heroes and their achievements. Where are these paintings now? Many are only known from dusty large glass negatives in picture research agencies which still prove invaluable to the compilers of children's encyclopedias. Others have been consigned to the murky cellars of regional art galleries across the world, all too often still despised by the curators and unseen by the public.

There is, however, one very famous exception to this trend, *And When Did You Last See Your Father?* (Pl. 173) by William Frederick Yeames (1835–1918). Yeames was a member of the St John's Wood Clique, a group of artists united not only by their choice of abode in the artistic suburb of north London, but also by a fresh attitude to History painting, and a determined preference for subjects dealing with the British Civil Wars. They possessed a lively sense of humour, for they adored dressing up and eccentric behaviour. They strove to depart from the tradition of depicting a particular specific historic event by creating instead imaginary situations which captured the mood of bygone times. Childhood themes particularly appealed to them.

A specialist in the Tudor and Stuart historical periods, Yeames painted works with titles such as *Lady Jane Grey in the Tower*, *Amy Robsart* and *Prince Arthur and Hubert*. Of his most famous painting, *And When Did You Last See Your Father?*, Yeames wrote: 'I had at the time I painted this picture living in my house a nephew of an innocent and truthful disposition and it occurred to me to represent him in a situation where the child's outspokenness and unconsciousness would lead to disastrous consequences, and a scene in a country house occupied by the Puritans during the Rebellion in England suited my purpose.' The painting's fame derives from the moral dilemma which it presents so clearly, the problem of the loss of childhood's innocence, and the realization which has dawned on the weeping girl that her brother, not understanding the guile of his interrogator, will inadvertently blurt out the secret of the whereabouts of his father. After the work's first exhibition in 1878 it slowly but surely became famous, its title providing it with a useful role for political cartoonists, journalists and popular song-writers. It finally achieved the ultimate accolade of fame by being turned into a waxwork tableau in Madame Tussaud's.

171

172

173
William Frederick Yeames
**And When Did You Last
See Your Father?**
1878
oil on canvas, 131 × 251.5cm
(51¼ × 99in)
Walker Art Gallery, Liverpool

The leader of the St John's Wood Clique was Philip Hermogenes Calderon (1833–98), who looked like a Spanish hidalgo and was nicknamed 'the fiend'. Clad as Mephistopheles and singing the 'Satanic' aria from Gounod's *Faust*, he loved to make his entry at parties in a flash of blue flame! Half French and half Spanish, he painted scenes from the reign of Isabella in the fifteenth century. His painting *Her Most High, Noble and Puissant Grace* (Pl. 174) is an intriguing example of a historical story-telling picture – for unfortunately nobody knows in this case what the story was. No actual historical moment is depicted, and perhaps Calderon was only contrasting the pomp and majesty of high office, and the mock solemnity of the court, with the vulnerability of the young queen.

Like Yeames, Frederick Goodall (1822–1904) painted a number of Tudor and Stuart subjects, in addition to his rather unwise ventures on religious themes from Egypt and the Holy Land. His *Puritan and Cavalier* (Pl. 175) shows a small boy dressed

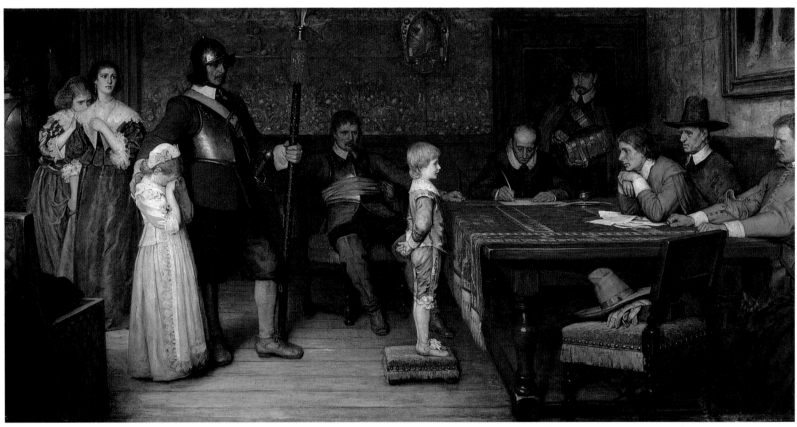

173

as a Cavalier and armed with a sprig of mistletoe in his hand pursuing a girl wearing Puritan dress in order to kiss her. She hides behind a nineteenth-century screen of crewel wool with a tree-of-life pattern, an interesting example of the fake seventeenth-century 'Jacobethan' studio furniture found in many artists' studios at this time. Her hiding place has been discovered by a King Charles spaniel.

Romantic Civil War themes were not the sole prerogative of the St John's Wood Clique, but were often tackled by other artists throughout the Victorian era. In 1890 Ernest Crofts (1847–1911) exhibited *Whitehall: January 30th, 1649* (Pl. 177), showing Roundhead troops surrounding the scaffold outside Inigo Jones's Banqueting House on which Charles I stands with the Bishop of London before his execution. The Scottish painter John Pettie (1839–93) painted scenes from Sir Walter Scott's novels such as *Peveril of the Peak* with the familiar ingredients of Cavalier boy, Presbyterian little girl and King Charles spaniel. He was also attracted by Regency

themes, his most famous venture in this field being *Two Strings to her Bow* (Pl. 176), a work closer to the frivolous Regency costume dramas of Georgette Heyer than the novels of Jane Austen. Pettie's best friend was Sir William Quiller Orchardson (1832–1910), whose most famous work was another essay at a History painting, *On Board HMS Bellerophon* (Pl. 178), which portrays the Emperor Napoleon on the ship which took him to lifelong exile on St Helena. Orchardson was also gifted at subjects from contemporary life, particularly high-society scenes imbued with the atmosphere of Galsworthy's *Forsyte Saga* (Pls. 481, 482).

In conclusion this brief survey of genre painting must examine its close connections with advertising, and the two famous phrases 'chocolate box' art and 'every picture tells a story'. The latter phrase is frequently thought to have been an old adage, descriptive of genre paintings on show at the Victorian Royal Academy summer exhibitions, but its first use was, however, as an advertising slogan which accompanied an Edwardian poster for Doane's Backache Kidney Pills, showing sufferers bent double with pain exclaiming 'Oh, my aching back'.

'Chocolate box' art has an earlier origin. In the early Victorian age C.R. Leslie's *Uncle Toby and the Widow Wadman* (Pl. 149) became extremely well known as an advertising image. It was reproduced as a polychrome transfer print on the lids of pots containing 'Russian Bear's Grease' (gentlemen's hair dressing), and it is not too fanciful to imagine a Victorian 'Widow Wadman' giving such a pot to her 'Uncle Toby' during their courtship. This was an early use of a painting in this way, and of considerable historical importance, since this was also one of the first methods of colour reproduction.

The pots had been manufactured from the 1830s, the finest examples being produced by the firm Messrs. F. & R. Pratt. At their stand at the Great Exhibition of 1851 they included pots with lids printed by some of the best-known genre subjects, *The Blind Fiddler* after Wilkie, *The Last In* after Mulready, *Highland Music* after Landseer, *The Truant* after Thomas Webster and so on, a list which includes most of the major genre artists. The pots could contain anything from 'Bear's Grease Perfumed', Cherry Tooth Paste, Lip Salve, Cold Cream of Roses, Venetian Pomade, Naples Shaving Paste, to Meat and Fish Pastes, Gentlemen's Relish … and Chocolate Paste.

This last item has considerable interest, being the first citation of the use of pictures to decorate a container for chocolate. Such an association was to continue, for the parameters of genre painting and advertising art frequently overlapped. Indeed, 'chocolate box art' is the term which is perhaps most frequently used when describing genre paintings. Artists such as Arthur J. Elsley (1860–1952) specialized in painting works suitable for reproduction upon boxes of chocolates or tins of biscuits,

174
Philip Hermogenes Calderon
Her Most High, Noble and Puissant Grace
1865
oil on canvas, 119.4 × 213.4cm
(47 × 84in)
Leeds City Art Gallery

175
Frederick Goodall
Puritan and Cavalier
1886
oil on canvas, 113 × 184.8cm
(44¼ × 72¾in)
Walker Art Gallery, Liverpool

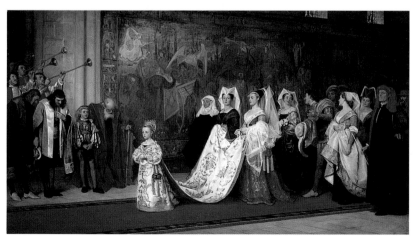

174

175

176
John Pettie
Two Strings to her Bow
1882
oil on canvas, 82.6 × 119.4cm
(32½ × 47in)
Art Gallery and Museum,
Kelvingrove, Glasgow

177
Ernest Crofts
**Whitehall: January 30th,
1649**
1890
oil on canvas, 158.6 × 129.4cm
(62½ × 51in)
Forbes Magazine Collection,
New York

178
William Quiller Orchardson
**On Board HMS
Bellerophon**
1880
oil on canvas, 164.9 × 248.6cm
(65 × 98in)
Tate Gallery, London

176

177

variations on the themes of children and animals made popular by Landseer and
Briton Rivière. Prints after Elsley's works were also used as promotions for compa-
nies such as Bovril, or issued with the special Christmas numbers of journals such as
Pears Annual (see p. 180) and the *Illustrated London News*.

Genre subjects in whatever graphic form have much to tell us concerning not
only the joys and sorrows but the tastes of the Victorian middle and lower classes. In
the towns and cities the poor enjoyed selecting the lids on their favourite pots of meat
paste, while the middle class purchased engravings or bought the actual paintings.

In the countryside, in smoky public house bars up and down the land, sporting
prints depicting steeplechases, the local hunt or passing mail coaches gradually
became kippered tobacco brown by the pipes and cigars of the customers. Many of
those prints have never gone out of production since the day they were made, for
they cater to the English love of sport and rural life, reflected in the sporting and ani-
mal paintings which are discussed below (pp. 212–23).

Equally wide interest was also felt for the familiar concerns of women and chil-
dren and the ever-present problems of the poor and underprivileged. In all these areas
the Victorian genre artist would find a steady demand for paintings which created
visually compelling narratives, some of which would prove even more moving than
the old woman scraping carrots which George Eliot so admired.

In the twentieth century photography was to emerge as a powerful rival to the
genre painter's role of depicting the ordinary man and woman, and the dichotomy
between the real and the ideal has continued to dominate the genre impulse from the
1880s to the present day. But genre painting, whether Dutch seventeenth-century or
Victorian, continues to cast a spell over us, for in these works we find reflected the
attitudes of bygone eras to the comedy of human life, ever changing yet ever the
same.

178

The panorama shows of the nineteenth century affected universal visual perceptions almost as radically as the television screen changed the way we look at the world in the twentieth century. Both were British inventions but rapidly became truly international in their effect. The world's first panorama, a 360-degree painting of Edinburgh seen from Calton Hill, went on show in 1789 at Archers Hall in Edinburgh (Pl. 180). Its creator, the Scottish artist Robert Barker (1739–1806), predicted that his discovery would set art free, for no longer would painting be confined by the limits and proportions of a frame. Spectators visiting these all-embracing pictures could imagine that they were actually there, experiencing exciting views of the fleet at anchor at Spithead, or far-away cities like London, Paris or Constantinople.

Why did these curious entertainments become so

179 John Martin, **Belshazzar's Feast** (detail of Pl. 188)

180

popular, and how did they begin? The Grand Tour, such a feature of life of the eighteenth century, took on different dimensions in the much larger Victorian world. News of travel to Italy, Spain and the Exotic East, the exploration of the 'dark continent' of Africa, the opening up of America and Australia, provided topographical painters with novel themes and created great escapist interest in the public which could not travel so far. This desire for the experience of travel, that basic human instinct, could, however, be satisfied vicariously by a visit to the new entertainment of the panorama. Although invented in the late eighteenth century it came to the zenith of its popularity in the Victorian era, and its influence on more 'establishment' art was an important one, for it fostered a public appetite for paintings of large dimensions, particularly landscapes.

In America the panorama's influence was to be even more profound. The landscape painter Thomas Cole saw panoramas when he was in London in 1829, and on his return to America began to paint landscapes in the panoramic manner such as *The Oxbow* (Pl. 486), a scene on the Connecticut river. From Cole the style spread to artists as diverse as Albert Bierstadt and Frederic Edwin Church, and the panoramic manner played a formative role in forging the uniquely American phenomenon of the Hudson River School (see below, pp. 392–5).

Amazingly, the walls of the world's first 'custom-made' panorama building still survive in London. If you stand outside the Odeon, Leicester Square, and look over the roofs on the north side of the square you can still just see the upper part of the enormous brick cylinder which was built by Robert Barker in 1792 to show the paintings for which the word 'panorama' was coined. (The building now houses the church of Notre Dame de France, Soho.) A vivid idea of the entertainment is provided by a print of the building by the architect Robert Mitchell, *Section of the Rotunda, Leicester Square* (Pl. 181). The lower group of visitors are enjoying a view of the grand fleet lying at Spithead, with a capsizing boat in the foreground. The painting was hung in the lower circle at a uniform distance of 30 feet from the edge of the platform. So vivid was the effect of reality that when Queen Charlotte viewed it with George III, she complained of feeling seasick. In the smaller viewing saloon above the visitors enjoyed a panorama of London. This was developed from detailed drawings made by Barker's 16-year-old son Henry during the winter of 1790–1 from the roof of the Albion Sugar Mills in Southwark, then one of the highest viewing points in London.

The panorama earned its inventor a fortune, and began a craze for 'panoramic' views that swept around the world. Several well-known artists worked as panorama painters, most notably Thomas Girtin (1775–1802), who painted an *Eidometropolis* or *Panorama of London* measuring 108 feet by 18, and was engaged on a panorama of

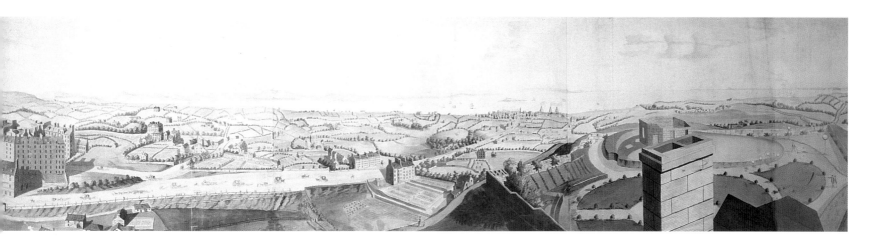

Paris when he died at the early age of 27 in 1802. Both projects are now known to us only by watercolours and a series of acquatints. Picturesque scenes of such famed vistas as Rome and the Bay of Naples, battlefields and naval engagements were popular subjects during the first half of the nineteenth century. Indeed, panoramas became the newsreels of the Napoleonic era. When Nelson met Robert Barker in 1799 the Admiral thanked him 'for keeping up the fame of his victory in the Battle of the Nile for a year longer than it would have lasted in the public estimation'.

There were of course critical voices, one being that of the young artist John Constable, who in May 1803 wrote home to his friend Dunthorne in Suffolk with news of London:

> Panorama painting seems all the rage. There are four or five now exhibiting, and
> Mr Reinagle is coming out with another, a view of Rome, which I have seen. I
> should think he has taken his view favourably, and it is executed with the greatest
> care and fidelity. This style of painting suits his idea of the art itself, and his
> defects are not so apparent in it – that is, great principles are neither expected nor
> looked for in this mode of describing nature.

Twenty years later Constable was also to criticize the diorama, saying, 'True Art pleases by reminding not by deceiving.' Despite his reservations it is interesting to note that one of Constable's first extensive watercolours was a 360-degree depiction

180
Robert Barker
Edinburgh from Calton Hill
1792
watercolour version of the
original panorama, 41 × 326cm
(16¼ × 128½in)
Edinburgh University

181
Robert Mitchell
**Section of the Rotunda,
Leicester Square, in which
is Exhibited the Panorama**
1801
Coloured aquatint,
28.5 × 44.5cm (11¼ × 17½in)

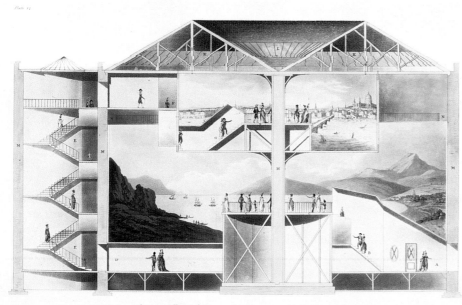

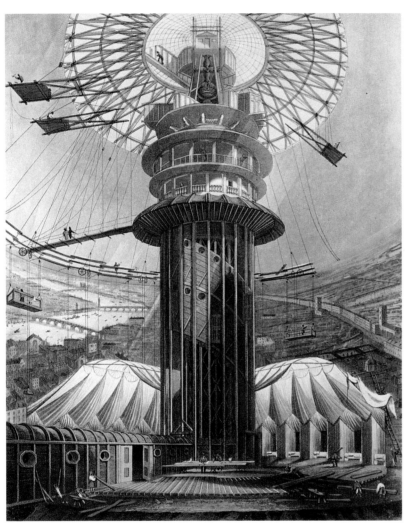

182

of his beloved Stour valley painted as a wedding present for a young lady who was leaving the district.

Constable's friend and biographer C.R. Leslie found the panorama experience exciting. Writing to his brother in Philadelphia in 1812 he said: 'I have been to see Mr Barker's panoramas, the *Siege of Flushing* and *Bay of Messina* … the effect is very astonishing. I actually put on my hat imagining myself to be in the open air. I was so far deceived that I could form no idea how far the canvas was from my eye, in one spot it appears thirty miles off and in another not so many feet …' But later in a lecture at the Royal Academy in 1849 Leslie echoed Constable's criticism, finding 'something unpleasant in all art of every kind of which deception is an object'.

The largest of all panoramas was created by Thomas Hornor (1785–1844). He took advantage of repairs to the dome of St Paul's Cathedral to make 10,000 drawings of London which he used to paint the vast surface of *London from the Summit of St Paul's Cathedral*. It was housed in the Regent's Park Colosseum (Pl. 182), a building designed by the architect Decimus Burton, which was modelled on the Pantheon in Rome and was for fifty years a major London landmark. It spawned imitations in New York, where in the 1870s a new Colosseum was erected by the great showman Phineas T. Barnum on Broadway at 35th Street, which showed *London by Day* alternating with *Paris by Night*!

While both these paintings of capital cities have long since mouldered into dust, there still survives a bird's-eye view of a market town which also came into being through the restoration of an ecclesiastical building. In 1844 the local Lincolnshire artist William Brown (1788–1859) climbed to the top of the scaffolding surrounding the great 294-foot spire of St James in Louth and made hundreds of detailed drawings. These he used in the next three years to paint a 120-square-foot complete panorama of the town and adjacent countryside (Pl. 183). In so doing he preserved in a time warp a busy sunny day at Louth in the 1840s. Among the bustling tradesmen and shoppers going about their daily tasks we can spy a funeral procession making its way to a churchyard, coaches moving noisily through the streets, and gardens laid out in scrollwork beds of the type just made fashionable by J.C. Loudon's *The Suburban Gardener and Villa Companion* (1838).

The word 'panorama', derived from two Greek words for 'all-encompassing view', was originally intended to describe vast, stationary 360-degree paintings. It was, however, rapidly applied to virtually any painting displaying a broad scene. Soon rival attractions opened, all with variations on the inspired title – dioramas, cosmoramas, cycloramas, myrioramas and a host of other 'oramas', a craze which *Punch* satirically dubbed 'Panoramania!'

One of the most important innovations was the 'moving panorama', which became even more popular than the 360-degree variety. This consisted of an enormous canvas 20 feet high and several hundred long wound round a concealed spool hidden behind the proscenium. It unwound horizontally across the back of the stage on to a second concealed spool. The earliest example was a series of views of 'the most magnificent buildings in London' which was displayed at Drury Lane's Christmas pantomime, *Harlequin Amulet*, in 1800. These became a regular feature of such entertainments, and the clown Grimaldi often featured against the moving back-

ground in a mime, as in 1824 when he undertook 'a panorama balloon trip from London to Paris'.

Thomas Grieve (1799–1882), a member of the famous Victorian family of stage designers, was a fine painter of moving panoramas. In 1837 the young Queen Victoria made a triumphant visit to the City of London on 9 November, the day of the Lord Mayor's annual show. To commemorate the occasion that winter, Grieve painted for Drury Lane's pantomime, *Harlequin Jack-a-Lantern*, a panorama celebrating a royal visit by the Queen's great predecessor, entitled *A Grand Moving Panorama of London in the Time of Elizabeth I* (Pl. 184).

A few years later Grieve found this experience useful when working at the Princess's Theatre, where the exacting actor-manager Charles Kean was producing a

183
William Brown
View of Louth
1844–5
oil on linen, section looking
west 183 × 274cm (72 × 108in)
Louth Town Council

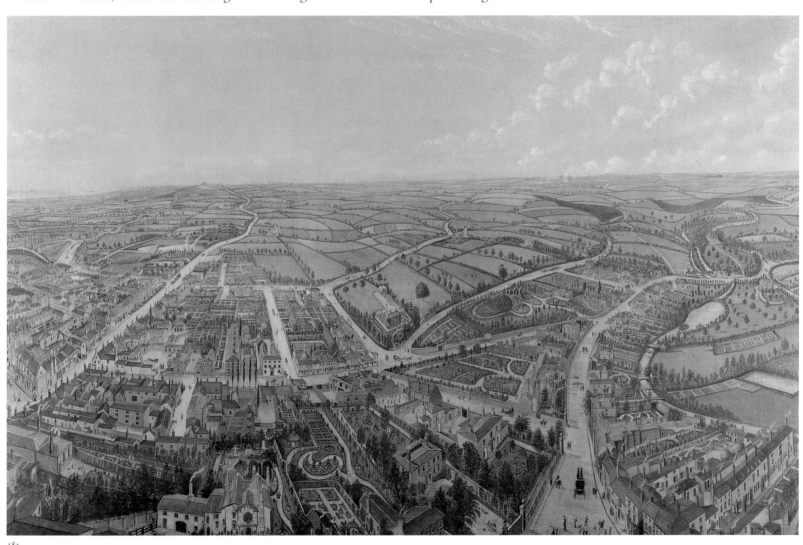

183

spectacular series of Shakespearian productions, all mounted with immense attention to historical accuracy. For *Henry VIII*, produced in May 1855, Grieve painted a moving panorama based on Wenceslaus Hollar's long *Prospect of London* of 1647. This unwound while actors mimed a boat rowing out to Henry VIII's ship *The Royal George*.

Another important new attraction was the diorama, the invention of Louis Daguerre (1789–1851), inventor of the daguerreotype, who used the profits from his diorama shows to finance his experiments in photography. Basically the diorama was a series of screens leading to a vast transparency. This was a translucent cloth painted on both sides, providing two different effects when lit from the front or the back.

184
Thomas Grieve
A Grand Moving Panorama of London in the Time of Elizabeth I
1837
artist's record of the original panorama, tempera on paper, 17.5 × 172cm (6⅞ × 67¾in)
Victoria and Albert Museum, London

The only source of light was daylight which was subtly controlled by different coloured blinds, skylights, shutters and screens. The first diorama opened in Paris in 1822. Its vast painted screen was the same size as a modern IMAX film screen. Daguerre's Regent's Park Diorama in London opened a year later in 1823, in a building designed by A.C. Pugin, father of A.W.N. Pugin, which still stands. We gain an idea of the experience of visiting the Diorama from a surviving oil painting by Daguerre of *The Ruins of Holyrood Chapel, Edinburgh, Effect of Moonlight* (Pl. 185). Looking at it we can visualize the subtle changes of light and the sound effects of monks singing and the torches being lit which animated the sombre scene. After the spectacle had been seen, a low subterranean rumbling led to the whole auditorium being slowly swung around to face another tableau, a mountain landscape in the Alps. In it the day slowly dawned, birds sang, a tethered goat bleated and the distant sound of an alpenhorn echoed across the valley, before dusk fell after a spectacular sunset and the stars emerged.

Other typical diorama effects included moonlit nights, winter snow turning into a summer meadow, rainbows after a storm, illuminated fountains, waterfalls and sound effects such as bells, thunder and lightning. These pictorial entertainments both reflected the Romantic vision of nature, and were precursors of the cinema and such figures as D.W. Griffith and Cecil B. De Mille. Their films, in particular Griffith's *Intolerance* (1916), with its spectacular Babylonian scenes, look back to the work of

184

four major Victorian artists particularly associated with vast illusionist canvases: Clarkson Stanfield, David Roberts, John Martin and Francis Danby.

Born in Sunderland, Clarkson Stanfield was apprenticed to a heraldic coach painter before going to sea on a collier in 1808 at the age of 15. In July 1812 in London he was pressed into the Royal Navy and served as foremast hand on the guardship *Namur* at the Nore, under the alias 'Roderick Bland'. After being pensioned from the Navy following a fall, he joined the merchant service, travelling on the *Warley* to China in 1815 and returning the following year. In September 1816, having missed his ship for a voyage to India, he took a job as scene painter at the East London Theatre opposite the Tower of London. Going aloft, both to furl sails at sea and to handle scenery in the theatre, demands physical strength, courage and a good head for heights. For the next eighteen years Stanfield earned his living painting scenery – working in the New Coburg (today the 'Old Vic') and Astley's Amphitheatre. While touring with Astley's in 1820–1 he met David Roberts in Edinburgh, with whom he was to become closely associated as friend, colleague and rival. Both worked at the Coburg until 1822, when they switched to the Theatre Royal, Drury Lane.

David Roberts, born in a village near Edinburgh, was apprenticed as a boy to a house painter, but joined a strolling company of actors as a scenery painter. He later wrote that this 'was in itself anything but a creditable pursuit, yet it jumped with my

wishes … to follow the bent of my mind – in drawing pictures on a large scale – which might lead to something better', an ambition later fulfilled, for Roberts became the foremost topographical artist of his day.

Between 1828 and 1829 Stanfield and Roberts produced their most remarkable illusionistic work for a rival establishment to Daguerre's Regent's Park Diorama, the British Diorama in the Royal Bazaar, Oxford Street. The amphitheatre was stationary and the paintings were moved on and off by rollers. Roberts and Stanfield also painted 'moving panoramas' of two celebrated naval actions, *The Bombardment of Algiers* and *The Battle of Navarino*, which after their London showing toured England, Holland and Germany. In all, eight large dioramas by Stanfield and Roberts were shown at the British Diorama.

One of the most dramatic dioramas was Stanfield's *The City of York with the Cathedral on Fire*, re-creating the incident of 1 February 1829 when the painter John Martin's mad brother Jonathan set fire to the roof of York Minster. As a spectacle the re-enactment of this event was remarkable but was to have disastrous results. The show opened only two months later on 20 April 1829. On 27 May a chemical reaction which produced a 'safe fire' effect in the painted flames ignited by mistake, and before the real flames could be dowsed virtually the whole building was burnt to the ground, including the four dioramas on display and four more which had been exhibited earlier.

With fire hazards a commonplace, it was not surprising that in 1830 Roberts put diorama work behind him to concentrate on his exhibition works for the Royal Academy. In 1828 he had already achieved success on its walls with his painting *The Israelites Leaving Egypt* (Pl. 186), created ten years before he actually visited the Middle East. He chose the subject 'as a vehicle for introducing … that Grand although simple style of architecture, the Egyptian … from which the other three Greek orders have unquestionably sprung'. In the next few years Roberts travelled widely, painting the great cathedrals of Europe, and spending nearly a year in Spain. A visit to Morocco whetted his appetite for the rich visual potential of the Arab world, leading to later travels to the Middle East (see pp. 102–3).

In the autumn of 1830 Stanfield visited the Rhine and Venice, a trip which was to pay major visual dividends. Not only did it provide him with subjects for exhibition pictures but also inspired exciting material for moving dioramas for the Drury Lane Christmas pantomimes of 1830 and 1831. The first, entitled *The Military Pass of the Simplon*, was painted in the short space of eleven days for a fee of £300. The spectacle *Venice and its Adjacent Islands* of the following year must have been even more amazing. Gas lit, approximately 20 feet high and 300 feet long, it took about 15 to 20 minutes to be shown. It consisted of a main cloth, parts of which were transparent, and other pieces of scenery, such as boats, which were manoeuvred downstage of it. It was not in continuous movement, the views being stopped for the audience

185

186

to admire, each with special effects. Between the *Lido* and *The Bridge of Sighs* was a scene of *The Lagoons at Night* in which a chorus of gondoliers was heard singing 'List to the Boatman's Roundelay'.

This romantic effect was only slightly marred in the performance on 27 December 1831 by the sound 'of an invisible scene-shifter calling out to a pasteboard gondolier, who seemed to be rowing as well as he could, "Damn ye, keep close to the lights."' The *Times* critic who noted this was otherwise full of praise for the visual effects painted 'with a truth and finish which were never bestowed upon scene painting in our times at least, until he [Stanfield] applied his talents to the work … thus teaching pit and gallery to admire landscape art and the boxes to become connoisseurs'. In common with most of Stanfield's dioramas this Venetian spectacle saw long service after the close of the pantomime, being re-used in productions of Shakespeare's *Merchant of Venice* and Otway's *Venice Preserved*. We gain some idea of it from his watercolour *Venice: The Dogana and the Salute* (Pl. 187). Stanfield painted no fewer than sixteen of such moving displays, taking the Drury Lane audiences on armchair journeys to Gibraltar and Constantinople by sea (1828), to the Niagara Falls (1832) and along the Nile (1833).

In 1834, after a row with the manager of Drury Lane over scenery, Stanfield resigned, to concentrate full-time on his work as a marine painter (Pl. 109). He continued to design scenery only for his friends, such as the actor Macready and the stage-struck amateur Charles Dickens, whom he met in 1838, and who became one of his closest friends.

Together with his friend Roberts, Stanfield became a full member of the Royal Academy, unlike John Martin (1789–1854), an artist who frequently exhibited but was always a rather isolated figure, never fully recognized by his peers. Yet throughout his career Martin caught the public imagination with melodramatic scenes of cataclysmic events crowded with tiny figures placed in vast architectural settings. From an early date his works received a varied critical response. In 1821 David Wilkie shrewdly remarked of Martin's *Belshazzar's Feast* (Pl. 188): 'Common observers seem very much struck with this picture; indeed more than they are in general with any picture. But artists, so far as I can learn from the most considerable and important of them, do not admit its claims to the same extent.' These sentiments were echoed the same year by Sir Thomas Lawrence, who referred to Martin as 'the most popular painter of the day'. Martin's work was indeed truly popular, for his income was chiefly derived from the sale of his virtuoso mezzotints after his pictures rather than the paintings themselves.

Although he was not painting realistic landscapes, it was Martin's achievement to transport the spectator not just across the globe but also into a poetical and ideal world. There one could watch Milton's Rebel Angel raising Pandemonium from the abyss of Hell or such biblical scenes as Belshazzar's Feast and the catastrophe of the Flood. In 1828 the German art historian G.F. Waagen analysed the appeal of such works, citing Martin's *The Fall of Nineveh*: 'I now perfectly understand the extraordinary approbation which Martin's pictures have met with in England, for they unite, in a high degree, the three qualities which the English require, above all, in a work of art – effect, a fanciful invention inclining to melancholy, and topographic historical truth.' All these qualities might equally be applied to the documentary, non-aesthetic purposes of the panorama or diorama painter.

Such criticism was mild compared with Ruskin's dismissal of Martin's work as 'mere vulgar sensationalism'. This adverse reaction may in part have been attributable to the frequency with which Martin's (and Roberts's) work was plagiarized. In 1833 an enlarged copy of Roberts's *The Israelites Leaving Egypt* (1829) was replaced at

185
Louis Daguerre
The Ruins of Holyrood Chapel, Edinburgh, Effect of Moonlight
*c.*1824
oil on canvas, 211 × 256cm
(83¼ × 100⅞in)
Walker Art Gallery, Liverpool

186
David Roberts
The Israelites Leaving Egypt
1828
oil on canvas, 137.2 × 182.9cm
(54 × 72in)
Birmingham City Museum and Art Gallery

187
Clarkson Stanfield
**Venice: The Dogana
and the Salute**
1831
watercolour and bodycolour,
22.2cm × 31.8cm (8¾ × 12½ in)
British Museum, London

the British Diorama by a 2,000-square-foot enlargement of *Belshazzar's Feast*, despite Martin's unsuccessful attempt to shut down the show by a court order. Similar enlarged 'dioramic' versions of both artists' paintings were toured around the world by unscrupulous rivals. A blown-up dioramic version of *Belshazzar's Feast* was exhibited in New York in March 1835 in a brick building on Broadway, following the dioramic version of *The Israelites Leaving Egypt*, which had opened in January. The *New York American* gave *Belshazzar's Feast* a rave review:

> the contrast between the rays of living light darted from the fatal words [on the
> wall, foretelling the destruction of Babylon], and the lurid flames of incense
> which burn around the Idol, in the midst of Belshazzar's hall – the repose of the
> eternal skies above, and the soft, calm moon with her bow of silver, emerging
> from the surrounding clouds … constitute a spectacle that all should see.

One artist who may have seen both shows was Thomas Cole, whose *The Dream of the Architect* (Pl. 487) has echoes of both Martin's and Roberts's compositions.

John Martin resembled his friend, the engineer Isambard Kingdom Brunel, in

187

being a typical Victorian polymath. Like Brunel, he invented methods of building ships from iron instead of wood, and new methods of propulsion. He created ambitious schemes for the improvement of London's railways, its fresh water supply and sewage, the installation of the Thames Embankment, and the provision of fresh air and the prevention of explosions in coal mines. He claimed to have spent two-thirds of his adult life on these grandiose *Plans*, which by 1837 were estimated to have cost him £10,000. The resultant financial crisis was in part averted by a commission to paint *The Coronation of Queen Victoria*, showing the ceremony in Westminster Abbey. Many distinguished people came to his studio to sit for their portraits in the Coronation painting, which led to Martin selling several works and receiving commissions for others. Martin lived on to paint *The Country of the Iguanodon* (now lost), the prehistoric world revealed to him by the geologist Dr Gideon Mantell. Few artists have been subject to such posthumous extremes of critical fortune, for in the 1930s his vast paintings fetched only a pound or two, while today they are valued at many thousands.

One of Martin's greatest rivals was the Irishman Francis Danby (1793–1861), who shared a passion for grand, gloomy and fantastic subjects which chimed exactly with the Byronic taste of the 1820s. Danby settled in Bristol in 1812 and made a reputation with dramatic landscapes in part inspired by the scenery of the Avon gorge, but in 1830 had to leave England because of his involvement in an embarrassing marriage scandal. He spent the next ten years abroad as far afield as Norway and Naples, producing dark and dramatic landscapes lit by startling impressions of moonlight or spectacular sunsets which vied with the effects produced in panoramas and even more in dioramas. Danby's pictorial imagination was attuned to the colossal, and even before he left England he had begun to plan a 30-foot-long picture which did not materialize. In the late 1830s, however, he did create his own version of *The Deluge*

188
John Martin
Belshazzar's Feast
1820
oil on canvas, 95.3 × 120.6cm
(37½ × 47½in)
Yale Center for British Art,
Paul Mellon Collection,
New Haven, CT

188

which was over 15 feet long (Pl. 189). This painting announced his return to England in a dramatic way when it was exhibited in Piccadilly in 1840, having been painted shortly before on the continent.

Danby's choice of subject may have been in part dictated by the fact that in 1839 the *Art Journal* had announced the forthcoming re-exhibition at the Royal Academy of John Martin's 1826 version of *The Deluge* with two later companion works, *The Eve of the Deluge*, commissioned by the Prince Consort, and *The Assuaging of the Waters* (Pl. 190), both painted between 1834 and 1840. These large-scale epic visions depict the story of the Flood as told in the book of Genesis, relating the terrible punishment brought down by a wrathful God upon sinning humanity. In reviewing the

189

190

paintings Thackeray recalled that the subject of *The Deluge* had already been treated by Turner and Poussin but considered Danby's extraordinary performance to surpass them. Danby painted no more works of this type, turning to the romantic sunny landscapes of his later years, with their mood of solemn serenity and melancholy.

As the century passed the popularity of panoramas and dioramas waxed and waned. Rather surprisingly John Ruskin actually had a soft spot for Barker's panorama building, subsequently taken over by the Burford family. Robert Burford's name can be seen in a watercolour of the entrance to the building (Pl. 191), painted by Thomas Hosmer Shepherd (*fl.*1813–58) in 1858, when it was showing the topical Indian Mutiny subject of *The Fall of Delhi*. A few years later in 1863, writing of his first visit to Milan, Ruskin regretted the closure of the panorama building:

> I had been partly prepared for this view [of Milan Cathedral] by the admirable
> presentation of it in London a year or two before in an exhibition, of which the
> vanishing has been in later life a great loss for me – Burford's panorama in
> Leicester Square, which was an educational institution of the highest and purest
> value, and ought to have been supported by the government as one of the most
> beneficial school instruments in London.

Although panorama entertainments had much to offer as educational 'visual aids', Ruskin considered them nothing to do with real art, describing their creators as 'merely vulgar and stupid panorama painters'. His strictures were unconsciously and amusingly contradicted by the surveyor S. Brees, who stated that his panorama of New Zealand, shown in London in 1849, was 'not the work of a mere artist, but of a surveyor, whose business it was to explore and set down with topographical accuracy the natural features of the Colony'. Naval officers also learnt the art of panoramic recording of bays and ports.

Panoramic painting flourished widely in the Antipodes. As early as 1825 and 1827 Augustus Earle (1793–1838) had made watercolour panoramas of Sydney and Hobart (Pl. 192) which were used by Robert Burford in panoramas exhibited in London in 1829 and 1830. As more and more emigrants left for Australia there was an increasing demand for 'on the spot' visual reportage, and several amateur panoramas by woman settlers survive which were sent home to England to give relatives an idea of the immediate surroundings of their new homes.

In 1848 the watercolour painter John Skinner Prout (1805–76) returned to London from Tasmania and produced a panorama entitled *A Voyage to Australia*. He adapted it two years later to include a visit to the goldfields, produced in the form of a moving diorama. During the next twelve months he presented the show over 600 times in London, before touring it in the West Country. We gain an idea of the entertainment from the poster advertising the show, in the familiar, grandiloquent language of the panorama showman:

> The Emigrant Ship leaves Plymouth Sound
> Daily at 3 and 8 o'clock and arrives at
> MELBOURNE IN FORTY MINUTES!!!
> From which place the Voyagers, after witnessing a few phases of **Melbourne life**,
> and enjoying a hearty laugh at the absurdities of
> A GOLD DIGGER'S WEDDING,
> Linger awhile with
> THE ABORIGINAL INHABITANTS
> and enjoy a most easy conveyance
> to the society of the Gold diggers at
> MOUNT ALEXANDER

and so on … Such a 'spiel' conveys a little of the excitement of seeing a moving

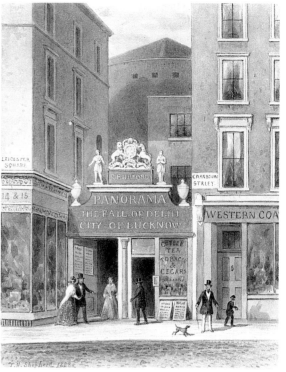

191

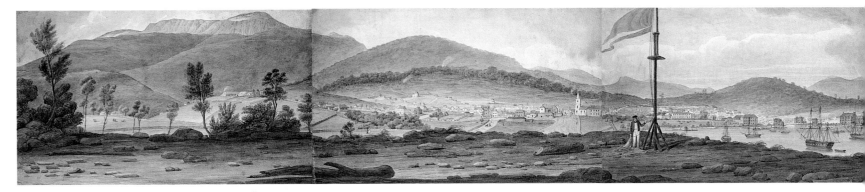

192

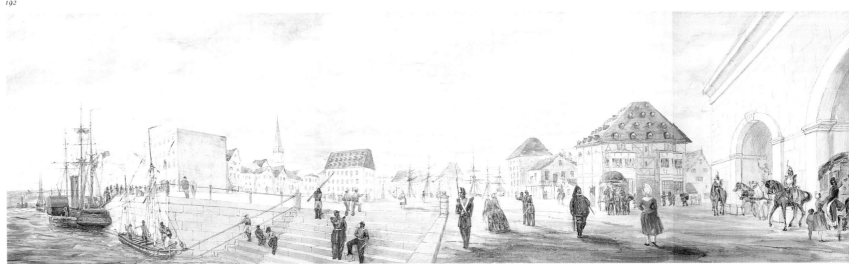

193

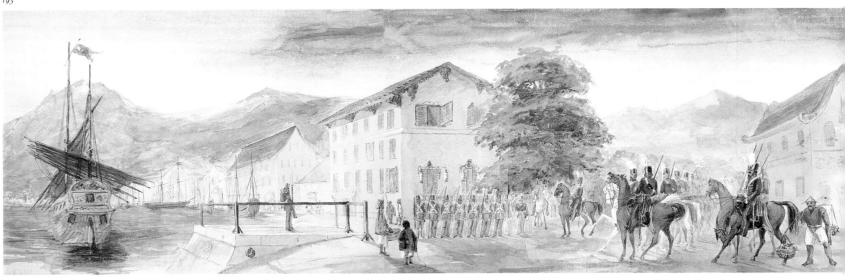

193

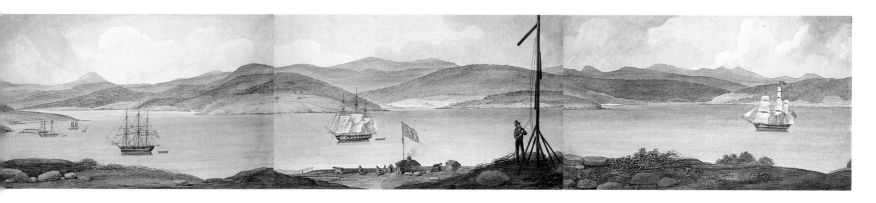

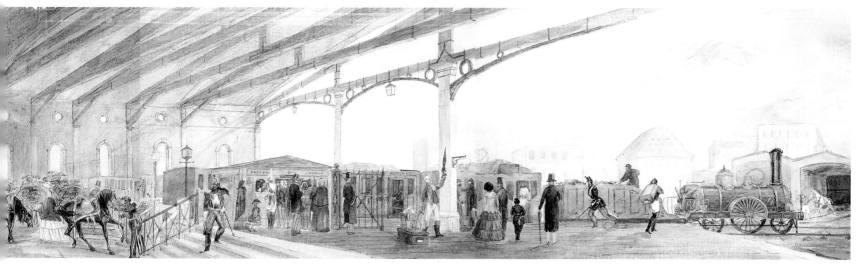

panorama entitled *London to Hong Kong in Two Hours* of which the original water-colour version survives (Pl. 193), or the thrill of hearing the famous panorama lecturer Albert Smith present his celebrated moving shows of the *Overland Mail* (Pl. 195) or the *Ascent of Mont Blanc* at the Egyptian Hall, Piccadilly. A popular feature of the late 1840s and 1850s were the Moving Panoramas of the Mississippi River, accompanied by a lecture laced with jokes and poetry delivered with an attractive Yankee twang by its creator John Banvard, who optimistically calculated that in a thousand days the attraction was seen by a million people. Other popular attractions included panoramic trips to destinations as various as Europe, Egypt, India and Afghanistan, while accounts of the *Overland Route on the Trans-Siberian Railway* and voyages around the world also flourished.

Rotundas to house the paintings were erected in major cities throughout Europe and North America, and as far afield as Brazil, Australia and Japan. A few still stand, including one near the Grand Palais in Paris. The dimensions of the 360-degree panorama became standardized – 50 feet in height, 400 feet in circumference – enabling panoramas to be exhibited round the world in specially designed buildings. We get a glimpse of one such structure in Charles Halkerston's *The Rotunda on the Mound, Edinburgh* (Pl. 194), which shows a panorama building offering shows of *Jerusalem* and *The Battle of Waterloo*.

Battle scenes were always popular attractions in England, Europe and America, and interest was intense in 1881 when the great national tragedy of *The Charge of the Light Brigade at Balaclava* was exhibited 'lit by electricity' at the Royal London Panorama, Leicester Square. A surviving veteran of the charge described the action. This was the first panorama to be given a *faux terrain* – earthworks and real guns placed between the viewing platform and the canvas. Similar effects were used in *The Battle of Gettysburg* (Pl. 196), painted by Paul Philippoteaux, a member of one of the

192
Augustus Earle
Panorama of Hobart
1827
watercolour, six sections,
each 36.8 × 54.6cm
(14½ × 21½in)
Dixson Galleries, State
Library of New South
Wales, Sydney

193
John Lamb I and II
**London to Hong Kong
in Two Hours** (details of
the port of Ostend and the
arrival in Hong Kong)
*c.*1860
watercolour, height
37.5cm (14¾in), length
of whole approx. 53.5m
(174ft)
Museum of London

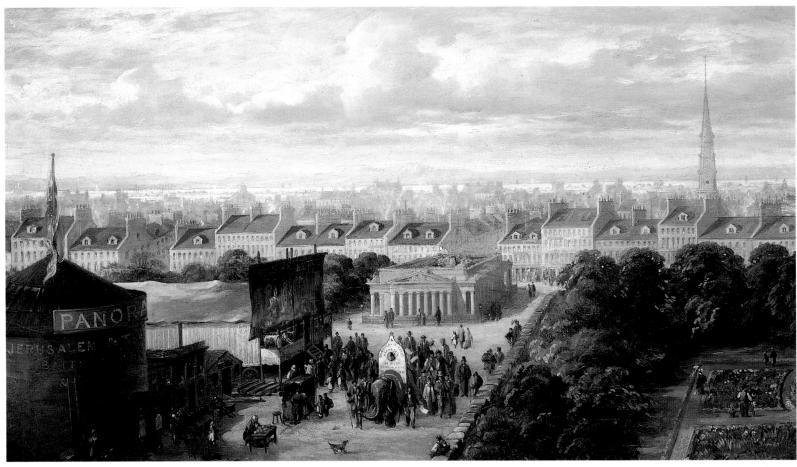

194

195

most famous families of panorama painters. It still survives today, as does his panorama of the *Battle of Atlanta* (1885–6).

In London between 1880 and 1900 a number of panoramas were shown, but all were imported from France, Belgium or Germany. There was, for example, tremendous interest in the effects on Paris of the siege and the Commune of 1870–1, and after being shown at Philadelphia, *The Siege of Paris*, by Félix and Paul Philippoteaux, was shown at the Crystal Palace with great success. The old subjects kept their appeal, one of the most popular in 1880s London being the *Niagara Falls* by Paul Philippoteaux, which gave way to *Egypt in its Grandeur* before the 'Niagara Hall', as the building was called, suffered the indignity of being transformed into an artificial ice rink.

With the coming of the cinema in the late 1890s the industry was wiped out, and only a few exceptional examples like Hendrik Mesdag's *Panorama of Scheveningen* (1881) in The Hague remained on show, as it still does today. The majority of the paintings were either cut up or destroyed, although a few were rolled up and stored. Forty years on Bishop & Sons, warehousemen in Belgrave Road in London, were using a *Jerusalem on the Day of the Crucifixion* and a *Siege of Paris* as coverings for their pantechnicons.

Right at the end of the century, Thomas Hardy, describing the eve of Waterloo and the burning of Moscow in *The Dynasts*, a play dealing with the Napoleonic Wars, conjured up the old dioramic entertainments in his elaborate stage directions:

> The blaze gains the Kremlin, and licks its walls, but does not kindle it. Explosions and hissings are constantly audible, amid which can be fancied cries and yells of people caught in the combustion. Large pieces of canvas aflare sail away on the gale like balloons. Cocks crow, thinking it sunrise, ere they are burnt to death.

Tragically, war and the panorama continue to be inextricably united, for since

the Second World War new battlefield panorama paintings have been created in Egypt, North Korea, Iraq, Russia, China and East Germany, all nations which have used the panorama to depict great moments in their history for propaganda purposes.

In the last few years there has been an awakening of interest in the subject. Old panoramas have been unrolled and carefully restored at enormous expense. At the Victoria and Albert Museum in London can be seen a panorama of *Rome* by Lodovico Carraciolo, while in the United States the magnificent *Panorama of Versailles* by John Vanderlyn (1775–1852) now hangs in the American Wing at the Metropolitan Museum of Art in New York (Pl. 197), although sadly not in a true 360-degree display.

The old Victorian entertainment of the panorama still has something to say to us today, freeing us from the tyranny of the artist's restricted forward vision of 120 degrees, and the confines of the picture frame. To use Barker's words in his original patent, panoramic vision gives us the thrill of feeling that we are indeed 'really on the very spot'. Today we experience this in the multi-screened cinemas which in China and Russia show films that achieve a convincing 360-degree experience of boating down the Yangtze River or flying round the streets of St Petersburg in a helicopter. In the Western world, Disney's Epcot centre and other theme parks use panoramic vision to add another dimension to 'white-knuckle rides' – the experience of electronic 'virtual reality'.

194
Charles Halkerston
The Rotunda on the Mound, Edinburgh
1843
oil on canvas, 27.5 × 47cm
(10¾ × 18½in)
Edinburgh City Art Centre

195
Albert Smith presenting a section of his 'Overland Mail' panorama, entitled 'From Suez to Cairo', at the Egyptian Hall, Piccadilly
wood engraving from *Illustrated London News*, 25 December 1852

196
Paul Philippoteaux
The Battle of Gettysburg
(detail)
1884
oil on canvas, 7.9 × 108.5m
(26 × 356ft)
Gettysburg Military Park

197
John Vanderlyn
Panorama of Versailles
c.1816–19
oil on canvas, 3.7 × 50.3m
(12 × 165ft)
Metropolitan Museum of Art, New York

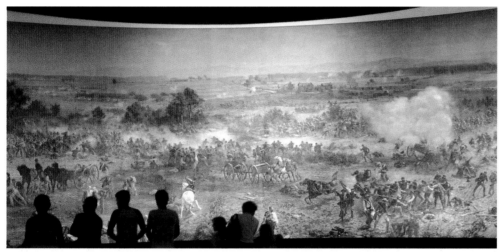

196

197

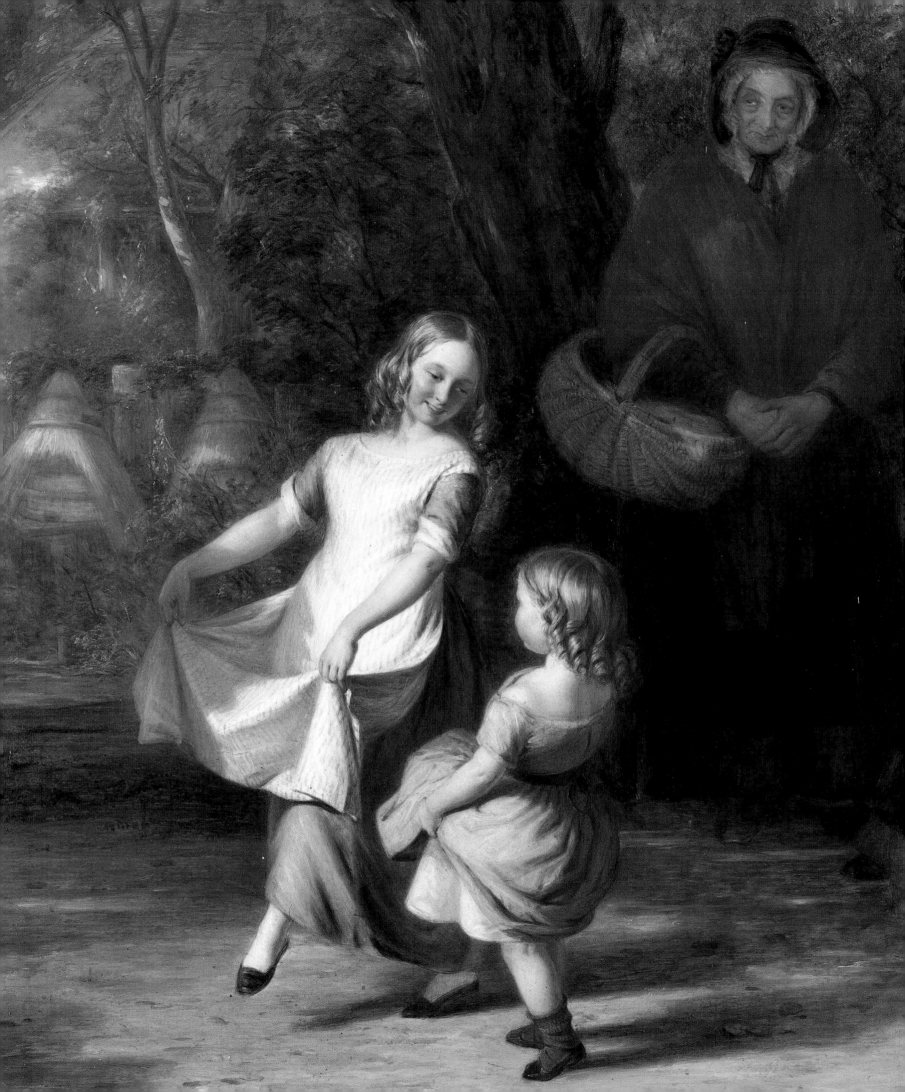

In 1891 Whistler was invited to hang the annual Liverpool Exhibition. Characteristically, he played a practical joke in his arrangement of the typical Victorian narrative paintings submitted, which he described as featuring 'the great British baby'. He wrote:

> You know, the Academy baby by the dozen had been sent in, and I got them all in my gallery – and in the centre, at one end, I placed the birth of the baby – splendid – and opposite, the baby with the mustard pot, and opposite that the baby with the puppy – and in the centre, on one side, the baby ill, doctor holding its pulse, mother weeping. On the other, by the door, the baby dead – the baby's funeral – baby from the cradle to the grave – baby in heaven – babies of all kinds and shapes all along the line … and on varnishing day, in came the artists – each making

199
William Quiller Orchardson
Master Baby
1886
oil on canvas, 108 × 166cm
(42½ × 65⅜in)
National Gallery of Scotland,
Edinburgh

200
Edwin Landseer
A Naughty Child
1834
oil on board, 38 × 27.9cm
(15 × 11in)
Victoria and Albert Museum,
London

for his own baby – amazing! … And they all shook my hand and thanked me –
and went to look – at other men's babies – and then they saw babies in front of
them, babies behind them, babies to the right of them, babies to the left of them.
Such displays can be all too vividly imagined, and Whistler's little joke acutely high-
lights a dilemma which confronts any artist who portrays children. Their work is
always open to accusations of mawkish sentimentality, or more sinister repressed
motivations. But at its best, as in William Quiller Orchardson's *Master Baby* (Pl. 199),
the successful 'baby fancier' can triumph, for this work was admired by both Degas
and Sickert and also the novelist and critic George Moore. While artistically we pre-
fer today the more objective works of the last decades of the nineteenth century,
which avoid bathos and 'sweetness', there is a strange fascination in many sentimen-

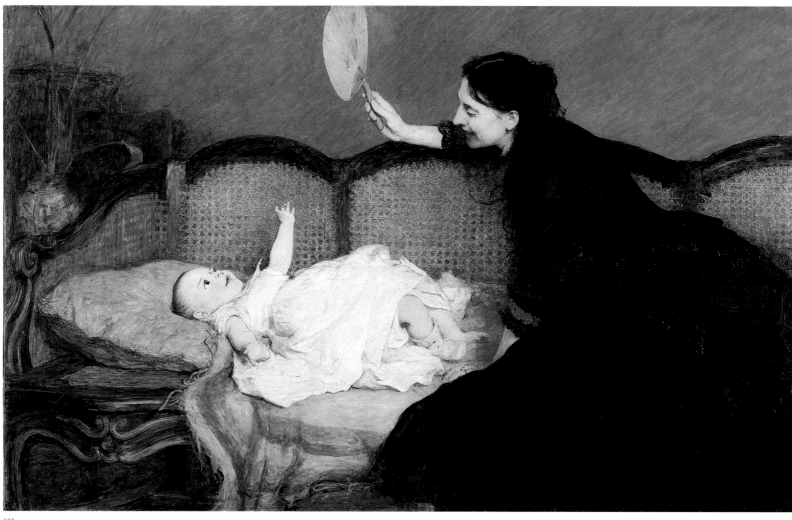

199

tal early Victorian depictions of childhood that reveal much concerning contempo-
rary attitudes.

For the early Victorians fun and retribution went hand in hand. The Evangelicals
preached that a child was innately sinful and in need of continual instruction and
chastisement, yet the spoilt child was also an ever-popular subject. The enthusiasm
for Dutch seventeenth-century anecdotal paintings that dominated the first decades
of the nineteenth century gave rise to a flood of representations of childhood which
reached tidal proportions by the early Victorian era. Even artists not normally asso-
ciated with this type of subject tried their hand, an example being Edwin Landseer's
candid treatment of one of the most trying aspects of childhood, *A Naughty Child* (Pl.
200). This depicts a child who has broken her slate in a fit of pique and been placed

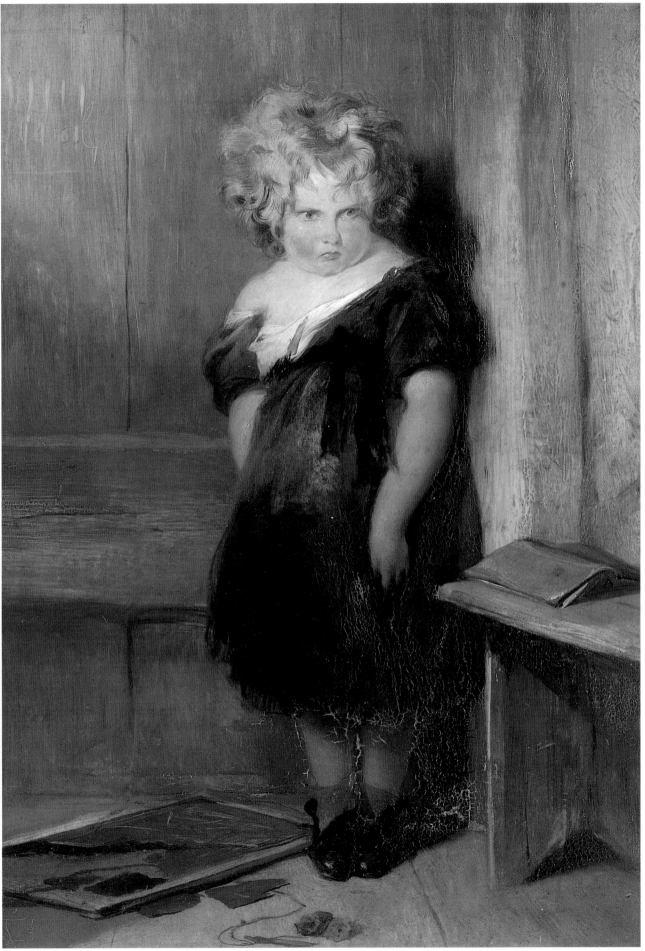

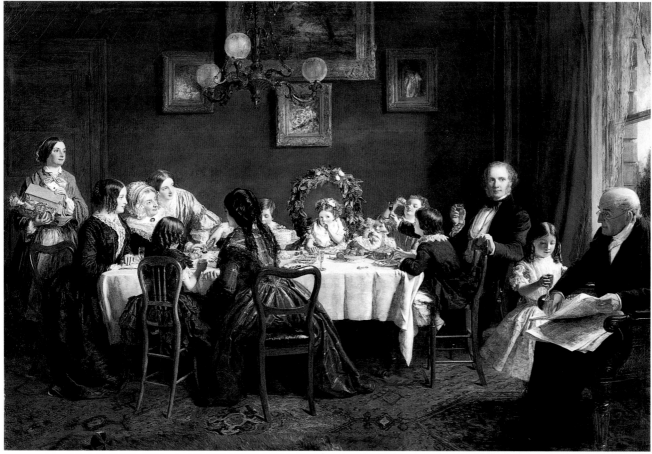

201

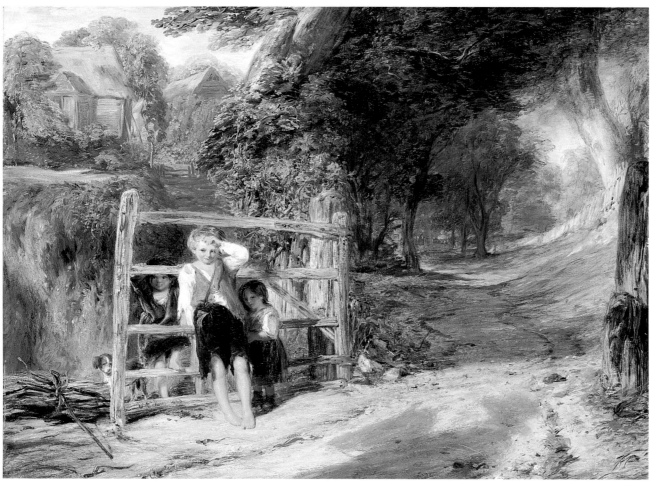

202

in the corner as a punishment. It possesses an added interest since we know that the little girl was in fact Lady Rachel Russell, his own daughter by his mistress Georgiana, Duchess of Bedford. The painting was hailed as an innovative masterpiece when exhibited at the British Institution in 1834, as children were more routinely depicted as angelic, and a petulant, sulky little horror was considered amusingly original. Landseer was inundated with letters of the following type:

> Lady Oxford is grieved that Mr Landseer cannot undertake to Paint her little
> Daughters at the present moment … if Mr Landseer will allow Lady Oxford to
> bring them to Mr Landseer on Tuesday at half eleven o'clock on their ponies just
> to let Mr Landseer see the Capability of Painting them after they return from the
> Continent …

While Landseer recorded the children of the aristocracy, William Powell Frith, in his *Many Happy Returns of the Day* (Pl. 201), celebrated the pleasures of middle-class family life at a little girl's birthday party. It is believed that Frith used himself, his wife and a daughter as models for the picture, which portrays a family seated round a table for a meal – an enduring symbol of happy domestic life. There is a certain piquancy in this, for Frith ran two separate families who only met at his funeral over his grave. Ruskin with sentimental solicitude commented on the painting: 'One is only sorry to see any fair little child having too many and too kind friends, and in so great danger of being toasted, toyed, and wreathed into selfishness and misery.'

William Collins (1788–1847), father of the novelist Wilkie Collins, was one of the most successful artists specializing in childhood themes. As a boy he had watched George Morland at work, and Collins's own subjects were also taken chiefly from English country life, often combining a landscape setting with an incident involving children. Unlike his contemporary Mulready, however, Collins did not use children as a subject for adult humour, did not laugh at their predicament at arriving late for school, but depicted each subject sympathetically, on its own terms, with no adult condescension. This may perhaps be due to Collins's contact with Coleridge and Wordsworth while staying at Sir George Beaumont's house at Coleorton in 1818, for certainly there is something Wordsworthian about the lyric quality of such a work as *Rustic Civility* (Pl. 202), which also raises social issues that are both complex and thought-provoking. Some barefooted children who have been gathering firewood nervously hold open the gate for a rider of rank whose presence is only indicated by the shadow cast on the ground. The eldest boy timidly 'pulls his forelock' in obeisance to the rider, and thus indirectly to each viewer who stands in front of the picture.

A similar emphasis on child education and good behaviour can be found in the works of William Mulready, a slow-working perfectionist whose oil paintings have a smooth, immaculate surface. Mulready's images of childhood often stress the importance of paternal guidance and good behaviour: *The Lesson* (1859) was exhibited with the subtitle *Just as the twig is bent, the tree's inclined*. A strong moral message is easily discovered in other Mulready works, such as *The Sailing Match – A Woman Urges on an Unwilling Schoolboy* (Pl. 203). This provides a classic example of the early Victorian artist's delight in giving innocuous subjects an inspiring moral flavour. The poor idle boys who attempt to blow their boat along with a roughly improvised roll of paper have sent one of their number to fetch a bellows. An industrious boy of higher social class who would like to join in their game is being 'led from temptation' by his mother or nurse. Such pictorial allegories demonstrate their origins in seventeenth-century Dutch paintings with a moral message.

Several artists utilized the theme of the seductive attractions of food and sweet stalls set up outside school gates or in fairgrounds, while the Scottish artist Alexander Hohenlohe Burr (1835–99) portrayed *The Night Stall* (Pl. 204), which depicts two

201
William Powell Frith
**Many Happy Returns
of the Day**
1856
oil on canvas, 81.5 × 114.5cm
(32 × 45in)
Mercer Gallery, Harrogate

202
William Collins
Rustic Civility
1833
oil on wood, 45 × 60cm
(17¾ × 23⅝in)
Victoria and Albert Museum,
London

203
William Mulready
**The Sailing Match –
A Woman Urges on an
Unwilling Schoolboy**
1836
oil on wood, 35.5 × 32.3cm
(14 × 12¾in)
Victoria and Albert Museum,
London

203

204
Alexander Hohenlohe Burr
The Night Stall
1860
oil on canvas, 52 × 46.9cm
(20¼ × 18½in)
National Gallery of Scotland,
Edinburgh

205
William Frederick
Witherington
The Hop Garland
1834
oil on wood, 44.4 × 34.9cm
(17½ × 13¾in)
Victoria and Albert Museum,
London

206
James Archer
**Summertime,
Gloucestershire**
1860
oil on canvas, 76.4 × 106cm
(30¼ × 41¾in)
National Gallery of Scotland,
Edinburgh

children visiting a food stall at night. The dramatic use of light is calculated to emphasize the novelty of their experience, for children are normally portrayed in reassuring daylight, not by artificial light in the hours of darkness.

Not temptation, but that most innocent pleasure of childhood, gathering flowers, also provided a popular theme. Among the many artists who treated this appealing subject was James Archer (1823–1904), whose *Summertime, Gloucestershire* (Pl. 206) provides a touching glimpse of children making daisy chains on a rural picnic. *The Hop Garland* (Pl. 205) by William Frederick Witherington (1785–1865), while sharing the charm of this theme, also serves as a reminder that hop-picking was, until comparatively recent times, the only summer holiday available to many poor London children who left their homes in the East End to pick hops in the Kent countryside. This subject was also to be treated by Thomas Webster, the leader of the Cranbrook Colony in Kent, whose works closely reflected the ordinary life of the area.

The Cranbrook Colony was a gathering of close friends and relatives who, from the early 1850s, settled in, or near, the village of Cranbrook. Unlike their immediate contemporaries the Pre-Raphaelite Brotherhood, the group had no intellectual plat-

204 *205*

form but shared a mutual interest in the themes of life in the countryside and childhood. Urban critics praised in glowing terms the 'simple rural life' portrayed by the Cranbrook Colony artists, which was tinged with an idealized nostalgia for the supposed certainties of country life. Some critics, such as the writer in *Blackwood's Magazine*, July 1860, became positively dithyrambic in their sentimental and unreal visions of a rural idyll:

> As long as an interesting mother dotes over her lovely infant – as long as the husband is prosperous in his work and happy in his pipe and ale – as long as the sunburnt children … go forth in joyous bands to glean the harvest field – as long as sunshine streams in at the cottage window and content smiles from every face – what cares the painter or the peasant for the politician's suffrage?

Webster had first achieved recognition in the 1820s with paintings of children at play, and for fifty years earned a steady living from such subjects. An unusually sentimental variation on the theme, even for Webster, was the sombre *Sickness and Health* (Pl. 207), in which the sick girl, to whom her brother has been reading, is diverted by watching children dance to the music of an itinerant Italian hurdy-gurdy player.

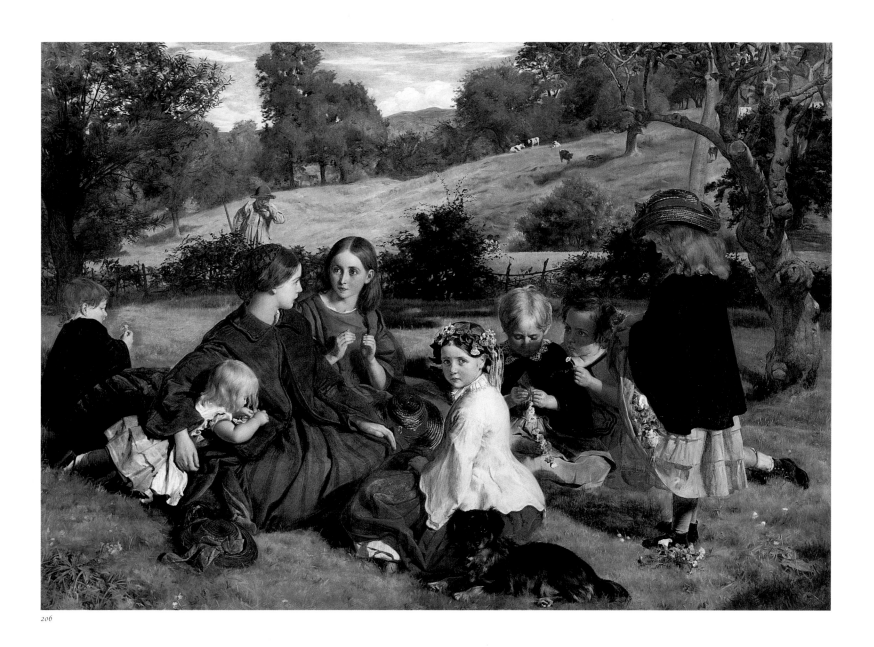

206

207
Thomas Webster
Sickness and Health
1843
oil on wood, 50.7 × 81.2cm
(20 × 32in)
Victoria and Albert Museum,
London

207

This theme of child sickness and death was of particular interest in those days of high infant mortality to a public which wept over such affecting scenes as the slow illness and decline of little Paul Dombey in Dickens's *Dombey and Son* (1848) or the death of Little Nell in *The Old Curiosity Shop* (1841). It will be recalled how Dickens had got behind with the last instalment of the novel and finished writing the scene with Little Nell's death while the tears ran down his cheek and the messenger waited impatiently for the text.

During the 1840s social attitudes towards children and childhood underwent a slow but considerable change. The evils of juvenile crime and child labour in the factories evoked the compassionate sympathy of writers such as Dickens, notably in *Oliver Twist* (1837) and the autobiographical *David Copperfield* (1849–50). Charles Kingsley, in the fairytale fantasy *The Water Babies* (1863), spoke out on the lot of the climbing boys employed by chimney sweeps. Novels of this type helped to create the more compassionate climate that led to the practical legislative measures introduced by Lord Shaftesbury.

208
John Calcott Horsley
**The Contrast:
Youth and Age**
1839
oil on wood, 45.7 × 40.6cm
(18 × 16in)
Victoria and Albert Museum,
London

209
Frederick Daniel Hardy
Playing at Doctors
1863
oil on canvas, 35.3 × 44.8cm
(14 × 17⅝in)
Victoria and Albert Museum,
London

208 *209*

At the other end of the social stage the sadistic cruelty and blinkered inefficiency of the English public school system led to the reform movement inaugurated by Doctor Arnold at Rugby, and chronicled by Thomas Hughes in *Tom Brown's Schooldays* (1857) and Dean Farrar in *Eric, or Little by Little* (1858). The criticism of 'sentimentality' which can be levelled at these literary depictions of childhood is also invariably applied to contemporary paintings of childhood themes. In both cases this criticism is over-simplistic, for it was precisely in their tendency to sentimentalize, or rather to demand the response of compassion, that such works afforded powerful incentives to public humanitarianism.

A much more cheerful treatment of childhood was provided by the work of another member of the Cranbrook group, Frederick Daniel Hardy (1826–1911). Hardy specialized in scenes depicting children engaged in adult activities, with such titles as *The Young Photographers* (1862) – an amusing glimpse of the children of a photographer pretending to take a *carte de visite* likeness. *Playing at Doctors* (Pl. 209), painted the following year, shows a doctor's family imitating their Papa by making up pills,

210
John Everett Millais
My First Sermon
1863
oil on canvas, 92 × 76.8cm
(36¼ × 30¼in)
Guildhall Art Gallery, London

211
John Everett Millais
My Second Sermon
1864
oil on canvas, 97.1 × 71.7cm
(38¼ × 28¼in)
Guildhall Art Gallery, London

212
John Everett Millais
The Boyhood of Raleigh
1870
oil on canvas, 120.5 × 142cm
(47¼ × 56in)
Tate Gallery, London

taking pulses and pounding up drugs in a mortar, while through the open doorway can be seen their mother and grandmother returning to this alarming scene. This painting has achieved a strange fame, being much in demand by pharmaceutical companies as an illustration to warn of the importance of keeping drugs out of the reach of small children. Both works, so full of diverse anecdote, are brilliantly successful in avoiding obvious humour because Hardy firmly and unpretentiously conveys a feeling of actuality, of surroundings which create the illusion of a real place.

John Calcott Horsley (1817–1903), another member of the group, has achieved posthumous fame not as a painter but as designer of the first Christmas card. His early works, for example *The Contrast: Youth and Age* (Pl. 208), have a direct charm which he lost in later elaborate costume pieces. Such a painting shows the full extent to which Mulready's and Webster's artistic preoccupations were shared and developed by their younger contemporaries, and the enthusiasm with which the theme of childhood and age was developed in the early nineteenth century. These contrasted themes also lent themselves to the sequential narrative device provided by the exhibition of paired subjects.

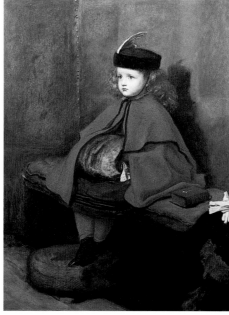 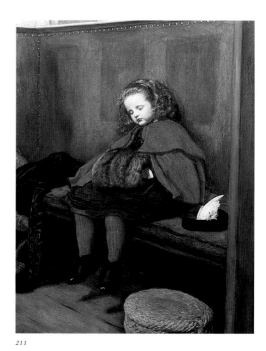

210 *211*

This device was used by Thomas Webster in a pair of paintings entitled *Going to the Fair* and *Returning from the Fair* (1837), which show grandparents being tugged along by eager children to experience all the merry-making, and the children's weary but triumphant return clutching new toys. The 'before' and 'after' formula was a device used frequently by Victorian genre painters, employed again by Webster in two works entitled *The Smile* and *The Frown*, and also by the watercolour painter William Henry Hunt to show subjects as various as the awful effects of smoking – *The First Cigar, the Aspirant* and *The First Cigar, Used Up* – and the sin of gluttony, as in *The Attack* and *The Defeat*, showing a boy eating a huge pie and subsequently suffering from indigestion.

After the intense years of his early Pre-Raphaelite phase John Everett Millais frequently painted childhood scenes, including perhaps the most famous of paired subjects, *My First Sermon* and *My Second Sermon* (Pls. 210, 211), showing a little girl in church, wide awake for her first sermon, but sound asleep for her second. When the second painting was shown at the Royal Academy in 1864, the Archbishop of Canterbury said at the banquet: 'I have learnt a very wholesome lesson ... I see a

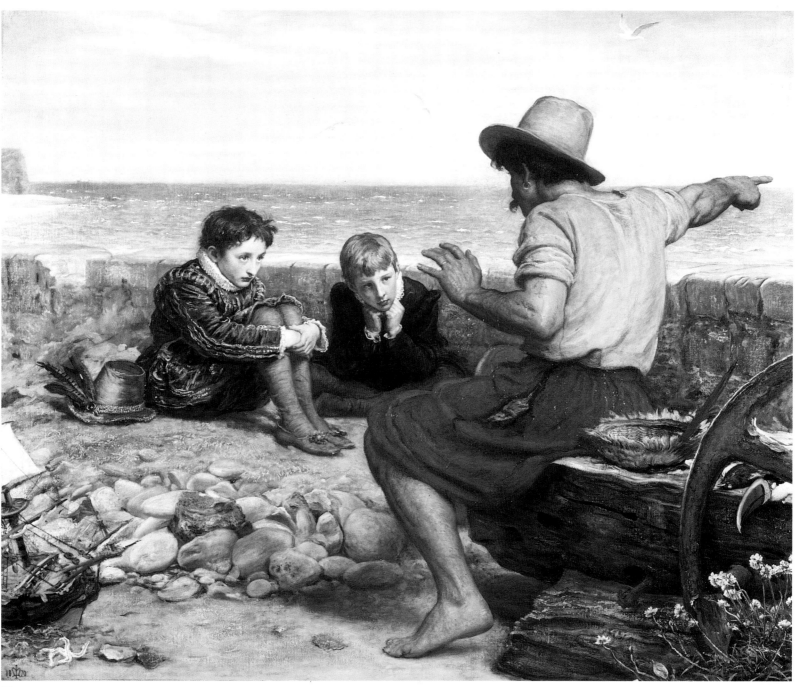

212

213
Charles Robert Leslie
A Garden Scene
1840
oil on canvas, 30.5 × 40.6cm
(12 × 16in)
Victoria and Albert Museum,
London

214
John Everett Millais
Bubbles
1865–6
oil on canvas, 109.2 × 78.7cm
(43 × 31in)
Unilever plc, on loan to the
Royal Academy, London

215
Charles Green
**Her First Bouquet: the
Lane Family with the
Clown George Lupino
at the Britannia Theatre,
Hoxton**
1868
oil on canvas, 54.5 × 79cm
(21½ × 31⅛in)
Private collection

little lady here … who, by the eloquence of her silent slumber, has given us a warning of the evil of lengthy sermons and drowsy discourses.'

A far more enthralled pair of children can be seen in Millais's portrayal of his sons Everett and George, posed as the young Walter Raleigh and Humphrey Gilbert (the colonizer of Newfoundland) in the famous *Boyhood of Raleigh* (Pl. 212). The two young boys listen entranced by the tales of an old sailor who points westward to the new world of the Americas. From such works Millais turned increasingly to fancy subjects in which his debt to the eighteenth century is clear, such as *Cherry Ripe* (1879) and *The Princes in the Towe*r (1878), which with its excess of sentiment really belongs in the present category although it was conceived as a historical painting. But by far the most celebrated work of this type was *Bubbles* (Pl. 214), although there had been earlier versions of the theme, the soap bubble being a widely understood poetic metaphor for the transience of human life.

The model in Millais's painting was his grandson, portrayed at the age of four. His later career in the navy, in which he was to rise to be Admiral, was haunted by the refrain of the popular song, 'I'm for ever Blowing Bubbles'. The look of wonder on the child's face conveys the innocence and charm suggested by the painting's original title, *A Child's World*. It is said that Millais had a sphere of glass specially made for him, in order to study in Pre-Raphaelite detail the colours and reflections of the large bubble. The work became the most famous of all Millais's paintings, attaining notoriety when it was sold to Thomas Barratt, the chairman of Pears Soap, who bought it in 1886 for use in the now famous advertisement. Barratt seems by a legal loophole to have obtained prior permission, much to Millais's real fury, to add a bar of soap to the composition. The painting's use as an advertisement led to great debate on the ethics of art and advertising.

Together with Millais's sentimental *Cherry Ripe*, *Bubbles* enjoyed the distinction of becoming one of the first and most famous successful colour reproductions appearing in the *Graphic* magazine, which from its very first issues featured a coloured wood engraving. The *Graphic*'s first colour plate, included in the special Christmas number for 1869, was entitled *The First Night of a New Pantomime, or Her First Bouquet*, after

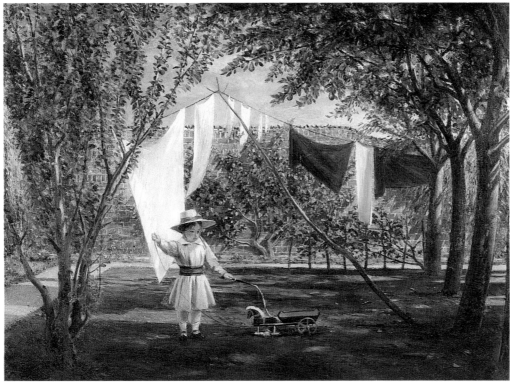

213

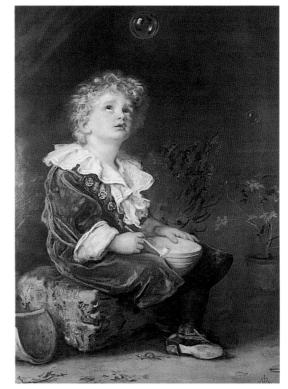

214

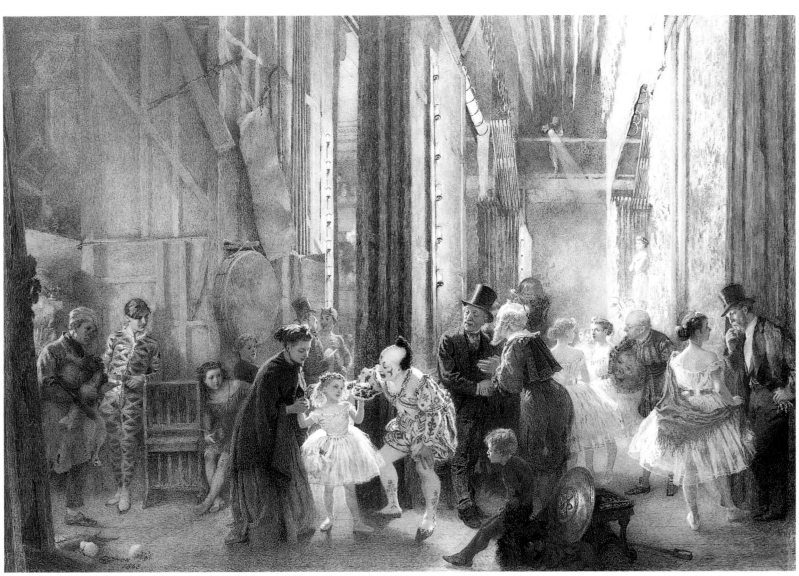

215

216
Ford Madox Brown
The English Boy
1860
oil on canvas, 39.6 × 33.3cm
(15⅝ × 13⅛ in)
Manchester City Art Gallery

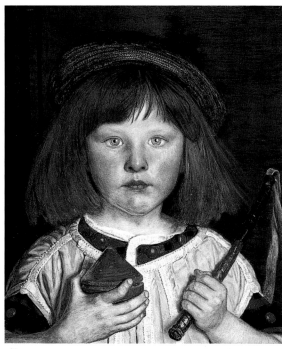

216

a painting by Charles Green (1840–98; Pl. 215). It shows the Lane family with the clown Lupino backstage at the Britannia Theatre, Hoxton, encouraging a nervous little girl dancer. The Britannia was famous for its pantomimes, the children's entertainment then enjoying a golden age. It was a favourite haunt of Charles Dickens, whose story *Choosing a Fairy* reveals the gritty reality of life behind the footlights for the performers playing fairies in the pantomimes, a theme which fascinated him.

One of the attractions of the theme of childhood for young Victorian artists was that their own families provided readily available models in the shape of parents, younger siblings or their own children. The close relationship between sitter and artist ensured the creation of some of the most appealing of all Victorian paintings. Examples include C.R. Leslie's *A Garden Scene* (Pl. 213), a study of the artist's infant son at play with a toy cart in the back garden of his home on the Edgware Road – a delightful evocation of childhood, freshly observed, and not overlaid with any conscious attempt at winsome charm. This quality can also be found in some intimate Pre-Raphaelite paintings, such as Ford Madox Brown's portrayal of his second son Oliver holding his whip and top in *The English Boy* (Pl. 216).

While such works reflect the pleasure we all feel in recording the rapidly changing likenesses of our own children, some very moving works were painted by Victorian artists portraying not their own families but children abandoned by their parents. This choice of subject reflected widespread concern for the plight of homeless and destitute children, for whom the Foundling Hospital was one of the few caring institutions, and almost the only one to support illegitimate children (in 1851 alone over 42,000 illegitimate babies were born in England and Wales). While housed at the Foundling Hospital, girls were tutored in domestic skills to fit them for work as maids and boys apprenticed to a trade or encouraged to join the army as band boys. This famous institution was established in 1739 by Thomas Coram, a sea captain who was appalled on his return to England from the American colonies by the sight of children abandoned and left to die. The original Hospital was built in 1745 in Lamb's Conduit Fields and quickly became patronized by many famous people, notably George Frederick Handel, Thomas Gainsborough and William Hogarth, whose painting of Thomas Coram is one of his finest portraits.

The history painter Edward Matthew Ward had the happy idea in 1863 of depicting *Hogarth's Studio in 1739 – Holiday Visit of Foundlings to View the Portrait of Captain Coram* (Pl. 148), a scene calculated to appeal to lovers of both children and English art. A more sombre note was struck by George Adolphus Storey (1834–1919), a member of the St John's Wood Clique, whose painting *Orphans* (Pl. 217) was described by a reviewer in the *Art Journal* thus: 'Two sweet little girls in deep mourning have been ushered into the apartment which will be their future schoolroom; and three other little orphans, in the asylum dress, look up from the desk and regard them, with feelings of interest and sympathy.' Both artists' works, although successful, do not reflect the first-hand experience and personal involvement which make the works of Emma Brownlow King (1832–1905) so moving. She was the daughter of a man who was admitted as a foundling in 1800 and had risen to become Secretary to the Governors. In her painting *The Foundling Restored to its Mother* (Pl. 218), a mother is united with her child, her fortunes having improved. The original receipt the mother was given for the baby lies on the floor. The successful and versatile painter Sophie Anderson (1823–1903) also tackled the theme of *Foundling Girls in their School Dresses at Prayer in the Chapel* (Pl. 219). The Foundling Hospital itself was demolished in 1926, and its name changed in 1954. Today it is known as the Thomas Coram Foundation for Children and continues to work with deprived and suffering children and young people.

Visual comment upon such moving social issues was not restricted to paintings; many illustrations on these themes appeared in such journals as *Once a Week*, *The Leisure Hour*, *Good Words*, the *Graphic* and many other publications. The most memorable work appeared during the 1860s, which has led to 'the Sixties' being used as a descriptive term for the illustrators of that era, which saw many significant contributions to wood-engraved magazine illustration. One of the finest of the illustrators was the short-lived Arthur Boyd Houghton, one of the most gifted draughtsmen of his time. Like his friend the *Punch* artist George Du Maurier, Houghton had early in life sustained the loss

217
George Adolphus Storey
Orphans
1879
oil on canvas, 104 × 149.7cm
(41 × 59in)
Forbes Magazine Collection,
New York

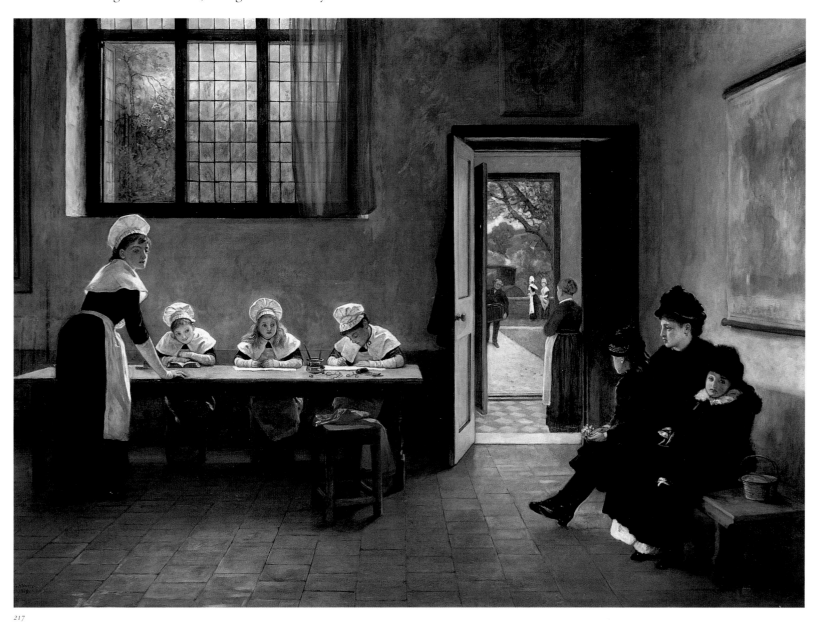

217

of an eye. This did not prevent him from excelling at the close work of wood engraving, but did restrict his paintings to a relatively small and intimate scale; a number of these jewel-like pictures are of children. These small informal works, prompted by vivid memories of his own happy childhood, do not always have fixed titles so exact dating is not easy. Among the scenes he painted were *Interior with Children at Play* (Pl. 220), and several small works of the early 1860s which chart the pleasures of a day at the seaside, at Ramsgate Sands, Broadstairs or Brighton.

218
Emma Brownlow King
**The Foundling Restored
to its Mother**
1858
oil on canvas, 76.2 × 101.6cm
(30 × 40in)
Thomas Coram Foundation
for Children, London

219
Sophie Anderson
**Foundling Girls in their
School Dresses at Prayer
in the Chapel**
c.1877
oil on canvas, 67.3 × 53.5cm
(26¼ × 21in)
Thomas Coram Foundation
for Children, London

220
Arthur Boyd Houghton
**Interior with Children
at Play**
c.1860
oil on canvas, 25 × 20cm
(9⅞ × 7⅞in)
Ashmolean Museum, Oxford

221
Myles Birket Foster
**Children Running down
a Hill**
c.1880
watercolour, 33.6 × 70cm
(13¼ × 27⅝in)
Victoria and Albert Museum,
London

222
John Morgan
**A Winter Landscape with
Boys Snowballing**
1865
oil on canvas, 61 × 130.7cm
(24 × 51½in)
Victoria and Albert Museum,
London

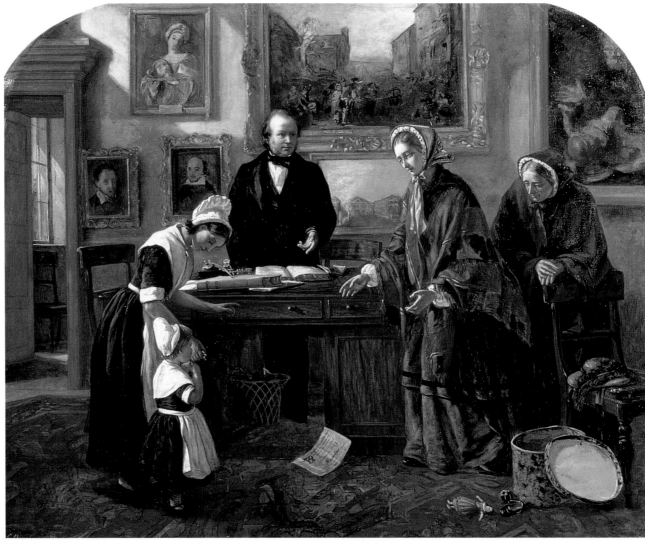

218

219

220

221

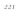

222

223
Augustus Edwin Mulready
**Remembering Joys
that are Passed Away**
1873
oil on canvas, 39.4 × 52.1cm
(15½ × 20½in)
Guildhall Art Gallery, London

224
Janet Archer
Girls Skipping
1883
oil on canvas, 51.3 × 48cm
(20¼ × 18⅞in)
Geffrye Museum, London

225
John Singer Sargent
Carnation, Lily, Lily, Rose
1885–6
oil on canvas, 174 × 153.7cm
(68½ × 60½in)
Tate Gallery, London

The theme of children at the seaside, first popularized by Frith's *Ramsgate Sands* (Pl. 317), became extremely popular in the 1860s, a notable example being a collaboration between William H. Hopkins and Edmund Havell Junior, who portrayed the pleasures of donkey and goat rides in *Weston Sands in 1864* (Pl. 319). Another Victorian artist fond of depicting children at play, either on the beach or elsewhere, was the watercolour painter Myles Birket Foster. Mere verbal descriptions of his works can make them seem cloying or mawkish, but on the whole Foster happily evaded the pitfalls of sentimentality. He is seen at his best in *Children Running down a Hill* (Pl. 221), which captures delightfully the freedom of rural childhood.

The more robust pastimes of winter are portrayed in *A Winter Landscape with Boys Snowballing* (Pl. 222) by John Morgan (1822–85), which recalls the outdoor pursuits seen elsewhere in *A Winter's Day in St James's Park* by John Ritchie (Pl. 324). Street urchins were also to provide the life-long theme of Augustus Edwin Mulready (1843–1904). At his best, as in his painting *Remembering Joys that are Passed Away* (Pl. 223), Mulready echoes Dickens's belief in the necessity of popular entertainment for the working class. As the Victorian era drew to an end there was no diminution in the number of artists who practised the painting of children as a lucrative and popu-

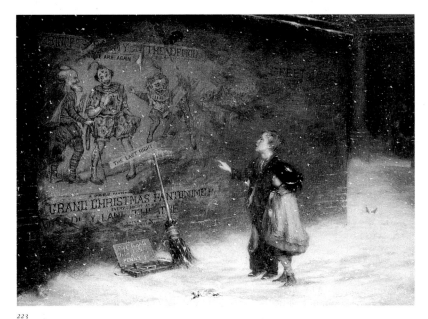

223

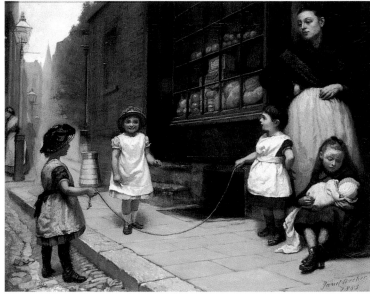

224

lar genre. The pastimes of street children were a popular artistic theme, to be seen in the painting of 1883 by Janet Archer (*fl.*1873–93) of street urchins playing with a skipping rope (Pl. 224), a work which could illustrate the early chapters of Charlie Chaplin's autobiography (1964), with its vivid account of growing up on the streets in the London of the 1890s.

Depictions of animated family groups, often accompanied by favourite pets, are now restricted to the decent obscurity of the family snapshot album kept secret from prying eyes. The Victorians were not so fortunate and many works reproduced here may strike us today as mawkish, their themes banal, and the historical re-creations wildly anachronistic. Late twentieth-century taste finds more acceptable depictions of children by artists who adopted the Impressionist *plein-air* techniques brought from France to England by John Singer Sargent. He used these methods to great effect when painting his most loved picture, *Carnation, Lily, Lily, Rose* (Pl. 225). An account of its creation provides a revealing glimpse of the artist's methods. In 1885, Sargent visited picturesque Broadway in Worcestershire, a favourite resort for artists, where he stayed with friends with young families. He had already painted a *Garden Study of the*

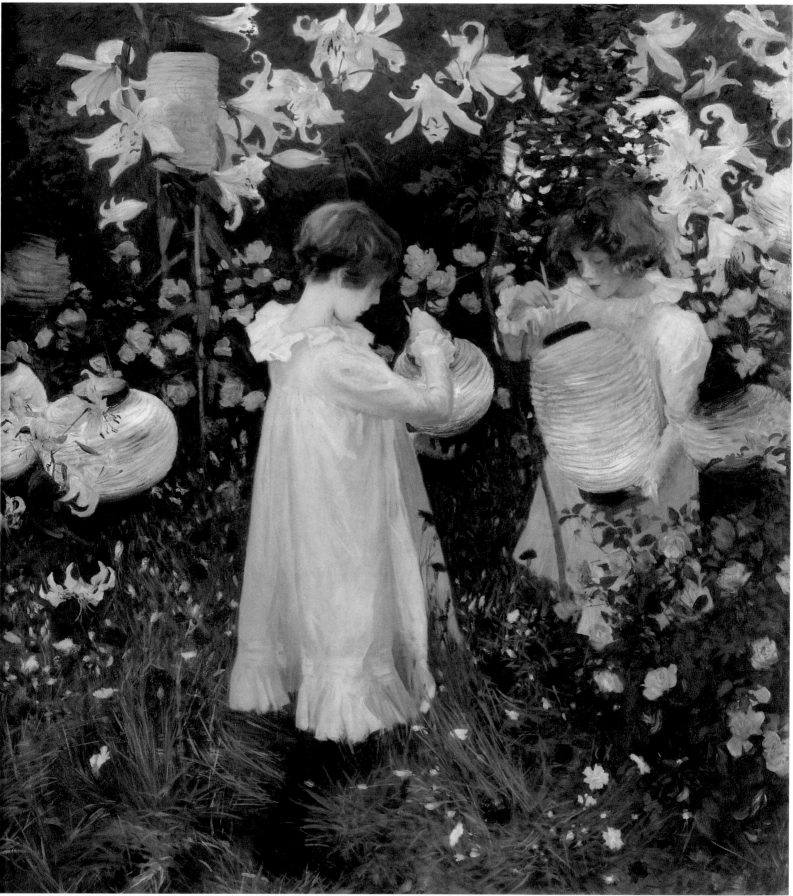

225

226
John Singer Sargent
**Garden Study of
the Vickers Children**
c.1884
oil on canvas, 137.5 × 91cm
(54¼ × 35⅞in)
Flint Institute of Arts, Michigan

227
Thomas Cooper Gotch
The Child Enthroned
1894
oil on canvas, 159 × 102cm
(62½ × 40in)
Private collection

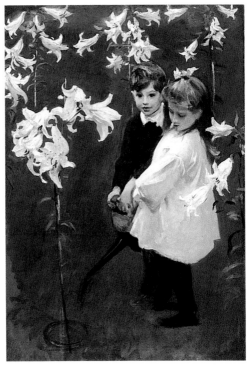

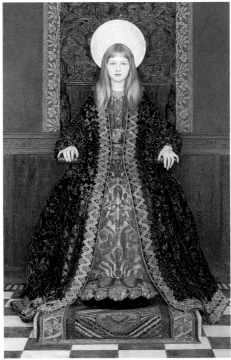

226

227

Vickers Children (Pl. 226), in which tall lilies in pots tower above two children struggling to pour heavy watering cans. In Broadway in late August he began to paint the two daughters of his friend the artist Frederick Barnard in a setting which he described in a letter of 10 September 1885: 'I am trying to paint a charming thing I saw the other evening. Two little girls in a garden at dusk lighting paper lanterns hung among the flowers from rose-tree to rose-tree. I shall be a long time about it if I don't give up in despair …' During September Sargent painted the subject at the same moment each evening. But as the temperature dropped and the sittings continued, the models Dorothy and Polly Barnard donned vests and pullovers for warmth. The writer Edmund Gosse recalled how all that summer and the next, Sargent laboured on the painting: 'we began our daily afternoon lawn tennis, in which Sargent took his share. But at the exact moment, which of course came a minute or two earlier each evening, the game was stopped, and the painter … ran forward over the lawn with the action of a wagtail, planting at the same time rapid dabs of paint on the picture …'

Sargent came to find the work irritating, sharing the view of the witticism attributed to Whistler, that the title should have been *Damnation, Silly, Silly Pose*. But the picture was a great success when it was exhibited at the Royal Academy in 1887. If this was Impressionism, it was felt, it was at least more cheerful than images of the hard-working poor.

Philip Wilson Steer (1860–1942) was also to employ Impressionist directness in his paintings of children happily playing knucklebones on the shingle beach at Walberswick in Suffolk (Pl. 228), or paddling on the sands at Calais, which similarly evoke a refreshing sense of freedom. They were created with no didactic purpose and carry no moral imperatives. George Moore, the novelist and Impressionist champion, described them as 'flowers … conscious only of the benedictive influences of sand and sea and sky', while Sickert wrote: 'these paintings make you feel that sunshine and wind and youth are glorious things.' He also praised Steer's 'natural and spontaneous grouping of the children', and the way in which they seem to be 'playing amongst themselves without a trace of self-consciousness', a quality also found in depictions of childhood by great Impressionist artists such as Renoir and Mary Cassatt.

The pleasures of the seaside and 'messing about in boats' free inhibitions and present the artist with unlimited opportunities for attractive compositions. Among many painters to take up such themes, few were as successful as the young Alfred Munnings (1878–1959), later to become a controversial President of the Royal Academy, who scored his first success on that institution's walls with his painting of two children in a rowing dinghy entitled *Stranded* (Pl. 612).

A very different image of childhood emerges from the work of Thomas Cooper Gotch (1854–1913), who began his career at Newlyn in 1887, painting realist works. This changed after he visited Florence in 1891–2 and developed a deep admiration for Italian *cinquecento* art, which shows itself in works glorifying the innocence and

228
Philip Wilson Steer
**Children Paddling,
Walberswick**
1894
oil on canvas, 64.2 × 92.4cm
(25¼ × 36¾ in)
Fitzwilliam Museum,
Cambridge

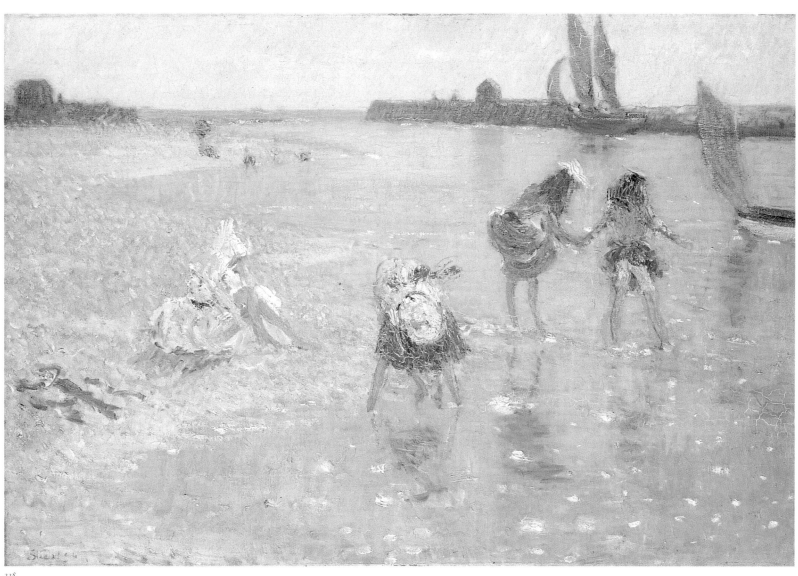

228

purity of youth such as *The Child Enthroned* (Pl. 227). The artist's daughter Hester was the model, and she regards the viewer with grave directness, an innocent child in an adult world. By happy coincidence the work was created the same year that the 'Children's Charter' introduced important new legislation for the protection of the young.

In the twentieth century new art theoreticians emerged who expressed an admiration for the art produced by children themselves, a process which was to dramatically affect the future direction of painting. Childhood itself became increasingly chronicled by the camera.

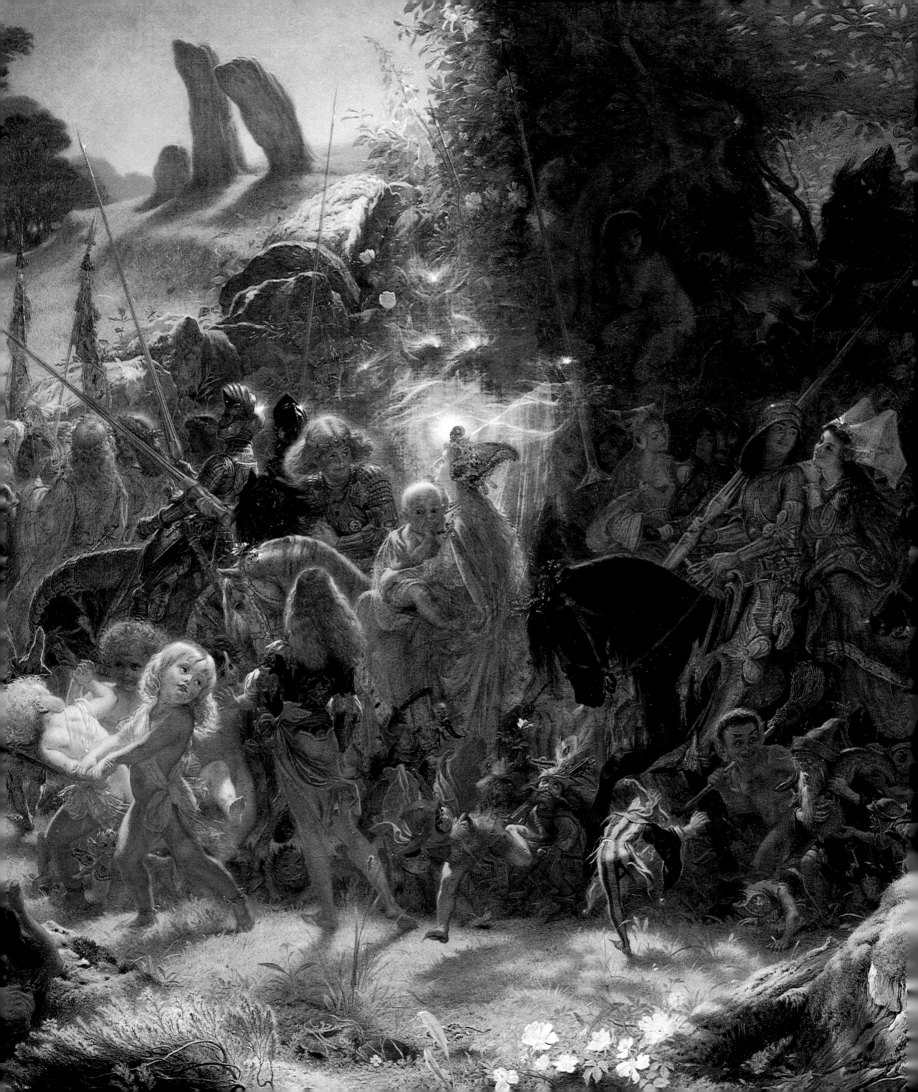

Today we associate the word 'glamour' particularly with Tinseltown – the 'dream factory' of Hollywood. There in the twentieth century movies have been made which have helped the public escape from the harsh realities of world wars and depressions. But the word 'glamour' has a much older and stranger pedigree. It comes from the widespread folk-tale of the fairy midwife which in essentials is always the same story. A human midwife is summoned in the middle of the night by mysterious figures to deliver a baby. Before she enters the house to which she is taken she is told to smear an ointment on her eyes. When she crosses the threshold, the house looks like a palace. Having safely delivered the child, she accidentally rubs one eye with a sleeve, and now sees that the palace is a hovel, and the people fairies. The ointment was fairy 'glamour', a magic potion. The fairy midwife legend is mentioned in a passage by

Shakespeare, whose plays provide the prime cause in making minute stature a prerequisite for a passport into fairyland. Mercutio's speech in *Romeo and Juliet* describing Queen Mab gives this sense of scale potent verbal expression:

> She is the fairies' midwife, and she comes
> In shape no bigger than an agate stone
> On the fore-finger of an alderman,
> … Her whip, of cricket's bone; the lash, of film;
> Her waggoner, a small grey-coated gnat,
> … Her chariot is an empty hazel nut …

These lines not only inspired Hector Berlioz to compose a magical *scherzo*, but also created a touchstone for the minuscule which was to inspire many fairy painters. Their concept of minute life was also derived from other sources, such as Jonathan Swift's Lilliput in *Gulliver's Travels*, and the sense of wonder reflected in William Blake's line, 'To see eternity in a grain of sand', and in his own watercolour depicting fairy revels at Oberon's court.

In the early Victorian era new discoveries about nature were made possible by the microscope and the camera lens which created a delight in minute details. This was, of course, reflected in the work of the Pre-Raphaelite painters and other masters of obsessive detail, like Ruskin's watercolour teacher William Henry 'Bird's Nest' Hunt (Pl. 129). But these artists celebrated the real world. Why was there also a desire to celebrate the imaginary world of fairyland?

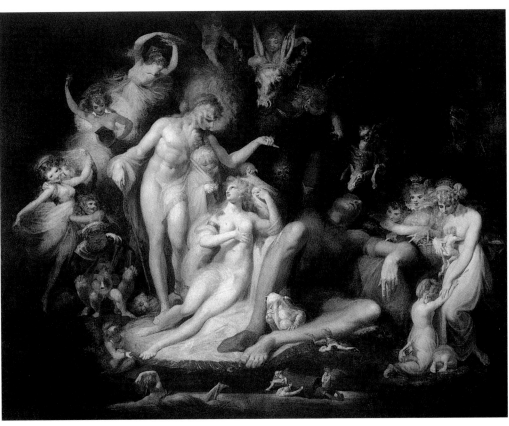

230

Fairies had featured prominently in the great pictorial celebration of the theatre, the Shakespeare Gallery, established by John Boydell (1719–1804). Boydell, an entrepreneur of great vision, was a successful engraver and print publisher, and an Alderman of the City of London, becoming Lord Mayor in 1790, the year after the Shakespeare Gallery opened in Pall Mall. From 1786 he commissioned works from such major artists as Reynolds, Romney and Fuseli, resulting in a total of 162 oil paintings, all of incidents in Shakespeare's plays. Boydell idealistically hoped by this venture to encourage the rise of 'a great national school of History Painting', and pragmatically to make a profit on the sale of engravings after the paintings. Among the most successful works commissioned by Boydell were two paintings by Henry Fuseli (1741–1825) illustrating *A Midsummer Night's Dream*. One of these, *Titania's Awakening* (Pl. 230), takes us into an erotic dream-like realm where Titania emerges from her infatuation with Bottom as an ass.

The plays of Shakespeare not only influenced fairy painting, but also, via the superb translations of August Wilhelm von Schlegel (1767–1845), contributed to the dawn of the Romantic movement in Germany. During the Romantic era interest was aroused in folk stories and legends throughout Europe, and these were recorded and published by figures such as Sir Walter Scott, in his *Minstrelsy of the Scottish Borders*, published in 1802–3, and the famous Brothers Grimm, whose *Kinder- und*

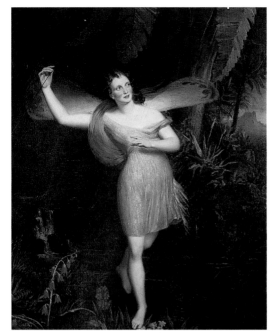

231

232

231
Alfred Edouard Chalon
**Standing on the Window
Ledge, La Sylphide Mourns
James's Betrothal to his
Childhood Sweetheart, Effie
(Act I)**
1845
watercolour, 40.6 × 27.9cm
(16 × 11in)
Private collection

232
Daniel Maclise
Priscilla Horton as Ariel
1838
oil on wood, 63.5 × 50.8cm
(25 × 20in)
Royal Shakespeare Company

Hausmärchen (1812–15) was published in England in 1823. Both the Grimm Brothers'
stories and Thomas Keightley's *Fairy Mythology* (1828) were illustrated by George
Cruikshank with remarkable etchings offering an ant's-eye view of frenzied fairy rev-
els. These plates, which Ruskin thought the best etchings since Rembrandt, brought
Cruikshank recognition as the leading exponent of fairy art in Europe, rivalling illus-
trators such as Moritz Retzsch (1779–1857), Moritz von Schwindt (1804–71) and
Ludwig Richter (1803–84), creators of works which abound with writhing, thorny
foliage and grotesque sprites and elves.

These stories and illustrations helped to create a never-never land, an area which,
as the poet Gautier observed to Heinrich Heine, might be said to resemble 'one of
the Bohemian sea-ports that Shakespeare loved', not to mention the brave new
world of Prospero's island. From this fertile soil were to spring the new sensual fairy
themes that emerged in the international Romantic ballet which became widely pop-
ular between the late 1820s and 1850s throughout Europe, from London and Paris in
the west to Moscow in the east. As a child, Queen Victoria was a tremendous fan of
the ballerina Maria Taglioni (1804–86), dressing several wooden dolls in costumes
recording her most famous roles, and making some creditable drawings of the great
dancer.

It was Taglioni who brought the technique of dancing 'on point' to effortless
perfection, and in so doing created an image of aerial weightlessness reflected in lith-
ographs by artists such as John Brandard (1812–63) and Alfred Edouard Chalon.
Chalon's haunting watercolour for the series of six lithographs recording the ballet
La Sylphide captures the moment when *Standing on the Window Ledge, La Sylphide
Mourns James's Betrothal to his Childhood Sweetheart, Effie (Act I)* (Pl. 231). These lith-
ographic images of the dancers of the 1840s, the 'pin-ups' of their day, capture the
delicate butterflies, the naiads, sylphs and faeries of the Romantic ballet, works which
are echoed in the fairies dancing in the borders created by Richard Doyle in the
1840s for the new satirical magazine *Punch*. Daniel Maclise may also have been
influenced by contemporary ballet prints when he portrayed the charms of Miss
Priscilla Horton (1818–95) and her fairy wand as she played Ariel in a revival by
William Macready of *The Tempest* on 13 October 1838 at Covent Garden (Pl. 232).
The part of Ariel in nineteenth-century productions of *The Tempest* was invariably

233
Francis Danby
**A Midsummer Night's
Dream**
1832
watercolour, 19.7 × 27.9cm
(7¾ × 11in)
Oldham Art Gallery

234
David Scott
**Puck Fleeing before the
Dawn**
1837
oil on canvas, 95.3 × 146cm
(37½ × 57½in)
National Gallery of Scotland,
Edinburgh

235
Daniel Maclise
**Undine and the Wood
Demon**
1843
oil on canvas, 44.5 × 61cm
(17½ × 24in)
Royal Collection

236
Robert Huskisson
**The Midsummer Night's
Fairies**
1847
oil on wood, 28.9 × 34.3cm
(11⅜ × 13½in)
Tate Gallery, London

played by a pretty young lady. Maclise's canvas is representative of many paintings of Ariel which featured in Royal Academy exhibitions from the 1840s to the 1870s, saved from indecorum by the pretence that the women depicted were not scantily dressed *real* women but innocuous fairies, tastefully 'veiled' in the trappings of allegory or myth.

Taglioni held the stage in the ballet *La Sylphide* until her retirement in 1847, but in 1843 London was enchanted by another great dancer, Fanny Cerrito, appearing in the title role of another famous ballet with a fairy theme, *Ondine*, based on Friedrich Heinrich Karl de la Motte Fouqué's *Undine*, the German Romantic classic which first appeared in 1811. The story inspired Maclise's *Undine and the Wood Demon* (Pl. 235), painted in 1843 and exhibited at the Royal Academy the following year, when it was bought by the Queen as a birthday present for the Prince Consort. Maclise came from Cork, where a rewarding early project was illustrating in 1826 the antiquarian Crofton Croker's pioneering *Fairy Legends and Traditions of the South of Ireland*.

This was the background which led to the appearance of so many paintings with fairy themes at the Royal Academy and elsewhere from the 1830s until the 1870s. Some interesting examples include Francis Danby's watercolour of *A Midsummer Night's Dream* (Pl. 233) and *Puck Fleeing before the Dawn* (Pl. 234) by David Scott (1806–49).

Little is known of Robert Huskisson (1819–61), who moved to London from his native town Nottingham in 1839, and introduced a novel compositional device, the main subjects being 'framed' by an elaborate proscenium arch decorated with classical figures which owe something to the nude studies of William Etty. In *The Midsummer Night's Fairies* (Pl. 236) a nude Titania slumbers unaware of Oberon standing over her, while a snail fights with miniature attendants. Even more voluptuous depictions of *Titania* in erotic poses – tastefully draped in muslin – were created by John Simmons (1823–76; Pl. 239). Such works were more than a little reminiscent of the louche *pose plastique* shows which made the racy Victorian gentleman's pulse race. Suggestive poses of this type lingered on until the days of the Windmill Theatre in the Second World War when nudes were allowed provided they never moved.

One of the most surprising patrons of fairy paintings was the renowned engineer Isambard Kingdom Brunel, who commissioned a set of Shakespearean subjects to decorate his dining room. On 14 December 1847 Landseer accepted an invitation to discuss the project over dinner with the other participants, the landscape painters Sir Augustus Wall Calcott, Thomas Creswick, David Roberts and Clarkson Stanfield, and the genre and literary painters Charles West Cope, Augustus Leopold Egg,

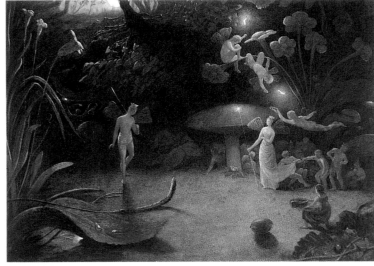

233

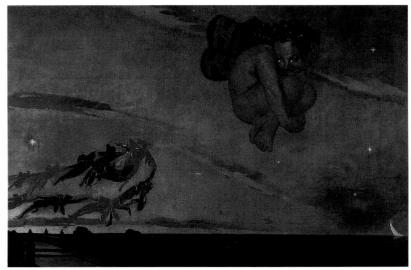

234

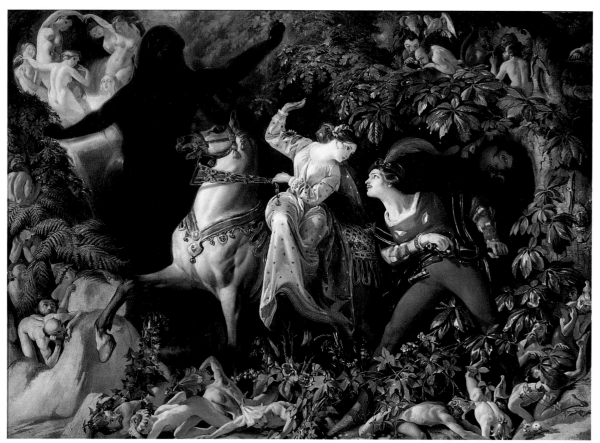

235

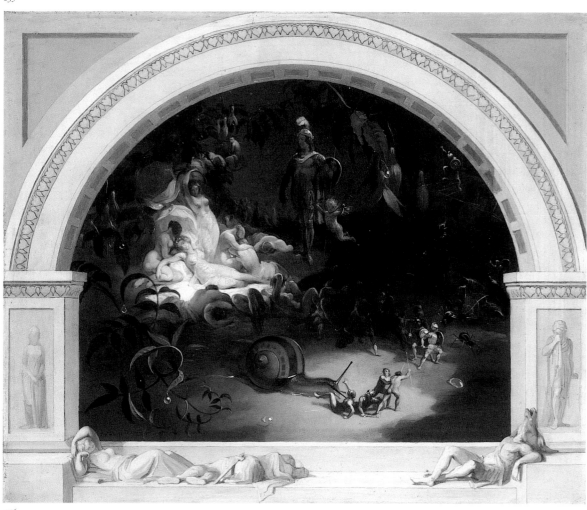

236

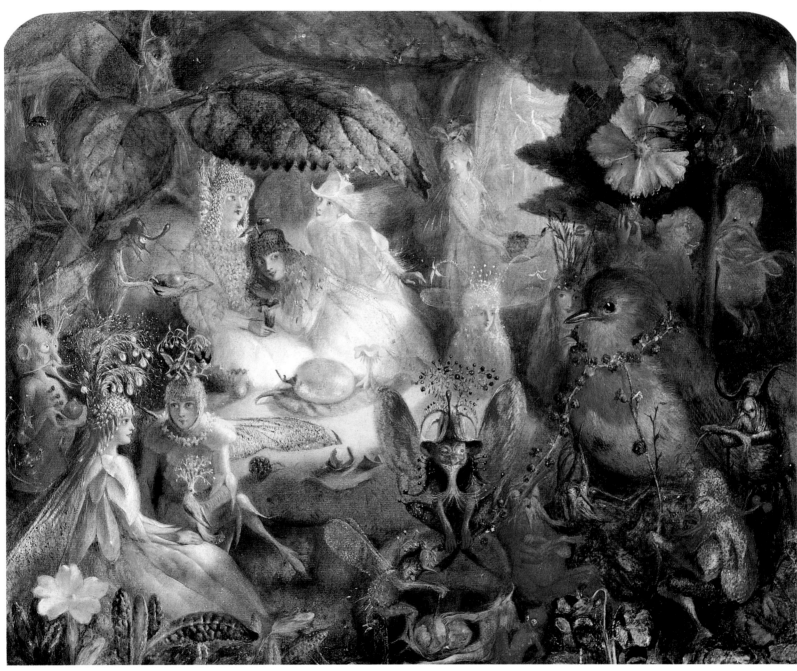

237

Charles Robert Leslie and Daniel Maclise. Brunel left the choice of individual subjects to the artists, stipulating only that they should either be scenes on stage or images suggested by the language from the more popular plays of Shakespeare.

Although David Roberts selected the supernatural theme of Macbeth and the witches, Landseer was the only artist to seize upon the opportunity to create a fairy painting. He chose a subject which provided him with an ideal opportunity to display his remarkable anthropomorphic skills on a fairy subject with obsessive detail and exotic fantasy. His picture illustrates Act III, Scene i of *A Midsummer Night's Dream* (Pl. 238). The fairies enter from the right, two of them mounted on white hares. Titania, bewitched by the magic potion, awakes to fall in love with Bottom the weaver transformed by an ass's head:

> And I do love thee: therefore, go with me;
> I'll give thee fairies to attend on thee,
> And they shall fetch thee jewels from the deep,
> And sing, while thou on pressed flowers dost sleep:
> And I will purge thy mortal grossness so

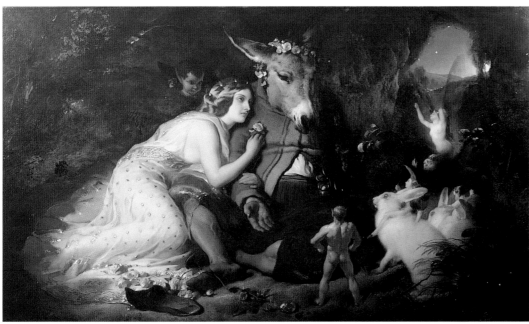

238

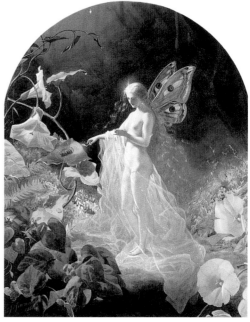

239

> That thou shalt like an airy spirit go.
> Peaseblossom! Cobweb! Moth! And Mustard-seed!

Landseer was said to have received 400 guineas for the painting, which Queen Victoria thought 'a gem, beautifully fairy-like and graceful'.

John Anster Fitzgerald avoided the oft-depicted fantasies of Shakespeare to create his own unique fairy world. In this he proved alarmingly successful, notably in his numerous variations on the theme of the Death of Cock Robin (Pl. 237). Fitzgerald seems to have spent much of his time working behind the scenes at the theatre, for he produced a number of illustrations of pantomimes for special numbers of the *Illustrated London News* in the 1850s and 1860s, some of which are elaborate double-page spreads. His regular contact with the limelights appears to have affected his works, which are painted with brilliant intensity in vivid colours and dramatic *chiaroscuro*.

There is something rather terrifying about Fitzgerald's most memorable paintings, which can at times be uncannily reminiscent of the works of Pieter Brueghel and Hieronymus Bosch, who also delighted in the depiction of the robbery of birds'

240
John Fitzgerald
Fairies in a Bird's Nest
*c.*1860
oil on canvas, 24.5 × 30.5cm
(9½ × 12in)
Private collection

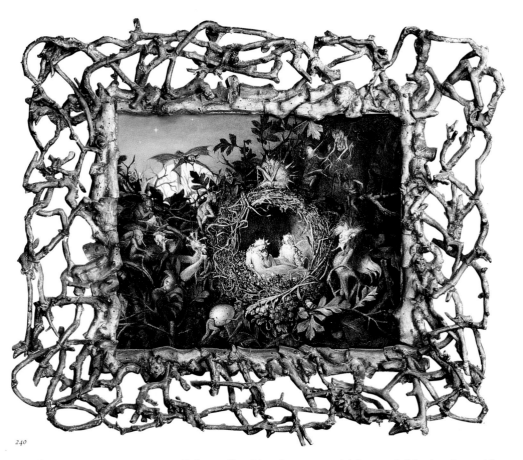

240

eggs by grotesque monsters. Prints after Bosch were widely available in the mid-nineteenth century and are known to have been collected by artists. Fitzgerald's *Fairies in a Bird's Nest* (Pl. 240), which is shown in a most unusual frame made of twigs, portrays many weird, Bosch-like mini-monsters.

Fitzgerald was a loner, one of those Victorian gentleman whose main domicile was their club, in his case the Savage Club. Other members remembered him after his death only for his imitations of long-dead actors such as Kemble, Kean and Macready, which makes him sound like the club bore. His commitment to fairy painting led to him being known as 'Fairy Fitzgerald', although one feels he would have disagreed with his life being described, as an obituary put it, as 'one long "Midsummer Night's Dream"'. He exhibited no fewer than 196 works at the Royal Academy and the British Institution over the years, often with allusive and narcotic titles, such as *The Pipe Dream*, *The Stuff that Dreams are Made of* or *The Captive Dreamer*. Such titles suggest that, like Charles Dickens's fictional character Edwin Drood, Fitzgerald was familiar with the opium dens which, with chloral and laudanum, represented the Victorian drug scene.

The public has always been fascinated by the concept of the mad artist, a creative genius in an alien world, a prey to hallucinations which his works reveal to us as visions from another world. The tragic Richard Dadd (1817–86) was just such a figure. As a young man he was a member of 'The Clique', an informal group of artists who came together in the year of Queen Victoria's accession, 1837. Other members included William Powell Frith, Henry O'Neil, Augustus Leopold Egg, John Phillip (1817–67), Edward Matthew Ward, Alfred Elmore and Thomas Joy (1812–66). It was essentially a sketching society for students, since Dadd, Phillip and Frith were all pupils of the Royal Academy Schools.

The young artists met weekly at Dadd's rooms, where they spent an hour or two sketching subjects drawn in the main from Shakespeare or Byron, after which one of

the guests would choose the best drawing. Dadd, generally acknowledged to be the finest draughtsman, often undertook character portraits of members of the group. The evenings ended with a light supper of bread, cheese and beer. At one of their meetings, they mapped out their futures, as young men will: 'Frith said he intended to paint pictures of ordinary life, such as would take with the public. O'Neil determined on painting incidents of striking character, appealing to the feelings, and Phillip desired to illustrate incidents in the lives of famous persons. Dadd proposed to devote himself to works of the imagination.' In this ambition he was to succeed beyond his wildest dreams.

Dadd was born in 1817 at Chatham in Kent where his father was a chemist. When in 1837 he entered the Royal Academy Schools, with a recommendation from Clarkson Stansfield, his father moved to London to provide him with a home. Dadd exhibited portraits and landscapes at the Academy and elsewhere until 1841, when he gained a major commission to paint a large number of panels for a nobleman's house in Grosvenor Square, some of the subjects being drawn from Byron's *Manfred*. The only known account of them describes how 'the Alpine mist or smoke about Manfred's head [was] … composed of minute figures of men and women, explained by Dadd to be ideas formed and unformed, as their outlines were distinct or indistinct'. At the summer exhibition of the Royal Academy that year Dadd exhibited one of his first important fairy paintings, *Come unto these Yellow Sands* (Pl. 241), with the lines from Ariel's song in *The Tempest*:

> Come unto these yellow sands
> And then take hands
> … Foot it featly here and there,
> And, sweet sprites, the burden bear.

Dadd's paintings of fairies before the onset of his insanity have a lightness and ethereal sense of freedom, quite different from the intensely detailed and elaborately wrought delicacy of the later paintings.

In July 1842, recommended by David Roberts, Dadd accompanied Sir Thomas Phillips on an expedition to Egypt and Asia Minor. He painted many vivid watercolours of picturesque views but gradually, after a bad sun-stroke at Thebes, became

241
Richard Dadd
Come unto these Yellow Sands
1841
oil on canvas, 57 × 78.6cm
(22½ × 31in)
Private collection

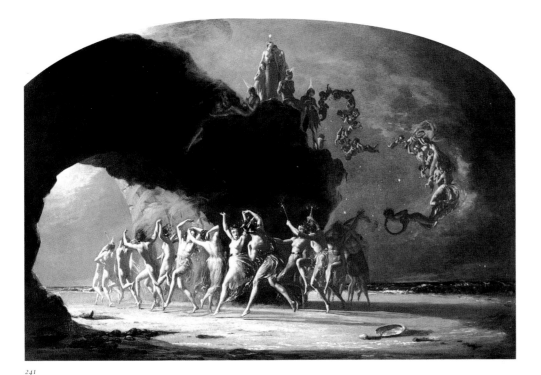

241

242
Richard Dadd
**Contradiction: Oberon
and Titania**
1854–8
oil on canvas, 61 × 75cm
(24 × 29½in)
Private collection

243
Richard Dadd
**The Fairy Feller's
Master-Stroke**
1855–64
oil on canvas, 54 × 39.4 cm
(21¼ × 15½in)
Tate Gallery, London

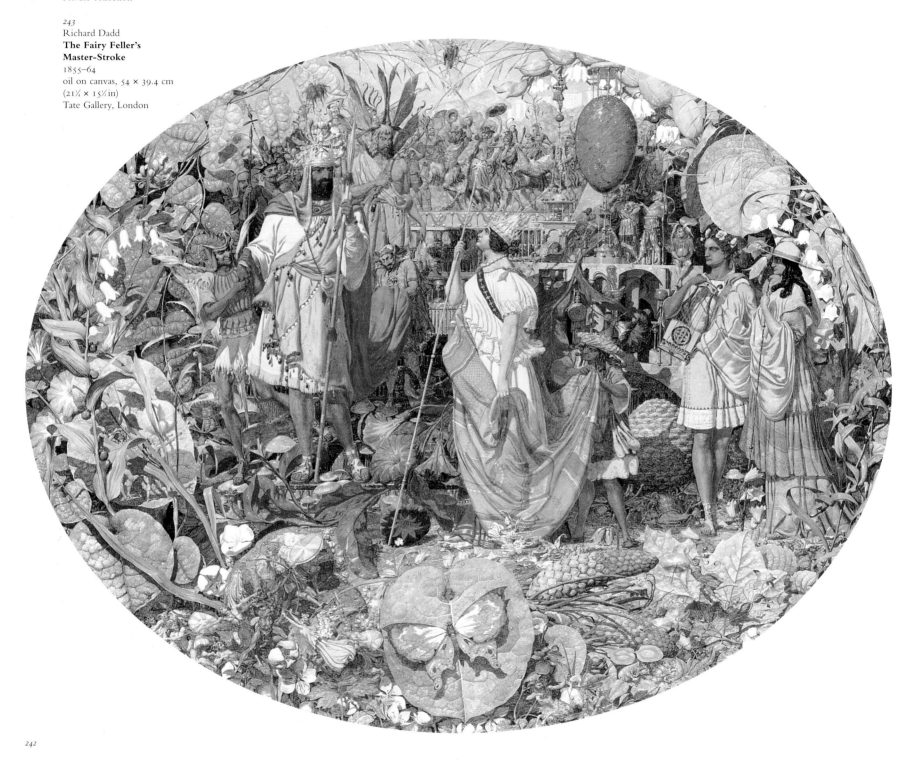

242

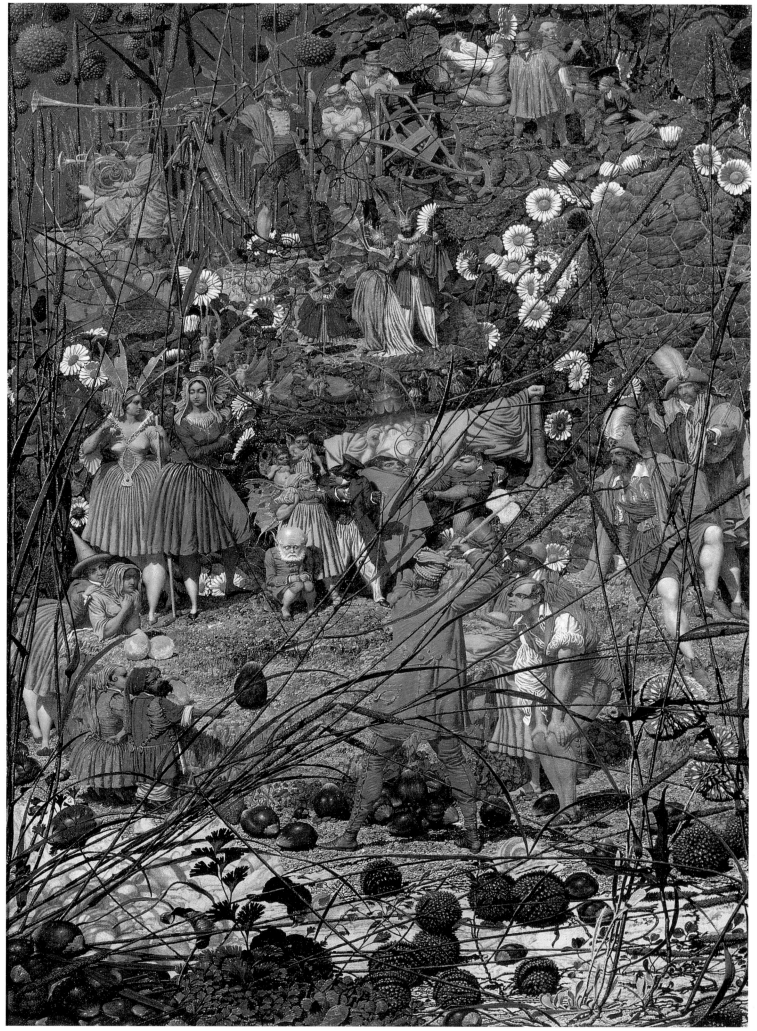

more and more disturbed. It now seems likely, however, that this was only a contributory factor to his condition, which we would today describe as paranoid schizophrenia. On the return journey the party visited Rome, where Dadd felt a strong inclination to attack the Pope 'in a public place', but 'overcame the desire' as the Pontiff was so well protected. In Paris, rather than see a doctor he fled back to London, where he arrived in April 1843 in time to submit a cartoon for Westminster of St George after the death of the dragon which, according to Frith, had an inordinately long tail. Stress and turmoil continued to assail him, and he became convinced that he was constantly being watched, a classic symptom of a persecution complex. His dementia grew until at the end of August he purchased a new cut-throat razor, which he used to kill his devoted father in Cobham Park.

Dadd fled to France, but was detained in Paris after trying to kill a fellow passenger on a coach, who was, he said, possessed by a devil. He remained in France for ten months before being returned to London, where he admitted his crime, claiming to be descended from the Egyptian god Osiris who had ordered him to kill his father who was possessed by the devil. On 22 August 1844 he was admitted to Bethlem Hospital, aged 27. Amazingly, most of his best work would be painted in the next forty-two years, at first at Bethlem and later at Broadmoor. From an early date he seems to have been given access to both watercolours and oils. He used the watercolours to paint a long series of works dealing with various human passions, and the oils to create his two masterpieces, *Contradiction: Oberon and Titania* (Pl. 242), the labour of four years from 1854 to 1858, and *The Fairy Feller's Master-Stroke* (Pl. 243), on which he worked from 1857 to 1864.

In *The Fairy Feller* our first visual impression of the work is akin to the sense of wonder when we lift a flagstone and stare down at the myriad activities of the insect world concealed underneath. Long grasses slant from side to side across the picture's surface, carpeted with hare bells, convolvulus, hazel-nuts and daisies, and a butterfly rests on a leaf. The fairy feller himself stands at the bottom right of the picture, with his primitive stone axe poised to split a nut to form a new chariot for Queen Mab. The complex cast of dwarves, fairies and figures, drawn from Dadd's watercolour works called *The Passions*, all stand motionless awaiting the fall of the axe, a complete world frozen in suspense.

Dadd wrote a long commentary to accompany the painting, entitled *An*

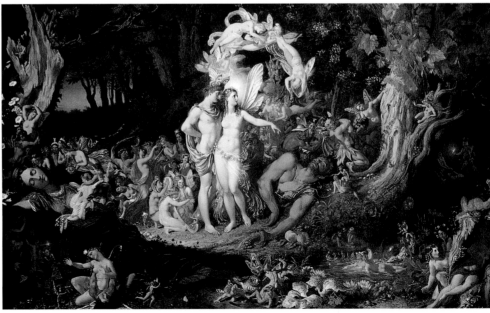

244

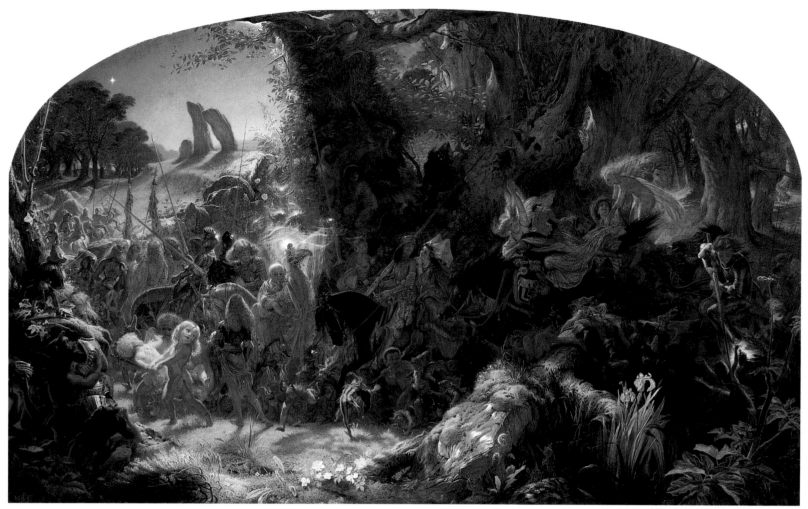

245

Elimination and dated January 1865, in which he asks us to forgive his fancies: 'You can afford to let this go for naught or nothing it explains. And nothing from nothing nothing gains.' Devoid of female companionship, he describes the loneliness of his own lot 'shut out from nature's game, banished from nature's book of life'. He died in January 1886.

Another notable painter of fairy subjects was the Scot, Sir Joseph Noel Paton (1821–1901). A keen antiquarian, Paton worked for three years as head designer in a muslin factory in Paisley before visiting London in 1842, and attended one term at the Royal Academy Schools before homesickness drove him back to Scotland. While at the Academy he met Millais, eight years his junior, with whom he became a life-long friend. It is possible that if Paton had not returned to Scotland, he might also have become a member of the Pre-Raphaelite Brotherhood, for he sympathized with their aims and worked with a similar regard to painstaking but painterly detail.

Paton preferred, however, to live nearly all his life in his native Dunfermline, exhibiting at the Royal Scottish Academy, where he showed his two early master-pieces, *The Reconciliation of Oberon and Titania* (Pl. 244), shown in 1847, and *The Quarrel of Oberon and Titania*, begun earlier but not displayed until 1850 when it was hailed as 'The Picture of the Exhibition'. In the next few years he continued to paint some small fairy pictures, and on 31 December 1861 began *The Fairy Raid* (Pl. 245), perhaps his finest fairy work. It shows the Faerie Queen's cavalcade carrying off a mortal changeling to their home among the great standing stones. Work on the picture was discontinued while Paton illustrated Charles Kingsley's classic fairy story *The Water Babies*, published in 1863, with its vividly realized underwater scenes. Its

246
Richard Doyle
The Fairy Tree
*c.*1865
watercolour, 75 × 63cm
(29½ × 24⅞in)
Private collection

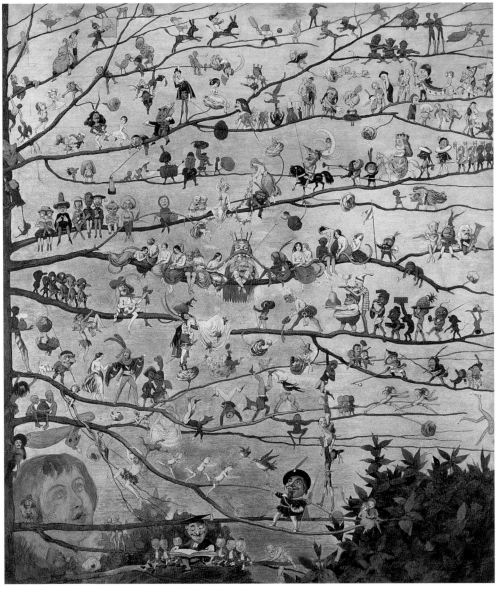

246

famous characters Mrs Doasyouwouldbedoneby and Mrs Bedonebyasyouwould made the book a favourite with Queen Victoria, who read it to her children. Work on *The Fairy Raid* was resumed on 5 September 1865 and completed in April 1867. It was exhibited accompanied by these lines:

Fast, fast through the greenwood speeding

Out in the moonlight bright,

Her fairy raid she is leading,

This dainty queen so light,

And the baby-heir of acres wide

She is carrying away to fairyland;

A changeling is left by the nurse's side,

And he in the young heir's place shall stand.

In later years Paton turned away from fairies to concentrate on large, gloomy paintings with titles such as *The Man with the Muck Rake*, religious paintings and re-creations of the studios of great Renaissance artists such as Dürer. He also designed medals and sculpted.

It may have been conversations with Paton which sparked off the idea in the mind of the young Millais for a painting which most clearly shows the relationship

between fairy painting and revolutionary new Pre-Raphaelite ideas. In *Ferdinand Lured by Ariel* (Pl. 247), Millais chose the scene from *The Tempest* when Ariel's song leads Ferdinand to Prospero and Miranda. His fellow Pre-Raphaelite F.G. Stephens posed as Ferdinand. This was a favourite theme for fairy painters, but most preferred to paint the sea-nymphs dancing on the shore described in Ariel's song, rather than Ariel and Ferdinand themselves. Shakespeare's stage direction gave the artist no help. It reads: 'Re-enter Ariel invisible, playing and singing; Ferdinand following.' Instead of the single bat mentioned by Shakespeare in the line, 'On the bat's back I do fly', Millais painted a flying seat made up of many bats for Ariel, which much resembles the grotesque carvings on medieval misericords.

Millais's imaginative idea was far too grotesque for the dealer who had commissioned the picture for £100. He turned it down, expressing distaste at the 'greenness of the fairies', but the picture eventually sold for £150 to a visitor to Millais's studio who slipped the cheque underneath the painting to give the artist a pleasant surprise. The painting remains the solitary venture into fairy painting of a leading Pre-Raphaelite.

When Paton's *The Quarrel of Oberon and Titania* was exhibited in 1850 Charles Lutwidge Dodgson, better known as Lewis Carroll, the author of *Alice in Wonderland*, noted enthusiastically that he had counted 165 individual fairies in the painting. The sheer number of fairies that could be crammed into a single composition was always an object of interest to painters of fairyland. One artist who excelled at this process was Richard (Dicky) Doyle (1824–83). A good example is *The Fairy Tree* (Pl. 246), one of his largest and most famous watercolours, which portrays over 200 fairies on the bare branches of a tree, gazed on in wonder by a boy. On a central branch sits a fairy king having his long moustaches combed by a number of female fairies. Hair had a peculiar fascination for Doyle, who loved to draw luxuriant tresses being braided and plaited into sinuous and convoluted intricacies.

It was said of Dicky Doyle that he was 'the most graceful and sympathetic of the limners of fairyland. In Oberon's court he would at once have been appointed sergeant-painter.' Although he was above all an illustrator who loved the imposed disciplines of the border, the initial letter or a story with a straightforward narrative line, Doyle was also, particularly in later life, an artist who took very seriously the more extended use of watercolour on a larger scale. Many of these sizeable works rely compositionally on the self-imposed constraints provided by the insertion either of the branches of a tree or its gnarled roots. Against these frameworks are arranged interlinked lines of tiny animated fairy figures. He achieved the effect of minuteness by juxtaposing their activities with natural forms to achieve magical effects of diminution in scale.

In such works we see Doyle's originality at its most striking. They represent not only the High Victorian delight in the escapist fairy world in its most developed form, but also the need to fantasize about the existence of extra-terrestrial beings – a recurrent feature of man's psyche, and one which finds its twentieth-century expression in science-fiction stories and films.

It may be argued that Doyle's work triumphs over his contemporaries because they all took the subject a little more seriously than it deserves. Paton, Maclise, Fitzgerald and notably, because of his insanity, Richard Dadd – in none of these do we find the glee, the gaiety and the sense of mischief which enables Doyle to avoid the mawkish pitfalls that can beset the fairy painter.

Doyle's masterpiece was his illustrations to the Pre-Raphaelite poet William Allingham's book *In Fairyland* of 1870. They reveal his secret fairy world at its most enchanting. Allingham's famous lines:

247
John Everett Millais
Ferdinand Lured by Ariel
1849–50
oil on wood, 64.8 × 50.8cm
(25½ × 20in)
Private collection

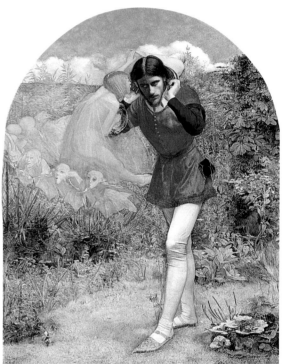

247

248
Charles Altamont Doyle
Self-Portrait: A Meditation
*c.*1885–93
watercolour, 17.8 × 26.5cm
(7 × 10½in)
Victoria and Albert Museum,
London

249
John Atkinson Grimshaw
Iris
1886
oil on canvas, 81.5 × 122.2cm
(32¼ × 48⅛in)
Leeds City Art Gallery

Up the fairy mountain
Down the rushing glen
We daren't go a'hunting
For fear of little men

possess something of the same menace as Christina Rossetti's poem 'Goblin Market' (1862). Allingham revelled in listing exotic fairy names (trolls, kobolds, nixies, pixies, wood-sprites), just as Doyle enjoyed creating densely populated and complex watercolours, such as *Under the Dock Leaves: An Autumnal Evening's Dream* (Pl. 250). This virtuoso watercolour would be remarkable simply as a pure landscape in its combination of minute observation and breadth of vision, but the element of fantasy and the imagined fairy ballet add a further dimension, enhanced by Doyle's use of giant burdock leaves to suggest the diminutive stature of the fairy troop. The fairies are incandescent, eerily lighting up the underside of the leaves; the bright azure kingfisher, depicted on the same scale as the fairies, adds to this illusion, and is a sign of calm weather.

Dicky Doyle's younger brother Charles Altamont Doyle (1832–93) was a tragic figure. He worked in Edinburgh as an assistant surveyor, which required the skills of architect, builder and draughtsman. Both to supplement his income and to escape

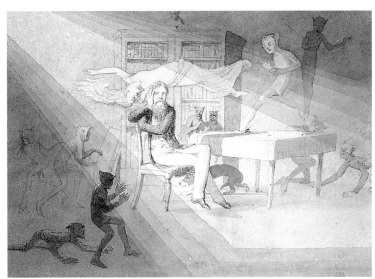

248

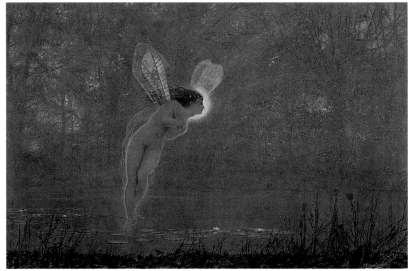

249

from a humdrum life, he painted droll whimsical fairy scenes which are quite different in quality from Dicky's works. As the years passed frustrated hopes led to the anodyne of alcohol, which, combined with the onset of epilepsy, resulted to his enforced incarceration in Montrose Lunatic Asylum, which he ironically described as 'Sunnyside' in a series of remarkable sketchbooks which provide glimpses of both fairies and asylum life, as in *Self-Portrait: A Meditation* (Pl. 248). Charles's later fairies 'exist' in real terms, in quite a different way from Richard's light-hearted fantasies, and in the Sunnyside volumes they are often eerily labelled with captions stating that they are based on actual observation. He was the father of Sir Arthur Conan Doyle, who in 1924 organized a retrospective exhibition of his father's work in London, significantly subtitled *The Humorous and the Terrible*. Two years earlier, in 1922, Sir Arthur had published his own book *The Coming of the Fairies*, illustrated with the notorious photographs of fairies taken by two little girls at Cottingley near Bradford which, to immense public bewilderment, Conan Doyle believed to be genuine.

An escapist love of fairy painting could sometimes quicken in the most unlikely artists. John Atkinson Grimshaw, who specialized in moonlit scenes of the docks in Liverpool or London, and the suburbs of his home town Leeds (Pls. 126, 127), made

one or two ventures in fairy painting, notably *Iris* (Pl. 249). Iris was the messenger of the gods, who was sent to wither flowers in autumn, but stopped to admire the waterlilies and was turned into a rainbow. The figure was drawn from the former actress Miss Agnes Leefe, Grimshaw's studio assistant and model as well as companion to his wife and children.

Queen Victoria died in 1901. She had privately been dubbed 'the Faery' by her favourite Prime Minister, Disraeli, in an ironic if romantic allusion to Spenser's *Faerie Queene*. Would the fantasy of fairyland survive the accession of her son, King Edward VII? The year after her death, Fitzgerald exhibited his last fairy painting, entitled *Alice in Wonderland* (now lost). Soon Alice would be joined by another classic tale of fairyland, James Barrie's *Peter Pan in Kensington Gardens* as illustrated by Arthur Rackham

250
Richard Doyle
Under the Dock Leaves: An Autumnal Evening's Dream
1878
watercolour and bodycolour,
50 × 77.5cm (19¾ × 30½ in)
British Museum, London

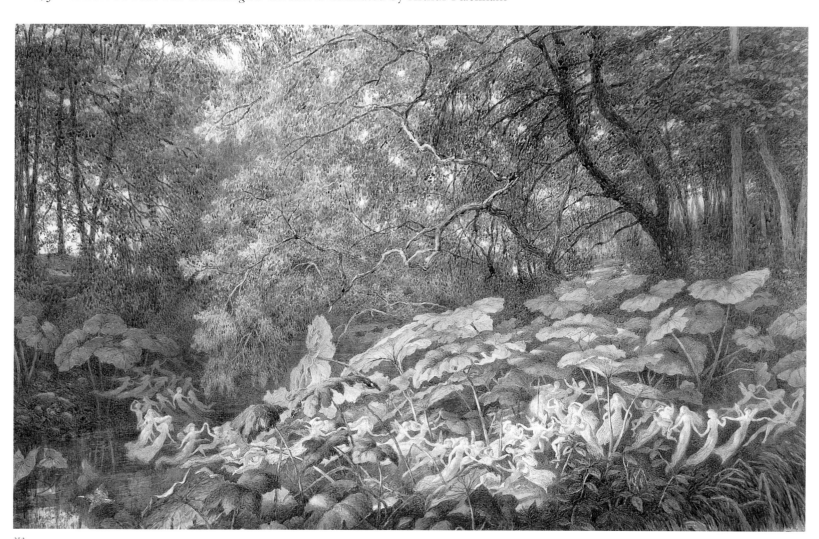

250

(1867–1939), who with Edmund Dulac (1882–1953) was to create new fairy worlds for the Edwardian public. When in the mid-1930s Walt Disney was working on his first full-length feature cartoon, *Snow White*, he tried to persuade Arthur Rackham to come to Hollywood to work on the film, and lead fairyland into the exciting new dimension of animation. Although old age prevented this, Rackham's influence is easily spotted. Even today, in the more traditional medium of oil on canvas, Peter Blake still continues to demonstrate the lasting fascination and glamour of the fairy world.

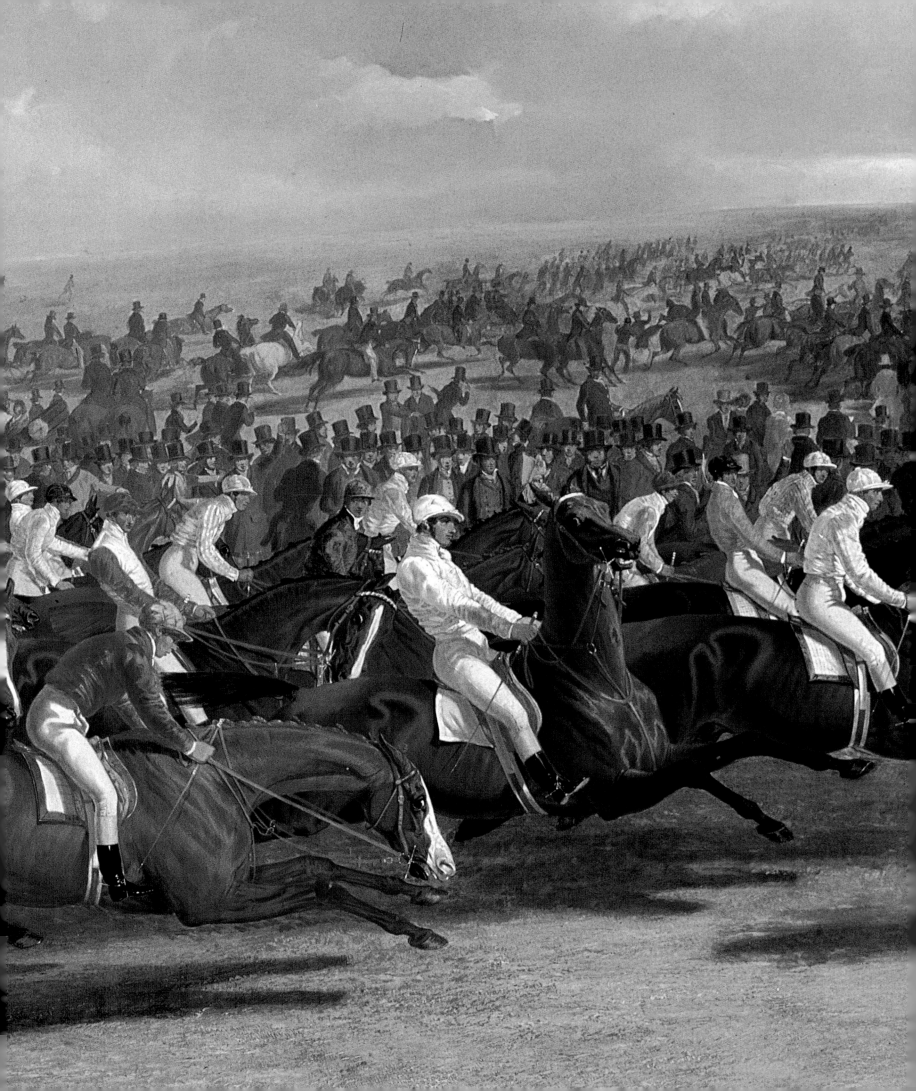

The name of the great animal painter and sculptor Sir Edwin Landseer (1802–73) was reviled for many years during the twentieth century as being synonymous with the double standards of Victorian sentimentality and cruelty.

'Who does not glory in the death of a fine stag?' wrote Landseer. 'There is something in the toil and trouble, the wild weather and savage scenery which makes butchers of us all.' These thoughts, so alien to the sentiments of the late twentieth century, arose from the way in which a stag at bay symbolized for the Victorians the nobility of nature and man's primacy in the created world. They also made deerstalking a particularly suitable pursuit for the Royal Family, who loved the privacy of their retreat at Balmoral in Scotland away from the public gaze, where the Prince Consort enjoyed the sport, recorded in many paintings by Landseer of the Royal Family and their ghillies

251 John Frederick Herring, **The Start of the 1844 'Dirty' Derby** (detail of Pl. 267)

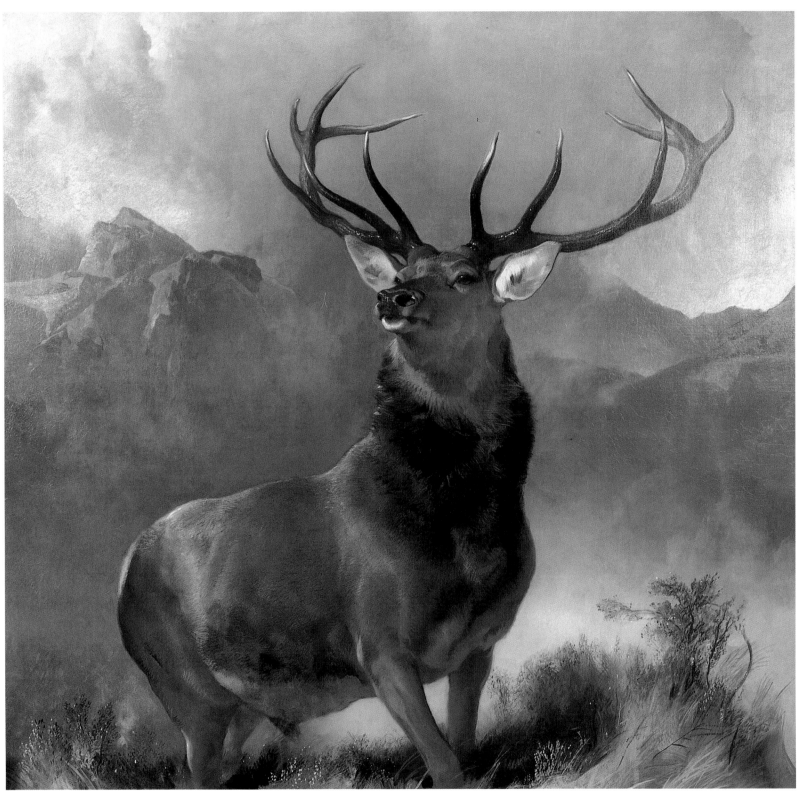

hunting deer. But sometimes Landseer, despite the words just quoted, was troubled by the thought that 'in truth [he] ought to be ashamed of the assassination', a sentiment reflected in the grandeur of his most famous painting, *The Monarch of the Glen* (Pl. 252). It was this nervous sensibility, the ability to see himself both as happy butcher and bloodstained assassin while identifying also with his prey, which gives his painting its frisson of terrible beauty and contributed to the growing stress, melancholia and alcoholism of his last years.

Like his friend Millais, Landseer was a child prodigy, who when a student at the Royal Academy was described by Fuseli as 'my little dog boy', an amusing reference to Landseer's early predilection for canine subjects. It is indeed easy to categorize his work as a dog phase, followed by a deer phase, and culminating in the commission of 1859 to model the lions for the base of Nelson's Column in Trafalgar Square. But to do so is to bypass his special talent for both child genre and landscape, and the transference of human emotions to animals in several of his most famous works, such as *Dignity and Impudence* (1839) and *The Old Shepherd's Chief Mourner* (Pl. 254), which combine human sentiments and animal behaviour. In other works such as *Laying Down the Law* (Pl. 253) and *A Jack in Office* (1833) Landseer constructs virtually a canine equivalent of the judicial bench or seekers for parliamentary office. It is worthwhile remembering that the public love of such anthropomorphic subjects was very great even before Darwinian controversy on evolution, sparked off by the publication of *The Origin of Species* in 1859.

Landseer's immense contemporary popularity was largely due to the wide dissemination of his works by reproductive engravings. No fewer than 126 different engravers copied his work, which went into virtually every cottage and house in the country. When he died his fortune of £200,000 had come largely from the royalties. Subsequently Landseer's reputation has shared in the vicissitudes of fashionable reactions to the art of the Victorian period, his work being denounced as 'blood and soft soap' by Geoffrey Grigson in 1961, reviewing a commemorative exhibition at the Academy. But in more recent years his powerful skills as painter and draughtsman have been reappraised.

Two Liverpool-based artists were in some ways rivals to Landseer in their choice of themes. William Huggins (1820–84) once vaingloriously claimed that if he could have instructed Landseer for a day 'he could have made a man of him'. Huggins's

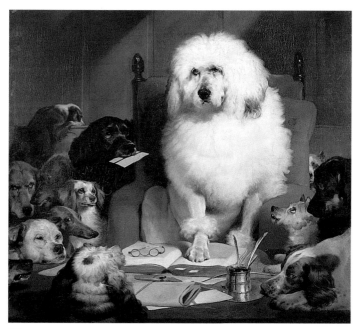

253

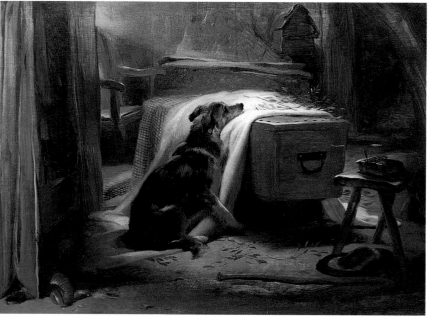

254

255
William Huggins
**A Lion Resting in the
Midday Sun**
1865
oil on wood, 40.6 × 55.9cm
(16 × 22in)
Private collection

256
Ben Marshall
Anti-Gallican
1821
oil on canvas, 103 × 128cm
(40½ × 50½in)
Walker Art Gallery, Liverpool

paintings of dogs, donkeys and their foals demonstrate how he excelled at the depiction of the texture of fur and hide, skills also to be seen in *Lion* (Pl. 255), a subject to which he often returned. But Landseer's real rival was Richard Ansdell (1815–85), whose large, vigorously painted pictures of field sports such as the Waterloo Cup coursing meeting at Altcar or *A Shooting Party in the Highlands* (Pl. 257) greatly appealed to High Victorian England. His work, so long forgotten, is now, like Landseer's, being reassessed.

Even more perhaps than the individual face of man or woman, the British love to capture the likeness of a favourite animal. Ben Marshall (1768-1835), the great sporting artist of an earlier generation, put it memorably: 'The second animal in creation is a fine horse and at Newmarket I can study him in the greatest grandeur, beauty and variety … for I know many a man who will pay £50 for a portrait of his horse who will give only £10 for a portrait of his wife.' Marshall's successful career as a portrait painter of horses such as *Anti-Gallican* (Pl. 256) is an eloquent vindication of these words. Such sentiments were to provide sporting and animal painters with a flourishing practice throughout the nineteenth century. If you were able to

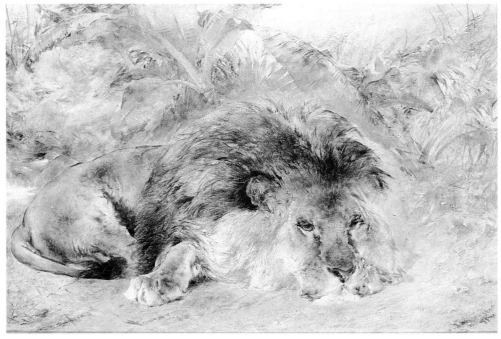

255

paint skilfully both owner and horse or dog you were assured of success, particularly with the Royal Family. This was why the Queen and Prince Consort loved Landseer's portraits of them and their dogs and children in *Windsor Castle in Modern Times* (Pl. 67).

While more formal portraits of the Royal Family were painted by one German artist, Winterhalter, another, Carl Haag (1820–1915), recorded their informal moments on holiday at Balmoral. This Scottish estate was acquired by the Queen in 1848, and soon became for her a 'truly Princely & romantic little Kingdom', 'my dear Paradise' where, safely withdrawn from public gaze, she and Prince Albert could revel in the rare privilege of privacy. Although we associate his name very much with Balmoral, Landseer did not paint there during the last fourteen years of his life and it was not Landseer but Haag who produced the watercolour *Morning in the Highlands* (Pl. 258), which is surely one of the happiest of all the many depictions of Queen Victoria's family.

The subject was planned after an expedition up Lochnagar, a mountain nearly

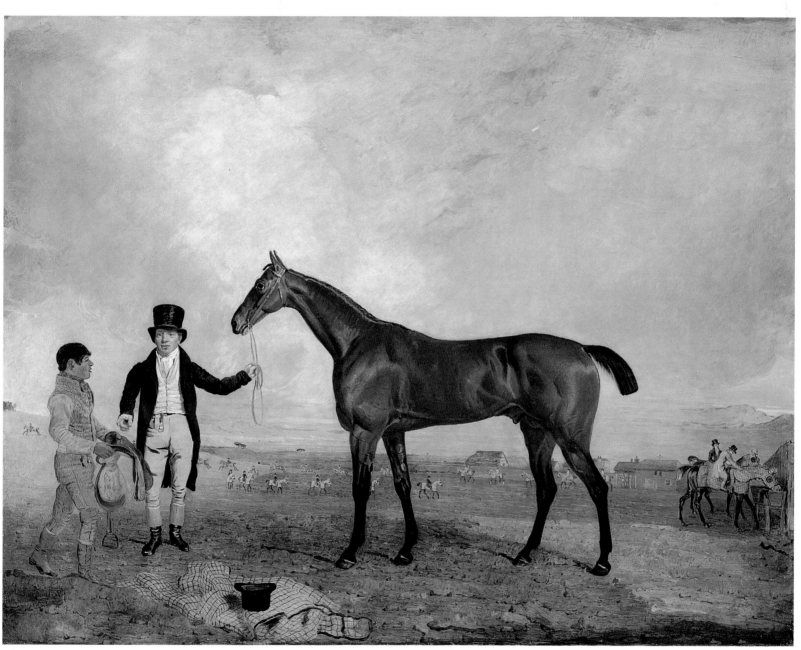

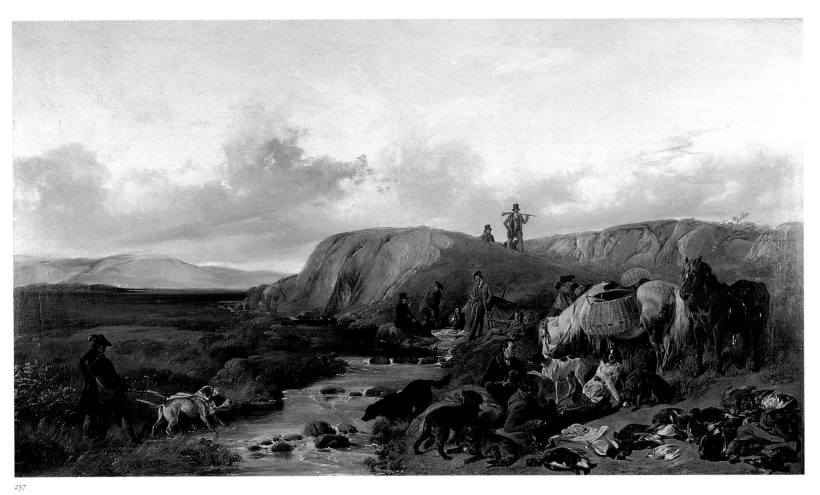

257

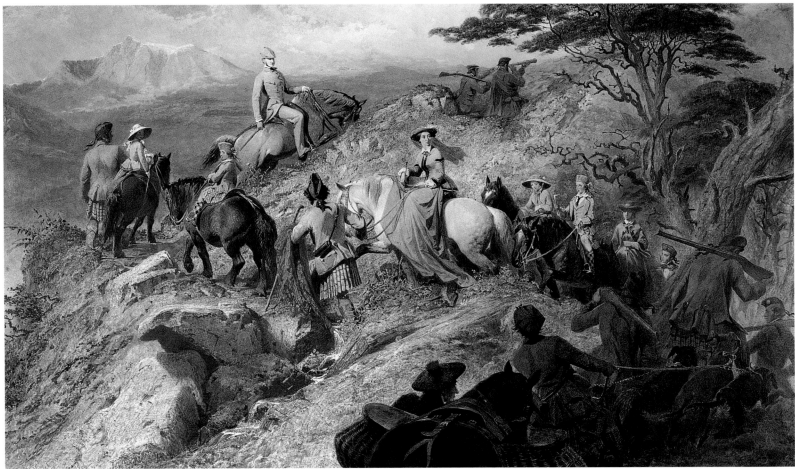

258

4,000 feet high that lay to the south of Balmoral, which the Queen called 'the jewel of all the mountains here'. It shows the Royal Family setting out on the expedition, with the mountain in the distance. Behind the Prince Consort rides Princess Alice, and Prince Alfred precedes the Queen and other members of the Royal Family in what is both a delightful portrait and a fine sporting painting.

It was in the field of sporting art that British painting first became influential on the continent. The works of both Landseer and James Ward (1769–1859) were greatly admired in France and played an important role in the symbolic identification of animal energy with the Romantic movement. During a visit to England, from 1820 to 1821, in which he painted his celebrated *Epsom Derby*, Théodore Géricault (1791-1824), the guiding genius of the French Romantic movement, became a friend of James Ward, who introduced him to the new graphic medium of lithography. After visiting the Royal Academy, Géricault wrote: 'You have no idea of the animals painted by Ward and Landseer – the masters have produced nothing better of this type.' He was referring to Landseer's early works such as *Chevy Chase* (Pl. 13) which pay tribute to the Flemish tradition of Rubens and Snyders.

James Ward not only painted some of the best hunting pieces of his time, but also forcefully expressed the Romantic image of the horse in a series of fifteen favourite horses of great generals, among them a deeply moving portrayal of Napoleon's favourite charger Marengo alone on the field of Waterloo on which a blood-red sun slowly sinks (Pl. 259). Ward's painting takes its place with depictions of horses frightened by lions, lightning, serpents and wolves, a theme popular throughout the Romantic era in both England and France.

One of Ben Marshall's ablest pupils was Abraham Cooper (1787–1868), who began his career as a rider and groom at Astley's Theatre, a great attraction of early nineteenth-century London, which combined a proscenium stage with a circus ring. Here were enacted such scenes as the highwayman Dick Turpin's ride to York, various battles and stirring historical events with an equine theme. After leaving the circus Cooper worked for three years with Marshall, completely assimilating his style. A striking example of his work is his depiction of *The Day Family* (Pl. 260) showing

257
Richard Ansdell
A Shooting Party in the Highlands
1840
oil on canvas, 97.1 × 161.3cm
(38¼ × 63½ in)
Walker Art Gallery, Liverpool

258
Carl Haag
Morning in the Highlands
1853
watercolour, 77 × 133.6cm
(30¼ × 52⅝ in)
Royal Collection

259
James Ward
Napoleon's Horse, Marengo, at Waterloo
1824
oil on canvas, 81.8 × 109.7cm
(32¼ × 43¼ in)
Alnwick Castle,
Northumberland

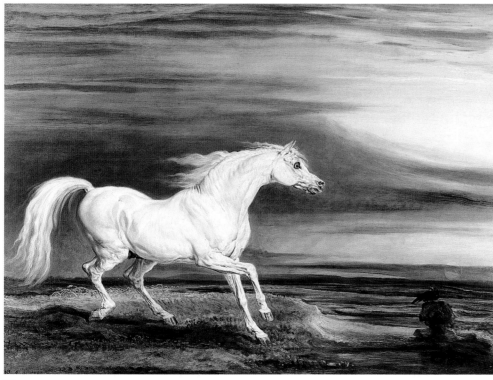

259

260
Abraham Cooper
The Day Family
1838
oil on canvas, 70.5 × 90.8cm
(27¾ × 35¾in)
Tate Gallery, London

261
John Ferneley
The Council of Horses
1840
oil on canvas, 249 × 211cm
(98 × 83in)
Calke Abbey, Leicestershire

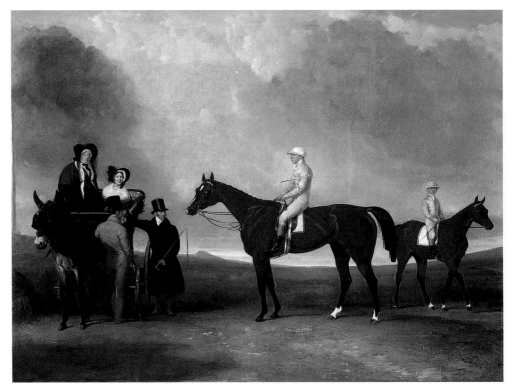

260

the trainer John Day, whip in hand, and his two sons who were also both jockeys. (It is interesting to note that Day was an ancestor of the famous jockey of our own day, Lester Piggott.) Between 1812 and 1868, during a long career, Cooper exhibited 332 works at the Royal Academy, many of them variations on the theme of noble horses in history.

John Ferneley (1782–1860), another of Marshall's pupils, was apprenticed to his father, a master wheelwright, at his birthplace in Thrussington in Leicestershire. There is little reason to doubt the romantic story of the young Ferneley using the foreboards of waggons brought in for repair as supports for paintings of hunting incidents. These long, narrow, rectangular paintings which graphically recorded the thrills and spills that make for a memorable run on the hunting field gained the name 'Hunt Scurry' with which Ferneley's name will always be associated. One of these paintings was brought to the notice of the Duke of Rutland, who arranged for Ferneley to go to London as an apprentice to Ben Marshall for a fee of £200. Ferneley stayed with Marshall for three years, studied at the Royal Academy Schools, and travelled widely in Ireland before settling at Melton Mowbray, the centre of hunting England, where throughout his career he was content to paint portraits of individual horses and huntsmen for 10 guineas, and larger compositions for 30 to 60 guineas depending on the number of horses and riders portrayed. Every year Ferneley used to visit London during the summer season, where he painted horse portraits for his patrons, which he set in Rotten Row and the fashionable end of Hyde Park, and which all featured Marble Arch and the Achilles Statue.

One of Ferneley's largest paintings was *The Council of Horses* (Pl. 261), a title which comes from John Gay's fable of an equine utopia. It is a lyrical work, reminiscent of Sawrey Gilpin's earlier series of six oils illustrating the last book of Swift's *Gulliver's Travels* (1768-72). Both Gilpin and Ferneley enjoyed the fantasy of imagining the horse as ruler, not servant, sentiments anticipating George Orwell's *Animal Farm*.

Ferneley's most famous pupil and friend was Francis Grant (1803–78), the first

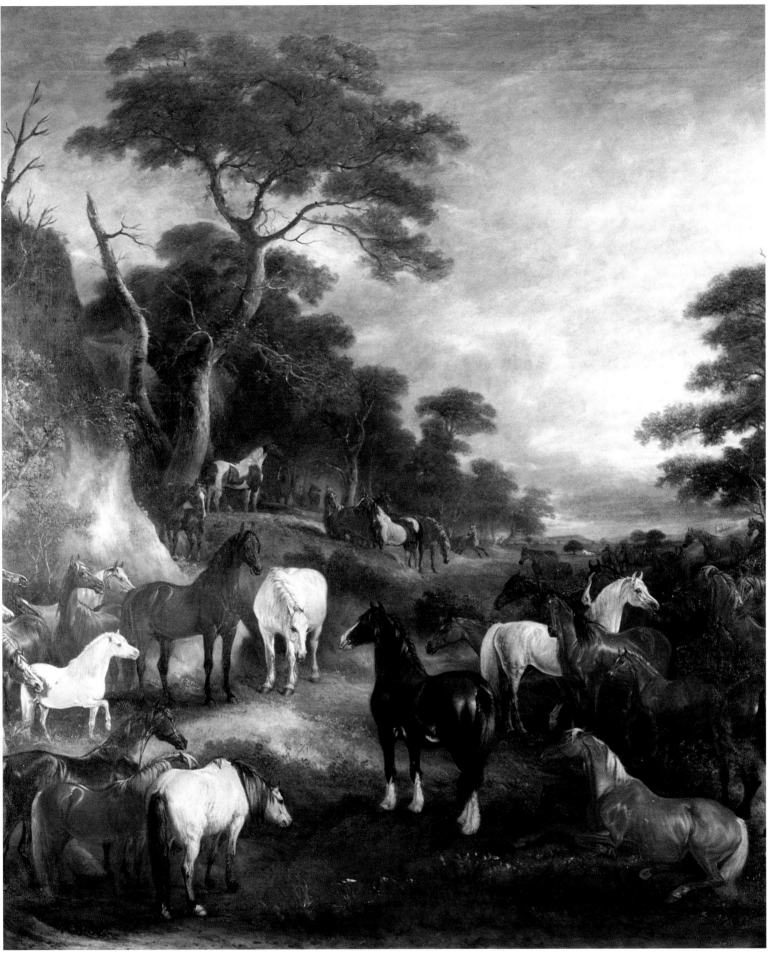

sporting painter to become President of the Royal Academy. The younger son of a Perthshire laird, Grant was educated at Harrow and Edinburgh High School. As a young man he inherited £10,000, but the money slipped through his fingers on the hunting field, for Grant was a Meltonian, a member of a hunt who prided themselves on the cut of their coats and the high gloss of their boots, which were cleaned with a mixture of boot blacking and champagne. (The sporting writer 'Nimrod' (C.J. Apperley), who described Melton Mowbray in the *Quarterly Review* of 1830, estimated that the average sportsman hunting from the town maintained a stable of ten horses, costing at least 200 guineas each and 1,000 guineas to keep in stables.) In Ferneley's portrait of *John, Henry and Francis Grant at Melton* (Pl. 262), Grant and his two brothers, each of them every inch the fashionable sportsman, can be seen with Melton Mowbray in the distance.

In 1830, at the age of 27, Grant became a professional painter, having started to take lessons from Ferneley in the early 1820s. Queen Victoria noted with her usual acuity that he was 'a very good looking man, was a gentleman, spent all his fortune and now paints for money'. By 1840 he had achieved some success as a portrait

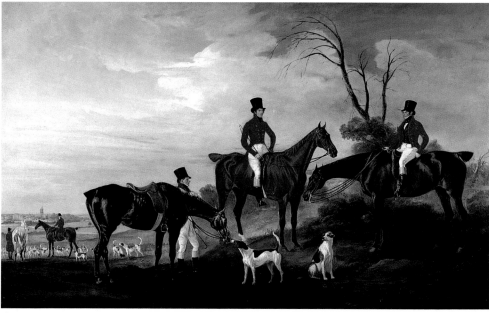

262

painter, partly due to his social status and partly to his ability to produce a flattering likeness, which gives his fashionable portraits of pretty girls riding side-saddle great charm. The turning point in his career occurred in 1840 with *Queen Victoria Riding out with her Gentlemen* (Pl. 69), showing the young Queen riding side-saddle upon Comus, a prancing dun horse, accompanied by her bounding dogs, Islay and Dash, between Lord Melbourne and Lord Palmerston.

After this success Grant became one of the most famous and fashionable painters of his day, although he never allowed his career to interfere with his fox-hunting at Melton. He was elected Associate Royal Academician in 1842, Royal Academician in 1851, and after Sir Charles Eastlake's death in 1865 and Landseer's refusal to succeed him on grounds of ill health, Grant became President of the Royal Academy. Queen Victoria did not approve of this, and wrote to Lord John Russell in 1866: 'The Queen will knight Mr Grant when she is at Windsor. She cannot say she thinks his selection a good one for Art. He boasts of *never* having been to Italy or studied the Old masters. He has decidedly much talent, but it is much the talent of an Amateur.' The Queen was for once much mistaken, as Grant became an extremely

successful President, counting among his achievements the acquisition of a 999-year lease of Burlington House, still the Royal Academy's home, for a rent of one pound a year when the institution had to leave the National Gallery in 1868.

We gain a vivid impression of the social aspect of the hunt from a watercolour by Eugène Lami (1800–90) entitled *A Hunting Breakfast in England* (Pl. 263). Lami was a French watercolourist, genre painter and lithographer who studied under Antoine-Jean Gros (1771–1835) and Horace Vernet (1789–1863). He lived in London for four years from 1848 to 1852, painting sparkling watercolours of high society scenes of balls and military revues. The poet and critic Charles Baudelaire described him as being 'a poet of dandyism, his love of all things aristocratic making him almost English'.

Like Grant, Charles Cooper Henderson (1803–77) differed from the majority of sporting painters by coming from an affluent upper-class background. As a boy he had lessons from the watercolour painter Samuel Prout. In 1829 he married against

263
Eugène Lami
**A Hunting Breakfast
in England**
1870
watercolour, 26.3 × 46.9cm
(10¼ × 18½in)
Victoria and Albert Museum,
London

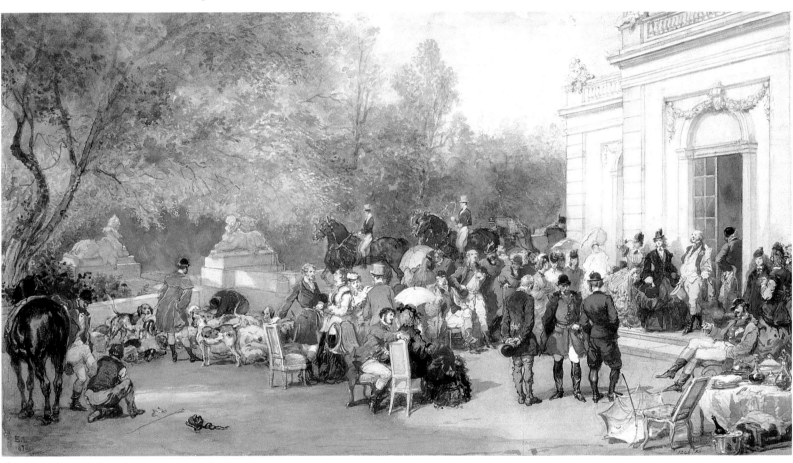

263

his father's wishes, was disinherited and turned to painting to earn his living. In 1850 Cooper Henderson inherited a fortune from his mother, and subsequently only painted as a hobby. This was fortunate for him, as his new-found affluence coincided with the virtual end of the coaching era and the mail coaches which he painted with such flair, such as *The Edinburgh Mail Coach and Other Coaches in a Lamplit Street* (Pl. 264).

The opening decades of the nineteenth century had seen remarkable improvements in the road system of the United Kingdom. The work of Telford and McAdam ensured that a steady pace of ten miles an hour could be maintained by coaches on long journeys, thus preparing the public mind for the still greater speeds of the railroads. Ironically, rail was used to transport horses to the Midlands for the last decades of the golden age of fox-hunting, amusingly described in R.S. Surtees's

novels, illustrated so vividly by the *Punch* artist John Leech with the memorable characters of Mr Jorrocks the sporting grocer and the unscrupulous Mr Sponge.

James Pollard (1792–1867) was a master of the acquatint process, as is apparent in his handling of oil paint. His youth was spent in Islington and Holloway where he could see the great mail coaches to the North of England pass every day. He first exhibited at the Royal Academy in 1821 and during the next decade produced his finest paintings of mail coaches, then at the height of their splendour. For William Hazlitt, 'the sublimest object[s] in nature' were 'the mail coaches that pour down Piccadilly of an evening, tear up the pavement, and devour the way before them'. In *The Royal Mail Coaches for the North Leaving the Angel, Islington* (Pl. 265) we see Pollard's first great public success, a painting which vividly captures the mail coach at the height of its glory, before its rapid decline, overtaken by the irresistible advance

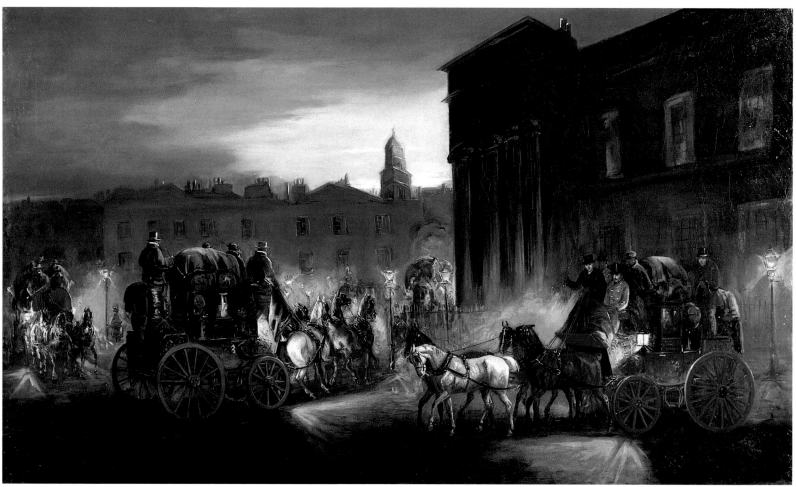

264

of steam and the new railway age. By 1842 the 80 mail coaches leaving London daily had dwindled to 11.

From 1830 to 1840 Pollard's coaching paintings gave way increasingly to racing and steeplechase subjects, as well as some angling and cricket pictures. The death of his wife and daughter in 1840 stopped him painting for two years, and from that point onwards his paintings diminish in size, and omnibuses not coaches begin to form the bulk of his work, a typical example being *A Street Scene with Two Omnibuses* (Pl. 266), which portrays two early London omnibuses of the type introduced by George Shillibeer in 1829. These remained the standard type until the Great Exhibition of 1851, when a demand arose for more and bigger vehicles, and gradually passengers found their way on to the seat next to the driver, and seating areas were created on the top deck.

John Frederick Herring (1795–1865) was brought up in London. The fastest mode of transport at any time possesses a unique fascination for the young, and as a boy Herring, like Pollard and Cooper Henderson, was also absorbed by the glamour of the crack coaches which he saw pass daily outside his father's fringe-making shop in Newgate Street. He drew horses for his own diversion from an early age, and had his first lessons in painting from a family friend, the driver of the London to Woking coach. When aged 19 he went to Doncaster and worked as a coachman for five or six years. While thus employed he painted inn signs and coach panels. In 1815 he was commissioned by a Doncaster publisher to paint the winner of the St Leger, the first of a long series of portraits of 18 successive winners of the Derby and no fewer than 33 winners of the St Leger. His paintings become immensely popular, and he received commissions from George IV, William IV and Queen Victoria. It is a tribute to his lasting popularity that many of his engravings are still being produced to this day.

One of Herring's most remarkable racing paintings depicts the start of the 1844 Derby – the 'dirtiest' running in the 200-year history of the race (Pl. 267). The full complex story would be rejected by the author of any sporting thriller as too improb-

265
James Pollard
The Royal Mail Coaches for the North leaving the Angel, Islington
1827
oil on canvas, 103.2 × 146.4cm
(40¼ × 57⅝ in)
Tate Gallery, London

266
James Pollard
A Street Scene with Two Omnibuses
1845
oil on board, 24.7 × 32cm
(9¾ × 12⅝ in)
Museum of London

265

266

able, for it involved doping, 'pulling' horses by corrupt jockeys, 'switching horses' and the interment and disinterment of horses' bodies with and without identifying teeth! The essence of the drama lies in the fact that a four-year-old horse would win the Derby easily over a field of less hardy three-year-olds. By the use of hairdresser's dye, and the deliberate duplication of a scar, two horses could pass quite close visual scrutiny as being identical. A skilled veterinarian could, of course, by examining their mouths determine the true age of the horses, but the gamble was taken that this would not occur. This was by no means a new idea and similar attempts had been made to disguise a horse in the Derbys of 1832, 1833 and 1840. But the 1844 case was so glaring that far stricter supervision of runners was introduced.

To our eyes one of the strangest aspects of this painting, in common with many other racing paintings, is the curious way in which the horses are all depicted at full stretch, in what was known as the 'rocking-horse straddle'. This was a universally accepted convention which led artists as knowledgeable as Stubbs, Géricault and Herring to portray horses in a bizarre 'ventre-à-terre' posture, floating almost like small hovercraft, a few inches above the ground. This convention ended appropriately with a bet, made by the millionaire Leland Stanford in 1872 at Palo Alto in

267
John Frederick Herring
The Start of the 1844 'Dirty' Derby
1844
oil on canvas, 102.9 × 209.6cm
(40½ × 82½in)
Brodick Castle, Isle of Arran

268
John Frederick Herring
Seed Time
1854–6
oil on canvas, 106.6 × 183cm
(42 × 72½in)
Victoria and Albert Museum,
London

California, that all the feet of his racehorse left the ground when galloping. The British photographer Eadweard Muybridge (1830–1904) devised a method by which the movement of the horse could be analysed by stop-action photography. His photographs showed that the horse in fact only removed all four feet from the ground when they were closest together, and *not* when farthest apart. Stanford won his bet, and Muybridge's discoveries became widely known through his books, notably *Animal Locomotion* (1887), a work which was to become as influential on later sporting art as had Stubbs's *The Anatomy of the Horse* after its publication in 1766.

In about 1847 Herring settled at Meopham in Kent and turned from racing to rural subjects – stables, farmyards, domestic animals and agricultural and hunting scenes, occasionally collaborating with Landseer and John Phillips. He argued with his sons, who were also sporting artists and whom he accused of plagiarism – although at his best his son Benjamin Herring had real originality.

Two characteristic examples of Herring's agricultural scenes are a pair of paintings entitled *Seed Time* (Pl. 268) and *Harvest Time* (1859), which offer a detailed treatment of mid-nineteenth-century agricultural methods, all the accepted cultivation procedures of both seasons being portrayed simultaneously. On the left of *Seed Time* the stubble is being ploughed up, while in the centre is the Cambridge roller, suit-

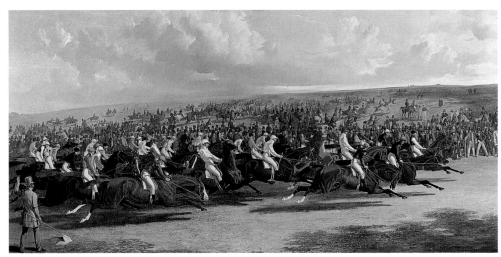

267

ably weighted down with stones on the box on top of the equipment. Seed is being broadcast by the men walking from left to right, and in the mid-distance a team of horses is being readied to harrow the tilth after the sowing. In reality it is a little unlikely that all four processes would have taken place simultaneously, although not completely infeasible, as the pace is dictated by a horse's gait.

Both pictures can be seen as visual lectures on farming methods, and a conscious attempt on Herring's part to eulogize the peace of the Kentish weald after the rick-burning disturbances of the 1820s and 1830s. No hint of these turbulent times can be found in the work of Thomas Sidney Cooper (1803–1902), who also painted the Kent landscape, spending nearly a century peacefully depicting the ruminant family, especially cows. Cows are rewarding models, for they stay very still, and some of Cooper's depictions of well-groomed coats, wet muzzles and beautiful eyes are remarkably tactile *tours de force*. He lived at Canterbury in Kent, and at the art gallery he left to the town one can still see his homage to the great seventeenth-century Dutch cattle painter Paulus Potter (1625–54), whose life-size bull is in the Mauritshuis in The Hague. Cooper's splendid *Bull* is a worthy rival to the Dutch artist's painting. Cooper was also aware of the calm serenity of Cuyp's cattle pictures, echoes of whose style can be seen in a particularly fine example of his work in the

268

269
Thomas Sidney Cooper
The Victoria Jersey Cow
1848
oil on wood, 45.1 × 61cm
(17¾ × 24in)
Royal Collection

270
John Charles Dollman
**Les Misérables (A London
Cab Stand)**
1888
oil on canvas, 98.5 × 158cm
(38¾ × 62¼in)
Museum of London

271
Henry Stacy Marks
A Select Committee
1891
oil on canvas, 111.6 × 86.6cm
(44 × 34⅛in)
Walker Art Gallery, Liverpool

272
Joseph Wolf
Greenland Falcons
1877
watercolour, 76.2 × 61cm
(30 × 24in)
Ulster Museum, Belfast

273
Joseph Crawhall
The Aviary, Clifton
1888
watercolour, 51 × 35.5cm
(20 × 14in)
Burrell Collection, Glasgow

Royal Collection, *The Victoria Jersey Cow* (Pl. 269). This was a portrait of Queen Victoria's favourite cow, 'Buffie', whose official name was 'Victoria' because the white mark on the forehead of the animal formed a 'V'.

Cooper's uneventful 'cowscapes' are infinitely superior to the many Scottish Highland cattle paintings which decorated the large dining rooms of Victorian homes. Perhaps because of the Royal Family's residence in Balmoral there was a steady demand for paintings of Highland cattle, so much so that Peter Graham (1836–1921) kept a herd of Highland cattle at his studio at Gerrard's Cross in Buckinghamshire to be studied at first hand.

Such idyllic rural surroundings were not the lot of every animal. The genre painter John Charles Dollman (1851–1934) produced a work which rivalled the sombre work of Social Realist painters. His vivid painting of a London cab stand was first exhibited at the Royal Academy in 1888 with the ironic title *Les Misérables (A London Cab Stand)* (Pl. 270) taken from Victor Hugo's novel *Les Misérables*. It provides a pictorial record of a London cab stand of the type described in Anna Sewell's classic novel for children, *Black Beauty* (1877), which charts the vicissitudes of a black horse's life from its happy youth in the country to its final years working at the literally killing pace of a London cab horse. Another book, *The Horse World of London* by W.J. Gordon, published in 1893 by the Religious Tract Society, also describes the phases of a horse's life, from pulling a royal coach to ending in the knacker's yard, with the ignoble end of being turned into cat's meat or boiled down for glue.

The title given by Dollman to his painting succeeds in giving a human dimension to an animal's position. This device was often used in the Victorian Royal Academy by artists such as Henry Stacy Marks (1829–98). He specialized in Shakespearian and ornithological themes, often with a humorous anthropomorphic twist, such as *A Select Committee* (Pl. 271). When it was exhibited at the Royal Academy one reviewer described it as depicting 'a council, board and congress … of blue, white and black parrots and cockatoos perched in an aviary and gravely discussing the affairs of birdland'.

A painter of great individuality whom Landseer praised as 'the best all-round animal artist who ever lived' was Joseph Wolf (1820–99). Brought up in the Rhineland, he illustrated a magnificent book on falconry, but after the 1848 political unrest on the continent he settled in England to paint commissions for bird books and record animals at London Zoo. Wolf preferred painting wildlife compositions to illustration, and particularly enjoyed depicting the wildness of nature, with animals sheltering or searching for prey in bleak mountain landscapes. In *Greenland Falcons* (Pl. 272), the young fully fledged falcons perched on the high rocks form a framework as they watch an adult hunt a ptarmigan in a desolate mountain valley below. Wolf was adept at painting the subtle markings and modelling of plumage in the light and shadow of natural settings.

Two artists with very different aims from the purely illustrative were Joseph Crawhall (1861–1913) and John Macallan Swan (1847–1910). Crawhall learnt much from Impressionism which he studied in Paris, and was also deeply influenced by Japanese and Chinese art. He preferred to work with fluent application of watercolours or gouache and stark economy of line on brown holland linen, and loved to paint domestic poultry, colourful roosters and white ducks and geese, when he was not busy with equestrian subjects, at which he also excelled. One of his most virtuoso works depicts the many-hued splendours of the parrot house at Bristol Zoo, in *The Aviary, Clifton* (Pl. 273).

On Lord Leighton's advice Swan studied in Paris with Jean-Léon Gérôme (1824–1904) and Emmanuel Fremiet (1824–1910), the foremost French animal sculptor.

269

270

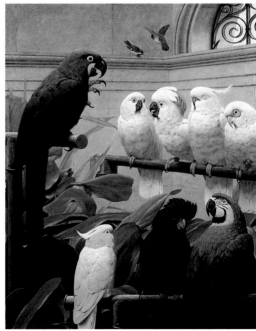

271

272

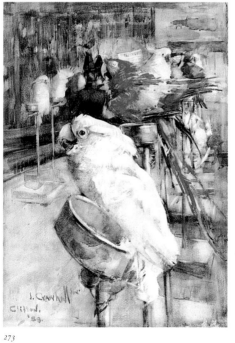

273

274
Winslow Homer
Croquet Scene
1866
oil on canvas, 40.3 × 66cm
(15⅞ × 26in)
The Art Institute of Chicago

275
Henry Garland
The Winner of the Match
1864
oil on canvas, 78.7 × 134.6cm
(31 × 53in)
Marylebone Cricket Club,
London

276
John Lavery
The Tennis Party
1886
oil on canvas, 77 × 183.5cm
(30¼ × 72¼in)
Aberdeen Art Gallery
and Museum

277
Charles March Gere
The Tennis Party
1900
oil on canvas, 39.3 × 107.4cm
(15½ × 42¼in)
Cheltenham Art Gallery
and Museum

278
Walter Greaves
**Hammersmith Bridge on
Boat Race Day**
*c.*1870
oil on canvas, 91.4 × 139.7cm
(36 × 55in)
Tate Gallery, London

Both as sculptor and painter, Swan was too fastidious to produce much, but at his best there is something very original in his feeling for animal life and particularly the big cats. His painting *Orpheus* (Pl. 364), for example, shows how he loved to paint panthers, tigers and leopards at play. Swan combined a love of homo-erotic themes with a remarkable awareness of the structure and movement of animals.

The historian G.M. Trevelyan once observed that 'if the French *noblesse* had been capable of playing cricket with their peasants, their châteaux would never have been burnt'. Remarkably, this seems to have been virtually true, for on 14 July 1789, while the mob stormed the Bastille, Lord Winchelsea was twice bowled out for a 'duck' by a Kentish commoner named William Bullen. In the Victorian age cricket was to continue to be universal in its appeal and was depicted by some surprising artists. George Frederic Watts's lithographs illustrating stroke play gave batsmen the nobility of the Elgin Marbles, while the American artist Winslow Homer (1836–1910), when working as an illustrator for *Harper's Weekly* in the 1860s, produced amusing visual records of cricket matches on Boston Common. In 1866 Homer also painted an engaging depiction of that most Victorian of lawn games, croquet (Pl. 274), a theme also used by Edouard Manet. Perhaps because of the game's relatively static nature another great Impressionist painter, Camille Pissarro, painted the game of cricket five times.

Less well-remembered names were also to capture cricketing themes to great advantage. The triumphal *Winner of the Match* (Pl. 275) by Henry Garland (*fl.* 1854–90) shows the colourful shirts which were then in vogue, influenced by the popularity of Garibaldi's red shirt worn on his triumphant visit to England the same year as this painting.

While cricket has been seen as part of the social cement in the class system, football, from 1361 right up to the present, has frequently been subject to bans and restraints as representing a threat to public order. There are very few early paintings of soccer, the genre painter Thomas Webster's *Football Match* which was exhibited at the Royal Academy in 1839 being almost the sole exception. Although the original is lost, oil copies after the engraving abound.

The late Victorian age was the period which saw the laws of both association football and rugby first codified. British engineers building railways took soccer to every part of the world. In the second half of the nineteenth century sports gained in popularity for the working classes, who saw in them an escape from industrial tedium, and exciting career opportunities as professional sportsmen in cricket, football or the prize ring. These activities, although commemorated in engraved illustrations in sporting journals, became from a very early date the province of the photographer and not of the artist.

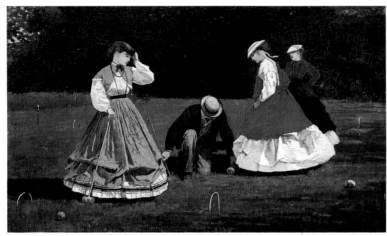

274

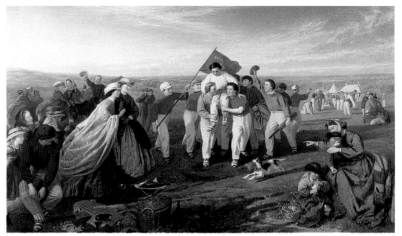

275

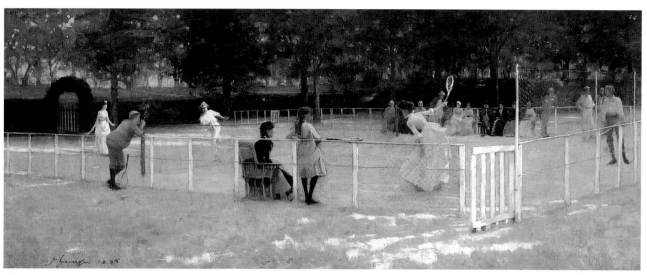

276

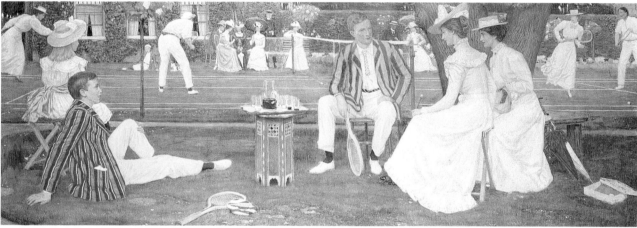

277

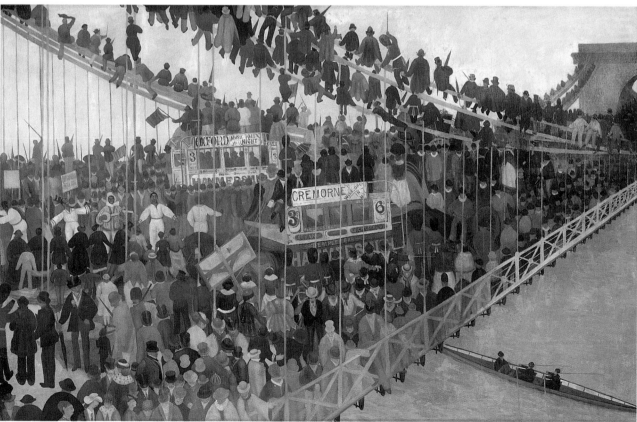

278

279
Edith Hayllar
A Summer Shower
1883
oil on canvas, 53.3 × 43.1cm
(21 × 17in)
Forbes Magazine Collection,
New York

280
Briton Rivière
Sympathy
1877
oil on canvas, 121.7 × 101.5cm
(48 × 40in)
Royal Holloway College,
University of London, Egham,
Surrey

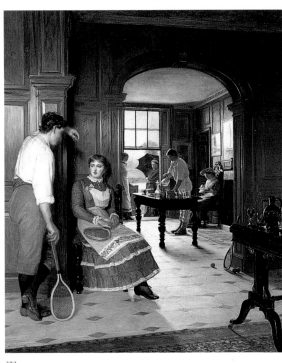

279

The late Victorian age also saw a growing enjoyment of games by both sexes in the greatly enlarged middle classes. Women, previously only able to practise archery, skate and play croquet, took with enthusiasm to the new game of lawn tennis which began in the early 1870s. Most of the initial credit for its invention must go to Major John Wingfield, who suggested that this game for players of all ages and both sexes might be played on ice as well as grass! Sphairistiké, as the new game was briefly known, was thought by some too taxing for women, others considering it only a woman's game. Both these points of view seem far removed from the enjoyable pursuit so engagingly portrayed by artists such as Edith Hayllar (1860–1948), in *A Summer Shower* (Pl. 279), and John Lavery and Charles March Gere (1869–1957), who both painted pictures entitled *The Tennis Party* (Pls. 276, 277).

The Henley Regatta and the Oxford and Cambridge Boat Race were all essentially middle-class events which also attracted vast popular interest from all sections of society. The excitement of one of these events is vividly captured in a painting by Walter Greaves (1846–1930), one of the most memorable 'primitive' painters of Victorian times, in a picture which invites comparison with the work of Le Douanier Rousseau (1844–1910). *Hammersmith Bridge on Boat Race Day* (Pl. 278) captures the tremendous excitement which the annual University Boat Race from Putney to Mortlake created in Victorian London, and the dense crowds which turned out to enjoy the event, recklessly climbing up the stanchions of the bridge. A horse omnibus caught in the traffic jam advertises the attractions of Cremorne Gardens, where Greaves often sketched his erstwhile friend Whistler.

It seems appropriate, however, to end this chapter, not with the vigorous game of tennis and the hotly contested annual struggle of the Boat Race, but with the sentimental British love of dogs as portrayed by Landseer's best-known follower, Briton Rivière (1840–1920), who was born in London into a family of French origin. His painting *Sympathy* (Pl. 280) shows a little girl who has been sent to bed early as a punishment sitting on the stairs being comforted by a dog. The artist recorded that he painted the little girl from his daughter Millicent, and the dog 'with slight alterations (as my animals are never portraits) was done from a bull terrier belonging to a man who has supplied me with dogs for some considerable time'. When exhibited it produced one of the soppiest of all Ruskin's reviews:

> It is long since I have been so pleased in the Royal Academy ... as I was by Mr Briton Rivière's *Sympathy*. The dog is uncaricatured doggedness, divine as Anubis, or the Dog-star; the child entirely childish and lovely, the carpet might have been laid by Veronese. A most precious picture in itself, yet not one for a museum. Everyone would think only of the story in it; everybody would be wondering what the little girl had done, and how she would be forgiven, and if she wasn't, how soon she would stop crying, and give the doggie a kiss, and comfort his heart ...

and so on in similar vein. The painting was purchased for £2,625 by Thomas Holloway, excluding the lucrative copyright retained by the dealers Agnews.

It is very easy indeed to make fun of a work such as *Sympathy*, and yet as a small boy in the Second World War the present writer was evacuated to a gloomy house in the New Forest full of large engravings of many of the Victorian paintings in this book. Among them I can recall works by Landseer, Millais and Rivière's *Sympathy* which hung on the stairs, and I can remember looking at it in the company of a black and white Labrador dog when in disgrace. The trouble with criticizing such works for their cloying sentiment is that they do capture some continuing moments of real experience. Scratch a cynic and you will always find a sentimentalist, a process which provides us with one of the fundamental keys to an understanding of Victorian genre painting.

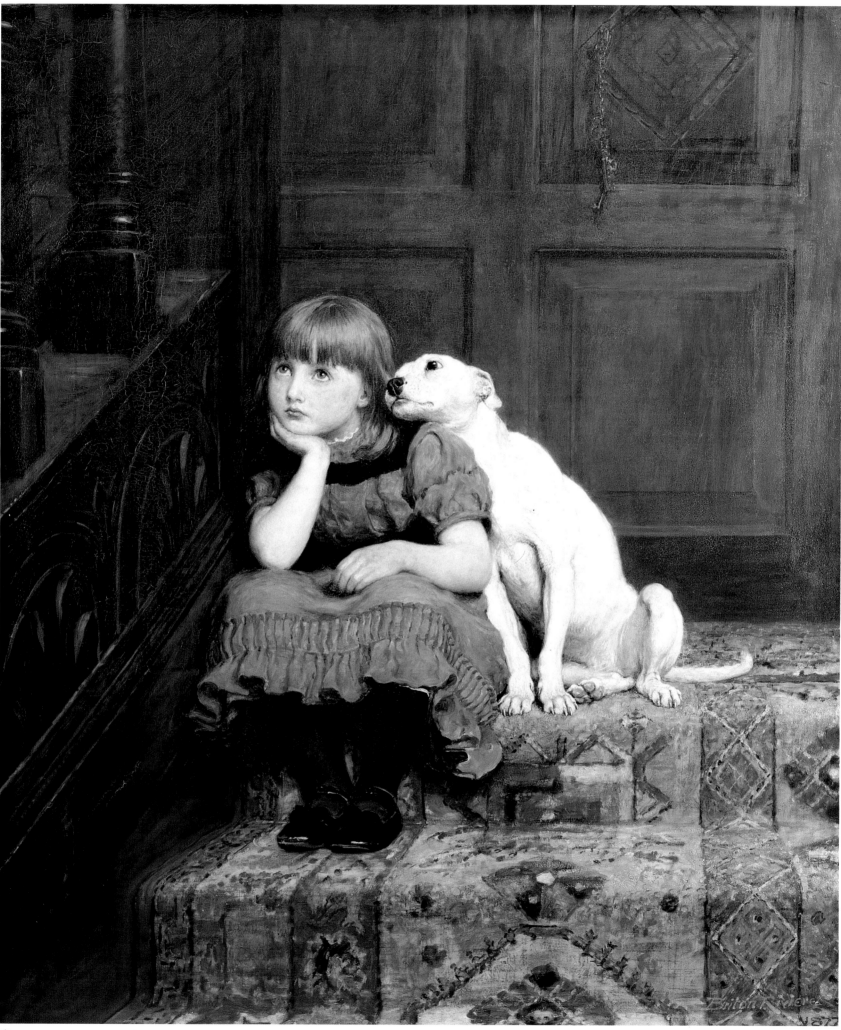

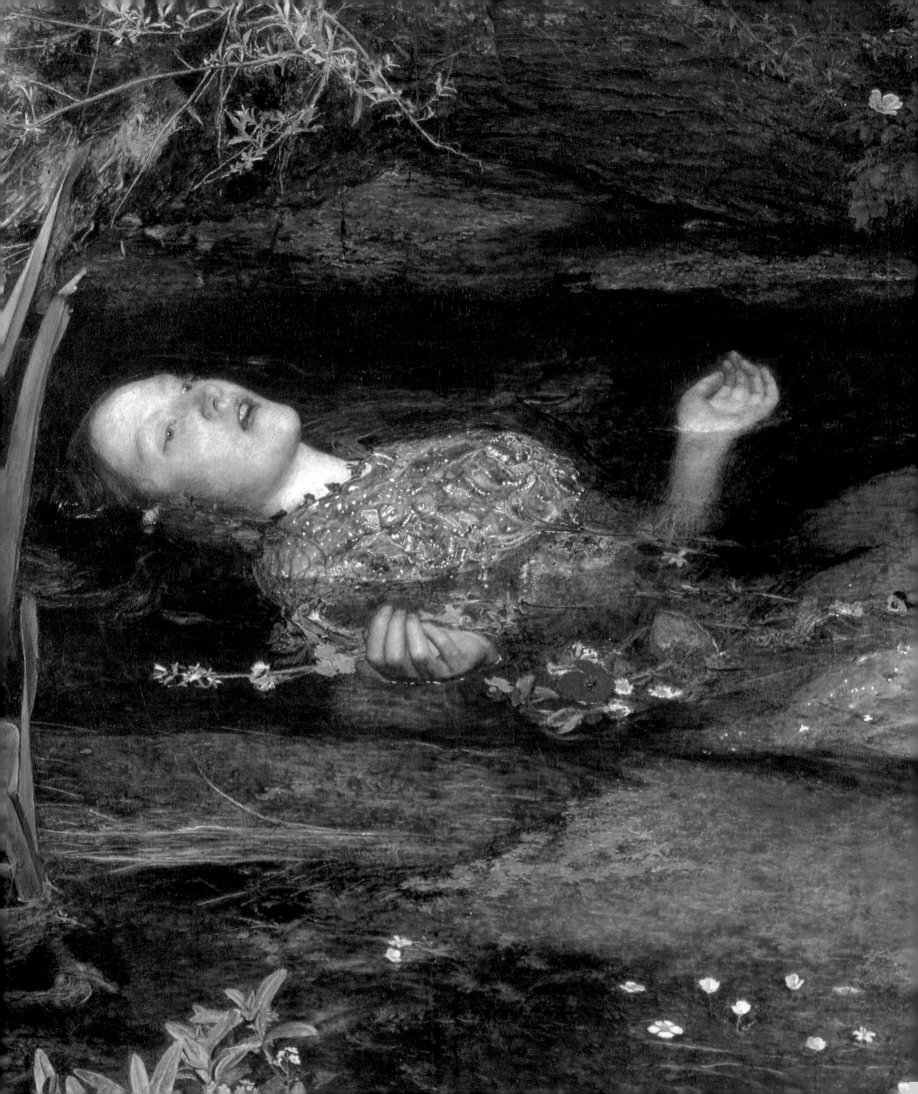

One. To have genuine ideas to express; Two. To study Nature attentively, so as to know how to express them;

Three. To sympathise with what is direct and serious and heartfelt in previous art, to the exclusion of what is conventional and self-parading and learnt by rote; and

Four. Most indispensable of all, to produce thoroughly good pictures and statues.

When William Michael Rossetti wrote these words in 1895, as a description of the Pre-Raphaelite Brotherhood's original aims, the group's activities had already passed into myth.

Myth is the quality that most ensures the recurrent fascination with the Pre-Raphaelite movement. For each successive generation the central myths of the story possess a fresh potency, an obsessive quality that constantly enthrals. The familiar dramas of the story

281 John Everett Millais, **Ophelia** (detail of Pl. 293)

282
Dante Gabriel Rossetti
The Girlhood of Mary Virgin
1848–9
oil on canvas, 83·2 × 65·4cm
(32¼ × 25¾in)
Tate Gallery, London

are told and retold: Millais painting Elizabeth Siddal immersed in a tin bath as Ophelia, unaware that the heating system had broken down; Holman Hunt in the Holy Land painting *The Scapegoat* with a rifle across his knees; Rossetti's menagerie at Cheyne Walk; the eternal triangle of Millais, Effie and Ruskin – all these stories possess the hallucinatory fascination of myth, legend or, in the exhumation of Lizzie Siddal to retrieve Rossetti's poems, a symbolic quality which was greatly to influence European art.

It is, however, a mistake to treat the Pre-Raphaelite Brotherhood in isolation from the other artistic developments of their time, which saw a wave of medievalism in every sphere of the arts from architecture to the initial letters and borders in Punch inspired by illuminated manuscripts. Another tenet of Pre-Raphaelite doctrine was a belief in the importance of contemporary subjects, and they, like others, tackled certain major social problems such as emigration and prostitution (Pls. 434, 471, 476).

1848 was a year of revolution in France, Germany and Italy. In London the Chartist movement made its demands for a major extension of male suffrage. This revolutionary fervour found an equivalent in the arts in an upstairs room in Gower Street, London, where a group of young men sat far into the night arguing the pros and cons of painting and expressing contempt for the academic tradition of Sir Joshua Reynolds, whom they dubbed Sir Sloshua.

On the strength of some engravings after Benozzo Gozzoli's frescos in the Campo Santo, Pisa, they came to the conclusion that art had taken a wrong turning after Raphael. They resolved to become revolutionary by looking backwards to the more direct, less idealized methods of painting before Raphael, the idol of the art world, who, they dared to think, was not altogether free from imperfections. Deeply serious, they attempted to infuse their paintings with emotion and poetry by depicting scenes not only from the Bible and Shakespeare, but also from the work of John Keats and new poems by Alfred Tennyson, appointed Poet Laureate in 1850. These lofty aims were later amusingly condensed by one member, James Collinson, in his journal for 6 January 1850. He outlined his plans for the year in a resolution to 'cut the Wilkie style of Art for the Early Christian'.

The mainspring of the group was a handsome young man with long dark curly hair, the son of an Italian political refugee from Naples whose love for the poet Dante had led him to name his son after him – Dante Gabriel. For Rossetti, son of a Neapolitan, it came naturally to turn the group into a secret brotherhood. This was a master stroke of publicity, for the mysterious initials PRB possessed from the first a remarkable ability to cause outrage and scandal.

The group was formed by Rossetti, William Holman Hunt, John Everett Millais, James Collinson, the sculptor Thomas Woolner, Frederick George Stephens and Rossetti's brother William Michael (1829–1919), who became the historian of the group's activities. An elder statesman, not actually a member, was Ford Madox Brown, who had visited Rome and worked with the Nazarenes (see above, p. 44).

What made this group different from other groups discussed elsewhere was the sheer ability of three of its number. The charismatic Rossetti was both the most sensual of Victorian painters and a poet of great romantic power; Holman Hunt, the keenest adherent to the group's idealistic aims, was an artist with remarkable painstaking powers of realistic delineation; while Millais from childhood had been groomed to become one of the most accomplished narrative artists of his time. Today we feel unusually close to the troubled and intense lives and loves of these long dead men and women, perhaps because of their practice of using each other as models, creating an illusion that we know them almost personally.

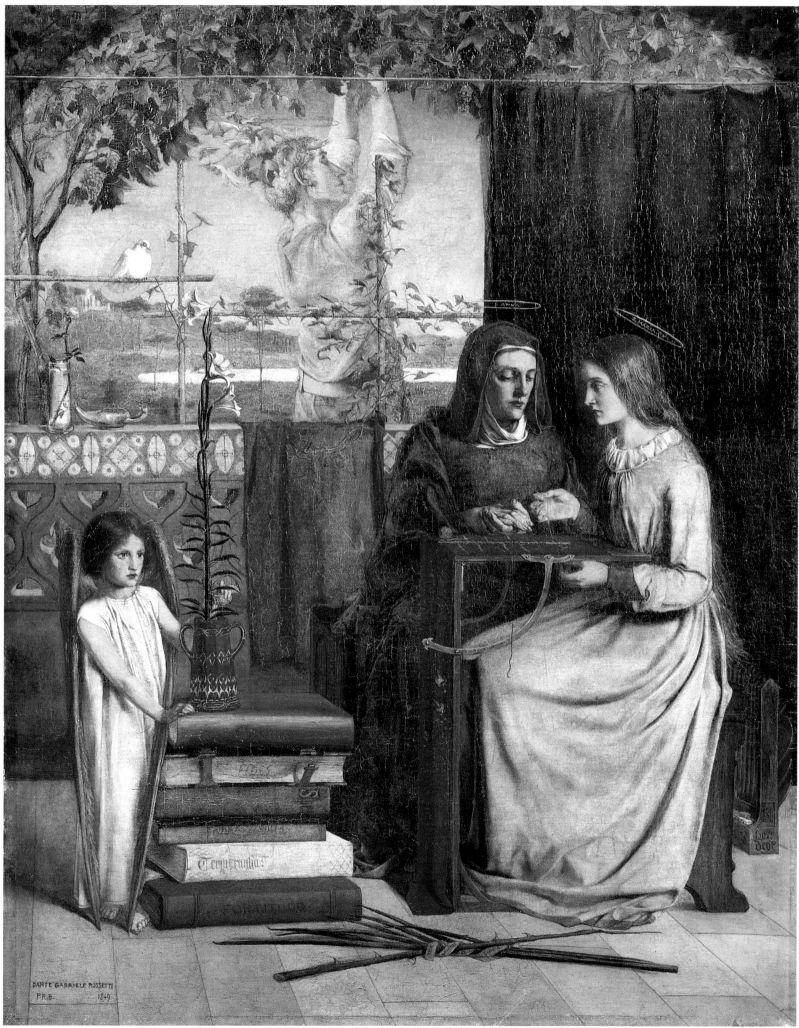

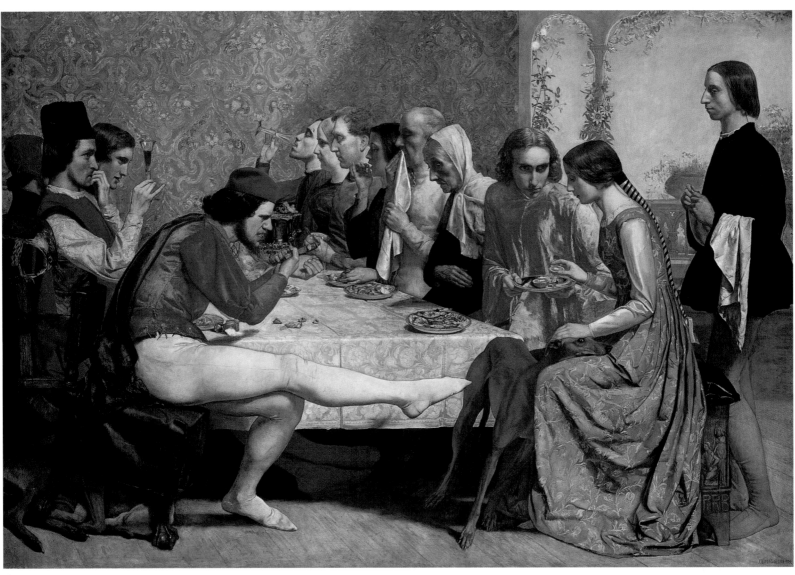

Working at a time when photography was changing methods of perceiving nature, the Pre-Raphaelites vied consciously to surpass the penetrating analysis of the camera's lens. They painted with meticulous observation of external reality, an intense 'fidelity to nature' championed by Ruskin. The first of their monthly meetings was held in the autumn of 1848, and in 1849 Hunt, Rossetti and Millais all exhibited their first paintings bearing the cryptic monogram PRB.

The first such painting to be exhibited was Rossetti's first major oil, *The Girlhood of Mary Virgin* (Pl. 282), for which his sister, the poet Christina, sat for the Virgin and his mother for Saint Anne. Two sonnets inscribed on the frame explain the complex religious symbolism of details of the painting such as the lamp, the palm leaves, the thorn branches, the lilies and the embroidered red cloth. His friend William Bell Scott described Rossetti painting the picture 'in oils with watercolour brushes, as thinly as in watercolour, on canvas which he had primed with white till the surface was as smooth as cardboard, and every tint remained transparent'. In this technique Rossetti strove to emulate the early Italian 'primitives', as they were described by Sir

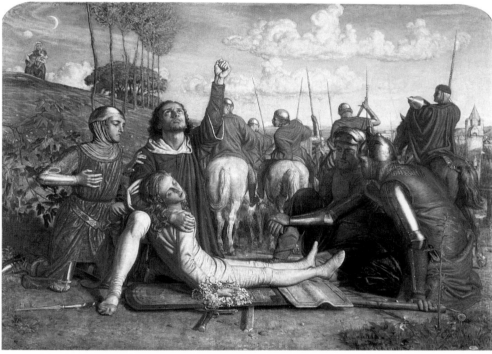

284

Charles Eastlake, the Director of the National Gallery, in his pioneering *Materials for a History of Oil Painting* (1847, 1869), one of the greatest books on the craft of painting yet published.

The painting was shown at the Free Institution at Hyde Park Corner, while Millais's *Isabella* (Pl. 283) and Holman Hunt's *Rienzi* (Pl. 284), both also bearing the cryptic PRB acronym, were shown at the Royal Academy and were well received by the press. Holman Hunt's painting was an appropriately revolutionary subject with the lengthy title *Rienzi Vowing to Obtain Justice for the Death of his Young Brother, Slain in a Skirmish between the Colonna and Orsini Factions*. Inspired by Bulwer-Lytton's novel *Rienzi* (1835), it reflects not only contemporary interest in the struggle for freedom in Italy, but also Hunt's involvement closer to home with the great Chartist meeting on Kennington Common for worker's rights, echoed perhaps in Rienzi's clenched fist.

By May of the following year, 1850, four numbers of a PRB journal entitled *The Germ* had been published and the secret of what the monogram stood for was out.

283
John Everett Millais
Isabella
1848–9
oil on canvas, 102.9 × 142.9cm
(40½ × 56¼in)
Walker Art Gallery, Liverpool

284
William Holman Hunt
Rienzi Vowing to Obtain Justice for the Death of his Young Brother, Slain in a Skirmish between the Colonna and Orsini Factions
1848–9
oil on canvas, 86.3 × 122cm
(34 × 48in)
Private collection

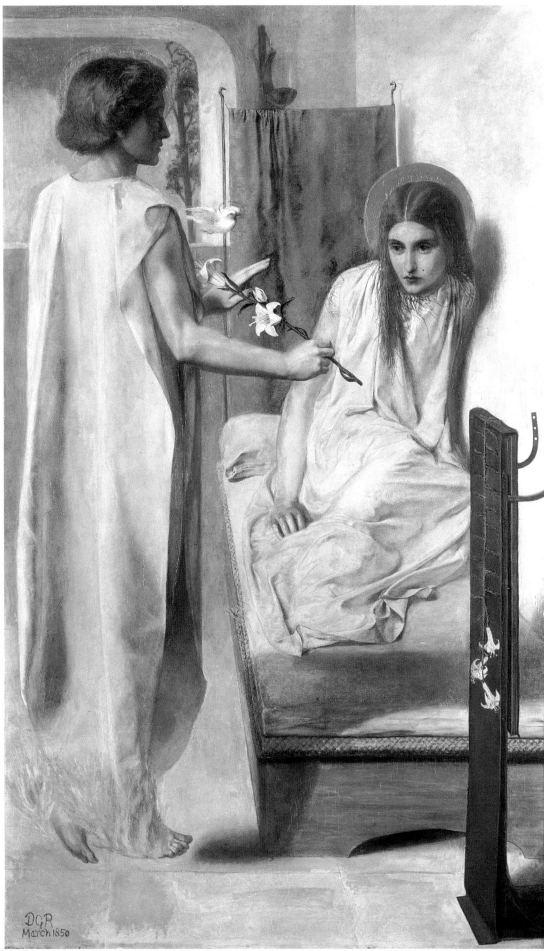

Today it is difficult to understand quite why what we would now describe as a 'media' storm should burst upon the movement in 1850. But two main preoccupations of the British public at the time were a fear of revolutionary secret organizations or 'brotherhoods', and acute concern over the drift towards Roman Catholicism in the Anglican Church caused by the Oxford Movement. Both threats appear to emerge in Rossetti's painting of the Annunciation, *Ecce Ancilla Domini* (Pl. 285), for the original frame bore 'Popish' Latin mottoes.

The storm really broke over Millais's *Christ in the House of His Parents* (Pl. 286), the argumentative sensation of the Royal Academy exhibition of 1850. Millais had used a real carpenter to model for the arms of Joseph. The public did not like this realism or the symbolism revealed in the Christ Child's hand which has been hurt and bleeds, prefiguring the Crucifixion and the nails of the Cross. These qualities

285
Dante Gabriel Rossetti
Ecce Ancilla Domini
1849–50
oil on canvas, 72.6 × 41.9cm
(28⅝ × 16½in)
Tate Gallery, London

286
John Everett Millais
Christ in the House of His Parents
1849–50
oil on canvas, 86.4 × 139.7cm
(34 × 55in)
Tate Gallery, London

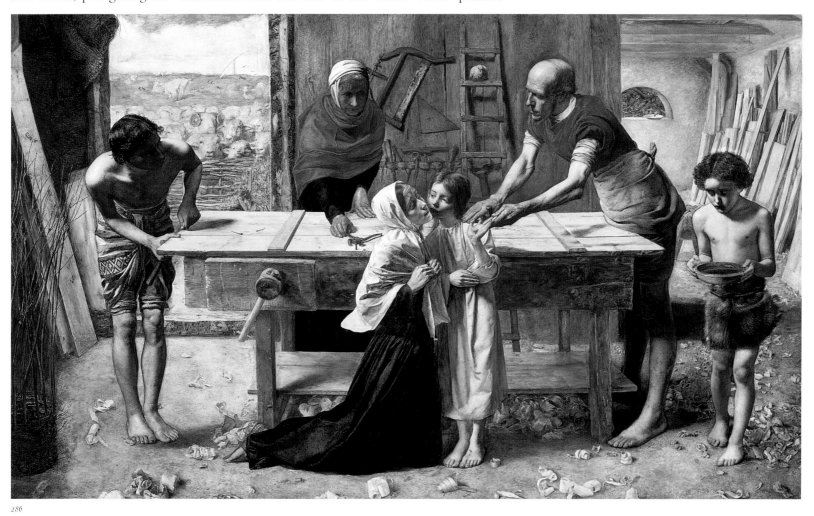

286

were denounced by Charles Dickens, who disliked the work intensely, and although in later years he had the good grace to retract what he had written, and became a close friend of Millais, it is worth quoting his diatribe to give an idea of the virulence of public hostility to Pre-Raphaelite aims. He wrote:

> You behold the interior of a carpenter's shop. In the foreground … is a hideous, wry necked, blubbering, red headed boy, in a bed gown, who appears to have received a poke in the hand, from the stick of another boy with whom he has been playing in an adjacent gutter, and to be holding it up for the contemplation of a kneeling woman, so horrible in her ugliness that she would stand out … in the vilest cabaret in France or in the lowest gin shop in England.

Millais particularly disliked the criticism of *The Times*, which found the painting's

287
John Everett Millais
**The Return of the Dove to
the Ark**
1851
oil on canvas, 87.6 × 54.6cm
(34¼ × 21½in)
Ashmolean Museum, Oxford

288
Charles Collins
Convent Thoughts
1850–1
oil on canvas, 82·6 × 57·8cm
(32½ × 22⅞in)
Ashmolean Museum, Oxford

289
William Holman Hunt
Claudio and Isabella
1850–3
oil on canvas, 77·5 × 45·7cm
(30½ × 18in)
Tate Gallery, London

287

'loathsome minuteness' 'disgusting', and also attacked Holman Hunt's *A Converted British Family Sheltering a Christian Missionary from the Druids* (1849–50) for being too Tractarian and 'High Church'.

Millais asked his friend, the poet Coventry Patmore, to persuade Ruskin to defend his painting, which he did initially in letters to The Times, later in 1851 issuing a pamphlet on Pre-Raphaelitism praising especially Hunt's work, which he compared to Dürer. Ruskin was also persuaded to look sympathetically at the Pre-Raphaelites' work by the mural and landscape painter William Dyce, who had studied with the Nazarenes and was himself to follow Pre-Raphaelite principles in his later work. Ruskin's intervention was crucial in the development of Victorian art. He became closely identified with the new movement, indeed virtually a Pre-Raphaelite prophet.

Undeterred by the adverse criticism he had received in 1850, Millais exhibited another religious work, *The Return of the Dove to the Ark*, in 1851 (Pl. 287). It was purchased by one of the perceptive patrons who helped the Pre-Raphaelites in their difficult early years, Thomas Combe, who had already bought Hunt's Missionary and now also purchased *Convent Thoughts* (Pl. 288) by Charles Collins (1828–73). The three religious works hanging side by side like a triptych must have made a fine sight. The lilies, water-lilies and the passion flower held by the nun in Collins's work were all painted from nature in Combe's own garden in the quadrangle of the Clarendon Press in Oxford.

Millais turned to more literary themes for his two other exhibits in 1851, choosing a poem by his friend Coventry Patmore, 'The Woodman's Daughter' and Tennyson's 'Mariana'. Holman Hunt selected a subject from Shakespeare's *The Two Gentlemen of Verona*, a scene of great sexual tension, *Valentine Rescuing Sylvia from Proteus* (1850–1), in which Valentine saves his beloved Sylvia (posed by Elizabeth Siddal) from rape by his best friend Proteus. Such scenes of frustrated sexuality had a particular interest for Holman Hunt. In 1850, spurred on by a commission from Augustus Egg, who himself later painted *Past and Present* (see Pls 462–4), Hunt began work on *Claudio and Isabella* (Pl. 289), another Shakespearean theme from *Measure for Measure*. In the painting we see Claudio in chains unjustly imprisoned. His life will only be spared if his sister Isabella yields herself to the lustful Angelo, the villain of the play. Isabella's purity is symbolized by her dress, a simple white habit which shows that she is a member of the order of Saint Clare, and the blossom seen through the bars of the cell. Hunt would use the latter device in a more sophisticated form in the mirror reflecting nature in *The Awakening Conscience* (Pl. 476), not a respectable Shakespearean subject but the powerful contemporary sexual theme of the 'kept woman'. Rossetti also decided in 1854 to confront directly the problem of prostitution in his explicit painting *Found* (Pl. 471), a theme which he had long been gestating.

The model for the figure of the carter in Found was Rossetti's close friend Ford Madox Brown. Born at Calais, Brown had studied at the Academies of Bruges, Ghent and Antwerp. His early works were painted in what he called a 'sombre Rembrandtesque style', but after seeing works by Holbein at Basle and visiting the Nazarenes Cornelius and Overbeck at Rome in 1845, he adopted a lighter palette. His painting *Chaucer at the Court of Edward III* (Pl. 290) was first exhibited at the Royal Academy in 1851. 'It was', Brown remarked, 'the first picture in which I endeavoured to carry out the notion, long before conceived, of treating the light and shade absolutely as it exists at any one moment, instead of approximately, or in generalised style.' Just before the sending-in day in April 1851 Rossetti sat from eleven o'clock at night till four in the morning for the portrait of Chaucer which dominates

288

289

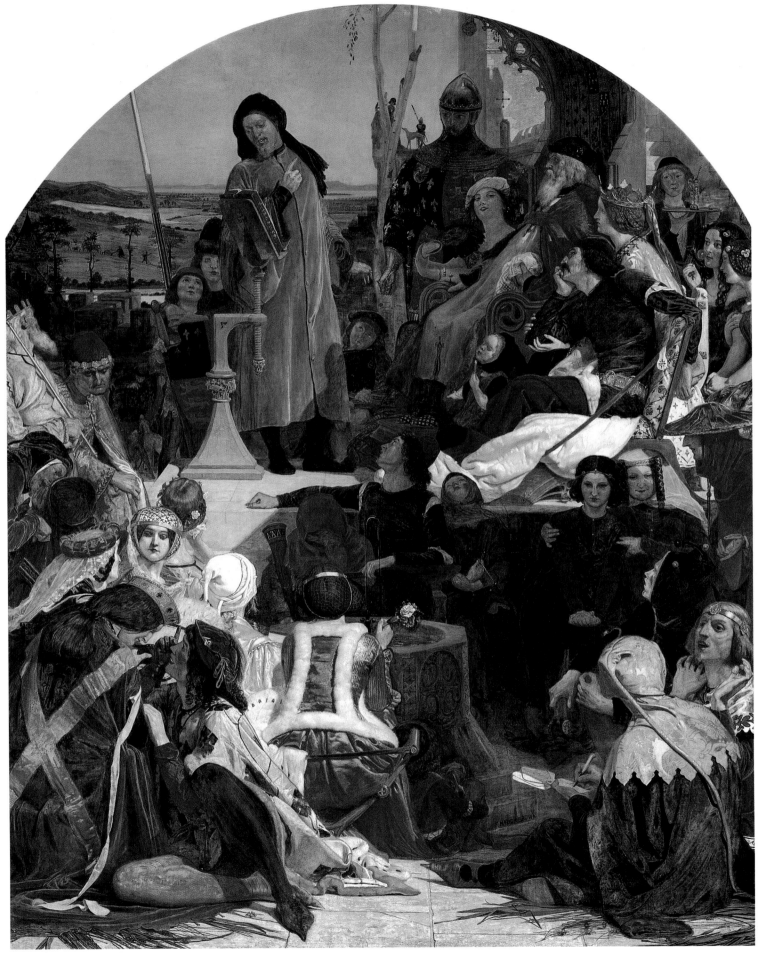

the composition. Brown's long-term project was *Work* (Pl. 291), on which he laboured in 1852, and from 1856 to 1865. It was an elaborate allegory about manual and mental work – Brown particularly admired the British navvy seen here digging, but spending all he earns on beer. He also put in the picture brain workers like the writer Thomas Carlyle, who, according to the artist's accompanying statement: 'seeming to be idle, work, and are the cause of well-ordained work and happiness in others'.

In *The Hireling Shepherd* (Pl. 292) Holman Hunt tried the daring experiment of setting an incident from a play by Shakespeare in a contemporary setting. The painting was inspired by Edgar's song in *King Lear*:

290
Ford Madox Brown
Chaucer at the Court of Edward III
1846–51
oil on canvas, 372 × 296cm
(146¼ × 116⅝ in)
Art Gallery of New South Wales, Sydney

291
Ford Madox Brown
Work
1852, 1856–65
oil on canvas, 137 × 197·5cm
(54 × 77¾ in)
Manchester City Art Gallery

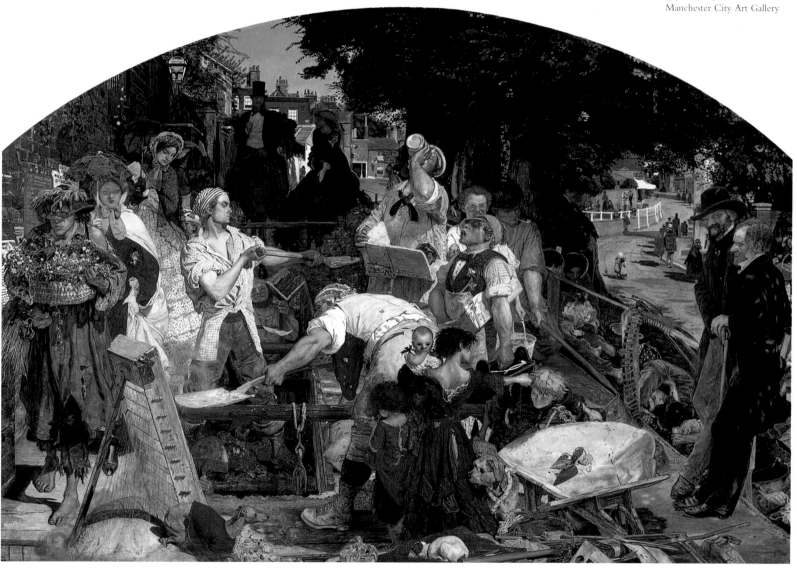

291

Sleepest or wakest thou, jolly shepherd?
Thy sheep be in the corn:
And, for one blast of thy minikin mouth,
Thy sheep shall take no harm.

'My first object', wrote Hunt many years later, 'was to pourtray [sic] a Real Shepherd and Shepherdess … sheep and absolute fields and trees and sky and clouds instead of the painted dolls with pattern backgrounds called by such names in the pictures of the period.' In many days of hard work at Ewell, Surrey, in the summer of 1851, Hunt painted the background to the picture in meticulous detail. The sheep proved

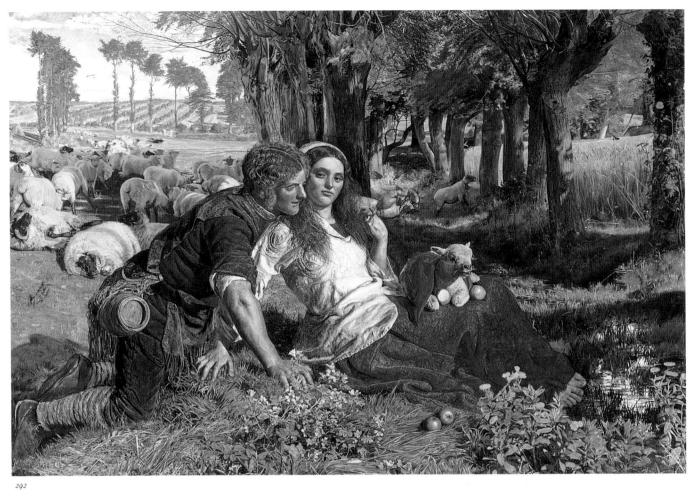

292

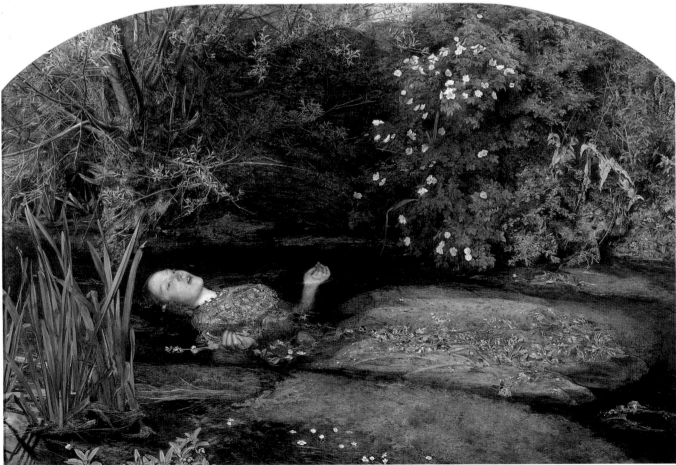

293

particularly intractable models, who had to be held down by servants, and Hunt only finally completed painting them in early December, when he returned to London to finish the human figures.

Reviewers commented on the ruddy features of the lovers, which they attributed to 'over-attention to the beer or cyder keg', and certainly the painting can be interpreted as an indictment of intemperance, for the barrel slung from the shepherd's waist refers to the very common practice of supplying beer to field workers in lieu of pay. The couple's negligence has led to the evil consequences of the lamb eating green, unripe apples, and the untended sheep straying in the meadow, both potentially fatal disasters symbolized by the Death's Head Moth which the shepherd shows his sweetheart.

While Hunt worked on the painting, he shared lodgings with Collins and Millais, who was working on another Shakespearean theme, *Ophelia* (Pl. 293), exhibited at the Royal Academy in 1852. It illustrates the tragic end of the heroine of Hamlet. Driven mad, Ophelia has picked flowers by the stream:

> Her clothes spread wide,
> And, mermaid-like, awhile they bore her up;
> Which time she chanted snatches of old tunes …
> Till that her garments, heavy with their drink,
> Pull'd the poor wretch from her melodious lay
> To muddy death.

With amazing skill and botanical fidelity, all the flowers mentioned in the text of the play are depicted in a remarkable demonstration of the Pre-Raphaelite principle of truth to nature. The model for the picture was Elizabeth Siddal (1829–62), whom Rossetti eventually married in 1860 after long years of indecision. She posed in a bath full of water kept warm by lamps placed underneath, but the heating failed and she caught a severe chill. Elizabeth Siddal was to occupy a central role in the Pre-Raphaelite movement, for her beauty was to inspire some of Rossetti's greatest works, while she herself produced drawings and watercolours which were praised by Ruskin for their direct power (Pl. 375).

Hunt turned from Shakespearean themes to the Bible for one of his main exhibits in 1854, *The Light of the World* (Pl. 295), perhaps the most famous religious painting of the century, which hangs in Keble College, Oxford. It was shown with the text from Revelations (3:20): 'Behold, I stand at the door, and knock: if any man hear my voice, and open the door, I will come in to him, and will sup with him, and he with me.' Millais noted in his diary at Ewell on 4 November 1851, 'This evening walked out in the orchard (beautiful moonlight night, but fearfully cold) with a lantern for Hunt to see effect.' Via the medium of engravings and chromolithographs, this painting was to become a Protestant icon. Hunt made two other versions of the picture; the larger one, now in St Paul's Cathedral, was toured extensively in Australia and elsewhere during the Victorian era.

While Millais and Hunt eventually succeeded in making their new works annual attractions at the Royal Academy, Rossetti, increasingly infatuated with early Italian art and poetry and medieval fantasy, fastidiously eschewed its walls. Indeed, after the harsh reception of *Ecce Ancilla Domini* he rarely exhibited publicly again, preferring to drive hard bargains with dealers and cultivate individual patrons. In the 1850s he concentrated upon his obsessively worked, colour-saturated watercolours or elaborate pen and brush studies of such mysterious themes as the 'Doppelgänger', as in *How They Met Themselves* (Pl. 294), which shows two medieval lovers meeting themselves in a dark wood. Increasingly his favourite themes were subjects which enabled him to use Lizzie as model, whether as the Virgin Mary, Dante's Beatrice or

292
William Holman Hunt
The Hireling Shepherd
1851
oil on canvas, 76·4 × 109·5cm
(30 × 43⅛in)
Manchester City Art Gallery

293
John Everett Millais
Ophelia
1851–2
oil on canvas, 76·2 × 111·8cm
(30 × 44in)
Tate Gallery, London

294
Dante Gabriel Rossetti
How They Met Themselves
c.1850–60
bodycolour, 33.9 × 27.3cm
(13⅜ × 10¾in)
Fitzwilliam Museum,
Cambridge

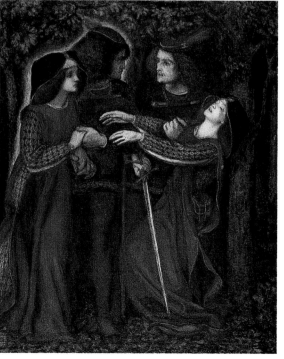

294

295
William Holman Hunt
The Light of the World
1851–3
oil on canvas, 125.5 × 59.8cm
(49⅜ × 23½in)
Keble College, Oxford

296
William Holman Hunt
**Our English Coasts, 1852
(Strayed Sheep)**
1852
oil on canvas, 43.2 × 58.4cm
(17 × 23in)
Tate Gallery, London

297
William Holman Hunt
The Scapegoat
1854–5
oil on canvas, 85.7 × 138.4cm
(33¾ × 54½in)
Lady Lever Art Gallery,
Port Sunlight, Liverpool

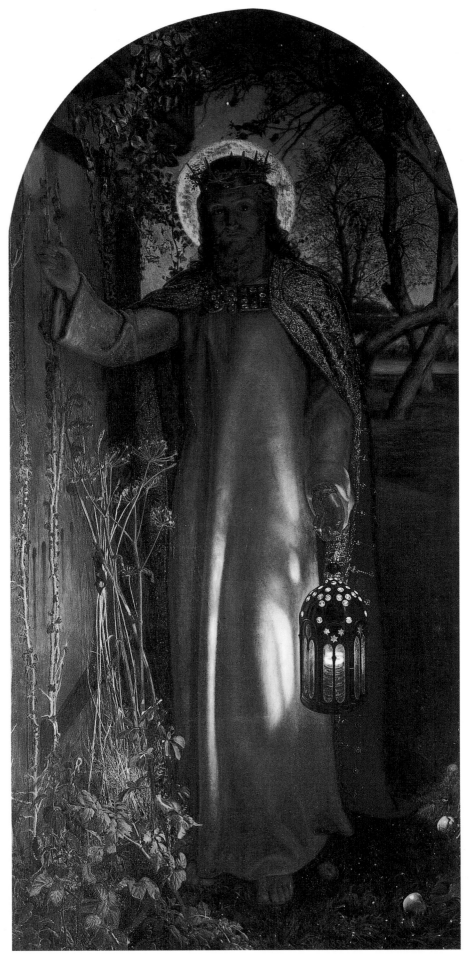

295

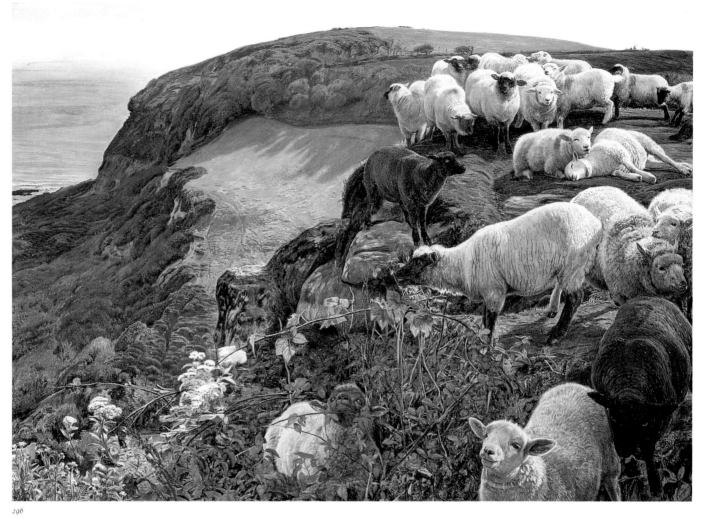

296

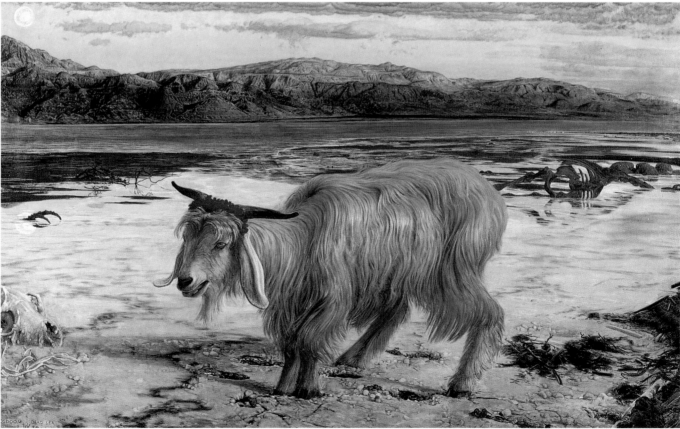

297

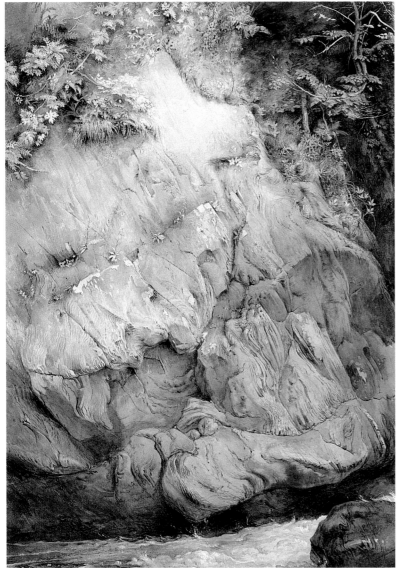

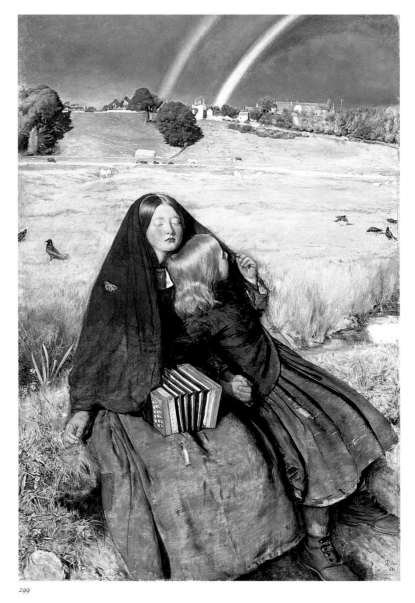

298 *299*

Queen Guinevere. The Arthurian stories as retold by Tennyson in *The Idylls of the King* took centre stage in the mid-1850s, culminating in the 1857 decoration of the Oxford Union building. Rossetti could not do this on his own, so he enlisted a group of younger friends to help him (see above, pp. 50–1).

In 1852 fears of a French invasion were current owing to the activities of Napoleon III. According to his friend Frederick Stephens, Hunt painted *Our English Coasts, 1852 (Strayed Sheep)* (Pl. 296) as a satire 'on the reported defenceless state of the country against foreign invasion'. It is set on the cliffs near Hastings on a sunny day. Clearly, Hunt enjoyed depicting sheep both as symbols and because their wool was perfectly adapted to the stippling technique at which he so excelled and which he would soon use to paint another ruminant species, a goat. When the painting was shown in Paris in June 1855, the threat of war having passed, Delacroix found himself 'really astounded by Hunt's sheep' and called the Pre-Raphaelites 'the Dry School', admiring their 'feeling for truth towards what is real and characteristic in detail'.

On 13 January 1854 Hunt set off to Egypt and the Holy Land to paint the Bible stories where they had taken place, accompanied for some of his visit by the land-scape painter Thomas Seddon (1821–56). In Leviticus Hunt had come across an account of a Day of Atonement ritual in which two goats were selected as symbols of the Jews' annual expiation of their sins. One was sacrificed in the Temple, the

other 'presented alive before the Lord, to make an atonement with him, and to let him go for a scapegoat into the wilderness'. For Hunt *The Scapegoat* (Pl. 297), painted in the wilderness by the Dead Sea, paralleled its human counterpart *The Awakening Conscience*. He saw both animal and woman as exploited victims, and his urge to paint this subject became an obsession. He purchased a goat and brought it to his camp at Oosdoom where the Dead Sea ends in a salt marsh, near the site of the biblical Sodom, the decadent city of the plains. Tethered out in the sun, the goat died. Another was purchased, and Hunt painted on, adding a scarlet garland to the goat's horns as a symbolic antecedent of Christ's crown of thorns, and in reference to the text in Isaiah: 'though your sins be as scarlet, they shall be as white as snow; though they be red like crimson, they shall be as wool.'

With Hunt's departure for Egypt in 1854, the PRB, never a very cohesive group, began to fragment. Millais became ensnared in one of the most scandalous and distressing Victorian love stories. He had become friendly with Ruskin in 1853 when Ruskin's wife Effie (Euphemia Gray) had modelled for Millais's Jacobite history painting set in 1746, the prophetically named *The Order of Release*. The two men and Effie went on holiday together that summer to Brig o' Turk in the Trossach hills of Scotland, where they stayed for nearly four months. During that time Millais began his famous portrait of John Ruskin (see Pl. 31) standing in the middle of a rocky stream. Millais at first tried out a treatment of the subject in a small painting, *A Waterfall in Glenfinlas* (1853), using Effie as a model, and during the process began to realize that the Ruskins' marriage was a sham. He formed an attachment with Effie which would lead to their own marriage two years later, after her bond with Ruskin had been annulled in July 1854 on the grounds of non-consummation. Although produced under such tension, the resultant portrait is one of the great masterpieces of the nineteenth century. Millais paints Ruskin standing on gneiss rock, associated with the lava of volcanic eruptions. Ruskin, who made his own *Study of Gneiss Rock at Glenfinlas* (Pl. 298), was to describe the volcanic rock in the fourth volume of Modern Painters as 'the symbol of a perpetual fear'. This symbol of natural turbulence matches in intensity the seething cauldron within Ruskin's own mind in failing to come to terms with his own sexuality.

While his private life was in such turmoil, Millais painted several modern-life subjects, notably *The Blind Girl* (Pl. 299), which he exhibited at the Royal Academy

298
John Ruskin
Study of Gneiss Rock at Glenfinlas
1853
pen and ink with wash,
47.8 × 32.8cm (18¾ × 17⅞in)
Ashmolean Museum, Oxford

299
John Everett Millais
The Blind Girl
1854– 6
oil on canvas, 82.6 × 62.2cm
(32½ × 24½in)
Birmingham City Museum
and Art Gallery

300
Dante Gabriel Rossetti
Bocca Baciata
1859
oil on wood, 33.7 × 30.5cm
(13¼ × 12)
Museum of Fine Arts, Boston

301
Dante Gabriel Rossetti
Regina Cordium
1860
oil on canvas, 25.4 × 20.3cm
(10 × 8in)
Johannesburg Art Gallery

302
Dante Gabriel Rossetti
Helen of Troy
1863
oil on canvas, 32.8 × 27.2cm
(12¾ × 10½in)
Kunsthalle, Hamburg

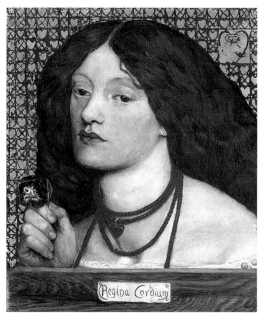

300

301

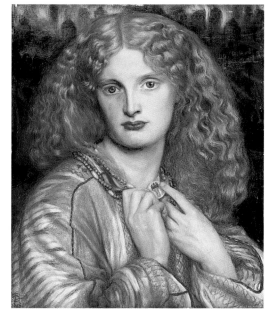

302

303
James Collinson
**The Renunciation of Queen
Elizabeth of Hungary**
1850
oil on canvas, 121.7 × 184cm
(48 × 72½in)
Johannesburg Art Gallery

in 1856. It was completed at Perth in Scotland, where Millais and Effie had gone for their honeymoon, although the background was painted at Winchelsea in Sussex. Perhaps no more touching example of the use of detail in a Pre-Raphaelite painting exists than the tortoiseshell butterfly spreading its wings upon the plaid draped around the blind girl's shoulders. She touches a blade of grass, and in her lap she holds a concertina; although unable to see the beauty of the butterfly she can still use her remaining senses of touch and hearing, and smell the fresh air of the countryside. Both *The Blind Girl* and *Autumn Leaves*, also exhibited in 1856, show Millais's abilities at their best; they also mark the close of Millais's Pre-Raphaelite years, for in the next forty years his style and aims would undergo radical changes.

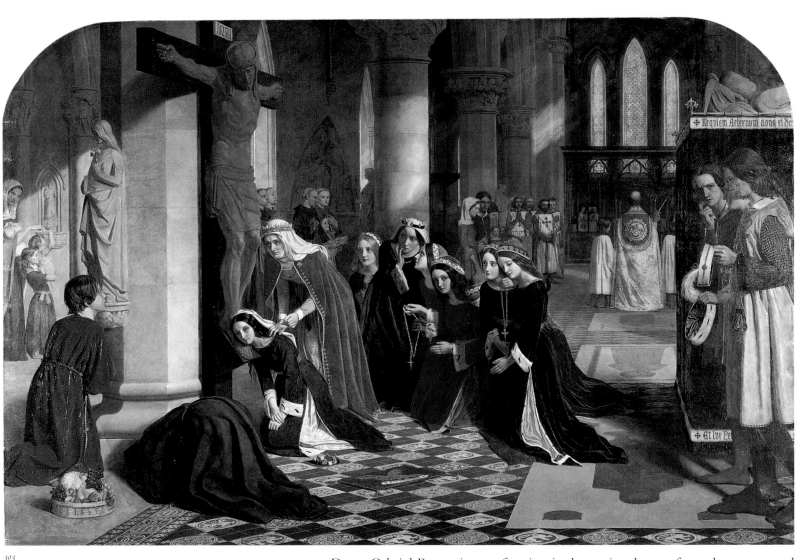

303

Dante Gabriel Rossetti was often inspired to paint themes from the poetry and life of his namesake, Dante, such as *The First Anniversary of the Death of Beatrice (Dante Drawing an Angel)* (1853). He later began increasingly to visualize Lizzie Siddal as Beatrice. This leitmotif recurs again and again in the romantic story of their lives, throughout their ten-year engagement and two years of marriage, during which Rossetti made many wonderful portrait drawings of her, among the most beautiful drawings ever made by a man of a woman. Christina Rossetti wrote a poem about these studies, with the haunting line: 'One face looks out of all his canvases'.

In reality, of course, she was not his only inspiration, and in 1859 Rossetti began to paint a series of small, intense portraits of women, all roughly the size of this page, which are some of his most remarkable works. Of them he wrote, 'I am very desirous

of painting, whenever I can find leisure and opportunity, various figures of this kind, chiefly as studies of rapid flesh painting.' Taken together, *Bocca Baciata* (Pl. 300), model Fanny Cornforth, *Regina Cordium* (Pl. 301), model Elizabeth Siddal, and *Helen of Troy* (Pl. 302), model Annie Miller, have an almost palpable presence – direct statements which tell us of Rossetti's involved love affairs. *Bocca Baciata* literally translates as 'the kissed mouth' and derives from a sonnet by Boccaccio with lines which read: 'The mouth that has been kissed loses not its freshness; still it renews itself even as does the moon', hinting at the robust, direct sensuality of Rossetti's relationship with Fanny, very different from his more spiritualized partnership with Lizzie Siddal, his *Regina Cordium*. With Annie Miller, the model for *Helen of Troy*, the story becomes even more complex. From a poor background, Annie had modelled for the courtesan in Hunt's *The Awakening Conscience*. Like Professor Higgins in Pygmalion, Hunt tried to educate her and turn her into a 'lady'. While away in the Middle East Hunt left instructions with his friend Stephens as to whom Annie might meet; Rossetti was pointedly excluded from the list, which inevitably led him to begin an affair with Annie. When Hunt returned the affair died down, but Rossetti's relationship with Hunt, never very friendly, ceased. Rossetti continued to use Annie as a model alongside others, some whom he met by chance, such as Ford Madox Brown's maid who posed for *Girl at a Lattice* (1862).

Rossetti was a shrewd businessman, well aware that while major works got discussed, smaller-scale head-and-shoulder paintings of beautiful women sold. Pictures of single girls in elegant costume were extremely popular in early Victorian England, appearing in volumes of poetry with engraved illustrations known as Keepsakes or Books of Beauty. Although the Pre-Raphaelites affected to scorn the triviality of such works, many of Rossetti's and Millais's most successful early paintings are small single figures of women.

While Millais, Hunt and Rossetti began to go their separate ways, what of the other members of the Brotherhood? James Collinson (1825–81), like many idealistic young men of the period, had a religious leaning to Catholicism and latterly the priesthood, which brought his engagement to Christina Rossetti to a frustrating end. In 1849 and 1850 he painted three 'modern-day' subjects, the first depicting itinerant *Italian Image Makers at a Roadside Alehouse*, the other two on emigration themes discussed elsewhere (Pl. 433). His most compelling Pre-Raphaelite work, however, is *The Renunciation of Queen Elizabeth of Hungary* (Pl. 303), an incident full of ritualistic interest as the Queen casts away her crown and prostrates herself at the foot of the crucifix.

Collinson resigned from the PRB in 1850 and entered the Jesuit college at Stonyhurst, but on losing his vocation for the priesthood he left in 1854 and resumed the painting of genre subjects, notably two oval paintings, *For Sale* (Pl. 304) and *To Let*, both exhibited in 1857 and both with ambiguous titles. Until his death in 1881, Collinson repainted these early successes many times. Each features an attractive woman, the younger with an empty purse at a church bazaar, the other a plump beauty placing a 'To Let' sign in a window above pots containing a lily and a 'Bleeding Heart'. Victorian eyes alert to the 'language of flowers' would surely have noted the lady's dark costume and wedding ring, and interpreted the subject as a variation on the theme of the amorous widow, made famous by Mr Pickwick's landlady Mrs Bardell. In what is now the Tate Gallery's version of *For Sale*, viewers would have noticed on the table a small religious print of *Christ bearing the Cross*, inscribed 'follow me'.

When Collinson resigned from the PRB, William Howell Deverell (1827–54) was proposed for membership by Rossetti, with whom he shared rooms. It was

304
James Collinson
For Sale
*c.*1857
oil on canvas, 58.4 × 45.7cm
(23 × 18in)
Castle Museum and
Art Gallery, Nottingham

304

305
Frederick George Stephens
Mother and Child
1854–6
oil on canvas, 47 × 64.1cm
(18½ × 25¼in)
Tate Gallery, London

306
William Howell Deverell
The Grey Parrot
1852–3
oil on canvas, 53.5 × 35.2cm
(21 × 13⅞in)
National Gallery of Victoria,
Melbourne

Deverell who 'discovered' Elizabeth Siddal working as a milliner in Leicester Square and persuaded her to sit for a Shakespearean subject – *Twelfth Night* (1849–50). He was never actually elected to the group, which was by this stage disintegrating. Although Deverell died in 1854 aged only 27, a handful of paintings reveal a real talent, notably the portrait *The Grey Parrot* (Pl. 306).

After training at the Royal Academy Schools, Frederick George Stephens (1828–1907) became a founder member of the PRB in 1848, nominated by his friend Holman Hunt. Painting soon proved the wrong career choice, for portentously his first picture, a *Morte d'Arthur*, remained unfinished, a fate which met other works, culminating in Stephens declaring 'with satisfaction' but inaccurately that he had destroyed all his paintings, and turning to his real metier as a writer and art critic. One picture to survive the holocaust was *Mother and Child* (Pl. 305), a tragic commentary on the Crimean War which broke out in March 1854, symbolized by the toy hussar and British lion the child is playing with on the table. The letter the grief-stricken woman is holding announces the loss of her soldier husband at the front.

Although the original group fragmented, its doctrines began to attract other young artists, who, fired by enthusiasm for Pre-Raphaelite principles, produced some remarkable works. Amongst them was Robert Braithwaite Martineau, another pupil of Holman Hunt. Both his *Kit's First Writing Lesson* (Pl. 307) and *Last Day in the Old Home* (Pl. 436) possess the same loving care in depicting detailed clutter.

Arthur Hughes (1832–1915) became influenced by the Pre-Raphaelites as a result of reading their short-lived magazine The Germ. Hughes was an artist of whom Ruskin said 'his sense of beauty is quite exquisite', a judgement surely vindicated by *April Love* (Pl. 308), inspired by Tennyson's poem 'The Miller's Daughter' which describes a lovers' quarrel and reconciliation. It shows what is surely one of the most beautiful uses of the colour blue in any Pre-Raphaelite painting. When exhibited in 1856 it was bought by William Morris. Hughes painted several other works showing lovers' encounters, notably *Aurora Leigh's Dismissal of Romney (The Tryst)* (1860), inspired by a poem by Elizabeth Barrett Browning, and *The Long*

305

306

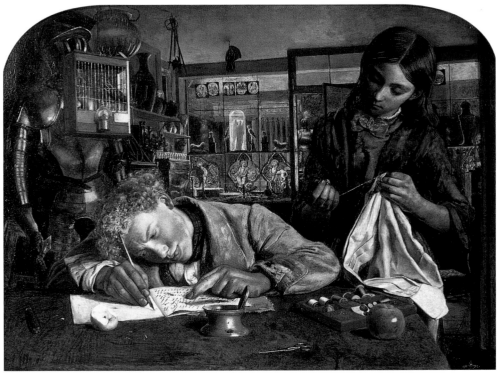

307
Robert Braithwaite Martineau
Kit's First Writing Lesson
1852
oil on canvas, 52.1 × 70.5cm
(20¼ × 27¾in)
Tate Gallery, London

307

Engagement (Pl. 309), painted between 1853 and 1859. It was exhibited with a quotation from Chaucer:

> For how myght ever sweetnesse hav be known
>
> To hym that never tastyd bitternesse?

The girl Amy seems to be trying to cheer up her clerical fiancé with Chaucer's moral injunction as they stand by the tree-trunk upon which he carved her name some years before. It is now covered with ivy, suggesting the length of their engagement, a situation and theme reminiscent of the novels of Anthony Trollope, and a poignant comment on the plight of couples who could not afford to marry.

Henry Wallis (1830–1916) was a Liverpool-based artist who also painted with true Pre-Raphaelite intensity. His most famous painting, exhibited at the Royal Academy in 1856, depicts the suicide of the 17-year-old poet Thomas Chatterton, whose forgeries had hoodwinked literary London in the eighteenth century, but who possessed real poetic talent. In *Chatterton* (Pl. 310), Wallis makes powerful contrasts between the dead poet's livid face and Titian hair, and between his bright blue breeches and the plum reds of his discarded coat, while the clear morning light shines in through the open window, with its plants and distant view of St Paul's Cathedral, upon the body and torn-up manuscript.

In 1857, Wallis also, like Landseer, Courbet and Brett, painted that most moving of themes, *The Stonebreaker* (Pl. 311). More than any other version of this subject, Wallis's low-keyed painting, set at the fall of dusk, captures the utter weariness of physical toil in the exhausted figure of the labourer. Wallis shows the worker, legs splayed asunder, slumped in exhaustion on the ground. When first exhibited at the Royal Academy Exhibition of 1858, the painting was accompanied by a quotation from Thomas Carlyle's *Sartor Resartus*, 'For us was thy back so bent, for us were thy straight limbs and fingers so deformed …' Brett's painting (Pl. 112) is more cheerful, showing a boy knapping flints on Box Hill, Surrey, while his dog plays nearby. It is possible that Brett's painting owes something to Landseer's version (Pl. 14), which was widely known through an engraving by John Burnet, published in 1844. Certainly both pictures contain a white-haired terrier, a minor point of resemblance,

308
Arthur Hughes
April Love
1855–6
oil on canvas, 88·9 × 49·5cm
(35 × 19½in)
Tate Gallery, London

309
Arthur Hughes
The Long Engagement
1853–9
oil on canvas, 105·4 × 52.1cm
(41½ × 20½in)
Birmingham City Museum
and Art Gallery

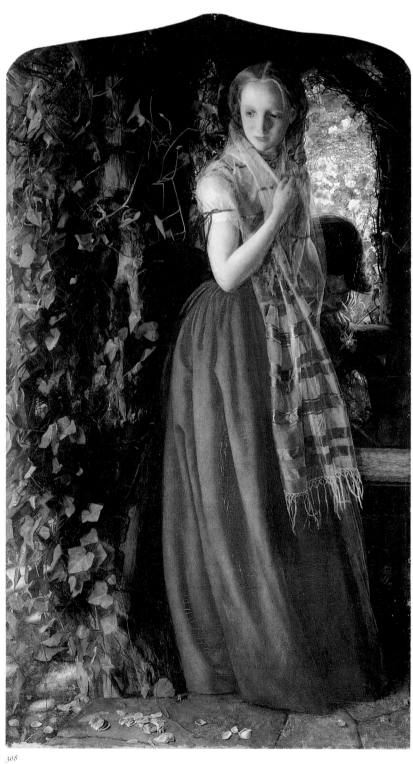

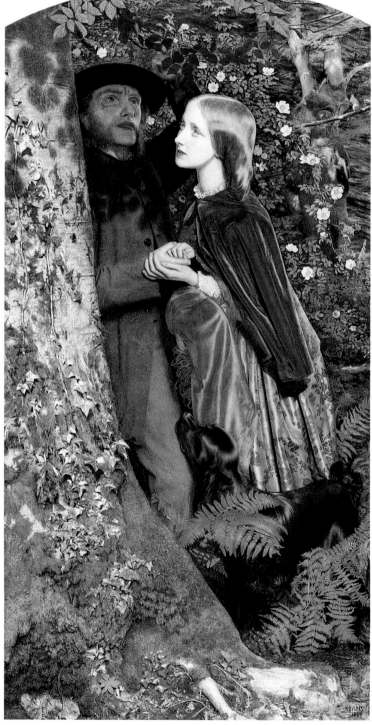

308

309

but a meaningful one, for Brett, like other aspiring young artists, had probably read John Ruskin's *Pre-Raphaelitism* of 1851, in which Landseer's 'eminent success' is ascribed to his 'healthy love of Scotch terriers'. All three works form intriguing parallels with the most famous treatment of the theme by Courbet (Pl. 396), painted in 1851.

The 'jovial adventure' of 1858, the painting of the Oxford Union frescos, discussed above (pp. 50–1), became a defining moment for the second wave of Pre-Raphaelitism. More immediately, its importance arose from the emergence of one of the most 'stunning' of all Pre-Raphaelite models. Jane Burden was the daughter of a livery stable manager, whom Rossetti had met one evening in the theatre at Oxford with her sister. Always alert for a new exotic model, Rossetti persuaded her to sit for him. Early studies for Guinevere in the Union paintings, it is intriguing to note, were from Lizzie Siddal; later ones, and the fresco itself, are from Jane. Although Rossetti and Jane felt a deep mutual attraction, it was William Morris who became absolutely overwhelmed by Jane's beauty. No description of the Pre-Raphaelite movement would be complete without Morris's only easel painting, portraying Jane as *Queen Guenevere* (Pl. 312), also known as *La Belle Iseult*, on which

310
Henry Wallis
Chatterton
1855–6
oil on canvas, 60·2 × 91·2cm
(23¾ × 36in)
Tate Gallery, London

311
Henry Wallis
The Stonebreaker
1857
oil on canvas, 65.4 × 78.7cm
(25¾ × 31in)
Birmingham City Museum
and Art Gallery

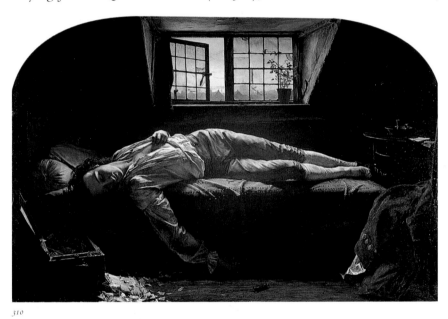

310

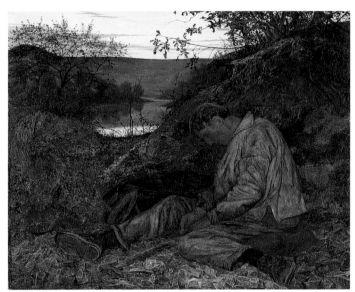

311

Morris is once said to have inscribed, 'I cannot paint you but I love you.' She stands alone in her bedchamber, a little love-gift of a dog lying in Tristram's place on her bed. Prophetically for both Iseult and Jane, down the side of the mirror is inscribed the word DOLOURS (grief), and her crown has sprigs of rosemary for remembrance. For many years the painting belonged to Rossetti, who wanted 'an early portrait of its original, of whom I have made so many studies myself'.

William and Jane married and had a large house built – the Red House at Bexley in the Kentish countryside, designed by Morris's friend the architect Philip Webb. Unable to obtain fabrics or furniture he liked, Morris decided to found the famous firm which would produce decorative art objects. For him Webb designed the St George's Cabinet (Pl. 314) which Morris painted with an Arthurian story, and Edward Burne Jones decorated a wardrobe (1858–9) with a story from Chaucer as a wedding present to his life-long friend. These experiments led to a joint venture for the firm, the creation of painted furniture for the 1862 International Exhibition. These pieces, inspired by the belief that medieval furniture of the twelfth and thirteenth centuries had been painted, are an interesting by-product of the Pre-Raphaelite involvement with the revolution in the decorative arts initiated by Morris.

312
William Morris
Queen Guenevere
1858
oil on canvas, 71.3 × 50.7cm
(28¼ × 20in)
Tate Gallery, London

313
Dante Gabriel Rossetti
Beata Beatrix
*c.*1864–70
oil on canvas, 86.4 × 66cm
(34 × 26in)
Tate Gallery, London

314
Philip Webb and
William Morris
St George's Cabinet
1861
painted wood,
height 85.7cm (33¾in)
width 176.4cm (69½in)
depth 43.8cm (17in)
Victoria and Albert Museum,
London

315
Edward Burne-Jones
Sidonia von Bork
1860–1
watercolour and gouache,
33.3 × 17.1cm (13⅛ × 6¾in)
Tate Gallery, London

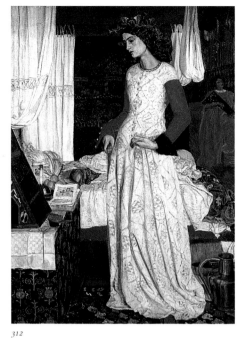

312

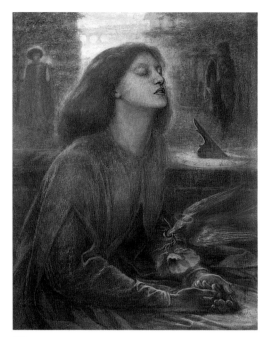

313

Edward Burne-Jones, Rossetti's pupil, used Fanny Cornforth as his model for *Sidonia von Bork* (Pl. 315), one of the most powerful of his early works. It illustrated a story by the German Romantic, Wilhelm Meinhold, translated by Lady Wilde (Oscar's mother). The amazingly elaborate patterning and sinister yet bewitching evil of this femme fatale contribute to the power of this haunting work.

Elizabeth Siddal's end was a tragic one, for on 11 February 1862 she took her own life with an overdose of laudanum while depressed after a miscarriage. Overcome with remorse, Rossetti placed the manuscripts of his unpublished poems in her coffin. Safely dead, Lizzie could be transformed by Rossetti into Dante's Beatrice even more completely, using the many drawings he had made of her, in her great memorial *Beata Beatrix* (Pl. 313). This is a very different type of picture from the small 'fleshly' portrait of 1860 (the *Regina Cordium*). In the distance is the Ponte Vecchio, a reminder of the setting of the story in Florence. The central figure of Beatrice is posed in ecstasy while a haloed dove, symbolizing the Holy Spirit, bears an opium poppy, traditional symbol of sleep, dreams and death. Yet in a letter of 1871 Rossetti said: 'It must of course be remembered in looking at the picture that it is not at all intended to represent Death … but … a trance, in which Beatrice seated at the balcony over-looking the city is suddenly rapt from Earth to Heaven.' These words, and the painting, show how far Pre-Raphaelitism had progressed from its first objective phase.

Some years later Rossetti wrote another cycle of poems to Jane Morris and wished to retrieve his earlier poems and publish both series of verse together. The body of Elizabeth Siddal was exhumed in October 1869 and the manuscripts recovered, to be published with the other poems in April 1870. As news of the exhumation spread, so did the legend that Lizzie's hair had continued to grow after her death, so as to fill the coffin luxuriantly with its gold. In his sonnet 'Life in Love', Rossetti wrote movingly of 'that golden hair undimmed in death'.

With these words the shadowy mood and distinctive concerns of Symbolism are heralded in, which were to dominate the later achievements of the Pre-Raphaelite movement (see below, pp. 439ff.).

314

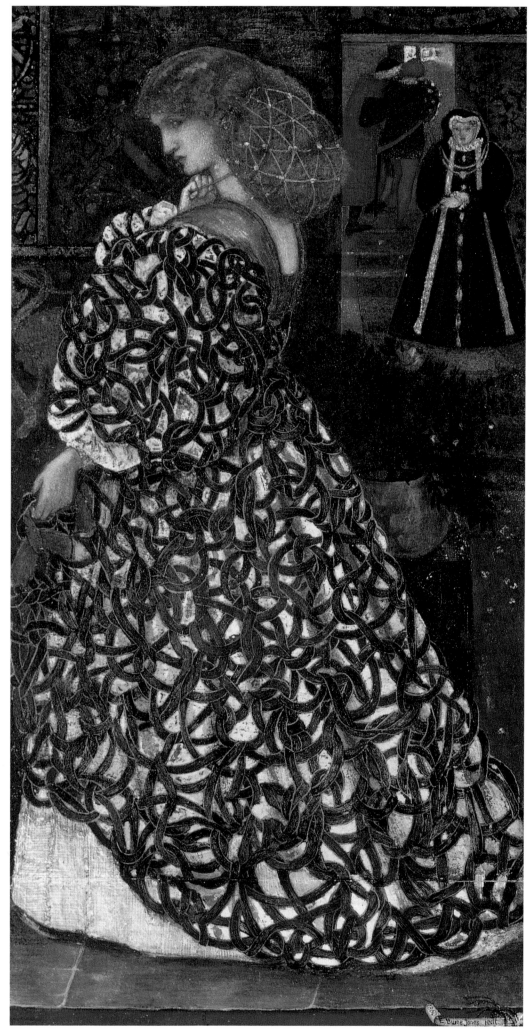

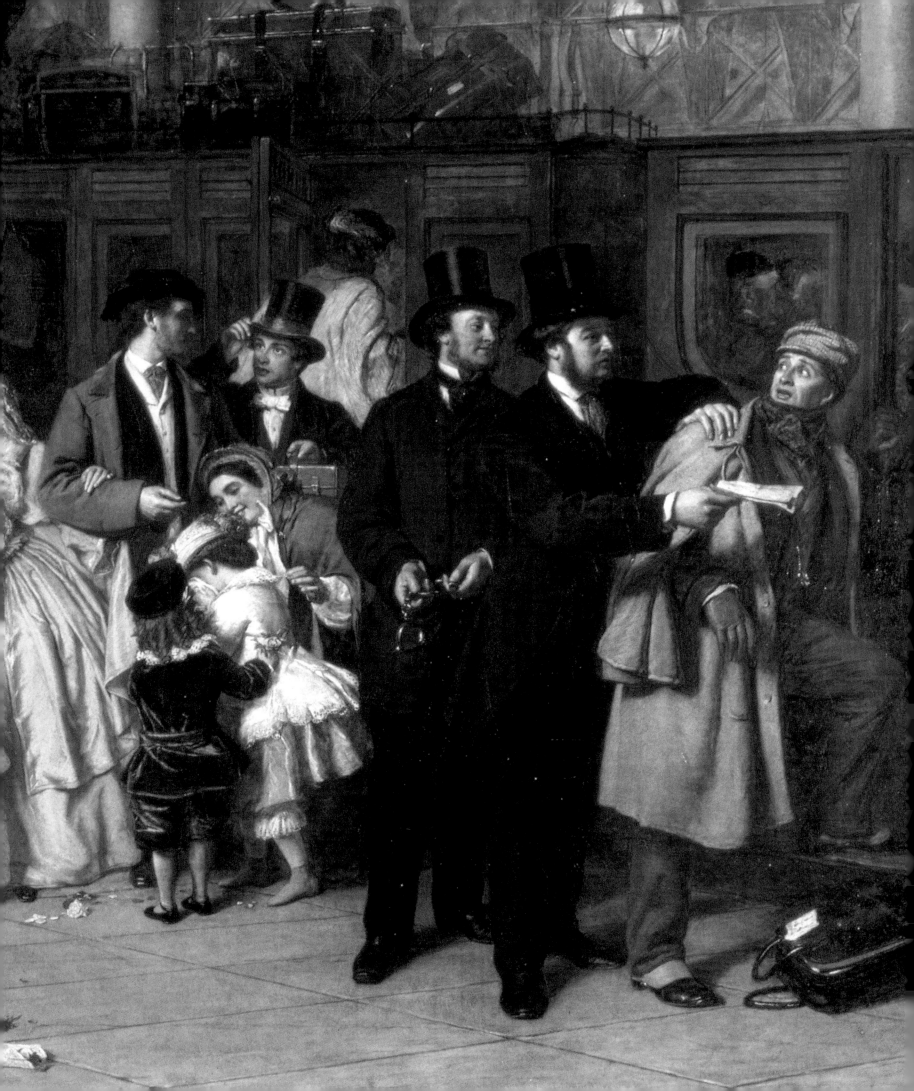

For over a century the motto of the sensational Sunday newspaper *The News of the World* was 'All Human Life is Here'. Its detailed reportage of the most notorious English murders enlivened many a breakfast table and relieved the tedium of many English Sundays. The motto might also be used to describe the large-scale paintings of group activities which became extremely popular midway through the nineteenth century, and are particularly associated with William Powell Frith.

Frith's whole career might almost have been designed to make him the perfect pictorial chronicler of his day. As a boy he wanted to become an auctioneer, not an artist, and there is something of the viewpoint of the auctioneer, high above the crowd on his rostrum, in all three of his major pictorial records of his time. Like an auctioneer you can imagine him drawing attention to the points of interest in the

317
William Powell Frith
**Life at the Seaside
(Ramsgate Sands)**
1854
oil on canvas, 76.2 × 153.7cm
(30 × 60½ in)
Royal Collection

works up for sale, works which are surely the most quintessential of all Victorian paintings.

Frith's first successes were not records of the social scene. He first attracted notice at the Royal Academy as a painter of literary scenes from Molière, Laurence Sterne (Pl. 152), Oliver Goldsmith and Charles Dickens illustrating the foibles of human nature. When resting from these labours he discovered the theme of his first major canvas depicting contemporary life – *Ramsgate Sands* (Pl. 317), shown at the Royal Academy in 1854 under the more general title *Life at the Seaside*. Frith wrote in his *Autobiography*:

> My summer holiday of 1851 was spent at Ramsgate. Weary of costume painting,
> I had determined to try my hand on modern life, with all its drawbacks of unpic-
> turesque dress. The variety of character on Ramsgate Sands attracted me – all
> sorts and conditions of men and women were to be found there. Pretty groups of
> ladies … reading, idling, working, and unconsciously forming themselves into
> very paintable compositions.

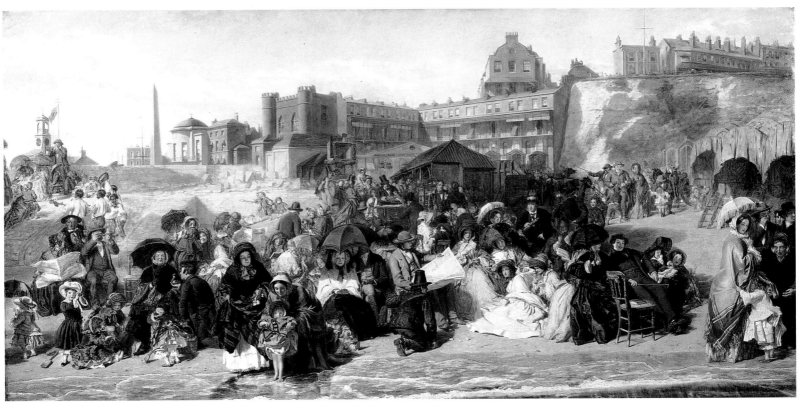

317

He recalled how delighted he was to discover 'a theme capable of affording … the opportunity of showing an appreciation of the infinite variety of everyday life'.

Seeing him at work on his sketches, Frith's friends Edward Matthew Ward, Augustus Egg and Thomas Webster encouraged him to create a large full-scale paint-ing on the subject. He returned to Ramsgate the next year to paint the architecture, cliffs and bathing machines, writing in his diary: 'September 11. Clock tower, obelisk, and hotel. Will all this repay me in any way? I doubt it!'

In February 1853 Frith was elected a full member of the Royal Academy on the strength of his earlier costume works. The news spread that he was engaged upon a large 'modern-life' subject, prompting an elderly Academican to say to one of Frith's friends: 'Doing the people disporting on the sands at Ramsgate is he? Well, thank goodness I didn't vote for him! I never could see much in his pictures; but I didn't think he would descend to such a Cockney business as that you describe. This comes

of electing these fellows too hastily.' Frith kept his nerve and worked steadily at the painting for three and a half years, elaborating, on the advice of John Leech, the *Punch* cartoonist, such details as the donkeys and bathing machines on the right and the Christy Minstrels, and Punch and Judy booth on the left. Of the 'animal show' Frith wrote: 'The drummer wore a wonderful green coat; he was very ugly, but an excellent type of his class … I made up my mind to introduce the whole show, taking the moment of the hare's performance as the chief point.'

Frith's mention of 'an excellent type of his class' reveals his interest in the study of physiognomy, and the widely held belief that the facial and bodily features indicate specific mental and moral characteristics. Phrenology, the theory that the mental faculties and affections are located in distinct parts of the brain indicated by prominence on the skull, was also a subject which fascinated many Victorians. Frith's great crowd scenes, which required the detailed portrayal of literally hundreds of faces, provided him with the ideal opportunity to put to good use his belief in the principles of physiognomy and phrenology. Both the artist and his public shared certain ideas about exactly *how* particular human types should look, and this helps to explain the immense popularity of Frith's works.

These cross-sections of the modern, urban crowd provided a parallel with a biologist taking a drop of pond water, placing it on a slide, magnifying it and counting the myriad types of pond life. In like manner, Frith, believing himself to be both artist and anthropologist, observed and recorded the kind of physiognomical distinctions which were believed to indicate individual characteristics, social class and racial types. While we may think these ideas dangerous and outmoded, leading to the genetic fantasies of the 'Aryan super-race', they die surprisingly hard. Their legacy can still be seen today in the racial stereotyping used by cartoonists.

Frith also welcomed the compositional problems posed by such large subject pictures, believing 'there must be a main incident of dramatic force, and secondary ones of interest'. The focal point of the composition in *Ramsgate Sands* is formed by the pretty little girl who gingerly dips her toe into the water to the left of centre, the only person to have direct contact with the sea. But even she, like the other little girls, is wearing a bonnet upon the brim of which is mounted a strange contraption known as an 'ugly'. Like the 'modesty umbrellas' fitted to bathing machines, this device could shield the complexion from the dangerous rays of the sun. The ladies also wear gloves and carry parasols despite the all-too-familiar grey skies. They sit on an extraordinary medley of chairs, for the deck chair had not yet arrived, and dining and bedroom chairs ended their days on the sands. Several telescopes can be seen in use, their observers attempting to view the strictly segregated sexes bathing, behaviour which led to a complaint by a visitor to Ramsgate in 1860: 'Bathers on the one hand, and the line of lookers-on on the other, some with opera glasses or telescopes, seem to have no more sense of decency than South Sea Islanders.'

An entry in Queen Victoria's diary on 30 July 1847 reads: 'Drove down to the beach with my maid and went into the bathing machine, where I undressed and bathed in the sea (for the first time in my life), a very nice bathing woman attending me. I thought it delightful until I put my head under the water, when I thought I should be stifled.' It may have been her memory of this experience which led the Queen, on visiting the Royal Academy exhibition in 1854, to fall in love with *Ramsgate Sands*. Frith was fortunate enough to be on the hanging committee with Thomas Sidney Cooper and Thomas Webster, and thus the picture was ensured a good position. Frith recorded in his diary: 'April 28. Drove to R.A. at a quarter to twelve; the Royal Family came. Eastlake presented me to the Queen. She was delighted with "Seaside".' The painting had already been sold to the well-known

318
Abraham Solomon
Brighton Front
*c.*1860
oil on wood, 48.2 × 101.6cm
(19 × 40in)
Tunbridge Wells Museum
and Art Gallery

dealer Lloyd for 1,000 guineas: but Lloyd resold it to the Queen for the original price, with the understanding that he might borrow it for three years to have an engraving made. The engraved plate when completed was sold on to the London Art Union for £3,000. Frith was swift to learn from this transaction, and in all his future compositions the reproduction rights were to feature prominently in the financial arrangements for their sale.

Ramsgate Sands established a fashion for seaside paintings, and several artists in the 1850s and 1860s painted delightful regional variations on the theme. Abraham Solomon's *Brighton Front* (Pl. 318) shows a distant glimpse of the sea and the crowded road and pavements outside the Bedford Hotel. Painted during the height of the vogue for the crinoline, it portrays young ladies with parasols jostling an invalid in a bath chair, while being ogled by 'heavy swells' with 'Dundreary whiskers'.

Another attractive example of a beach scene is *Weston Sands in 1864* (Pl. 319) by William H. Hopkins (*fl.*1853–92) and Edmund Havell (1819–94). Weston-super-Mare, sometimes known as Weston-super-Mud because of its vast muddy beach

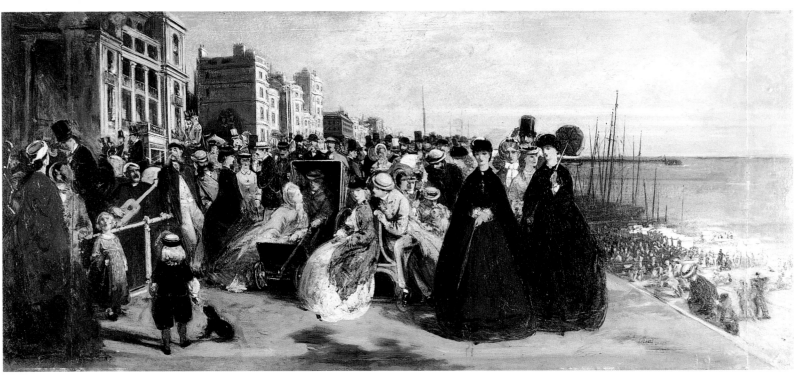

318

which seems to stretch to infinity when the tide goes out, remained a small resort even after being connected by rail to Bristol in 1841, and in this view everyone looks very relaxed, even the donkeys and goat with a cart waiting to give children a ride. In 1866 the railway line was developed to cater for special excursions, and with the return fare from Bristol at 1s. 6d., the resort expanded rapidly.

The vivid characters of the turf were a favourite theme of Ben Marshall (1768–1835), who excelled at conveying the glitter of silks, glossy coats and shining leather, the quick, sharp glances of jockeys, trainers, lads and the nonchalant proud stance of the owners (Pl. 256). Marshall was also an accomplished sporting journalist, and his description of Derby Day in 1830 still rings true: 'a day of extraordinary excitement to all sportsmen, and to millions of others in all parts of England … for … the art of cramming horses down people's throats had been practised more successfully than ever was known.'

In 1858 Frith captured this sense of 'extraordinary excitement' in his vivid *Derby Day* (Pl. 320). Frith's first visit to a race meeting, at the now long defunct minor

course at Hampton, was packed with incidents which his memory would retain for future use. He watched with amusement some gypsies eating a Fortnum and Mason pie, and with horrified fascination saw an unsuccessful gambler try to cut his throat. 'The idea occurred to me that if some of the salient points of the great gathering could be grouped together, an effective picture might be the result,' he wrote in his *Autobiography*. His lady companion at the races condemned the idea, saying, 'that it was impossible to represent such an enormous crowd upon canvas, without producing confusion worse compounded'. Frith, with the success of *Ramsgate Sands* behind him, no doubt regarded this as a challenge, and *Derby Day* is the triumphant answer. His original title for the work was 'The Humours of a Race-Course', which he changed at the suggestion of Henry Dorling, General Manager and Clerk of the Course at Epsom, and the stepfather of the future Mrs Beeton, who spent much of her early life in the Grandstand.

319
William H. Hopkins and
Edmund Havell
Weston Sands in 1864
1864
oil on canvas, 61.5 × 97.7cm
(24¼ × 38½in)
Bristol Museum and Art
Gallery

320 (overleaf)
William Powell Frith
Derby Day
1856–8
oil on canvas, 101.6 × 223.6cm
(40 × 88in)
Tate Gallery, London

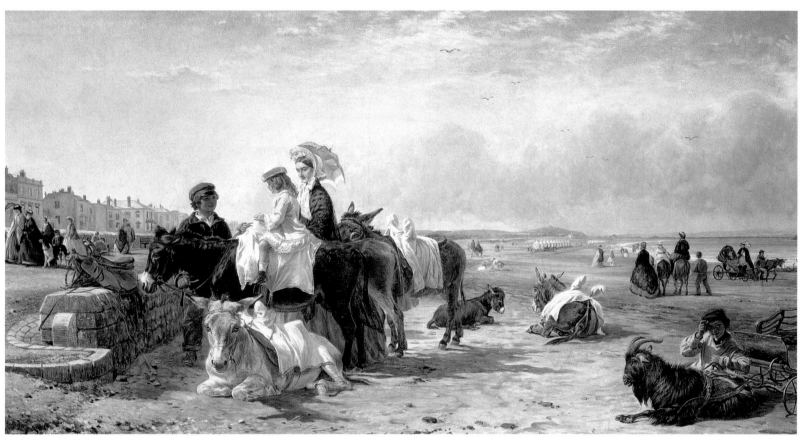

319

By the 1850s Derby Day had become established as Britain's national fête, and the race itself was for many visitors almost irrelevant. They went to Epsom Downs for what both the French social commentator Hippolyte Taine and the English critic John Ruskin described as the 'English carnival'. 'It is quite proper', wrote Ruskin in an unusually perceptive review in his *Academy Notes* for 1858, 'that this English carnival should be painted', adding a description of Frith's work as 'a kind of cross between John Leech [the *Punch* cartoonist] and Wilkie [the masterly painter of Scottish low-life scenes] with a dash of daguerreotype here and there, and some pretty seasoning with Dickens's sentiment'.

Frith's first visit to the Derby itself took place in 1856. He wandered round the course with his friend Augustus Egg, who had difficulty restraining Frith from losing all his money to a 'thimble-rigging gang'. Frith was fascinated by the diversity of the crowd: 'The acrobats with every variety of performance, the nigger minstrels, Gipsy

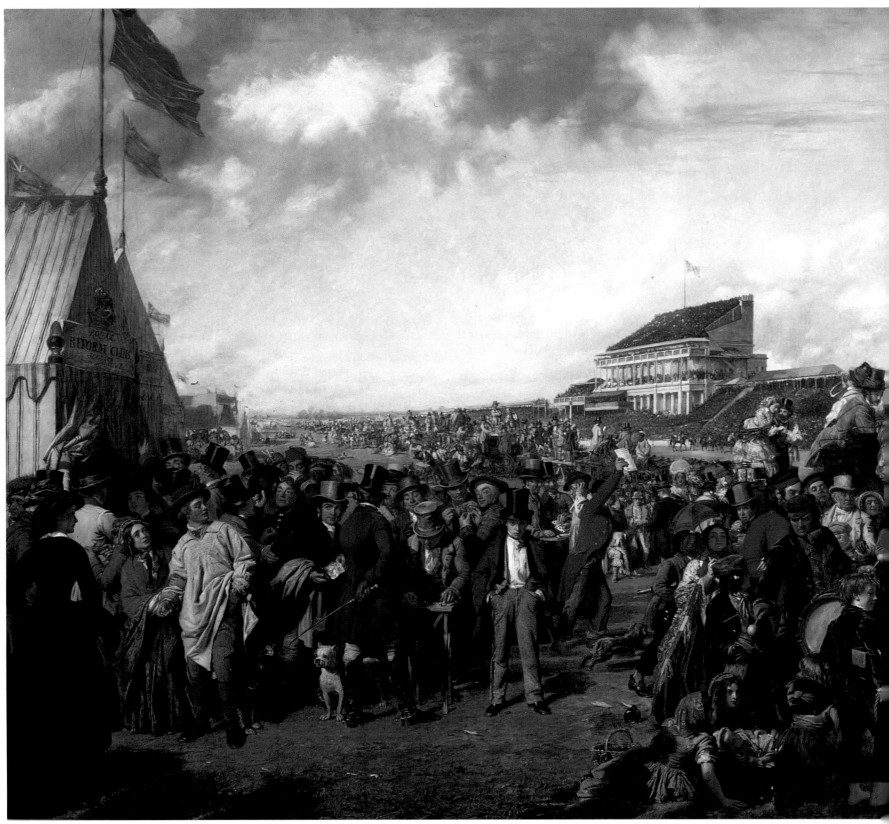

320

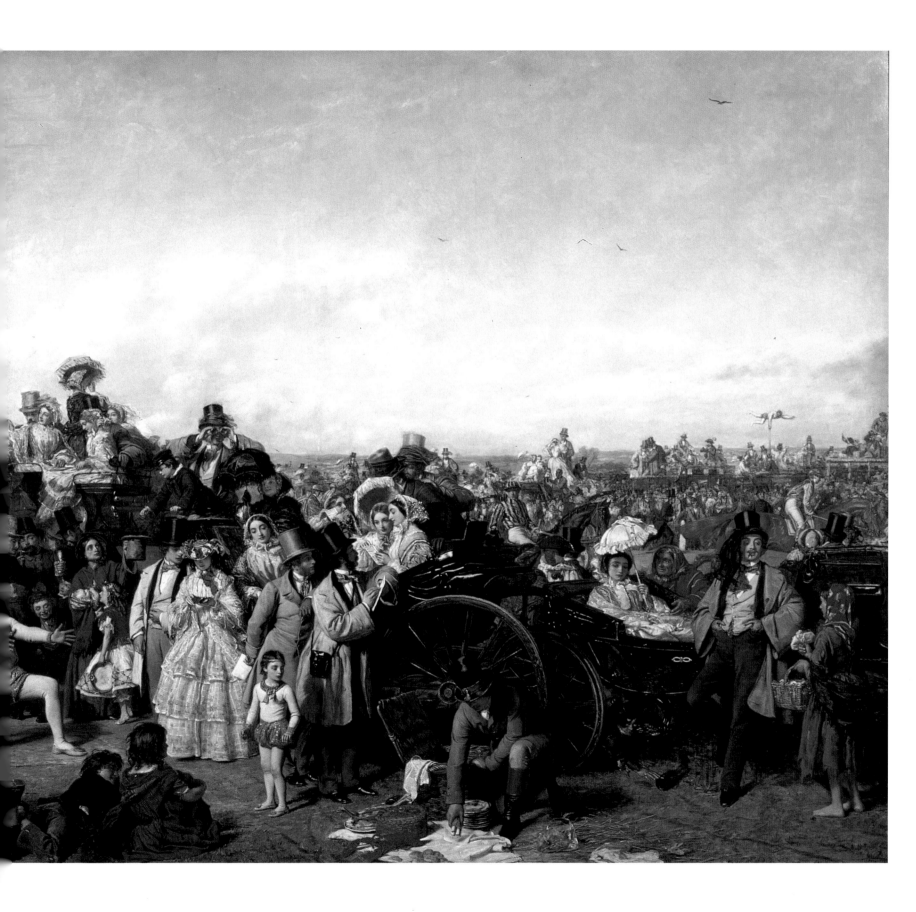

fortune-telling, to say nothing of carriages filled with pretty women, together with the sporting element … the more I considered the kaleidoscopic aspect of the crowd on Epsom Downs, the more firm became my resolve to reproduce it.' He took the imaginative step of enlisting a photographer named Robert Howlett 'to photograph from the roof of a cab as many queer groups of people as he could'. Such aids helped him, as his friend the artist Daniel Maclise wrote, 'to drop in, here and there, little gem-like bits into the beautiful mosaic' of the picture. This was the first time the camera was used in the creation of a great painting. Frith was undaunted by the compositional problems involved. 'I cannot say I have ever found a difficulty in composing great numbers of figures into a more or less harmonious whole. I don't think this *gift* or *knack* can be acquired … and granting the facility, too much time can be spent in making preliminary studies, always from nature, of separate figures and groups.'

Shortly after the Derby of 1856 Frith roughed out his first idea for the picture in 'a small careful oil-sketch' painted while on his annual holiday at Folkestone. On seeing this sketch, his old friend the pharmaceutical tycoon Jacob Bell commissioned 'a picture five or six feet long'. Bell, a man-about-town, delighted in producing the female models. 'What is it to be this time?' he would ask, 'fair or dark, long nose or short nose, Roman or aquiline, tall figure or small? Give your orders.' In the next fifteen months Frith devoted all his energies to working up sketches, having first decided on the principal incident of the picture, the hungry child acrobat distracted by seeing a sumptuous picnic hamper packed with lobster and other delicacies which are being laid out on the grass by a footman. Frith surrounds this incident with an amazing cross-section of human life: touts, gypsies, beggars, policemen, fashionable and unfashionable characters, all integrated into a coherent composition which is rewarding to 'read' with the same close attention to detail as the original spectators.

On the left of the painting Frith used his experience of 'thimble-rigging' to great effect. This game, one of the oldest of all conjuring tricks, involves the victim guessing which of three thimbles conceals a pea. We see the game in full swing while a young dupe, a 'city gent', the *yuppy* of his day, stands dejected, hands deep in empty pockets. The 'con man', wearing boots and spurs, stands with a whip behind his back, facing the eager crowd. Immediately to his left, holding a £5 note, is another member of the thimble-rigging gang, easily recognizable to Victorian audiences as John Thurtell, a famous murderer, whose physiognomy was studied by both scientists and artists. Under the table a bulldog growls at the mongrel owned by a country man wearing a smock, whose wife tries to restrain him from joining the game. In the crowd the figure with the red fez was modelled on Frith's friend, the artist Richard Dadd.

The glimpse of horses going down to the start was carefully based on a sketch by John Frederick Herring. In his *Autobiography* Frith explains that: 'My determination to keep the horses as much in the background as possible … did not arise from my not being able to paint them properly, so much as from my desire that the human being should be paramount.'

The incident on the extreme right of the painting is modelled on a drawing by John Leech in *Punch*. A 'kept' woman in a carriage refuses to have her fortune told by a gypsy, while her lover leans languidly against the carriage. The barefoot girl who offers him flowers may well have been prompted by the chapter in Charles Dickens's *Old Curiosity Shop* (1840–1) describing Little Nell's day at Epsom. Around the young man's hat is a 'puggaree' which could be pulled over the face to keep off the dust during a journey. Unlike at Ascot, where high fashion has always dominated the scene, the crowd on Derby Day sports a cross-section of the dress worn by all classes of society, and Frith's painting is one of the most meticulously observed of all

costume studies in the mid-nineteenth century. The crinoline was just beginning the ten-year cycle of its vogue as high fashion. The flounced skirts were supported by numerous stiff starched petticoats, reinforced by horsehair, rather than the later steel cage. These light attractive dresses formed an admirable foil for the gentlemen in their loose flowing top-coats with wide lapels, bright cravats and top hats.

Frith did not start on the final canvas until January 1857. After 'fifteen months incessant labour' it was completed in time for the Royal Academy exhibition of 1858, where it enjoyed a phenomenal success. The public crowded round the picture so closely that it had to be guarded by a policeman and protected by a stout iron rail. Frith wrote jubilantly to his sister that this had only occurred once before in the history of the Academy, when Wilkie exhibited his *Chelsea Pensioners* (Pl. 9).

Queen Victoria and Prince Albert were very enthusiastic about the picture, and Frith loyally recorded the Prince's reactions to *Derby Day*. 'He told me why I had done certain things and how, if a certain change had been made, my object would have been assisted. How the masses of light and shade might still be more evenly bal-

321
William Powell Frith
The Railway Station
1862
oil on canvas, 116.7 × 256.2
(46 × 101in)
Royal Holloway College,
University of London, Egham,
Surrey

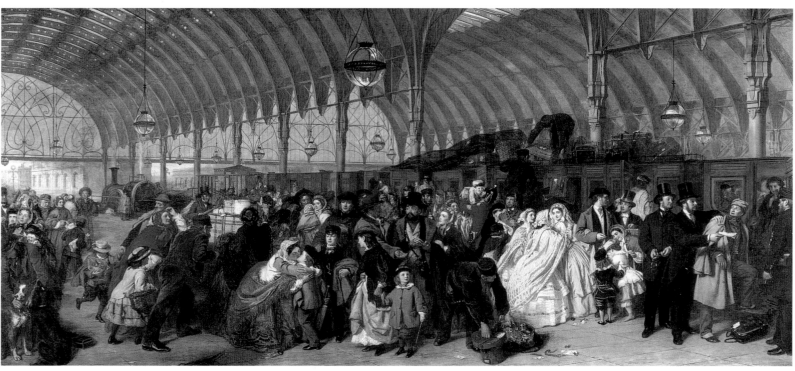

321

anced, and how some parts of the picture might receive still more completion – I put many of the Prince's suggestions to the proof after the close of the exhibition, and I improved my picture in every instance.'

Frith received £1,500 from Jacob Bell for the picture, the highest fee ever paid to that date for a painting by a living artist. Frith retained the engraving rights, which he sold to the famous dealer Gambart for an additional sum of £1,500, plus £750 for the rights of exhibition for five years. The canvas set out on a world tour which included such venues as Paris, Vienna, the United States, Sydney and Melbourne, and improbably the Australian goldfields of Ballarat and Geelong. Bell died in 1859 before he could enjoy the work on his own walls, but left the painting to the National Gallery. The picture finally ceased its tour after a public outcry and entered the National Gallery in November 1865. Now in the Tate Gallery, it remains one of its most popular paintings.

Encouraged by the earlier success of his seaside and race-course paintings, Frith

322
William Maw Egley
Omnibus Life in London
1859
oil on canvas, 44.8 × 41.9cm
(17⅝ × 16½ in)
Tate Gallery, London

turned to the then glamorous subject of railway travel (Pl. 321) for his next subject. He wrote in his diary on 28 August 1860: 'Commenced picture of railway platform; another long journey, to which I go with almost as good a heart as I did to the "Derby Day". May it be as successful!' The setting was the Great Western Railway terminus at Paddington, built by Isambard Kingdom Brunel, the great Victorian engineer, and the architect Matthew Digby Wyatt between 1850 and 1852. It was, to use a modern idiom, a 'state-of-the-art' building of an exciting nature. Frith enlisted specialist help from the architectural draughtsman W. Scott Morton to paint the roof with its combination of wrought iron and glass, cast-iron columns and decorative tracery in the lunettes at the end of the shed.

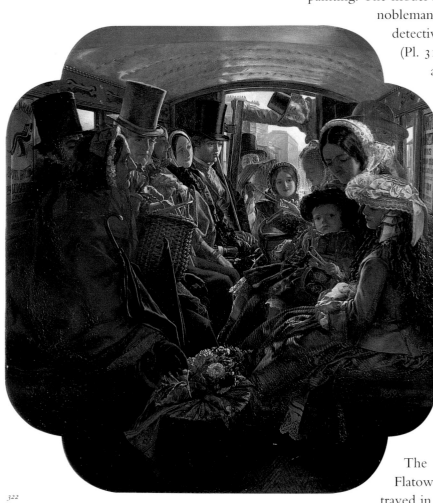

Frith himself, his wife and children form the family group in the centre of the painting. The model for the foreigner disputing with the cab driver was a Venetian nobleman employed to give Frith's daughters Italian lessons. Two famous detectives of the time are seen in action on the right, making an arrest (Pl. 316): Michael Haydon (on the left with handcuffs in his hands) and James Brett (with his hand on the criminal's shoulder). The fugitive was identified in most reviews as a bankrupt or forger on the run, about to enter the carriage in which his wife is already waiting. Both policemen posed for Frith, who found them 'admirable sitters' because they were used 'to standing on the watch, hour after hour, in the practice of their profession, waiting for a thief or a murderer'.

Frith based his painting of the locomotive on a photograph of the 'Sultan', a 4–2–2 broad-gauge engine of the 'Iron Duke' class. Robert Howlett, the photographer who helped Frith on *Derby Day*, had died in 1858, and his place was taken by Samuel Fry, whom Frith engaged to supply a set of photographs, as reported in the *Photographic News* of 26 April 1861 under the headline 'Photography and Art':

Mr Samuel Fry has recently been engaged in taking a series of negatives, 25 inches by 18 inches, and 10 inches by 8 inches, of the interior of the Great Western Station, engines, carriages, etc, for Mr Frith, as aids to the production of his great painting *Life at a Railway Station*. Such is the value of the photograph in aiding the artist's work, that he wonders now however they did without them!

The small rotund man talking to the engine driver is the dealer Flatow, who commissioned the painting and insisted on being portrayed in it. Flatow's financial arrangements with the artist were a matter of great contemporary interest, and in describing them it is well to remember Frith's boyhood ambition to be an auctioneer, and his understandable wish to make money. (He had two large families to support, for his wife Isabelle had 12 children, and his mistress, Mary Alford, later to be his second wife, had 7). Frith felt that dealers 'were able both to offer certain artists twice or thrice the sum that the private patron would have given and to secure a very handsome return for themselves' by the widespread sale of engravings. Flatow initially paid Frith the handsome price of £4,500 for the painting and £750 for the exhibition rights, to be paid in instalments of £500 every three months. But the arrangement became complicated due to the question of copyright. In 1861 Flatow published a statement in the *Athenaeum* that the total price paid to Frith was 8,000 guineas (£9,187 10s. 0d.). It is unnecessary to follow every twist and turn of the negotiations but important to remember, as Jeremy

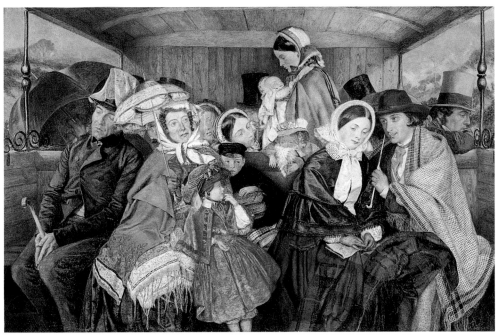

323

323
Charles Rossiter
**To Brighton and Back
for 3s. 6d.**
1859
oil on canvas, 61 × 76cm
(24 × 29⅞in)
Birmingham City Museum
and Art Gallery

Maas pointed out, that the dealers Flatow and Gambart 'really woke up the great British public to the desirability of possessing pictures, or at least engravings'.

The Railway Station was first exhibited in Flatow's Gallery in the Haymarket in the spring of 1862; 21,150 people paid for admission and many subscribed for the engraving. The rights to sell engravings of *The Railway Station* continued to be a lucrative business, and in 1863 the print dealer Henry Graves purchased both the painting and reproduction rights for £16,300. The painting toured extensively in Great Britain, France and America, before finding its final home in the collection formed by Thomas Holloway in 1881 for his University College for young ladies at Egham in Surrey. Holloway purchased the picture in 1883 for the bargain price of £2,000, as the commercial reward from the engravings had finally subsided.

All three of Frith's major paintings of cross-sections of society can find parallels in French art. Railway travel and the contrasts between first-, second- and third-class passengers provided fruitful themes for Honoré Daumier (1809–79), who painted a number of powerful studies of the interiors of railway carriages. The themes beloved by Frith – the seaside, the race course and the railway – were also later to be paralleled by the Impressionists and their interest in chronicling the changing aspects of the urban scene, often seen from the top of omnibuses, Degas's preferred mode of travel.

Degas's views on this point were shared by several Victorian painters of 'modern-life' themes, notably William Maw Egley, whose *Omnibus Life in London* (Pl. 322) portrayed every class of society from an old family servant to young city clerk. It was described by the *Illustrated London News* as 'a droll interior, the stern and trying incidents of which will be recognized by thousands of weary wayfarers through the streets of London'. In the crowded bus depicted in the painting, the conductor is making the lady on the right take her rather large child upon her lap to make room for another passenger. There is a general feeling of being cramped and of too much luggage for comfort, which is still all too familiar a feature on journeys by public transport in London to the great railway terminals.

Once safely arrived at the station, however, long-distance transport was available in a manner never previously possible, for by the 1850s holiday excursion trains had grown in popularity by offering much cheaper fares. Station platforms were

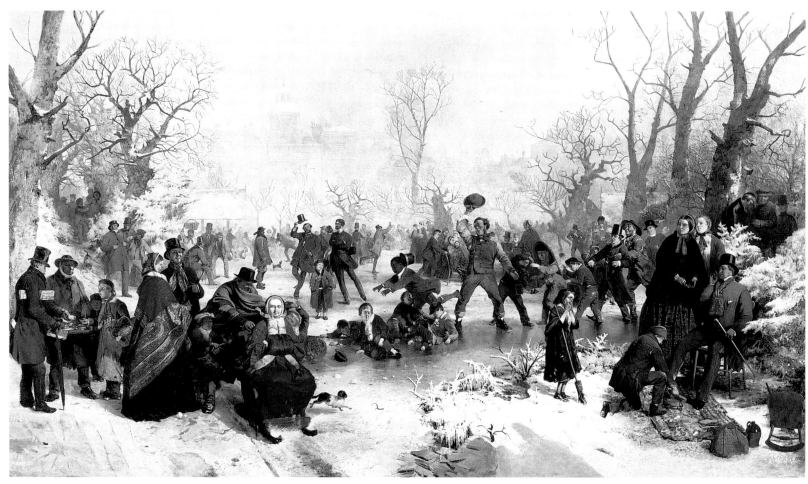

324

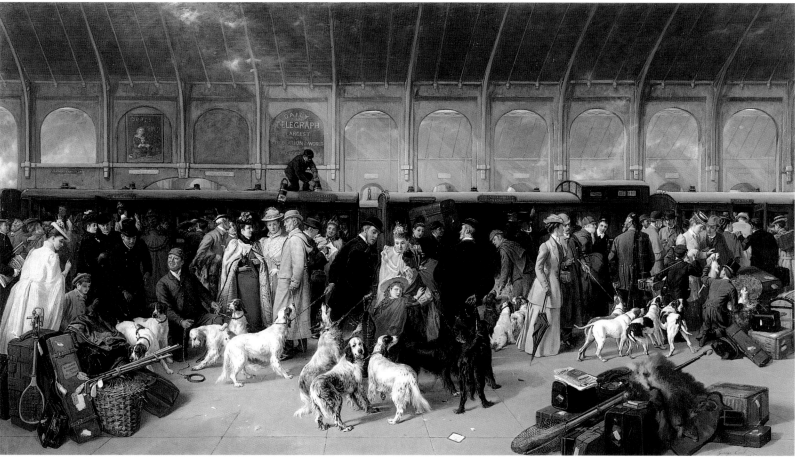

325

crowded with excursionists, much to the disgust of the regular train passengers.

By the 1860s Cook's Tours were beginning to transport people on far longer journeys. The first Cook party to visit the wonders of Pompeii arrived in 1864, arousing the wrath of the British residents who resented the intrusion of strangers. Humbler travellers from London had the more familiar pleasure of a cheap day out at the seaside, as in *To Brighton and Back for 3s. 6d.* (Pl. 323) by Charles Rossiter (1827–after 1890). The fun of a day away became universally available after 1871 when the provisions of the Bank Holiday Act first ensured the right of a day's annual summer holiday a year to all workers. From these humble beginnings arose the vast industry of modern tourism.

Far longer summer breaks were the prerogative of high society, which trekked north to Scotland every year for the arrival of the 'Glorious Twelfth' of August and the beginning of the grouse-shooting season. This subject provided a successful and engaging theme for George Earle (*fl.*1857–1901). At the Royal Academy in 1876 he exhibited a painting of London's King's Cross Station, entitled *Going North* (Pl. 325), which he followed the next year with a painting of the return process at Perth Station in Scotland called *Coming South*. The first work is full of grandees and gillies, footmen, porters and no fewer than 20 dogs. Piles of luggage form pyramids: golf clubs, fishing rods, tennis rackets and gun cases, one marked 'Baggage Bombay' which surely belongs to an Imperial civil servant who has been dreaming of this home leave in India, and whose little girl is held by an ayah in the centre of the painting. High on the walls of the smoky station can be seen a Pears Soap advertisement featuring *Bubbles* (Pl. 214).

Frith's successful formula inevitably led to other artists following his example in painting cross-sections of human life with a wide range of characters from varied social classes. Like Frith, John Ritchie (*fl.*1855–75) began by exhibiting genre scenes in sixteenth- and seventeenth-century costume. An inclination towards extensive contemporary scenes can be seen in a fine early painting, *A Border Fair*, which graphically portrays an animated rural fairground with its theatrical booths and stalls. In 1858, at the British Institution, he exhibited *A Summer Day in Hyde Park* and its companion piece, *A Winter's Day in St James's Park* (Pl. 324), the latter being originally priced by the artist at £50 more – £350 as opposed to £300. In *A Winter's Day* Ritchie arranges the crowds with Dickensian zest, in a scene reminiscent of Christmas at Dingley Dell in the *Pickwick Papers*. On the right a boy fits skates on to the boot of a gentleman leaning back in a chair. A young black footman in livery falls into a pile of boys who have crashed into the ice on their slide. Around them tumble oranges dropped by an errand boy from his basket. On the left, warmly wrapped up in a fur tippet, muff and shawl, an old lady enjoys the fun as she is propelled across the ice seated in a sleigh.

Frith's most important follower, George Elgar Hicks (1824–1914), enjoyed a career with two distinct phases, first as a painter of modern-life subjects in the 1850s and 1860s, and later as a society portrait painter from the 1870s until his virtual retirement in the mid-1890s. His first major painting, *Dividend Day at the Bank of England*, was exhibited in 1859. This was the first of a series of paintings of London life created in the next six years, the most famous being *The General Post Office, One Minute to 6* (Pl. 327). The painting, crowded with incidents, vividly conveys the dash and bustle of the General Post Office at St Martin's-le-Grand, built by Sir Robert Smirke in 1812 and now demolished. The scene portrayed recalls an account by George Augustus Sala (1828–96), a bohemian journalist who was a friend of personalities as diverse as Frith and Rossetti. Sala wrote it for Dickens's weekly journal *Household Words*:

324
John Ritchie
A Winter's Day in St James's Park
1858
oil on canvas, 75.6 × 128.5cm
(29¾ × 50½in)
Private collection

325
George Earle
Going North, King's Cross Station
1893
oil on canvas, 121.9 × 213.4cm
(48 × 84in)
National Railway Museum, York

326
George Elgar Hicks
Billingsgate Fish Market
1861
oil on canvas, 68.5 × 124.3cm
(27 × 49in)
Fishmongers' Hall, London

327
George Elgar Hicks
**The General Post Office,
One Minute to Six**
1860
oil on canvas, 89 × 135cm
(35 × 53¼in)
Museum of London

A fountain of newspapers played in at the window. Water-spouts of newspapers broke from enormous sacks and engulfed the men inside … Now and then there was a girl; now and then a woman; now and then a weak old man; but as the minute hand of the clock crept near to six, such a torrent of boys, and such a torrent of newspapers came tumbling in together pell-mell, head on heels, one above another, that the giddy head looking on chiefly wondered why … the boys didn't post themselves nightly along with the newspapers, and get delivered all over the world. Suddenly it struck six. Shut, sesame!

One of the finest of Hicks's paintings was *Billingsgate Fish Market* (Pl. 326), remarkable both for the quality of its still-life painting and the lively depiction of the busy market workers. Once again Hicks obtained the subject from George Augustus Sala, whose articles, after publication in *Household Words*, appeared as a book with illustrations by William McConnell from which Hicks lifted many visual ideas. The painting shows Billingsgate Market in full swing at about 6 a.m.:

The market opens at four, but for the first two or three hours, it is attended solely by the regular fishmongers and 'bummarees' who have the pick of the best there. As soon as these have gone, the costers (i.e. street sellers with barrows) sale begins … The wooden barn-looking square where the fish is sold, is soon after six

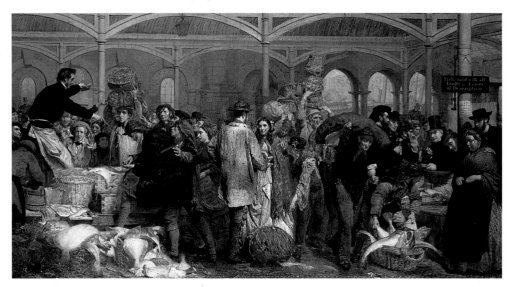

326

o'clock crowded with shiny cord jackets, and greasy caps. Everybody comes to Billingsgate in his worst clothes, and nobody knows the length of time a coat can be worn until they have been to a fish sale. Through the bright opening at the end are seen the tangled rigging of oyster boats and the red worsted caps of the sailors. Over the hum of voices are heard the shouts of the salesmen, who, with their white aprons, peering above the heads of the mob, stand on their tables, roaring out their prices … Boys in ragged clothes, who have slept the night under a railway arch, clamour for employment.

The men carrying baskets of fish on their heads were the 'fellowship porters' who had 'the sole privilege of landing the fish from the vessels … they are the veritable Caryatids of the commerce of Billingsgate'. Each porter wore 'a kind of tarpaulin hat, which fits close to the skull, boasting a rim of nine inches in width at the rear, and which curls up at the edges to catch and retain the moisture which would else flow down his back from his dripping burden. His outer garment is a whitish hybrid surtout, half jacket, half smock-frock, reaching down to the middle of the thigh; it is opened at the breast, and displays a voluminous neckerchief, tied in a double knot, the long ends fluttering in the breeze. His trousers are of any material you like to

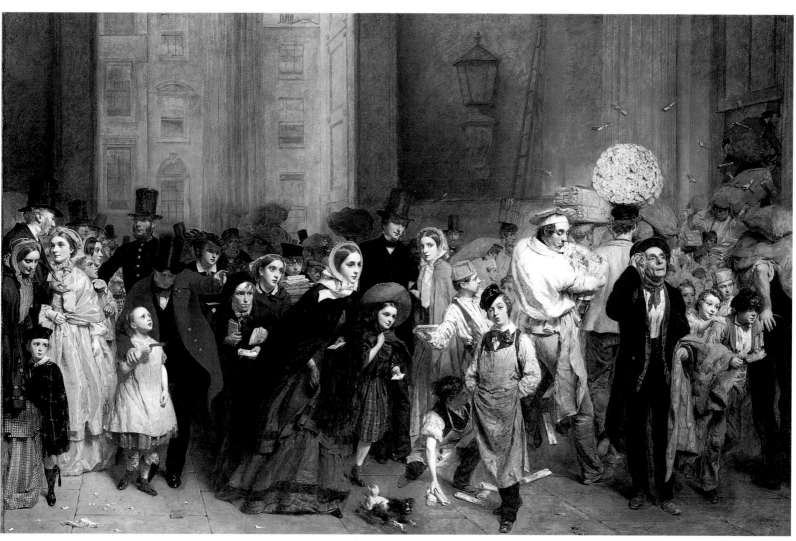

327

328
Phoebus Levin
**The Dancing Platform
at Cremorne Gardens**
1864
oil on canvas, 66.2 × 107.5cm
(26 × 42⅜in)
Museum of London

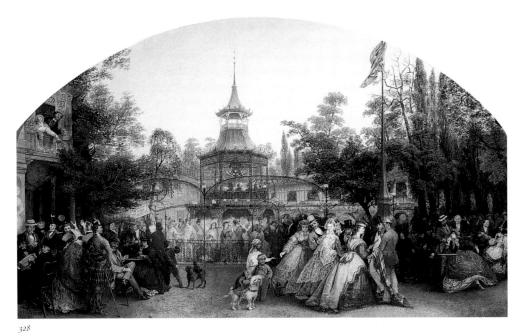

328

imagine, as imagination alone can penetrate the coating of mud which is all that is visible to the eyes ...'

In 1862 Frith was commissioned by the dealer Gambart to paint a series of three London street scenes for the guaranteed fee of £10,000. But sadly Frith never completed the series, being deflected from the commission by a flattering request from the Queen to paint the wedding of the Prince of Wales and the guests (see Pls. 27, 455). As a result the commission from Gambart was abandoned at the sketch stage. If completed the series would have rivalled Hogarth's *The Four Times of Day*, dealing with the same social ills of prostitution, theft and poverty.

Two paintings by the German-born Phoebus Levin (1836–1908) pursue similar themes. *Covent Garden Market from James Street* (1864) depicts a raffish youth with a prostitute and a long-haired woman being ejected, fighting, from a pub. In *The Dancing Platform at Cremorne Gardens* (Pl. 328), a group of prostitutes and their clients play with a performing monkey mounted on a poodle led by a dwarf in the right foreground, while in the background a stout wife knocks off her husband's hat, having discovered him chatting up a young woman. On the platform, a man offers a woman a bundle of notes. The pleasure grounds at Cremorne, a notorious nightspot, opened in 1845 as a rival to Vauxhall Gardens. The land was formerly a Chelsea farm, the property of Viscount Cremorne. It became a popular venue for outdoor dancing and entertainments, celebrated for its firework displays on Saturday nights which inspired several Nocturnes by Whistler and drawings by his follower Walter Greaves. The Gardens were closed in 1877 after many local complaints. The derelict Lots Road Power Station near Battersea Bridge now occupies its site, and there are plans to transform it once more into a pleasure garden.

The theme of gambling touched on in *Derby Day* continued to intrigue Frith. In 1871 he exhibited *The Salon d'Or, Homburg* (Pl. 329), showing the gamblers crushed round the tables at a casino at the fashionable spa of Bad Homburg in Germany. Such establishments had a sinister glamour for the general public who were appalled by tales of gambling for high stakes in aristocratic circles. The Prince of Wales himself became involved in the 'Tranby Croft' affair in 1891, in which a guest at a country house party, Sir William Cumming, was accused of cheating while playing baccarat. Cumming was exposed and forced to promise that he would never play cards for money again, but inevitably the scandal leaked to the press. The public were

shocked at the revelation that the Prince was such a regular gambler that he carried his own crested counters with which to wager when playing backgammon.

Frith was clearly both attracted and repelled by gambling, and in the *Salon d'Or* painted himself and his wife standing behind the table to the left of centre looking appropriately shocked. He explored similar themes in two series, each of five paintings, *The Road to Ruin* (1878) and *The Race for Wealth* (1880). In *The Road to Ruin* gambling drives a young man to destroy his family and commit suicide. Of it Frith wrote, 'Without any pretension to do my own work on Hogarthian lines, I thought I could show some of the evils of gambling; my idea being a kind of gambler's progress, avoiding the satirical vein of Hogarth, for which I knew myself to be unfitted.'

In *The Race for Wealth* series Frith wished 'to illustrate … the common passion for speculation, and the destruction that so often attends the indulgence of it, to the lives and fortunes of the financier's dupes'. The story line was based on the career of the Kensington entrepreneur Baron Albert Grant, which also inspired Anthony Trollope's novel *The Way We Live Now*, serialized from 1874 to 1875. In the fifth

329
William Powell Frith
The Salon d'Or, Homburg
1871
oil on canvas, 125 × 260cm
(49¼ × 102⅜in)
Museum of Art, Rhode Island
School of Design

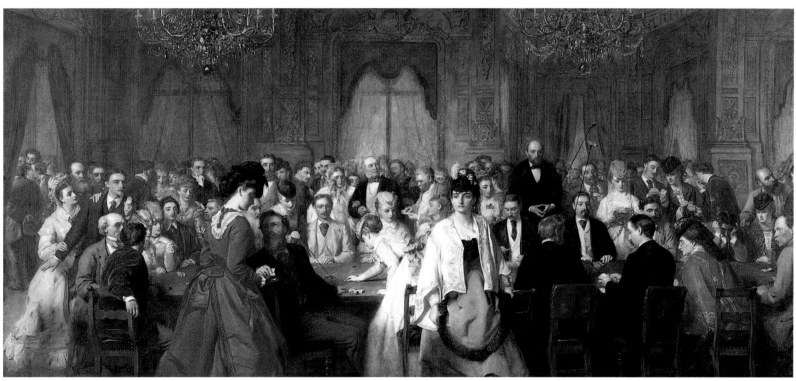

329

painting, *Retribution* (Pl. 330), the fraudulent financier is portrayed at exercise in the yard of Millbank Prison, the site of the future Tate Gallery! With his usual thoroughness Frith obtained the permission of the prison Governor to paint the scene. The scene inevitably recalls Oscar Wilde's experience while exercising in the yard of Reading Gaol when a fellow convict whispered to him, 'I am sorry for you: it is harder for the likes of you than it is for the likes of us.' For both Haydon and Frith, prison yards provided an insight into a tragic cross-section of society.

But Frith's day was short-lived. In 1874 he was chided by the *Art Journal* for being an artist more interested in subject-matter than in beauty, 'devoted to telling stories on canvas … eminent among the men who paint for those who like pictures without liking art'. Four years later the same journal commented on the gulf between Frith's concept of art and that appreciated by the new generation of critics, 'the gentlemen who have "affinities" and inner souls, and aspirations after the ideal'. In 1893, three years after his retirement from the Royal Academy, Frith wrote bitterly, 'the

330
William Powell Frith
Retribution
1878
oil on canvas, 30.8 × 39.4cm
(12¼ × 15½in)
Birmingham City Museum and
Art Gallery

331
Frank Walton and
Thomas Walter Wilson
The Lawn at Goodwood
1886
oil on canvas, 91.4 × 152.4cm
(36 × 60in)
Goodwood House, Sussex

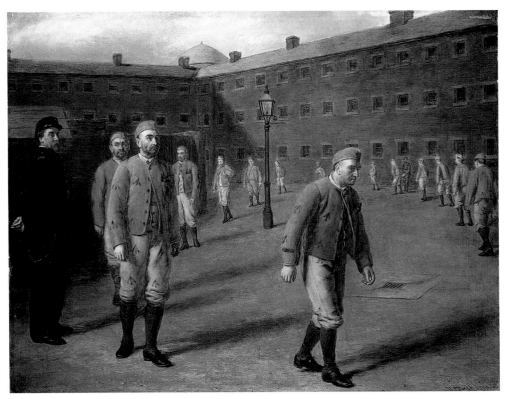

330

British Public has taken to Impressionism, and values … and nocturnes and symphonies, etc … I am going to the R.A. tomorrow to look if there are still any traces of the British School to be found – A very short time will see the curtain drop on the British School of Painting. You may take my word for that …'

Despite Frith's gloomy views, other less remembered artists continued to paint Private Views, Race Meetings, Royal Garden Parties, the Royal Yacht Club at Cowes, Jubilee Processions and the Eton and Harrow Cricket Match at Lords. A notable example of this type is by Frank Walton (1840–1928) and Thomas Walter Wilson (fl.1870–1903), *The Lawn at Goodwood* (Pl. 331), the private race course of the Duke of Richmond. It remains today one of the most beautiful of race courses, but in Victorian times the July meeting there possessed the extra social *cachet* of being the last event of the London season. The crowd includes many recognizable portraits, probably painted from photographs, including the Prince of Wales and Gilbert and Sullivan, and although the picture possesses a curious resemblance to a completed jigsaw puzzle with the individual portraits having been 'dropped into' the composition, it still has great charm.

As Frith's fortunes waned in the 1870s, the fickle public turned more and more to the sophisticated glimpses of high society life provided by the Anglo-French artist James Tissot, who was a friend of Manet, Degas and Whistler. He only lived for ten years in England in the middle of his career, but is chiefly remembered as a Victorian painter, although this oversimplifies his artistic position. His most ambitious English painting is *The Ball on Shipboard* of 1874 (Pl. 332). An amusing aspect of Tissot's methods of composition is reflected in the fact that no fewer than three pairs of 'twins' wear exactly the same outfit, which was social death at a fashionable ball, and surely an ironic comment by the artist on the couturier's art.

Tissot's *Hush (The Concert)* (Pl. 333) was another successful treatment of a high society scene, although it was criticized at the time for its blandness, because 'most of the people in the picture are just types'. In fact it has been suggested that the musicians were Sir Julius Benedict and Diaz de Soria and that the company included

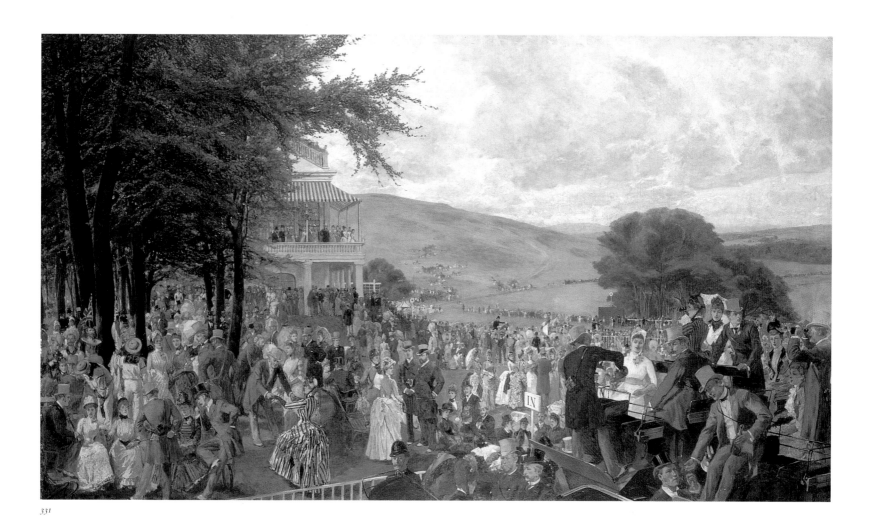

331

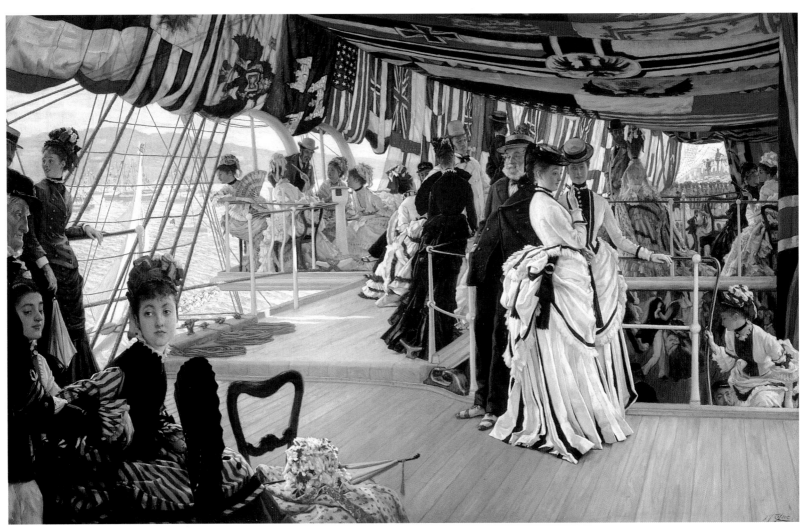

332

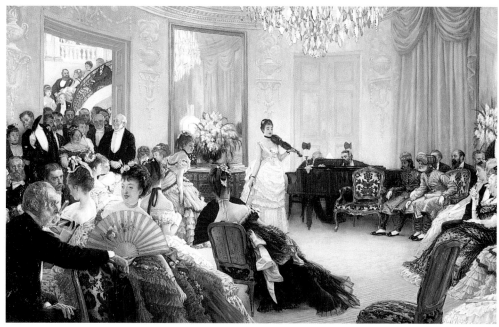

333

332
James Tissot
The Ball on Shipboard
1874
oil on canvas, 84.1 × 129.5cm
(33 × 51in)
Tate Gallery, London

333
James Tissot
Hush (The Concert)
*c.*1875
oil on canvas, 73.7 × 111.8cm
(29 × 44in)
Manchester City Art Gallery

Prince Duleep Singh, Frederic Leighton and in the doorway the artists Ferdinand Heilbuth and Giuseppe De Nittis.

These paintings may have inspired Frith's last major work, *Private View of the Royal Academy, 1881* (Pl. 32), exhibited at the Royal Academy in 1883. Frith wrote of this painting in his autobiography:

> Beyond the desire of recording for posterity the aesthetic craze as regards dress, I
> wished to hit the folly of listening to self-elected critics in matters of taste … I
> therefore planned a group, consisting of a well-known apostle of the beautiful,
> with a herd of eager worshippers surrounding him. He is supposed to be explain-
> ing his theories to willing ears, taking some pictures on the Academy walls as his
> text. A group of well-known artists are watching the scene. On the left of the
> picture are a family of pure aesthetes absorbed in affected study of pictures. Near
> to them stands Anthony Trollope, whose homely figure affords a striking contrast
> to the eccentric forms near him.

The 'well-known apostle of the beautiful' is of course Oscar Wilde (Pl. 20), wearing a lily and surrounded by a circle of female admirers including Ellen Terry with her son Gordon Craig. Just to her right is the bearded figure of the caricaturist George Du Maurier, the *Punch* satirist of the aesthetic movement. Gladstone is seen slightly behind Trollope, with Thomas Huxley and Robert Browning nearby. In the centre can be seen the Archbishop of York and the 'society beauty' Lily Langtry. Other figures include Millais and Lord Leighton, the President of the Royal Academy.

Today we still enjoy looking at Victorian crowd scenes of events such as going to a private view, visiting the Derby, travelling by rail or passing a day at the seaside. We are transported back in time, and we realize that many of our pleasures are sim-ilar to those of our great-grandparents. Just as in Frith's day our pleasure is much dependent upon the weather. So it has always been, so will it always be. After an appalling wet Derby day in 1863 Charles Dickens walked to the station through 'an oasis of boards in a sea of mud'. He remembered, 'last year it was iced champagne, claret cup and silk overcoats, now it ought to be hot brandy and water, foot bath and flannels'. Whatever the weather, the crowds go to Epsom as they did in Frith's and Dickens's times, and whether we look at the actual event today, or Frith's picture – all human life is indeed there …

In September 1808 an artist recorded in his diary his search for inspiration by reading the classics: 14th. Read Homer in English to stir up my fancy, that I might conceive and execute my hero's head with vigour and energy.

15th. Read eight hours.

16th. Read nine hours.

17th. Read Virgil; can make it out very well, but his idea of the bird, etc., not so beautiful and true as Homer's who makes the feathers fly out and quiver in the air. Quite in the feeling of Latin and Greek. Thirteen hours reading, right eye rather strained.

18th. Read Homer – many fine passages. I go to the Greek and make it out, but with great bungling.

20th. Began my picture again.

This is the unmistakable voice of Benjamin Robert

335
James Stephanoff
The Virtuoso
1833
watercolour, 51 × 59cm
(20 × 23⅓in)
British Museum, London

Haydon musing on the troubles he was having painting *The Assassination of Dentatus*. It transports us back to a world where familiarity with Latin and Greek was widespread in a way we cannot possibly imagine today. It was a world in which any schoolboy worth his salt could translate Virgil and Horace, and the great mythical stories of antiquity were understood without recourse to a classical dictionary to explain who were Perseus, Orpheus, Eurydice or Diana. Many collectors and connoisseurs prized their copies of classical works, a pleasure delineated in James Stephanoff's watercolour *The Virtuoso* (Pl. 335), showing a connoisseur seated amid the Elgin Marbles and other antiquities in the British Museum.

In the summer of 1807, Haydon had for the first time the thrilling experience of seeing the Elgin Marbles – actual Greek sculptures from the Parthenon in Athens – in a shed especially constructed by Lord Elgin in Park Lane. 'I felt', Haydon later recalled, 'as if a divine truth had blazed inwardly upon my mind, and I knew that they would at last rouse the art of Europe from its slumber of darkness.' For him the marbles showed 'the most heroic style of art combined with all the essential details of actual life', and thus confirmed his belief that the artist's primary duty was to study the human form through life drawing and anatomy, as he believed the sculptors of the Elgin Marbles had done.

The display of the sculptures was an event of major importance to the course of British art, hailed with enthusiasm not only by Haydon, but by Benjamin West, Henry Fuseli and the sculptor John Flaxman (nicknamed 'the Yorkshire Phidias' after the greatest sculptor of classical Greece, who was responsible for the Parthenon sculptures which form the Elgin Marbles). Poets as varied as Keats and Byron wrote on the beauty of the marbles, although Byron deplored the way in which they had been removed from the Acropolis.

335

The Elgin Marbles did, however, highlight a dilemma. There was a general agreement that in the words of Theophile Gautier, 'of all the arts the one which least lends itself to the expression of the romantic ideal is sculpture, which seems to have received its definitive form in antiquity'. Throughout the first half of the nineteenth century, while painters grew agitated as to whether Raphael marked the beginning or the end of artistic excellence, the relentless question to confront every practising sculptor was whether trousers were to be preferred to togas. In the Victorian era the male trouser and the female crinoline and bustle flourished, but nevertheless the conventional emphasis on the study of the classics in the public school system produced a continuing desire for depictions of classical antiquity.

The first major artist to devote his career to painting academic nudes was William Etty (1787–1849). He was born into a Methodist family in York, and remained devoted to his native city for the whole of his life. His talents were recognized by a wealthy uncle, a banker who encouraged him throughout his career. In

336
William Etty
The Judgement of Paris
1843
oil on canvas, 182.9 × 274.3cm
(72 × 108in)
Lady Lever Art Gallery,
Port Sunlight, Liverpool

1805, aged 18, Etty moved to London to study at the Royal Academy Schools, and he also worked as a studio assistant for Sir Thomas Lawrence, who had a great influence on him. But it was the life class of the Royal Academy which was to be his most important source of instruction. 'He was from the beginning', to quote from Richard Redgrave's memoir,

> one of the most constant in attending the schools, and … became wholly
> absorbed in the study of the nude … he took with avidity to the use of the brush
> and ever after *painted* his studies, thus he gained a power over the imitation of
> flesh, both as to colour and texture, beyond that of any other artist … on his
> election as a member he still continued to frequent the schools … almost to the
> end of his life … from painting so constantly by gaslight, he became accustomed
> to great breadth of light and shade.

This latter practice helps to explain why Etty was never afraid to use dramatic colour, and why his skin tones have a vibrancy rare in the Victorian era. Following the death of his uncle in 1809 Etty became financially independent, and this enabled him to be bold in his choice of nude subjects. From 1822 to 1824 he made a prolonged visit to France, during which time he met Delacroix. He subsequently visited Italy, finding in the works of the Venetian school the rich, warm colouring so congenial to his taste. On his homecoming his works met with greater success. In 1824 Delacroix returned the visit in London, and found 'Etty's sketches above all praise but thought that like all painters he constantly spoilt them in the finishing'.

Etty's works grew in size: *The Combat*, exhibited in 1825, was no less than 10 feet 4 inches by 13 feet 3 inches, and depicted a life-sized half-naked woman separating two half-naked men. Although praised for its resemblance to Italian Renaissance art, its size alarmed prospective buyers, until the intrepid visionary painter John Martin purchased it for £300. In Martin's studio it was seen and admired by Lord Darnley, who commissioned Etty to paint his masterpiece, *The Judgement of Paris* (Pl. 336); when exhibited in 1843 it was, however, criticized by *Blackwood's Magazine*, who thought that the Three Graces looked as though they had been wearing stays.

Etty's works were frequently attacked on the grounds of indecency, *The Times* considering them 'entirely too luscious for the public eye'. Etty referred contemptu-

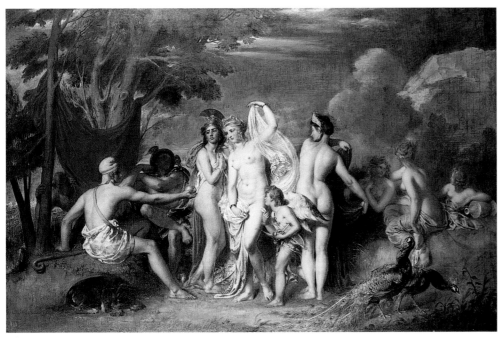

336

337
William Mulready
Bathers Surprised
1852–3
oil on canvas, 59 × 44cm
(23¼ × 17⅜in)
National Gallery of Ireland,
Dublin

338
Franz Xaver Winterhalter
Florinda
1852
oil on canvas, 179.1 × 244.5cm
(70½ × 96⅓in)
Royal Collection

339
William Edward Frost
**Diana and her Nymphs
Surprised by Actaeon**
1846
oil on canvas, 121.8 × 182cm
(48 × 71¼in)
Museo de Ponce, Puerto Rico

ously to such prim, mealy-mouthed critics as 'noodles'. Fortunately these 'Mrs Grundys' were not the only contemporaries to pass judgement on him, for in 1849 the Society of Arts awarded him the rare honour of a one-man retrospective exhibition which brought together 133 of his paintings. The exhibition met with a mixed reception, for his voluptuous Venetian method of working was already being superseded by detailed Pre-Raphaelite naturalism. Undeterred, late in life Etty defended his canvases in resolute terms: 'Finding God's most glorious work to be Woman, that all human beauty had been concentrated in her, I dedicated myself to painting, not the Draper's or Milliner's work – but God's most glorious work, more finely than had ever been done.' This was indeed Etty's great achievement. His work at its best invites comparison with Delacroix and anticipates Gustave Courbet. His canvases make no sacrifice of the formal values of paint to the predominant demands of the Victorian era for laboriously painstaking details. 'He is *revelling* in colour and in form,' the actor William Macready, whose portrait Etty painted, wrote on 7 April 1846, while Thackeray warned: 'Look for a while at Mr Etty's pictures, and away you rush, your "eyes on fire" drunken with the luscious colours that are poured out for you on the liberal canvas, and warm with the sight of the beautiful sirens that appear on it.'

Although Ruskin was the exponent of truth to nature in all its details, he never attended life classes and was apparently dismayed by the discovery on his wedding night that women had pubic hair. One cannot help speculating what would have ensued if Ruskin, at some time, had studied life drawing under the guidance of Etty. Be that as it may, Etty's life studies, sometimes dismissed as 'bottomscapes', reveal him as a surprisingly modern artist. But there was no escape from the double standards of the age, the conflict between the demands of propriety, reality and High Art. As Richard and Samuel Redgrave observed in their *Century of British Painters*: 'It must be allowed that many of Etty's pictures were of a very voluptuous character, and clashed with the somewhat prudish spirit of the age. There has always been a stronger objection to the nude figures of the painter than the more tangible works of the sculptor.' These objections led the establishment of a virtual taboo among painters upon classical themes and paintings of the nude.

During those years, however, the discipline of the life class continued to be taught. A notable practitioner of life drawing was William Mulready, who had trained as a boxer, and had the pugilist's shrewd eye and controlled knowledge of anatomy. Like a boxer, he believed in keeping himself in training, and at the age of 74 still attended the life school, remarking: 'I had lost somewhat of my powers in that way, but I have got it up again: it won't do to let these things go.' Mulready only painted two nude subjects, both in 1849, *The Bathers* and *Bathers Surprised* (Pl. 337).

Surprisingly, Queen Victoria herself was far from prudish and greatly enjoyed paintings of the nude, purchasing for the Prince Consort's birthday in 1852 *Florinda* (Pl. 338), a painting of a large group of semi-draped figures by Franz Xaver Winterhalter, which she found 'most lovely' and hung in her sitting room at Osborne. The Queen had a mind of her own, and in 1853 expressed admiration for Mulready's drawings of the nude, brushing aside officials who tried to prevent her seeing them in an exhibition. The Royal Family also patronized the only artist to continue to make the nude his main concern, Etty's pupil William Edward Frost (1810–77), who made his initial reputation at the Royal Academy as a portrait painter before turning to literary and mythological themes. Works such as *Diana and her Nymphs Surprised by Actaeon* (Pl. 339) proved both popular and lucrative. At their best Frost's works have a distinctive jewel-like charm, his attractive young women models possessing a pert, self-conscious quality which makes them much more titillating

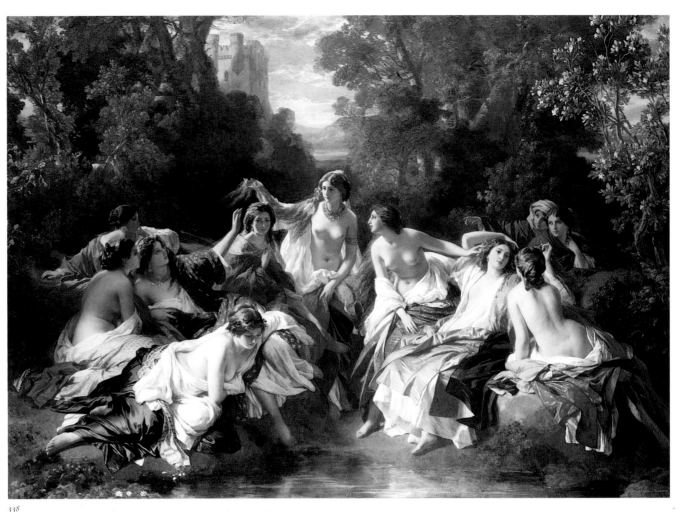

338

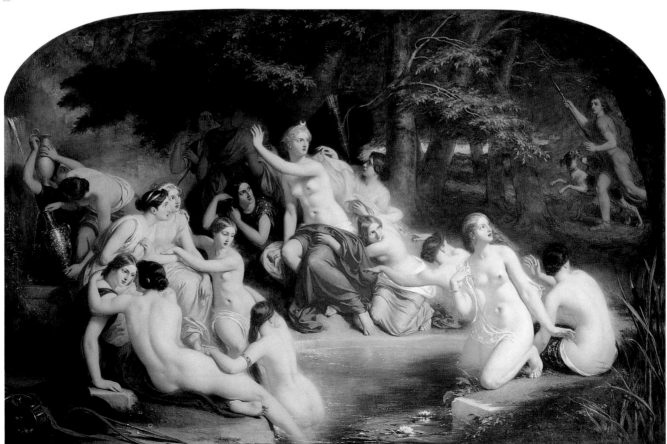

339

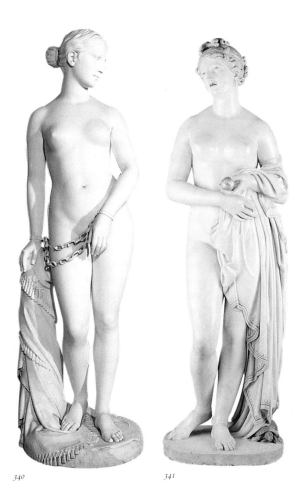

340 *341*

than Etty's more powerful studies, although they always remain 'chaste and proper for the eyes of the British matron in her dining room'. But further proof of the truth of Redgrave's observation concerning the public's tolerance of the nude in sculptural form was to be provided by two sculptures which were to have a considerable influence upon later paintings.

In 1851 at the Great Exhibition the American sculptor Hiram Powers (1805–73) exhibited a fair Circassian *Greek Slave* (Pl. 340) which caused a sensation. It had been inspired by the Greek War of Independence and depicts a Greek maiden who has been captured by the Turks and forced to stand naked in the slave market. In the Crystal Palace the sculpture was chastely displayed in a curtained alcove but placed on a revolving stand which could be discreetly rotated by gentlemen using their umbrellas to reveal its posterior charms. In a pamphlet Powers, an ardent Swedenborgian, explained that the slave's faith in God shielded her and kept her from shame, thus effectively dispelling moral objections to her nudity, always a major issue for the Victorian public. Powers carved no fewer than six versions of the sculpture. The original version toured American cities where it acted as a catalyst in the growing anti-slavery movement.

A star attraction at the 1862 International Exhibition at South Kensington was another statue, *The Tinted Venus* (Pl. 341) by John Gibson (1790–1866), who had spent his entire working life in Rome, maintaining complete adherence to the classical tradition. He once memorably declared that: 'The human figure concealed under a frock-coat and trousers is not a fit subject for sculpture.' *The Tinted Venus*, with its painted lips, hennaed hair and other tinted details, was criticized by many writers for displaying an unnecessary realism, while others saw it as being over-decorative. To Gibson, however, it demonstrated the Greek principles of sculptural polychromy. Both these sculptures were to influence the standing Venuses of the late 1860s by Leighton (who knew both Powers and Gibson in Rome) and Albert Moore (see Pls. 355, 356).

Although George Frederic Watts, dubbed 'England's Michelangelo', was not a pupil of William Etty, he greatly admired him, sharing a consuming interest in painting the female nude. While studying in Italy in 1846, he began to paint *Orlando Pursuing the Fata Morgana* (Pl. 342), which shows the hero attempting to wrest from her the key to a prison in which she has locked several knights seduced by her beauty. He completed the work when back in England, and despite the widespread prudery of the age continued to paint major nude subjects such as *The Judgement of Paris*. He also defended the life school against attacks, writing that 'to abolish the practice of painting the nude model would be to abolish art'.

In *The Wife of Pygmalion* (Pl. 343) Watts assayed the theme from Ovid of Pygmalion, King of Cyprus, who fell in love with the statue of a girl he had made. Aphrodite breathed life into her, and she became his wife. Watts significantly painted not from a live model but from two fragments of classical Greek sculpture. In an important review of the work when it was shown at the Academy in 1868, the poet Swinburne said that it recalled the Venus de Milo, and that an ancient Greek painter must have painted women in this manner. As Watts completed the Pygmalion theme Edward Burne-Jones began to treat it more extensively in a series of four paintings (1868–70), *The Heart Desires*, *The Hand Refrains*, *The Godhead Fires* (Pl. 345) and *The Soul Attains*, which epitomize the conflict between the real and the ideal, between the classical tradition and Pre-Raphaelite sensuality.

Swinburne, a close friend of Burne-Jones, was also an admirer of the poetry of Rossetti, and wrote extolling the poet's feeling for 'firm outline, the justice and chastity of form. No nakedness could be more harmonious, more consummate in its

fleshly sculpture … the beautiful body as of a carven goddess gleams through this august poetry tangible and taintless, without a spot or default.' This hothouse prose extolling nakedness in the abstract was one thing; the reality, or even the depiction of reality, was quite another. One of Rossetti's rare nudes, *Ligea Siren* (1873), proved very difficult to sell, leading Rossetti to write: 'the unpopular central detail will eventually be masked by a fillet of flying drapery coming from a veil twisted in the hair so as to render it saleable', while the earlier voluptuous *Venus Verticordia* (Pl. 344) predictably led Ruskin to criticize the painting, albeit in a curiously indirect way, by averting his eyes from the naked breasts, and attacking the honeysuckle and roses as 'awful – I can use no other word – in their coarseness'.

As a boy Frederic Leighton travelled widely throughout Europe studying art in

342
George Frederic Watts
Orlando Pursuing the Fata Morgana
1846–8
oil on canvas, 165 × 120cm
(65 × 47¼in)
Leicester Museum and Art Gallery

343
George Frederic Watts
The Wife of Pygmalion
1868
oil on canvas, 66.6 × 53.3cm
(26¼ × 21in)
Buscot Park, Oxfordshire

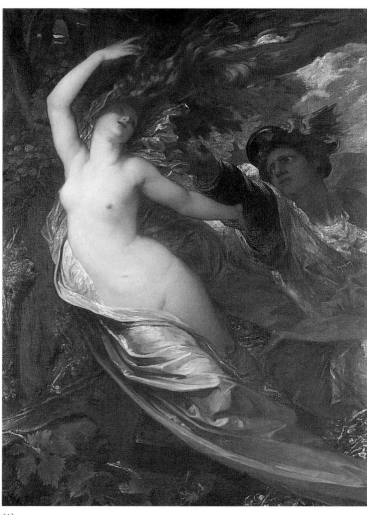

342

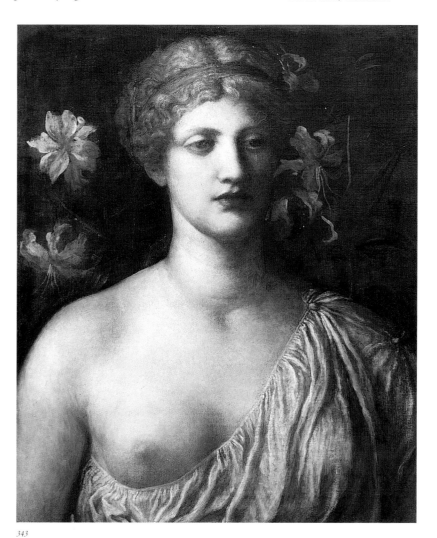

343

Florence, Paris and most notably in Frankfurt with Baron Steinle, the last of the Nazarenes. From 1855 to 1858 he worked in Paris, meeting the two great masters of the nude, Delacroix and Ingres (Leighton later owned a nude study for Ingres's *Odalisque and the Slave*), and also his own contemporaries such as Ary Scheffer, Alexandre Cabanel and Adolphe William Bouguereau, whose smooth technique in paintings of the nude closely parallels his own work. He also absorbed the appeal of the classical subjects of the French Academician Thomas Couture and his followers. Leighton synthesized this spectrum of influences into his own highly distinctive style, particularly after his visit to Greece in 1867. In 1869 he turned to Ovid as a source for the legend of *Daedalus and Icarus* (Pl. 346), which tells of the inventor Daedalus imprisoned with his son Icarus on Crete, who contrived to escape by making wings

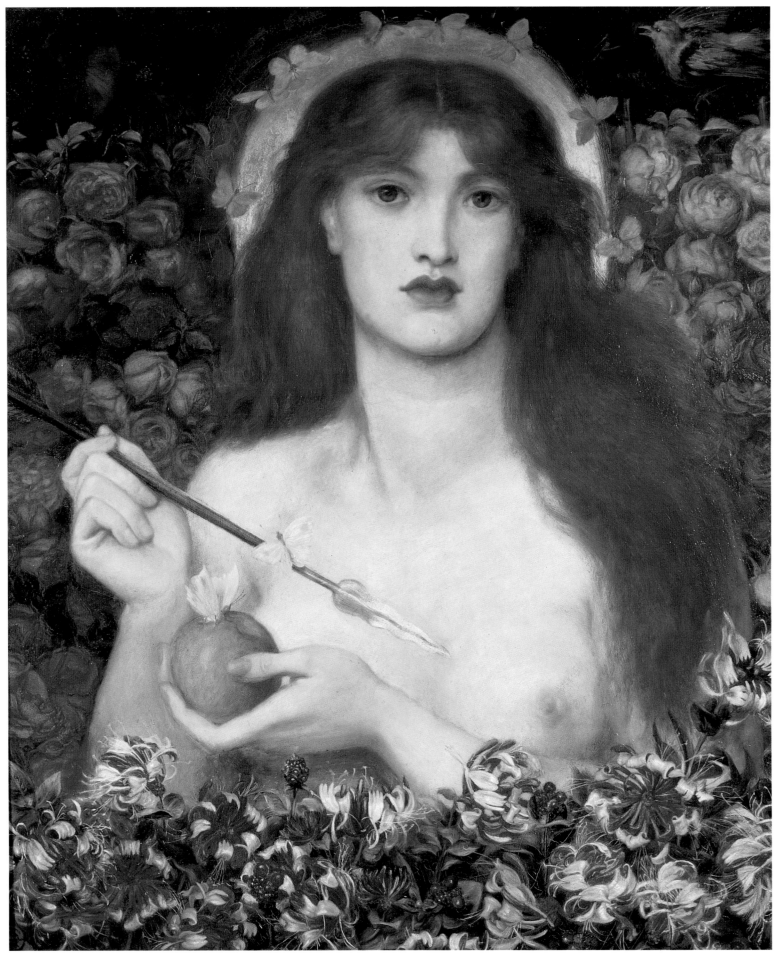

344

344
Dante Gabriel Rossetti
Venus Verticordia
1864–8
oil on canvas, 98 × 69.9cm
(38⅝ × 27½in)
Russell Cotes Art Gallery and
Museum, Bournemouth

345
Edward Burne-Jones
The Godhead Fires
1878
oil on canvas, 97.5 × 75cm
(38⅜ × 29½in)
Birmingham City Museum
and Art Gallery

346
Frederic Leighton
Daedalus and Icarus
1869
oil on canvas, 138.2 × 106.5cm
(54⅜ × 41⅞in)
Buscot Park, Oxfordshire

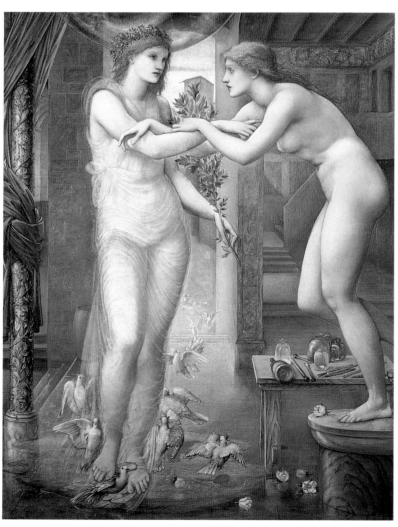

345

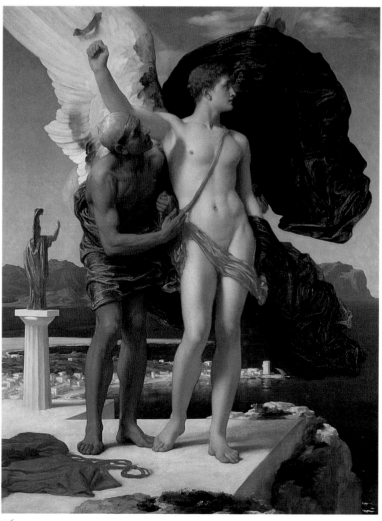

346

out of feathers and wax. Disobeying his father's instructions Icarus flew too near the sun, which melted the wax, and he fell to his death. The subject probably appealed to Leighton less for its dramatic story than as an opportunity to paint the nude male torso, an adaptation of the pose of the Apollo Belvedere, one of the most famous of all classical statues.

Leighton's relatively few nudes always escaped critical censure because they were so obviously idealized. *Actaea, the Nymph of the Shore* (Pl. 347), for example, was described by the *Art Journal* as 'ideal in form and romantic in motive', referring to the story of the nymph Actaea who rose from the ocean to comfort the grief-stricken Achilles. Swinburne felt that the charm of this work was limited to Leighton's skill as a draughtsman, and that the Hellenic quality was artificial. Indeed it has obvious parallels not with Greek art but with Cabanel's *Birth of Venus*, purchased by Napoleon III at the Salon of 1863. This work provided a striking example of an 'acceptable' nude subject, made respectable by its classical title; it was considered by one critic as 'wanton and lascivious' but 'not in the least indecent', a case of 'having your cake and eating it'.

During the Second Empire (1852–70) the Paris Salon became filled with such works, prompting a caricature by Daumier of scandalized Parisian ladies throwing up their hands in horror at the sight of walls crowded with nudes, exclaiming 'toujours des Vénus'. But the writing was on the wall for the supremacy of this classical convention. The year 1863 was also that of the Salon des Refusés in which Edouard Manet's controversial *Déjeuner sur l'herbe* caused a sensation. As Zola ironically put it: 'a woman has just emerged from a river and is drying her naked body in the open air … Good heavens! How indecent! What! A woman without a stitch of clothing seated between two fully clad men! Such a thing has never been seen before!'

It was all the worse when it became known that Manet had taken the idea for the composition from Giorgione's *Fête Champêtre*, interpreted in an engraving by Marcantonio Raimondi, which also echoed Raphael's *Judgement of Paris*. Manet's total rejection of idealism shocked not only the Emperor but also the public, whose reaction was typified by the English critic P.G. Hamerton:

> some wretched Frenchman has translated this into modern French realism, on a
> much larger scale, and with … horrible modern French costume … Yes, there
> they are, under the trees, the principal lady entirely undressed … another female
> in a chemise coming out of a little stream that runs hard by, and two Frenchmen
> in wide awakes sitting on the very green grass with a stupid look of bliss. There
> are other pictures of the same class, which lead to the inference that the nude,
> when painted by vulgar men, is invariably indecent.

Vulgarity, like indecency, is in the eye of the beholder, and it is intriguing to speculate how Hamerton would have reacted to another work based on the same engraving painted twenty years later. *A Visit to Aesculapius* (Pl. 348) by Sir Edward Poynter (1836–1919) is a work carefully calculated to titillate public taste and not shock it, for a classical theme and an unpronounceable title derived from the decent obscurity of a dead language provided a literary fig-leaf which protected the artist from charges of indecency.

Like Leighton, Poynter believed that art should deal with subjects that were entirely imaginary. After leaving the Royal Academy Schools where he was a close friend of Simeon Solomon, Poynter formed his academic style in Italy, where he met Frederic Leighton, and in Paris where he studied with Charles Gleyre, then acknowledged as the leading European master of the classical nude. Poynter became one of the group of artists including Whistler, Thomas Armstrong, Thomas Reynolds Lamont and George Du Maurier, chronicled in the latter's novel *Trilby* (1894). The

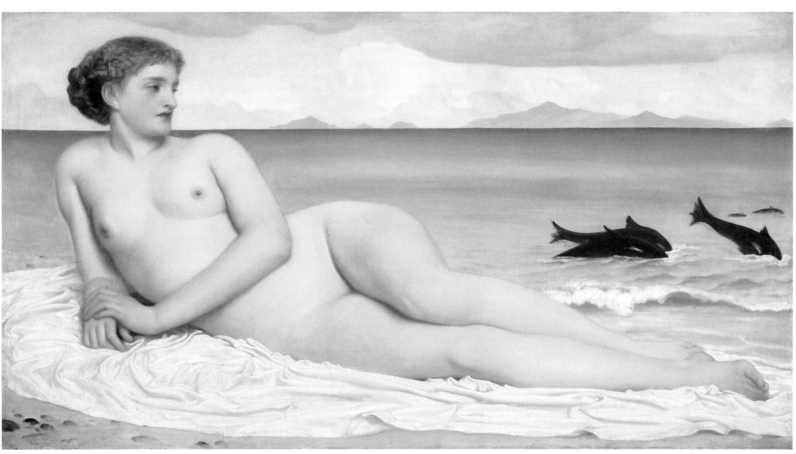

347

348
Edward Poynter
A Visit to Aesculapius
1883
oil on canvas, 151.1 × 228.6cm
(59¼ × 90in)
Tate Gallery, London

349
Edward Poynter
The Catapult
1868
oil on canvas, 155 × 183.5cm
(61 × 72¼in)
Laing Art Gallery, Newcastle-
upon-Tyne

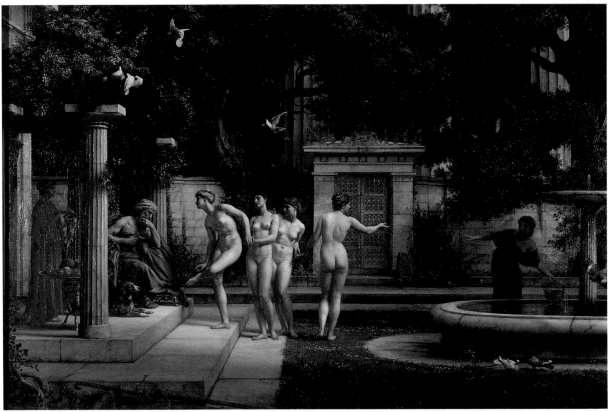

348

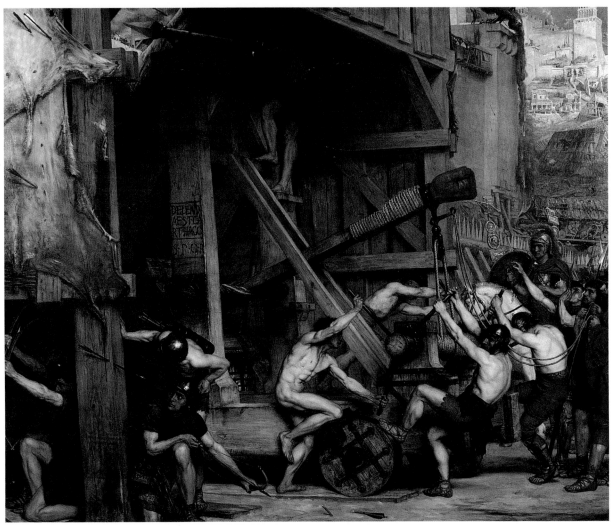

349

four years which he passed in Gleyre's atelier in the 1850s grounded Poynter in the academic technique of constructing compositions from individual studies of figurative elements. Throughout his long career he created hundreds of life drawings, often on terracotta, green or blue paper as well as the more usual cream, studies of great intrinsic beauty. He tried to inculcate these standards when teaching at the Royal Academy Schools, once observing: 'Constant study from the life model is the only means ... of arriving at a comprehension of the beauty of nature.'

Poynter's early reputation was made with the success of such paintings as *Faithful unto Death* (1865), depicting a centurion remaining at his post during the eruption of Vesuvius, and *Israel in Egypt* (1867), depicting labouring Hebrew slaves. He continued to examine the theme of the Roman soldier with his painting *The Catapult* (Pl. 349), a composition dominated by a naked Roman warrior, and a demonstration of his mastery of the male nude.

During the 1880s a lively correspondence from its readers appeared in the staid pages of *The Times* on the subject of nudity, begun by a diatribe from 'A British Matron' objecting to nudes in general, and including Poynter by implication. Undeterred, he continued to paint mildly titillating female nudes with piquant titles and carefully researched and meticulously executed Roman settings, for like Alma-Tadema, Poynter was also extremely gifted in the portrayal of the texture of marble. In works such as *The Cave of the Storm Nymphs* (Pl. 351) the figures are treated with a virtuoso tactile realism quite different from the muted detail of the 'ideal' classical nude in Poynter's earlier, more academic life studies. Poynter was by this time a full-time art administrator, and his official roles left less time for painting. Nevertheless, he continued to create a series of small-scale classical works, which when attacked by Roger Fry in 1914 for being old-fashioned, were supported by Sickert, who defended 'the excellent Ingres tradition that lingers in Sir Edward Poynter's painting'.

If Leighton and Poynter established the classical nude as a worthy and respectable subject, Lawrence Alma-Tadema (1836–1912) made it fun. With only a few exceptions he depicted the everyday life of the Greeks and Romans rather than heroic events from classical history. Increasingly his painstaking archaeological reconstructions became the setting for mildly erotic anecdotal subjects.

Alma-Tadema was of Dutch birth and acquired his taste for antiquity when studying art and archaeology in Antwerp. A visit to London to see the International Exhibition in 1862 gave him his first contact with the Elgin Marbles and the great Egyptian collections of the British Museum. The following year he married, and on his Italian honeymoon became fascinated by Roman remains and the excavations at Pompeii. He had found his life-long mission 're-animating the life of the old Romans', themes which provided him with the freedom to depict nudes to his heart's content.

Such works also provided an additional thrill for their *nouveau riche* owners, for by displaying them they could show evidence of classical leanings, if not a classical education, by representations of the tepidarium, frigidarium and apodyterium, subjects which allowed the aesthetic and enjoyable appreciation of titillating female nudes. The tepidarium was the warm Roman bath which provided artists such as Ingres, Gérôme and Chassériau with themes of relaxed sensuality. While Alma-Tadema was a student in Paris, the Musée de Luxembourg acquired Chassériau's *Tepidarium* of 1853, which he must have known, but his own painting was to have a far more direct sensuality than Chassériau's grand composition. In Alma-Tadema's *In the Tepidarium* (Pl. 352) the girl's open lips, closed eyes and strategically placed ostrich feather, the rug, marble, cushion and flower create a *tour de force* of tactile values. The model's right hand holds a strigil used for scraping the skin after oiling it,

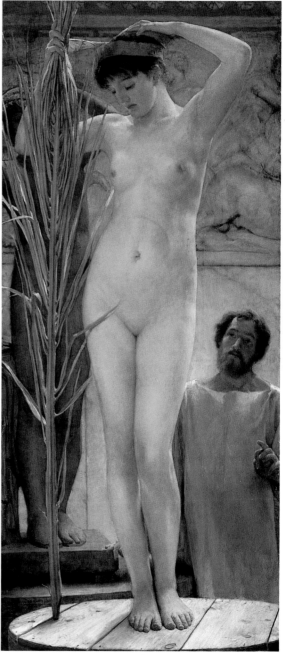

350
Lawrence Alma-Tadema
The Sculptor's Model
1877
oil on canvas, 195.6 × 84cm
(77 × 33in)
Private collection

350

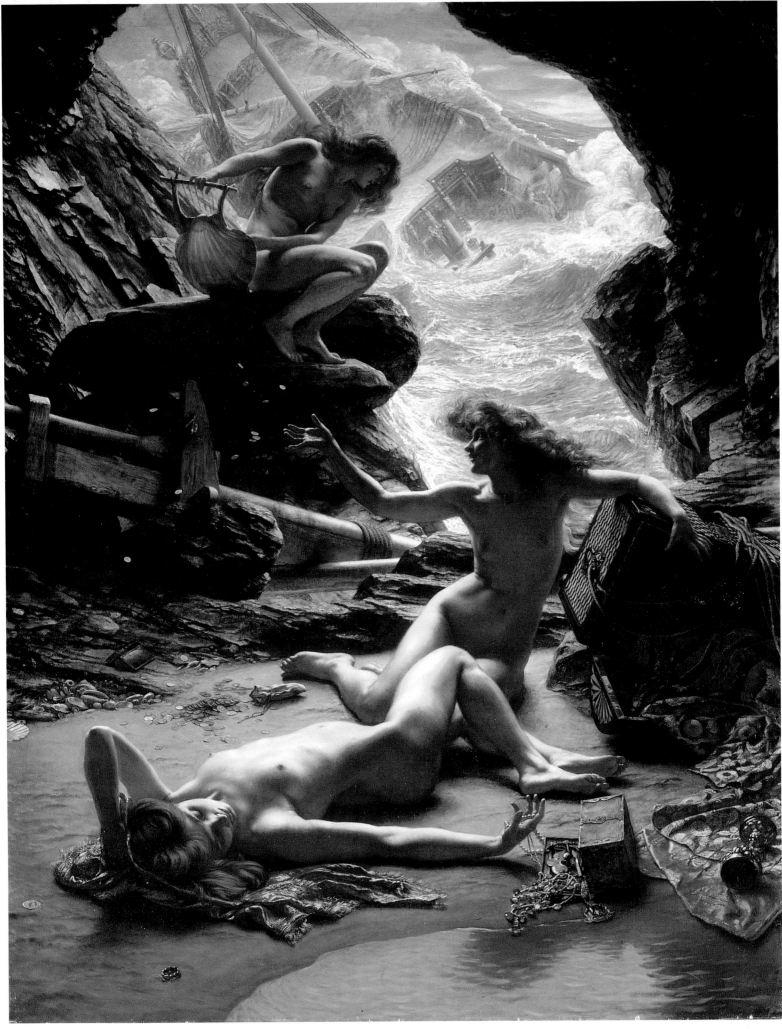

351
Edward Poynter
**The Cave of the Storm
Nymphs**
1903
oil on canvas, 145.9 × 110.4cm
(57½ × 43½ in)
Private collection

352
Lawrence Alma-Tadema
In the Tepidarium
1881
oil on wood, 60.9 × 83.7cm
(24 × 33in)
Lady Lever Art Gallery, Port
Sunlight, Liverpool

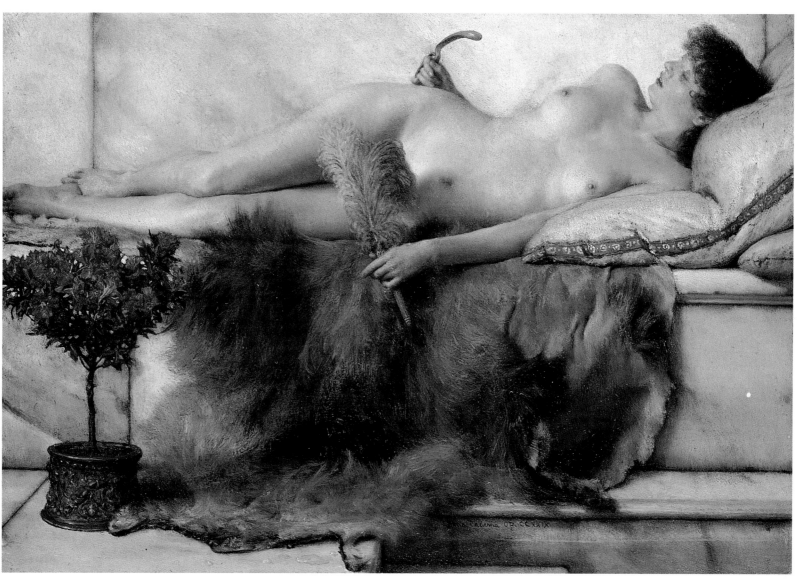

352

353
Lawrence Alma-Tadema
The Roses of Heliogabalus
1888
oil on canvas, 132.1 × 213.7cm
(52 × 84¼in)
Private collection

354
Albert Moore
Azaleas
1867
oil on canvas, 198.1 × 100.3cm
(78 × 39½in)
Hugh Lane Municipal Gallery
of Modern Art, Dublin

an archaeological detail designed to assuage the ire of critics and reassure viewers over-sensitive to the realism of the nude girl.

Inevitably, Alma-Tadema was occasionally subjected to outraged criticisms, such as the alarm aroused by *The Sculptor's Model* (Pl. 350). Its exhibition at the Academy in 1877 led the Bishop of Carlisle to write to the portrait painter George Richmond:

> My mind has been considerably exercised this season by … Alma-Tadema's nude Venus … [there may] be artistic reasons which justify such exposure of the female form … In the case of the nude of an Old Master, much allowance can be made, but for a living artist to exhibit a life-size almost photographic representation of a beautiful naked woman strikes my inartistic mind as somewhat if not very mischievous.

The troubled Bishop, however, was in a minority, for in 1882 the Grosvenor Gallery

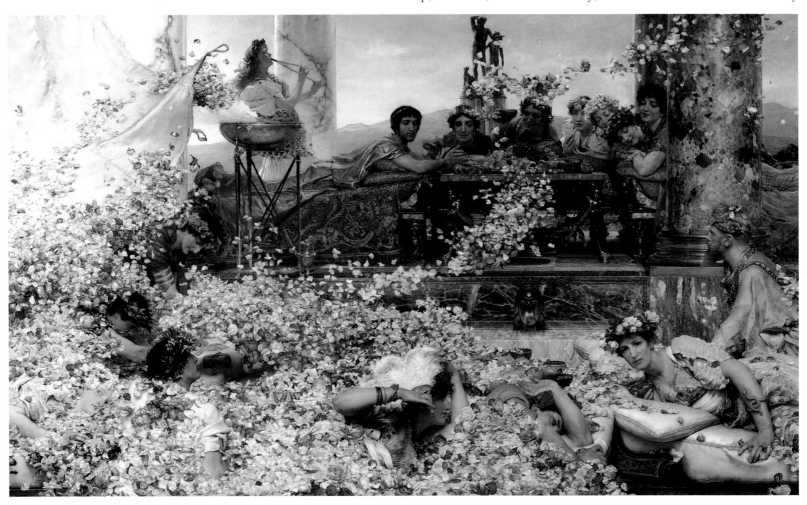

353

staged a successful exhibition of 287 of Alma-Tadema's paintings. 'Marbellous!' quipped *Punch* on seeing the work of the leading exponent of cool white stone, blue skies and exotic blossoms like azaleas. Among the most spectacular of his works is *The Roses of Heliogabalus* (Pl. 353), which depicts the psychopathic Emperor suffocating his guests at an orgy under a cascade of rose petals. The blossoms depicted were sent weekly to the artist's London studio from the Riviera for four months during the winter of 1887/8.

Another artist in whose compositions flowers played an indispensable role, who indeed could not work without the stimulus of flowers in his studio, was Albert Moore (1841–93). They feature throughout his work, from exotic azaleas to the humble daisy and dandelion in his moving final painting *The Loves of the Winds and the Seasons* (Pl. 566). When reviewing the Royal Academy exhibition of 1868

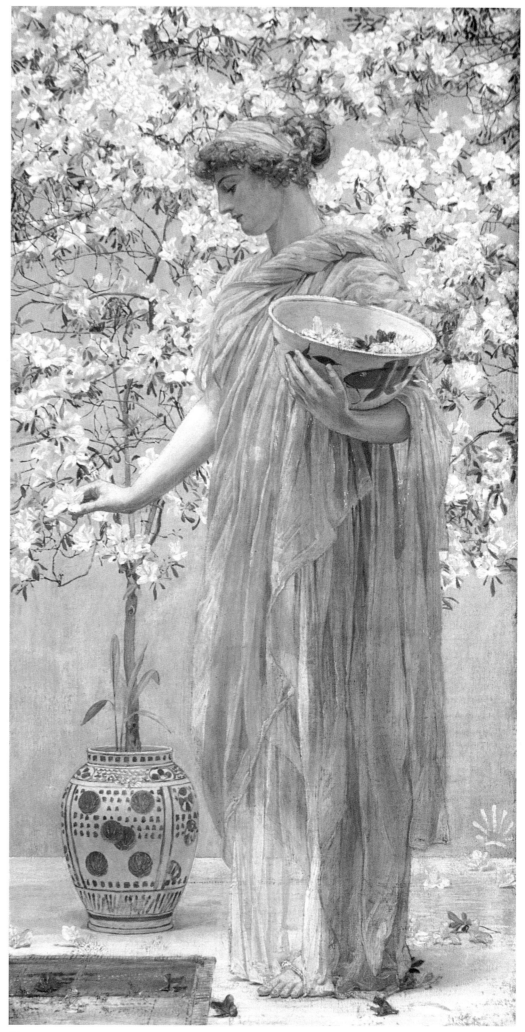

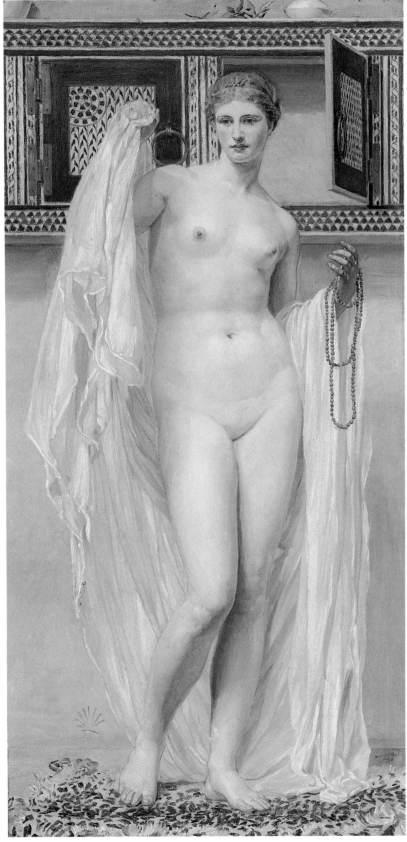

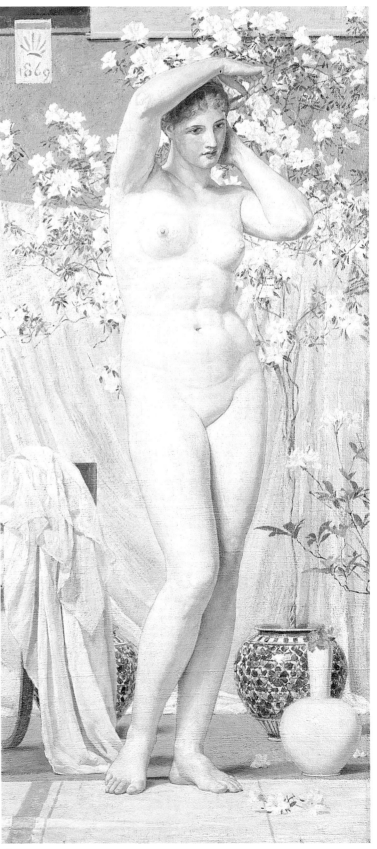

355

356

Swinburne described Moore's *Azaleas* (Pl. 354), which presents a draped woman:

> showing well the gentle mould of her fine limbs through the thin soft raiment,
> with pale small leaves and bright white blossoms about her and above, a few rose-
> red petals fallen on the pale marble ... a strange and splendid vessel ... clasped by
> one long slender hand and filled from it with flowers of soft white, touched here
> and there in to blossoms of blue ... such a painting has no reason for being
> except its beauty, its melody of colour and 'symphony of form'.

Another exquisite exercise in colour harmonies was painted in 1867, entitled *A Wardrobe* (Pl. 355) and the first of Moore's paintings to show a single full-length nude.

Describing the colours in any of Moore's paintings put contemporary critics on their mettle. *A Venus* of 1869 (Pl. 356) was, according to the critic of the *Pall Mall Gazette*, remarkable for its palette of colours which 'ran with delicate intervals through the fainter notes of salmon, gold, blue and green, with the whitest white as its highest tone ... the lines of the body are of exquisite beauty – intimately delight-ful, though firm, chaste and severe.' Many of Moore's works play visual variations on the themes of still-life painting of exotic flowers and hanging strings of beads which add carefully considered notes of colour.

Whistler was a great admirer of Moore as an artist, and for a while in the late 1860s there was a close relationship between their work. Whistler began to introduce classical elements, experimenting with groupings of women in Graeco-Japanese dress, notably in the *Six Projects* series, designs for a frieze which marked a turning point in Whistler's career, enabling him to synthesize his interests in classicism, Japonism and music into a coherent aesthetic. Unlike Moore, Whistler painted few nudes, but those that do exist reveal a subject ideally suited to an artist gifted with such remarkable sensitivity, as in the attractive watercolour of the dark-skinned gypsy or Italian model who posed for the *Dancing Girl* of 1885–90 (Pl. 357).

The discipline of Egyptology made remarkable strides in the Victorian age; as major discoveries were made, interest in Egyptian themes grew. Although Alma-Tadema only visited Egypt in 1902 towards the end of his career, and neither Poynter nor Edwin Long (1829–91) ever went there, all three painted elaborate paintings of life in pharaonic times. Indeed Long, who had begun his career as a painter of Spanish genre scenes, became celebrated both for his Egyptian subjects and large bib-lical and historical subjects, most notably *The Babylonian Marriage Market*, exhibited at the Royal Academy in 1875 (Pl. 358).

Long took his subject from the *Histories of Herodotus*, recently popularized in a translation by George C. Swayne (1870). The entry for the painting in the Royal Academy catalogue described the Babylonian convention of auctioning off the young women in an order judged on their appearance, so that the prettiest girl would be auctioned first, and so on until 'the damsel who was equidistant between beauty and plainness, who was given away gratis. Then the least plain was put up, and knocked down to the gallant who would marry her for the smallest consideration, – and so on until even the plainest was got rid of to some cynical worthy who decidedly preferred lucre to looks.' Swayne commented that this method of finding a husband was a good idea, for 'it at least possesses the merit of honesty and openness, and tends to a fair distribution of the gifts of fortune'.

Ruskin, surprisingly, admired the 'anatomical precision of the twelve waiting girls, from great physical beauty to absolute ugliness', and considered it worthy of purchase by the Anthropological Society, while another critic, Henry Blackburn, in the *Academy Notes*, admired the 'touch of genius in concealing the faces of the Alpha and Omega of comeliness'. The painting was sold at Christie's in 1881 and made the world-record price for a painting by a living artist of £6,615 – a record which lasted

355
Albert Moore
A Wardrobe
1867
oil on canvas, 100·3 × 49·6cm
(39½ × 19in)
Johannesburg Art Gallery

356
Albert Moore
A Venus
1869
oil on canvas, 160 × 76cm
(63 × 30in)
York City Art Gallery

357
James Abbott McNeil Whistler
Dancing Girl
1885–90
watercolour, 27.9 × 20.3cm
(11 × 8in)
Cecil Higgins Art Gallery,
Bedford

357

358
Edwin Long
**The Babylonian Marriage
Market**
1875
oil on canvas, 172.5 × 304cm
(68 × 120in)
Royal Holloway College,
University of London, Egham,
Surrey

for ten years. It was bought by Thomas Holloway for the Women's College which
he founded at Egham in memory of his dead wife. There it has remained, an amaz-
ingly chauvinist statement on matrimony and an object of ironic interest for genera-
tions of young women.

A similar theme also provides the subject of George Du Maurier's novel *Trilby*
(1894). The eponymous heroine is a seventeen-year-old model, whose innocence
enables her to pose '"in the altogether"… Truly, she could be naked and unashamed.'
Yet once she meets British students embarrassment sets in. The novel's hero, Little
Billee, retreats in horror when he finds her posing in the nude: 'suddenly a quick
thought pierced her through and through … Could it possibly be that he was *shocked*
at seeing her sitting there?'

Such a reaction reminds us that in the 1850s only married students at the Royal
Academy were allowed to draw from the female nude model. Such attitudes contin-

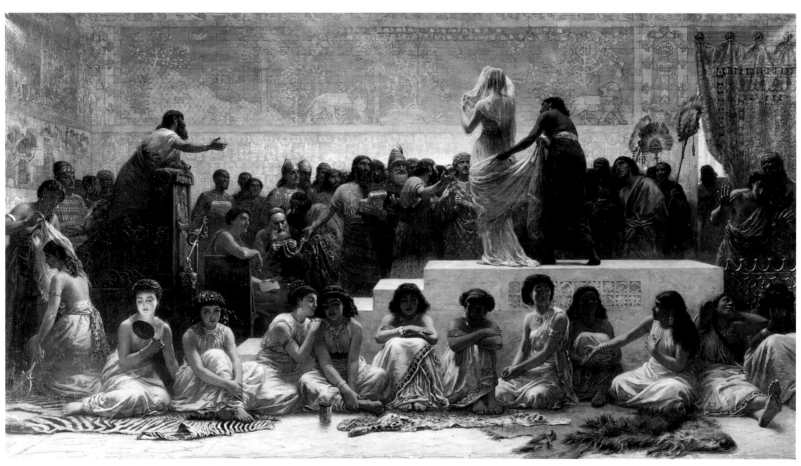

358

ued to flourish and are particularly associated with the puritanical academician J.C.
Horsley, who was given the inevitable nickname of 'Clothes Horsely'. Just before an
exhibition in which Whistler exhibited some nude pastel studies, Horsley wrote in
forthright terms to the Church Congress of 1885, deploring the effect of nude mod-
els on both artist and model:

> If those who talk and write so glibly as to the desirability of artists devoting them-
> selves to the representation of the naked human form, only knew a tithe of the
> degradation enacted before the model is sufficiently hardened to her shameful
> calling, they would forever hold their tongues and pens in supporting the prac-
> tice. Is not clothedness a distinct type and feature of our Christian faith? All art
> representations of nakedness are out of harmony with it.

Hearing of this Whistler added an ironic comment to one of his studies, *Note in Violet
and Green*, 'Horsley soit qui mal y pense.'

Such views were also ridiculed at the music halls by the singer Florrie Ford, who satirized the philistine British view that 'if it's nude, it's rude' in a song beginning:

My old man is a very clever chap

He's an artist in the Royal Academy

He paints pictures from morning until night

Paints them with his left hand, paints them with his right

And all his subjects – take a tip from me

Are very, very Eve and Adamy

And I'm the model who has to pose for his pictures every day …

With a little red nose

And very little clothes

And the stormy winds do blow.

This is all very innocent, as are the millions of Christmas cards featuring nubile young girls which were designed in the 1870s and 1880s by the aesthetic designer W.S. Coleman (1829–1904), the art director of the porcelain manufacturers Minton's. But although the female nude continued to proliferate in the late 1860s, with the

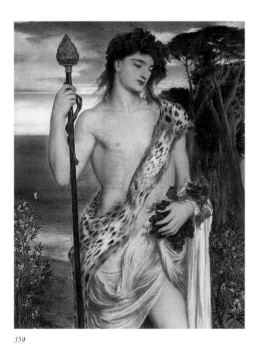
359

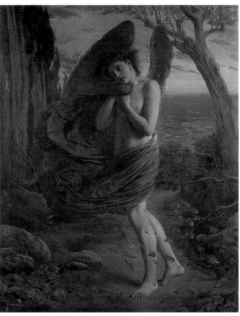
360

359
Simeon Solomon
Bacchus
1868
watercolour, 49.5 × 37cm
(19½ × 14⅝in)
Private collection

360
Simeon Solomon
Love in Autumn
1866
oil on canvas, 84 × 64cm
(33 × 25⅛in)
Private collection

emergent Aesthetic Movement interest began to shift from 'the female form divine' to the male nude – especially in the form of the androgynous figures of Simeon Solomon (1840–1905), whose watercolour *Bacchus* of 1868 (Pl. 359) was based on a poem by William Morris, and whose oil of the same subject was praised by Walter Pater (Pl. 477). *Love in Autumn* (Pl. 360) is one of the most famous of Solomon's works, capturing perfectly the mystical idealism which the artist verbalized in his prose poem, *A Vision of Love Revealed in Sleep* (1873): 'The shame that had been done him had made dim those thrones of Charity – his eyes; and as the wings of a dove, beaten against a wall, fall weak and frayed, so his wings fell about his perfect body.'

By the 1880s the Aesthetic Movement's preoccupation with classical themes had created a demand for allegorical nude subjects, which tempted many artists unfamiliar with such themes to try them out. *The Renaissance of Venus* (Pl. 361) by Walter Crane (1845–1915), the illustrator's first large-scale painting, provides an amusing example of this process in action. His wife was a daughter of Frederick Sandys and had suffered from her father's notorious womanizing. She therefore refused to allow Crane to study from the female nude, and Crane was forced into using a male model

361
Walter Crane
The Renaissance of Venus
1877
tempera on canvas,
138.4 × 184.1cm (54½ × 72½ in)
Tate Gallery, London

362
Henry Scott Tuke
Ruby, Gold and Malachite
1902
oil on canvas, 116.7 × 158.6cm
(46 × 62½ in)
Guildhall Art Gallery, London

as Venus. On seeing Crane's picture Frederic Leighton recognized the male Italian model Alessandro di Marco, always in great demand by London artists, supposingly prompting Leighton to exclaim, 'But my dear fellow, that is not Aphrodite – that's Alessandro!' Studio gossip relates that Leighton comfortingly continued, 'Never mind – she was a fine upstanding slip of a boy!'

Another artist not usually associated with nude subjects was Frederick Walker. During his short life Walker was regarded by many as the English artist whose career was most likely to lead to great things. He first worked as an illustrator, and was conscious of having missed out on academic training as an artist. Ruskin suggested that 'it may have been the attempt to prove to himself and others that he could paint a "High Art" subject' which led to Walker painting *The Bathers* (Pl. 363), and continued, 'under which sorrowful terms being told also by your grand academicians that he should paint the nude and, accordingly, wasting a year or two of his life in trying to paint schoolboys' backs and legs without their shirts or breeches'. Walker's vision remains a curiously unresolved picture to this day – an intriguing byway which led to the work of the relatively little-remembered painters of the male nude, Henry Scott Tuke (1858–1929) and John Macallan Swan (1847–1910).

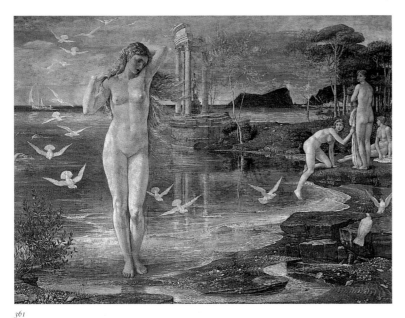

361

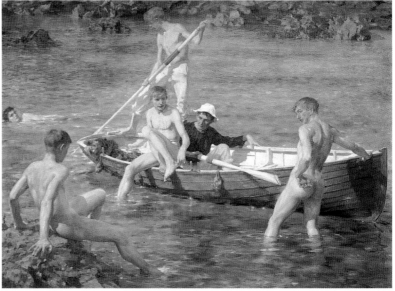

362

Tuke studied at the Slade and in Paris from 1881 to 1883, where he became fascinated by the challenge of painting nude subjects in open-air rural settings. Later, in Florence, he began to specialize in painting boys and the effect of sunlight on naked flesh, returning in 1885 to Falmouth in Cornwall, his childhood home, where he made paintings of the rocky coast, sailing ships and fisherboys the major theme of his career. Tuke discussed in *The Studio* in 1895 his new interest in trying to 'study … the undraped figure, to depict it with the pure daylight upon it, instead of the artificial lighting of the studio … I always return to my first opinion, the truth and beauty of flesh in sunlight by the sea.'

These aims were achieved with particular effectiveness in *Ruby, Gold and Malachite* (Pl. 362), painted about two miles from Falmouth in the summer of 1902. Tuke's paintings became known through reproduction in *The Studio*, which also published photographs of nude Sicilian and Italian boys by the German Baron von Gloeden (1856–1931), and Frederick Rolfe (1860–1913), the self-styled Baron Corvo, author of the novel *Hadrian the Seventh* (1904). Corvo much admired Tuke's work, writing from Venice in vivid and powerful words: 'a painter like Tuke would

have a free field here: for there is not a single painter of young Venetians poised on lofty poops, out on the wide lagoon, at white dawn, when the whole world gleams with the candid iridescence of mother-of-pearl, glowing white flesh with green blue eyes and shining hair … Tuke is the only man alive who can do them [such paintings]; and he has not seen them …'

John Macallan Swan was primarily an animal painter who like many English animal painters often aspired to the 'higher level' of History painting. Throughout his career, he was to work both as painter and sculptor, though it is his sculptures, and especially his bronzes of big cats, which are most remembered today. In his *Orpheus* (Pl. 364), first exhibited in 1894, lions, panthers, tigers and leopards are captivated by the music of Orpheus, which also attracts birds and butterflies. Contemporary critics admired the animals but deplored the figure of Orpheus. 'He ought surely … to possess … antique beauty whereas he only has the body of a lithe and vigorous gypsy lad,' fulminated the critic of *The Athenaeum*, while *The Times* found Orpheus just a 'beast charmer'.

In 1901 John William Waterhouse (1849–1917) exhibited his Diploma painting

363
Frederick Walker
The Bathers
1867
oil on canvas, 92·7 × 214·7cm
(36¼ × 84½in)
Lady Lever Art Gallery,
Port Sunlight, Liverpool

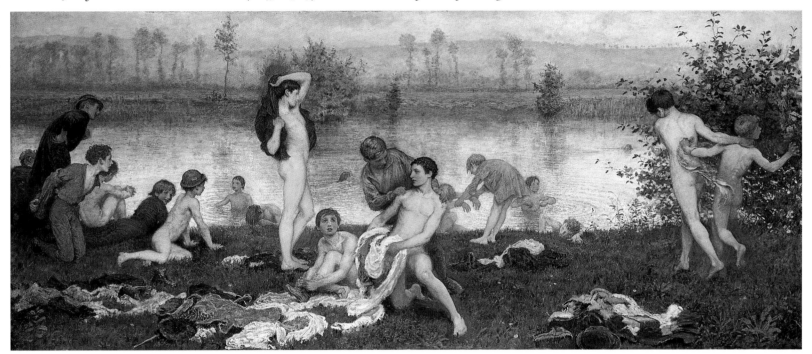

363

at the Royal Academy, *The Mermaid* (Pl. 366). One of the most poetic of all his works, it shows a mermaid about to deck her dull-red hair with baroque pearls that lie in an iridescent oyster shell. In another work of this time, *The Siren*, the mermaid gazes sadly at a drowning sailor as she draws him to his doom, recalling Matthew Arnold's poem 'The Forsaken Mermaid'. *The Mermaid* strikes a less menacing note, but both works successfully treat the legends which symbolize the artist's recurrent interest in themes of frustrated male desire and unattainable female beauty.

In 1888 Philip Wilson Steer painted one of the most daring but least typical of all Victorian nudes, *A Summer's Evening* (Pl. 365). It depicts three women on the beach at Walberswick, and is a bold experiment in divisionism, at that time the latest and most advanced form of Impressionism. Its technique would challenge even the avant-garde figures of the New English Art Club, founded in 1886 by artists opposed to the reactionary teachings of the Royal Academy. But with the turn of the century a direct and sensual treatment of the nude would emerge as the work of progressive artists such as Walter Sickert and William Orpen came to the fore.

364
John Macallan Swan
Orpheus
1896
oil on canvas, 127·5 × 184cm
(50¼ × 72½in)
Lady Lever Art Gallery,
Port Sunlight, Liverpool

365
Philip Wilson Steer
A Summer's Evening
1888
oil on canvas, 146 × 228.6cm
(57¼ × 90½in)
Private collection

366
John William Waterhouse
A Mermaid
1901
oil on canvas, 98 × 67cm
(38½ × 26¼in)
Royal Academy, London

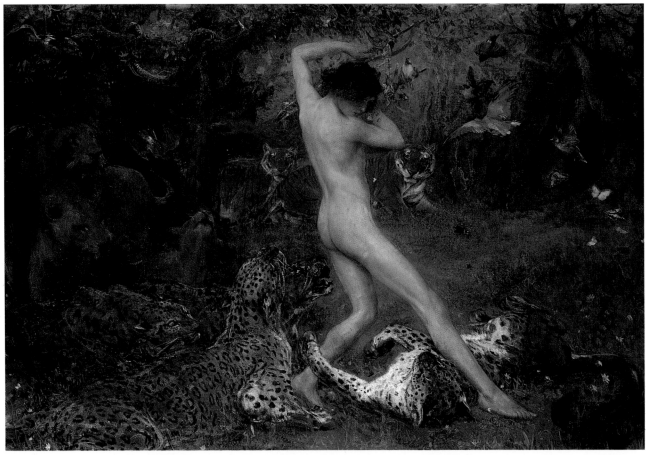

364

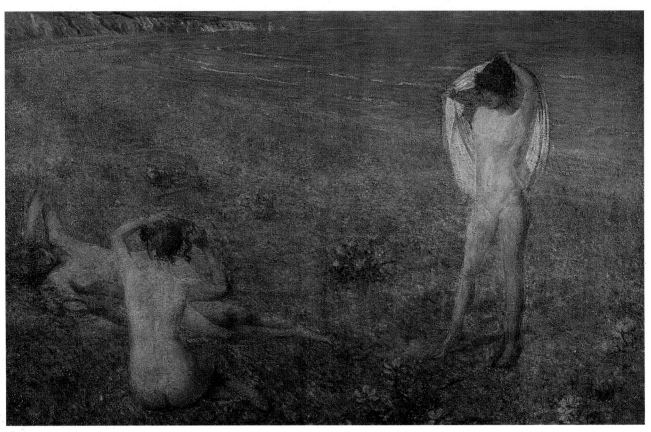

365

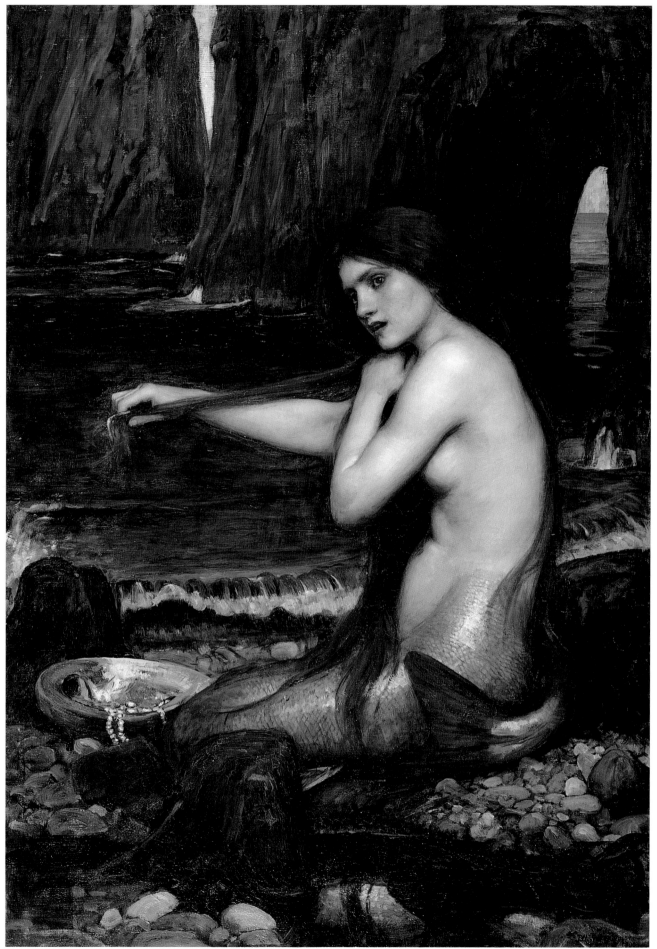

'**A**mazon's work this; no doubt about it ...' (John Ruskin). Some of the most interesting recent art-historical research into the Victorian age has been directed at the achievements of nineteenth-century women artists. They and their work are far more difficult to assess than the achievements of nineteenth-century women writers. For exponents of both vocations life was hard, but certain advantages were to be found in the relative freedom of the writing process. We know that Jane Austen created her novels in the cramped conditions of a shared bedroom, under constant threat of interruptions. But at least on the whole she could keep her manuscript private, safe from prying eyes, until publication, although many women authors, such as the Brontës, preferred to publish under a male *nom de plume*.

For the painter life was more difficult, since it was considered most unbecoming for a lady to earn money

367 Lady Butler (Elizabeth Thompson), **The Roll Call (Calling the Roll after an Engagement, Crimea)** (detail of Pl. 388)

from the accomplishment of painting, and indecorous to draw attention to herself in public spheres. It was most unusual to act like Rolinda Sharples (1793–1838), who missed no opportunity to show her work at both the Royal Academy and regional exhibitions. She was the most talented of a Bristol family of artists recording the passing show of the city's markets, fairs, balls and race meetings with cool detachment. Her self-portrait reveals her straightforward critical gaze as she sits at the easel, brushes and mahlstick in hand, watched proudly by her mother, the walls of the studio lined with canvases (Pl. 368). It is a face which irresistibly reminds us of Jane Austen and her heroines, and there is a great temptation to look for and extend such analogies, and try to parallel the literary talents of the Brontë sisters, Mrs Gaskell and George Eliot with the achievements of major women artists. But such parallels can be over-simplistic.

What type of pictures did women create in the early Victorian era? As might be expected there were many miniaturists, for there was a constant demand for portraits of absent members of the family circle. A notable lady miniaturist was Miss Annie Dixon (1817–1901), who lived at Horncastle and Hull, and exhibited at the Royal Academy from 1844 to 1893. She painted over 1,000 miniatures and was commissioned by the Royal Family. A fine example of her work is a portrait of Princess Helena (Pl. 369), the third daughter of Queen Victoria, and wife of Prince Christian of Schleswig-Holstein. In an age where drawing was an accomplishment taught in many girls' schools, amateur water-colourists, often of high calibre, also abounded. Much of their work has been lost, but occasionally a cache of work of exceptional quality will suddenly emerge from an attic. We see a notable example in the self-portrait of Mary Ellen Best (1809–91) at work at her table with her paints (Pl. 371). She painted many marvellously detailed interiors both in her native Yorkshire and in Germany after her marriage.

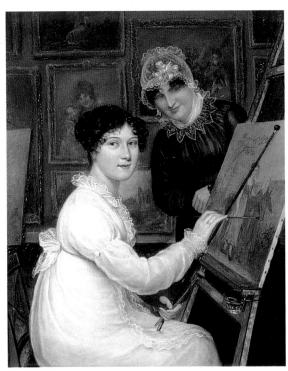

368

369

Two main fields of activity inspired more individual female contributions, the most extensive being the production of works of a Pre-Raphaelite nature, and the most unexpected being in the field of military and animal paintings. Somewhat surprisingly, there was very little of what might be called strictly feminist work highlighting specifically female concerns, apart from the touching works of Emma Brownlow King and Sophie Anderson on the Foundling Hospital discussed elsewhere (Pls. 218, 219). There were no works on such sensitive issues as marital rights, so central to Anne Brontë's novel, *The Tenant of Wildfell Hall* (1848). Its readers will recall how it deals with the vulnerability of female artistic freedom to male arrogance. The heroine Helen, who aspires to be an artist, describes her brutal husband destroying her work:

'Now then,' sneered he, 'we must have a confiscation of property. But first, let us take a peep into the studio'… My painting materials were laid together on the corner table, ready for tomorrow's use, and only covered with a cloth. He soon

spied them out, and putting down the candle, deliberately proceeded to cast them into the fire – palette, paints, bladders, pencils, brushes, varnish – I saw them all consumed – the palette knives snapped in two, the oil and turpentine sent hissing and roaring up the chimney. He then rang the bell.

'Benson, take those things away,' said he, pointing to the easel, canvas, and stretcher; 'and tell the housemaid she may kindle the fire with them: your mistress won't want them any more.'

Fortunately not *all* Victorian husbands behaved quite so appallingly, but the 'accomplishment' of drawing, although thought proper for a young lady to acquire, was not expected to lead to a professional career as an artist. The stigma of professionalism was a nineteenth-century phenomenon. For the Victorians all definitions of 'amateur' and 'professional' were beset with nuances of meaning, whether concerned with the arts, music, sport or the stage. It was considered proper that from the 'amateur' artist should come works which, although 'made for the abstract love of art for art's sake', were less accomplished than work produced for financial gain. In the eigh-

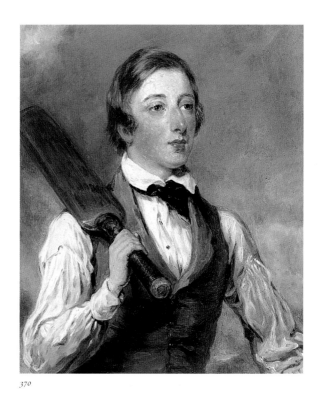

370

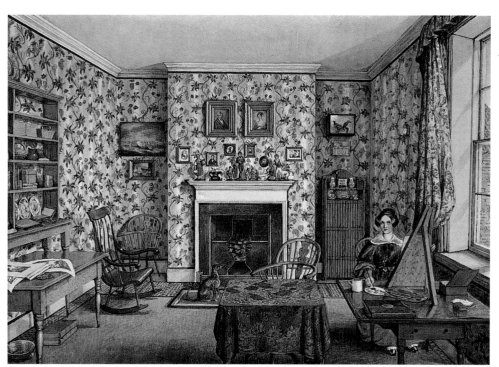

371

370
Margaret Sarah Carpenter
H.B.W. Milner
1841
oil on canvas, 26 × 20.3cm
(10¼ × 8in)
Eton College Collection,
Windsor

371
Mary Ellen Best
**The Artist in her Painting
Room, York**
1837–9
watercolour, 25.7 × 35.8cm
(10⅛ × 14⅛in)
York City Art Gallery

teenth century there were two women artists among the 36 Foundation Members of the Royal Academy, namely Angelica Kauffmann (1741–1807) and the flower painter Mary Moser (1744–1819), but after them no women were elected to membership for more than 150 years.

One artist who would certainly have become an Academician except for the disqualification of her gender was Margaret Carpenter, née Geddes (1793–1872). Born in Salisbury, she studied art with a drawing master and by 1812 she was practising as a portrait painter. In 1817 she married William Hookham Carpenter, a bookseller, publisher and artist who from 1845 was Keeper of Prints and Drawings at the British Museum. After his early retirement she supported him with the proceeds from the sale of 147 portraits exhibited at the Royal Academy and nearly 70 elsewhere. She seems to have had some connection with Sir Thomas Lawrence, finishing some of his portraits after his death. She is particularly remembered today for her long series of Eton leaving portraits of attractive young men (Pl. 370).

372
Mrs E.M. Ward
Palissy the Potter
1866
oil on canvas, 106.5 × 131cm
(42 × 51⅝in)
Leicester Museum and Art
Gallery

373
Louise Jopling
Blue and White
1896
oil on canvas, 123.5 × 84cm
(48⅝ × 33in)
Lady Lever Art Gallery,
Port Sunlight, Liverpool

Another well-known woman exhibitor at the Royal Academy, Henrietta Ward (Mrs E.M. Ward; 1832–1923), had a problem, for her maiden name was the same as her married name. Her grandfather was the famous animal painter James Ward, related by marriage to George Morland and John Jackson. In her autobiography she describes a veritable scrum of artists round her cradle – Landseer, C.R. Leslie, the Chalon brothers – and her precocious visits to private views at the Royal Academy, which from an early age left her unable to play with her peer group, for she was 'totally different from other children … frankly, they bored me.' In 1843 at the age of 11 she met and fell in love with yet another artist named Ward – Edward Matthew Ward, a history painter who specialized in subjects taken from the romantic reign of the Stuarts (see also Pl. 148). They married secretly with the help of Edward's friend Wilkie Collins in 1848.

It was by her own account an idyllic marriage, and despite bearing eight children (one of whom became Sir Leslie Ward, 'Spy'; see Pl. 74), Henrietta managed to

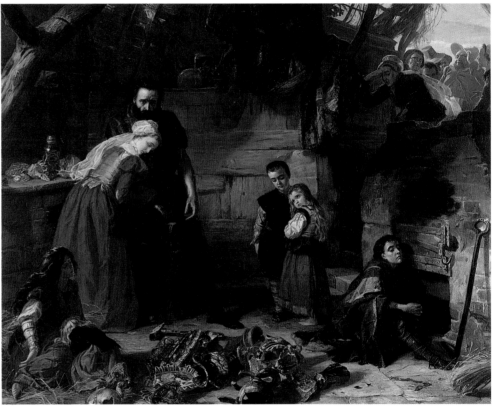

372

embark on a successful and varied career of her own, using her offspring as models in her child genre subjects. Invariably, with what must have been infuriating regularity, every notice written praising her paintings was prefaced by long rehearsals of her pedigree, and endless comparisons of her own work with that of her male relatives. She also worked as a history painter, portraying such varied scenes as *Palissy the Potter* (Pl. 372), showing the great French ceramic experimenter after blowing up his home when firing a kiln, or Thomas Chatterton (1752–70) forging the 'medieval' poems that brought him notoriety. On her husband's death in 1879 she was in her late forties, still with dependent children, a circumstance which led her to open a school 'for the art education of young ladies', with visiting tutors who sound like a roll call of the good and the great, including Alma-Tadema, Frith and Millais.

Another school was opened in the 1880s by Louise Jopling (1843–1916). She had studied abroad at the beginning of her own career, but after ruefully becoming her

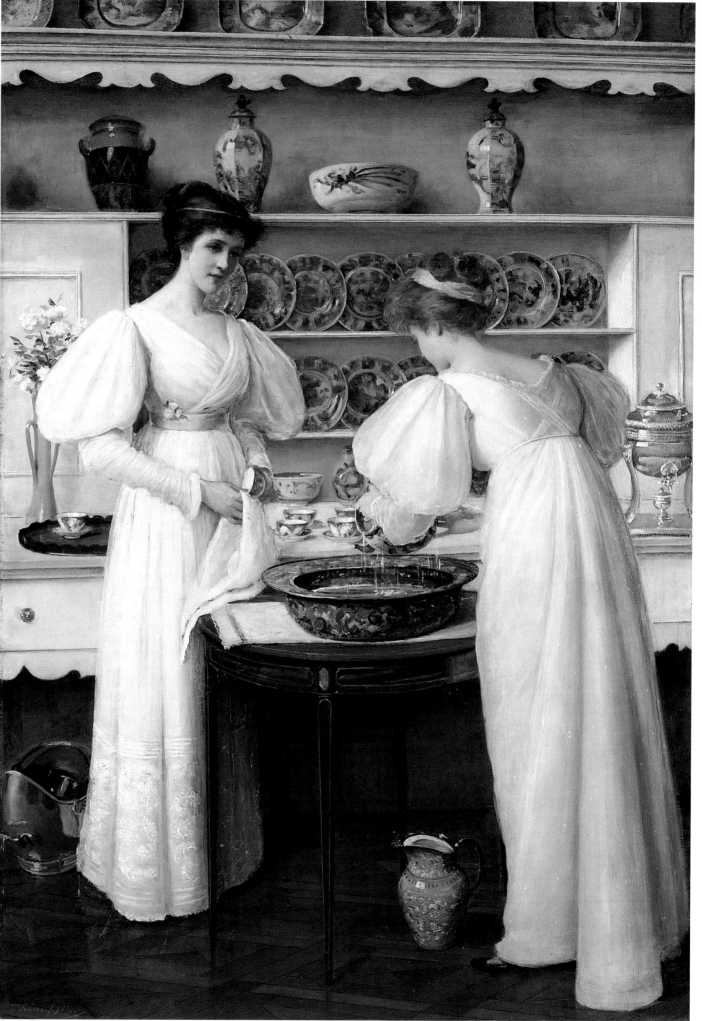

own instructor, she asked rhetorically: 'Does not someone say that, if you teach your-self, you have a fool for a master?' In fact no one could be less of a fool than Louise Jopling, whose charm and ready wit made her a close friend of both Whistler and Millais. She built up a successful practice as a portrait painter and creator of engaging 'fancy' paintings. One of these, a picture of two women washing up blue and white porcelain (Pl. 373), was bought by Lord Leverhulme for his gallery at Port Sunlight; he saw its humorous potential as a soap advertisement, as well as its interest as a doc-ument of aesthetic taste.

From the 1850s women could receive an art education at a government school of design, although women students could be handicapped by the assumption that their primary interest was marriage and a family. Physical charms could be a positive disadvantage, as Mr Chadwick, in his 1855 Report on the Female Government School of Art, remarked: 'The females have been so far advanced in mental power and influence as to have been lost to the service by matrimonial engagements obtained with exceeding rapidity. To avoid these losses, plainer candidates were selected for training, but they, too, have obtained preference as wives to a perplex-ing extent.'

Other opportunities to study included Carey's or Leigh's establishments. These were virtually preparatory schools for the Academy, although entrance for women to attend the Academy Schools was not achieved until the 1860s and then only after a vigorous campaign, with severe restrictions at first. But as the years passed conditions gradually improved, and the Slade School was open to men and women from its foundation in 1870.

In 1893 at the Royal Academy women students were at last allowed to draw from the male nude, although very careful precautions were listed to ensure that the proprieties were observed:

> It shall be optional for Visitors in the Painting School to set the male model
> undraped, except about the loins, to the class of Female Students. The drapery to
> be worn by the model to consist of ordinary bathing drawers, and a cloth of light
> material 9 feet long by 3 feet wide, which shall be wound round the loins over
> the drawers, passed between the legs and tucked in over the waistband; and
> finally a thin leather strap shall be fastened round the loins in order to ensure
> that the cloth keep its place.

Such excitements as the male life school were not to be afforded to the majority of women artists in the Pre-Raphaelite circle, whose physical beauty and work, during their own lives and posthumously, have received both disproportionate attention and neglect, respectively.

One very remarkable woman on the perimeter of the group whose work has been largely forgotten was Florence Anne Claxton (fl.1860), whose *The Choice of Paris: An Idyll* (Pl. 374), painted about 1860, has the distinction of being the wittiest contemporary satire on Pre-Raphaelite activities, packed with amusing references to the Brotherhood and their pictures. In this watercolour the 'truth to nature' ideal is parodied by the man examining the surface of the outside wall through opera glass-es. Millais plays the role of Paris, the Trojan prince who had to choose the most beautiful of three goddesses, Venus, Juno and Minerva. Claxton represents the god-desses as a Raphaelesque Madonna, a woman in contemporary costume and an angu-larly drawn medieval figure representing the Pre-Raphaelite ideal, to whom Millais awards the apple.

In reality the part of Paris should perhaps go to Rossetti, whose pursuit of 'stun-ners' was to create for posterity some of the most memorable of all paintings of women. Today, just as we find it fascinating to trace Picasso's involvement with the

374
Florence Anne Claxton
The Judgement of Paris
*c.*1860
watercolour, 13 × 17cm
(5¼ × 6⅝in)
Victoria and Albert Museum,
London

375
Elizabeth Siddal
**A Lady Affixing a Pennant
to a Knight's Spear**
*c.*1858
watercolour, 13.7 × 13.7cm
(5⅜ × 5⅜in)
Tate Gallery, London

375

376

different women in his life in his paintings and drawings, so it is with Rossetti's sensuous portrayals that reflect the waxing and waning of his love and his involvement with the sitters.

This is particularly so in the case of Elizabeth Siddal, who in life was the archetypal Pre-Raphaelite 'stunner', the model for both Millais's and Rossetti's finest works. In death she became one of the most potent of Victorian myths, of symbolic importance not only for England but all Europe (see p.254). With all the attention paid to her life, her own work, very Arthurian watercolours such as *A Lady Affixing a Pennant to a Knight's Spear* (Pl. 375), has tended to become forgotten.

The haunting individuality of Siddal's watercolours and drawings made them far more than 'feminine likenesses of Rossetti', which was how they were dismissively described by the painter Arthur Hughes. But while Hughes was surprisingly insensitive, Ruskin unexpectedly offered either to buy all her pictures as she completed them, or, if she preferred, to settle £150 a year on her for all her works. Being a typical Pre-Raphaelite story, this was not as straightforward an offer as it seems, for he hoped by encouraging her also to gain prior claim upon the work of Rossetti. As so often when involved with the subject of women artists Ruskin contradicts himself, at times sharing in the widespread mid-Victorian belief that a woman could not paint professionally, at others urging women to practise art, even presenting to Whitelands College for Women Teachers a varied selection of works for them to emulate, ranging from copies of Turner's watercolours to plates from John Gould's monographs on birds.

In 1857 Elizabeth Siddal moved to Sheffield and enrolled in the ladies' class at the art school. We long to know more about her work there. Recent research has focused upon such enigmas – the personalities and artistic output of women of considerable originality in the Pre-Raphaelite group whose work has been overlooked. One artist of great interest was Rebecca Solomon (1832–86), the sister of Abraham and mentor of her younger brother, the errant Simeon. She worked for some years as studio assistant to Millais but her own major individual contribution was as a genre painter. She made original interpretations of both familiar themes such as the governess and the idle and the industrious student, and less familiar subjects such as the education of Indian women, and poaching. In *The Wounded Dove* (Pl. 377) she embarked upon an exercise in what might be described as an aesthetic genre subject of her own devising. In it a young woman sits before a fireplace upon which are arranged a display of Japanese fans and blue and white porcelain, which in 1866 marks an early phase of the craze for 'japonaiserie'. In her hands the girl tenderly cradles a wounded dove, perhaps suggesting the biblical theme of the Return of the Dove to the Ark, a subject treated by Millais in 1851 (Pl. 287). There were also precedents in works by Greuze or the Pre-Raphaelites such as Walter Deverell's *The Grey Parrot* (Pl. 306). In male artists' handling of the motif, as Pamela Gerrish Nunn has pointed out, the bird is often caged, evoking sexual or erotic associations.

A woman Pre-Raphaelite artist of particular note was Marie Stillman (née Spartali; 1844–1927), whose richly coloured watercolours possess such evocative titles as *Cloister Lilies* or *Messer Ansaldo Showing Madonna Dianova his Enchanted Garden* (Pl. 376). She was a member of the Anglo-Greek community which loomed so large in intellectual circles in late Victorian London where her father was Greek Consul-General. Like her younger sister Christine she was famous for her beauty and posed for many artists, notably Burne-Jones and Rossetti and the photographer Mrs Julia Margaret Cameron. In the late 1860s she began to take lessons from Ford Madox Brown, and exhibited at the Dudley Gallery and the Royal Academy from 1867. In 1871 she married an American diplomat, W.J. Stillman, and lived in Florence and

377

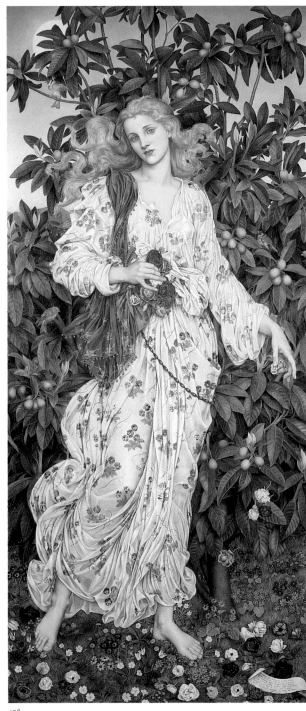

378

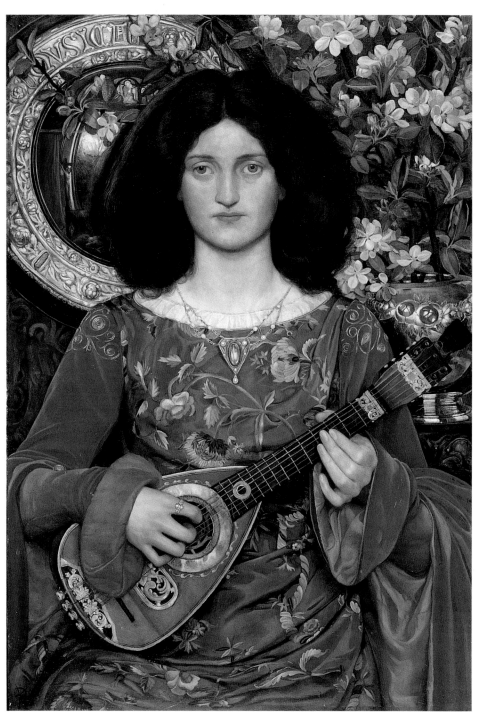

379

Rome, continuing to exhibit at the Grosvenor and later at the New Gallery. In 1898 she returned to England, living after her husband's death with her daughters in Kensington. Her subjects are almost always taken from works by Dante or from Boccaccio's *Decameron*, sometimes from Rossetti's translations in his *Early Italian Poets* (1861). Her watercolours reflect her love of the frescos of Ghirlandaio and Benozzo Gozzoli and the strong influence of Rossetti.

Another lover of Botticelli and the early Italian masters was Evelyn De Morgan (née Pickering; 1855–1919). In 1873, despite parental opposition, she entered the Slade, leaving in 1875 to study in Rome and Florence with her uncle John Roddam Spencer Stanhope. She fused her love of the early Renaissance with the influence of Watts, Burne-Jones and Stanhope to create an allegorical style all her own. When only 21 she was invited to exhibit at the opening of the Grosvenor Gallery. In 1887 she married the potter and novelist William De Morgan. They settled in Chelsea, but wintered in Italy until the outbreak of the First World War. Her painting *Flora* (Pl. 378) is generally agreed to be her masterpiece, and clearly owes much to Botticelli's *Primavera*.

Rossetti's voluptuous female portraits were also influential on the work of Kate Elizabeth Bunce (1858–1927). The artist's father, editor of the *Birmingham Daily Post*, was a committed follower of Ruskin and helped to create the amazingly rich Pre-Raphaelite collections in the City Art Gallery. In Kate Bunce's *Melody* (Pl. 379) the sitter may have been her sister Myra Bunce, whose beaten metalwork probably inspired the repoussé silver plaque inscribed MUSICA at the upper left.

Eleanor Fortescue Brickdale (1872–1945) was to continue to practise Pre-Raphaelite methods of painting well into the twentieth century. The daughter of a barrister, she studied art at the Crystal Palace School of Art and the Royal Academy Schools. Familiar with the early Italian schools through numerous visits to Italy and influenced by the Pre-Raphaelites, she exhibited at the Royal Academy from 1896. Once established, she became the first woman member of the Royal Institute of Oil Painters and joined the Royal Watercolour Society. She held a series of exhibitions beginning in 1901, entitled *Such Stuff as Dreams are Made of*, which demonstrated the dazzling virtuosity of her handling of watercolour and gouache. A fine example is *In the Springtime* (Pl. 380).

A number of women artists were greatly influenced by the attention shown to their work by Ruskin, whose interest in women's education was most famously expressed in his book *Sesame and Lilies* (1865). One such Ruskinian protégée was Louisa Stuart, Lady Waterford (1811–91), one of the most remarkable amateur artists of her time. Born in Paris, the daughter of the British Ambassador, she was brought up to take her place in high society, but also pursued artistic interests, being taught by several drawing masters, and given some unsatisfactory tuition in painting in oils. As a child she visited Rome and Naples. In 1842 she married Henry, Lord Waterford, whose estates were in Southern Ireland, but he died shortly afterwards. In 1859 she retired to the Northumberland village of Ford, and there on the walls of the village school created a remarkable series of paintings depicting children in biblical scenes, dominated by two extremely large compositions at either end of the hall, *Suffer the Little Children to Come unto Me* (Pl. 381) and *Christ among the Doctors*. Explaining the inspiration that drove her, Lady Waterford wrote to a friend in 1863:

> I want to do a *modern* representation of the Holy Family, represented by a real
> poor cottage mother and child, who have taken refuge in a snowy barn, and are
> found and comforted by the love of poor neighbours, who bring their offerings, as
> the shepherds and kings of all – taking the composition of the old masters exactly
> as a model, and trying to treat modern dress and rags as picturesquely as I can.

378
Evelyn De Morgan
(née Pickering)
Flora
1894
oil on canvas, 198 × 86.4cm
(78 × 34in)
De Morgan Foundation,
London

379
Kate Elizabeth Bunce
Melody
c.1895–7
oil on canvas, 76.3 × 51cm
(30 × 20⅛in)
Birmingham City Museum
and Art Gallery

380
Eleanor Fortescue-Brickdale
In the Springtime
1901
watercolour, 39.4 × 26.3cm
(15½ × 10⅜in)
Private collection

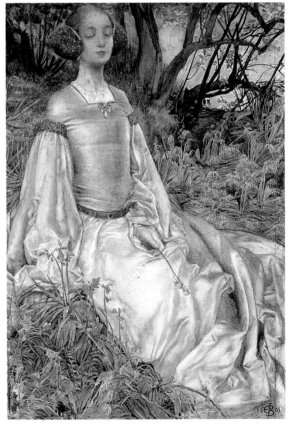

380

381
Louisa Stuart (Lady Waterford)
**Suffer the Little Children
to Come unto Me**
1871–2
watercolour on paper laid
on linen, approx. 6.1 × 4.6m
(20 × 15ft)
Lady Waterford Hall, Ford,
Northumberland

382
Kate Greenaway
The Garden Seat
*c.*1890
watercolour on board,
20.4 × 25.5cm (8 × 10in)
Royal Albert Memorial
Museum, Exeter

383
Helen Allingham
**A Cottage at Chiddingfold,
Surrey**
*c.*1885
watercolour, 39.3 × 33cm
(15½ × 13in)
Victoria and Albert Museum,
London

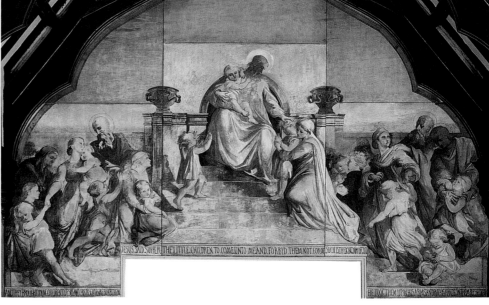

381

Another devoted admirer of Ruskin was Kate Greenaway (1846–1901), whose children's books began a fashion for the Regency period as the Pre-Raphaelites had for the Middle Ages and Alma-Tadema for classical antiquity. A characteristic example of her work is *The Garden Seat* (Pl. 382) in which a little girl sits motionless like a beautiful doll, while a small boy poses self-consciously with a hoop, and their governess or elder sister sits besides them completely absorbed in the frivolous pursuit of reading a novel. Ruskin admired her illustrative works, but being Ruskin, strove repeatedly to encourage her to draw not from her imagination but from nature. He set her subjects such as wild flowers and shamrocks, studies of 'rocks, moss and ivy' found in walks near his home at Brantwood, and prepared ornithological specimens such as a kingfisher. He also begged her (without success) to make studies from the nude.

Both Ruskin and Thomas Hardy admired the work of Helen Patterson, the maiden name of Helen Allingham (1848–1926), whose marriage in 1874 to the poet William Allingham, a member of the Rossetti circle, gave her sufficient financial independence to concentrate on watercolour painting. Before that date she worked as an illustrator for the *Graphic* and the *Cornhill Magazine*, in which Thomas Hardy's *Far From the Madding Crowd* first appeared as a serial in 1873. Hardy wrote to the editor: 'In reference to the illustrations, I have sketched in my note-book during the past summer a few correct outlines of smock-frocks, gaiters, sheep crooks … These I could send you if they would be of any use to the artist, but if he is a sensitive man and you think he would rather not be interfered with, I would not do so.'

When Hardy discovered that the artist was actually a woman their correspondence flourished, but nothing came of their romance, and they both married other people. Over forty years later Hardy wrote to Edmund Gosse saying: 'she was the best illustrator I ever had … please give her my kind regards, but you must not add that those two almost simultaneous weddings would have been one but for a stupid blunder of God Almighty.' Characteristically Hardy wrote a poem which speculated on what might have happened had they married.

Such romantic speculation is particularly fascinating since Helen Allingham's legacy – her numerous paintings of the dilapidated cottages of rural England – parallels Hardy's own chronicle of Victorian rural life. In a catalogue, she wrote lament-

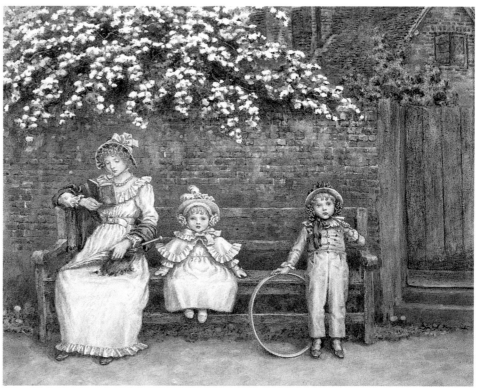

382

383

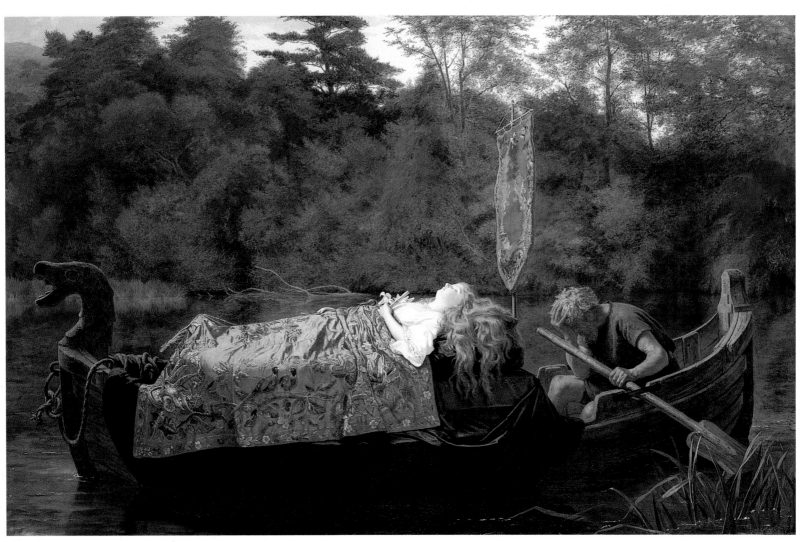

384

ing the development and 'improvement' of villages such as Haslemere in Surrey: 'they supplant fine old work … rub out a piece of Old England … the cherry or apple-tree … will probably be cut down, and the wild rose and honeysuckle hedge be replaced by a row of pales or wires.'

Helen Allingham was a close friend of Kate Greenaway and in 1890 they both painted a cottage about to be demolished in Pinner. Kate Greenaway added some children gathering cowslips in the foreground, while Helen Allingham, as usual, painted at the gate her familiar sun-bonneted woman with a child in her arms. A particularly attractive example of her use of this motif can be seen in *A Cottage at Chiddingfold, Surrey* (Pl. 383).

The sleeping or drowning woman was a compulsive theme for male painters in the Victorian era. It is therefore intriguing to see it tackled by the versatile Mrs Sophie Anderson. Born and trained in France, she moved to America where she married, and then settled with her husband in England in 1854 where she made her reputation as a genre painter before turning to such works as *Elaine* (Pl. 384). The painting was bought by the Walker Art Gallery, Liverpool from its autumn exhibition in 1871, and has a particular interest as it was the first work paid for from the rates, despite typically patronizing reviews commenting on the picture's 'powerful vigour and fertility of detail that has nothing in common with the popular notion of ladies' work'. It is noteworthy that Liverpool Corporation was suffiently broad-minded to make such a crucial purchase from a half-American, half-French *female* artist. *Elaine* tells the sad story of the Lily Maid of Astolat, from one of Tennyson's *Idylls of the King* (1859). She fell deeply in love with Lancelot and died of a broken heart when her love was not returned. Her body was laid on a barge steered by a mute attendant and carried down the stream to Camelot, where King Arthur gave it a royal burial.

Tragic symbolism can also be seen in *Love Locked Out* (Pl. 385) by Anna Lea Merritt (1844–1930). The artist was born Anna Lea in the United States but found it difficult as a woman to be accepted into an art school, and studied briefly in Dresden. She later settled in England and married an art critic and teacher, Henry Merritt, but was tragically widowed after just three months of marriage. The event inspired her to design a tombstone for their joint grave, which was only realized in the painting and in the naked figure of love which it shows. She feared it would be taken for a symbol of forbidden love, but in fact it represents 'waiting for the door of death to open and the reunion of the lonely pair'. Such a preoccupation with death was also implicit in Phoebe Traquair's mortuary chapel (Pl. 57).

After the rarefied world of the Pre-Raphaelites and their followers it is refreshing to turn to that great British preoccupation, the natural world. Just as the German Winterhalter's portraits of the British royal family set an acknowledged standard of excellence, so did the animal paintings of French woman Rosa Bonheur (1822–99). She was born in Bordeaux, one of four children, three of whom were to become painters, while her brother Isidore became a sculptor. She was trained by her father, and exhibited regularly at the Salon from 1841, where her paintings of tigers, lions, wolves and other animals were soon very popular. She was the first woman artist to be awarded the prestigious cross of the Légion d'Honneur, conferred on her in 1865 by Empress Eugénie, who declared that 'genius has no sex'. She was also the recipient of an even rarer distinction, for when painting her huge *Horse Fair*, to avoid drawing attention to herself in male surroundings, she managed to obtain a special permit from the Prefect of Police in Paris to appear in male clothing.

Inevitably this led to rumours, to some extent supported by her lifelong friendship with the artist Nathalie Micas (1824–89), with whom she shared a studio in the

384
Sophie Anderson
Elaine, or The Lily Maid of Astolat
1870
oil on canvas, 158.4 × 240.7cm
(62⅜ × 90⅞in)
Walker Art Gallery, Liverpool

385
Anna Lea Merritt
Love Locked Out
1889
oil on canvas, 115.6 × 64.1cm
(45½ × 25¼in)
Tate Gallery, London

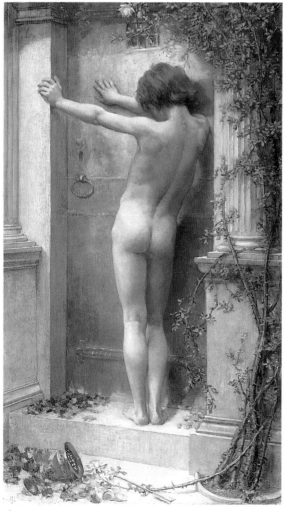

385

386
Rosa Bonheur and Nathalie
Micas
The Horse Fair
1853
oil on canvas, 120 × 254.6cm
(47¼ × 100⅛ in)
National Gallery, London

387
Rosa Bonheur
Changing Pastures
1863
oil on canvas, 64 × 100cm
(25¼ × 39⅜ in)
Kunsthalle, Hamburg

388
Lady Butler
(Elizabeth Thompson)
**The Roll Call (Calling the
Roll after an Engagement,
Crimea)**
1874
oil on canvas, 91 × 182.9cm
(35½ × 72in)
Royal Collection

389
Lady Butler
(Elizabeth Thompson)
Scotland Forever!
1881
oil on canvas, 101.6 × 194.3cm
(40 × 76½ in)
Leeds City Art Gallery

rue d'Assas, and who collaborated on the National Gallery version of *The Horse Fair* (Pl. 386). The studio housed her ever-changing private menagerie which at one time consisted of a horse, a donkey, two dogs, a goat, an otter, a monkey, a sheep, two hoopoes and seven lapwings.

The dealer Ernest Gambart saw the potential for vast sales of engravings after Bonheur's *The Horse Fair*, which had been hailed as a masterpiece when shown at the Salon of 1853. To coincide with the exhibition of the painting in his gallery in London, Gambart organized a grand tour of England for the artist in 1855, and with brilliant flair for exploiting the media managed to infer a relationship between Rosa Bonheur and the inveterate bachelor Landseer, who jokingly said that he would be

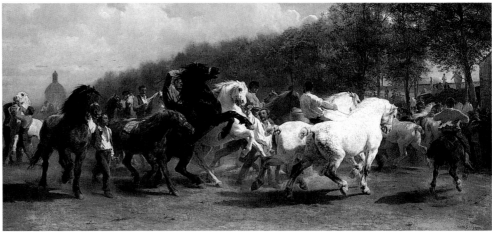

386

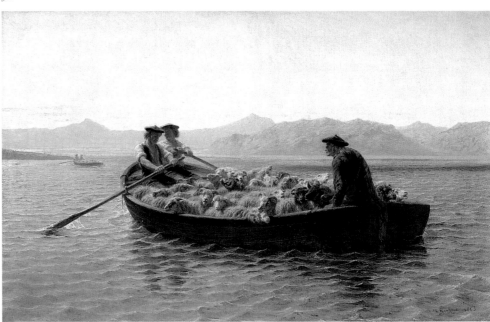

387

'only too happy to become "Sir Edwin Bonheur"'. Their carefully stage-managed meeting was a great success. Hopes also ran high that Queen Victoria would buy the work when it was sent round to Buckingham Palace on the afternoon of 5 September, but these hopes were unrealized, although she did command a letter to be sent expressing her admiration.

In 1857 Rosa made a second visit to Britain which was also a great success. In the Highlands of Scotland she made innumerable studies of deer, horses, Highlanders, lochs and mountains. These were later to be used in paintings of Highland cattle, and works such as *Changing Pastures* (Pl. 387), depicting sheep being ferried across a loch.

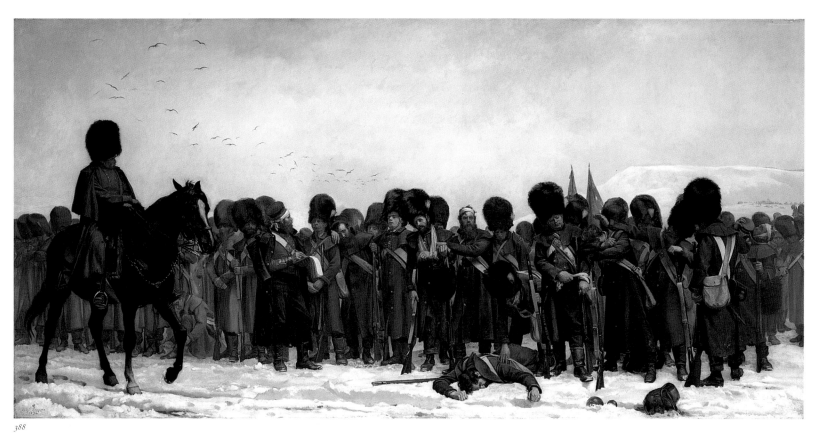

388

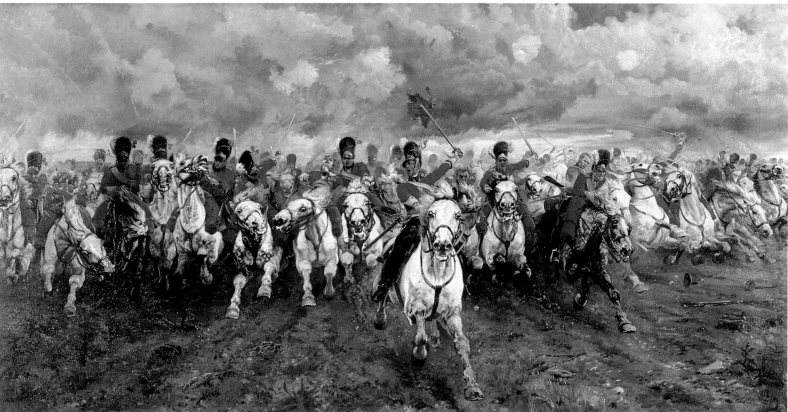

389

Bonheur's example, and particularly her ability to work on a heroic scale, provided inspiration for another important woman artist, Elizabeth Thompson (1846–1933). Both surpassed any male competition in their chosen genres, which they practised with complete and absolute authority. After her marriage in 1877 to an army officer, Elizabeth Thompson became better known by her married name, Lady Butler. Throughout her studies she was guided by a determination to become a military painter. There was little competition, for in contrast to France there was no great tradition of military painters such as Horace Vernet. At that time only two artists, Thomas Jones Barker (1815–82) and George Jones (1786–1869), were exhibiting battle pictures, and both were nearing the end of their careers. In 1874, when *The Roll Call* (Pl. 388) was exhibited at the Royal Academy, there was only one other battle painting on view, *La Charge des Cuirassiers Français à Waterloo* by the panorama painter Félix Philippoteaux.

It was the appearance of *The Roll Call (Calling the Roll after an Engagement,*

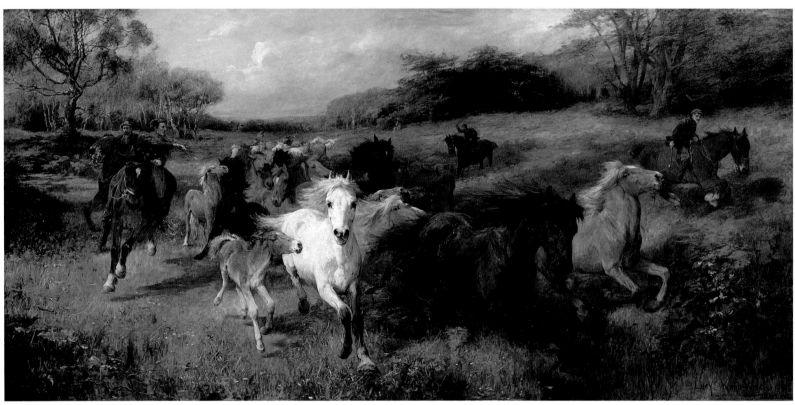

390

Crimea), which brought Elizabeth Thompson to the attention of the public. It was praised by the Prince of Wales in his opening speech at the Royal Academy dinner, and purchased by Queen Victoria. Even Ruskin, when he saw it, said that it forced him to admit he had been wrong in believing that 'no woman could paint'. Like Wilkie and Frith before her, the artist was to enjoy the pleasure of seeing a barrier erected before the painting to protect it from the enthusiastic crowds. Her long and successful career as a military painter witnessed one more public triumph on the same scale. Her own forthright words tell the story of *Scotland for Ever!* (Pl. 389), which shows the onrushing cavalry of the Scots Greys at Waterloo:

> I owe the subject to an impulse I received that season from the Private View at
> the Grosvenor Gallery, now extinct. The Grosvenor was the home of the
> 'Aesthetes' of the period, whose sometimes unwholesome productions preceded
> those of our modern 'Impressionists'. I felt myself getting more and more
> annoyed while perambulating those rooms, and to such a point of exasperation

was I impelled that I fairly fled and breathing the honest air of Bond Street, took
a hansom to my studio. There I pinned a 7-foot sheet of brown paper on an old
canvas, and with a piece of charcoal and a piece of white chalk, flung the charge
of 'the Greys' upon it.

During the First World War both the British and German armies (the latter with suit-
able alterations) used this scene for propaganda purposes. Yet Lady Butler was not
merely an unaesthetic, patriotic imperialist. She said, 'I never painted for the glory of
war, but to portray its pathos and heroism.' She was not afraid to go against public
opinion, as her painting *Evicted* shows (Pl. 426). After the carnage of the First World
War, attitudes to her work changed and she has been crassly described by modern
critics as someone who 'helped provide the public support for the imperial adven-
tures of the military heroes of the Victorian age'. But as Beryl Bainbridge has
remarked of her, 'She was not a jingoist, but simply someone who could wield a
brush and whose childhood imagination had been fired by war. Also she was jolly
near perfect at painting gun-smoke and horses.'

The work of Lucy Kemp-Welch (1868–1958) was cast in the same mould as that
of Rosa Bonheur and Lady Butler. Her childhood was spent at Malvern, with holi-
days in the New Forest. She was encouraged to sketch by her artistic mother and
learnt to ride, becoming a first-class horsewoman. Her parents died early, and with
her sister in 1891 she arrived at Sir Hubert von Herkomer's School of Painting at
Bushey, having initially been refused entrance because of her poor drawing. Emphasis
was placed on life drawing, a discipline she welcomed, but she never lost her preoc-
cupation with the horse. The sight of gypsies driving a string of ponies and cobs
through Bushey on the way to the famous horse fair at Barnet inspired her to buy an
eight-foot canvas and start work on a vast painting of the scene. Herkomer was
amazed at the half-finished painting upon seeing it for the first time, and at the
progress Lucy had made after only six months at the school. *The Gypsy Drovers* was
hung in an excellent position at the Royal Academy in 1895, followed two years later
by another large painting, *Colt Hunting in the New Forest* (Pl. 390), which was pur-
chased by the Chantrey Bequest for the newly established Tate Gallery.

Old attitudes to the role of women as artists died slowly, even with the more
enlightened figures of the art establishment. In an interview with Grace Cooke of the
Girl's Realm in 1898, Walter Crane, then Principal of the Royal College of Art, was
asked: 'Which branch of art would you advise a woman to follow if she has to earn
her own living?'

Mr Crane hesitated; he drew wonderful geometrical figures in red ink on the
blotting paper in front of him, and it was only when he reached the stage of a
design of sunflowers that he answered me, 'The idea of anyone working at art to

391
Beatrix Potter
**Fly Agaric
(Amanita muscaria)**
*c.*1890
watercolour, 10.1 × 17cm
(4 × 6¾in)
Beatrix Potter Gallery,
Hawkshead, Cumbria

392
View of the Marianne North
Gallery at Kew Gardens, show-
ing her botanical paintings. It
opened to the public in June
1882

391

392

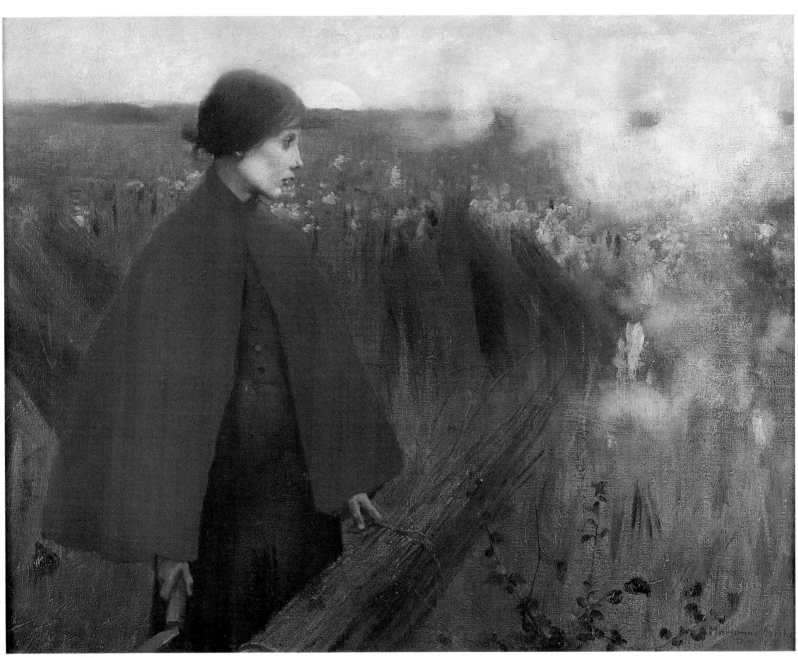

393

me is repulsive. I dislike the competition and hack-work that always results … Ambition to succeed in art for art's sake should spur a girl on … The best form of art for a girl to succeed in is, I believe, design, decorative work and leather work. Women have always stood high where design is concerned. You see, the work requires great daintiness and nicety of feeling, also that sense of the fitness of things which a woman only seems to possess. A girl is, from her earliest days, trained in decorative schemes. Take her dress, for instance … then again … black and white work opens out a very large field to the girl artist.

Crane's advice would have been scorned by Beatrix Potter (1866–1943), a very determined young lady. In her early twenties she was eager to earn some money of her own to give her an illusion of independence from her over-protective parents. Her remarkable abilities as a botanical artist, which were unfortunately not recompensed, can be seen in her studies of fungi (Pl. 391). The idea occurred to her of using these skills in the design of Christmas cards. In 1890 she wrote in her private journals: 'I began privately to prepare Six Designs, taking for my model that charming rascal Benjamin Bouncer our tame Jack Hare.' The cards were ready by Easter and accepted by the second firm approached, Hildesheimer & Faulkner, who sent a cheque for £6 together with a request to see more designs. Delighted, she wrote in her diary: 'My first act was to give Bounce (What an investment that rabbit has been in spite of the hutches) a cupful of hemp seeds, the consequence being that when I wanted to draw him next morning he was partially intoxicated and wholly unmanageable.' Beatrix Potter was launched on her career as an artist-illustrator.

Another woman to excel as a botanical painter was Marianne North (1830–84), the daughter of Frederick North, MP for Hastings. Family friends included the watercolour painter William Henry Hunt, the botanist Sir William Hooker and Edward Lear. After the death of her father, Marianne, aged 40, began to plan the epic journeys which occupied the last decade of her life, and took her to every continent, where she made a pictorial record of the tropical and exotic plants of the world. Often alone and in danger, she brought back to England her brilliantly coloured paintings of unknown species, which were admired by figures as various as Swinburne and Charles Darwin. In 1879, during a brief stay in London between visits to India and Australia, she offered to build a gallery to house her collection at Kew Gardens, an offer which Sir Joseph Hooker, the Director, accepted with alacrity. To visit the gallery today is a most rewarding experience for anyone interested in the display of Victorian paintings. She arranged the 832 paintings which line the crowded walls herself, and painted the frieze and decorations surrounding the doors (Pl. 392).

The independence so fiercely prized by the women described in this chapter was generally hard won. Two notable women artists came from overseas to train in Europe, and then settled in England where they enjoyed successful careers. The Canadian Elizabeth Armstrong (1859–1912), who married Stanhope Forbes, became a leading light of the Newlyn School (see Pl. 424), while the Austrian Marianne Preindlsberger (1855–1927) trained at Munich and Paris before marrying the artist Adrian Stokes and settling in London. Her *Passing Train* (1890; Pl. 393) is a work of great individuality, a strange synthesis of Impressionism and Symbolism. But let us end this chapter as we began, with a remarkable self-portrait: not the cool appraising eyes of Rolinda Shaples, but the sensitive gaze of Gwen John in her Paris studio in 1902 (Pl. 394), a face which reflects some of the greater freedoms and stresses that would affect women artists in the new century.

393
Marianne Stokes
The Passing Train
1890
oil on canvas, 61 × 76.2cm
(24 × 30in)
Private collection

394
Gwen John
Self-Portrait
1902
oil on canvas, 44.8 × 34.9cm
(17⅞ × 13¾in)
Tate Gallery, London

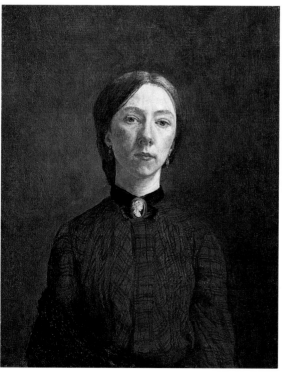

394

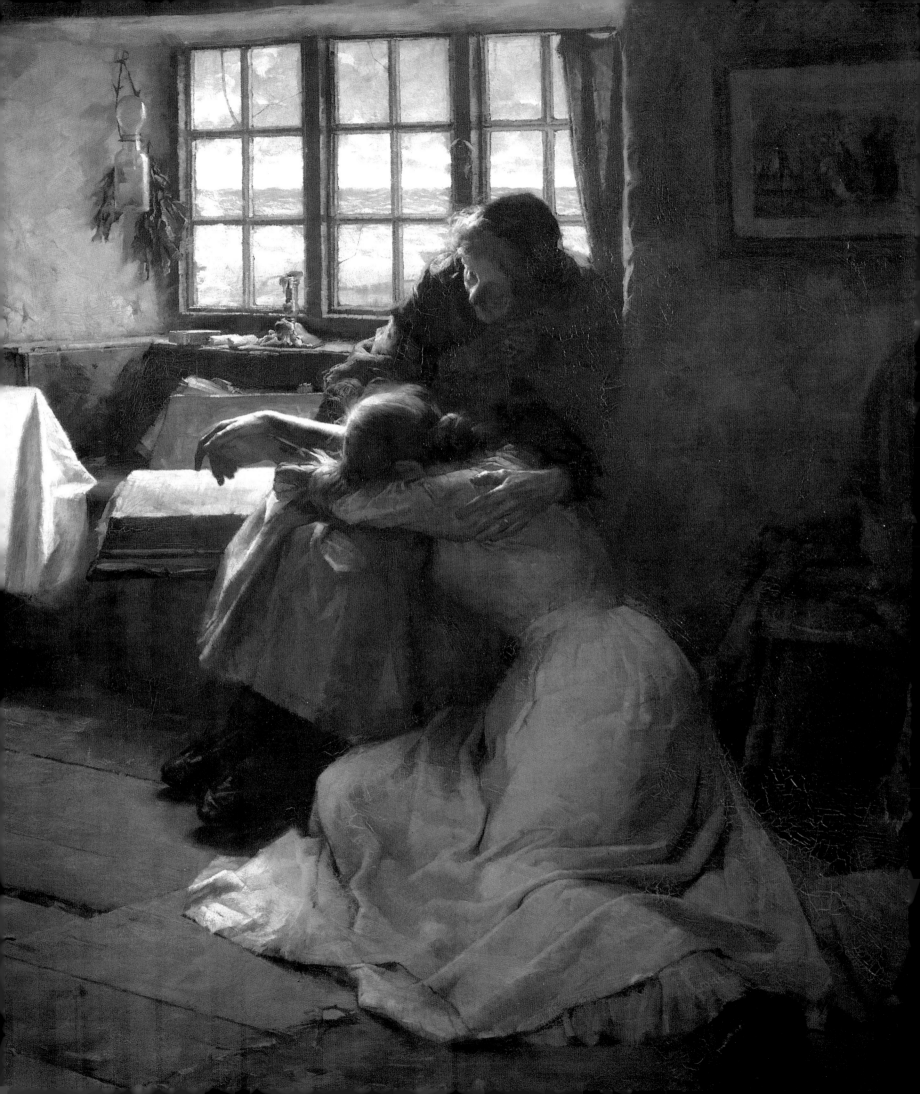

All over Europe from the 1840s onwards con-cern for natural justice and the struggle between capital and labour were to influence both writers and artists. At the Salon of 1850 Gustave Courbet (1819–77) established himself as the leader of the Realist school of painting with his huge canvas *Burial at Ornans*. The burial scene made an immense impact: it was attacked for its crudity and ugliness, but also hailed for its powerful naturalism. His painting *The Stonebreakers* (Pl. 396), one of the cornerstones of the Romantic Realist school, was described by Courbet's friend Pierre Joseph Proudhon, the anar-chist philosopher, as 'the first Socialist picture ever painted … a satire on our industrial civilization which continuously invents wonderful machines to perform all kinds of labour, yet is unable to liberate man from the most backbreaking toil'.

In 1855, dissatified with the official arrangements

395 Frank Bramley, **A Hopeless Dawn** (detail of Pl. 421)

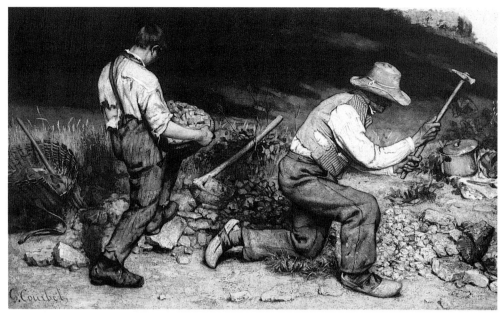

396

at the Paris International Exhibition, Courbet organized a pavilion for his own work, calling it 'Le Réalisme' and showing both his earlier canvases and *The Studio* (1855), which Richard Redgrave (who was in Paris as organizer of the British Art exhibition) described as 'wrought with the execution of a house painter who has just taken up art. It is bad both in form and colour.' A month later, in more charitable vein, Redgrave wrote: 'To be impartial needs a large mind, and mine is but limited. It is very difficult to find a standard by which art is to be universally judged.'

Redgrave's more charitable observation is just, for in the 1850s there did indeed seem to be two conflicting currents in art, the idealistic world of late Romanticism and classicism, and a groundswell of artistic belief throughout Europe rejecting idealism in favour of more realistic social concerns.

We do not know what Redgrave thought of another leader of the French Realist school, Jean-François Millet (1814–75), whose desire was 'to make the trivial express the sublime' in his serious, even melancholy, scenes of rural life, which emotionalized the labours of the soil and the backbreaking labour of agricultural work. He said of such subjects that a picture was only completed when the artist also felt the pain of straightening his back after heavy physical labour. In 1849 he settled in the village of Barbizon, where with his friend Théodore Rousseau he founded a school of landscape painting. In the next half-century a growing interest in landscape painting and the lifestyles of peasants and fishermen would lead to the growth of several such 'art colonies' in both Europe and America, Barbizon being joined by Grez-sur-Loing and Pont-Aven in France, Newlyn and St Ives in Great Britain, Skagen in Denmark and Provincetown in Massachusetts.

Many of the principles of the Barbizon School were admired and shared by the Hague School, a group of Dutch artists who worked in The Hague from 1860 to 1900. They painted views of everyday life, scenes on the beach and landscapes. The pious sentiment of the paintings of fishermen and peasants by Jozef Israels (1824–1911) earned him the nickname of 'the Dutch Millet'.

Both the Barbizon and Hague Schools of painting were greatly to influence the course of British art, but this effect was not immediate. The soul-destroying work of the mines and factories did not lend itself to heroic visual interpretations as did the toil of the agricultural labourer or fisherman. The lot of the urban poor became a

prime issue for those appalled by the effects of industrialism, but this first took literary rather than artistic form.

In 1845 the rising young politician Benjamin Disraeli categorized the 'Two Nations of England, the Rich and the Poor' in his novel *Sybil*, and went on to describe conditions in the poverty-stricken industrial towns, and the activities of the Chartists and emergent trade unionists. *Sybil* was only one of a number of novels concerned with such social problems; others included Charlotte Brontë's *Shirley* (1849), Charles Dickens's *Hard Times* (1854), Mrs Gaskell's *Mary Barton* (1848) and *North and South* (1855), and George Eliot's *Silas Marner* (1861) and *Felix Holt the Radical* (1866).

Side by side with this awareness of poverty was a concern for man as a victim of the progress brought about by the Industrial Revolution. While commentators like Carlyle and Ruskin became increasingly pessimistic, the visual arts too reflected the changing times. The happy scenes of contented country folk so lovingly portrayed by William Mulready, Thomas Webster and fellow practitioners of idyllic rural genre

397
George Cruikshank
Cold, Misery and Want Destroy their Youngest Child (from 'The Bottle')
1847
watercolour, 25.5 × 36cm
(10 × 14¼in)
Victoria and Albert Museum, London

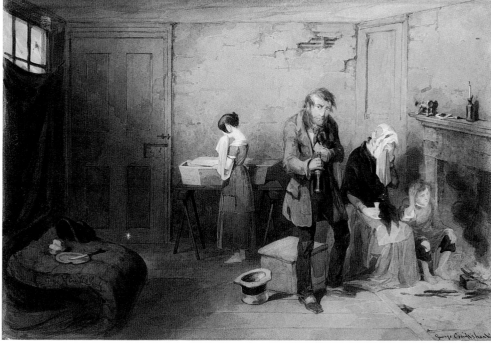

397

scenes were no longer valid. Slowly but surely scenes of doom and gloom began to feature more and more in Victorian genre painting shown at the Royal Academy and elsewhere.

Themes included the effects of drunken behaviour, a subject particularly associated with George Cruikshank, who after a bibulous youth became a fervent advocate of the teetotal cause. His vast painting *The Worship of Bacchus* (1863) was an extension of his famous print series *The Bottle* (1847), which preached the virtues of temperance and the evils of drink. A preliminary watercolour, *Cold, Misery and Want Destroy their Youngest Child* (Pl. 397), creates a compelling image of the poverty which was so associated with the effects of alcoholism. Other subjects tackled by socially concerned artists in the early Victorian years included sweated labour and the plight of the homeless, a fine example of the former being Richard Redgrave's *The Sempstress* (Pl. 465).

Strong pressures arose to record both in words and pictures the sheer diversity of poverty. This resulted in a classic sociological treatise, Henry Mayhew's *London*

398
Alphonse Legros
The Tinker
1874
oil on canvas, 140 × 170cm
(55¼ × 67in)
Victoria and Albert Museum,
London

399
Gustave Doré
**The Exercise Yard
at Newgate**
1869
wood engraving, 40 × 30.5cm
(15¾ × 12in)

Labour and the London Poor (1851–2), which was significantly illustrated with engravings based on daguerreotypes, the new photographic invention. This thirst for truthfulness was also to show itself in the desire for accurate visual reportage of novel or sensational forms of poverty, crime and urban squalor. Journals such as *Punch, Fun, Judy, Household Words* (founded by Charles Dickens in 1850), the *Illustrated Times* and especially the *Illustrated London News* set a high standard in visual commentary. The boundaries between the fine art of painting and high-calibre 'art work' become very blurred, particularly when we consider the achievement of several French artists who produced some of their most memorable work in England, inspired by aspects of the urban scene of London, beginning with Théodore Géricault in 1820–1 (see above, p. 215). Their work played a major part in establishing the Social Realist visual themes which became central to British art.

Constantin Guys (1802–92) had a career analogous to that of a modern newscameraman. He took part with Lord Byron in the Greek War of Independence and

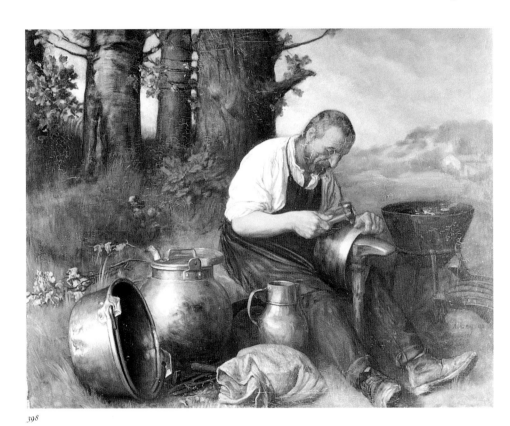

398

399

later covered the Crimean War as reporter and war artist for the *Illustrated London News*. He is best remembered for his vivid drawings and watercolours of high society, low life and the prostitutes of London (Pl. 475) and Paris, which led Baudelaire to write one of his finest critical essays, describing Guys as 'the painter of modern life'.

The most influential French artist to record the life of London was Gustave Doré (1833–83). His book *London: A Pilgrimage* was published in 1872 but conceived in 1869, with an accompanying text by Blanchard Jerrold. Doré had come over from France in connection with the opening of the Doré Gallery, a changing display of 40 of his paintings which for the next twenty years occupied a building, now Sotheby's the auctioneers, in New Bond Street. Doré explored the city with Jerrold, who wrote:

> We had one or two nights in Whitechapel, duly attended by police in plain
> clothes; we explored the docks; we visited the night refuges, we journeyed up

and down the river; ... we saw the sun rise over Billingsgate, and were betimes at the opening of Covent Garden market; we spent a morning in Newgate ... we entered thieves' public houses; in short I led Doré through the shadows and the sunlight of the great world of London.

Two or three of the images in Doré's book have become instantly recognizable symbols of aspects of Victorian life, notably *The Exercise Yard at Newgate* (Pl. 399), memorably copied in February 1890 by Vincent Van Gogh, and *Over London by Rail*, a nightmare vision of back-to-back housing, with tiny back yards in which washing hanging out to dry is besmirched by the soot of the trains on the giant viaduct. Jerrold described Doré's purely aesthetic response to the heart-rending sights of London's slums:

> One Sunday night (as we had been talking over a morning spent in Newgate, and of our hazardous journeys through the Dens and Kitchens of Whitechapel and Limehouse) Doré suddenly suggested a tramp to London Bridge. He had been deeply impressed with the groups of poor women and children we had seen upon the stone seats of the bridge one bright morning on our way to Shadwell. By night, it appeared to his imagination, the scene would have a mournful grandeur. We went. The wayfarers grouped and massed under the moon's light, with the ebony dome of St Paul's topping the outline of the picture, engrossed him. In the midnight stillness, there was a most impressive solemnity upon the whole, which penetrated the nature of the artist. 'And they say London is an ugly place!' was the exclamation.

Doré's reactions to London were akin to the poet Francis Thompson's evocation of the 'River of the Suicides' in *A City of Dreadful Night* (1874), and visually also owe something to the vast cataclysmic scenes of disaster by John Martin.

While the work of French illustrators was important, two French painters also played crucial roles in the Anglo-French cross-pollination of Social Realist themes, namely Alphonse Legros and Jules Bastien-Lepage.

Alphonse Legros (1837–1911), a close friend of Henri Fantin-Latour and Whistler, first visited London in 1860, when he posed for Whistler's painting *Wapping* (Pl. 503). Three years later he returned to serve for the rest of his life as drawing master, first at the South Kensington Museum and later at the Slade School. He was one of the great teachers of drawing of his time, who constantly referred his students to the work of the Old Masters. Like Millet, Legros was both a humanist and an agnostic. Both artists painted works entitled *The Angelus*, but Legros's version was not set in the fields, like Millet's, but in the gloomy nave of a suburban church. The painting was greatly admired by Baudelaire, who praised the depiction of 'these simple people with their *sabots* and umbrellas, all bowed with work, wrinkled with age and their skin parched with the flame of sorrow'. Legros's continuing interest in such themes is reflected in a later work, *The Tinker* (Pl. 398), which conveys the desolating loneliness of the itinerant worker mending pots and pans, an image of Flaubertian mood and intensity. This mood was sustained in a series of etchings – harsh studies of tramps and outcasts – entitled *A Garden of Misery*, a theme which can usefully describe the work of many artists of the time.

Another dark and sombre French painter was Jules Bastien-Lepage (1848–84),whose work was once described by Emile Zola as 'Impressionism corrected, sweetened and adapted to the taste of the crowd'. He is chiefly remembered today for his rural subjects, which were frequently exhibited at the Grosvenor Gallery and elsewhere. Many British artists greatly admired these works and emulated his small full-length studies of children going to school or wrapped in sacks to protect them from the elements while guarding their flocks, as in *La Pauvre Fauvette* (Pl. 400).

400
Jules Bastien-Lepage
La Pauvre Fauvette
1881
oil on canvas, 162.5 × 125.2cm
(64 × 49⅛in)
Art Gallery and Museum,
Kelvingrove, Glasgow

400

401
James Guthrie
To Pastures New
1883
oil on canvas, 92 × 152.3cm
(36¼ × 60in)
Aberdeen Art Gallery
and Museum

402
George Clausen
Breton Girl Carrying a Jar
1882
oil on canvas, 46 × 27.5cm
(18¼ × 10⅞in)
Victoria and Albert Museum,
London

403
Stanhope Forbes
**A Street in Brittany
(Cancale)**
1881
oil on canvas, 104.2 × 75.8cm
(41¼ × 29⅞in)
Walker Art Gallery, Liverpool

North of the border in Scotland, Bastien-Lepage was a crucial influence upon James Guthrie (1859–1930), whose goose girl steering her flock in *To Pastures New* (Pl. 401) is one of the finest of many renditions of this popular theme. Guthrie became a devoted exponent of rural naturalism, while in England George Clausen (1852–1944) was Bastien-Lepage's most devoted disciple. Clausen said of his idol: 'The work of Bastien-Lepage ranks, to my mind, with the very best in modern art. He brought to us what was in some ways a new vision of nature.'

Clausen's admiration found visual expression in an engaging study, *Breton Girl Carrying a Jar* (Pl. 402), which echoes Bastien-Lepage's work in mood and in the manner of applying paint to canvas with a square brush. The use of this technique became a hallmark of the committed followers of Bastien-Lepage, particularly Stanhope Forbes (1857–1947), the founder of the Newlyn School, whose study of a Breton girl making lace, *A Street in Brittany (Cancale)* (Pl. 403), reveals their affinity of interests.

Bastien-Lepage also loved London, which he considered possessed qualities of light and colour not present in Paris. For him the colour red denoted London: 'you cannot look down a street without a strong bit of red somewhere, the wheels of a cab, a postbox, the letters on a shop, the uniform of a soldier.' On several visits to London, he painted cockney characters such as flower-sellers and child bootblacks. His *London Bootblack* (Pl. 404), portrayed against the background of the rushing traffic of Cheapside, is one of the most striking of all child studies made in Victorian London. The boy, wearing a bright scarlet coat and hat band, was persuaded to pose for the picture in a studio owned by a friend of the artist, who described how the lad 'turned out to be a restless, troublesome little fellow, and was quite unconscious of

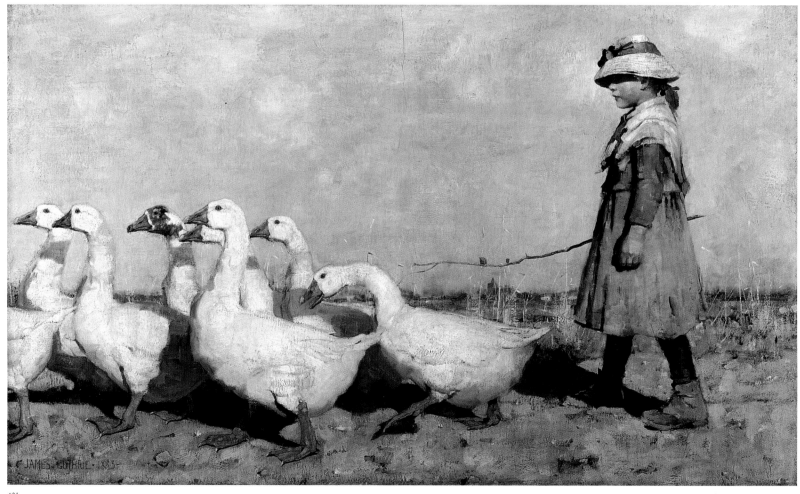

401

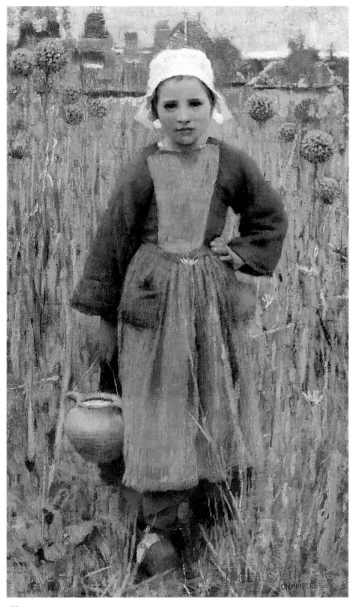

402

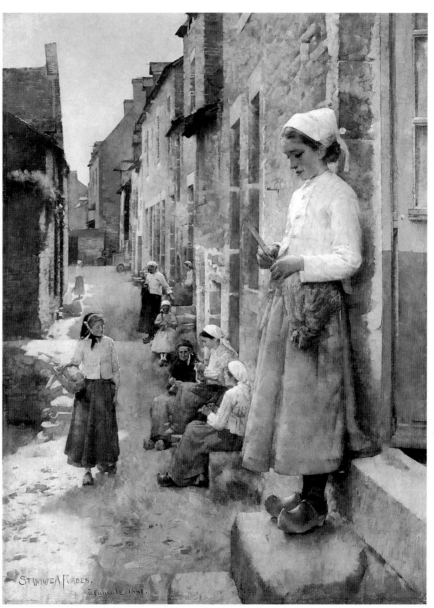

403

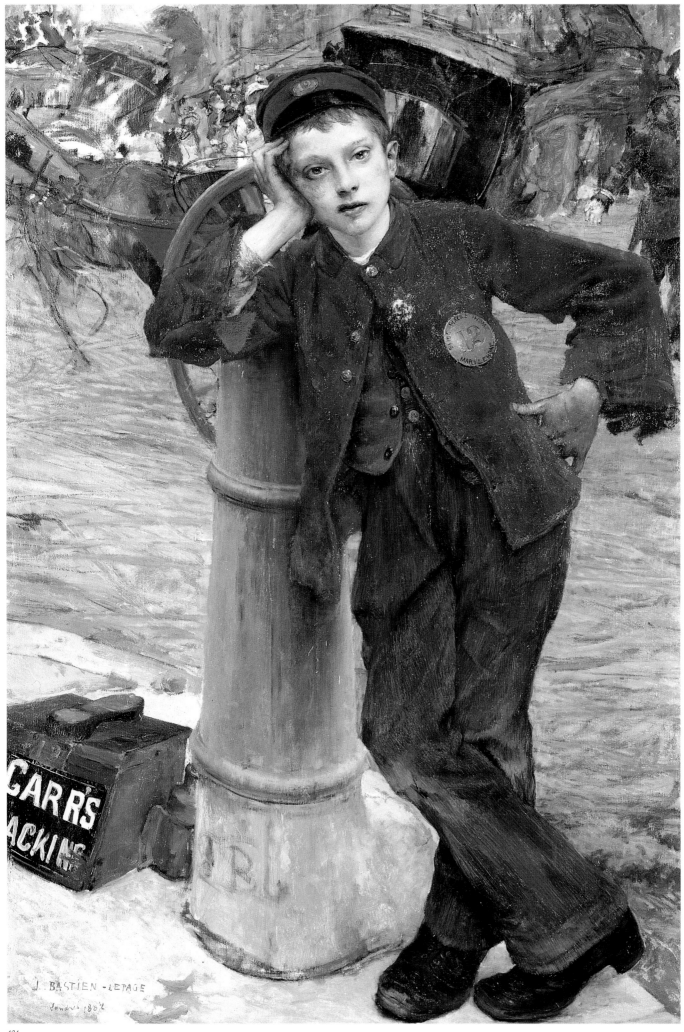

J. BASTIEN-LEPAGE
Londres 1882

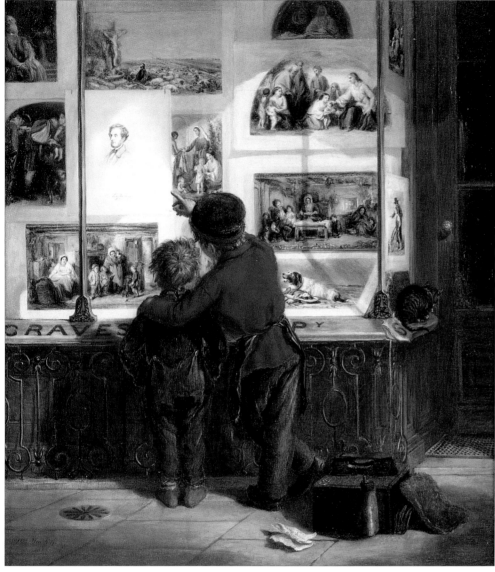

405

404
Jules Bastien-Lepage
The London Bootblack
1882
oil on canvas, 132.5 × 89.5cm
(52¼ × 35¼in)
Musée des Arts Décoratifs, Paris

405
William MacDuff
**Shaftesbury, or Lost
and Found**
1862
oil on canvas, 47 × 40.6cm
(18½ × 16in)
Museum of London

the honour done to him. Bastien-Lepage expected long hours and very great quiet from his models. This the shoe black found irksome, and it was with the greatest difficulty he was prevailed on to return, though he was munificently paid and feasted.'

The boy belonged to the Shoe Black Brigade, whose original 25 members cleaned 101,000 pairs of shoes during the Great Exhibition of 1851. The brigade was an idea of the great defender of the poor and downtrodden, Anthony Ashley Cooper, 7th Earl of Shaftesbury (1801–85). His work is celebrated in the painting *Shaftesbury, or Lost and Found* (Pl. 405) by the little-known painter William MacDuff (*fl.*1844–66). It shows a boy chimney sweep and a bootblack peering through the shop window of the famous print-sellers, Messrs Graves, at a number of engravings of poor children and a portrait of Lord Shaftesbury. On the pavement lies a crumpled poster announcing a meeting at the Exeter Hall of the Ragged School Union of which he was President. Affection for Shaftesbury was widespread, and found expression after his death in the memorial of Eros by Alfred Gilbert in Piccadilly Circus, the best-loved of all London's street monuments.

In the 1860s and 1870s the growth of literacy, in part produced by the Ragged School Union, resulted in an upsurge in the production of illustrated books and periodicals. Many great Victorian painters, such as Leighton, Millais and Rossetti, produced impressive work in this field, as did a number of less well-known specialist

406
Frederick Walker
The Vagrants
1867
oil on canvas, 83.2 × 126.4cm
(32¾ × 53¾in)
Tate Gallery, London

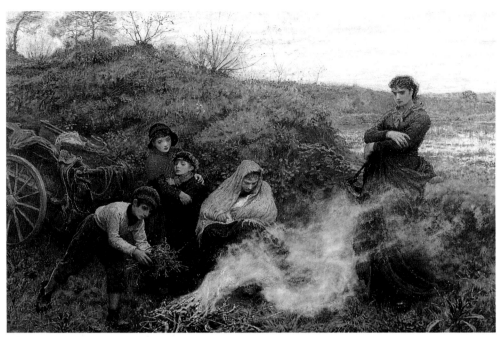

406

artists in the technique of wood-engraving, creating a golden age of brilliant black-and-white illustration. The more notable of the minor figures included one of the most popular illustrators of the 1860s, Frederick Walker, whose wood engraving *The Vagrants*, made for *Once A Week* in 1866, depicted a family of dejected gypsies by the roadside. He reused the composition in an oil painting of the same title which he exhibited the following year (Pl. 406). Walker's friend John William North also took up the theme of underprivileged gypsies in a watercolour, *A Gypsy Encampment* (Pl. 146). In similar illustrations dealing with social problems for the journals *Good Words*, the *Cornhill* and *Once a Week*, Walker and his friends began to cover subjects of a type which would be taken up enthusiastically in the *Graphic*, a new periodical which was to become one of the most important journals of the Victorian era.

It first appeared in December 1869 and from the start had a major impact upon Victorian Social Realist art. The editor, William Luson Thomas, emphasized the visual quality of the new journal, which he wanted to be judged by the extremely high standard of its black-and-white illustrations. Its leading contributors were Luke Fildes, Frank Holl and Hubert von Herkomer, all of whom later forsook their sombre early vein for more lucrative careers as portrait painters (Pls. 91, 92). But first, in the pages of the *Graphic*, they were able to try out, in the powerful and concise medium of wood-engraving, subjects which they subsequently reworked as oil paintings.

Luke Fildes (1844–1927) was brought up by his grandmother, who in 1819 was present on the speaker's platform in Manchester at the Peterloo Massacre, one of the great formative moments of the history of the Left, when eleven workmen at a meeting in favour of parliamentary reform were killed by the military. This connection helps to explain Fildes's own compassionate concern for the lot of the poor. He had already made his mark as a graphic artist before meeting the editor of the *Graphic*, who commissioned a major illustration as a contribution to the new journal as early as June 1869. The plate *Houseless and Hungry* certainly got the magazine off to a good start when the first issue appeared on 4 December 1869. It was accompanied by an article by Fildes explaining the genesis of the print. Fildes wrote:

> I made a drawing of an incident I saw in the streets one winter's night when I
> first came to London in '63 … I had been to a dinner party, I think, and hap-
> pened to return by a police station, when I saw an awful crowd of poor wretches

applying for permits to lodge in the Casual Ward. I made a note of the scene and after that often went again, making friends with the policemen and talking with the people themselves … The figures in the picture before us are portraits of real people who received the necessary order for admission on a recent evening …

The new journal arrived at Charles Dickens's home, Gad's Hill, near Rochester, Kent, where Millais was staying on a visit. On seeing Fildes's illustration, Millais rushed into Dickens's room waving the paper over his head exclaiming 'I've got him' – 'Got who?' said Dickens, 'A man to illustrate your *Edwin Drood*.' Dickens wrote to Fildes saying, 'I see from your illustration in *The Graphic* this week that you are an adept at drawing scamps, send me some specimens of pretty ladies.' Fildes did so and was invited to Gad's Hill a few months before Dickens's unexpected death on 9 June 1870, leaving the novel *The Mystery of Edwin Drood* unfinished. Fildes's depiction of Dickens's empty chair in an empty room (Pl. 418) is very different from that of Buss's conception, thronged with the creations of Dickens's protean imagination (Pl. 73).

When the oil version of *Houseless and Hungry* was exhibited at the Royal Academy in 1874 as *Applicants for Admission to a Casual Ward* (Pl. 407) it was accompanied by a quotation from a letter from Dickens: 'Dumb, wet, silent horrors! Sphinxes set up against that dead wall, and none likely to be at the pains of solving them until the *general overthrow*.' The posters on the wall rub in the point. One reads 'Child Deserted £2 Reward', the other 'Lost, a Pug Dog, £20 Reward', which gives a clear message that a society which values a child less than a dog is heading for destruction and anarchy. Dickens's italicized words take on a special significance when the anarchical chaos of the siege of Paris and the Commune which took place three years earlier is recalled.

Although Fildes's name is so closely associated with the *Graphic* he was not a very frequent contributor. By the late 1870s he had turned almost exclusively to painting

407
Luke Fildes
Applicants for Admission to a Casual Ward
1874
oil on canvas, 137.1 × 243.7cm
(54 × 96in)
Royal Holloway College, University of London, Egham, Surrey

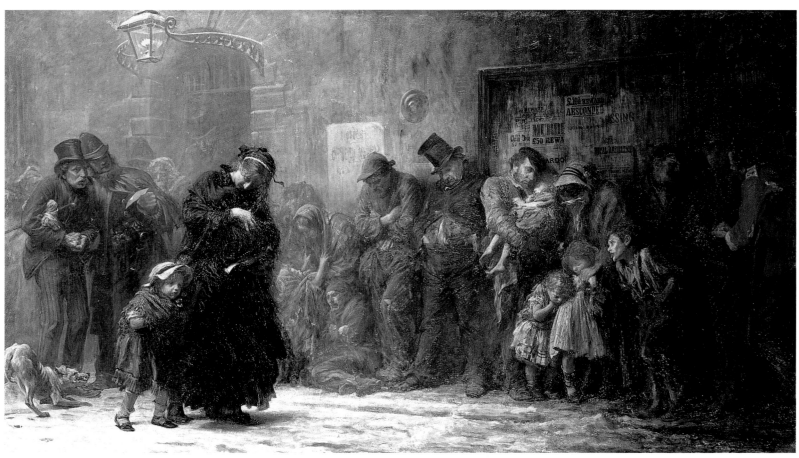

407

408
Luke Fildes
The Doctor
1891
oil on canvas, 166.4 × 241.9cm
(65⅝ × 95⅛in)
Tate Gallery, London

409
William Small
The Good Samaritan
1899
oil on canvas, 15.9 × 24.5cm
(6¼ × 9⅝in)
Leicester Museum and Art
Gallery

410
Frank Holl
No Tidings from the Sea
1871
oil on canvas, 66 × 91.3cm
(26 × 36in)
Royal Collection

411
Frank Holl
Her Firstborn
1876
oil on canvas, 109.2 × 155.6cm
(43 × 61¼in)
McManus Galleries, Dundee

Venetian genre scenes and portraiture. But he did produce a few more Social Realist paintings, the first being *The Widower*, which he exhibited in 1876, a sombre interior of a labourer's cottage depicting an exhausted father nursing a dying child, while three younger children play. He returned to a similar mournful theme in 1891 when he was commissioned for £3,000 by Sir Henry Tate to paint *The Doctor* (Pl. 408) for presentation to the nation. The subject had been in Fildes's mind since 1877, when on Christmas morning his eldest son Paul had died; the bearing of Doctor Murray, the family physican, had deeply impressed the artist. Fildes built an elaborate cottage window in his studio to get the right effect of dawn breaking, in contrast to the lamplight picking out the doctor's face, the bedding and the restless child.

Another *Graphic* artist to paint a similar subject was William Small (1843–1929) who in one of his rare oil paintings depicted a gypsy encampment with a doctor treating a feverish girl (Pl. 409). The theme of childhood sickness in the days before antibiotics were discovered was of universal interest in the nineteenth century.

Illness and mortality were frequent themes for Frank Holl (1845–88), whose short life was overshadowed by tragedy and death. He was born in London, the son of an engraver, and found early success in the Royal Academy Schools. From the beginning, portraiture and dramatic social problem pieces formed the central themes of his career, and he was already an established figure before the foundation of the *Graphic*. In 1869 he exhibited *The Lord Giveth and the Lord hath Taken Away; Blessed be the Name of the Lord*, a family at prayer after the death of the father, which impressed Queen Victoria herself, then still deeply committed to mourning her beloved Prince Albert, and won Holl a two-year travelling scholarship which he spent more in Munich, Cologne and Antwerp than in Italy. On his return Queen Victoria commissioned *No Tidings from the Sea* (Pl. 410), exhibited at the Royal Academy in 1871, painted after a two-month stay at Cullercoats on the coast of Northumberland. Possibly modelled on Jozef Israels's work, it shows a distraught fishing family waiting for the sound of their father, the fisherman who will not return, thus anticipating themes later popular with the Newlyn School.

Holl began to work for the *Graphic* in 1871. As with Fildes, several of his drawings for the journal were reworked as successful Academy paintings. The subject of maternal grief at infant death formed the theme of both a painting entitled *I am the Resurrection and the Life* (1872), and a pair of canvases with the self-explanatory titles, *Hush!* and *Hushed*, dating from 1876. These prepared the way for his moving picture *Her First Born* (Pl. 411) from the same year. It shows a procession of mourners led by four young girls bearing a tiny coffin in a white pall.

408

409

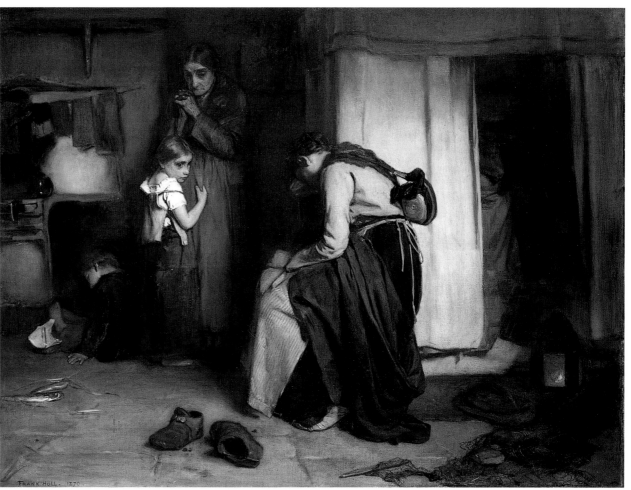

410

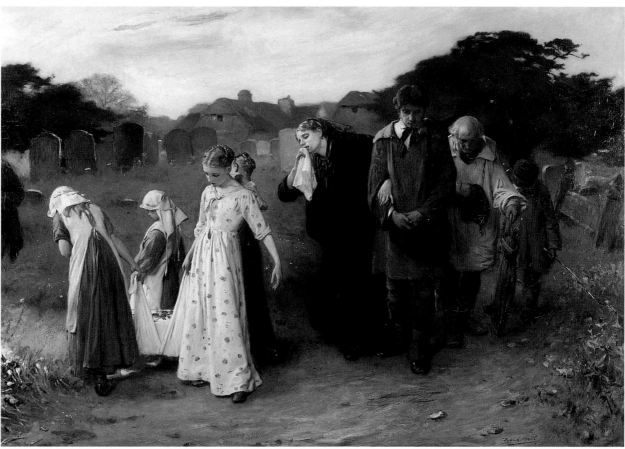

411

412
Frank Holl
**Newgate – Committed for
Trial**
1878
oil on canvas, 155.4 × 215cm
(61¼ × 84½in)
Royal Holloway College,
University of London, Egham,
Surrey

413
Frederick Walker
The Harbour of Refuge
1872
oil on canvas, 116.8 × 197.5cm
(46 × 77¾in)
Tate Gallery, London

414
Hubert von Herkomer
**Eventide – A Scene in
the Westminster Union**
1878
oil on canvas, 110.5 × 198.7cm
(43½ × 78¼in)
Walker Art Gallery, Liverpool

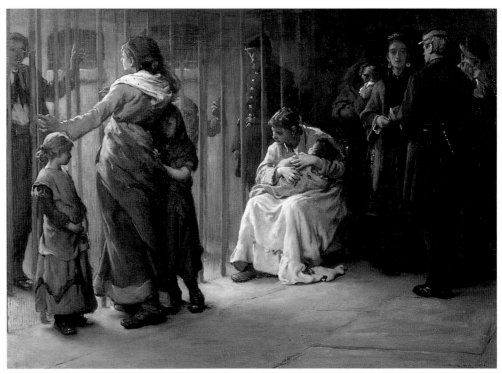

412

The painting for which Holl is most remembered today, and the largest work he ever painted, was *Newgate – Committed for Trial* (Pl. 412), which really established his reputation as the leading Social Realist painter of his time when it was first exhibited at the Royal Academy in 1878. The Governor of Newgate Prison was a friend of Holl, and on visiting him one day Holl was deeply moved by seeing:

> the part of Newgate prison called the cage – in which prisoners whilst on trial are
> permitted at certain hours, & on certain days, to see their friends – on the inner
> side the prisoners are placed, & in the passage – their friends are conducted to
> them … A Warden walks between the two gratings, who can hear and see every-
> thing that takes place between the friend & prisoner – It is particularly impressive
> for scenes of such pathos & agony of mind on both sides take place … I wit-
> nessed this scene some years before I painted the picture … I shall never forget
> the impression it made upon me – Prisoners of all sorts of crime were there – the
> lowest brutal criminal – swindlers, forgers, & boy thieves – all caged together,
> awaiting the results of their separate trials, & in one or two cases, the misery of
> their friends in seeing them in this hopeless condition, fell but lightly on their
> brains dulled by incessant crime …

The most prolific artist of the *Graphic* group was Hubert von Herkomer (1849–1914). He greatly admired Frederick Walker's most famous painting, *The Harbour of Refuge* (Pl. 413), shown at the Royal Academy in 1872. It depicts a group of old people sitting in the garden of an almshouse (the Jesus Hospital at Bray), their age being contrasted with a vigorous young reaper, who symbolically wields a scythe. This theme influenced Herkomer's two later famous treatments of old people, *The Last Muster* (Pl. 445), and *Eventide – A Scene in the Westminster Union* (Pl. 414), which portrays not old soldiers at the end of their lives but old women. He wrote: 'I felt that everyone of these old crones had fought hard battles in their lives – harder battles by far than those old warriors I painted – for they had to fight single handed and not in the battalions as the men did.'

Herkomer, active as an artist in both Germany and England, was a man of many parts. Before holding the post of Slade Professor of Fine Art at Oxford from 1885 to

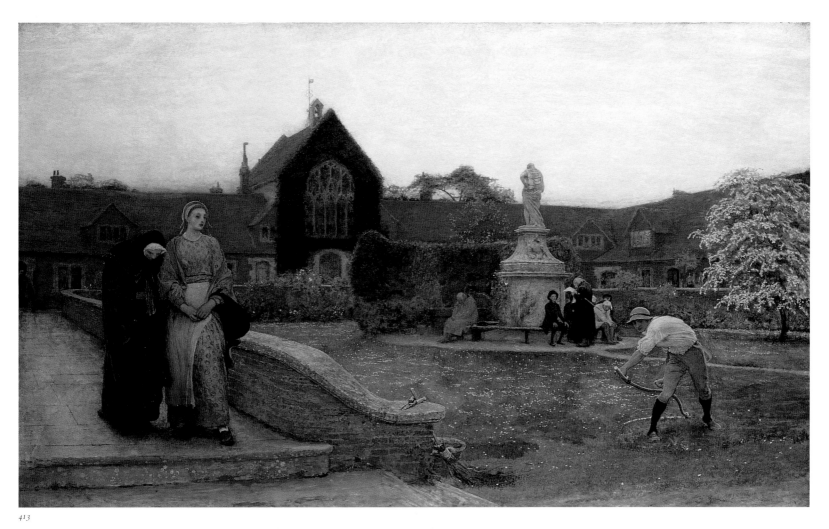

413

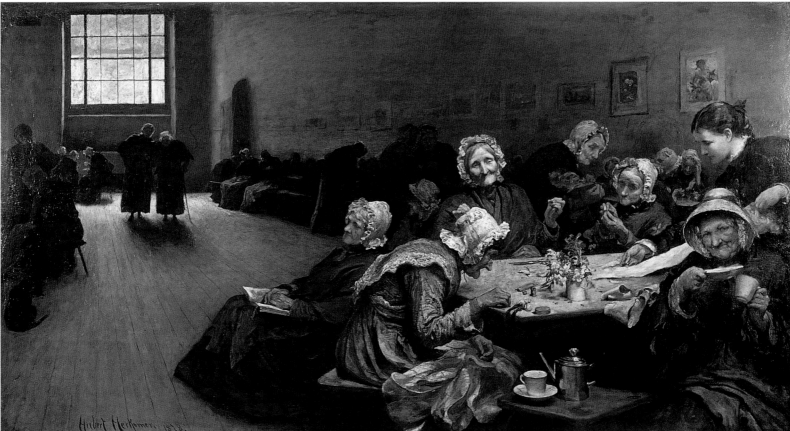

414

415
Frederick George Cotman
One of the Family
1880
oil on canvas, 102·6 × 170·2cm
(40¼ × 67in)
Walker Art Gallery, Liverpool

1894, he founded and directed in 1883 an excellent school of art at Bushey, Hertfordshire, near his home, Lululand, a neo-Gothic fantasy designed by his friend the American architect H.H. Richardson. One of the achievements of his school of art was to illustrate, under Herkomer's guidance, Thomas Hardy's novel *Tess of the d'Urbervilles* when it was serialized in the *Graphic* between 4 July and 26 December 1891. Both in Hardy's novel and the children's classic *Black Beauty* by Anna Sewell (1877), the fortunes of humble families are shown to be absolutely dependent upon the well-being of their horse, which is quite literally 'one of the family'. Not only is it the main breadwinner, but also a family friend, as it is affectionately portrayed in an engaging painting by Frederick George Cotman (1850–1920), *One of the Family* (Pl. 415). On the right of the painting, just visible behind the door, the father of the family, returned from ploughing, hangs up a piece of horse's tack. He and his horse have together been earning the daily bread which the old woman cuts into pieces, one of which is given to the horse who leans through the window. The association with the words of the Lord's Prayer is made simply but effectively.

A scene reminiscent of the opening of several Hardy novels was provided by Herkomer's *Hard Times* (1885), showing a destitute itinerant family resting by the

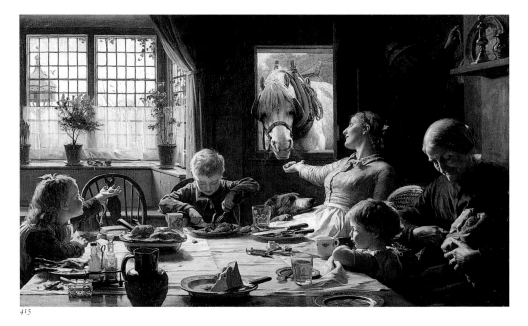

415

road with their children. The phrase 'hard times' echoes through the second half of the nineteenth century, from Charles Dickens's novel of 1854 to George Gissing's novel *New Grub Street* (1891) about the commercial hacks who worked and died in 'the valley of the shadow of books'. Another lone worker and his family formed the subject of Herkomer's Diploma painting *On Strike* (Pl. 416), perhaps occasioned by the great dock strike of 1889. Without the pietistic overtones of the Holy Family seen in *Hard Times*, the monumental figure of the striker is left deliberately ambiguous. This is not the case in an American painting of 1886 by the socialist painter Robert Koehler (1850–1917), depicting an actual strike in a Pittsburgh steel mill (Pl. 417), with the classic confrontation of top-hatted mill owner and hostile workers, one of whom is bending down to pick up and throw a rock.

Both major and minor artists who worked for the *Graphic* magazine were greatly admired and sometimes lovingly reinterpreted by Vincent Van Gogh, who twice lived in England as a young man. In 1873 he worked briefly in London for the international firm of picture dealers Goupil & Co., and 'used to go every week to the show windows of the *Graphic* … to see the new issues'. Later, in 1876, he worked as

a schoolteacher at Ramsgate and at Isleworth, near London, becoming a lay preacher in his spare time. The subject of his most important sermon preached at Richmond, Surrey, to justify his view of life as 'a pilgrim's progress', was inspired by a painting by George Henry Boughton (1833–1905) entitled *God Speed!*, dating from 1874. Boughton, brought up in America and France, settled in London in 1862 and is now mainly remembered for the way in which this painting was used by Van Gogh.

During both periods in England Van Gogh became interested in the artists working for the *Graphic* who illustrated the theme of manual labour, and read with deep emotion the novels of Dickens, which he loved. Several years later in 1882, when living at The Hague, he bought an almost complete run of the *Graphic*, and wrote excitedly to his brother Theo: 'The *Graphics* are now in my possession. I have been looking at them far into the night … While I was looking them over, all my memories of London ten years ago came back to me – when I saw them for the first time, they moved me so deeply that I have been thinking of them ever since.' Van Gogh described his collection as 'a kind of Bible to an artist'. The English illustrators proved

416
Hubert von Herkomer
On Strike
1891
oil on canvas, 228 × 126.4cm
(89⅞ × 49¾in)
Royal Academy, London

417
Robert Koehler
The Strike
1886
oil on canvas, 249 × 279.4cm
(98 × 110in)
Private collection

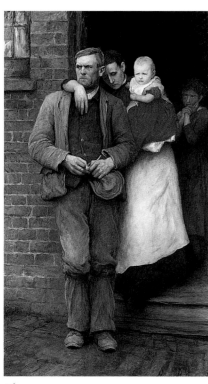

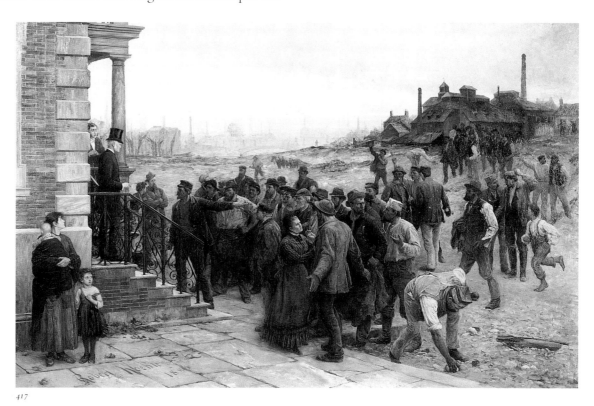

416 *417*

to be a vital source of inspiration: 'Every time I feel a little out of sorts, I find in my collection of wood engravings a stimulus to set to work with renewed zest … in their work there is something lofty and dignified – even when they draw a dunghill.' Van Gogh particularly admired a series of illustrations in the *Graphic* entitled 'Heads of the People', to which less-remembered names such as William Small and Matthew Ridley as well as Herkomer contributed. The 'Heads of the People' are powerfully assimilated into his first masterpiece, *The Potato Eaters*, which he finished in 1885.

Van Gogh writes movingly about many of the *Graphic* artists: 'For me the English black and white artists are to art what Dickens is to literature. They have exactly the same sentiment, noble and healthy, and one always returns to them … I am organizing my whole life so as to do all the things of everyday life that Dickens describes and the artists I've mentioned draw,' he wrote to his friend Van Rappard in September 1882. Van Gogh's deep love of Dickens was closely linked to his visual tastes. He greatly admired Fildes's illustration *The Empty Chair* (Pl. 418). He wrote

418
Luke Fildes
The Empty Chair (detail)
1870
engraving from *The Graphic*,
Christmas 1870

419
Vincent Van Gogh
Gauguin's Chair
1888
oil on canvas, 90.5 × 72.5cm
(35¾ × 28⅝in)
Van Gogh Museum,
Amsterdam

418 *419*

to his brother Theo describing how 'Luke Fildes [was] brought into contact with Dickens through these small illustrations [for Edwin Drood], entered his room on the day of his death, and saw his empty chair, and so it happened that one of the old numbers of the 'Graphic' contained that touching drawing "The Empty Chair".'

Van Gogh's admiration for both Dickens and Fildes became the inspiration for several of his own major paintings at Arles. The pose of Mr Gradgrind, head in hands, consumed with remorse for the fate of his son, in Arthur Boyd Houghton's frontispiece to an edition of Dickens's *Hard Times*, was to be transformed into the old man in Van Gogh's drawing and lithograph inscribed *At Eternity's Gate* of May 1890. Fildes's *Empty Chair* was the inspiration for *Gauguin's Chair* (Pl. 419).

While Van Gogh conducted his own curious education in art by admiring English artists in London from the 1870s onwards, many British painters began by studying on the continent, and in particular in France. Indeed contemporary French art, with its emphasis on outdoor painting and the portrayal of the life of the fisherman and the peasant, held an irresistible attraction for foreign students. Many British artists spent some time working in the artist colonies in the country at Grez, Barbizon or on the coast at Pont-Aven in Brittany, where the picturesque costumes of the Breton fisherfolk were an added attraction. During the 1880s the charismatic figure of Paul Gauguin, and his followers the Nabis, took over the artist's colony at Pont-Aven, influencing several British and American artists. An interesting and far too little-known English follower of Gauguin was Eric Forbes-Robertson (1865–1935), a member of a distinguished theatrical family, whose subtly lit painting of *Breton Children, Pont Aven* (Pl. 594) has great sensitivity.

Back in England, however, the symbolic relationship of death and the sea, and the hard life of the fisherman, became a principal theme. This led many painters to work at the Yorkshire fishing village of Staithes and the Suffolk coastal village of Walberswick. But by far the most popular place for British artists was the Cornish peninsula and the two fishing villages of St Ives and Newlyn. There the mild climate made *plein-air* painting more possible than elsewhere in England, and although the local fisherfolk lacked the picturesque costumes of Brittany, Newlyn in particular began to attract artists not just for the summer months, but all their lives. St Ives remained much more cosmopolitan, crowded with artists from all over the world – Russian, German, Australian and an important Scandinavian group, which included Anders Zorn (1860–1920).

The first artist to settle permanently at Newlyn, in January 1882, was the Birmingham painter Walter Langley (1852–1922). His watercolour *But Men Must Work and Women Must Weep* (Pl. 420) was inspired by a poem of 1851 by Charles Kingsley. While reading the poem Langley heard a signal gun: 'He went out into the black night – an awful storm was howling – and he saw the blue rockets being fired from Penzance as a signal to those who were at sea … the idea at once suggested itself.' The titles of other major works by Langley, *Disaster* (1889) and *'… Never Morning Wore to Evening but some Heart did Break'* (1894) reveal his interest in the tragic aftermath of wrecks at sea. This most sombre of all themes was also memorably treated by Frank Bramley (1857–1915) in *A Hopeless Dawn* (Pl. 421).

Bramley also painted a remarkable child funeral scene, a moving study of a cortège all dressed in white, *For of Such is the Kingdom of Heaven* (Pl. 423). This picture arose from the same motivation as inspired the leading figure of the Newlyn School, Stanhope Forbes, whose aim was to paint a history of the life of a fishing community. Under his direction the mood of the works produced by Newlyn artists enjoyed a sea-change from gloom to affirmation. His *Fish Sale on a Cornish Beach* (Pl. 422), *The Village Philharmonic* (1888) and *The Health of the Bride* (Pl. 458) celebrate not only the sorrows but also the joys of the fishing community. Shortly after completing the last work, Forbes himself married the Canadian-born Elizabeth Armstrong, who became a talented member of the group. Her *School is Out* (Pl. 424) is one of the best-loved Newlyn paintings.

The work of Newlyn School artists and their associates was often featured in the *Studio* magazine, founded in 1893. The *Graphic* had begun to lose its special role in conveying man's vulnerability to death and tragedy in the muted, sombre overtones of the wood-engraving. Renouncing this process for new photo-mechanical methods, the *Studio*'s pages are full of photographs of themes which feature in the end of the Victorian era and in the story of British Impressionism.

420
Walter Langley
**But Men Must Work
and Women Must Weep**
1882
watercolour, 90.5 × 53cm
(35⅝ × 20⅞in)
Birmingham City Museum
and Art Gallery

421
Frank Bramley
A Hopeless Dawn
1888
oil on canvas, 123 × 167.4cm
(48½ × 66in)
Tate Gallery, London

420

421

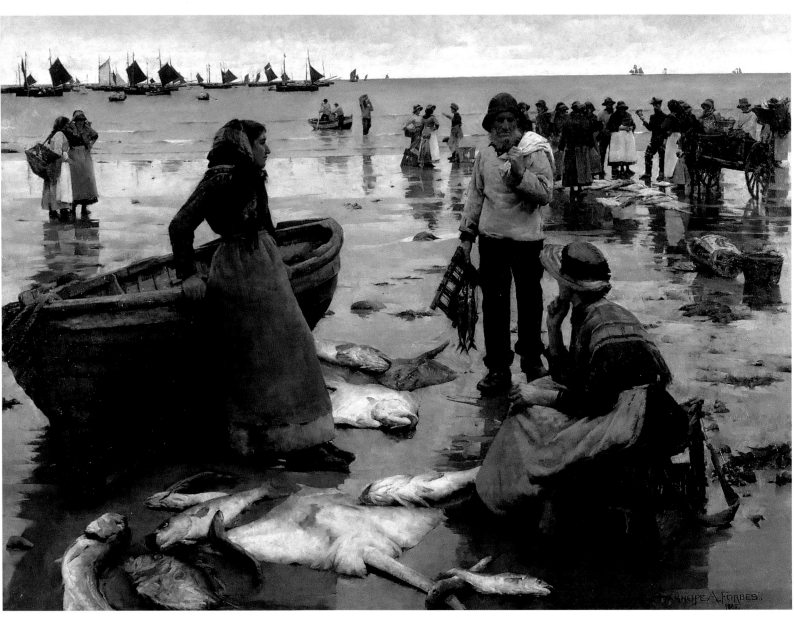

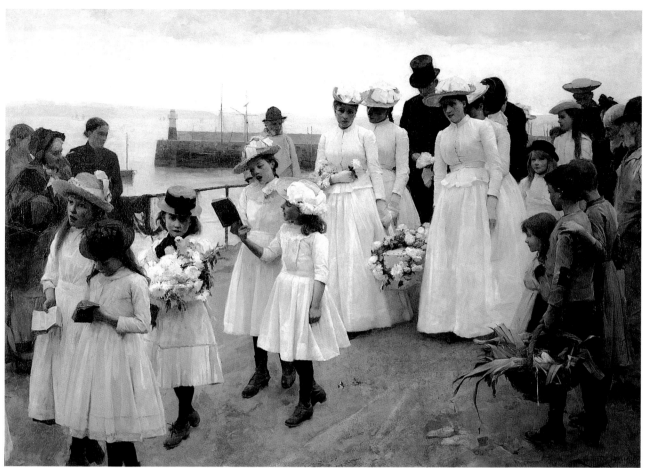

423

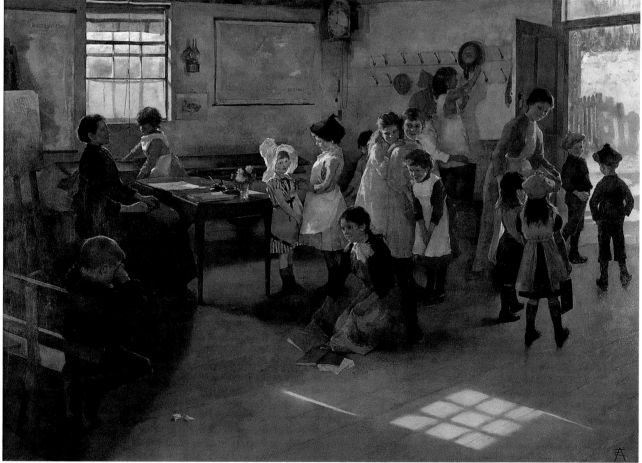

424

422
Stanhope Forbes
A Fish Sale on a Cornish Beach
1885
oil on canvas, 121 × 155cm
(47¾ × 61⅛in)
City Museum and Art Gallery,
Plymouth

423
Frank Bramley
For of Such is the Kingdom of Heaven
1891
oil on canvas, 182.9 × 254cm
(72 × 100in)
Auckland Art Gallery

424
Elizabeth Armstrong
School is Out
1889
oil on canvas, 106.4 × 145cm
(41⅞ × 57in)
Penlee House Gallery
and Museum, Penzance

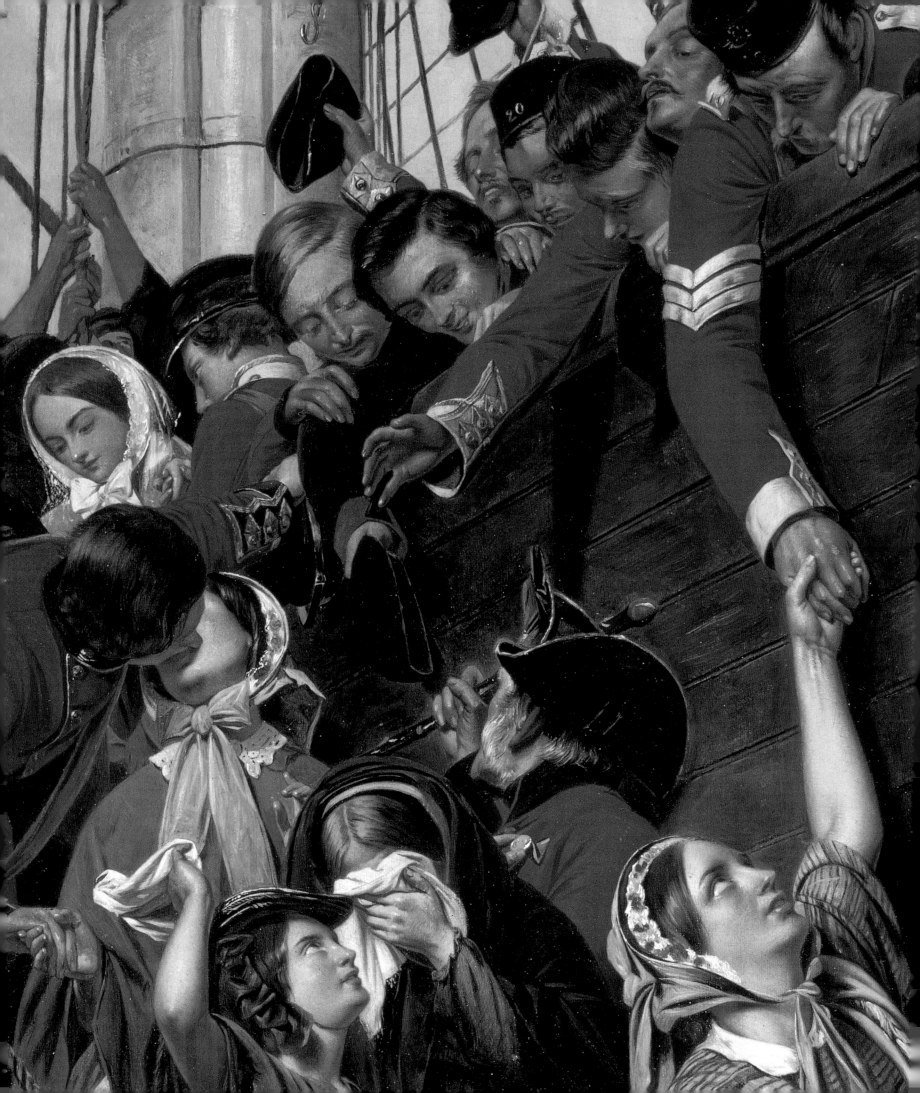

Awoman stands desolate outside the smouldering ruins of her cottage. Around her are the gentle hills of Ireland, while in the distance the police who have set fire to the cottage and effected the eviction are retreating. Such a theme reminds us of the continuing tragedy of Ireland, which in 1890 went through one of the darkest moments in its cycle of hope and despair. The career of the charismatic Nationalist Irish leader Charles Stewart Parnell was ruined by his involvement in a divorce case, thus damaging irretrievably the future of the Home Rule movement. Major General Sir William Butler, the husband of the artist Lady Butler, was a Catholic and a friend and fervent admirer of Parnell, and detested the policy of coercion in response to Irish agitation which was then being advocated by the Prime Minister Lord Salisbury.

In her memorable canvas entitled *Evicted*

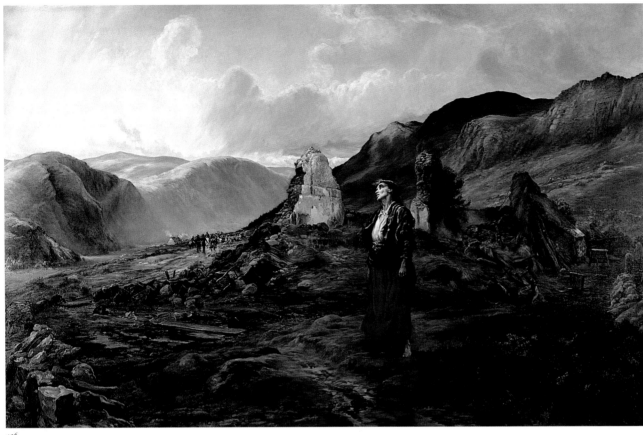

426

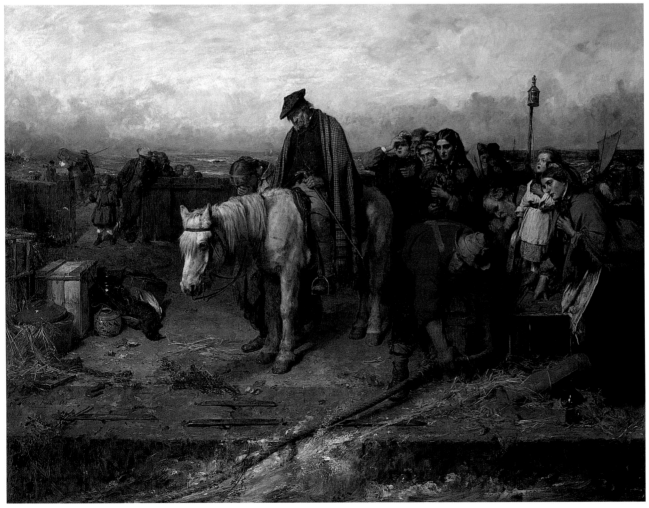

427

(Pl. 426), Lady Butler encapsulated these views, just as her earlier canvases captured more heroic aspects of life in the armed services (Pls. 388, 389). The picture was based on an incident she witnessed near Glendalough, Co. Wicklow, where she and her husband were staying for the shooting season. She heard that some evictions were taking place nine miles away and:

> got an outside car and drove off to the scene, armed with my paints. I met the
> police returning from their distasteful 'job', armed to the teeth and very flushed.
> On getting there I found the ruins of the cabin smouldering, the ground quite
> hot under my feet, and I set up my easel there. The evicted woman came to
> search amongst the ashes of her home to try and find some of her belongings
> intact. She was very philosophical, and did not rise to the level of my indignation
> as an ardent English sympathiser.

When the painting was exhibited at the Royal Academy that summer Lord Salisbury made the main speech and with crass insensitivity made a facetious attack on the picture, which he saw as a direct condemnation of the policy of his administration, saying, 'there is such an air of breezy cheerfulness and beauty about the landscape which is painted, that it makes me long to take part in an eviction myself.'

The painting has subsequently found wide fame through being used on the dust-jacket of Cecil Woodham-Smith's classic *The Great Famine: Ireland 1845–9*. An alternative image for that purpose might well have been George Frederic Watts's painting *The Irish Famine* (Pl. 428), which shows a starving evicted family. It was inspired by Watts's friend, the Irish poet Aubrey De Vere, who had devoted himself to relief work on his family estates when the potato crop failed in 1846. De Vere referred to Watts's painting as your 'Irish Eviction', and it certainly matches the mood of De Vere's poem 'The Year of Sorrow – Ireland – 1849':

> But thou O land of many woes!
> What cheer is thine? Again the breath
> Of proved Destruction o'er thee blows,
> And sentenced fields grow black in death.
> In horror of a new despair
> His blood-shot eyes the peasant strains,
> With hands clenched fast, and lifted hair,
> Among the daily darkening plains.

By 1890 such expulsions had become less common, but it was still a period when tenant farmers were driven off the land, and not only in Ireland. *Evicted* stands with *The Last of the Clan* (Pl. 427), by the Scottish painter Thomas Faed (1826–1900), as a useful symbol for the main reasons leading to the diaspora of Irish and Scots around the world in the reign of Queen Victoria.

Faed's painting depicts an old crofter seated on a pony watching the hawser letting loose a ship which bears all the young and able-bodied men away from their family crofts, which have been sacked by a landlord determined to maximize his profits by sheep farming or setting up a shoot. When exhibited at the Royal Academy it was accompanied by an explanatory paragraph probably written by Faed: 'When the steamer had slowly backed out, and John MacAlpine had thrown off the hawser, we began to feel that our once powerful clan was now represented by a feeble old man and his grand-daughter, who, together with some outlying kith and kin, myself among the number, owned not a single blade of grass in the glen that was once all our own.'

Faced with such pressures, emigration could for many prove an exciting challenge, the emotion captured in five familiar lines from Emma Lazarus's poem inscribed upon Bartholdi's Statue of Liberty:

426
Lady Butler
Evicted
1890
oil on canvas, 136 × 177·8cm
(53¾ × 70¼in)
University College, Dublin

427
Thomas Faed
The Last of the Clan
1865
oil on canvas, 144·8 × 182·9cm
(57 × 72in)
Art Gallery and Museum,
Kelvingrove, Glasgow

428
George Frederic Watts
The Irish Famine
1848–9
oil on canvas, 180·4 × 198·1cm
(71 × 78in)
Watts Gallery, Compton,
Surrey

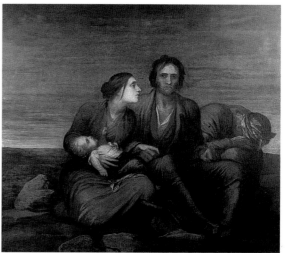

428

Give me your tired, your poor,
Your huddled masses yearning to breathe free,
The wretched refuse of your teeming shore.
Send these, the homeless, tempest-tost to me,
I lift my lamp beside the golden door!

Yet while freedom proved a reviving draft for oppressed political refugees, and poor emigrants welcomed the chance to live and not starve, for others slightly higher up the social scale it was an agonizing decision to emigrate. The self-inflicted pain of being cast asunder from one's family, probably forever, made the act of emigration a type of living death. The theme of parting, while it explains the sentimental 'keep-sake albums' of the 1840s and 1850s, could also take more poignant forms.

The cold statistical facts of emigration from Great Britain record that out of a population of 27 million over 4 million emigrated between 1840 and 1860 to start a new life in Canada, America, Australia and New Zealand. When interpreted in terms of a family circle, these statistics mean that one in six people left home to go abroad

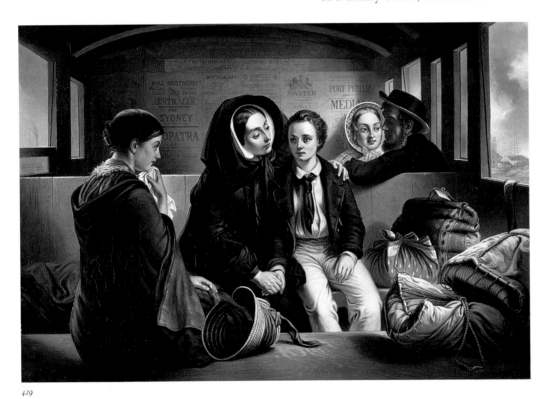

429

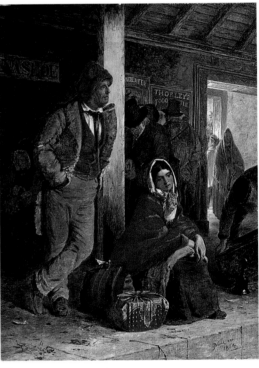

430

in those years, rarely to return. Thus parting from loved ones, knowing you would probably not meet again, became a universal and deeply felt experience, shared by many family circles at all levels of society.

The chance to depict affecting farewells proved irresistible to artists such as Paul Falconer Poole (1807–79), whose *The Emigrant's Departure* (Pl. 431) is one of the earliest emigration paintings. Erskine Nicol (1825–1904), a Scottish artist who also worked in Ireland, painted the theme on several occasions, notably in *The Emigrants* (Pl. 430), which depicts Irish emigrants at Ballinasloe station en route to Galway and the west. Similarly a painting by Abraham Solomon, *Second Class – The Parting* (Pl. 429), was subtitled 'Thus part we: rich in sorrow parting poor.' It shows a worried mother seeing her son off to a destination which is probably Australia, a fact which can be deduced from the posters stuck to the walls of the railway compartment, advertising passages to Sydney and the gold diggings.

Also popular were paintings set either at home or abroad which depicted the

431
Paul Falconer Poole
The Emigrant's Departure
1838
oil on canvas, 66 × 91.4cm
(26 × 36in)
Forbes Magazine Collection,
New York

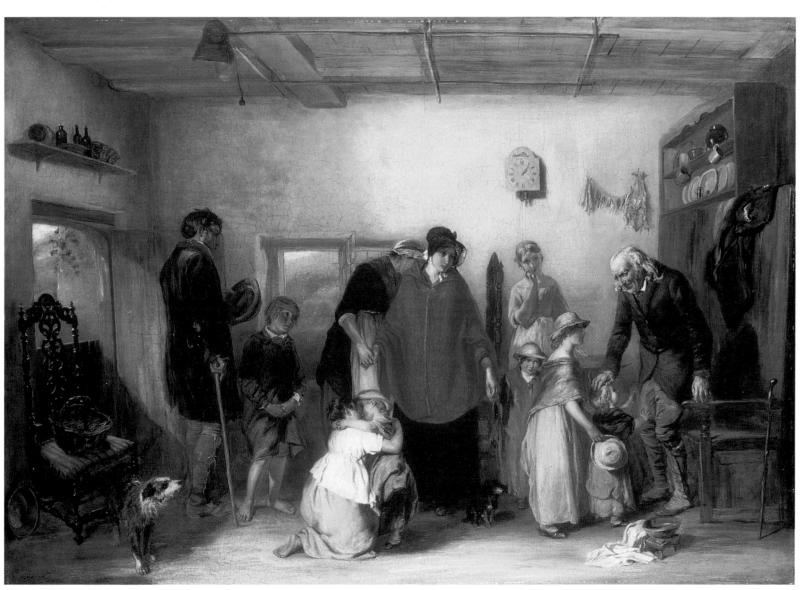

431

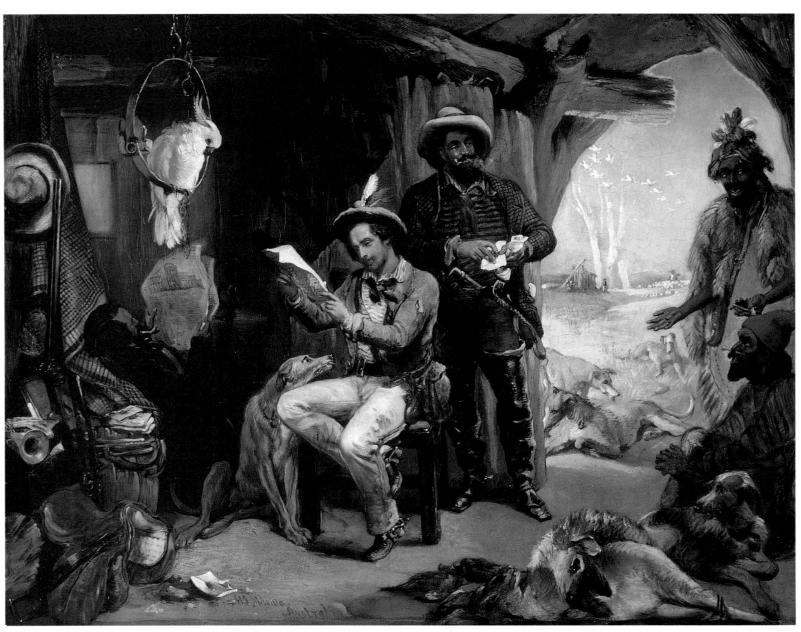

432

familiar device of the arrival of a letter containing family news. A fine example is *The Squatter's Hut: News from Home* (Pl. 432) by Harden S. Melville (*fl.* 1837–79). In their hut diggers on the gold rush, accompanied by their pet cockatoo, relax by reading letters from their families. On the wall is tacked a print showing the wonders of the Crystal Palace at home in England, while outside the hut lies the alien, sunstruck Australian landscape. The pair to this painting, *News from the Diggings* (1850–1), depicts a delighted family in the 'old country' receiving a letter enclosing a £100 note. Both works enjoyed wide fame as they were reproduced as Baxter prints, the first method of colour print reproduction which used oil paints on as many as fifteen different woodblocks.

Two other paintings on this theme were by the Pre-Raphaelite painter James Collinson, entitled *Answering the Emigrant's Letter* (1850) and *The Emigration Scheme* (Pl. 433). In the latter, a family ponder whether or not to emigrate, while a boy reads the *Australian News*. Collinson was deeply attracted to the subject of emigration, which, it could be conjectured, may have had something to do with his personal life.

432
Harden S. Melville
The Squatter's Hut:
News from Home
1850–1
oil on canvas, 87.8 × 102.1cm
(34⅝ × 40⅜in)
National Gallery of Australia,
Canberra

433
James Collinson
The Emigration Scheme
1852
oil on wood, 56·5 × 76·2cm
(22¼ × 30in)
Private collection

433

He had become engaged to Christina Rossetti in 1848, but the relationship ended when he resigned from the Pre-Raphaelite Brotherhood in May 1850 on his conversion to the Roman Catholic faith. Did he, as so many have done, consider emigration as a means of escaping from an emotional relationship which had gone wrong? But instead, late in 1852 or early in 1853, after selling all his artist's equipment, he entered the Jesuit seminary of Stonyhurst, although he never took Holy Orders, and left in 1854 to take up painting once again (see p.249).

Thoughts of emigration were also on the mind of the artist who created by far the most important work to deal with the subject, *The Last of England* (Pl. 434), begun in 1852 by the Pre-Raphaelite associate Ford Madox Brown. Its immediate inspiration was the emigration of the sculptor Thomas Woolner (1825–92) to seek his fortune in the goldfields of Australia on 24 July 1852 on the ship *Windsor*. Woolner had failed to secure any sculptural commission for five years, and was profoundly depressed by his recent failure to win the competition for a Wordsworth monument.

Ironically he was to find the goldfields unrewarding: 'we were just 8 months too late, the numbers had multiplied vastly, the richest places were exhausted'. Instead he turned to portrait sculpture in Melbourne, selling 24 portrait medallions, enough to pay for his passage home in July 1854, before the completion of Brown's painting. Woolner's boyish adventure had inspired a masterpiece which commemorates the nineteenth-century peak of migration from the United Kingdom. In that year, 369,000 Britons left for overseas.

'Very hard up and a little mad', Brown was himself meditating emigration to India when he began to paint *The Last of England* while snow was falling in the garden outside his lodgings at Hampstead. He used himself as the model for the man and his second wife Emma Hill (whom he married in 1853) as the woman. Their own baby's tiny hand can be seen held by the woman. It is impossible not to feel sorry for Emma, for Brown's theories of fidelity to nature required him to paint the picture only when the weather was appropriately awful.

Brown wrote a lengthy description of the painting, which is reproduced here for its insight into one of the greatest of Victorian paintings, and also for its candid reflection of the class and gender attitudes of the time:

> This picture is in the strictest sense historical. It treats of the great emigration movement which attained its culminating point in 1852. The educated are bound to their country by quite other ties than the illiterate man, whose chief consideration is food and physical comfort. I have, therefore, in order to present the parting scene in its fullest tragical development, singled out a couple from the middle classes, high enough, through education and refinement, to appreciate all they are now giving up, and yet depressed enough in means to have to put up with the discomforts and humiliations incident to a vessel 'all one class'. The husband broods bitterly over blighted hopes and severance from all he has been striving for. The young wife's grief is of a less cankerous sort, probably confined to the sorrow of parting with a few friends of early years. The circle of her love moves with her.
>
> The husband is shielding his wife from the sea spray with an umbrella. Next to them in the foreground, an honest family of the green-grocer kind, father (mother lost), elder daughter, and younger children, makes the best of things with tobacco pipe and apples &c, &c. Still further back a reprobate shakes his fist with curses at the land of his birth, as though that were answerable for *his* want of success; his old mother reproves him for his foul-mouthed profanity, while a boon companion, with flushed countenance, and got up in nautical togs for the voyage, signifies drunken approbation.
>
> The cabbages slung round the stern of the vessel indicate to a practised eye a lengthy voyage; but for this their introduction would be objectless. A cabin-boy, too used to 'leaving his native land' to see occasion for much sentiment in it, is selecting vegetables for the dinner out of a boatful …

Brown concluded by discussing his pictorial methods: 'To insure the peculiar look of *light all round*, which objects have on a dull day at sea, it was painted for the most part in the open air on dull days, and when the flesh was being painted, on cold days. Absolutely without regard to the art of any period or country, I have tried to render the scene as it would appear. The minuteness of detail which would be visible under such conditions of broad daylight, I have thought necessary to imitate, as bringing the pathos of the subject more home to the beholder.'

Brown's choice of details ranged from the White Cliffs of Dover in the distance, to the name of the ship – the *Eldorado*. The painting was virtually completed on 2 September 1855. Brown wrote in his diary: 'today fortune seemed to favour me. It

435

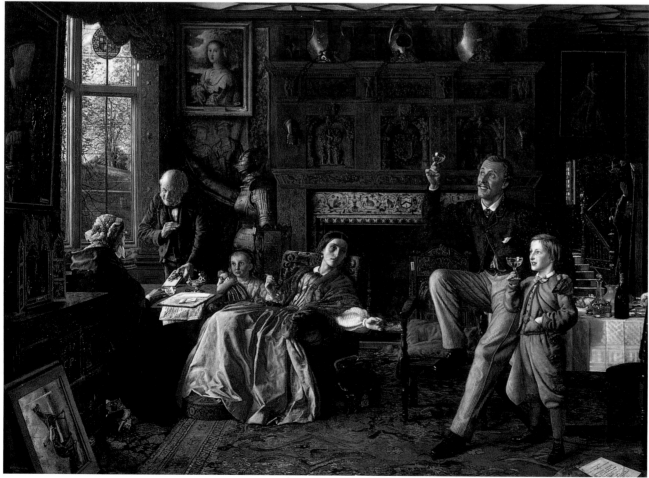

436

has been intensely cold, no sun, no rain – high wind, but this seemed the sweetest weather possible, for it was the weather for my picture & made my hand look blue with the cold as I require it in the work, so I painted all day out in the garden.' The powerful message of the painting lies in the tragic intensity of the man's gaze, a sad regard which crosses the intervening years to linger in our minds today.

The 1850s also saw the creation of another great painting inspired by the theme of emigration, *The Emigrant's Last Sight of Home* (Pl. 435) by Richard Redgrave, not a Pre-Raphaelite, but in sympathy with their aims. Redgrave was not a full-time painter, for he held the administrative post of Keeper of what is now known as the Victoria and Albert Museum, and also became Surveyor of the Queen's Pictures – the Royal Collection. The picture, one of his most successful landscapes, was probably painted at Leith Hill in Surrey near Abinger where he had a holiday cottage. When exhibited at the Royal Academy in 1859, the work was accompanied by these lines from Oliver Goldsmith's poem of 1764, 'The Traveller':

> Have we not seen, round Britain's peopled shore
>
> Her useful sons exchanged for useless ore?
>
> Forced from their homes, a melancholy train
>
> To traverse climes beyond the western main.

Throughout the poem Goldsmith repeated the idea that it was tyrannical rulers and laws that were devastating the stability of English rural life and forcing villagers to leave their homeland – ideas repeated in his best-known poem, 'The Deserted Village' of 1770. In this work Goldsmith, an Irishman, drew on his memories of his childhood at Lissoy and explored the similar theme of the depopulation of rural Britain due to unfair policies and the practices of absentee landlords. Sadly, such themes remained topical well into Queen Victoria's reign, which began with the tragic decade of the 'Hungry Forties', when the great potato famine saw 2 million people leave Ireland out of a population of 6 million.

Redgrave's choice of verse was severely criticized by the *Illustrated London News*, which complained that: 'the time is gone by for such maudlin stuff as this, and artists, if they would minister to the requirements of the age in "Britain's peopled shore", and in new homes "beyond the Western main" would do wisely to adopt a more ennobling view of a great social and political movement'. But the reviewer admired the subject of the painting: 'an emigrant party on their way to the far West ... on a rising ground, waving hands to the straggling village on the opposite hill, and along the road in the valley, the inhabitants of which come out in knots to wish them well'. On the face of the head of the family there is no trace of fear or remorse; over his shoulder is a carpenter's bag with a small saw in it, and perhaps he is meant to be interpreted as a modern Joseph escaping with his family to a new land and life. Left behind, half-way down the hill, is a small crippled boy, unable to accompany his family on their new life.

Another painting which portrays people waving farewell, the most basic ritual of parting, is *Good-bye – On the Mersey* (Pl. 437) by James Tissot, the artist's last exhibit at the Royal Academy before he returned to France after the death from tuberculosis of his mistress and favourite model, Kathleen Newton, in November 1882. She stands, waving farewell with a handkerchief, on the vessel in the foreground – probably a ferry crossing the Mersey from Liverpool to Birkenhead. The large ship beyond is setting out on a transatlantic voyage to the United States or Canada. Its rails are lined with passengers also waving vigorously, although they can no longer distinguish to whom they are waving. The figures on the ferry in the foreground of the painting are all well dressed, and range in years from youth to old age.

Tissot also painted a series of works based on the parable of the Prodigal Son,

435
Richard Redgrave
The Emigrant's Last Sight of Home
1858
oil on canvas, 69·5 × 98·4cm
(27 × 38¾in)
Tate Gallery, London

436
Robert Braithwaite Martineau
The Last Day in the Old Home
1862
oil on canvas, 107.3 × 144.8cm
(42¼ × 57in)
Tate Gallery, London

437
James Tissot
Good-bye – On the Mersey
1881
oil on canvas, 83 × 52·9cm
(33 × 21in)
Forbes Magazine Collection, New York

437

438
Hubert von Herkomer
**Pressing to the West: A
Scene in Castle Garden,
New York**
1884
oil on canvas, 143 × 215cm
(56¼ × 86in)
Museum der Bildenden Künste,
Leipzig

which with its theme of exile and redemption has obvious parallels with that of departure and emigration. The Prodigal's home-coming also formed the subject of Charles Dickens's novel *Great Expectations* (1860–1), which tells the story of the unauthorized return of the convict Magwitch from Australia. The Prodigal Son squandering his inheritance was the theme of *The Last Day in the Old Home* (Pl. 436) by the Pre-Raphaelite associate and pupil of Holman Hunt, Robert Braithwaite Martineau, although its mood seems to be closer to that of the last act of Chekhov's *The Cherry Orchard*, for only the aged servant and reproachful wife seem distressed at the sale and break-up of the old home. Surrounded by pictures of horses, the dissipated owner and his young son drink champagne, oblivious of the lot numbers and catalogue on the floor which indicate an imminent auction by Christie's.

438

Tissot's elegant travellers and Martineau's dissipated aristocrats move in a very different world from those portrayed in *Pressing to the West: A Scene in Castle Garden, New York* (Pl. 438) by Hubert von Herkomer. Famine due to the failure of the potato crop in the lower Rhine area had occurred in Germany in the 1840s, during the same years as the Irish famine, and led to extensive German emigration to the United States. As a small boy aged two, Herkomer had endured the horrors of a steerage crossing from Germany to New York, a voyage which took six weeks to complete, and from which few families emerged unscathed by death.

Thirty years later, in 1883, Herkomer revisited New York while on a successful American lecture tour. He returned to the former concert hall at Castle Gardens which he remembered from childhood, when it served as a holding camp for 5,000

immigrants. There, where the Swedish singer Jenny Lind had made her American début, 8 million people were processed into America between 1855 and 1892. The experience revived painful memories of his childhood and he began to paint *Pressing to the West*. Writing of the picture he recalled vividly how 'the extraordinary medley of nationalities interested me; but the subject touched me in another way that was more personal – here I saw the emigrant's life and hardships – conditions in which my parents found themselves when they left the Fatherland for this Land of Promise.' But Herkomer's depiction of the squalor of the holding unit where emigrants waited to be dispersed, either by boat up the Hudson or by railroad to the West, was too much for Ruskin's sensibility. He wrote: 'Some artists are apt to become satirists and reformers instead of painters; to use the indignant passion of their freedom no less vainly than if they had sold themselves into slavery. Thus Mr. Herkomer, whose true function is to show us the dancing of Tyrolean peasants to the fife and zither, spends his best strength in painting a heap of promiscuous emigrants in the agonies of starvation.'

If the Irish famine of the 1840s marked the worst economic and social problems of the era, the outbreak of the Crimean War in 1853 saw the beginning of the worst martial adventure of Queen Victoria's reign, a campaign marred by the snobbery, blunders and stupidity of the officers and distinguished by the incredible courage of the men.

Back home in England the public were desperate for news of the war, and the beginnings of what we would call media coverage began to emerge with the appointment, by the art dealer Agnews, of the first war photographer, Roger Fenton, who worked closely with William Howard Russell, the *Times* correspondent. His records of the battlefield vied with the work of the watercolour painter William Simpson (1823–99), sent to the Crimea by another dealer, Colnaghi and Son, to prepare lithographs of the campaign, while the artist Edward Alfred Goodall (1819–1908) covered the war for the *Illustrated London News*.

Simpson's works are often dismissed as being visual records of historic but not artistic merit, but at his best he captured with great flair the appalling conditions which made troop movement so arduous, as in *Commissariat in Difficulties* (Pl. 439), showing the problems of moving convoys of troops in the deep mud of Sebastopol. Just as there was a great desire for detailed news and information from the British forces at the front, so the troops in the Crimea longed for news of home. *The Welcome Arrival* (Pl. 440), by John Dalbiac Luard (1830–60), gives a detailed picture

439
William Simpson
Commissariat in Difficulties
c.1855
watercolour, 14·9 × 27·3cm
(10⅞ × 16⅞in)
Victoria and Albert Museum,
London

440
John Dalbiac Luard
The Welcome Arrival
1857
oil on canvas, 76 × 100cm
(27⅞ × 39⅝in)
National Army Museum,
London

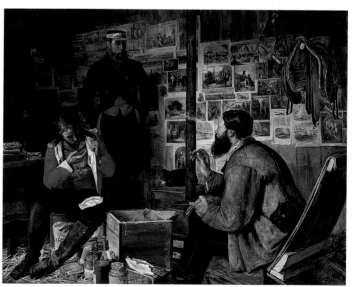

439 *440*

441
Jerry Barrett
**The Mission of Mercy:
Florence Nightingale
Receiving the Wounded
at Scutari**
1858
oil on canvas, 139·7 × 210·8cm
(55 × 83in)
National Portrait Gallery,
London

of three officers at Balaclava unpacking a gift hamper from England, in a hut whose walls are covered with illustrations cut from magazines. One officer scrutinizes a miniature or photograph of a loved one, while the two others, 'bearded like the pard' as was the current military fashion, puff contentedly at pipes, and the cat purrs on the stove. The painting was shown with great success at the Royal Academy in 1857. The cat 'Tom' died at Sebastopol on 31 December 1856, and his body was brought back to England, stuffed, and is now preserved in the National Army Museum next to the painting.

Information of the appalling conditions of the hospitals and the inefficiencies of the back-up forces, symbolized by a notorious shipment of only left-footed boots, filtered back to England via Russell's reports in *The Times*. The public watched with approbation when Queen Victoria and Prince Albert visited the Crimean wounded at Chatham Hospital in 1855. This event was painted by Jerry Barrett (1824–1906) and thousands of engravings after it were sold.

In 1858 Barrett painted an even more successful picture, *The Mission of Mercy: Florence Nightingale Receiving the Wounded at Scutari 1856* (Pl. 441). When Florence

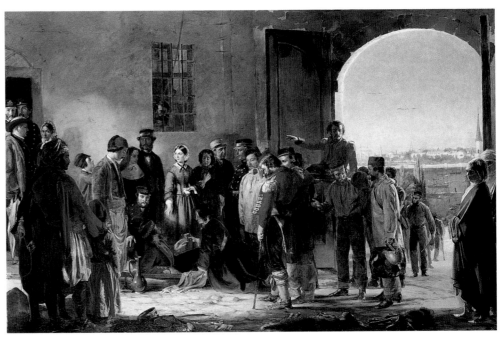

441

Nightingale arrived in 1854 she had discovered that the hospital was so unhygienic and badly administrated that it was killing wounded soldiers faster than enemy bullets! The military authorities were hidebound by bureaucracy and deliberately obstructed her reforms, but before she returned to England in July 1856 she had transformed the Barrack Hospital in Scutari, reformed nursing throughout the Crimea and laid the foundations for sweeping reforms in the army medical services which led to the beginning of modern nursing methods.

The most famous incident in the Crimean War, the Charge of the Light Brigade, was left to the Poet Laureate, Alfred Lord Tennyson, to commemorate in one of the most famous of Victorian poems. The greatest pictorial commemoration of the war, *The Roll Call* by Lady Butler (Pl. 388), was not to be painted until twenty years later.

Partings, not caused by emigration but by war, continued to provide popular pictorial themes. *Eastward Ho! August, 1857* (Pl. 442) by Henry Nelson O'Neil records the embarkation of relief troops to quell the Indian Mutiny. The Mutiny had begun in May 1857 when Hindu Indian troops, for whom the cow was a sacred

animal, were told that the bullets which they had to bite when using their guns were impregnated with beef fat. Fanned by extremists the Indian troops revolted, and the summer and autumn saw desperate fighting and the capture by the mutinous forces of Delhi, Cawnpore and Lucknow. In August 1857 troops were sent in large numbers from Britain to reinforce those units struggling to suppress the mutinying Bengal army and relieve the three cities. Tales of massacres, rapes and reprisals abounded in the British press, and the public responded with immense patriotic fervour to O'Neil's painting in the Academy that year, which enjoyed a success rivalled only by Frith's *Derby Day*. Two other paintings with themes dealing with the mutiny were also exhibited. Abraham Solomon's *The Flight from Lucknow* (Pl. 443) shows the evacuation from Lucknow which took place between 14 and 18 November 1857. An

442
Henry Nelson O'Neil
Eastward Ho! August, 1857
1858
oil on canvas, 135.7 × 107.8cm
(53¼ × 42½in)
Private collection

443
Abraham Solomon
The Flight from Lucknow
1858
oil on canvas, 61 × 45.7cm
(24 × 18in)
Leicester Museum and Art
Gallery

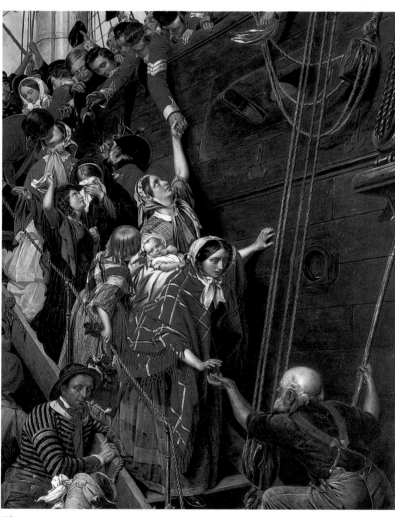

442

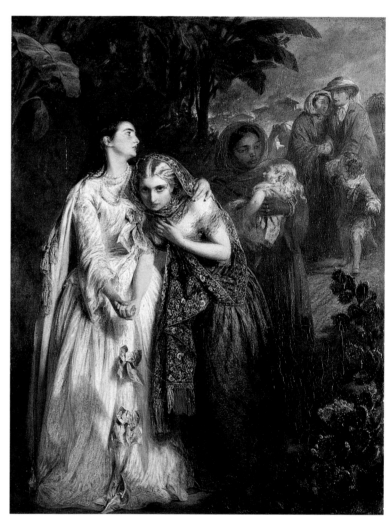

443

English memsahib protects her terrified companion, followed by an Indian ayah carrying a baby. Visual reportage, however, could not be too explicit. Frederick Goodall initially conceived *Jessie's Dream: The Campbells are Coming: Lucknow, September, 1857* (Pl. 444) as a scene of impending rape and massacre, but after adverse press criticism modified it to a much tamer portrayal of rescue and deliverance.

The following year, after the mutiny had been subdued with great loss of life, O'Neil followed up the success of *Eastward Ho!* with a pendant, *Home Again* (1858), also exhibited at the Royal Academy. It showed the reunion of soldiers wounded in the campaign with their families – one soldier triumphantly waving a medal to his father who is a Chelsea pensioner, a veteran of earlier campaigns.

444
Frederick Goodall
**Jessie's Dream: The
Campbells are Coming,
Lucknow, September, 1857**
1858
oil on canvas, 80.4 × 121.9cm
(31¾ × 48in)
Sheffield Museum and Mappin
Art Gallery

445
Hubert von Herkomer
The Last Muster
1875
oil on canvas, 208 × 154.8cm
(82 × 61in)
Lady Lever Art Gallery,
Port Sunlight, Liverpool

The bright scarlet coats worn by the Chelsea pensioners feature in one of the most moving paintings of the aftermath of war, Herkomer's *The Last Muster* (Pl. 445), which shows a service in the chapel of Chelsea Hospital. As the critic in the *Illustrated London News* put it: 'One ... figure sitting on a bench in the immediate foreground ... strikes the keynote of the pathetic composition. His head is drooping, his eyes are closed, he does not respond to the friendly challenge of the grip at his wrist of the old companion-in-arms at his side – it is verily the "last muster" for him.' The subject had first been conceived as a woodblock in the *Graphic* in 1871, and met with widespread admiration when Herkomer turned it into an oil painting. Its theme went to the heart of the Victorian preoccupation with death and parting, whether when young, as an emigrant, in the heat of battle or in old age. To use any of these themes the Victorian painter had to be prepared to believe, as Herkomer claimed to have learnt in England, 'that truth in art must be enhanced by sentiment'.

An earlier work which demonstrates the truth of this observation was *Home from Sea* (Pl. 446) by Arthur Hughes. During the last years of his long life, Hughes, a modest and retiring man, became used to the role of 'benevolent survivor from the past',

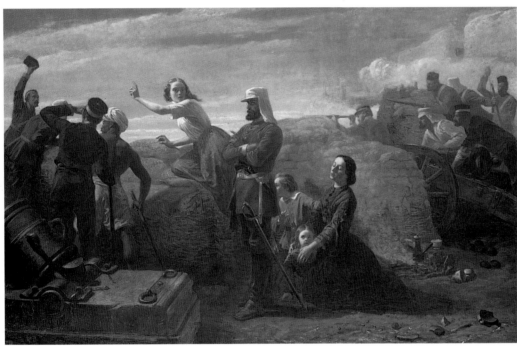

444

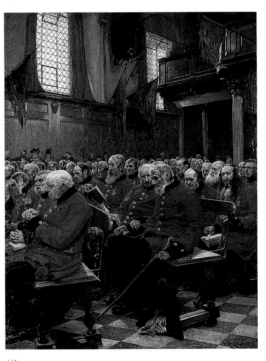

445

sought out, as he himself put it, 'because we happen to know some great ones gone' in Pre-Raphaelite circles. In 1910 he was delighted to find his early painting hung in a new display devoted to the Pre-Raphaelites at the Ashmolean Museum in Oxford, as he had not seen it for many years. A few years earlier Hughes had written to an enquirer describing his work on the painting:

> Well about that sailor boy picture; I called it though 'Home from Sea' and it rep-
> resented a young sailor lad in his white shore going suit, cast down upon his face
> upon the newly turfed grave where his mother had been put in his absence – his
> sister in black kneeling beside him: his handkerchief bundle beside – sunshine
> dappling all with leafy shadows old Church behind with yew tree painted at
> Old Chingford Church, Essex. At the time I painted it my wife was young
> enough to sit for the sister, and I think it was like.

It remains the most poignant of all Victorian paintings dealing with the subject of parting from a loved one.

446
Arthur Hughes
Home from Sea
1856–62
oil on canvas, 50.8 × 65.1cm
(20 × 25⅝in)
Ashmolean Museum, Oxford

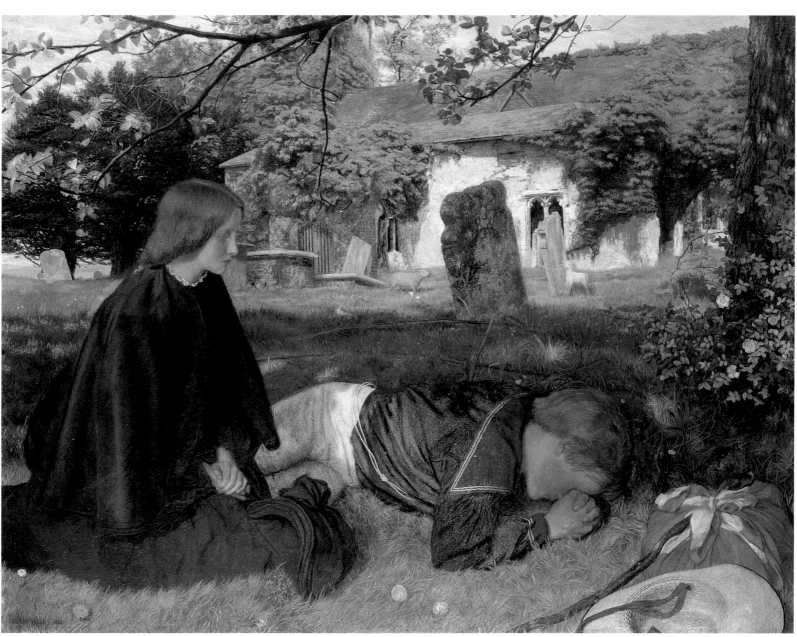

446

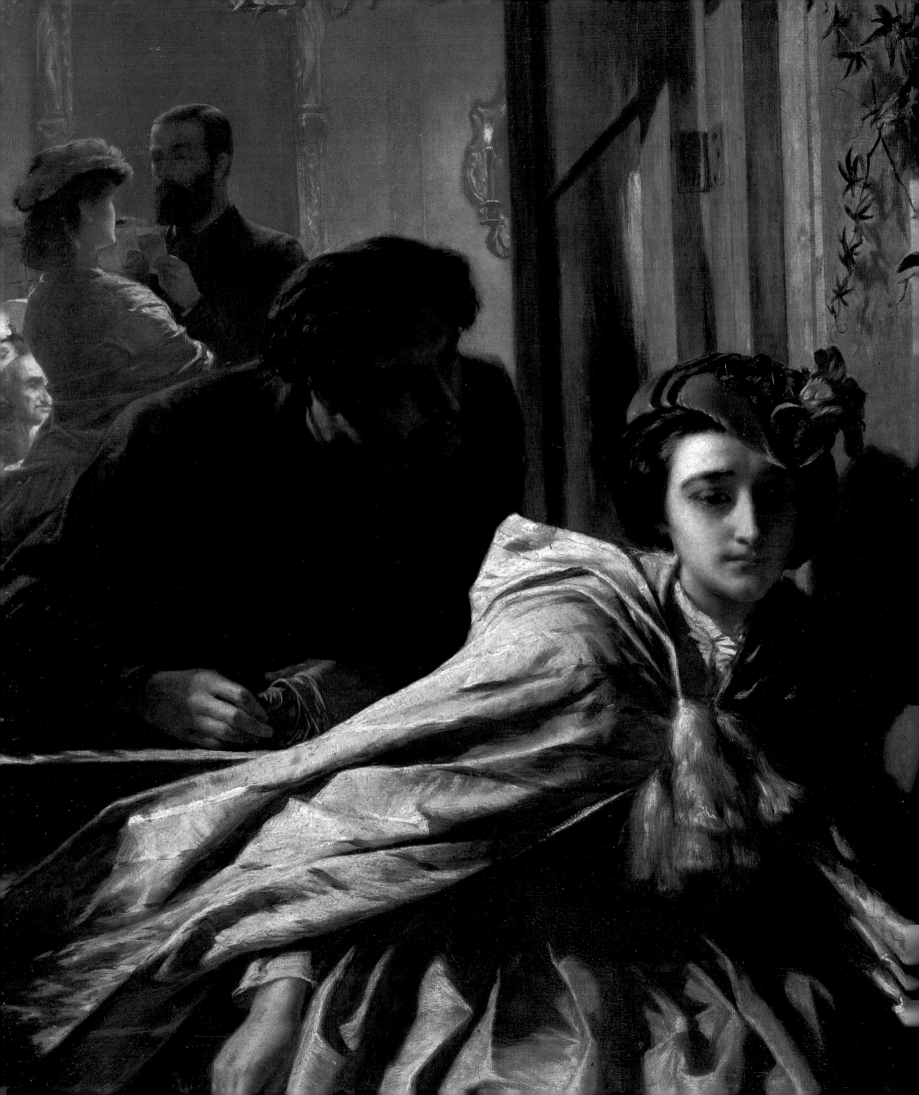

A moving drawing by Elizabeth Siddal, *Pippa Passing Close to Loose Women* (Pl. 448), illustrates the poetic drama *Pippa Passes* (1841) by Robert Browning. The conduct of all the characters in the play is affected by Pippa's innocent voice singing as she walks through the countryside on her one day's annual holiday from the drudgery of the silk mills at Asolo. In the drawing, her innocence is contrasted with the foul-mouthed worldliness of the loose women, a daring choice of subject for a woman to tackle in the mid-Victorian era. The drawing thus illustrates vividly a theme upon which scholars in recent years have written at length, the central polarity of virgin/whore, Madonna/Magdalen in Victorian depictions of women. This polarity, it is claimed, lies behind not only so many Pre-Raphaelite visual representations of the medieval past, but also such key 'modern life' works as *Past and Present,* three paintings by Augustus

447 Alfred Elmore, **On the Brink** (detail of Pl. 460)

448
Elizabeth Siddal
**Pippa Passing Close
to Loose Women**
1841
pen and brown ink,
23.4 × 29.8cm (9¼ × 11¾in)
Ashmolean Museum, Oxford

449
Charles Robert Leslie
**Queen Victoria in her
Coronation Robes**
1838–9
oil on canvas, 45.7 × 60.9cm
(18 × 24in)
Victoria and Albert Museum,
London

Egg which chart the dire consequences to a family whose mother breaks her marriage vows by committing adultery (see p.374).

Yet to concentrate on such issues, although enthralling, illuminates only some aspects of women's lives in the nineteenth century. A fascinating dichotomy arises. Women are often seen as ministering angels, as portrayed for example in Rebecca Solomon's *The Wounded Dove* (Pl. 377), or as ethereal visions like the great dancer Taglioni as *La Sylphide* gently replacing a bird's nest in a tree (Pl. 231). But women are also seen as powerful figures of authority, the paragons of domesticity outlined by Mrs Isabella Beeton in *Beeton's Book of Household Management* (1859–61), who are described as holding 'the reins with a tight, firm hand, never parting with, but seldom using, the whip'.

The presence of a queen upon the throne of one of the world's most powerful countries invested the already complex status of women with symbolic interest of a remarkable nature. Victoria came to epitomize, in one person at one and the same time, Empress and Faery Queen, the Grandmother of Europe. She also became the royal embodiment of the ideal Victorian woman described in memorable terms by Mrs Beeton:

448

449

> As with the commander of an army, or the leader of any enterprise, so it is with the mistress of a house. Her spirit will be seen through the whole establishment; and just in proportion as she performs her duties intelligently and thoroughly, so will her domestics follow in her path … on a knowledge of household duties … perpetually depend the happiness, comfort and well being of a family. In this opinion we are borne out by the author of *The Vicar of Wakefield*, who says, 'The modest virgin, the prudent wife, and the careful matron, are much more serviceable in life than petticoated philosophers, blustering heroines or virago queens.'

Such stereotypes posed problems for Victorian women. How could a young woman choose between the roles available? Such choices lie at the heart of the contrasting dilemmas faced by George Eliot's heroine Maggie in *The Mill on the Floss* (1960) and Dora in Dickens's *David Copperfield* (1849–50). How could the balance be found between self-fulfilment and being a submissive paragon, 'a happy angel who scarcely bends the petals of celestial flowers with the tips of her pink toes'? No wonder some cracked under the strain of all the conflicting advice for girls and women, who were often dubbed 'the frailer sex' after Hamlet's pronouncement: 'Frailty, thy name

is woman!' Victorian art abounds with idealized visions of women of varying degrees of frailty, notably Millais's *Ophelia* (Pl. 293) and Waterhouse's *Lady of Shalott* (Pl. 575).

Most fragile of all, however, was the youthful figure of the Queen herself when called to take up the arduous duties of the Crown. C.R. Leslie portrayed her in her coronation robes at the moment when she divested herself of her Crown, Orb, Sceptre and other regalia to take the sacrament from the Archbishop of Canterbury during her coronation service (Pl. 449). Leslie has caught the moment when some rays of sunlight suddenly pierced the dark of Westminster Abbey to illuminate her figure with dramatic effect, which reduced some members of the congregation to tears. The work illustrated is a study for a much larger painting of the event in the Royal Collection.

450
Frederick Smallfield
Early Lovers
1858
oil on canvas, 76.4 × 46.1cm
(30⅛ × 18⅛in)
Manchester City Art Gallery

451
William Mulready
The Sonnet
1839
oil on wood, 35 × 30.5cm
(14 × 12in)
Victoria and Albert Museum,
London

450

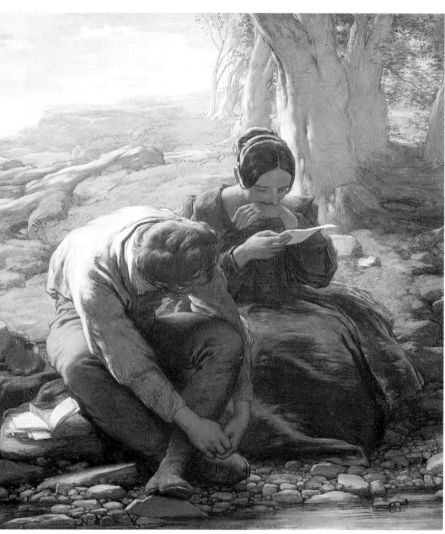

451

The marriage of the young Queen in 1841, and the steady annual growth of her young family, led to an ever-increasing emphasis on the portrayal of women's lives as patterns of domesticity. They were shown to progress from the joys and sorrows of first love and rites of courtship to the ideal state of matrimony and life as happy wives, responsible mothers and finally grandmothers.

This cycle was often portrayed, beginning with the charms of first love and pains of flirtation. Courtship was surely never more touchingly portrayed than in William Mulready's *The Sonnet* (Pl. 451), while Frederick Smallfield (1829–1915) in *Early Lovers* (Pl. 450) and Arthur Hughes in *April Love* (Pl. 308) and *The Long Engagement* (Pl. 309) convey the pleasures and pains of love with Pre-Raphaelite intensity. The

452
Philip Hermogenes Calderon
Broken Vows
1856
oil on canvas, 91.4 × 67.9cm
(36 × 26⅞in)
Tate Gallery, London

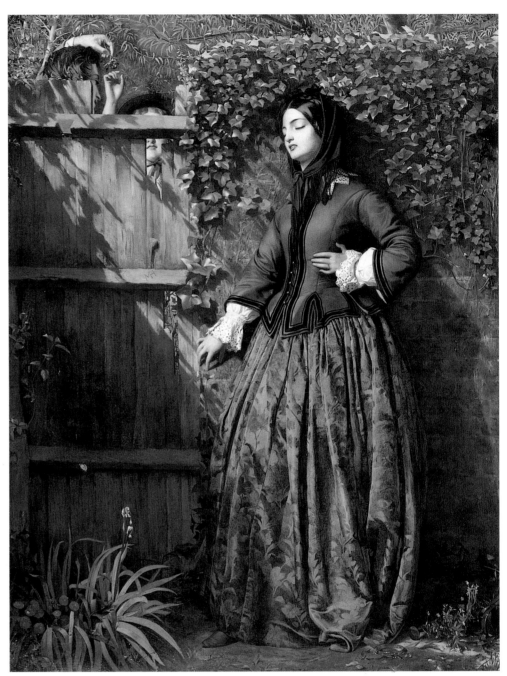

452

often-quoted adage that 'the course of true love never did run smooth' also formed the popular pictorial theme of *Broken Vows* (Pl. 452) by Philip Hermogenes Calderon (1833–98), in which we see an unfortunate young woman overhearing her faithless lover flirting outrageously with another girl on the other side of an ivy-covered fence.

The celebration of matrimony was also a popular visual theme. It could take many forms, ranging, as do wedding speeches, from the jocose to the inspirational. The exchange of vows itself was perhaps most successfully portrayed in Frith's large painting of *The Marriage of the Prince of Wales, 10th March 1863* (Pl. 455). The marriage of Edward, Prince of Wales, and Princess Alexandra (Alix) of Denmark took place in Saint George's Chapel, Windsor, to give the recently widowed Queen Victoria the maximum possible privacy and shield her from the public gaze. The work was commissioned from Frith for £3,000 by Queen Victoria, who had long admired his skill as a crowd painter and owned his *Ramsgate Sands*, and may have recalled the Prince

Consort's admiration of Frith's powers. During the service a musical composition by Prince Albert, entitled *Albert's Chorale*, was performed, and all eyes turned to the balcony where the Queen was sitting dressed in deep mourning, despite the festive occasion.

We are reminded of yet another Royal Wedding in George Elgar Hicks's *Changing Homes* (Pl. 456), which shows a wedding party on their return from church, in the drawing room of a fashionable house. The wedding dress worn by the bride resembles that worn by Princess Alice when she married Prince Louis of Hesse at Osborne House in 1862, which was portrayed in the *Illustrated London News*. Wedding parties are always good for amusing situations; in Hicks's painting one of the ostentatious vases on the table to the right, upon which are arrayed wedding presents, is about to be smashed by a small boy despite the intervention of the horrified bridesmaid. The painting was denounced by *The Times* in a scathing review: 'Mr Hicks is, in short, Mr Frith gone to wreck on the shoals of prettiness and sentimentality.'

Painters also delighted in recording much humbler weddings on canvas. No review of Victorian wedding paintings should omit *The Wedding Morning* (Pl. 457) by John H.F. Bacon (1868–1914), in which in a country cottage a grandmother helps to adjust the bride's wedding dress. Stanhope Forbes's *The Health of the Bride* (Pl. 458) is set at a reception in the village inn at Newlyn, in which a sailor proposes the toast to the happy couple. A year after completing the painting the artist himself married the brilliant Canadian painter Elizabeth Armstrong (see Pl. 424).

After the wedding ceremony the inexorable process began that led from 'prudent wife to careful matron'. There were many attempts to capture the joys of matrimony on canvas, ranging from Arthur Boyd Houghton's charming paintings of family life (Pl. 220) to such works as Charles West Cope's *The Young Mother* (Pl. 453). Although today viewed as over-sentimental, Cope's painting, when first exhibited, held a much deeper contemporary significance. It emerges as far more than a conventional essay on the theme of maternity when viewed against the mid-nineteenth-century background of the alarming incidence of death in childbirth through the ravages of puerperal fever. In the same way *An Anxious Hour* (Pl. 454) by Mrs Alexander

453
Charles West Cope
The Young Mother
1845
oil on wood, 30.4 × 25.4cm
(12 × 10in)
Victoria and Albert Museum,
London

454
Mrs Alexander Farmer
An Anxious Hour
1865
oil on wood, 30.2 × 40.7cm
(11¾ × 16in)
Victoria and Albert Museum,
London

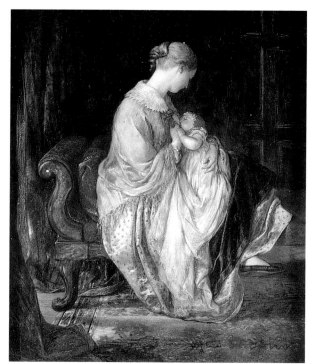

453

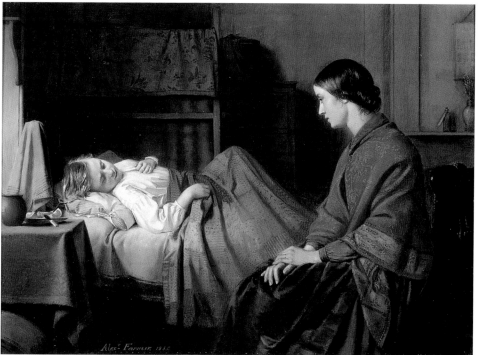

454

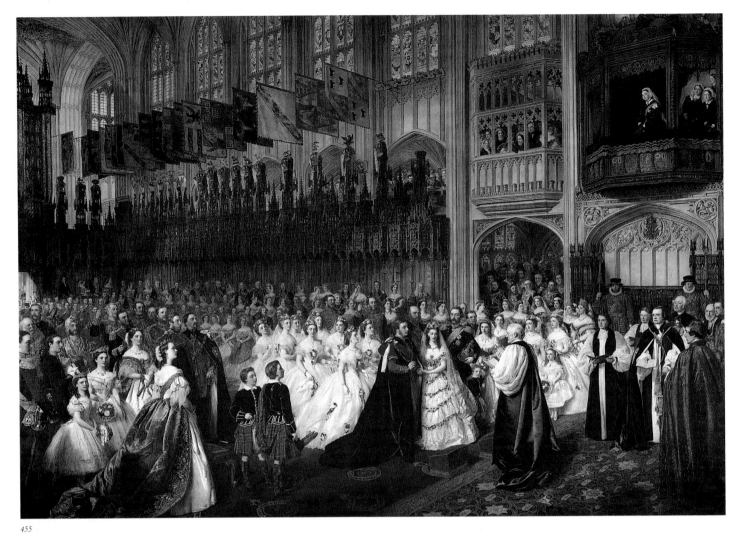

455

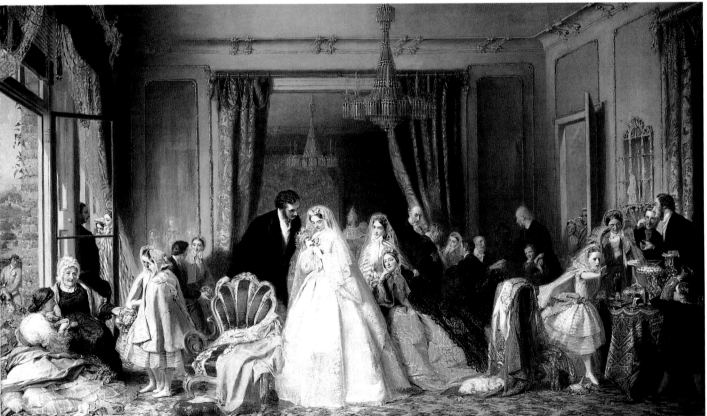

456

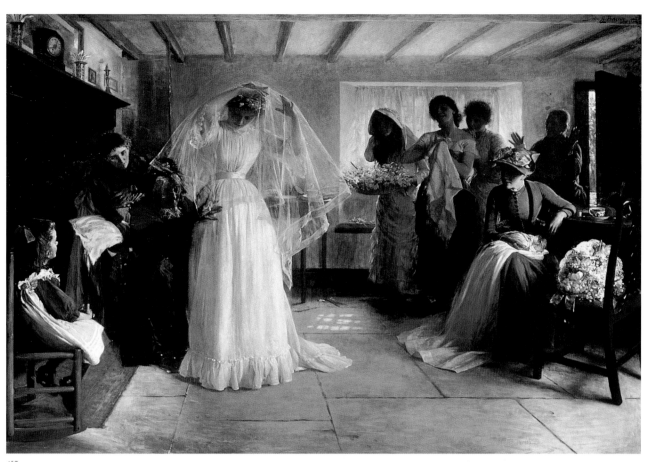

455
William Powell Frith
**The Marriage of the Prince
of Wales, 10th March 1863**
1863–5
oil on canvas, 217.8 × 306.4cm
(85¾ × 120⅝in)
Royal Collection

456
George Elgar Hicks
Changing Homes
1862
oil on canvas, 151 × 165cm
(59½ × 65in)
Geffrye Museum, London

457
John H.F. Bacon
The Wedding Morning
1892
oil on canvas, 116.7 × 162.4cm
(46 × 64in)
Lady Lever Art Gallery,
Port Sunlight, Liverpool

458
Stanhope Forbes
The Health of the Bride
1889
oil on canvas, 152 × 199.8cm
(60 × 78⅝in)
Tate Gallery, London

457

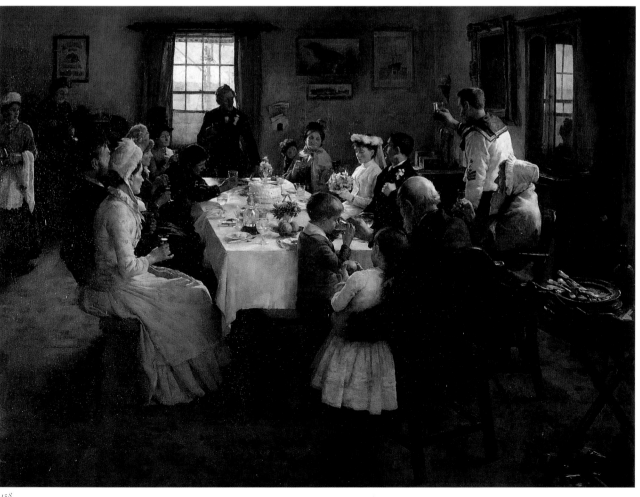

458

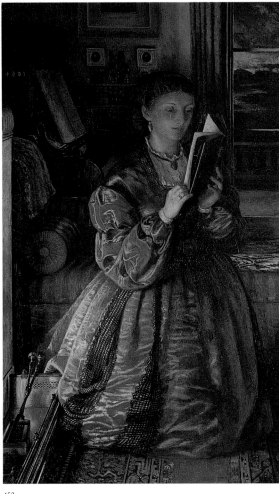

459

Farmer (*fl.*1855–1867) assumes deeper meaning when the distressing figures of infant mortality through typhoid are remembered.

To the Victorian mind the institution of the family was sacred, and no tragedy, even the loss of a child, was more terrible than a fall from moral rectitude in ways that jeopardized the sanctity of the home. The dilemma of the 'fallen woman' exercised immense sway over the minds of mid-Victorian artists and novelists. Their work confirms the fears of those sensitive to sexism that most male attitudes of the Victorian era were deeply chauvinist.

In Robert Braithwaite Martineau's painting *The Last Chapter* (Pl. 459), a woman reads late at night in a comfortable middle-class interior. There is a piano and the walls are densely hung with paintings. Unable to see by the light through the moonlit window, she kneels and holds up the novel to read in the light given by the fire's glowing embers. The painting is a comment on the contemporary popular craze for 'sensation novels', lurid stories frequently involving guilty secrets. Classics of the genre include Wilkie Collins's thrilling detective story *The Woman in White* (1860), Mary Elizabeth Braddon's *Lady Audley's Secret* (1862) and Mrs Henry Wood's *East Lynne* (1861), which in spite of a pedestrian style became *the* classic sensation novel. It attained even more fame in many stage melodrama versions (including the 1874 version by T.A. Palmer which introduced the infamous line, 'Dead, dead! … And never called me mother!'). The story tells the tragic tale of a woman who after her marriage breaks down is cast out by her unforgiving husband. She returns several years later, heavily disguised as a nurse and unrecognized by her husband, to look after her dying daughter.

The themes of such Victorian literary tearjerkers now strike us as bathetic. We find it difficult to credit the extent to which double standards then flourished, although they had an agonizing reality for their contemporary women readers. As Caroline Norton, an early feminist (and victim of a broken marriage), put it, 'the faults of women are visited as sins, the sins of men are not even visited as faults.' Similar attitudes are present in such contemporary works as *Past and Present* (Pls. 462, 463, 464), by Augustus Egg (1816–63), first exhibited in 1858 with no title, but with the inscription: 'August the 4th – Have just heard that B – has been dead more than a fortnight, so his poor children have now lost both parents. I hear she was last seen on Friday last near the Strand, evidently with no place to lay her head. What a fall hers has been!'

The central theme of the triptych is the discovery of infidelity and its consequences. In Egg's first painting of the series, the wife lies prostrate before her heartstricken partner, who holds a letter, the evidence of her treachery, in his hand. Their two children look up from their amusement of building card castles at the sound of her fall. Their card castle has a French novel (by Balzac, who specialized in the theme of adultery) for its foundation – a Hogarthian indication of the source of their mother's corruption. This mode of painting a moral is carried still further by 'a goodly apple rotten at the heart'. The apple has been cut in two, and half has fallen to the floor, a reference to the pictures on the wall of 'Adam and Eve driven out of Paradise' and a shipwreck entitled 'The Abandoned'. The symbolism can be pursued even further – the miniature portrait of the lover which is ground under the husband's foot near the wife's outstretched arms, which are braceleted in a way to make them appear shackled, and the mirror reflecting the open door through which the erring wife will soon go, never to return.

The second painting is set in a moonlit garret five years later. The few decorations include two portraits of the mother and father, the latter of whom has just died according to the information of the caption. The two forsaken girls cling to

each other for comfort, the elder gazing sadly out over the roof tops at the moon.

In the third picture the moon is again the sole source of illumination, and its position makes it plain that it is exactly the same time as its predecessor. It illuminates the arches under the Adelphi, a notorious refuge for down-and-outs in Victorian London. We see the crouching figure of the outcast mother, with a baby in her arms, clearly the result of her illicit affair, which is now a thing of the past. On the walls are posters, two advertising the plays *Victims* and *The Cure for Love*, and another for pleasure excursions to Paris. When exhibited the three paintings caused much adverse comment on their theme, and remained unsold at the time of the painter's death.

> Looking at these scenes we vividly recall the cry of the heroine of *East Lynne*:
> Oh reader, believe me! Lady! – wife – mother! Should you ever be tempted to
> abandon your home, so will you awake. Whatever trials may be the lot of your
> married life, though they may magnify themselves to your crushed spirit as
> beyond the endurance of woman to bear, *resolve* to bear them; fall down on your
> knees and pray to be enabled to bear them: pray for patience; pray for strength to
> resist the demon that would urge you to escape; bear unto death, rather than for-
> feit your fair name and your good conscience; for be assured that the alternative,
> if you wish to rush on to it, will be found far worse than death.

Augustus Egg was, it is no surprise to know, a great friend of Charles Dickens, and acted with him in the amateur theatrical performances which so obsessed Dickens during the 1850s and 1860s. Theatricality is indeed a quality which lurks just beneath the surface of many paintings of this period, known as 'problem pictures', which choose as their subject moments of human drama, frozen at a climactic point as in a Japanese kabuki play.

The dramatic painting *On the Brink* (Pl. 460) by Alfred Elmore (1815–81), for example, vividly contrasts the gaiety and the excitement of the casino at Bad Homburg with the despair of the woman on the darkened terrace, who has lost her money and is hesitating between death and dishonour, 'a fate worse than death'. The lilies and passion flowers which grow on the wall beside her provide a parallel to her dilemma – will she lose her fortune, her virtue, or both?

In 1863, five years after the exhibition of Egg's *Past and Present*, George Elgar Hicks also exhibited a triptych, entitled *Woman's Mission*, representing women in three phases of her duties as 'ministering angel', described respectively as *Guide of*

460
Alfred Elmore
On the Brink
1865
oil on canvas, 113.7 × 82.7cm
(48¾ × 32⅝in)
Fitzwilliam Museum,
Cambridge

461
George Elgar Hicks
**Woman's Mission:
Companion of Manhood**
1863
oil on canvas, 76.2 × 64.1cm
(30 × 25¼in)
Tate Gallery, London

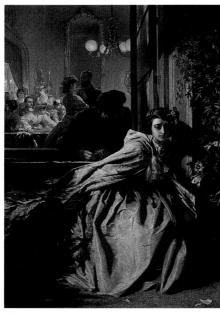

460

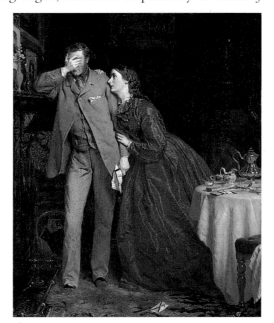

461

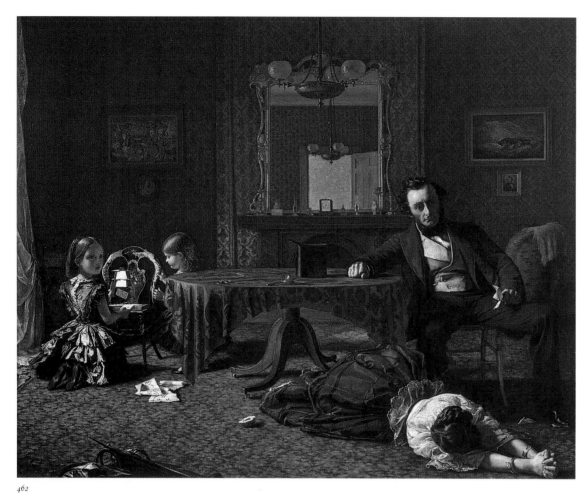

462

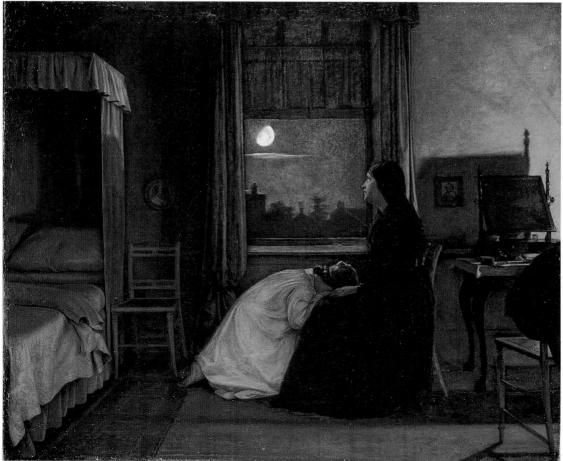

463

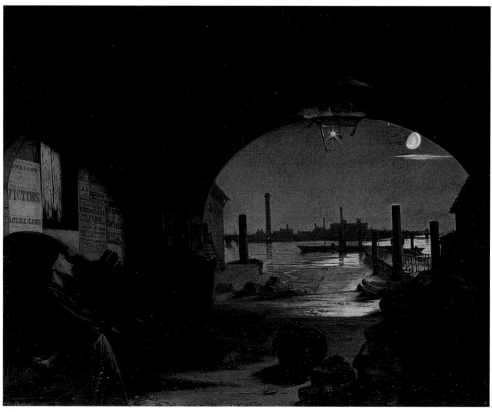

462
Augustus Egg
Past and Present No. 1
1858
oil on canvas, 63·5 × 76·2cm
(20 × 30in)
Tate Gallery, London

463
Augustus Egg
Past and Present No. 2
1858
oil on canvas, 63·5 × 76·2cm
(20 × 30in)
Tate Gallery, London

464
Augustus Egg
Past and Present No. 3
1858
oil on canvas, 63·5 × 76·2cm
(20 × 30in)
Tate Gallery, London

464

Childhood, *Companion of Manhood* and *Comfort of Old Age*. Only the central *Companion of Manhood* has survived (Pl. 461). It echoes the prevailing view of women's purity and submissiveness poeticized by Coventry Patmore in his highly popular poem 'The Angel in the House' (1854–63). It also anticipates by two years John Ruskin's essay 'Of Queens' Gardens' in his book *Sesame and Lilies* (1865), in which he pontificates upon relationships between men and women. With disturbing and painful predictability he recommends that the education of girls should lead to 'true wifely subjection' on the part of 'her who was made to be the helpmate of man'. The passage continues:

> The man's power is active, progressive, defensive. He is eminently the doer, the creator, the discoverer, the defender. His intellect is for speculation and invention; his war is just, whatever conquest necessary. But the woman's power is for rule not battle – and her intellect is not for invention or creation, but for sweet ordering, arrangement and decision … Her function is praise. By her office and place she is protected from all danger and temptation … This is the true nature of home – it is the place of Peace, the shelter, not only from all injury, but from all terror, doubt and division … And whenever a true wife comes, the home is always round her.
>
> She must be enduringly, incorruptibly good; instinctively, infallibly wise – wise not only for self-development, but for self-renunciation: … a woman ought to know the same language, or science, only so far as may enable her to sympathize in her husband's pleasures, and in those of his best friends.
>
> The path of a good woman is indeed strewn with flowers; but they rise behind her steps, not before them …

In dramatic contrast to this clear perception of the 'path of a good woman', women were often shown by painters as the victims of rejected love or as outcasts caught up as wage slaves in order to support themselves. The worst sweated labour was to be found in the textile industry, activities denounced by Thomas Hood in

465
Richard Redgrave
The Sempstress
1846 (original version lost)
oil on canvas, 63.5 × 76.2cm
(25 × 30in)
Forbes Magazine Collection,
New York

466
Richard Redgrave
**The Governess: She Sees no
Kind Domestic Visage Near**
1844
oil on canvas, 71.1 × 91.5cm
(28 × 36in)
Victoria and Albert Museum,
London

467
Richard Redgrave
Going into Service
1843
oil on canvas, 78.7 × 100.3cm
(31 × 39½in)
Private collection

'The Song of the Shirt', first published in *Punch* in 1843. The poem inspired a spate of paintings of impoverished sempstresses, most notably Richard Redgrave's *The Sempstress* (Pl. 465), exhibited at the Royal Academy in 1844 with these lines from Thomas Hood's poem:

> Oh men with sisters dear,
> Oh men with mothers and wives,
> It is not linen you're wearing out
> But human creatures' lives.

In the painting we see that the hour on the clock is half past two in the morning, yet the sempstress, emaciated, hopeless and worn-out with red-rimmed eyes, is still plying her needle to finish an order. A fellow artist, Paul Falconer Poole, wrote to Redgrave concerning *The Sempstress*: 'Believe me, *I* think it is the most powerful for truth and touching picture I have ever seen. Who can help exclaiming "Poor soul! God help her"? If any circumstance could make me wage war against present social arrangements, and make us go down shirtless to our graves, it is the contemplation of this truthful and wonderful picture.'

Two of Redgrave's sisters were governesses, one of whom, Jane, 'pined over the duties of a governess away from home', caught typhoid fever and died before she was twenty. These experiences inspired him to paint several moving works on the theme of the loneliness and isolation of the teacher and the governess. The collector John Sheepshanks admired one of these works, *The Poor Teacher*, and commissioned another treatment of the same theme. On receiving it, however, Sheepshanks objected to the terrible loneliness of the forlorn governess in the empty room, and at his request Redgrave added the playing children seen through the open doorway. The painting was exhibited at the Royal Academy in 1845 with the title *The Governess: She Sees no Kind Domestic Visage Near* (Pl. 466), the sentiment of the subject being emphasized by the words of the music on the piano, 'Home, Sweet Home', the ballad popularized by Jenny Lind, 'the Swedish Nightingale'. The tears in the governess's eyes, the black-edged paper of the letter she holds, her full mourning dress and even the thin, dry bread on the plate, underline the pathos of her position, and contrast with the privileged happiness of the girls at play in the loggia beyond.

It is all too easy to cite this picture, and Redgrave's Royal Academy diploma work *The Outcast* (1851), which shows a young unmarried mother and her baby being thrown out into the snow by a stern Victorian *paterfamilias*, as expressions of the worst type of Victorian sentimentality. But Redgrave was far more than a mere sentimentalist. His work should be judged by the criteria of his own times, and it can then be seen as a sensitive man's reaction to dilemmas which confronted the alert social conscience of the period. *The Governess* takes its place as a social document alongside Charlotte Brontë's *Jane Eyre* and other works concerned with the role of women in a male-dominated society, by writers as diverse as Charles Dickens, John Stuart Mill and John Ruskin.

Early in life Redgrave had worked as a rent-collector, as L.S. Lowry would also do nearer our own time. It was a job Redgrave loathed but which left him with a compassionate heart. He wrote:

> It is one of my most gratifying feelings that many of my
> best efforts in art have aimed at calling attention to the tri-
> als and struggles of the poor and oppressed. In the *Reduced*

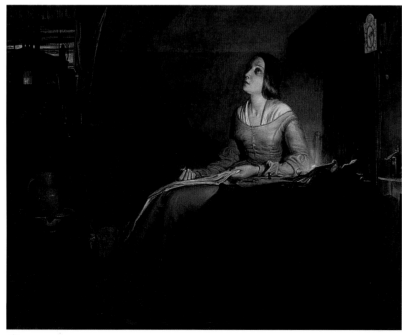

465

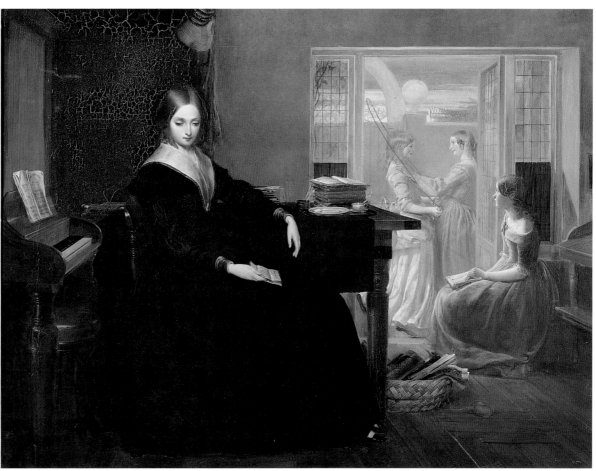

466

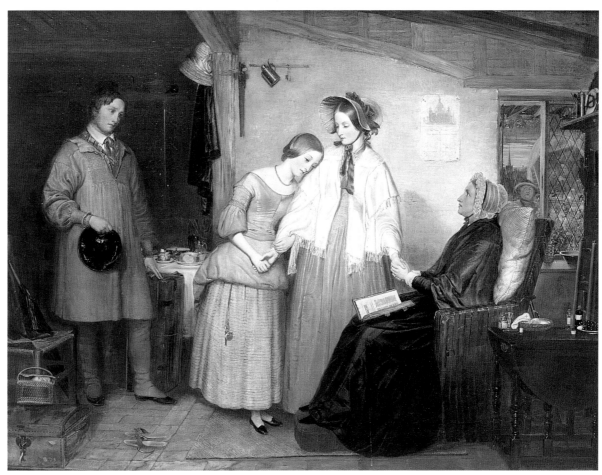

467

468
Gustave Doré
**'Glad to death's mystery,
swift to be hurt /
Anywhere out of the world!'**
1871
Indian ink heightened
with white, 24.7 × 18.3cm
(9¾ × 7¼in)
Victoria and Albert Museum,
London

469
Thomas Graham
Alone in London
*c.*1904
oil on canvas, 56.1 × 92.7cm
(22 × 36½in)
Perth Museum and Art Gallery

470
George Frederic Watts
Found Drowned
*c.*1849–50
oil on canvas, 144.7 × 213.4cm
(57 × 84in)
Watts Gallery, Compton,
Surrey

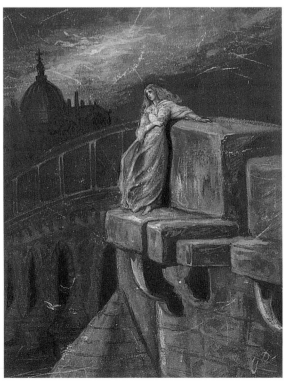

468

Gentleman's Daughter, The Poor Teacher, The Sempstress, Fashion's Slaves and other works, I have had in view the helping them to right that suffer wrong at the hands of their fellow men. If it has been done feebly it has at least been done from the heart …

In Redgrave's painting *Going into Service* (Pl. 467), a country lass leaves home to go into service in the city in order to support her invalid mother, who sits with an open Bible on her knees. Labels on the luggage show the girl's destination to be 'Ladies Fashions' in the West End of London, and the sewing accessories at her waist suggest she may become a sempstress and potential victim of city life. Outside the window a cartload of young women also appear to be bound for London, where without good prospects they all may end up on the streets. The Hogarthian message is hammered home by a poster on the wall, imprinted *The True Ballad of Roguish London Town* and depicting St Paul's Cathedral. This landmark was often used to symbolize the wicked city in portrayals of prostitutes, such as Gustave Doré's *Glad to death's mystery, swift to be hurt /Anywhere out of the World* (Pl. 468), which shows a woman standing poised upon the parapet of London Bridge, about to commit suicide by throwing herself into the Thames, the traditional melodramatic end for the prostitute.

The river as the 'final solution' for a life of prostitution was a theme made familiar both by Charles Dickens in *Oliver Twist* in 1837, and pictorially by George Frederic Watts in the late 1840s in two works – *Under a Dry Arch*, showing women huddling for warmth under a bridge, and *Found Drowned* (Pl. 470), depicting a woman who has ended her life by drowning herself. The same theme was tackled by Abraham Solomon in the now lost painting *Drowned! Drowned!* (1860) in which a woman's body is drawn from the river by a bargeman, while a policeman turns the light of his bull's-eye lantern on her face. The face is recognized by her seducer who passes by on his way home from a *bal masque*. One of the last examples of this genre was provided by the Scottish painter Thomas Graham (1840–1906), whose *Alone in London* (Pl. 469) portrays a flower-seller gazing forlornly at the river from the new Thames Embankment as dawn breaks and the gas streetlights flicker.

Such themes and titles, and the serial device utilized by Egg and Hicks of a triptych to tell a story over the passage of several years, do much to explain the popularity of the 'novels in paint' of William Hogarth at this time. His pictorial series with such evocative titles as *The Rake's Progress*, *The Harlot's Progress* and *Marriage à la Mode*, and his use of details to heighten dramatic effect, were greatly to the taste not only of Redgrave but also of the emergent Pre-Raphaelite Brotherhood, whose admiration for Hogarth showed itself in their advocacy of modern moral subjects as themes for their work. This led in 1859 to the foundation of the short-lived and controversial Hogarth Club. During the year or two of its existence, it held one of the rare shows of the work of Rossetti, who disliked having his work exhibited.

Rossetti was, it may be inferred, especially interested in Hogarth's *The Harlot's Progress*. For several years, in both his painting and his poetry, the mistress or the prostitute became a frequently used theme. As early as 1846, when he was only 18, he had begun work on the poem 'Jenny', with its subject of a man musing while gazing at a prostitute, who has fallen asleep against his knees. The poem lingers in the mind for its sympathy for its subject:

> Lazy laughing languid Jenny,
> Fond of a kiss and fond of a guinea.

The original manuscript of this poem was one of the documents retrieved from the coffin of Elizabeth Siddal after her exhumation in October 1869. The pages, Rossetti wrote to Ford Madox Brown, were 'in a disappointing state … there is a great hole right through all the leaves of *Jenny* which was the thing I most wanted. A good deal

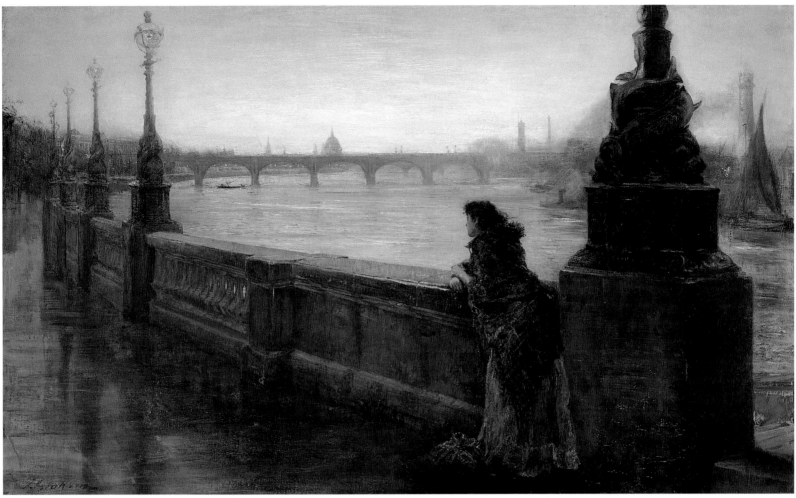

469

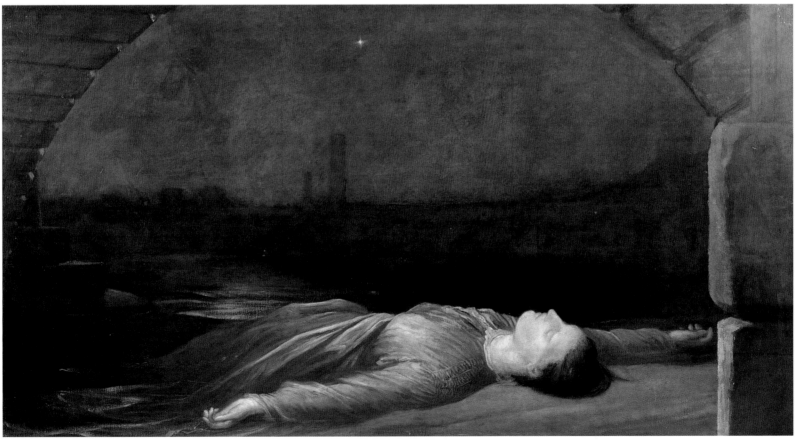

470

471
Dante Gabriel Rossetti
Found
1854–
oil on canvas, 91.4 × 80cm
(36 × 31½in)
Delaware Art Museum

472
Dante Gabriel Rossetti
The Gate of Memory
1857–64
coloured chalks on paper,
33.6 × 26.6cm (13¼ × 10½in)
Private collection

is lost; but I have no doubt the things as they are will enable me, with a little rewriting and a good memory and the rough copies I have, to re-establish the whole in a perfect state.' When published in 1870 it roused the indignation of Ruskin and the criticism of Robert Buchanan in 'The Fleshly School of Poetry' (see below, p. 445).

It may be conjectured that part of the reason why Rossetti was so keen to retrieve and complete his poem 'Jenny' arose from his inability to complete his painting on a similar theme begun in 1854, entitled *Found* (Pl. 471), which was described by Helen Rossetti Angeli (the artist's niece): 'a young drover from the country, while driving a calf to market, recognizes a fallen woman on the pavement, his former sweetheart. He tries to raise her from where she crouches on the ground, but with closed eyes she turns her face from him to the wall.'

Rossetti painted the calf bound in the cart at the home of the long-suffering

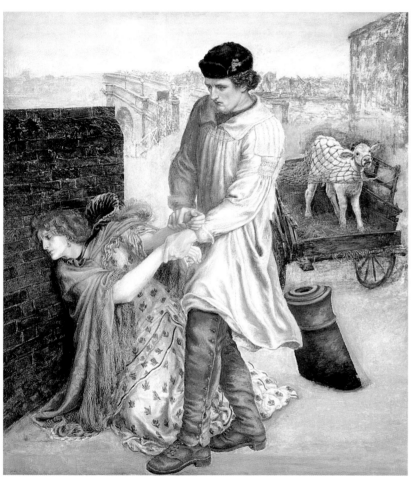

471

472

Madox Brown, who sat for the figure of the drover. Fanny Cornforth, Rossetti's most sensual model, with her 'harvest yellow' blonde hair, posed for the head of the woman, who crouches by the brick wall of a cemetery. Rossetti's search for the ideal cemetery 'brick wall' succeeded when he found a wall at Chiswick, in 1854, near the grave of Hogarth, which he thought a good omen for his 'modern picture'. His choice of this subject was also possibly partially inspired by a poem 'Rosabell' by William Bell Scott. Although Rossetti denied this, he did illustrate another scene from the same poem entitled *The Gate of Memory* (Pl. 472), an impressive, little-known work, showing a prostitute looking at innocent children dancing to the music of a barrel organ.

Fanny Cornforth was much in demand as a model, and also posed for another

famous painting with prostitution as a theme, *Thoughts of the Past* (Pl. 473) by John Roddam Spencer Stanhope (1829–1908). Fanny, her long hair hanging loose over her blue dressing gown and her face transformed to make her look consumptive, is shown by a window with an extensive view of shipping on the Thames, overcome with remorse as she thinks of the past. A man's glove and walking stick lie on the floor, and money is on the table. The picture was painted at 14 Chatham Place, Blackfriars, by the Thames, and Fanny, whose good humour endeared her to all men, was kept busy flitting between the studios of Rossetti on one floor and Stanhope on another.

The artist George Price Boyce, whose diaries are an invaluable source of information concerning Pre-Raphaelite activities, has left us a glimpse of Fanny in 1858–9. Boyce noted: 'He [Stanhope] was painting his picture of a gay woman in her room by the side of the Thames and Fanny was sitting to him. She afterwards went up to Rossetti and I followed.' Boyce liked painting the Thames at Blackfriars, anticipating Whistler in trying to capture the beauties of the river at dusk (see Pl. 142). While doing this one day in Rossetti's studio, seated at an easel, Fanny leaned over his shoulder affectionately, providing Rossetti with the chance to create one of his most intimate drawings (Pl. 474). When Rossetti moved to Chelsea, Boyce took over the flat at Blackfriars, while Fanny moved in to Cheyne Walk as Rossetti's model, mistress and housekeeper. Their friendship amicably survived many vicissitudes, Rossetti drawing several amusing caricatures of Fanny as an Elephant, his nickname for her, caused by her growing girth.

Rossetti was never to finish *Found* (Burne-Jones partially completed it after his death), but he wrote a cross letter to Ruskin on learning the news that Holman Hunt was also embarking on a painting with a 'mistress' theme, *The Awakening Conscience* (Pl. 476). This was a time, it must be recalled, when 'originality of subject' ruled in British art, and novelty of theme was as important as the quality of painting. Holman Hunt had in fact spent some time searching for a suitable subject, and found it after reading Charles Dickens's *David Copperfield* (1849–50), with its account of the seduction of Little Em'ly by Steerforth. Once he had the idea, with steadfast loyalty to Pre-Raphaelite principles of 'fidelity to nature', he hired, as the actual setting for the painting, a *maison de convenance* at Woodbine Villa, 7 Alpha Place, St John's Wood, which was then notorious for such establishments, one of which Swinburne visited regularly, to gratify his need for flagellation.

Holman Hunt recorded how: 'in scribbles I arranged the two figures to present the woman recalling the memory of her childish home, and breaking away from her gilded cage with a startled holy reserve, while her shallow companion still sings on, ignorantly intensifying her repentant purpose.' The girl's face eloquently expresses her remorse for lost innocence, which has been aroused by her lover playing on the piano the haunting melody by Tom Moore with its affecting lyric, 'Oft in the Stilly Night'. As Ruskin remarked, 'there is not a single object in that room, common, modern, vulgar, but it becomes tragical if rightly read.' He commented particularly upon 'the fatal newness of the furniture', the cheap rosewood veneer of the piano, and what he believed to be a reproduction of *The Woman Taken in Adultery* (actually a print by Frank Stone called *Cross Purposes*). Ruskin added: 'every feature in the room adds its emphasis to the total effect, the mangled bird in the cat's clutches, the unravelling tapestry on the frame, the soiled and discarded glove. Even the ornate wallpaper design is symbolic: "The corn and the vine are left by the slumbering cupid watchers, and the fruit is left to be preyed on by thievish birds."'

The sheer intensity of Holman Hunt's vision makes his work come alive in a way quite different from other works examined in this chapter. This is also true in a

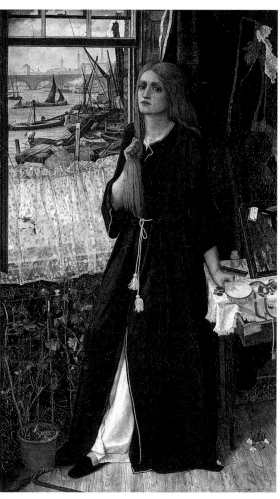

473
John Roddam Spencer
Stanhope
Thoughts of the Past
1859
oil on canvas, 86.4 × 50.8cm
(34 × 20in)
Tate Gallery, London

473

474
Dante Gabriel Rossetti
**G.F. Boyce and Fanny
Cornforth**
c.1858
pen and ink, 22.2 × 31.8cm
(8¾ × 12½in)
Carlisle Museum and Art
Gallery

475
Constantin Guys
**Study of Prostitutes in the
Haymarket**
c.1850
pen and ink and grey wash,
27.3 × 23.5cm (10¾ × 9¼in)
Leeds Castle, Kent

476
William Holman Hunt
The Awakening Conscience
1853–4
oil on canvas, 76.2 × 55.9cm
(30 × 22in)
Tate Gallery, London

474

475

very different way of the swift, compelling watercolours of the French artist Constantin Guys, dubbed by Baudelaire 'the painter of modern life', who from the 1840s to 1860s made long visits to London, and in the 1850s worked as Crimean War correspondent for the *Illustrated London News*. He painted many memorable records of prostitutes in the London Haymarket (Pl. 475), the visual equivalents of Fyodor Dostoevsky's descriptions of the subject in his *Winter Notes on Summer Impressions* (1863), the account of his visit to London. Gustave Doré also recorded the same themes in the epic *London: A Pilgrimage* (1872).

To be poor and a woman did not, of course, always end inevitably in either starvation, sweated labour or immorality. Eyre Crowe (1824–1910) in *The Dinner Hour: Wigan* (Pl. 477) created that rarity, a Victorian painting of the working class which is not laboriously making some point about oppression. As *The Times* put it, it is 'a praiseworthy attempt to find paintable material in the rude life of some of the most unlovely areas of Lancashire'. In the background the cotton mills are clearly humming with activity, a welcome contrast to their silence during the 1860s when they were shut during the cotton famine caused by the American Civil War.

A group of women, mainly weavers, wearing colourful red, blue and yellow dresses under white overalls, are relaxing during their lunch hour – eating, drinking, chatting, one reading a letter, one standing catching an apple at the end of the frieze-like group, using her apron to cast a shadow on a baby. Only one figure looks out of the picture at us, the barefooted girl, whose quizzical expression is enigmatic. Although the *Athenaeum* thought, 'it was a pity Mr Crowe wasted his time on such unattractive materials', and that 'a photographer could have contrived as much', we may think today that this curious and puzzling picture has qualities reminiscent of the pastoral romances of George Morland or Francis Wheatley in the eighteenth century, coupled with a remarkable modernity, which demonstrates that the frailer sex need not inevitably remain frail or become fallen women.

But in biblical terms, vigilance was constantly necessary to counteract the temptations of the imagination. In *Factory Girls at the Old Clothes Fair, Knott Mill, Manchester* (Pl. 478) by Frederic James Shields (1833–1911), we see the second-hand clothes stalls, all run by Irish women, where 'thread-bare garments, translated by the

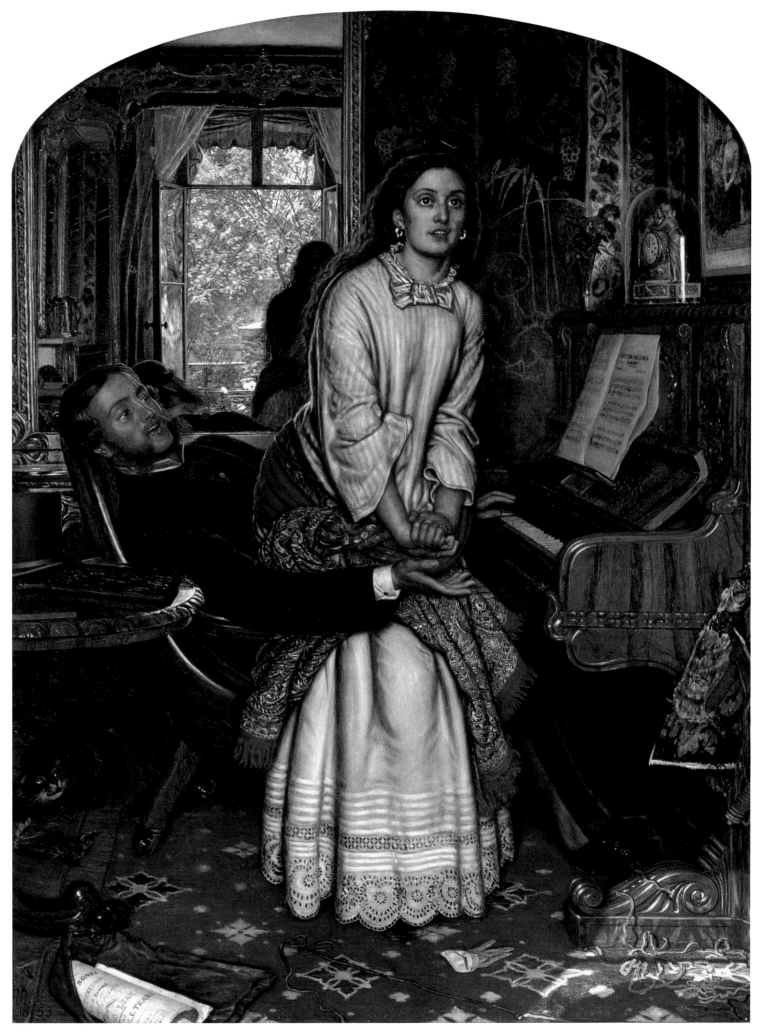

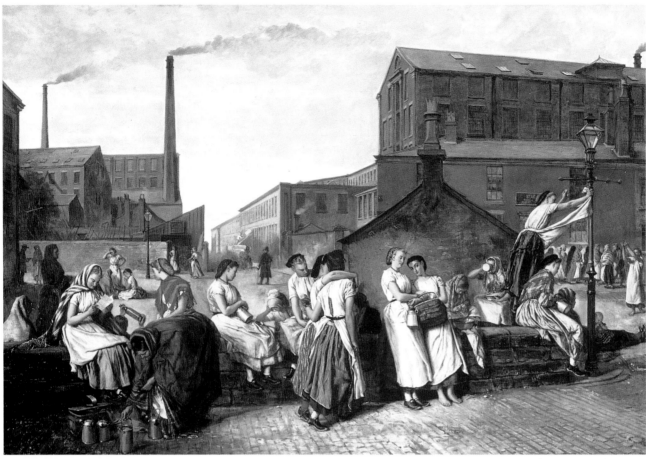

477

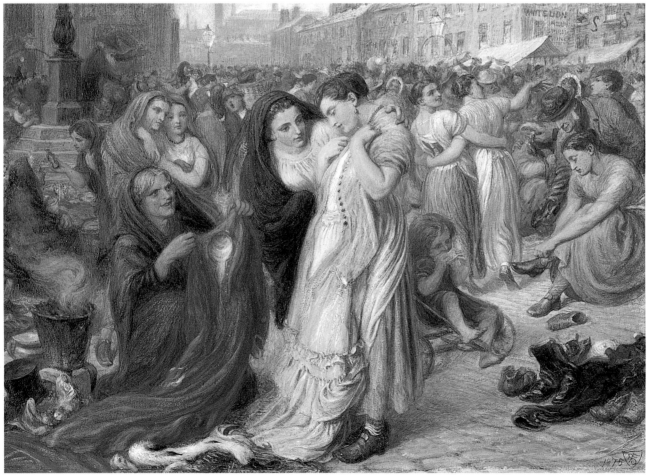

478

cunning hand of the cleaner and mender into a delusive freshness, are sold to the needy poor of the busy city'. Fantasies and delusions of grandeur are clearly present in the mind of the poor mill girl wearing the stout boots demanded by her industrial toil, as she examines with longing the beautiful cast-off fashionable dress of a wealthy woman.

Just such a dress is worn in one of the most enticing of all Tissot's many paintings of his mistress Kathleen Newton, *October* (Pl. 479). She is poised, in surely the most fetching of all versions of the 'little black dress', silhouetted against a background of bright horse-chestnut leaves, caught in motion with a swish of frothy pleats and petticoats revealing a 'well-turned ankle', inviting the spectator to follow her. Born Kathleen Kelly in 1854, her mother died when she was a child, and at the age of 16 she was sent out to India to marry a Dr Newton, but fell in love with another officer on the journey out. She was duly married to Dr Newton but ran away from him and had an affair with her lover, who deserted her when she became pregnant. Sent home to London, she lived with her sister, just round the corner from Tissot in St John's Wood.

Tissot fell deeply in love with her when they met in 1875 or 1876 and swept her off her feet, choosing her clothes and dressing the Irish colleen like a Parisienne. A son was born in 1876 which was probably his. In any event she became the principal theme of his art, for from the time of their first meeting until her death from tuberculosis six years later, he painted little else but their love story, reflected in the ambiguity of such titles as *The Convalescent* and *The Last Evening*. In Tissot's liaison with Kathleen Newton we see reflected in real life not the agonized victim of Holman Hunt's *Awakening Conscience* but a figure closer to Marguerite Gautier, the heroine of Dumas's *La Dame aux Camélias* (1852), whose death through consumption and self-sacrifice inspired Verdi's *La Traviata* (1853). This might well be the opera about to be performed for the fashionably dressed group of beautiful aesthetic women whom we see *In the Front Row at the Opera* (Pl. 480) by William Holyoake

477
Eyre Crowe
The Dinner Hour, Wigan
1874
oil on canvas, 76.3 × 107cm
(30 × 42⅛in)
Manchester City Art Gallery

478
Frederic James Shields
Factory Girls at the Old Clothes Fair, Knott Mill, Manchester
1875
watercolour, 23.8 × 32.1cm
(9⅜ × 12⅝in)
Manchester City Art Gallery

479
James Tissot
October
1877
oil on canvas, 216 × 108.7cm
(85 × 42¾in)
Montreal Museum of Fine Arts

480
William Holyoake
In the Front Row at the Opera
c.1875
oil on canvas, 62·2 × 81·3cm
(24½ × 32in)
Art Gallery and Museum, Kelvingrove, Glasgow

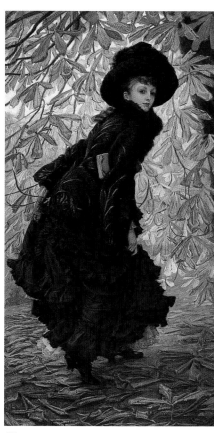

479

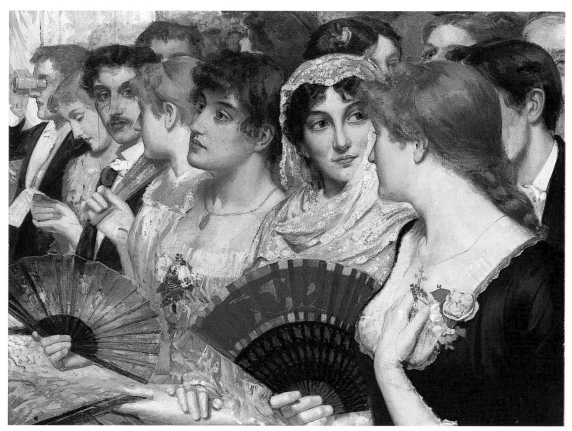

480

(1834–94). Beautiful though they are, there is something enigmatic and mysterious about them, just a hint that their passage through matrimony and life may be a troubled one.

In the 1880s a loveless marriage for wealth was a theme which provided a popular pictorial moral subject for William Quiller Orchardson. He was the master of the 'dramatic moment', as he demonstrated in several works which form a Victorian version of Hogarth's *Marriage à la mode*. Orchardson had, however, moved on from the Hogarthian details that hammered home the didactic messages in the work of Hunt and Egg, realizing that an element of ambiguity added dramatic tension. Orchardson's daughter questioned him about a painting which showed 'a young man and a young woman sitting on a sofa together'. She inquired: 'But whatever is it? Are they quarrelling? Or has he proposed or been refused? Or does he want to propose but feel afraid?' 'I don't know,' replied her father, 'it might be any of these things, it is an enigma.'

At his best, Orchardson also used expressive body language in the Scottish tradition of characterization which descended from Sir David Wilkie. In *Mariage de Convenance* (Pl. 481), an elderly, balding but clearly very wealthy man sits gazing the length of a long dining table at his beautiful, but bored, wife. She sits with jaded

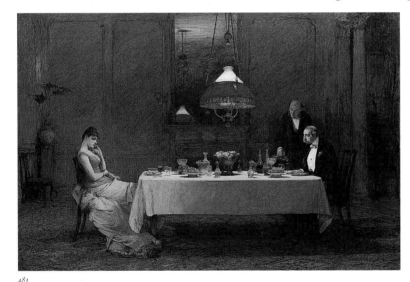

481

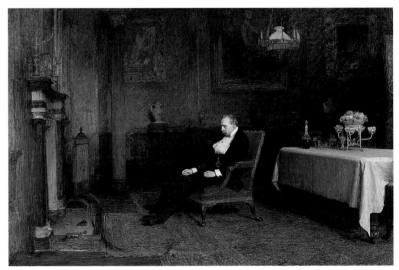

482

appetite before her untasted meal, brooding over the misery of marriage to a boring old man. The silence between the couple is almost audible, the only source of noise in the room coming from the wine which the butler deferentially pours for his master. The servant's obsequious stance emphasizes the heavy weight of conventional respectability and the wealth and status of the husband, forming a strong counterpoint in the composition – a contrast between age and youth. In a related painting on marital breakdown, *The First Cloud* (1887), the young wife sweeps from the room. The silence has clearly been broken, and the accusations, denials and counter-accusations of a quarrel hang in the air.

In *Mariage de Convenance – After!* (Pl. 482), the wealthy old man sits alone, slumped by the fire, gazed down on by a portrait of his wife. The dejection in his pose, the bulging 'stiff' shirt with its untidy cuffs, the spiritless droop of head and shoulders, the untouched decanter of wine, produce a powerful effect. Such works remind us of the society dramas of Pinero, and even more of the *Forsyte Saga* of John Galsworthy, and the relationship between Soames and Irene. Striking analogies arise also from Sir Frank Dicksee's *The Confession* of 1896 (Pl. 483), in which we see a man confessing to a woman, or vice versa; the relationship is deliberately left ambiguous.

Such confessions were a feature of virtually every play by Oscar Wilde, whose own transgressions and fall formed a new cliché, that of 'the fallen man'. Adherents like Wilde of 'the love that dare not speak its name' were all too vividly aware of the importance in fashionable society of maintaining double standards.

In the 1890s a new level of explicitness became current, initiated by the first performances in London of Henrik Ibsen's *A Doll's House*, *Hedda Gabler* and *Ghosts*, which dealt with the unpalatable themes of venereal disease, alcoholism and suicide, which *Punch* dubbed as the horror of 'Ibsenity'. Ibsen's disciple, George Bernard Shaw, in his play *Mrs Warren's Profession* (1894), discussed prostitution with great free-

483
Frank Dicksee
The Confession
1896
oil on canvas, 114.2 × 159.9cm
(45 × 63in)
Private collection

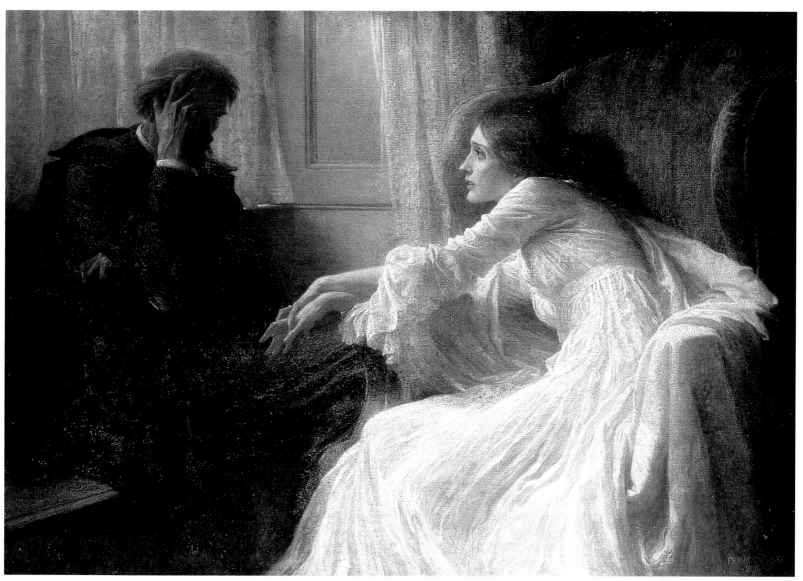

483

dom. Ibsen's and Shaw's heroines and their cry for independence became associated in the popular mind with the emergent claims of women for equality, both at the polling booth, in the medical profession and at the universities. A new spirit was abroad which would see the problems of 'the frailer sex' and the 'fallen woman' in a different light, and the emergence of 'the new woman', who would soon begin in earnest the long struggle to gain the vote and true equality with man.

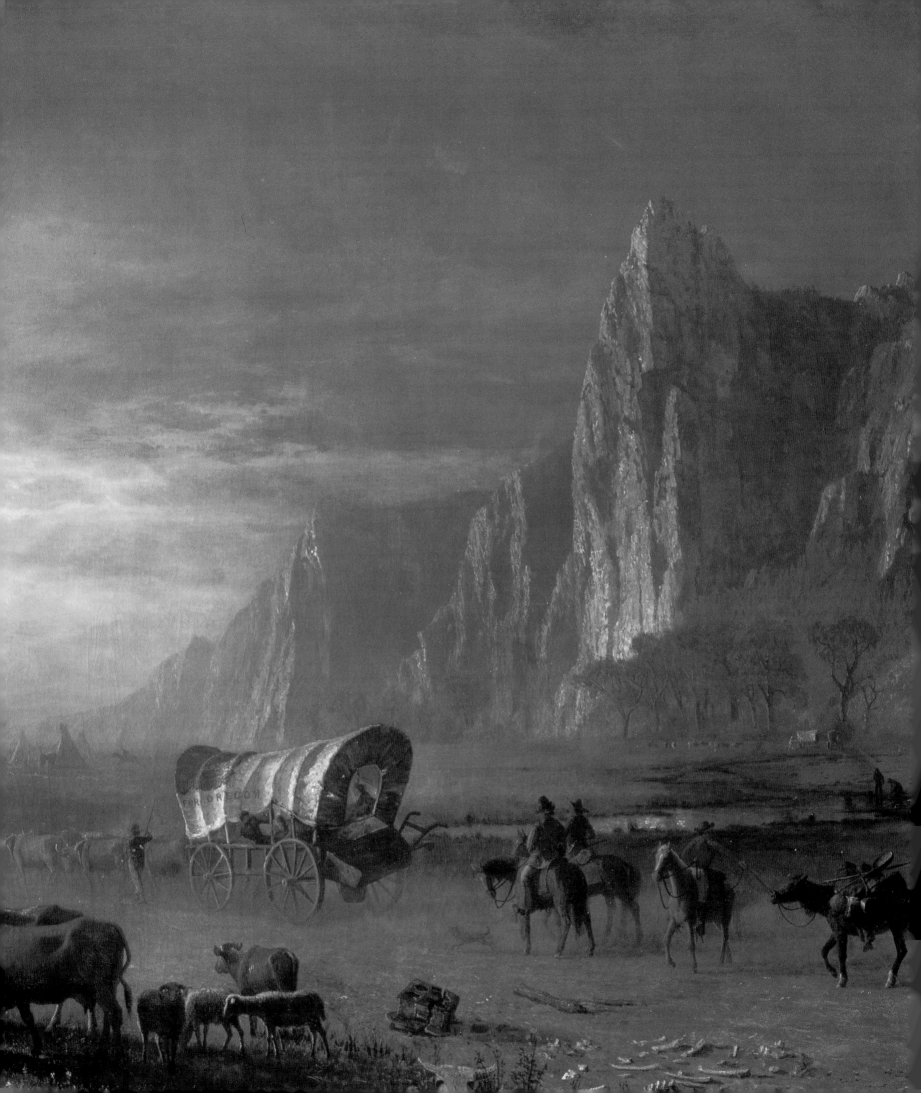

In 1837 the Society for the Sons of St George in Philadelphia was eager to honour the young Queen of the United Kingdom, for there was considerable interest in her appearance in America. The Society asked Thomas Sully (1783–1872), the best American portrait painter of the time, to paint Queen Victoria's portrait (Pl. 485). Sully, an Englishman who came to America with his circus performer family in 1792, first practised as a miniature painter in Norfolk, Virginia. He became a naturalized American in 1807, the same year in which he visited the great portrait painter Gilbert Stuart at Boston. Sully then settled in Philadelphia as a portrait painter, and from there visited England twice, in 1809–10 when he studied with Benjamin West, and again in 1837. After Gilbert Stuart's death in 1828 Sully became by default the most sought-after American portrait painter. The seal on his success was set by his impressive portrayal

485
Thomas Sully
Queen Victoria
1838
oil on canvas, 142.5 × 112.5cm
(56¼ × 44⅜in)
Wallace Collection, London

486
Thomas Cole
The Oxbow
1836
oil on canvas, 130.8 × 193cm
(51½ × 76in)
Metropolitan Museum of Art,
New York

487
Thomas Cole
The Dream of the Architect
1840
oil on canvas, 134.7 × 213.4cm
(53 × 84in)
Toledo Museum of Art, Ohio

485

of Queen Victoria at the very beginning of her reign. She sat for him several times in the spring of 1838; on the second sitting on 2 April, the Queen's 'ladies of honour' were present and the Queen 'laughed and talked like a happy innocent girl of eighteen'. Sully completed the portrait in the autumn. It was then exhibited in New York, Boston, Montreal, Quebec and New Orleans.

The picture stands as a symbol for the transatlantic exchange which is the theme of this chapter, the curious 'special relationship' in both politics and the arts which has formed a bridge between the two cultures – wittily described as being kept apart by a common language. In the Metropolitan Museum of Art, New York, is another version of the portrait and some spirited studies of the jewellery the Queen is wearing, which reminds us that while in current American usage it is acceptable to use the word 'Victorian' as a term to describe jewellery and other decorative arts, it is not always proper to describe the paintings produced in America during the Queen's reign as 'Victorian', as Germany, even more markedly France, and various other national traditions were also potent influences on the American schools of painting in the nineteenth century. It is, however, rewarding to trace the artistic 'special relationship' between the two countries of Britain and America during those years, a process which had actually begun much earlier in the eighteenth century.

Following the death of Reynolds in 1792, the American Benjamin West, who had spent most of his career in England, was appointed the second President of the Royal Academy. West had gained early recognition as a portraitist in New York before sailing to Italy in 1760, where he enjoyed great success in Rome, in part due to the novelty of his being an American (a blind cardinal believed he was a Red Indian!). Settling in London in 1763, he was acclaimed as a history painter; his *Death of General Wolfe* in 1770 (Pl. 4) led to his appointment as History Painter to George III. The noble hero expiring on the scene of battle was a theme later adopted by another American artist long resident in England, the Bostonian John Singleton Copley (1738–1815), with his *Death of Major Peirson* (1783). Even more successful was Copley's *Death of The Earl of Chatham* (Pl. 5), which showed the great Parliamentarian Pitt the Elder collapsing on the floor of the House of Lords into the arms of his son, after making a vigorous speech against the acknowledgement of American Independence.

Thus, somewhat surprisingly, American artists played a major role in shaping British art in the late eighteenth century. This tradition continued into the early Victorian era with the engaging personality of Charles Robert Leslie, brought up in Philadelphia and a master of literary genre scenes (Pls. 149, 150), who is now chiefly remembered for his classic biography, *Memoirs of the Life of John Constable* (1843).

Throughout Europe in the early nineteenth century, Neoclassicism flourished as an international style, with its theory of the elevation of approved models above personal expression. In America also, order, clarity and reason ruled. Neoclassicism became the prevailing official style in art and even more so in architecture, mirrored in buildings as various as Thomas Jefferson's Monticello and L'Enfant's layout of the capital city, Washington. For some American artists who visited Rome to study antique classical art at its purest, the experience had curious results, for once their archaeological zeal had been sated, their enthusiasm was transformed into a nostalgic yearning for a lost 'Golden Age'. The term 'Romantic Classicism' emerged to characterize an interest in classicism tinged with Romantic feeling.

Thomas Cole (1801–48), founder of the Hudson River School, experienced this transformation. Born in Lancashire, he emigrated to America in 1819, working in his father's wallpaper factory at Steubenville, Ohio, before becoming a Romantic landscape painter, and moving in 1827 to the Catskills on the Hudson River, where he

486

487

made sketches of the mountains which he worked up in his studio. 'All nature here is new to art,' he wrote, 'no Tivolis, Ternis, Mont Blancs, Plinlimmons, hackneyed and worn by the daily pencils of hundreds; but primeval forests, virgin lakes and waterfalls.'

Cole's fellow artists in the Hudson River School thought of themselves as 'God's stenographers', recording His wilderness. In so doing they were essentially American, not slavish followers of the European tradition. Their landscapes recorded 'Pure Nature' – not, as in the European schools, a record of man's impact on nature. Yet as Cole wrote in his 'Lecture on American Scenery': 'American scenes are not destitute of historical and legendary associations; the great struggle for freedom has sanctified many a spot, and many a mountain stream and rock has its legend worthy of poet's pen or painter's pencil.'

Cole's painting *The Oxbow* (Pl. 486) shows the artist following his own advice. Seated almost hidden at an easel set on a rocky outcrop, he stares back at us from the foreground which overlooks a vast sweep of New England countryside dissected by the meandering course of the Connecticut River. But Cole was not content to just paint American scenes, merely taking descriptions of the marvels of European art on trust. He did not follow the counsel of his friend the artist Asher Brown Durand (1796–1886), advice of a type often repeated during the nineteenth century: 'Go not abroad then in search of material for the exercise of your pencil while the virgin charms of our native land have claims on your deepest affections. America's untrodden wilds yet spared from the pollutions of civilization afford a guarantee for a reputation of originality …' From 1829 to 1832, and in 1841–2, Cole travelled in Europe, studied Turner and John Martin, and began to produce such mysterious works as a fantasy of a Druidic Tree of Life. After returning to New York he found himself torn between public demand for his landscapes and the creation of three grandiose historical and allegorical series, *The Course of Empire*, *Departure and Return* and *The Voyage of Life*, works that expressed his own imaginative concern with Romantic themes of change, the passage of time and the mutability of earthly things.

The finest expression of this aspect of Cole's work is his masterpiece, *The Dream of the Architect* (Pl. 487), a work that can stand as a symbol of the artistic dilemma which characterized the early Victorian era: the transition from the Neoclassical ideal world of peace and order to the frenzied gloom of the Gothic Revival. In this painting we see an architect, reclining on a classical capital, who turns his back on the pyramids and classical buildings of Egypt, Greece and Rome, to dream a Gothic fantasy of cathedral spires and flying buttresses in a gloomy forest, reminiscent of Caspar David Friedrich, the Gothic elaboration of A.W.N. Pugin, and John Martin's apocalyptic visions. Although it may represent an ideal, *The Architect's Dream*, we feel, has also an air of impending disaster, reminiscent of the Gothic romances which Edgar Allan Poe was writing not far away in Baltimore.

Today many thousands of people visit Olana each year, high above the Hudson, the aesthetic home of Frederic Edwin Church, Cole's most important pupil. Not far away on the other side of the Hudson River, Cole's own last home stands unvisited and curiously neglected. To sit on the veranda where photographs of Cole's major works are displayed, or to visit the small, beautifully proportioned classical lavatory, a survival from Cole's day, makes one experience a lesson on the transient nature of human fame.

Frederic Church (1826–1900) continued with the preoccupation of other artists of the Hudson River School, charting the landscape of the great river and its tributaries. But he also travelled far beyond the state of New York and the Niagara Falls (Pl. 488), following the steps of the great explorer of South America, Baron von

488
Frederic Edwin Church
Niagara Falls, from the American Side
1867
oil on canvas, 260 × 231cm
(102¼ × 91in)
National Gallery of Scotland, Edinburgh

489
George Catlin
Comanche Indians Chasing Buffalo with Lances and Bows
1846–8
oil on canvas, 49.8 × 70.1cm
(19⅝ × 27⅝in)
National Museum of American Art, Washington DC

490
John James Audubon
Golden Eagle
1833–4
watercolour, graphite and pencil, 96.6 × 64.7cm
(38 × 25½in)
New York Historical Society

491
Albert Bierstadt
Emigrants Crossing the Plains
1867
oil on canvas, 170.2 × 259.1cm
(67 × 102in)
National Cowboy Hall of Fame and Western Heritage Center, Oklahoma City

492
Frederick Remington
A Dash for the Timber
1889
oil on canvas, 122.6 × 213.7cm
(48¼ × 84¼in)
Amon Carter Museum, Fort Worth

Humboldt, to Venezuela, Colombia, Ecuador, Peru and Mexico. For Church, nature was God's architecture. He revelled in painting, often on a huge scale, the most spectacular aspects of natural scenery: icebergs, exploding volcanoes and the tropical forests of South America. These canvases, long out of fashion, are now once more highly esteemed.

The renewed interest in such paintings reflects contemporary ecological concerns and also illustrates a long-term American phenomenon, the almost simultaneous process of both worshipping and destroying the wilderness. Some of the most striking early instances of this are the paintings made by George Catlin (1796–1872) from his native Philadelphia as records of the Native American Indians before their culture became threatened and overwhelmed by the white man (Pl. 489). It was Catlin's distinction to be the first artist to set out for the West with the intention: 'by the aid of my brush and pen, to rescue from oblivion so much of their primitive looks and customs as the industry and ardent enthusiasm of one lifetime could accomplish'.

Between 1832 and 1838 Catlin visited 48 tribes, and painted 320 portraits and 200 pictures of hunting scenes, ceremonials and dances. His charting of the decline of the buffalo created some of the most memorable images of the wilderness. One day in the spring of 1832 Catlin, seated on a hill in South Dakota, fantasized over a map of the United States: 'Below me', he wrote, 'I could see the blue chain of the great lakes … the Rocky Mountains, and beneath them and near their base, the vast and almost boundless plains of grass which were speckled with bands of grazing buffaloes!'

This pastoral vision was clouded by the gloomy prescience with which Catlin foresaw the fate of the buffaloes, symbols of the abundant gifts of nature, 'wheeling about in vast columns and herds' before scattering to escape death at the hands of the huntsmen of the plains. He wrote: 'Some lay dead and others were pawing the earth for a hiding place – some were sinking down and dying, gushing out their life's blood in deep drawn sighs – and others were contending in furious battle for the life they possessed and the ground they stood upon.'

It is tempting to make a symbolic parallel replacing the word 'buffalo' with

489

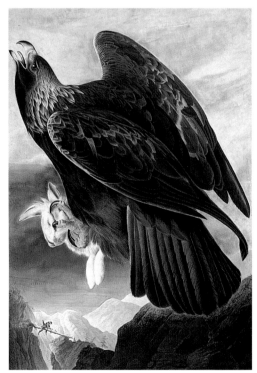

490

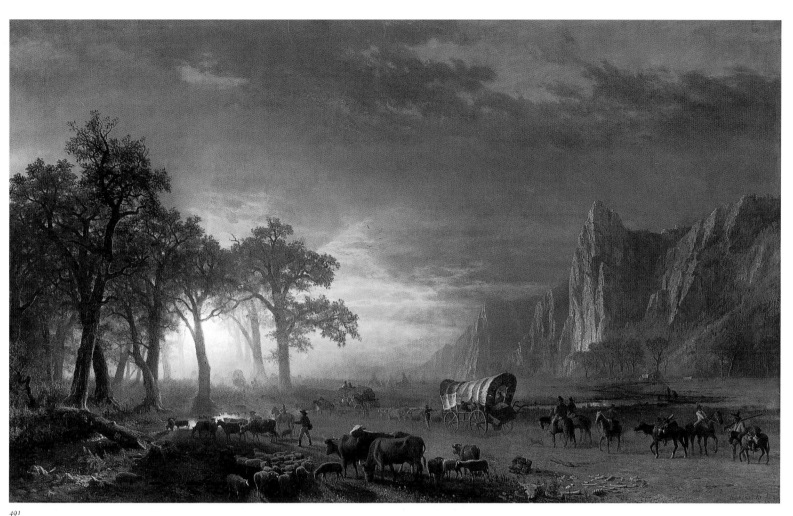

491

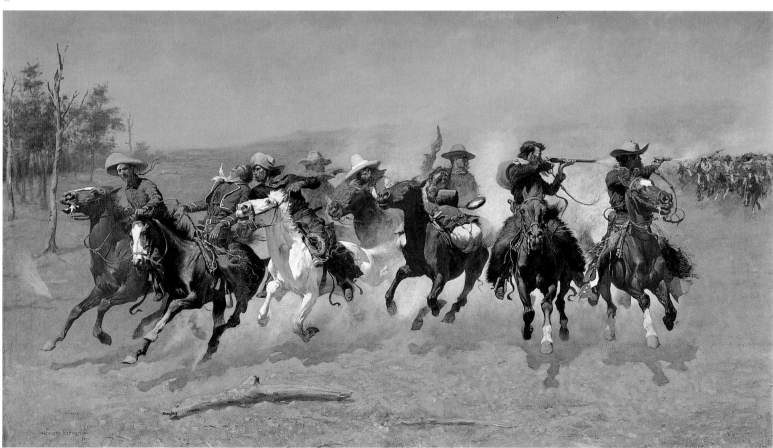

492

493
William Sidney Mount
Cider Making
1841
oil on canvas, 68·6 × 86·7cm
(27 × 34⅛in)
Metropolitan Museum of Art,
New York

'Native American', but although the tragic theme of the dispossession of the Indian peoples and the coming of the white man would continue to occupy American artists, other major themes also emerged.

The flamboyant explorer, painter and naturalist John James Audubon (1785–1851) was educated in France, and claimed to have studied in the studio of Jacques-Louis David. Audubon's interest in both art and ornithology led to his resolve to make a complete pictorial record of all the bird species of North America. Unable to find a publisher in America he went to Great Britain in 1826, and set Edinburgh and London talking about the tall, striking figure dressed in a coonskin coat and hat like the frontier guide Davy Crockett. His *The Birds of America, from Original Drawings*, with 435 plates, was published in four huge 'double elephant' folio volumes of hand-coloured aquatints in London from 1827 to 1838, and ranks among the most famous books of the world. The *Golden Eagle* (Pl. 490) is of particular interest, since it shows, at the bottom left of the watercolour, a diminutive huntsman,

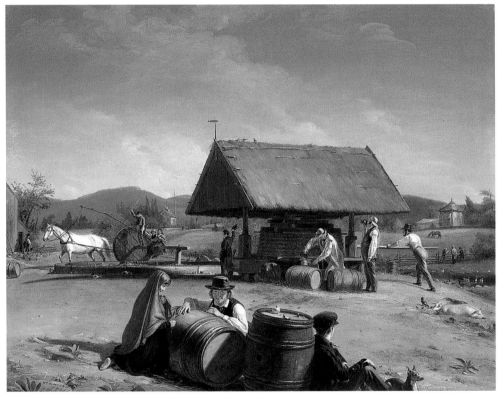

493

thought to be a self-portrait. He edges his way across a log over a ravine with the body of a golden eagle slung across his back. *Birds* was followed by *The Viviparous Quadrupeds of America*, two volumes, imperial folio, published in New York between 1845 and 1848.

Audubon explored widely to make these studies, travelling from Kentucky and Louisiana, up and down the Ohio and Mississipi, through the swamps of Florida and the ice and snow of eastern Canada. His works, like that of Cole and his followers, capture something of the potent appeal of the wilderness summed up by Ralph Waldo Emerson's paean of praise in his essay *Nature* (1836): 'In the woods, is perpetual youth … In the woods, we return to reason and faith … I become a transparent eye-ball; I am nothing; I see all; the currents of the Universal Being circulate through me; I am a part or particle of God.'

The West was also gradually opening up. In 1839 the first convoy of covered waggons made its way along the Oregon Trail across the Sierras to California, ten

years before the discovery of gold would lead to vast numbers of fortune hunters in the Californian Gold Rush of 1849. That event marked the beginning of a steady exodus of emigrants across the plains chronicled by artists as varied as Benjamin Franklin Reinhart (1829–85) and the better-known Albert Bierstadt (1830–1902). Of German parentage, Bierstadt, after studying in Düsseldorf and Rome, returned to America, where in 1858 he joined a surveying expedition which was planning an overland waggon route from Fort Laramie, Wyoming, to the Pacific. On reaching the Rockies he set off on his own to sketch, returning to New York in 1859 and taking a studio in the same building as Church, whose work he admired and emulated. Bierstadt's huge landscapes captured the drama of such themes as *Emigrants Crossing the Plains* (Pl. 491). In the foreground of the painting can be seen the scattered cattle bones emblematic of previous travellers who had died on the trail. For Bierstadt's emigrants, however, all seems to bode well as they ride off into the sunset.

The beginning of the American love affair with the West had begun. The exodus was accelerated by the dynamic New York editor Horace Greeley, the vigorous advocate of the anti-slavery cause, who once made the famous injunction 'Go west, young man, go west.' Walt Whitman hauntingly described the romance of the west:

494
George Caleb Bingham
The Verdict of the People
1854–5
oil on canvas, 116.7 × 164.9cm
(46 × 65in)
The Boatmen's National Bank
of St Louis

495
George Caleb Bingham
**Fur Traders Descending
the Missouri**
*c.*1845
oil on canvas, 73.7 × 92.7cm
(29 × 36½in)
Metropolitan Museum of Art,
New York

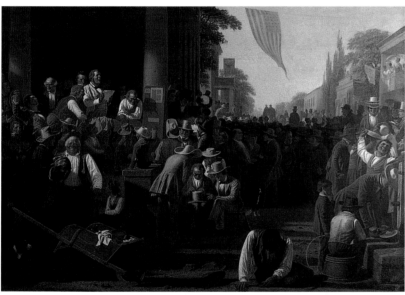

494

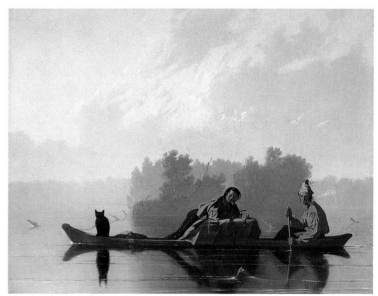

495

'the herds of cattle and the cowboys, bright eyed as hawks, with their swarthy complexions and their broad brimmed hats, always on horseback, with loose arms raised and swinging as they ride'. The illustrator, sculptor and painter, Frederick Remington (1861–1909) vividly portrayed such scenes in paintings like *A Dash for the Timber* (Pl. 492). Remington's works were highly influential in forming the potent myth of the cowboy and the popular Hollywood genre of the Western.

While the relentless march westwards across America continued, the growing industrial urban societies of the eastern seaboard demanded escapist pastoral pictures, just as did the cities of Victorian England. The Long Island genre painter William Sidney Mount (1807–68) provides a striking example in *Cider Making* (Pl. 493), which achieves a distinctively American bucolic charm. American artists were beginning to create their own highly individual interpretations of traditional themes.

This process can be seen even more clearly in the work of George Caleb Bingham (1811–79). In Missouri in 1854 and 1855, at the height of the political turmoil over slavery in Kansas and Nebraska, Bingham produced a series of genre scenes dealing with every facet of electioneering, including canvassing, bribing, campaigning and

496
Thomas Hovenden
The Last Moments of John Brown
1884
oil on canvas, 196.3 × 160.5cm
(77¼ × 63¼in)
Metropolitan Museum of Art,
New York

497
Emanuel Leutze
Washington Crossing the Delaware
1851
oil on canvas, 378·5 × 647·7cm
(149 × 225in)
Metropolitan Museum of Art,
New York

voting. These works, which find their origin in prints of Hogarth's *Election* series, have titles such as *The Verdict of the People* (Pl. 494), which recall Haydon's *Mock Election* (Pl. 10). They also form an intriguing parallel with the great cross-sections of human life that Frith was painting at the same time in England (Pls. 317, 320, 321).

There was another more lyrical side to Bingham's productions which forms an evocative parallel with one of the greatest works of nineteenth-century American literature, Mark Twain's *Huckleberry Finn* (1884). In Bingham's paintings such as *Fur Traders Descending the Missouri* (Pl. 495) we find reflected the peaceful river scenes seen by Huck Finn, son of the town drunkard, and by Jim the escaping black slave, as they make their way by raft down the great river. Sadly, after a trip to study abroad in Düsseldorf in 1856–8, Bingham's work lost much of its racy freshness and charm, and became overlaid with sentimentality.

Another striking parallel with English art was the continuing demand for History painting. In London the Houses of Parliament were being decorated with stirring scenes from British history. In America there was a demand for paintings of the heroic events of the American War of Independence, which possessed a powerful contemporary relevance in the years following the American Civil War. A particularly fine example is one of the largest oil paintings in the Metropolitan Museum of Art, New York, a huge picture by Emanuel Leutze entitled *Washington Crossing the Delaware* (Pl. 497), which is reproduced in countless history books and has become something of a national icon like the Statue of Liberty. Neither work was actually created in America, for Bartholdi completed the statue in Paris, while Leutze painted his work in Düsseldorf. (Ironically, Leutze's smaller initial version of the painting was destroyed by allied fire in Bremen during the Second World War.) Leutze's frescos in the Capitol at Washington are discussed above (p. 54).

The powerful painting *Approaching Thunderstorm* (Pl. 498), by Martin Johnson Heade (1819–1904), with its ominous title and lowering electric skies threatening thunder, seems to portend the gathering storm of the American Civil War (1861–4), the titanic struggle between North and South, Union and Confederate forces. There are very few paintings which commemorate the war, apart from panoramas of the battlefields of Gettysburg (Pl. 196) and Atlanta. This almost certainly arises from the fact that Matthew Brady's photographs of the war recorded for the first time the awful realities of the battlefield in a way impossible for any painter.

There was, however, one interesting History painting, created twenty years after the actual event took place, by an Irishman from Cork, Thomas Hovenden (1840–95), who came to America aged 23, in the last year of the Civil War, returning to Europe to study with Alexandre Cabanel in Paris and exhibit in England between 1874 and 1880. On his return to America he settled in the Philadelphia area. His melodramatic tableaux on noble themes, full of sentiment and with a strong narrative line, such as *Breaking Home Ties*, appealed to late Victorian ideals of what art ought to be, and were extravagantly praised. His most famous painting was *The Last Moments of John Brown* (Pl. 496). It portrays the leader and figurehead of the anti-slavery movement, who helped at least 50,000 fugitive slaves to escape via the 'underground railroad' to the northern States and Canada, and raided a Federal arsenal with the intention of arming Southern slaves and starting an insurrection. He was captured, tried and hanged, but his name and 'soul went marching on' in a song that became a rallying battle cry for the Union armies of the north. Hovenden's painting shows Brown on his way to execution kissing a black baby. For all its melodramatic pathos, it provides us with an example of the trend towards almost photographic 'history' pictures which emerged in both America and Europe in the mid-Victorian era (see Pl. 177).

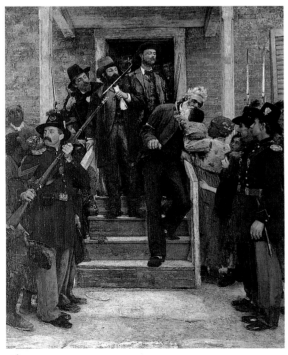

496

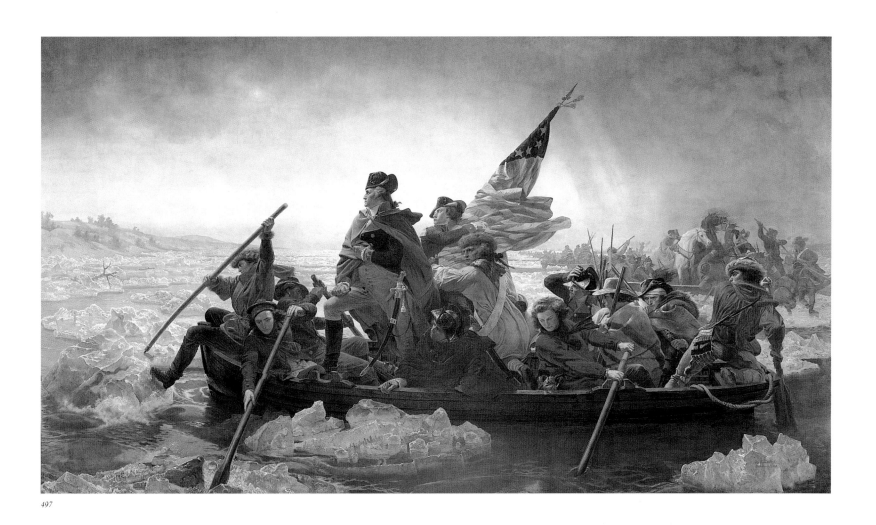

497

498
Martin Johnson Heade
Approaching Thunderstorm
1859
oil on canvas, 71·7 × 111·8cm
(28 × 44in)
Metropolitan Museum of Art,
New York

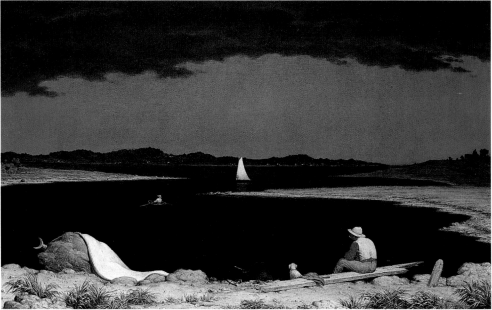

498

Such sentimental scenes, whether incorporating contemporary, romantic or classical subject-matter, were always carefully attuned to popular taste. They would find their true spiritual heirs in costume movies in Hollywood in the twentieth century, but in the nineteenth century they provided the stodgy academic fare from which naturalistic artists of real originality rebelled. In the United States the two major realist painters were Winslow Homer and Thomas Eakins.

Apprenticed to a lithographer, Winslow Homer was later an illustrator for *Harper's Weekly* magazine, executing drawings from the front line during the Civil War. He was in Paris for a few months in 1867–8 but seems to have been more interested in the countryside than in French modern art, although he was impressed by Manet's broad tonal contrasts. A far more critical turning point in his career was his visit to Cullercoats in Northumberland in England in 1881. His reasons for selecting such an isolated spot remain puzzling, although he seems to have been motivated by a desire for 'atmosphere and colour' lacking in his homeland, America, where there was too much 'sameness' in the people and towns. Apparently he selected Cullercoats by a mere accident arising from a chance conversation with a man on the voyage over, who 'told him to go to the village … where he would find just the subjects for his brush that he was seeking'. To a friend at Cullercoats, Homer observed: 'look at the fishergirls. There are none like them in my country in dress, feature or form. Observe the petticoat that girl is wearing … No American girl could be found wearing a garment of that colour or fashioned in that style.'

In a large number of watercolours Winslow Homer evoked the noble grandeur of humble fisherwomen, making striking analogies with the draperies of antique classical sculpture. His final statement on the subject was an oil painting upon which he worked for some twenty-five years, entitled *Early Evening* (originally *Sailors Take Warning*) (Pl. 499).

In the early morning of 21 October 1881, just a few months after Homer had settled in Cullercoats, following a week of heavy storms in the North Sea, the 1,000-ton barque *The Iron Crown* was driven aground while trying to make harbour at Tynemouth. A rocket with a line enabled a breeches buoy to be connected and five crewmen were rescued, but only with great difficulty was the lifeboat, the *Charles Dibden,* launched. According to contemporary reports, it was 'a scene of great excitement and perseverance', for the waves kept pushing the boat 'broadside on the sand'

and only after '25 to 30 men struggled there for upwards of an hour' was the boat finally able to put to sea. Fourteen additional crewmen and the captain's wife were rescued. The experience, seared into Homer's memory, was commemorated in the watercolour *Wreck of the Iron Crown* (Pl. 500), a pivotal work in his artistic development. Reminiscences of the event return again and again in later works that he painted at Prout's Neck on the coast of Maine. There he lived in isolation, painting many majestic canvases of the ocean breaking on a rocky shore.

Thomas Eakins (1844–1916), often regarded as the outstanding American painter of the nineteenth century, was of Scots-Irish descent, but there the influence ends, for he was never to visit Britain. Born in Philadelphia, from 1866 to 1870 he studied in Europe. Like Winslow Homer, Eakins was fascinated by the play of light on water. From 1871 to 1874 he experimented by painting a series of rowing scenes showing the reflection of light on water at various times of day, which also enabled him to deal with another favourite theme, the depiction of bodies in motion. A fine example of this type of work is *The Biglin Brothers Racing* (Pl. 501).

Eakins had studied under Gérôme in Paris and later briefly visited Spain where he admired Velázquez and Ribera. There is indeed a strong reminiscence of the *morbidezza* of the latter artist in many of Eakins's most famous works, which share Ribera's stark realism, stress on anatomy and dark palette, notably in *The Gross Clinic* (Pl. 502). It portrays a surgical operation in progress, a subject which also recalls *The Anatomy Lesson of Doctor Tulp*, Rembrandt's famous painting of the same theme. It says much for the stature of Eakins as an artist that he was willing to take up such a challenging theme which would inevitably invite direct comparison with the Old Masters.

Eakins had a stormy career at the Pennsylvania Academy of Fine Arts, where he began teaching in 1876, and where Hovenden also taught. He was attacked for his insistence on working from nude models, and in 1886 he was forced to resign after allowing a mixed class to draw from a completely nude male model. In the last decades of his life he achieved recognition as a great master. His sporting paintings were particularly acclaimed, and proved extremely influential in the early twentieth century on the group of American realist painters nicknamed the Ashcan School, and notably on George Bellows, the painter of vivid boxing subjects.

In old age, when asked for his opinion as to 'the present and future of American art', Eakins replied:

499
Winslow Homer
Early Evening
1881–1907
oil on canvas, 83.8 × 98.5cm
(33 × 38¾ in)
Freer Gallery of Art,
Washington DC

500
Winslow Homer
The Wreck of the Iron Crown
1881
watercolour, 51.4 × 74.7cm
(20¼ × 29¾ in)
Baltimore Museum of Art

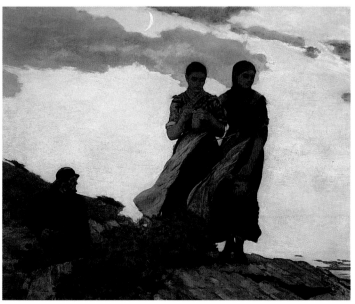

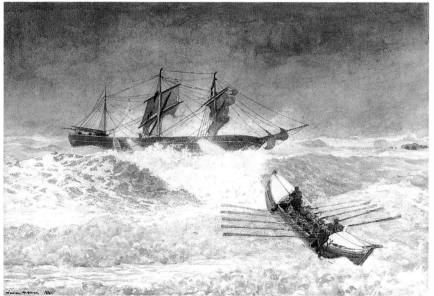

499

500

501
Thomas Eakins
The Biglin Brothers Racing
*c.*1873
oil on canvas, 61.2 × 91.6cm
(24⅛ × 36⅛in)
National Gallery of Art,
Washington DC

If America is to produce great painters and if young art students wish to assume a place in the history of the art of their country, their first desire should be to remain in America, to peer deeper into the heart of American life, rather than to spend their time abroad obtaining a superficial view of the art of the Old World … They must strike out for themselves, and only by doing this will we create a great and distinctly American art.

These words, so reminiscent of the earlier injunctions of Thomas Cole and Asher B. Durand, reflect one of the central dichotomies of American art in the second half of the nineteenth century, whether to restrict oneself to domestic pictorial themes and remain at home or to go abroad and gain international status while retaining a sense of national identity. Eakins's art, and to some extent Winslow Homer's, existed inde-

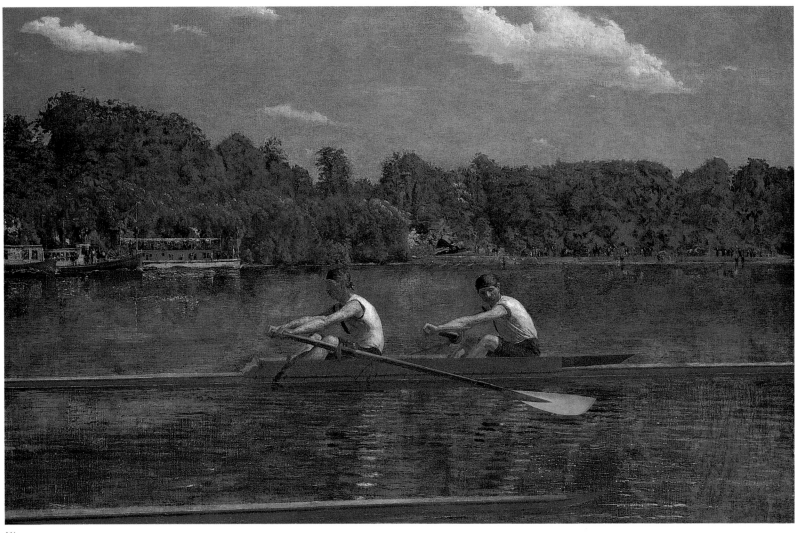

501

pendently of international trends, taking no part in the evolution from Realism to Impressionism through Post-Impressionism to the modern movements of the twentieth century.

So much, to use a sporting analogy, for the home team – what about the away team and the achievements of the greatest of all outsiders, the gadfly figure of Whistler, and the outstanding society portrait painter of his time, John Singer Sargent?

After Benjamin West, Whistler was the most influential of American expatriate artists to make his home in Europe. After training in Paris, he arrived in London in 1859 to plant the seed of the French Realist movement in British soil. The influence

of Courbet's gritty realism had been absorbed at first hand, for the two artists were friends, sharing the same model, the beautiful red-haired Irish girl Joanna Hiffernan. She appears as a prostitute discussing terms with clients (modelled by Whistler's friend Alphonse Legros) in one of Whistler's first works painted in England, *Wapping* (Pl. 503). This 'low life' subject is set in the first-floor bar of the Angel Inn on the south side of the Thames at Rotherhithe, looking across to the docks at Wapping seen through the masts, sails, ships and rigging of the Thames. In 1861 in a euphoric letter to Fantin-Latour, Whistler wrote, 'Shh! Don't speak of it to Courbet', as though the sordid subject was too tempting for the older artist to resist stealing.

Initially Jo's décolletage was much more pronounced. Whistler wrote in 1861, 'the bust is exposed, one sees the chemise almost entirely'. He laboured on the painting for four years, and experienced his first brush with the moral prudishness of British society, characterized as 'Mrs Grundy', when his friend Tom Armstrong warned him that the Royal Academy would never accept a picture in which so much cleavage was revealed! Whistler modified both the model's expression and dress, and the painting was exhibited at the Royal Academy in 1864.

Whistler was born to trouble as sparks fly upwards, his career being punctuated by one controversy after another, the most notorious being Ruskin's condemnation of Whistler's *A Nocturne in Black and Gold: The Falling Rocket* (Pl. 585) and the ensuing libel case (see below, pp. 470–5). Whistler won the case, but was awarded the insulting sum of a farthing's damages. What really stung was the personal animosity to his aims of artists he regarded as friends. Although not published at the time, Burne-Jones's statement to Ruskin's counsel summed up the widespread view that Whistler's work was 'meaningless scribbling', a 'bad joke'. Burne-Jones wrote:

> scarcely any body regards Whistler as a serious person … He has never yet produced anything but sketches, more or less clever, often stupid, sometimes sheerly insolent, but sketches always. Not once has he committed himself to the peril of completing anything … Thousands can sketch cleverly, amateurs often as adroitly as artists … his work has the merit that one sees in the work of a clever amateur … Mr Ruskin's language is justified.

After the experience of the Ruskin case, Whistler never felt completely at home in London again. He found refuge for a year in Venice where he painted one of his most haunting Nocturnes, *Nocturne in Blue and Silver: The Lagoon, Venice* (Pl. 586). On his return to England Whistler staged some remarkable exhibitions of his etchings and pastels which set new standards in aesthetic installation. In 1891, fourteen years after the trial, he finally had the satisfaction of selling the notorious *Nocturne in Black and Gold* for 800 guineas, rejoicing that 'the pot of paint flung into the face of the British Public for two hundred guineas has now sold for four pots of paint, and that Ruskin has lived to see it'.

Although only fifteen of his 69 years were passed in America, most of them being spent in France or England, Whistler still spoke two months before he died of America as 'my home'. His trenchant wit and highly individual aesthetic views published in *The Gentle Art of Making Enemies* (1890) confirmed his importance as the key artistic voice of his time. In it he wrote:

> Art should be independent of all claptrap – should stand alone, and appeal to the artistic sense of eye or ear, without confounding this with emotions entirely foreign to it, as devotion, pity, love, patriotism, and the like. All these have no kind of concern with it, and that is why I insist on calling my works 'Arrangements' and 'Harmonies'.

Although he was more concerned with evoking a mood than with the effects of light, Whistler's works are related to Impressionism, Aestheticism and Symbolism,

502
Thomas Eakins
The Gross Clinic
1875
oil on canvas, 243 × 198.1cm
(95⅜ × 78in)
Jefferson Medical College,
Thomas Jefferson University,
Philadelphia

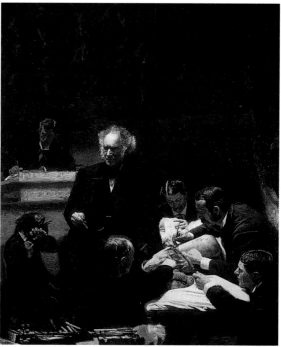

502

and he played a central role in the modern movement not only in England but the world.

Virtually as Whistler withdrew from the London scene in the 1890s, John Singer Sargent moved in, and as we have seen above (Pls. 93–5), he rapidly became the most sought-after portrait painter of his time in both England and America, which he often visited. He painted with equal facility the new money of the New World, and the high society of the Old World, but remained a very private person, who would end his career by painting one of the most moving records of the First World War, *Gassed* (1919).

In Paris in 1882, right at the begining of his career, Sargent painted *El Jaleo*

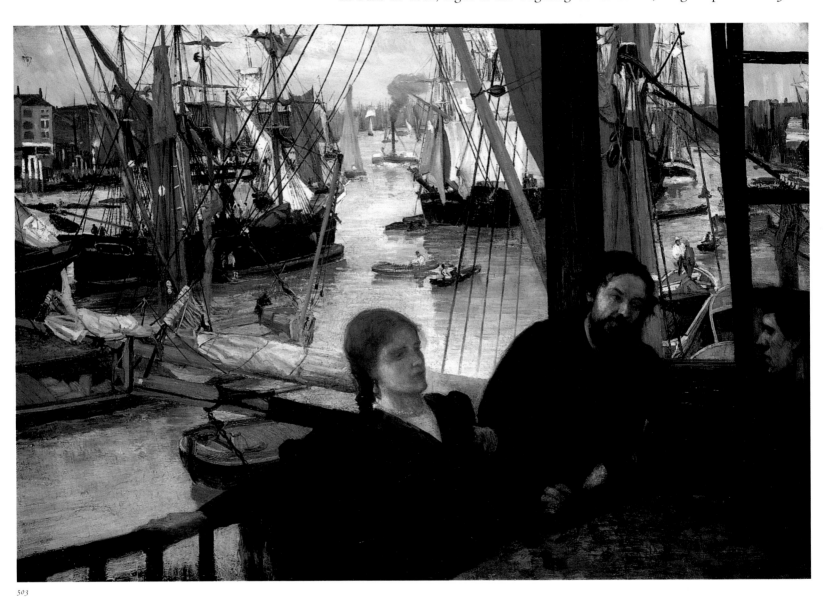

503
James Abbott McNeill Whistler
Wapping
1860–4
oil on canvas, 71·1 × 101·6cm
(28⅛ × 40⅛in)
National Gallery of Art,
Washington DC

503

(Pl. 504), a large Spanish flamenco scene worked up from notes made during an inspirational visit to Spain two years before. The dramatic, highlighted figures of the dancing gypsy and the seated guitar players give the work an immediate arresting quality, enhanced today by its setting in the Isabella Stewart Gardner Museum in Boston. The knobs on the lower moulding of the frame suggest footlights.

The favourable critical response which this large salon piece received when first exhibited may have been a determining factor in the course of Sargent's subsequent career. He was always to enjoy exotic subjects, depicting in 1889 a troupe of Javanese dancers at the Exposition Universelle in Paris. But his taste for the outré and the

sensual was to find expression increasingly in his portrait work, especially after the *succès de scandale* of his portrait of Madame Gautreau in 1884 (Pl. 93). Sensual and provocative portraits of wealthy women and powerful studies of haughty men flowed from his brush. He himself remained a fascinated observer of society, but always an outsider until in 1907, aged 51, at the height of his fame, he renounced painting portraits apart from his friends, and concentrated on landscapes, watercolours and murals.

In 1881, on a visit to London, Sargent met a young lady, Poppy Graeme, whom he had not seen for nine years. She wrote a revealing account of him in a letter to her mother: 'John is very stiff, a sort of completely accentless mongrel … rather French faubourg sort of manners'. Together they visited Burne-Jones's studio where Sargent especially admired a series of unfinished studies for the *Briar Rose* sequence (Pl. 496). Sargent's reaction to these works is of interest in view of later American attitudes to Pre-Raphaelite works. Although it is now accepted in both Britain and America that Pre-Raphaelitism was one of the major contributions to the art of the Victorian era, this acceptance has only come about relatively recently. Well into the

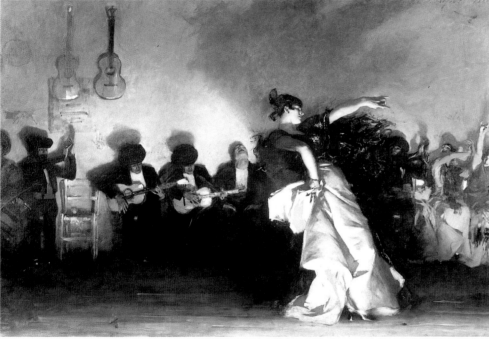

504

504
John Singer Sargent
El Jaleo
1882
oil on canvas, 239.7 × 347.6cm
(94½ × 137in)
Isabella Stewart Gardner
Museum, Boston

1960s and beyond, the American reaction against what was seen as the mawkishness of Rossetti and Burne-Jones was very entrenched. Indeed the very words 'Victorian art' produced a strong pejorative critical reaction. This is by no means a recent phenomenon, for as long ago as 1857–8 an exhibition of contemporary British art, containing a few key Pre-Raphaelite works such as Ford Madox Brown's *An English Autumn Afternoon* (Pl. 118), toured America. Organized by an entrepreneur, Captain Augustus Ruxton, and selected by William Michael Rossetti, it visited Philadelphia, New York and Boston, arousing barely a ripple of interest.

There were, of course, exceptions to this rule, notably Samuel Bancroft of Wilmington, Delaware, who, unlike any decent red-blooded American millionaire, collected Pre-Raphaelite paintings instead of Impressionists. This was seen as deeply eccentric. Even today old prejudices linger, and interest in Pre-Raphaelitism tends to be concentrated in the departments of English Literature in American universities concerned with the poetry of Morris and Rossetti and the critical views of Ruskin, rather than in faculties of Fine Art. Indeed it is interesting to observe how in many

505
Elihu Vedder
The Sphinx of the Seashore
1879–80
oil on canvas, 40.6 × 70.8cm
(16 × 27⅞in)
Fine Arts Museum,
San Francisco

506
Thomas Wilmer Dewing
Morning Glories
c.1900
oil on canvas mounted on
wood, 163·8 × 182·9cm
(64½ × 72in)
Carnegie Museum of Art,
Pittsburgh

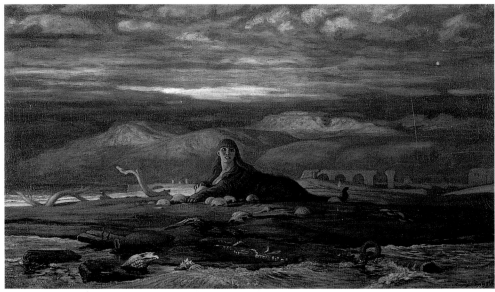

505

great American museums the word European is virtually synonymous with France, and examples of British and other European nineteenth-century paintings are little in evidence.

While neither the cause of Pre-Raphaelitism nor that of Symbolism was ever to become a major feature of the arts in America, there was one important artist concerned with such themes, the imaginative and eclectic Elihu Vedder (1836–1923), who like Whistler and Sargent was as much a European as an American artist. Born in New York, Vedder went to Paris in 1856 but soon departed for Florence, where he stayed until 1860, coming into contact with a highly original group of young realist painters known as the Macchiaioli (see below, p. 485). Vedder made many sketches, drawings and pastels in their manner, with such themes as the Roman Campagna, Egypt and Capri.

During the Civil War Vedder returned to America and worked as an illustrator, and after it was over he went back to Rome, marrying and settling there permanently in 1869. During the late 1860s he became close to Simeon Solomon, and was greatly influenced by Solomon's style and subject-matter, with its use of disembodied heads to symbolize night, sleep and death. His work also anticipates that of the Belgian Fernand Khnopff (1858–1921), particularly in the use of the sphinx motif in the enigmatic *Sphinx of the Seashore* (Pl. 505). In the 1880s Vedder, during frequent return visits to New York, worked with Louis Comfort Tiffany and designed decorative art objects ranging from fire backs to bell pulls and door knockers. In later life, while living on Capri, he turned to poetry and wrote an amusing autobiography.

Thomas Wilmer Dewing (1851–1938) was born in Boston and worked as a lithographer and portrait painter before studying for two years at the Académie Julian in Paris. On his return he worked in Boston and New York. Of his paintings it was said that his sole aim was 'to represent beautiful ladies … who seem to possess large fortunes and no inclination for any professional work'. At their best his frieze-like arrangements of women in classical drapery recall not only the work of Albert Moore and Burne-Jones, but even more, the eerie landscapes with figures of Khnopff. An unusual feature of Dewing's art were his screens, a notable example being *Morning Glories* (Pl. 506).

One of the finest groups of Dewing's work can be found in the Freer Gallery of Art in Washington, which also houses works by another artist who used symbolic overtones, Abbott Handerson Thayer (1849–1921). Believing that serene and

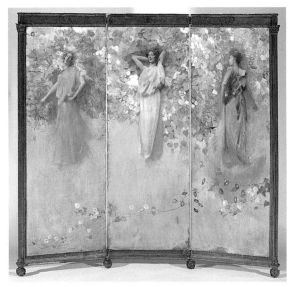

506

handsome women were the sacred embodiment of moral virtue, to emphasize their angelic qualities he would often supply his female subjects with wings, as in *Angel Seated on a Rock* (Pl. 507).

Albert Pinkham Ryder (1847–1917) was one of the most mysterious of American painters. Born at the fishing port of New Bedford, Massachusetts, he was largely self-taught, living and working most of his life as a solitary dreamer in New York. His paintings, often moonlit marine studies, reflect a haunting love of the sea, and an imaginative inner life. 'Have you ever seen an inch worm crawl up a leaf or twig, and then clinging to the very end, revolve in the air, feeling for something to reach something? That's like me. I am trying to find something out there beyond the place on which I have a footing.' Sadly, his oil paintings have often suffered from his faulty technique. Yet they possess at their best a strange power, as in *Toilers of the Sea* (Pl. 508) which, like his other marine paintings and like Victor Hugo's novel of the same title, conveys an imaginative identification with the sea as an elemental force.

If Symbolism found few American adherents, the same cannot be said of the theories and paintings of the Impressionist school, which from the 1880s began more and more to feature upon the walls of discerning American collectors. Although at first greeted with great hostility, something about the tenets of Impressionism – its direct recording of contemporary life, its objectivity, freshness and immediacy – struck a responsive chord in an America sated with academic teaching and anxious to create its own individual artistic idiom.

The greatest American exponent of Impressionism was Mary Cassatt (1844–1926), the daughter of a Pittsburgh stockbroker, one of the few woman artists to exhibit successfully with the Impressionists. Her work first caught the eye of the formidable misogynist Degas in 1874 at the Salon, who exclaimed: 'Voila! There is someone who thinks as I do', a sentiment which he later characteristically modified, exclaiming: 'No woman has a right to paint this well.'

507
Abbott Handerson Thayer
Angel Seated on a Rock
1899
oil on canvas, 213.5 × 153cm
(84 × 60¼in)
Freer Gallery of Art,
Washington DC

508
Albert Pinkham Ryder
Toilers of the Sea
c.1880–5
oil on wood, 29.2 × 30.5cm
(11½ × 12in)
Metropolitan Museum of Art,
New York

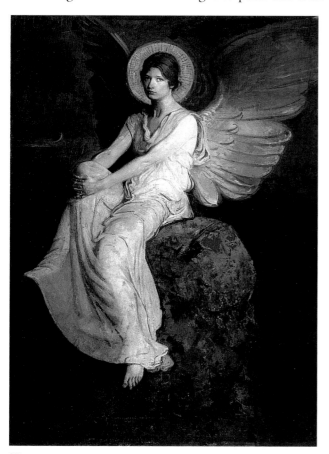

507

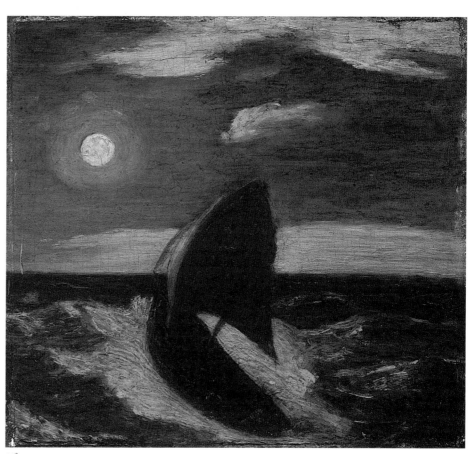

508

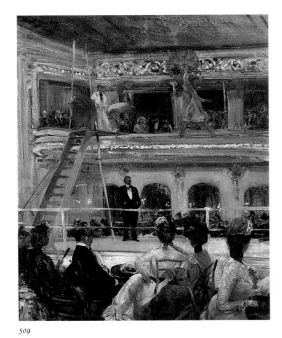

509

510

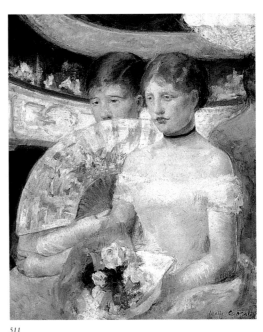

511

At that stage Cassatt's art was not yet dominated by the mother and child scenes and the influence of Japanese prints which preoccupied her after 1893, and she explored a wide range of scenes from public life. Her work was praised by Edmond Duranty: 'A most remarkable sense of elegance and distinction – and very English (she is an American) – marks these portraits.' Cassatt contributed to four of the Impressionists' shows, and subsequently exhibited her work via the famous dealer Durand Ruel. Through her family and her work she introduced many wealthy American art patrons to Impressionist paintings. Their purchases led to many fine examples of the Impressionist school finding their way into collections, and subsequently into museums, across the United States. 'I am an American, simply and frankly an American,' she told her French biographer in 1913. Although most frequently remembered for her studies of mothers and children, she also painted some engaging studies of the interiors of theatres such as *The Loge* (Pl. 511), in which two young women play with fan and bouquet, conscious of admiring male glances.

Many other American painters used techniques influenced by Impressionist principles, but major figures such as George Bellows, John Sloane and George Luks came to full maturity only in the 1900s and later, thus falling outside the scope of this study. William Glackens (1870–1938), however, just qualifies with his *Hammerstein's Roof Garden*, painted in 1901 (Pl. 509). In this work a girl tight-rope walker, clad in electric blue, uses a parasol as a balancing aid, in a composition which excitingly draws us into the audience gazing upwards at the act.

Although Childe Hassam (1859–1935) worked in a style close to that of the Impressionists, he only acknowledged the influence of Constable and Turner, whose works he had seen on two visits to England in 1883 and 1896. A great lover of New York, which he considered one of the most beautiful of all cities, he successfully captured the fashionable charms of *Washington Arch, Spring* (Pl. 510), the New York equivalent of the Arc de Triomphe in Paris, a subject which Hassam had painted two years earlier. In an interview in 1892 Hassam explained his motivations and beliefs: 'A true historical painter, it seems to me, is one who paints the life around him, and so makes a record of his own epoch.'

One of the greatest teachers of his time was William Merritt Chase (1849–1916), who settled in New York in 1878 after intensive study in Munich with the major German realist Wilhelm Leibl (1844–1900). He became a highly prolific artist, but

also found time to teach a generation of students, in New York, Brooklyn, Chicago, Philadelphia and finally at his own Chase School of Art, founded in 1896.

Highly sensitive to many international avant-garde movements, two elements in particular combine in Chase's work to give it its powerful individuality, realism and brilliant Impressionist technique. He was among the first American artists to practise *plein-air* painting, and also from the mid-1880s he frequently painted scenes of urban life, often set in New York's parks. Chase's early contact with Leibl and friendship with Whistler from 1885 gave his work a formal disciplined quality rarely seen in American Impressionist art, in which the influence of French examples is paramount.

From 1891 to 1902, Chase conducted classes outdoors at Shinnecock Hill near Southampton on Long Island, an area with which he became closely identified. There he painted many records of the ocean, among them his masterpiece, *At the Seaside* (Pl. 512), a delightful record of women and children enjoying the pleasures of a day on the beach, sheltered from the heat of the sun by brightly coloured Japanese parasols. The puffy little cumulus clouds give expression to Chase's doctrine: 'try to paint the sky as if we could see through it, not as if it were a flat surface, or so hard that you could crack nuts against it'.

As the twentieth century dawned new waves of emigrants flooded into America from Eastern Europe, southern Italy and Asia. 'We call England the Mother Country because most of us come from Poland or Italy,' wrote Robert Bentley. For a while the old artistic influences from France and England continued to hold sway, but as the century progressed artistic influences began increasingly to cross the Atlantic in the reverse direction from the New World to the Old.

American art had come of age …

509
William Glacken
Hammerstein's Roof Garden
*c.*1901
oil on canvas, 76·2 × 63·5cm
(30 × 25in)
Whitney Museum of American Art, New York

510
Childe Hassam
Washington Arch, Spring
1890
oil on canvas, 68·9 × 57·1cm
(27⅛ × 22½in)
Phillips Collection, Washington DC

511
Mary Cassatt
The Loge
1882
oil on canvas, 79·9 × 63·9cm
(31½ × 25⅛in)
National Gallery of Art, Washington DC

512
William Merritt Chase
At the Seaside
*c.*1892
oil on canvas, 50·8 × 86·4cm
(20 × 34in)
Metropolitan Museum of Art, New York

512

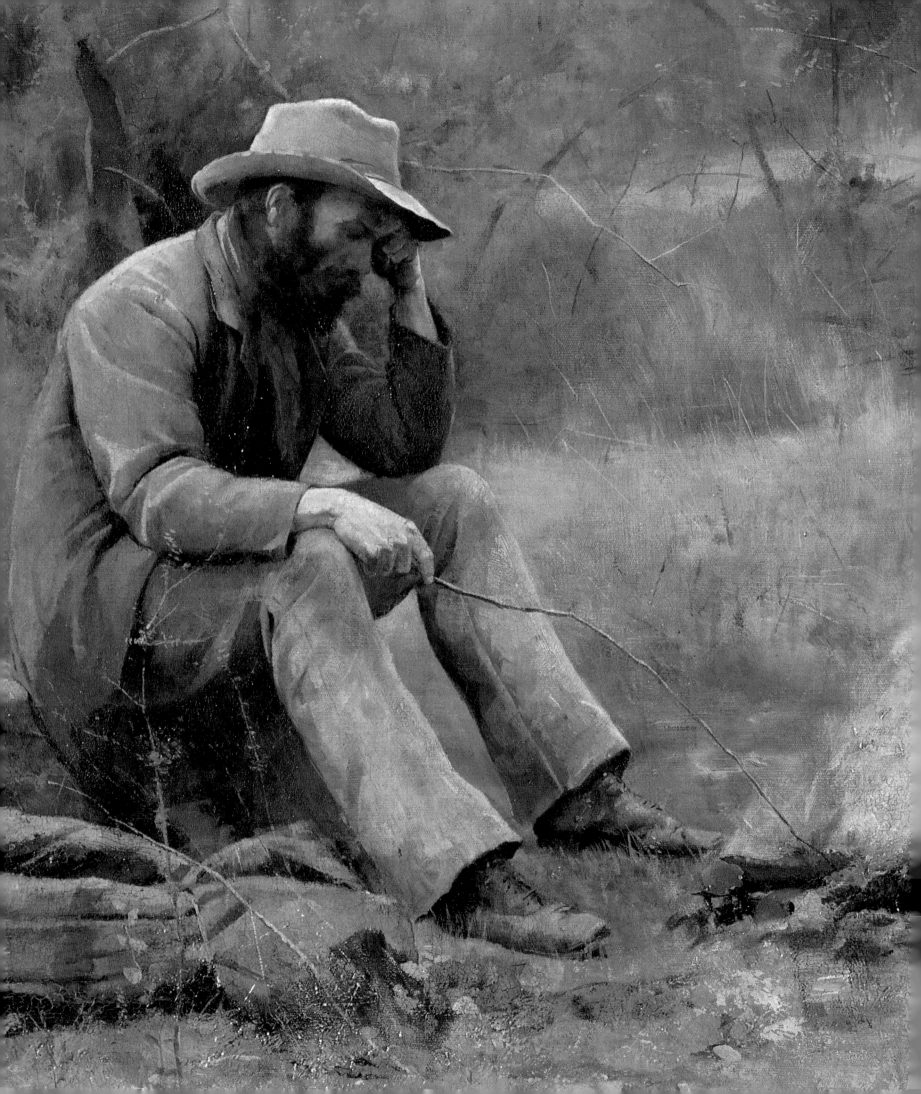

Queen Victoria was proclaimed Empress of India in 1877, a potent and symbolic event for the countries which became known as the British Empire. The conviction grew that the British were the richest and most powerful people on earth, and also the most moral and enlightened. Their mission, ordained by God, was to bring religion and the blessings of literacy, medicine, law, science and not least the arts to improve the lot of expatriates and civilize the native inhabitants of the new colonies and dominions. Such Imperial dreams were associated with Cecil Rhodes's desire to colour the map of Africa red from the Mediterranean to the Cape. They were very different motivations from the urge to explore and investigate uncharted lands which had commenced long before Victoria's reign.

Three distinct phases emerge in the development of the colonial arts. The initial impulse to draw and

513 Frederick McCubbin, **Down on his Luck** (detail of Pl. 530)

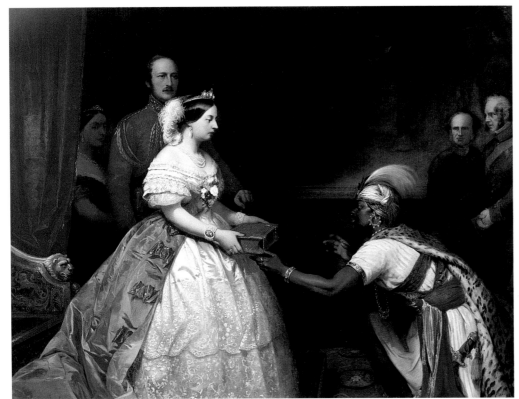

514

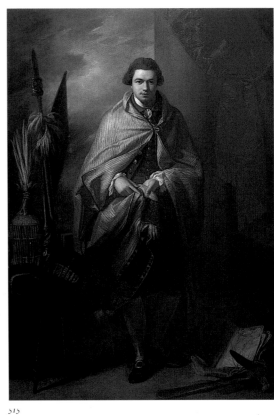

515

paint is associated with the demands of topography, botany and zoology, the need to record new landscapes and species. This was followed after the creation of new communities by a nostalgic and narrative artistic phase, either looking back with sentiment at the ways of the old country or modifying local behaviour to conform to the social mores of expatriate British customs. Finally there emerge new and distinct talents independent of the old country and with new aspirations. Some artists firmly repudiated old cultural ties, while others often returned to Britain and Europe to be taught, before establishing themselves once again in their home lands.

Benjamin West's portrait of the famous scientist Sir Joseph Banks (1743–1820), completed in 1771–2 (Pl. 515), contains within it many of the themes with which this chapter is concerned. It commemorates the triumphant return of the *Endeavour* from its first voyage to the South Pacific (1768-1771), captained by James Cook. On the voyage, a team of botanists and artists sponsored by Banks himself had recorded the 'discovery' of Australia and New Zealand, and the ship returned with many specimens of plants collected in 'Botany Bay'. These were neatly stored in the solander boxes named after Dr Solander, a distinguished member of the team.

Banks is shown wrapped in a Maori cloak of flax with a dog's hair fringe, and surrounded by other Polynesian and New Zealand trophies, including a boomerang, a Maori canoe paddle and ceremonial fighting club and a Tahitian head dress. Such a work by a great American artist of an English scientist whose investigations opened up the unknown continent of Australia and New Zealand marks a defining moment in the Western world. It presaged the eagerness to make new discoveries which was to characterize the nineteenth century. But such endeavours were sadly almost invariably to lead to the exploitation of the indigenous inhabitants, whether Aborigines in Australia, Maoris in New Zealand or Native Americans.

The second verse of Bishop Heber's missionary hymn 'From Greenland's Icy Mountains' describes the attitudes of most settlers to the indigenous ethnic art and artifacts they found in the new lands which formed their homes:

What though the spicy breezes
Blow soft o'er Java's isle,
Though every prospect pleases
And only man is vile:
In vain with lavish kindness
The gifts of God are strown
The heathen in his blindness
Bows down to wood and stone.

Objects made from wood, stone, metal and textiles were alike treated without respect. They were relegated, at best, to the role of curio, and at worse, as in the punitive expedition of General Pitt Rivers into Benin in 1896, to being looted as the degenerate productions of alien cultures. Attitudes to the indigenous art of the native inhabitants ranged from the contemptuous to the blankly incomprehending. Only a few sensitive observers came to realize that the way of life of the original inhabitants of these vast continents was threatened and needed to be recorded.

During her long reign Queen Victoria saw new frontiers unfold in the unknown continents of Africa and Australia. Although she never visited India, the great sub-continent was very close to her heart, an affection reflected in a painting by Thomas Jones Barker entitled *The Secret of England's Greatness* (Pl. 514). An Indian Prince nervously receives a Bible from the Queen in the Audience Chamber of Windsor Castle, while Prince Albert, Lord John Russell and Lord Palmerston look on impassively.

The importance of spreading the Christian faith provided the impetus for the travels of the great missionary explorers such as David Livingstone in Africa. But subversive doubts were soon to assail the certainties of conventional religious thought. When HMS *Beagle* sailed out of Plymouth in 1831 on a five-year survey round the world, her devout commander Captain Fitzroy did not foresee that the conclusions arrived at by the young naturalist Charles Darwin would change the course of human thought. Fundamental belief in the Bible would suffer greatly as a result of the public storm which blew up over the publication of Darwin's *The Origin of Species* in 1859, setting out the theory of evolution that had gradually developed from his natural history studies made on the expedition. Both Church and Establishment were

514
Thomas Jones Barker
The Secret of England's Greatness
c.1861
oil on canvas, 167.6 × 213.8cm
(66 × 84¼in)
National Portrait Gallery,
London

515
Benjamin West
Sir Joseph Banks
1771–2
oil on canvas, 233.7 × 159.8cm
(92¼ × 63in)
Usher Art Gallery, Lincoln

516
Augustus Earle
A Bivouac of Travellers in Australia in a Cabbage Tree Forest, Day Break
1838
oil on canvas, 118 × 82cm
(46½ × 32¼in)
National Library of Australia,
Canberra

517
Conrad Martens
Sydney Harbour Looking towards the North End
c.1836
watercolour, 44.5 × 63.5cm
(17½ × 25in)
Private collection

516

517

518
Thomas Griffiths Wainewright
**The Cutmear Twins:
Jane and Lucy**
*c.*1840
watercolour and pencil,
32 × 30cm (12⅝ × 11⅞in)
National Gallery of Australia,
Canberra

519
John Glover
My Harvest Home
1835
oil on canvas, 76.2 × 113.9cm
(30 × 44⅞in)
Tasmanian Museum
and Art Gallery, Hobart

520
John Glover
**The Bath of Diana, Van
Diemen's Land, 1837**
1837
oil on canvas, 76 × 114cm
(30 × 45in)
National Gallery of Australia,
Canberra

518

appalled at what they considered blasphemous theories; the controversy raged long and bitterly.

All this lay in the future when Darwin on board the *Beagle* met his fellow passenger, the artist Augustus Earle (1793-1838). He had enjoyed a truly remarkable life, for he was the first independent, professional artist to visit all five continents and record his experiences. The son of a well-known American portrait painter, Earle studied at the Royal Academy in London before travelling for two years in the Mediterranean, two years in North America and four years in Brazil. On his way to India he was shipwrecked on Tristan da Cunha, where he was rescued after eight months by the *Admiral Cocksure* bound for Hobart. During the ensuing two-year stay in Australia, Earle's industrious brush was rarely still. He travelled widely in the newly opened New South Wales, making copious drawings. He later visited New Zealand and India, before returning to London and embarking as topographical artist on the *Beagle* with Charles Darwin. He made several lively impressions of life on board, from the crude joking during the ceremony of crossing the Equator, to Bible readings and the fun and games of the midshipmen.

For health reasons Earle had to leave the *Beagle* in Montevideo to return to England. There he painted a final work, *A Bivouac of Travellers in Australia in a Cabbage Tree Forest, Day Break* (Pl. 516), which he exhibited at the Royal Academy in 1838. It portrays a group of travellers, accompanied by their native guides, seated round a blazing camp fire, and conveys mysteriously the life of the colonial frontiersman, an imaginative ideal which was beginning to supplant the idea of the Noble Savage in the European imagination.

Captain Fitzroy of the *Beagle* was fortunate to be able to replace Earle with an artist of the calibre of Conrad Martens (1801–78). He was born of German parentage in London, and studied under the famous watercolourist Copley Fielding. He too travelled extensively before finally settling in Sydney in 1835, where he remained until his death, becoming the most prolific of Australia's colonial painters, having inherited Copley Fielding's fecundity of inspiration. He will always be remembered for his many romantic interpretations of Sydney Harbour (Pl. 517) and the Blue Mountains, often reinterpreted as lithographic illustrations in books of picturesque views.

Australia was a little short on romance in the early decades of the Victorian era. Between 1788 and 1867, 150,000 British convicts were sent to Australia, and up until 1853 the hard-core recidivists were often sent to Port Arthur, on Van Diemen's Land. Three years later the island adopted the name Tasmania, unstained by penal associations. One convict painter should be mentioned, namely the fascinating figure of Thomas Griffiths Wainewright (1796–1847), forger, painter and poisoner, the subject of Oscar Wilde's witty essay 'Pen, Pencil and Poison' (1891). Wainewright exhibited at the Royal Academy before being convicted of forgery and transported to Hobart in 1837, where he was in demand as a portrait painter, producing such works as *The Cutmear Twins: Jane and Lucy* (Pl. 518). But his lot was unusual and the labouring convict, unlike the *banditti* portrayed by Salvator Rosa, never became a picturesque feature of the landscape.

In the 1830s the colony began to attract much publicity in England as being a desirable place to settle with a little capital. One artist to take up this challenge was John Glover (1767–1849). The son of a Leicester farmer, Glover had enjoyed a successful career as an artist in England, becoming known as the 'English Claude' for his large and somewhat dull landscapes, a nickname which greatly annoyed John Constable. He moved to London in 1805 where he exhibited at the Royal Academy, and became President of the Old Water Colour Society in 1807. Possessing, it is said,

519

520

521

522

as much as £60,000 to invest in his new life, he decided to leave England, settle with his family in the new colony, and paint its little-known scenery. He arrived in Hobart in February 1831 aged 64, where he obtained a large grant of land in the north-east of Tasmania. There he built a two-storeyed house, calling the estate 'Patterdale', after the lake in Cumbria in England near which he had lived for some years, only ten miles away from William Wordsworth, whom he may well have known. There is certainly something distinctly Wordsworthian in the remarkable landscapes of Glover's old age, works of an exalted nature, such as *My Harvest Home* (Pl. 519).

Unlike many European newcomers, Glover was interested in the native aboriginal people, sending home paintings of Corroborees, or such idyllic scenes as the ironically entitled *The Bath of Diana* (Pl. 520). He also realized that the trees, notably the Australian eucalypts, were fundamentally different from European trees. In the catalogue of a one-man show which was held in Bond Street, London, in 1835 he wrote: 'There is a remarkable peculiarity in the trees in this country; however numerous they rarely prevent you tracing through them the whole distant country.'

To stand in the gallery in Hobart where both the Glovers and Benjamin Duterrau's *The Conciliation* (Pl. 521) are on view is a deeply moving experience. Geographically as remote from Europe as it is possible to be, Glover echoed the identification with nature felt by artists as diverse as Claude and Samuel Palmer.

The world painted by Benjamin Duterrau (1767–1851), by contrast, was far from idyllic. Like Glover, Duterrau emigrated to Tasmania late in life, arriving there in 1832 at the age of 64. To him lies the strange distinction of producing the first History painting in Australian art, a scene he may actually have witnessed, unlike most history painters. *The Conciliation* shows George Robinson, the Methodist bricklayer who tried to protect the last Tasmanian aborigines by persuading them to follow him to a safe haven where no white man would persecute them. Tragically, they were placed on Flinders Island in Bass Straight where they pined away, a last moving portrayal of them being painted by Robert Dowling (1827–86). Dowling was brought to Tasmania by his father, a Baptist minister, in 1831. After studying art he returned to England and exhibited several paintings of aboriginal themes at the Royal Academy which evoked an atmosphere of melancholy brooding over the doomed race. His *Aborigines of Tasmania* (Pl. 522) is a haunting memorial of this tragedy. The last Tasmanian aborigine, Truganini, died in May 1876, but her bones endured the indignity of exposure in a museum until 1976, when they were cremated and the ashes scattered on the waters of the beautiful D'Entrecasteaux Channel.

The natural backcloth for Hobart in Tasmania is the landscape of Mount Wellington, captured in the 1840s by John Skinner Prout, nephew of the watercolourist Samuel Prout, who also liked to paint Fern Tree Valley just outside the town. A watercolour by Skinner Prout of particular interest is *Ancanthe, Lady Franklin's Museum, Van Diemen's Land* (Pl. 525), for it depicts one of the first Australian museums, where the formidable bluestocking, Lady Franklin, held court. On his return to London, Skinner Prout exhibited a panorama of *A Voyage to Australia* (see above, pp. 163–5)

Lady Franklin's patronage and friendship were important between 1838 and 1840 to the ornithologist John Gould and his wife Elizabeth. The Goulds had come to Hobart to make an illustrated record of all Australian bird species, a project of great interest to European ornithologists, fascinated by travellers' accounts of such exotics as black swans and cockatoos in the largely unknown continent. Gould went on field trips collecting specimens in South Australia, New South Wales and Tasmania, which his wife Elizabeth carefully drew. One of Gould's own powerful drawings is of the *Great Brown Kingfisher*, better known as the Laughing Kookaburra (Pl. 523). Later,

521
Benjamin Duterrau
The Conciliation
1840
oil on canvas, 121.2 × 170.5cm
(47¾ × 67⅛in)
Tasmanian Museum
and Art Gallery, Hobart

522
Robert Dowling
Aborigines of Tasmania
1859
oil on canvas, 152.7 × 304.3cm
(60½ × 119⅞in)
Queen Victoria Museum,
Launceston

523
John Gould
**Great Brown Kingfisher
(Dacelo gigantea)**
1843
pencil, watercolour and
coloured chalks, 54 × 37cm
(21¼ × 14½in)
Private collection

524
Samuel Thomas Gill
**Digger's Wedding in
Melbourne**
*c.*1856–80
watercolour over pencil,
18.9 × 25.7cm (7½ × 10⅛in)
La Trobe Picture Collection,
State Library of Victoria,
Melbourne

525
John Skinner Prout
**Ancanthe (Lady Franklin's
Museum), Near Hobarton,
Van Diemen's Land**
1845
watercolour with white
heightening, 26.3 × 18.3cm
(10⅜ × 7⅛in)
Tasmanian Museum
and Art Gallery, Hobart

back in England, drawings and specimens were both used in the creation of the 600 magnificent plates of the seven volumes of *The Birds of Australia* (1840–8), lithographed by Elizabeth Gould and H.C. Richter. Further volumes depicted kangaroos and other Australian mammals.

Several artists important in the evolution of Australian painting, like Skinner Prout, stayed there only for a few years. William Strutt (1825–1915) lived in Australia for eleven years. Trained in Paris under Ingres, Delaroche and Vernet, he had worked as an illustrator before eye-strain led him to emigrate to Victoria in search of an outdoor life. In February 1851 a tremendous bush fire swept through Victoria, covering Melbourne in a pall of smoke which blotted out the sun and made the temperature soar to 117 degrees. The dramatic theme proved irresistible to Strutt, who made copious sketches of the devastation and worked for three years on a vast picture over 11 feet long entitled *Black Thursday* (Pl. 526), which was exhibited at the Royal Academy and Crystal Palace, before touring Australia.

In 1852 Strutt painted another Australian theme, *Bushrangers on the St Kilda Road,*

524 525

before leaving for a visit to New Zealand in 1855, where he lived with his wife in a tree fern house for eighteen months, painting the Maoris and the scenery around New Plymouth. Returning to Melbourne in 1856, he sketched the departure of the Burke and Wills expedition in 1860, another theme to which several later Australian artists would return, including Sir Sydney Nolan in our own day. Strutt returned to England in 1862, but Australian and New Zealand subject-matter continued to play an important role in his work.

Samuel Thomas Gill (1818–80) was educated at the Naval and Military School, Plymouth, where his father was headmaster, and studied in London. In 1839 he emigrated to South Australia and settled at Adelaide as a topographical, portrait and animal painter. In 1846 he accompanied Horrocks's exploration party to the interior, and in 1851 joined the gold rush to Bendigo and Ballarat. His paintings, particularly the watercolours, have a gusto and wit that reflect Australian humour with its irony and irreverent attitude to authority. In 1869 he was commissioned by Melbourne

Public Library to make forty watercolours of the scenes he had witnessed at the diggings in the gold rush of 1851. Gill's energy and wit are seen to advantage in *The Digger's Wedding* (Pl. 524). Such works give him a status in Australia somewhere between that of Thomas Rowlandson and John Leech in England.

Gill's humour forms a welcome contrast to the nostalgia of a work such as *A Primrose from England* (Pl. 527) by Edward William John Hopley (1816-69). In 1842 Dr Nathaniel Ward invented a glazed case which he used successfully to create mini-climates, enabling him to transport tea plants from Shanghai to the Himalayas, and bananas from China to Fiji and Samoa. In a paper read at the Royal Institution in London, Ward described another application of his invention. An English primrose had been taken to Australia in a covered glass case, and: 'when it arrived there in full bloom, the sensation it excited as a reminiscence of ... the old country ... was so great that it was necessary to protect it by a guard'.

Such feelings of nostalgia coexisted with a realization that in Australia lay rich and exciting new vistas. These sentiments were described as early as 1839 in a report in the London journal *The Art-Union* entitled 'The State of Arts in New South Wales and Tasmania'. Dr John Lhotsky, a Polish scientist, enthused over the Australian landscape with its 'gigantic gum and acacia trees, forty feet in girth, some of them cov-

526
William Strutt
Black Thursday
1854
oil on canvas, 106.5 × 343cm
(41⅞ × 135in)
La Trobe Picture Collection,
State Library of Victoria,
Melbourne

526

ered with a most smooth bark, externally as white as chalk, the ... appearance of the forests, the foliage ... in a way defying description – mornings and evenings so pure and serene that the eye is absorbed as it were, in the depths of the azure of the horizon'. He forecast the emergence of a Salvator Rosa to portray these delights: 'Australian sky and nature awaits, and merits real artists to portray it.'

But before we examine how these prophetic words came to be fulfilled, it is worth examining the parallel development of art in New Zealand. Augustus Earle with his accustomed natural energy made the most of a nine-month visit in the 1820s, but after that the recording process rather than the artistic urge predominated.

Today, when videos to tempt tourists to visit exotic locations are a commonplace, it is interesting to note how in the 1840s the New Zealand Company, eager to attract potential settlers, sponsored virtually as 'visual aids' large-scale books illustrated by lithographs after the watercolours of one of their employees, Charles Heavy, a surveyor artist. The enterprise may have been partially responsible for almost 12,000 immigrants making the voyage during the decade.

There was great curiosity as to the appearance of the Maori race. This was partially satisfied by George French Angas (1822–88), who published his *New Zealanders*

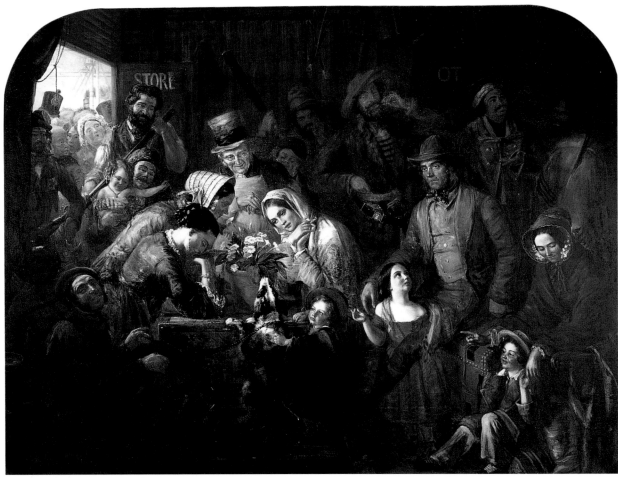

527

528

Illustrated in London in 1846–7, based on watercolours which he made during a six-month visit in 1844 and exhibited in the Egyptian Hall, Piccadilly, in 1846 (Pl. 529).

Before arriving in Auckland on North Island in 1852, Albin Martin (1813–88) had been a pupil of John Linnell and associate of Samuel Palmer, to whom he sent back watercolours and oil sketches of his new home. A founder member of the Auckland Society of Artists in 1869, he was instrumental in the opening of the Auckland City Art Gallery in 1888. His own individual vision of North and South Island scenery transformed the landscape into a Claudian idyll, as in the painting exhibited in 1882 entitled *Maoris Returning from Fishing: Evening View at East Tamaki*, also known as *The Artist's Farm at Tamaki* (Pl. 528).

While artists in New Zealand turned back to the traditions of seventeenth-century landscape, in Australia painters began a flirtation with the new spirit of Impressionist art. It was held that an artist could not really claim to be an artist without a period of study in Europe. The great Australian expatriate movement had begun, and John Russell (1858–1930), the first wealthy Australian artist to settle in Paris, came to know artists as various as Monet, Sisley and Van Gogh, whose portrait he painted and with whom he carried on a fascinating correspondence.

Sardonically, Russell boiled down the prospects facing Australian artists to two words: 'Genesis and Exodus'. But not all artists followed the rush to Europe, satirized in an ironic poem by Victor Daley, an Irish-born poet and champion of national aspirations:

> Correggio Jones an artist was
> Of pure Australian race
> But native subjects scorned because
> They were too commonplace.

Frederick McCubbin (1855–1917) was perhaps the most important artist not to visit Europe, at least not until 1907 when he had become fully established. Even during his student days in Melbourne, he succeeded better than any predecessor at painting the translucent qualities of the foliage of the Australian bush, the silvery grey tonal values of the bark of the trees and sinuous saplings. In 1886, prompted by his friend Tom Roberts's interest in the *plein-air* methods of Bastien-Lepage, he began his own large-scale social paintings. McCubbin's themes were drawn from Australian life in the bush, ranging from the anguish of *The Lost Child* (1886) to another familiar Australian theme, *Down on his Luck* (Pl. 530), a depiction of the unsuccessful gold digger. For *Bush Burial* (1890), the artist actually dug a little grave near his home at Blackburn and his wife posed as the bereaved mother. Inevitably these melancholy themes recall the sentiment of artists contributing to the British magazine the *Graphic*, which McCubbin may have known, but they also hark back to earlier colonial subjects and possess a distinctly national quality all their own.

This quality found its most exciting expression in the group of artists associated with McCubbin which became known as the Heidelberg School after a suburb of Melbourne, notably Tom Roberts, Sir Arthur Streeton and Charles Conder.

Tom Roberts (1856–1931) had emigrated to Australia from Dorchester when aged 13, and found work with a suburban photographer in Melbourne. His first teacher was the Swiss-born painter Abram Louis Buvelot (1814–88), whose style was an individual mix of the Barbizon and Swiss schools sensitively adapted to capture something of the strange beauty of the Australian landscape. In the evenings Roberts studied at the Melbourne School of Design, where his teacher Thomas Clark encouraged him to go abroad for further study. In 1881 Roberts went to Europe, travelling, it is said, on the same ship as John Russell. In London Roberts became

527
Edward William John Hopley
A Primrose from England
c.1855
oil on canvas, 122.5 × 159.5cm
(48¼ × 62¾in)
Bendigo Art Gallery, Victoria

528
Albin Martin
Maoris Returning from Fishing: Evening View at East Tamaki
1882
oil on canvas, 59.7 × 80cm
(23½ × 31½in)
Auckland Art Gallery

529
George French Angas
Maori Head
c.1844
watercolour
Location unknown

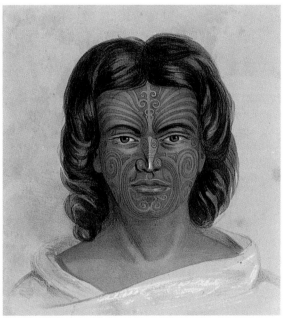

529

influenced by the work of Bastien-Lepage and worked for a while at the Royal Academy Schools. He also made visits to France, where he could have seen the seventh Impressionist Exhibition in 1882, and must surely have heard the vehement debate over the issues which it raised. But it was during a summer walking tour of Spain in 1883 with John Russell that Roberts seems to have had a Pauline conversion to Impressionist values. He met two Spaniards, Loreano Barrau and Ramon Casas, both pupils of Gérôme. They advised him to visit the Académie Julian at the heart of the contemporary art controversies in Paris, and passed on to him a dictum of Gérôme: 'When you draw, form is the important thing; in painting the *first* thing to look for is the *general impression* of colour.' Thus the paradox emerges that Gérôme, the arch-enemy of Impressionism, should inadvertently have been the midwife to the birth of another school of Impressionism on the other side of the world.

Back in Australia, Roberts and McCubbin set up camp together in the bush near Melbourne. In a number of paintings Roberts revealed that his visit to Europe had widened his vision in many ways. *Bourke Street* (Pl. 531), one of his most spirited

530

townscapes, he first called *Allegro con brio*, a musical term reminiscent of Whistler but in a completely different tempo and mood to Whistler's Nocturnes and Arrangements. Camille Pissarro's views of the *grands boulevards* are recalled by the daring viewpoint looking down on the bustling street. In his large canvas *Shearing the Rams* (1889/90), Roberts displays a quite different quality – an almost Pre-Raphaelite obsession with realism, perhaps the outcome of his years as a photographer's assistant.

It is, however, in major landscapes such as *A Breakaway!* (Pl. 532) that Roberts succeeds totally in capturing the very essence of the Australian landscape – the dryness, the silvery bark of the trees, the clouds of dust cast up by the herds of thirst-crazed stampeding sheep, controlled by the two twisting bodies of horse and rider.

Another recruit to the Heidelburg group was Arthur Streeton (1867–1943), who as a 19-year-old lithographic apprentice, dissatisfied with night school teaching, met Roberts when he and McCubbin were renting a cottage at Mentone on Port Philip Bay. He joined them there in 1887, and his work soon took on an early idyllic

maturity which captured the gold and blue landscapes of the Yarra Valley, that 'basked full three quarters of the year in sunlight' – qualities revealed in his *Fire's On* (Pl. 533). His own words vividly describe the atmosphere he caught on canvas as a team of railway navvies blasted a culvert through the rock:

> I work on the W. colour drying too quickly and the ganger cries 'Fire, Fire's On';
> all the men drop their tools and scatter and I nimbly skip off my perch and hide
> behind a big safe rock … a boom of thunder shakes the rock and me … All at
> work once more – more drills; the rock is a perfect blazing glory of white, orange,
> cream and blue streaks here and there where the blast has worked its force!

Like many other artists who came to Australia in the nineteenth century, Charles Conder (1868–1909) was sent in 1884 to learn surveying under the watchful eye of

531
Tom Roberts
Allegro con brio: Bourke Street
*c.*1886
oil on canvas, 51.2 × 76.7cm
(20¼ × 30¼in)
National Library of Australia, Canberra

531

an uncle. Born in London but brought up in India, there was in Conder always a hint of the exotic. After two years in surveyors' camps he got a job as a lithographic draughtsman on the *Illustrated Sydney News*. He met Roberts, then on a visit to Sydney, who taught him some of the principles of Impressionism. This led to the production of *Departure of the SS Orient from Circular Quay* (Pl. 534), one of the most powerful of all Australian Impressionistic paintings. In December 1888, Conder joined the Heidelburg group at Melbourne. Encouraged by his friends, he developed swiftly as an artist with works such as *A Holiday at Mentone* (Pl. 535), and in 1889 Roberts, Streeton and Conder jointly held the first Australian Impressionist show, called the 9 × 5 exhibition group (after the size of the cigar box lids on which most

532

of the paintings were made). Conder then left for Paris, where his subsequent career was to become one of the legends of the 1890s (see below, pp. 492–4).

In Canada, as in Australia, depictions of the original inhabitants of the new colonies were works with tragic resonances, which remind us that in the eighteenth and nineteenth centuries very few people had doubts concerning the sharp difference between a civilized man and a savage. The idealistic concept of the Red Man as a dignified 'noble savage' associated with Jean-Jacques Rousseau (1712–78) did little to ameliorate the threatened way of life of the Black Foot and other tribes, the recording of which became the life work of the Irish-born Canadian Paul Kane (1810–71). He had come to Canada in about 1818 and settled at Cobourg east of Toronto on Lake Ontario, working as an itinerant portrait painter. In 1842 he visited Italy and London where in 1843 his discovery of the work of the American artist George Catlin changed his life. Fom 1845 to 1848 he set out while travelling with Hudson's Bay Company to portray the Ojibwa people and their customs. He later used the drawings made on these travels when in 1851 he began a grand cycle of 100 canvases of Native Americans such as *Portrait of Kee-A-Kee-Ka-Sa-Coo-Way* (Pl. 536). These works both provide us with a form of History painting and represent the chief documentary record of several Native American tribes at this time.

Kane's specialized choice of theme did not bring him the widespread recognition of the most famous Canadian artist to emerge in the 1850s, the Dutch-born Cornelius (David) Krieghoff (1815–72). He had studied in Düsseldorf, lived in New York and served in the US Army, and returned to Europe to study in Paris before settling in Canada, after which he continued to make several trips to Europe. From 1853 to 1864 he was chiefly based at Quebec, creating some of his most popular subjects such as scenes on Habitant farms and *Merrymaking* (Pl. 538). They had great appeal to English settlers accustomed to both their own native genre tradition and the Dutch school. French settlers with more sophisticated tastes regarded them

533

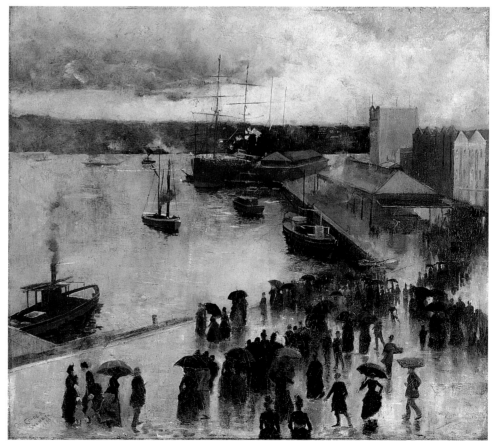

534

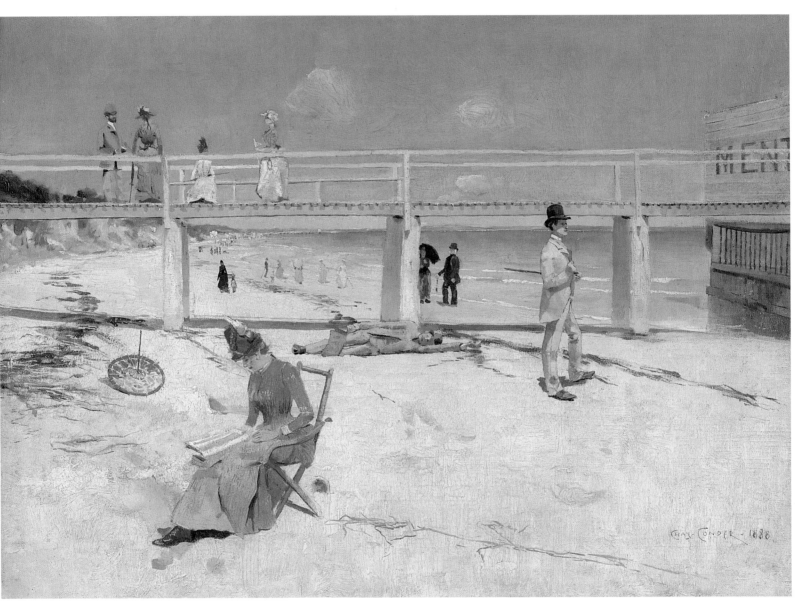

535

somewhat patronizingly, particularly such scenes as *The Officer's Trophy Room* (Pl. 539), with its wildly heterogeneous assemblage of objects ranging from the bust of Shakespeare to heavy gilt frames, a characteristic example of a cluttered mid-Victorian interior.

In May 1882 Oscar Wilde visited Toronto on a North American lecture tour and saw there some landscapes by Homer Watson (1855–1936) which he greatly admired, exclaiming 'The Canadian Constable!', a remark which impressed the artist hitherto unaware of Constable's work. Wilde later acknowledged in glowing terms on 15 February 1888 the receipt of a painting commissioned from Watson:

> My Dear Watson
>
> The picture has finally arrived and I have much pleasure in telling you how pleased I am with it. It is quite what I desired from your hand, in tone and technique and feeling: the treatment of the sheep is excellent and the whole sense of rain and wind entirely free and delightful.
>
> I have much pleasure in enclosing a cheque for $50. I hope to be able to get you some more commissions here, and I want to be able to have some day the pleasure of personally knowing one whose work gives me such great artistic pleasure.

Unfortunately this painting disappeared in Wilde's bankruptcy sale. It would be interesting to know if it shared the qualities to be found in Watson's *Before the Storm* (Pl. 540), executed in 1877 when the artist was at the peak of his powers. He wrote to a friend describing how he was 'painting like blazes. Have finished up that white road and dark sky affair and it is my best so far.' Its dramatic stormy sky does indeed come strikingly close to Constable. Watson eventually made the trip to England, where he stayed three years, meeting Wilde, who introduced him to Whistler.

An artist whose work possesses something of the intensity of the Pre-Raphaelite school was William G.R. Hind (1833–89), who was born in Nottingham, and followed his brother to Toronto. In 1861 the two brothers set out on a trip of exploration to Labrador. The watercolours and drawings made on the journey possess a focused clarity and power seen to admiration in *The Game of Bones* (Pl. 537).

As the railroads pushed their way west across the plains and the Rockies, artists charted their progress across the new continent in works such as *The Canada*

536 537

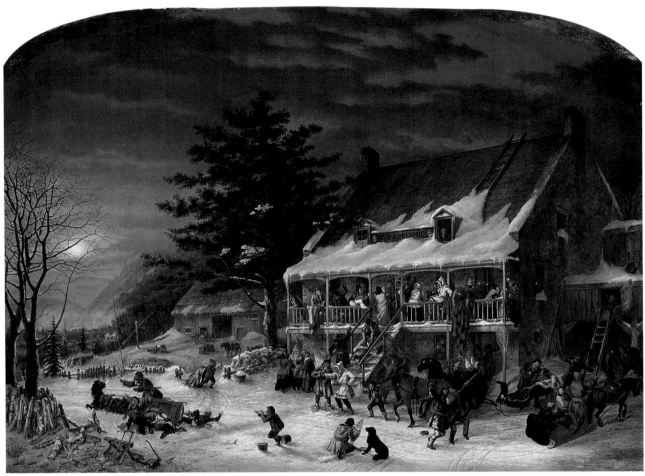

538

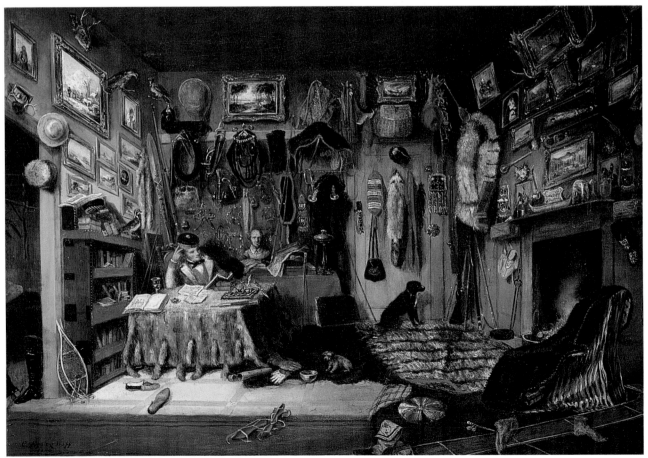

539

540

538
Cornelius (David) Krieghoff
Merrymaking
1860
oil on canvas, 87.6 × 121.9cm
(34½ × 48in)
Beaverbrook Art Gallery,
Fredericton, NB

539
Cornelius (David) Krieghoff
The Officers' Trophy Room
1846
oil on canvas, 44.5 × 63.5cm
(17½ × 25in)
Royal Ontario Museum,
Toronto

540
Homer Watson
Before the Storm
1887
oil on canvas, 61.4 × 91.5cm
(24¼ × 36in)
Art Gallery of Windsor,
Ontario

Southern Railway at Niagara (Pl. 541) by Robert Whale (1805–87), who specialized in 'portraits' of trains in spectacular settings. Later in the century the landscape painter Lucius O'Brien (1832–99) caught something of the great wilderness in such works as *A British Columbian Forest* (Pl. 542). These scenes would later inspire artists such as Emily Carr and the Group of Seven whose highly individual voice were not to be heard until the twentieth century and therefore do not enter the narrative of Victorian painting.

Queen Victoria, delighted with the Imperial crown, felt that England's duty in building the Empire was 'to protect the poor natives, and advance civilization'. Pictorial records of Imperial India were, however, to be very different from those of East India Company days, which had seen the flourishing of European painters such as Johan Zoffany, Tilly Kettle, the Daniells and the miniaturist John Smart.

The Victorian era was less well served with high-calibre artists, with one major exception. In 1871 Lord Northbrook was appointed Viceroy of India, and within a few weeks invited his old friend Edward Lear to visit him as his guest to see and record the country. Lear's trip to India and Ceylon was to be the last and longest journey of his life. The news of his impending visit spread, and in 1872 when Lear visited England from his home in San Remo he began to receive many commissions for Indian paintings, one from another friend of long standing, Lord Aberdare. To him Lear wrote, 'But will you not tell me if you have any special wish for one view more than another … Shall I paint Jingerry Wangery Bang, or Wizzibizzigollyworryboo?'

Lear finally reached Bombay in November 1873, and was overwhelmed by the visual variety. He felt: 'nearly mad from sheer beauty & wonder of foliage! O new palms!!! O flowers!! O creatures!! O beasts!! anything more overpoweringly amazing cannot be conceived!! Colours, & costumes, & myriadism of impossible picturesque-ness!!!' He painted many watercolours of subjects ranging from the inevitable Taj Mahal to the ghats at Benares and the hill stations of Simla, Poona and Darjeeling, where he arrived in January 1874, and decided that the subject of Mount Kangchenjunga, one of the highest peaks in the Himalayas, was the ideal one for Lord Aberdare's painting. He then repeated the subject for two other clients (Pl. 543).

541
Robert Whale
**The Canada Southern
Railway at Niagara**
*c.*1870
oil on canvas, 58.1 × 101.1cm
(22⅞ × 39¾in)
National Gallery of Canada,
Ottawa

542
Lucius O'Brien
A British Columbian Forest
1888
watercolour over graphite,
54.1 × 76.4cm (22⅞ × 30⅛in)
National Gallery of Canada,
Ottawa

543
Edward Lear
Mount Kangchenjunga
1877
oil on canvas,
185.2 × 284cm (73 × 112in)
Private collection

One cannot help wondering if Lear was influenced in this choice by his own admiration for the work of the American landscape painter Frederic Church, who for him was 'the greatest Landscape painter after Turner … One of his works [referring to a reproductive engraving], *The Heart of the Andes* hangs always before me'. Lear was at first captivated by the *'Wonderful wonderful* view of Kinchinjunga !!!!!', as he wrote in his diary, but later found it 'not – so it seems to me – a sympathetic mountain; it is so far off, so very god-like & stupendous, & all that great world of dark opal valleys full of misty, hardly to be imagined forms.' Lord Aberdare, as might be expected, was delighted with the finished work, which justifies so completely Lear's often repeated claim to be a 'Painter of Poetical Topography'.

The power of the armed forces both protected British interests and arbitrated between the numerous warring factions. After the Indian Mutiny in 1857 the rapid growth of an extensive railway network both enabled the multitudinous races of India to travel more easily and greatly facilitated the swift deployment of troops round the whole subcontinent. With the railways came stations, some of which in capital cities were of palatial dimensions. A spectacular example of such a building was *The Bombay and Baroda and Central India Railway Administrative Offices, later the Victoria Railway Terminal, Bombay* (Pl. 544). It was designed by the architect Frederick

541 *542*

William Stevens, who commissioned Axel Haig's watercolour of the subject. It is interesting to note that some of the most elaborate watercolours of the Victorian era were produced as interpretations for architects of projected grandiose commissions.

Although Stevens designed this station some time before 1878, construction did not begin until April 1894; it was completed in 1896 in time for the Queen's Diamond Jubilee. An amazing hotchpotch of Florentine Renaissance, Venetian Gothic, English Decorated and Indian Saracenic, it adds up to a uniquely Victorian and Anglo-Indian entity. The building's diversity rather puzzled the critic of the *Architect*, who described it as 'vast pile of modern buildings, with certain Gothic features freely added, but yet not Gothic', but the *Times of India* praised Stevens for carrying out in his designs 'with conspicuous success that blending of Venetian Gothic with Indian Saracenic by which he created a style of architecture so excellently suited to the climate and environment of Bombay'.

The life of George Chinnery (1774–1852), another fascinating artist who worked in India, would make a dramatic three-act play. The first act would be set in London where he was born, and Dublin where after a promising start as a miniature painter he made an unfortunate marriage. To escape from this situation he left his wife and two children to seek his fortune in India, and left first for Madras and Calcutta, where

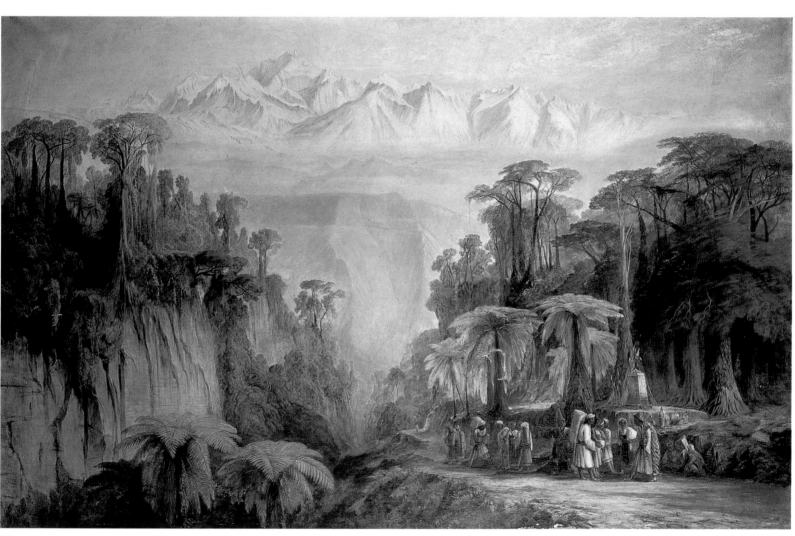

543

544

545

he painted portraits and landscapes, and where fifteen years later his family rejoined him. This was awkward as he had another wife and child, and enormous debts. To escape from these complications Chinnery fled to Macao, a Portuguese dependency near Hong Kong where English law was not valid. In Macao his genius flourished and he produced many hundreds of vivacious studies of street life such as *Chinese Street Scene at Macao* (Pl. 545), landscapes and portraits.

The issue of slavery, the fundamental cause of the American Civil War, had its origins in Africa, from whence slaves came. In 1840 a painting by François-Auguste Biard (1798/9–1882) representing the horrors of the African slave trade was shown at the Royal Academy (Pl. 546). In 1847 it was claimed that this single picture made the slave trade 'more infamous than it had been depicted by a score of advocates eloquent for its suppression'. It was presented to Sir Thomas Buxton, a leading abolitionist. He was an important influence on David Livingstone, the charismatic missionary, explorer and abolitionist who played a central role in the Victorian encounter with Africa.

546

544
Axel Haig
**The Great Indian Peninsula
Railway Terminus and
Administrative Offices,
Bombay**
1878
watercolour, 91.4 × 157.5cm
(36 × 62in)
India Office Library, London

545
George Chinnery
**Chinese Street Scene
at Macao**
*c.*1850
oil on canvas, 20.3 × 24.4cm
(8 × 9⅝in)
Victoria and Albert Museum,
London

546
François-Auguste Biard
The Slave Trade
*c.*1840
oil on canvas, 162.5 × 228.6cm
(64 × 90in)
Wilberforce House Museum,
Hull

Frustrated by missionary work in southern Africa, Livingstone embarked on the epic voyages of discovery which made him so famous, and which redrew the map of Africa. In 1855 he became the first European to see the Victoria Falls. Livingstone's second visit to Africa was a venture fraught from the start with danger and drama. Thanks to the painter Thomas Baines (1822–75), we can look with amazement at such moments as an incident early in January 1859 when Livingstone took the steam launch the *Ma Robert* up the river Shire, a tributary of the Zambezi. The painting *Elephant in the Shallows of the Shire River, the Steam Launch Firing* (Pl. 547) shows how the party encountered and hunted large herds of elephants. An account by another member of the party, John Kirk, conveys the effect of the fusillade when an elephant shot by the party 'instantly turned to us, spread out its enormous ears, curled its proboscis up like a butterfly and raised its tail in the air like a bull'. Baines later painted the first views ever made of the great natural wonder of the Victoria Falls, one being *Herd of Buffalo opposite Garden Island, Victoria Falls* (Pl. 548). These were worked up

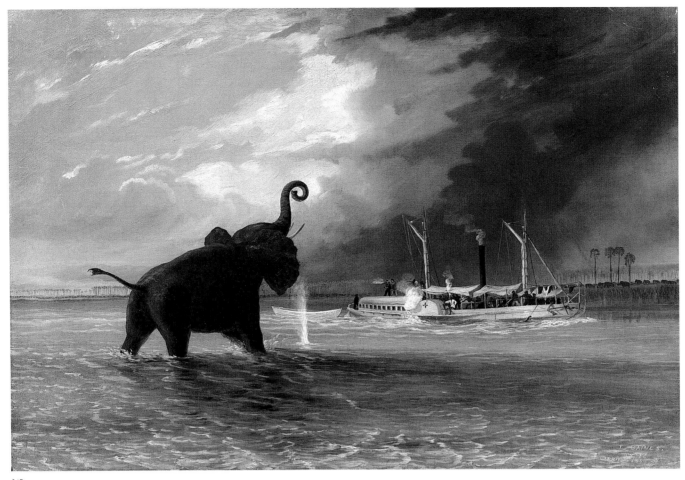

547

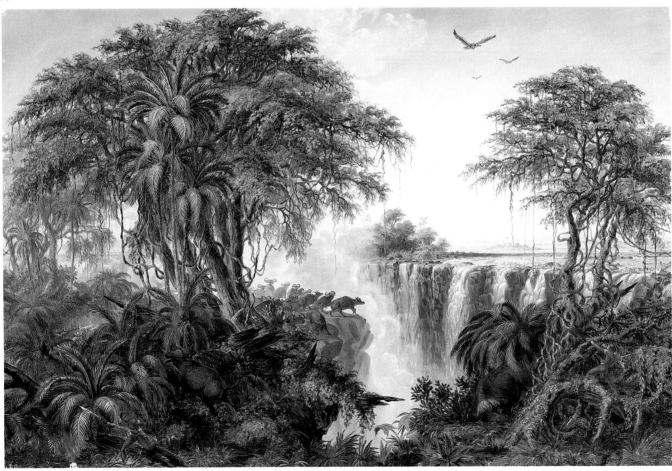

548

from drawings made in 1862, after his dismissal from Livingstone's party, and formed the basis for a lavish folio edition of lithographs, *The Victoria Falls and Zambezi River*, published in 1865.

The famous meeting between Stanley and Livingstone, which cries out for the attentions of a history painter, was only used as a subject by illustrators producing wood-engravings for journals such as the *Graphic* and *Illustrated London News*. This is surprising, for the activities of missionaries were a popular subject. George Baxter, whose prints were the first coloured reproductions, produced no fewer than thirty-five missionary subjects, often of massacres, for missionary societies in the 1840s.

Even more inspirational for late Victorian artists were the innumerable colonial wars, especially if they culminated in a dramatic and tragic encounter brought about by heroism, bravery and devotion in the face of official bungling. These catastrophes were commemorated in many canvases which grace the walls of Regimental Messes or the National Army Museum. A notable example of such a work is by Charles Edwin Fripp (1854–1906), *The Battle of Isandhlwana, 22 January 1879* (Pl. 550), which records an incident in the Zulu wars when 1,200 British troops were annihilated by a force of 20,000 Zulus.

Such situations were to occur all too often in the later decades of the Queen's reign, caused by depressingly similar factors of official red tape and incompetence. A prime example was the death of General Gordon on 26 January 1885, which shocked the nation. In 1883 the British Government had ordered Egypt to abandon the Sudan, a most hazardous policy to implement, particularly after a revolt broke out led by Mohammed Ahmed who proclaimed himself Mahdi. In 1884 General Gordon (1833–85), seen by some as the inheritor of the Livingstone mantle, was deputed to go to the Sudan and evacuate the Egyptian population, but he became beleaguered in Khartoum. He was besieged for many months while the Government at home hesitated to authorize relief forces, which finally arrived just two days too late to save him. He died grandly defying the followers of the Mahdi at the top of the steps of the palace at Khartoum. Painted eight years later in 1893, *The Death of General Gordon* (Pl. 549) by George William Joy (1844–1925) became an icon of British colonial rule, symbolizing, like the later Zulu and South African wars, British imperial ideals at their most extreme.

547
Thomas Baines
Elephant in the Shallows of the Shire River, the Steam Launch Firing
1859
oil on canvas, 46 × 65.7cm
(18¼ × 25⅞in)
Royal Geographical Society, London

548
Thomas Baines
Herd of Buffalo opposite Garden Island, Victoria Falls
c.1862–5
oil on canvas, 46 × 65.7cm
(18¼ × 25⅞in)
Royal Geographical Society, London

549
George William Joy
The Death of General Gordon
c.1893
oil on canvas, 236 × 175cm
(92⅞ × 68⅞in)
Leeds City Art Gallery

550
Charles Edwin Fripp
The Battle of Isandhlwana, 22 January 1879
1885
oil on canvas, 144 × 225cm
(56¾ × 88⅝in)
National Army Museum, London

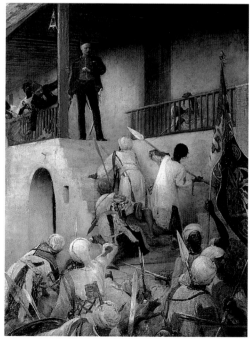

549

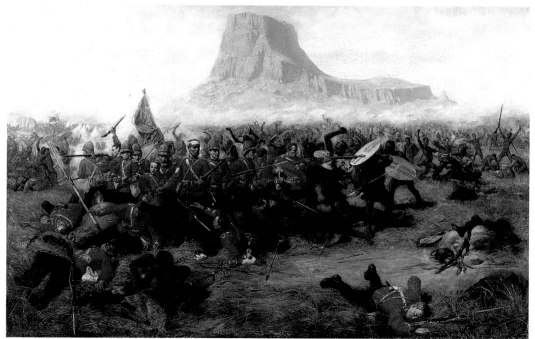

550

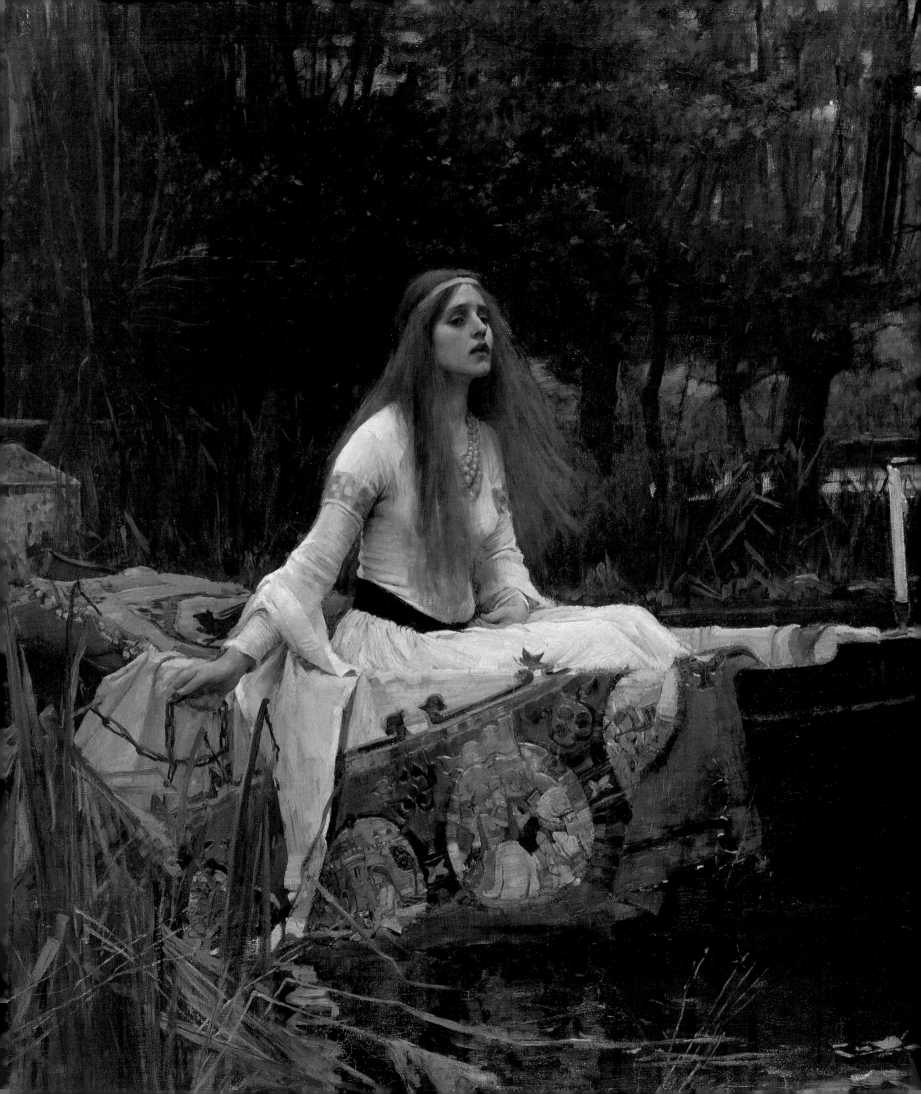

Upon the waning of the night, at that time when the stars are pale, and when dreams wrap us about more closely, when a brighter radiance is shed upon our spirits, three sayings of the wise King came unto me. These are they: 'I sleep, but my heart waketh;' also 'Many waters cannot quench love;' and again 'Until the day break, and the shadows flee away;' and I fell to musing and thinking much upon them.

This passage from the prose poem, *A Vision of Love Revealed in Sleep* (1873), by Simeon Solomon, the brilliantly gifted homosexual Jewish artist and friend of Pater and Swinburne, forms an apposite introduction to the second phase of the Pre-Raphaelite movement. Like the Soul in Solomon's poem, the artists of the movement were to fall to musing on the themes of sleep, dreams, love, night and death.

551 John William Waterhouse, **The Lady of Shalott** (detail of Pl. 575)

552
Dante Gabriel Rossetti
La Pia de' Tolomei
1868–80
oil on canvas, 105.3 × 120.5cm
(41½ × 47½in)
Spencer Museum of Art,
University of Kansas, Lawrence

Their work has been described variously as Aesthetic, Symbolist and Decadent; it certainly possesses elements of all these concepts. A letter written by the *Punch* cartoonist George Du Maurier in 1864 vividly describes the moment when their work began to take on a very different dimension from the earlier, more objective, aims of the Pre-Raphaelite Brotherhood, and the reasons why it began to cause concern in more orthodox circles:

> The other night I went to a bachelor's party to meet Rossetti and Swinburne at Simeon Solomon's. Such a strange evening; Rossetti is at the head of the proe-raphaelites [sic], for Millais and Hunt have seceded; spoilt so to speak by their immense popularity; whereas Rossetti never exhibits and is comparatively unknown; this strange contempt for fame is rather grand. He is also a great poet, and his translations from the early Italian poets are the finest things in their way that have been done. As for Swinburne, he is without exception the most extra-

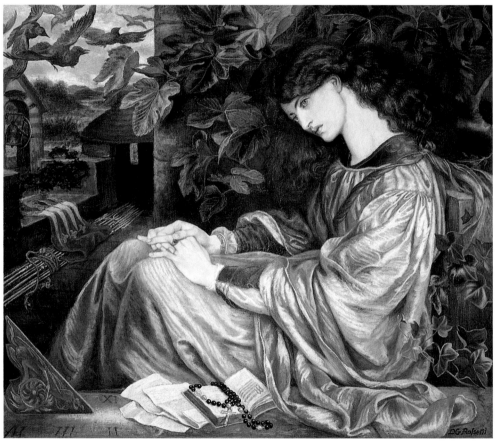

552

> ordinary man not that I have ever met only, but that I ever met or heard of; for three hours he spouted his poetry to us, and it was of a power, beauty and originality unequalled. Everything after seems tame, but the little beast will never I think be acknowledged for he has an utterly perverted moral sense, and ranks Lucrezia Borgia with Jesus Christ; indeed says she's far greater, and very little of his poetry is fit for publication.

This letter not only gives us a vivid picture of Swinburne, quivering with energy just as he is depicted in Bell Scott's portrait of 1860, aged 22, but also describes the position 'above the battle' which Rossetti had adopted. He had never shared the passion for 'truth to nature' insisted on by his fellow brethren, Hunt and Millais, and escaped as soon as possible to a world of medieval fantasy, where a series of voluptuous 'stunners' with extravagant coils of hair held him in thrall. Solomon's preoccupations with

sleep, dreams and death also featured at the heart of Rossetti's work, perhaps because of his personal fight against insomnia, which he tried to conquer with phials of laudanum and bottles of whisky. This may well have influenced his choice of strange, hallucinatory themes in his later work. For many of these paintings the model was Jane Morris, whose love affair with Rossetti caused William Morris such pain. To help him Rossetti used photographs which vividly capture her sultry beauty.

An early example of a work of this type was *La Pia de' Tolomei* (Pl. 552), a story taken from Dante's *Purgatory*. It describes how Pia was confined by her cruel husband to a fortress in Maremma, a malarial district near Siena, where she died either through fever or poison. This is one of several subjects concerning unhappy marriage which Rossetti painted at this time, given a heightened poignancy because of the personal anguish he felt over his love for his main model and inspiration, Jane Morris, the wife of his friend William Morris. The cloudy sky, sundial, rosary, devotional book and old letters all play their part in creating a mood of melancholy; Jane's listless pose and her long fingers toying with her wedding ring contribute to the effect.

One of the most memorable of all these paintings is *Dante's Dream at the Time of*

553
Dante Gabriel Rossetti
**Dante's Dream at the Time
of the Death of Beatrice**
1871
oil on canvas, 210.6 × 317cm
(83 × 125in)
Walker Art Gallery, Liverpool

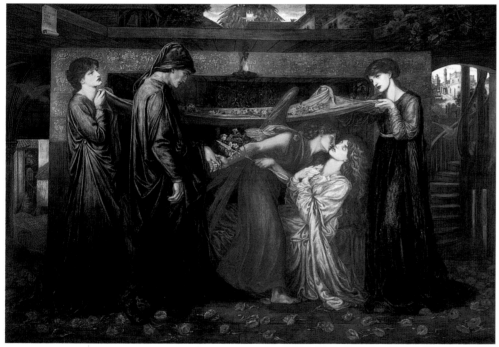

553

the Death of Beatrice, a reflection of Rossetti's life-long relationship with his namesake the Italian poet Dante. It represents an episode from the *Vita nuova* in which Dante dreams that he is led by Love to the deathbed of Beatrice Portinari, the object of his unrequited passion. In both the early watercolour version (1856) and the later oil painting (Pl. 553) the red poppies of death carpet the floor, flowers which also feature in *Beata Beatrix* (Pl. 313). In the second version, Rossetti's largest oil painting, he uses rich colours symbolically to produce a visionary world: the attendants wear green for hope, the spring blossoms signify purity, the red doves the presence of love, the poppies the sleep of dreams and death. The model for Beatrice in this oil version was once again Jane Morris.

In the 1860s most recognized centres for the exhibition of works of art were hostile environments for artists of aesthetic tendencies. Both Rossetti and Burne-Jones boycotted the overcrowded walls of the Royal Academy. At the conservative venues of the New and Old Water Colour Societies the traditional landscape reigned supreme. But there was one exception, the Dudley Gallery, which ever since it

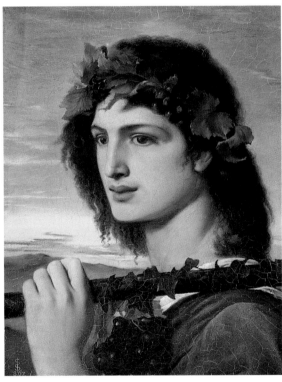

554
Simeon Solomon
Bacchus
1867
oil on paper laid on to canvas,
50.8 × 37.5cm (20 × 14¾in)
Birmingham City Museum
and Art Gallery

554

opened in 1865 at the Egyptian Hall, opposite the Royal Academy, had a resolute policy of independence. 'The Water Colour Societies reserve their walls entirely for Members,' claimed its manifesto; the Dudley, in contrast, eschewed membership, and held truly 'open' exhibitions. It soon attracted regular exhibitors of the calibre of Albert Moore, Frederick Sandys, Frederick Walker and especially Simeon Solomon, who exhibited annually works with such esoteric classical titles as *Crydippe with the Apple of Acontius* (1866), *Heliogabalus, High Priest of the Sun* (1868) or *Sacramentum Amoris* (1869), a painting which he sold to F.R. Leyland, Whistler's patron. Some of the artists at the Dudley Gallery were facetiously dubbed by critics the 'legendary', the 'archaic', the 'loathly', the 'mystico-medieval' or 'romantico-classic' school.

In 1864 Edward Burne-Jones had made his debut at the Old Water Colour Society, where his works had a powerful effect on the young Walter Crane (see below). For Crane it was as though 'the curtain had been lifted, and we had had a glimpse into a magic world of romance and pictured poetry, peopled with ghosts of "ladies dead and lovely knights" – a twilight world of dark mysterious woodlands, haunted streams, meads of deep green starred with burning flowers, veiled in a dim and mystic light, and stained with low tones of crimson and gold'. Although his work was regarded with suspicion by the critics, Burne-Jones continued to exhibit at the Old Water Colour Society, showing *Cupid Delivering Psyche* in 1867. Such sensual subjects were anathema to the *Art Journal*, who in 1869 condemned 'this art which has assuredly not the breath of life, the health of nature, or the simplicity of truth: it belongs to the realm of dreams, nightmares and other phantasms of diseased imagination'.

As Du Maurier had predicted, by the 1870s the works of the later Pre-Raphaelite poets and painters had become better known, or rather notorious, for they had caused much moral controversy. In 1870 Burne-Jones showed *Phyllis and Demophoön* (Pl. 555), in which not only was the figure of Demophoön naked and with visible genitalia, but Phyllis was recognizably given the features of Maria Zambaco, the beautiful Greek girl with whom Burne-Jones was currently conducting a fairly well-publicized affair. Complaints were made about the nude male figure and Burne-Jones removed the painting, resigning from the Old Water Colour Society. Apart from two works shown at the Dudley Gallery, he ceased to exhibit until the Grosvenor Gallery opened in 1877. Reviewing *Phyllis and Demophoön*, the *Art Journal* critic commented acidly: 'Mr Burne-Jones … stands alone: he has in this room no followers; in order to judge how degenerate this style may become in the hands of disciples, it is needful to take a walk to the Dudley Gallery.'

The Dudley Gallery was strictly reserved for watercolour paintings, and the Royal Academy remained the major arbiter of public taste, the visual arena where reputations were won or lost. Solomon therefore continued to exhibit his oil paintings at the Royal Academy, and in 1867 his painting *Bacchus* (Pl. 554) caught the eye of Walter Pater, who some years later recalled in it: 'the god of the bitterness of wine … of things too sweet … the sea water of the Lesbian grape become somewhat brackish in the cup'.

One of the most enigmatic of artists on the fringes of the Pre-Raphaelite movement was Frederick Sandys (1829–1904). From 1861 until 1869 he was an intimate friend of Rossetti, but the friendship ended when Rossetti accused him of plagiarism. Certainly both men produced some of the most smouldering sensual images of women, and gloried in depicting hair, but by the 1870s Sandys, blessed with dazzling virtuosity of technique, had created a style unique to himself, a highly original contribution to portraiture in the guise of nearly life-sized heads drawn in black with touches of coloured crayon on tinted papers, set against backgrounds of exotic

flowers and foliage. Sandys's *Medea* (Pl. 557) was thus described by Swinburne, with sinister relish: 'a being ... pale as from poison, with the blood drawn back from her very lips, agonized in face and limbs ... the fatal figure of Medea pauses a little on the funereal verge of the wood of death, in act to pour a blood-like liquid into the soft, opal coloured hollow of a shell'.

When more works of similar aesthetic tendencies featured at the Royal Academy in 1871, the reviewer of the *Art Journal* described the advent of a new school of painting: 'The brotherhood cherish in common, reverence for the antique, affection for modern Italy; they affect southern climes, costumes, sunshine, also a certain *dolce far niente* style, with a general sybarite state of mind which rests in Art and Aestheticism as the be-all and end-all of existence.' A rather mysterious artist, Robert Bateman (1842–1922), was the leader of this group of young artists inspired by Burne-Jones, who were also dubbed by hostile critics the 'Poetry-without-Grammar-School'. Bateman's strange *Three Women Plucking Mandrakes* (Pl. 556) depicts the agonizing

555
Edward Burne-Jones
Phyllis and Demophoön
1870
gouache, 91.3 × 45.6cm
(36 × 18in)
Birmingham City Museum
and Art Gallery

556
Robert Bateman
**Three Women Plucking
Mandrakes**
1870
bodycolour on paper laid
on to canvas, 31.2 × 45.8cm
(12¼ × 18in)
Wellcome Institute Library,
London

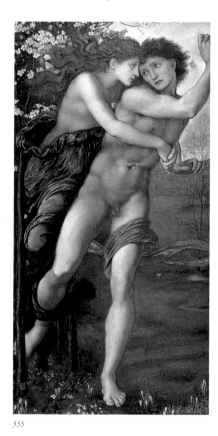

555

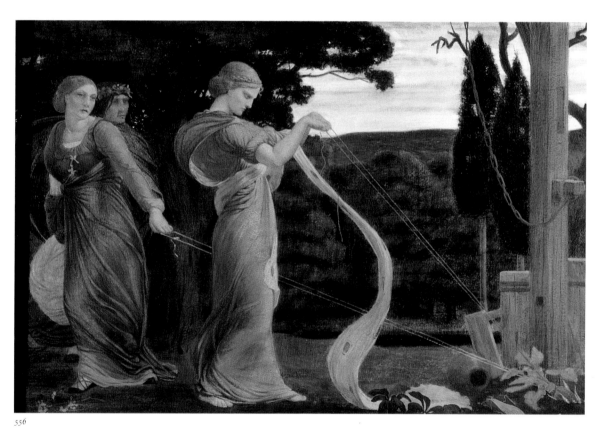

556

moment when according to legend the mandrake root shrieks as it is pulled from the ground.

Walter Crane (1845–1915) is usually thought of as a leading member of the Arts and Crafts movement, always busy with designs for wallpapers, textiles, ceramics, masques or children's books. Such activities were in reality only a part of his achievement, for he also exhibited at least one major painting every year from 1862, at first at the Royal Academy and later at the annual Grosvenor Gallery summer exhibition. Many possessed classical titles such as *The Renaissance of Venus* (Pl. 361) or *The Triumph of Spring* (1879). The embargo placed on him drawing from the female nude by his wife did on occasion cause difficulties, as in the case of his *Diana and Endymion* (Pl. 558), for which young Graham Robertson posed as the huntress; he later recalled 'holding in leash a large lean hound which had bitten the butcher during the foregoing week and always seemed to me to be looking round for more of him'.

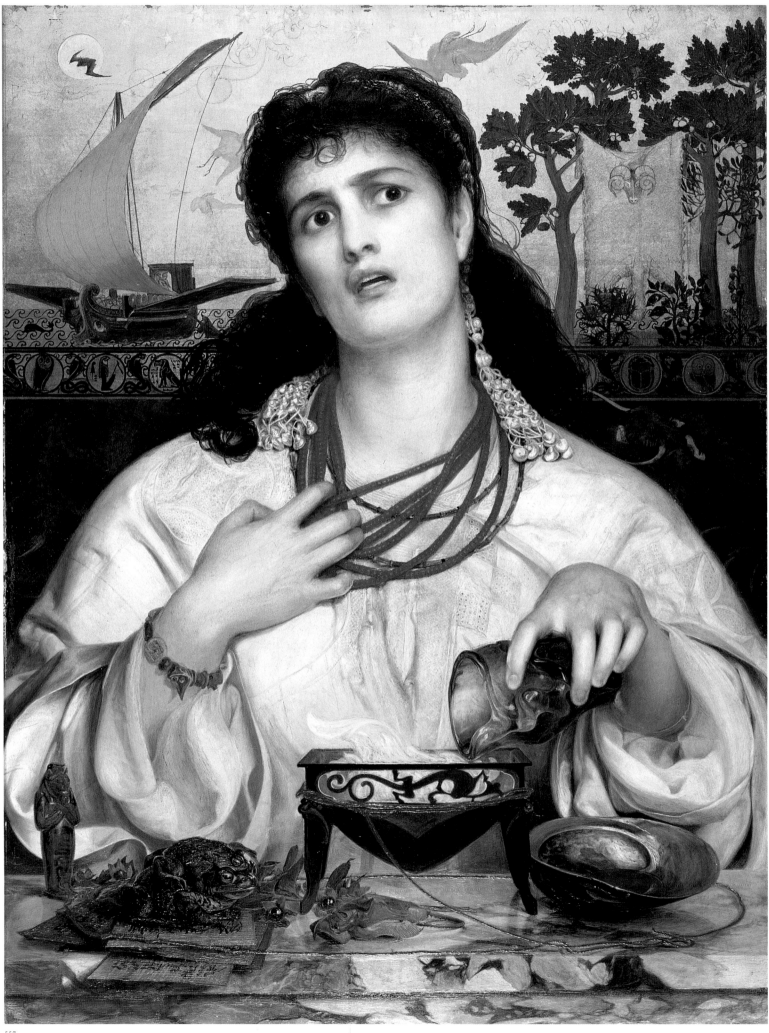

Visits to what sounds remarkably like a modern theme park to see chariot racing at Kensington Olympia gave Crane the inspiration both for the watercolour *The Chariot of the Hours* (1886–7) and *Neptune's Horses* (Pl. 559), a large oil portraying the god of the sea reigning back waves metamorphosed into the 'white horses' of crashing ocean breakers. Crane also painted such reassuringly obscure folk stories as *The Laidly Worm of Spindleston Heugh* (1881), a variation of the ever popular formula of dead dragon, knight in armour and naked lady.

While it is easy to be facetious about Crane, some of his early works created in Rome attained great distinction, notably paintings of his wife and cat in his studio and depictions of spring in the daffodil fields of the Roman Campagna. In 1870 he painted a picture entitled *Love's Altar* using his wife's face as Love, which was first exhibited by the courageous Old Bond Street Gallery – an early example of a commercial gallery being in the vanguard of advanced taste. Such occurrences were rare, however; large mixed public exhibitions provided for most artists the only path to fame, and for those rejected by the Royal Academy life was hard.

Simeon Solomon came in for particular censure in October 1871, with an

557
Frederick Sandys
Medea
1866–8
oil on wood, 62·2 × 46·3cm
(24½ × 18¼in)
Birmingham City Museum
and Art Gallery

558
Walter Crane
Diana and Endymion
1883
oil on canvas, 55·2 × 78·1cm
(21¾ × 30¾in)
McManus Galleries, Dundee

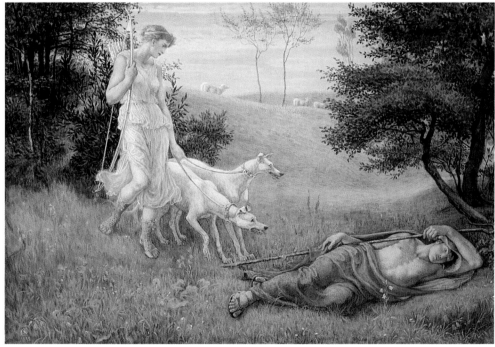

558

anonymous attack entitled 'The Fleshly School of Poetry' in the *Contemporary Review* on Rossetti's and Simeon Solomon's paintings and Rossetti's (unclaimed) pre-eminence as a poet. Rossetti's poems 'Jenny' and 'Troy Town' were singled out as being 'unhealthy' and capable of 'stifling the senses with overpowering sickliness', or more exotically, giving 'spasmodic ramifications in the erotic direction'. Rossetti, in a reply entitled 'The Stealthy School of Criticism', exposed the author as the jealous poet Robert Buchanan, who, unabashed, responded yet again by accusing Swinburne of extensive plagiarism from Baudelaire's *Les Fleurs du mal* (1857). Buchanan was to some extent justified in these remarks, for certainly Baudelaire was revered by the Aesthetes for his pose of morbid sensitivity, and later by the Decadents for his opium- and hashish-induced explorations of strange and exquisite sensations. Indeed these aspects of Baudelaire's work struck a sympathetic chord which Rossetti reflected in the lush romanticism of such works as *The Day Dream* (Pl. 561).

Originally entitled *Monna Primavera*, but soon renamed, the painting shows Jane Morris sitting in the fork of the sycamore tree in Rossetti's garden at Cheyne Walk,

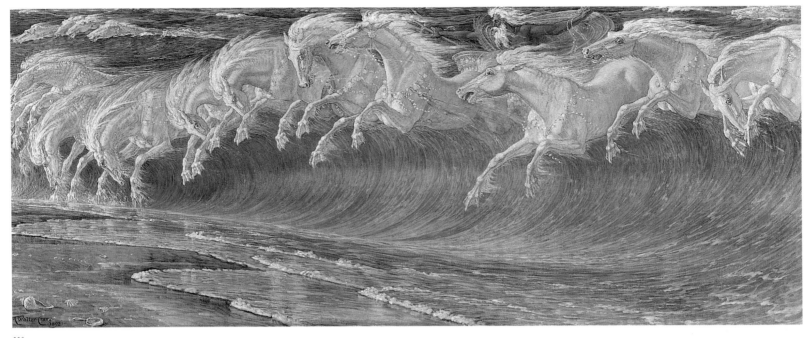

559

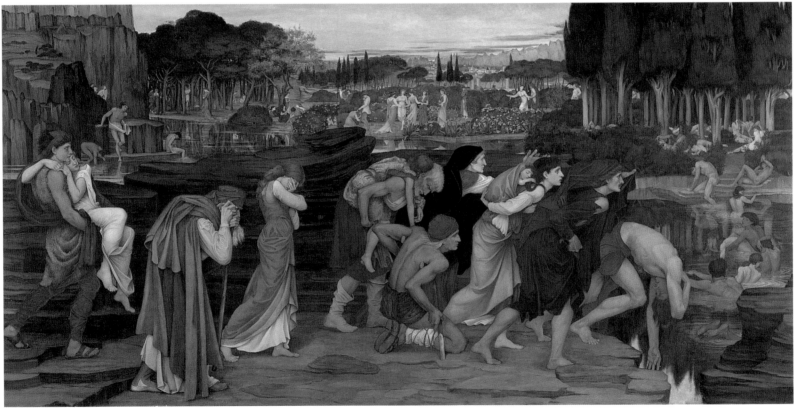

560

an open book on her knee and a sprig of honeysuckle in her hand. Of all the many portraits Rossetti made of Jane, this was his favourite. On its frame he wrote a sonnet which expresses his desire to escape from life's hard realities:

Within the branching shade of Reverie

Dreams even may spring till autumn.

Trance-like dreams became a major preoccupation, at first of the Pre-Raphaelites, and later of the wider Symbolist movement in Europe. Almost as influential was a fascination for the theme of the floating woman, initiated by Millais's *Ophelia* (Pl. 293) and continued by John William Waterhouse's *Lady of Shalott* (Pl. 575); these two works greatly influenced the emergent Symbolist movement, which became obsessed with the subject of drowned and drowning women. Indeed, Millais's *Ophelia* led to a whole morgue-full of drowned women, by the Dutch and Belgian Symbolists Jan Toorop and Jean Delville, and by French painters, such as Edmond Aman-Jean, Lucien Lévy-Dhurmer and Georges de Feure, who created what Philippe Jullian memorably described as 'Ophelias of the Seine'.

What might be described as a Tennysonian sleeping sickness permeated the studios. Sombre thoughts of sleep, poetry and death not only dominated Rossetti and Simeon Solomon, but also led to the production of such strange works as *The Waters of Lethe by the Plains of Elysium* (Pl. 560) by John Roddam Spencer Stanhope, who as a young man had worked on the Oxford Union frescos (see above, p. 51). *The Waters of Lethe* presents an elaborate allegory of humanity casting off its burdens in the waters of oblivion and death. The passage of the water symbolizes death, the island is the

559
Walter Crane
Neptune's Horses
1892
oil on canvas, 86 × 215cm
(33¾ × 84⅝in)
Neue Pinakothek, Munich

560
John Roddam Spencer Stanhope
**The Waters of Lethe
by the Plains of Elysium**
1879–80
tempera with gold paint
on canvas, 147.5 × 282.4cm
(58⅛ × 111⅛in)
Manchester City Art Gallery

561
Dante Gabriel Rossetti
The Day Dream
1880
oil on canvas, 158.6 × 92.6cm
(62½ × 36½in)
Victoria and Albert Museum,
London

562
Frederic Leighton
Elijah in the Wilderness
1879
oil on canvas, 235 × 210.2cm
(92½ × 82⅞in)
Walker Art Gallery, Liverpool

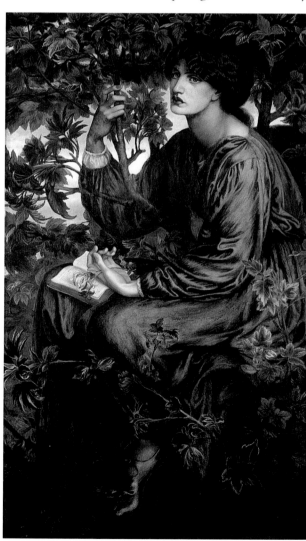

561

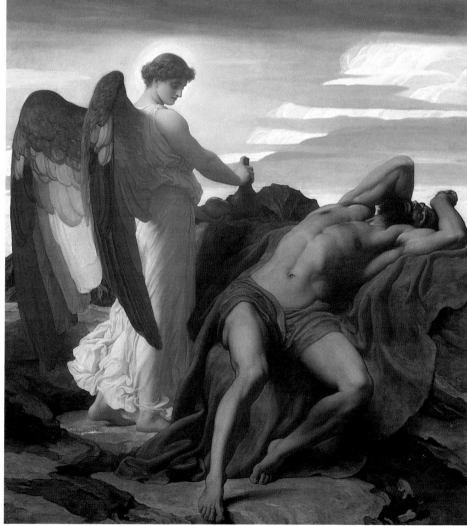

562

563
Frederic Leighton
Flaming June
*c.*1895
oil on canvas, 120.6 × 120.6cm
(47½ × 47½in)
Museo de Arte de Ponce,
Puerto Rico

564
Albert Moore
Midsummer
1887
oil on canvas, 158.6 × 152.2cm
(62½ × 6oin)
Russell-Cotes Art Gallery and
Museum, Bournemouth

grave, and the gardens in the distance the happiness of the future life. Its close European parallel is Arnold Böcklin's *Isle of the Dead* (1880).

Many other leading artists of the time were drawn to the theme, perhaps the best known being Frederic Leighton. His *Elijah in the Wilderness* (Pl. 562), showing the prophet asleep watched by an angel, can claim to be one of the greatest academic paintings of the Victorian era, while his *Flaming June* (Pl. 563) is one of the most famous. Both its subject and intensity of colour possess a remarkable affinity with Albert Moore's *Midsummer* (Pl. 564). Indeed, Moore used the theme of sleep throughout the whole of his career in a conscious attempt to eliminate expressive human emotions, as in *Dreamers* (Pl. 565).

Not only painters produced variations on the theme but also the remarkable

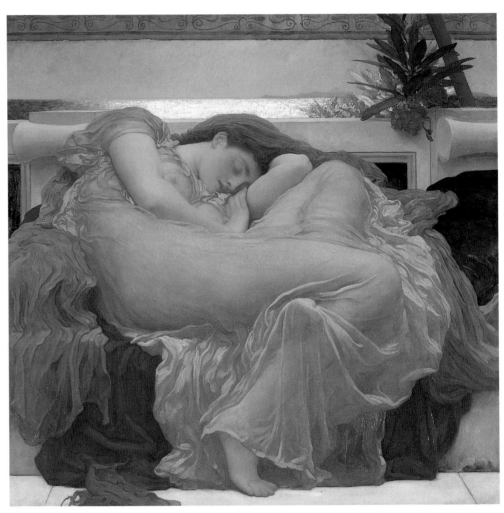

563

photographer Lady Hawarden, who made eerie studies of her two daughters asleep in an empty room. The motif was also adopted by artists of the Symbolist movement in France and Belgium, who painted many morbid yet hauntingly beautiful images of introspection and meditation. Notable works were produced in particular by Fernand Khnopff, a great admirer of Burne-Jones, and Belgian correspondent to the *Studio* magazine.

Indeed, the depiction of sleep became one of the most potent themes of Symbolist art. On the whole, women are more often portrayed asleep than men. It is rewarding and satisfying for an artist to depict a sleeping figure, as the model can hold a sleeping pose and keep completely still, but this is clearly an over-simplistic reason for the attraction of the subject. In sleep, problems of the relationships

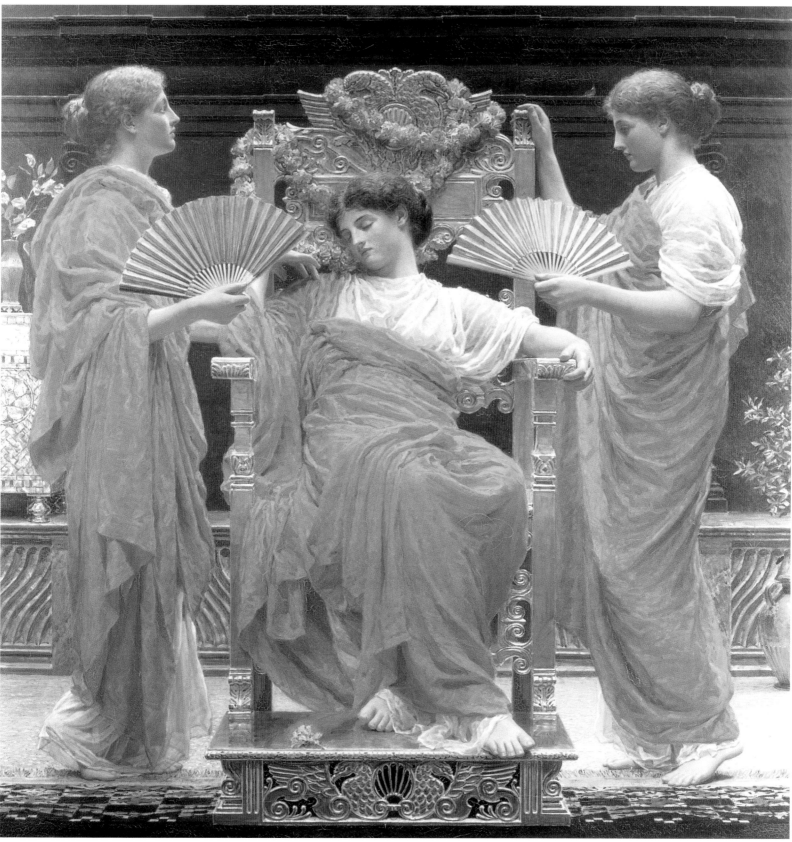

565
Albert Moore
Dreamers
1882
oil on canvas, 68.5 × 119.2cm
(27 × 47in)
Birmingham City Museum
and Art Gallery

between men and women are postponed. Eroticism is, of course, present in the relaxed poses of the models, but it is tempered by the respect felt by those awake at the sight of those asleep, a reluctance to intrude into the privacy of the sleeper's dreams.

There were also of course other themes, and even Albert Moore in his last work, *Loves of the Winds and the Seasons* (Pl. 566), returned to the arena of human emotions with a complex allegory of the four male winds and four female seasons. While Moore turned to classical themes, a stream of paintings emerged from Burne-Jones's large studio dealing with incidents in the legendary adventures of the mythical King Arthur and the Knights of the Round Table, works which fully succeeded in being what he wished, when he said, 'I mean by a painting a beautiful romantic dream – a reflection of a reflection of something purely imaginary.'

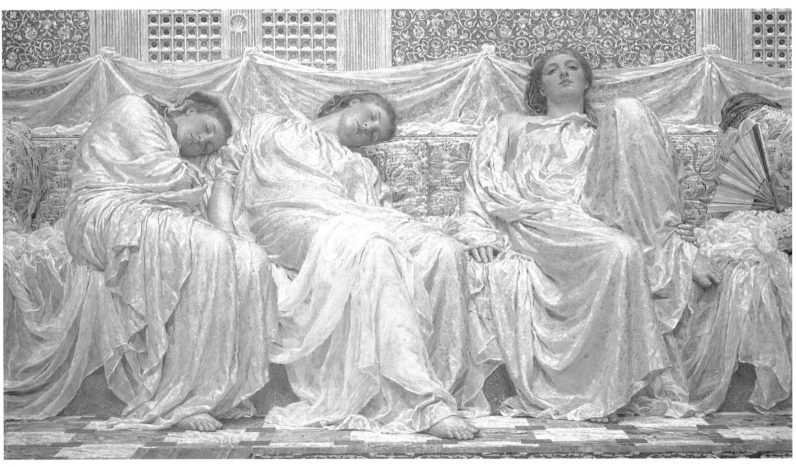

565

In 1877, with the opening of the Grosvenor Gallery, the general public were at last to have an opportunity to share these dreams. The event, which was of major significance in the development of British painting, raises the question as to why a new gallery was so important. The vast annual summer exhibitions at the Royal Academy, hung from floor to ceiling with thousands of competing works of art, were still great social events, as can be seen in the last of Frith's great cross-sections of human life, *Private View of the Royal Academy, 1881* (Pl. 32). Yet many major artists no longer exposed their works to the hurly-burly of the Academy walls, from Rossetti and Whistler to Burne-Jones, who resigned as an ARA in 1893.

At the Flemish Gallery, Pall Mall, in 1874, Whistler had mounted a one-man show which gave him the opportunity to arrange the lighting, colour of the walls and general presentation of the gallery in a manner which chimed happily with the

delicate tonal harmonies of his pictures. This precedent may well have influenced Sir Coutts Lindsay (1824–1913) in his new gallery venture; he could also have been encouraged by his friend Watts's belief that the 'best way to create interest in a more solemn and serious character of art would be to get together a sufficient number of pictures of the class, and exhibit them all together'.

Sir Coutts Lindsay was a wealthy dilettante amateur artist and poet, with stunning good looks, married to Blanche Fitz-Roy, a connection of the Rothschild family, whose fortune largely financed the opening of the new gallery. His initial motive was prompted by unfortunate experiences in exhibiting his own paintings at the Royal Academy. He decided to open a gallery where artists should be *invited* to exhibit: 'artists whose works have not been so much known … as I would have wished', as he explained to guests at the inaugural banquet, which took place the night before the auspicious opening on 1 May 1877, at 135 New Bond Street.

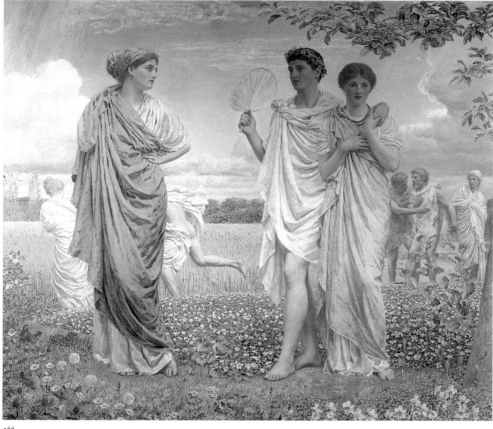

566

A sumptuous effect of Renaissance grandeur was achieved in the internal settings by Lindsay, who had spent £150,000 on building the gallery. He ran a masterly publicity campaign with glamorous private views attended by every section of the Victorian establishment from politicians to the aristocracy and the Prince and Princess of Wales. Years later Walter Crane recalled how Lindsay '… felt that many most distinguished artists were very inadequately represented at the exhibitions of the Royal Academy, being either entirely ignored or indifferently treated by them, while there were others who never submitted their work to that body at all. Among these were painters of such distinction as Edward Burne-Jones, Alphonse Legros, James McNeill Whistler, John Roddam Spencer Stanhope, Cecil Gordon Lawson, William Holman Hunt, and many less known younger artists.' Lindsay tried to persuade Rossetti to exhibit, who replied: 'What holds me back is simply the lifelong feeling of dissatisfaction which I have experienced from the disparity of aim and attainment in what I

566
Albert Moore
Loves of the Winds and the Seasons
1890–3
oil on canvas, 185 × 216cm
(72¾ × 85in)
Blackburn Museum and Art Gallery

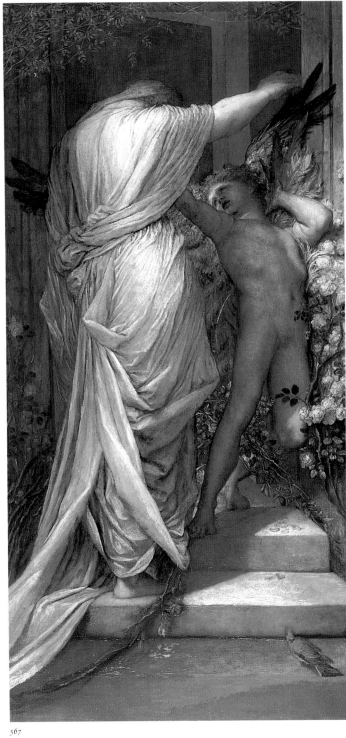

567

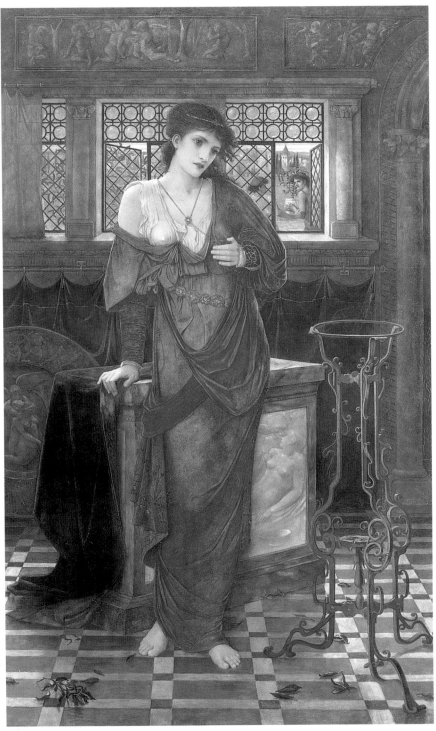

568

have all my life produced as best I can.' But he continued by saying encouragingly: 'Your scheme must succeed, were it but for one name associated with it – that of Burne-Jones – a name representing the loveliest art we have.'

Many other established artists accepted the invitation, and the 209 paintings and sculptures in the inaugural exhibition included works by Watts, Moore, Legros, ten paintings by Tissot, Gustave Moreau's *L'Apparition*, and also, surprisingly, works by Richard (Dicky) Doyle, the noted fairy painter, as well as Coutts Lindsay's own works. Watts's *Love and Death* (Pl. 567), one of the artist's first large-scale symbolic paintings, dominated the north end of the main West Gallery. Of it the artist wrote: 'Love is not restraining death for it could not do so. I wished to suggest the passionate though unavailing struggle to avert the inevitable … proving that Art, like Poetry and Music, may suggest the noblest and tenderest thoughts, inspiring and awakening, if only for a time, the highest sensibilities of our nature …'

Graham Robertson in *Time Was* (1931) vividly describes the impression made by the galleries on youthful eyes:

> The general effect of the great rooms was most beautiful and quite unlike any
> ordinary picture gallery. It suggested the interior of some old Venetian palace, and
> the pictures, hung well apart from each other against dim rich brocades and
> among fine pieces of antique furniture, showed to unusual advantage. I can well
> remember the wonder and delight of my first visit. One wall was iridescent with
> the plumage of Burne-Jones angels, one mysteriously blue with Whistler's noc-
> turnes, one deeply glowing with the great figures of Watts, one softly radiant
> with the faint, flower tinted harmonies of Albert Moore. Here too was the som-
> bre work of Legros, the jewelled fantasies of Gustave Moreau … here at last were
> the pictures of Burne-Jones and Whistler for all to see …
>
> The Whistler nocturnes did not as yet say much to me beyond – blue – blue –
> the intense but tender blue of twilight seen through the windows of a lamp-lit
> room.
>
> I was still a little boy, and a Burne-Jones is far easier to appreciate than a
> Whistler … Burne-Jones' art is the exquisite accompaniment to another's voice,
> Whistler's is the song itself.

The opening exhibition is not remembered for 'the noblest and tenderest thoughts' described by Watts but for the acrimonious dispute over Whistler's Nocturnes initiated by Burne-Jones's champion John Ruskin (see below, pp. 470–4), although such controversy was also exciting and newsworthy. Nor was Ruskin's notorious review the only adverse publicity to mark the opening exhibition. The society journal *Vanity Fair*, in May 1877, complained:

> Unless in future years he [Lindsay] reduces his Swinburne school of artists, he will
> find that the public will not throng to his galleries … if the eccentric and peculiar
> are to have in future exhibitions in these galleries … the Grosvenor Gallery would
> become a *merely* artistic lounge for the worshippers of the Fleshly School of Art
> … if they do the English School is certain to lose all that makes it healthy and
> beneficial … I can only venture to hope that a healthier feeling will prevail …

Undeterred, many works from the inaugural show at the Grosvenor found their way the next year to the Exposition Universelle at Paris where they were very well received, especially those of Watts, which were described by J.-K. Huysmans in his novel *A Rebours* (*Against Nature*) of 1884 described the 'hallucinatory … weirdly coloured pictures by Watts … a dreamy, scholarly Englishman afflicted with a predilection for hideous hues'.

In the next few years very much the same varied mixture kept the Grosvenor Gallery in the news, with paintings not only by Burne-Jones but his followers such

567
George Frederic Watts
Love and Death
c.1874–7
oil on canvas, 248·9 × 116·8cm
(98 × 46in)
Whitworth Art Gallery,
University of Manchester

568
John Melhuish Strudwick
Isabella
1879
tempera with gold paint on
canvas, 99 × 58.5cm (39 × 23in)
De Morgan Foundation,
London

569
Edward Burne-Jones
Laus Veneris
1878
oil on canvas, 121.8 × 182.7cm
(48 × 72in)
Laing Art Gallery,
Newcastle-upon-Tyne

570
Edward Burne-Jones
The Golden Stairs
1872–80
oil on canvas, 277 × 117cm
(106 × 46in)
Tate Gallery, London

571
Edward Burne-Jones
**King Cophetua and the
Beggar Maid**
1884
oil on canvas, 293 × 150cm
(115½ × 57½in)
Tate Gallery, London

as John Melhuish Strudwick (1849–1937), who worked as an assistant first to Spencer Stanhope and then to Burne-Jones. He was to stay loyal to the Grosvenor Gallery until it finally closed its doors in 1890, showing such works as *Isabella* (Pl. 568).

A notable exhibit in 1878 was Burne-Jones's *Laus Veneris* (Pl. 569), painted in 1873–8 but not previously exhibited. This famous painting carries a strikingly Freudian implication; the placing of the crown upon the lap of Venus, almost literally crowning the *mons veneris*, was criticized by the *Spectator* as being obscure: 'when we do arrive at the meaning, it is not one which we would care to explain to child or wife. The weariness of satisfied love, and the pain of unsatisfied longing, is hardly a theme, perhaps, to expend such magnificent painting upon.'

Much of Burne-Jones's energy in his later years went into the design of stained-glass windows, which may be a factor that influenced him in his creation of so many extremely tall and relatively narrow paintings. One of the first of these large-scale works was *The Golden Stairs* (Pl. 570), known at first as *The King's Wedding*, then as *Music on the Stairs*. The model for the bodies of the girls was an Italian, Antonia Caiva. Burne-Jones was asked from all over the world for an explication of the painting's theme, but refused to supply one.

The subject of *King Cophetua and the Beggar Maid* (Pl. 571) derives from a poem of 1612 published in Percy's *Reliques of Ancient English Poetry* (1765). The poem tells the story of a king in Africa whose aversion to women is overcome by a beautiful beggar girl. The composition was inspired by Crivelli and the figures by Mantegna's

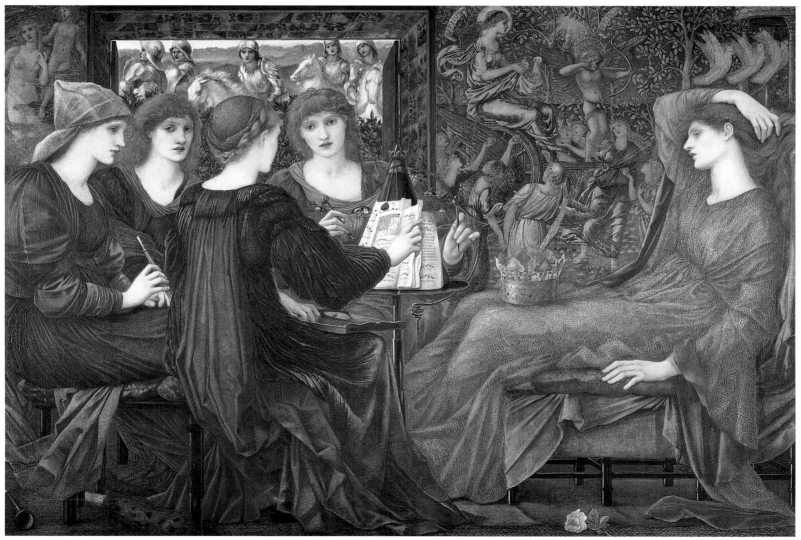

569

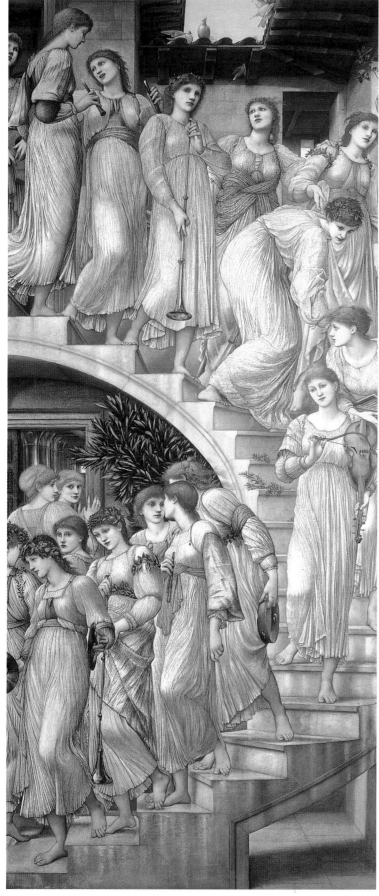

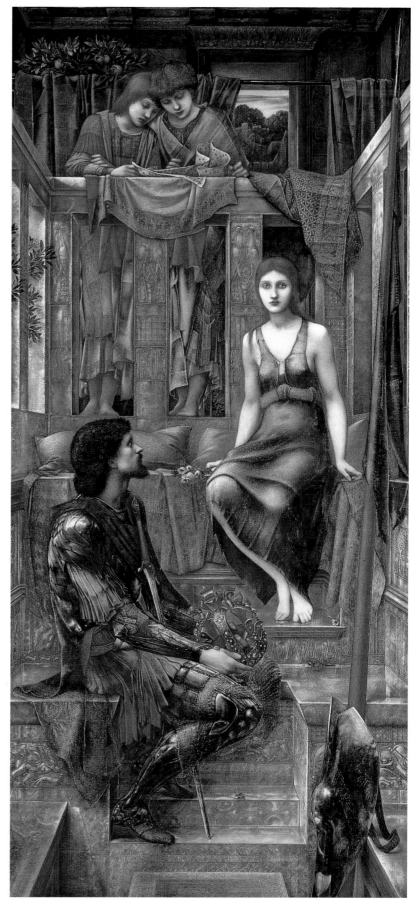

570

571

572
Edward Burne-Jones
The Car of Love
1870–98
oil on canvas, 4.6 × 1.85m
(15 × 6ft)
Victoria and Albert Museum,
London

573
Edward Burne-Jones
**The Briar Rose: The Rose
Bower**
1870–90
oil on canvas, 121.8 × 228.3cm
(48 × 90in)
Buscot Park, Oxfordshire

574
Edward Burne-Jones
**The Sleep of King Arthur
in Avalon**
1881–98
oil on canvas, 2.8 × 6.4m
(9 × 21ft)
Museo de Arte de Ponce,
Puerto Rico

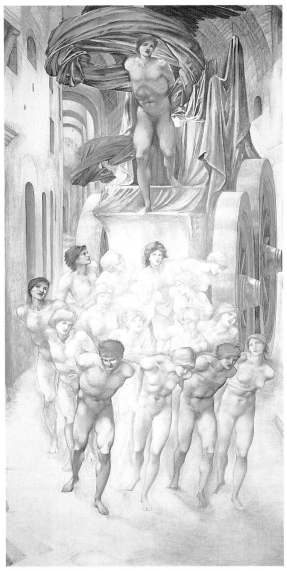

572

Madonna della Vittoria. When it was exhibited in Paris decadent poets enthused about it, especially over the girl's feet: 'ivoire taché de sang'. It is interesting to note that Burne-Jones, who had a witty and highly individual sense of humour, produced a caricature of *King Cophetua and the Beggar Maid* as though it had been drawn by Rubens (whom he particularly disliked) from a fat woman, rather than a thin willowy girl.

Some important but less well-known works by Burne-Jones include *Sponsa de Libano* (1891) and *The Car of Love* (Pl. 572), on which he was working when he died. *Sponsa de Libano* was based upon an ealier tapestry design inspired by the Song of Solomon. It shows the North and South Winds blowing at King Solomon's request on his bride of Lebanon, surrounded by lilies, symbols of virginity. This languourous dream is very different in mood from the anguished figures of young men and women who drag the *The Car of Love* mounted on huge wheels through the narrow streets of a city based upon Siena. This extraordinary work held, we may infer, special meaning for Burne-Jones, as the smouldering embers of his sensuality cooled with old age, and he looked back, as old men will, to his affair with Maria Zambaco in 1870, with her 'glorious red hair and almost phosphorescent white skin'.

Cultures all round the world have a version of the sleeping beauty story, although the older, darker elements from the European tradition have now been forgotten. They relate to the way in which the Princess is tricked into a deep sleep until she is ready for sexual awakening by the Prince, whose struggle through the thickets is both a test of his courage and the rite of passage to manhood. The finest pictorial treatment of this theme was produced between 1870 and 1890 by Burne-Jones in his series of paintings *The Legend of the Briar Rose*. They derive from Tennyson's *Day Dream*, although they had their origin in a set of tiles which Burne-Jones designed in the early 1860s for Morris and Company illustrating Perrault's *Sleeping Beauty*. Burne-Jones would also have known Walter Crane's *The Sleeping Beauty in the Wood* (1876), one of the most delightful of all his picture books for children.

Although there are other variant versions, the *Briar Rose* series when completed in 1890 comprised four paintings: *The Briar Wood*, showing the Prince entering the Briar Wood; *The Council Chamber*, in which the King and his courtiers are asleep; *The Garden Court*, showing a group of servant girls asleep at their work; and *The Rose Bower* (Pl. 573), showing the Princess and her maidens asleep.

Revealingly, Burne-Jones avoided painting the obvious incident – the moment when the Prince awakens the Princess by a kiss. He was content to leave the Prince caught for ever in the overgrown tangle of brambles at the edge of the enchanted wood. The picture provides a striking example of Burne-Jones's growing interest in natural ornament, which in the 1890s would influence the new sinuous and organic forms of Art Nouveau. The series was first shown to enthusiastic crowds in London's West End at Agnew's in 1890, and the following year in the East End at Toynbee Hall, Whitechapel. Today the paintings are built into the walls at Buscot Park, a National Trust house near Newbury, and richly repay the journey to go and see them, for they are magically beautiful.

Burne-Jones's last years became increasingly occupied with trying to complete works of massive size, begun earlier in his career. The most important of all these works was *The Sleep of King Arthur in Avalon* (Pl. 574). In *The Passing of Arthur* Tennyson's King Arthur gives a valediction:

> But now farewell. I am going a long way …
> To the island-valley of Avilion;
> Where falls not hail, or rain, or any snow.
> Nor ever wind blows loudly; but it lies

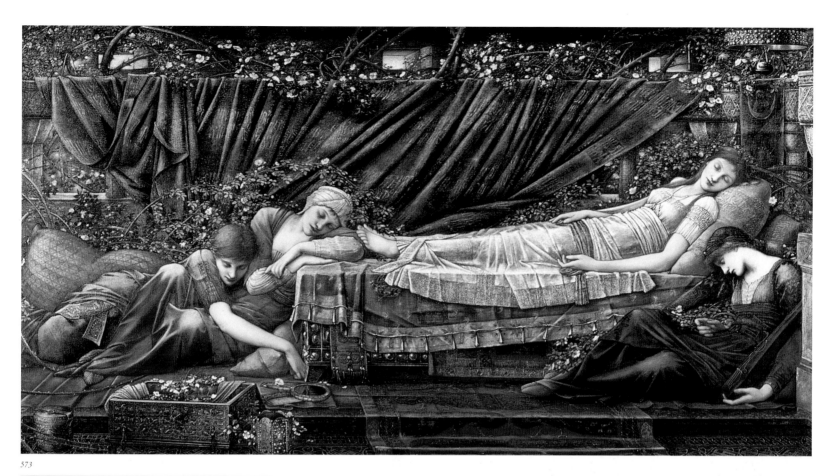

573

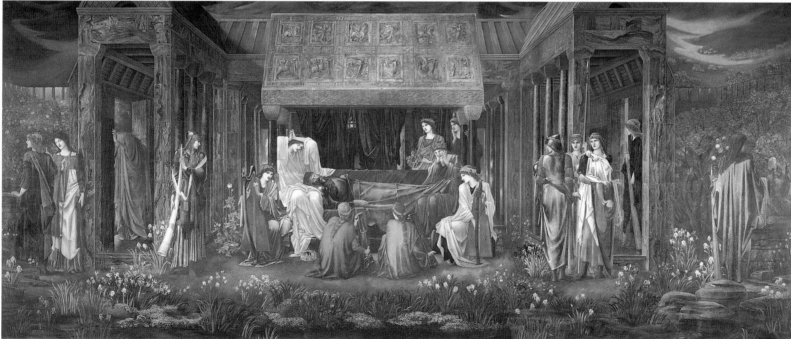

574

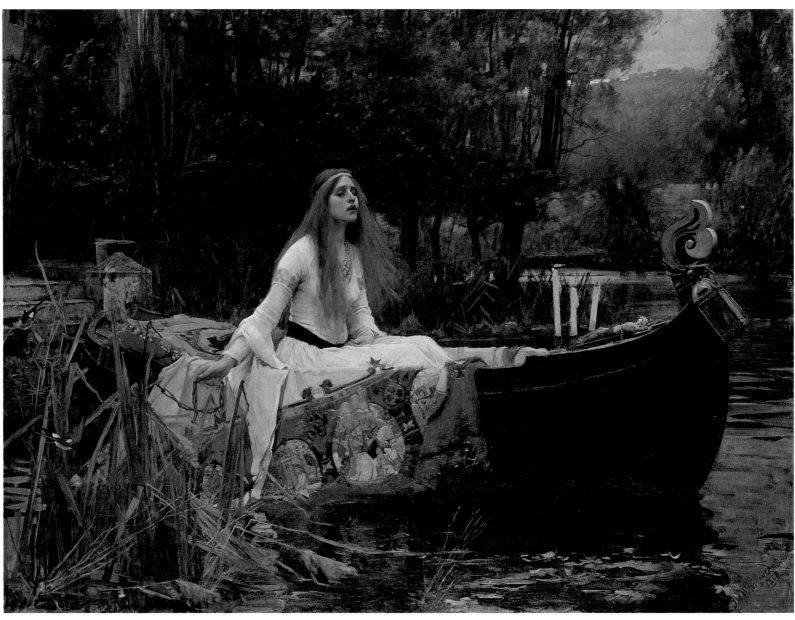

Deep meadow'd, happy, fair with orchard lawns

And bowery hollows crown'd with summer sea …

These lines have attained prophetic relevance for the painting itself, which rests not at Glastonbury as the legend ordained, but in Puerto Rico. The huge picture, almost as tall and long as a bus, hangs at the Ponce Museum there, which houses a remarkable collection of Victorian art. The painting is so big that it will never again leave its home, so that lovers of Burne-Jones, Tennyson and King Arthur will always have to make a pilgrimage to the Caribbean to see it. It is interesting to note that the painting was originally planned as a triptych, with the two wings showing at first battle scenes and later fairies!

The dreamily romantic style of John William Waterhouse (1849–1917) is seen to great advantage in Keats's *La Belle Dame sans Merci* (Pl. 576), and another Tennyson subject, *The Lady of Shalott* (Pl. 575). In the latter the intensity of a Pre-Raphaelite vision is muted into a luxuriant and mysterious reverie, a poetic visualization of some of the most loved lines in the English language. The painting vies with Millais's *Ophelia* for the honour of being the best-selling postcard published by the Tate Gallery. Two classical themes successfully treated by Waterhouse were *Hylas and the Nymphs* (Pl. 577), regarded by the *Art Journal* as possessing 'a combination of the better attributes and intentions of Leighton and Sir Edward Burne-Jones', and *Nymphs Finding the Head of Orpheus* (1900).

Other-worldly themes were also painted increasingly by G.F. Watts as he grew older, and became more and more concerned with Spiritualism. From 1880 onwards ideas of life, death and the cosmos occur more and more often in his work. Watts once asserted: 'I paint ideas, not things … I cannot claim for my pictures more than they are thoughts, attempts to embody visionary ideas … There is only one great mystery – the Creator. We can never return to the early ideas of him as a kind white-bearded old man. If I were ever to make a symbol of the Deity, it would be as a great vesture into which everything that exists is woven.'

One of Watts's most famous compositions was *Hope* (Pl. 579), of which several versions exist. Of one he wrote: 'I am painting a picture of Hope sitting on a globe with bandaged eyes, with a lyre which has all the strings broken but one …' In all versions of *Hope*, Watts's life-long study of the Elgin Marbles shows itself in the thin draperies clinging to the figure. Watts's powerful allegory of man's condition was rivalled by a painting depicting another classical legend by Lord Leighton, Watts's old friend and fellow admirer of the classical ideal. In *Clytie* (Pl. 578), Leighton painted the sun setting among great banks of cumulus cloud. Clytie is the diminutive figure on the right kneeling beside an altar abandoned by her lover, the god Apollo. In her distress she watches every day as Apollo drives the chariot of the sun across the sky. Gradually she was to be transformed into a flower, the heliotrope that turns its face to follow the sun.

In the 1890s, as both the Victorian era and the century grew to a close, art itself would turn in search of new directions.

575
John William Waterhouse
The Lady of Shalott
1888
oil on canvas, 153 × 200cm
(60¼ × 78¾in)
Tate Gallery, London

576
John William Waterhouse
La Belle Dame sans Merci
1893
oil on canvas, 110.5 × 81cm
(43½ × 32in)
Hessisches Landesmuseum,
Darmstadt

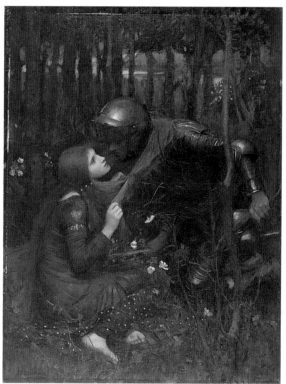

576

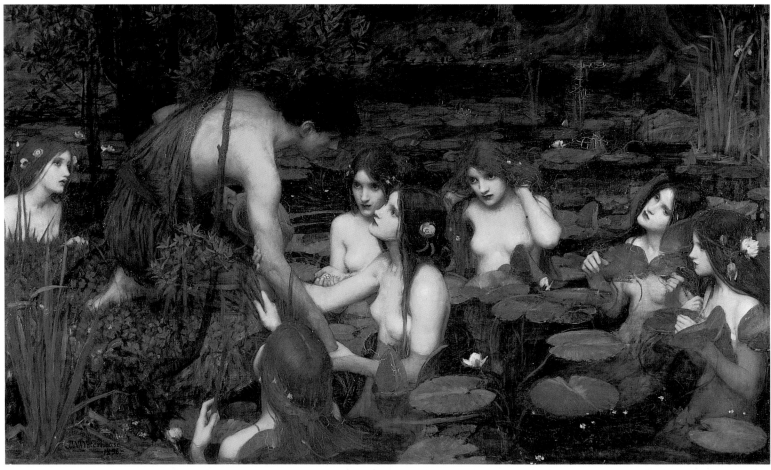

577

578

577
John William Waterhouse
Hylas and the Nymphs
1896
oil on canvas, 97 × 160cm
(38 × 63in)
Manchester City Art Gallery

578
Frederic Leighton
Clytie
1890–2
oil on canvas, 85.1 × 137.8cm
(33⅓ × 54⅓in)
Fitzwilliam Museum,
Cambridge

579
George Frederic Watts
Hope
c.1885–6
oil on canvas, 150 × 109cm
(60 × 43in)
Tate Gallery, London

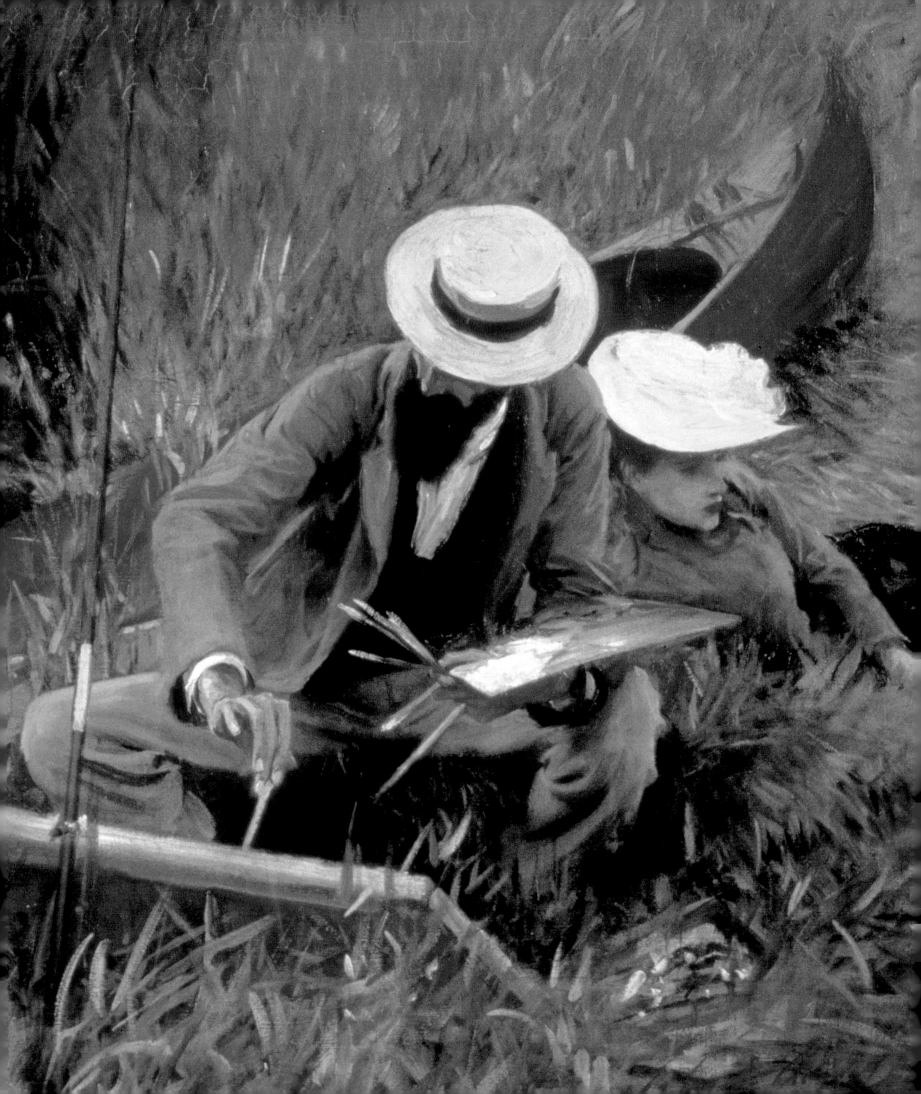

'It seems to me that we are descended from the English Turner. He was perhaps the first to make his colours shine with natural brilliancy. There is much for us to learn from the English school,' wrote Camille Pissarro in the *Artist* in 1892. The last three decades of the Victorian era were indeed to see a learning process take place in both France and England. Channel packet boats transported a two-way traffic of artists: the French who were seeking political asylum in England and the English who were anxious to study in Paris to escape from the High Victorian passion for narrative painting.

That being said, the specific programme of the French Impressionists was never to be adopted wholesale by British artists, although the word 'Impressionism', like the term 'Aestheticism', became widely and loosely used by painters and critics alike. As always, Oscar Wilde's views, expressed in an essay entitled

'The Decay of Lying' written in 1889, were highly pertinent, in a passage which clearly owes more to Whistler's musical analogies than to the works of Manet, Monet and their followers:

> Where, if not from the Impressionists, do we get those wonderful brown fogs that come creeping down our streets, blurring the gas-lamps and changing the house into monstrous shadows? To whom, if not to them and their master [i.e. Whistler], do we owe the lovely silver mists that brood over our river, and turn to faint forms of fading grace curved bridge and swaying barge? The extraordinary change that has taken place in the climate of London during the last ten years is entirely due to a particular school of Art.

To help us through this confusing semantic minefield to an understanding of British Impressionist painting it is necessary to survey from a different angle the career of Whistler and his new art, which he called 'Impressionism' but which we might describe as 'Aestheticism'. To do so we must first review the years of the Second Empire from 1852 to 1870, when Paris vied successfully with Rome, Düsseldorf and Antwerp as the favoured city in which to study the art of painting. In the 'city of light', as it was known, art was always headline news. Gustave Courbet (1819–77), casting himself in the role of artist-hero with his highly controversial *The Painter's Studio* (1855), became the leader of a new Romantic realist school of painting, a major precursor of the Impressionist school. Paris with its wider horizons and more permissive views was a magnet which both attracted and repelled British artists.

The appeal of better formal teaching was complemented by the charms of the Romantic world made familiar by Henri Murger's short stories *Scènes de la vie de Bohème* (1845), which later inspired Puccini's opera *La Bohème*. Nearly fifty years after Murger's book, George Du Maurier, the *Punch* cartoonist, was led by failing sight to turn to writing novels. In *Trilby*, serialized in 1894, he looked back nostalgically to his student years of the 1850s in the Latin Quarter, when he had shared a studio with Whistler and two other pupils of the Salon painter Gleyre, Thomas Armstrong and Edward Poynter, who were later to be both artists and museum administrators. The moral attitudes of the two books present a fascinating contrast. In Murger's Bohemia love affairs are conducted with amoral Gallic zest, while Du Maurier's heroine is embarrassed and horrified at the sight of Trilby posing in the nude (see above, p.298).

Surprisingly, even Rossetti reacted stuffily to the artistic freedom of the French capital. In November 1864, while staying in Paris, he wrote home to his mother: 'The new French school is simply putrescence and decomposition. There is a man named Manet to whose studio I was taken by Fantin whose pictures are for the most part mere scrawls and who seems to be one of the lights of the school. Courbet, the head of it, is not much better.' The letter continues by describing a visit to a shop selling Japanese prints where Rossetti bought four Japanese books, but 'found that all the costumes were being snapped up by a French artist, Tissot, who it seems is doing three Japanese pictures, which the mistress of the shop described to me as the three wonders of the world, evidently in her opinion quite throwing Whistler into the shade'.

Rossetti's blinkered insularity, so rampant in this letter, nevertheless reveals the importance of the cross-Channel role of Tissot, Whistler and Henri Fantin-Latour (1836–1904) in bringing new French ideas to England. Fantin-Latour was particularly well placed to undertake these activities, as his still-life flower compositions brought him many English clients. Writing to some friends in England on 23 November 1861, he vividly explained both the attractions and drawbacks of the French capital: 'Paris – that's free art. No one sells, but there one has freedom of expression and people who strive, who struggle, who approve; there one has partisans,

sets up a school; the most ridiculous as well as the most exalted idea has its ardent supporters.' Fantin-Latour was also a painter of portrait groups, a traditionalist with progressive friends on both sides of the Channel, some of whom he included in his most famous painting, *Homage to Delacroix* (1864), which includes Manet, Baudelaire and Whistler.

It was Whistler's destiny to form an intellectual bridge between Paris and London. Throughout his life he forged vital links between the artistic movements in both capitals, although always remaining loyal to his American roots. He was born in Lowell, Massachusetts, but his boyhood was passed in Russia where his father worked as a railway engineer. He had drawing lessons when aged 11 at the Imperial Academy of Fine Art at St Petersburg. For three years from 1851 to 1854 he attended the US Military Academy on the Hudson at West Point, from which he was discharged, nominally for failure in chemistry. 'If silicon had been a gas,' he used to joke, 'I should have been a Major General.' In reality he left the army because of his delight in confrontation, the adrenaline of a row, which seems always to have been a necessary part of his creative activities.

In 1855 he went to Paris where he copied in the Louvre, and studied intermittently at Gleyre's Academy, so vividly described in Du Maurier's *Trilby*. He acquired a life-long admiration for Velázquez and Japanese art. Through his friend Fantin-Latour he met Courbet, whose advocacy of realism inspired much of his earlier work. They both shared the services of Jo Hiffernan as a model, the beautiful red-haired Irish girl who was the subject for both Whistler's *The White Girl (Symphony in White No. 1)* (Pl. 581) and Courbet's *La Belle Irlandaise* (1865).

When he first settled in London, Whistler successfully exhibited *At the Piano* (1860) and *The Coast of Brittany: Alone with the Tide* (1862) at the Royal Academy. These successes were clouded by his failure, also in 1862, to exhibit *The White Girl*, a major work into which much hope and energy had been invested, but which was turned down by the Academy and, in the following year, by the Paris Salon. The simple white dress worn by Jo caused much of the scandal, forming too stark a contrast to the crinolines then at the height of their popularity. From that time onwards his work was always controversial, for as Millais remarked when he first saw a Whistler: 'It's damned clever; it's a damned sight *too* clever!'

Whistler's aims were indeed very different from those of the Pre-Raphaelite leader. As early as 1862 he wrote to Fantin-Latour grumbling about the problem of capturing ephemeral effects of light and weather while working *en plein air*. By 1868 he began to solve the problem, and wrote again to Fantin-Latour:

> It seems to me that colour ought to be, as it were, embroidered on the canvas,
>
> that is to say the same colour ought to appear in the picture continually here and
>
> there, in the same way that a thread appears in an embroidery, and so should all
>
> the others, more or less according to their importance. Look how well the
>
> Japanese understand this ...

His palette, restricted to subdued colours by his close study of Japanese art, with which he had great affinity, was brilliantly successful in capturing the low-toned tranquillity of the Thames at dusk. What was so difficult for the public to grasp was that for Whistler, subject and style were identical. His 'sauce', a runny mixture of copal, turpentine and linseed oil, had to be applied quickly and evenly like a watercolour wash. As he said when teaching a pupil: 'Paint should not be applied thick. It should be like the breath on a pane of glass.' For most Victorian critical eyes, used to the rich, juicy properties of oil paint, this was heresy, as was, to an even greater extent, the Impressionists' desire to eschew genre subjects and look at the world with a new freshness and immediacy.

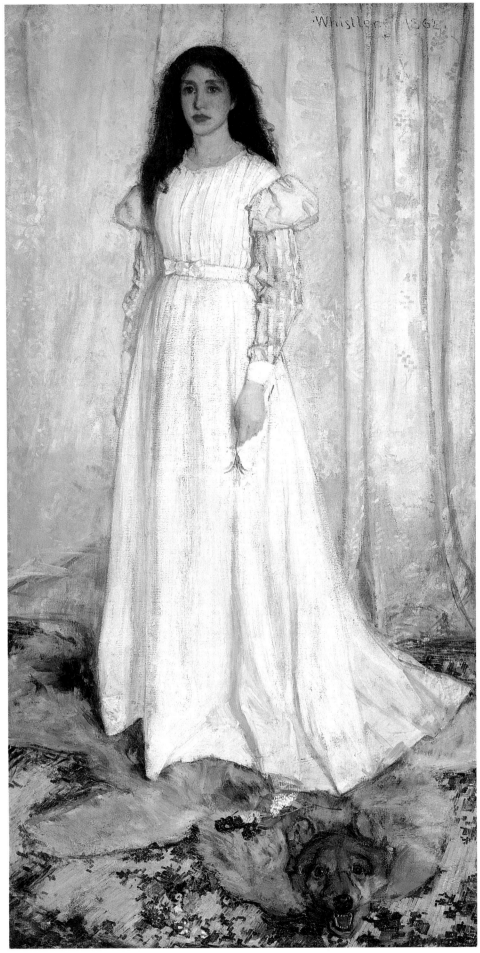

581
James Abbott McNeill Whistler
**Symphony in White No. 1:
The White Girl**
1862
oil on canvas, 214·6 × 108cm
(84¼ × 42½ in)
National Gallery of Art,
Washington DC

These ideas were evolving in France when the upheaval of the Franco-Prussian War in 1870 made life in Paris intolerable. To escape the turmoil of the war the Barbizon landscape painter Charles-François Daubigny (1817–78) and the Impressionists Claude Monet (1840–1926) and Camille Pissarro (1830–1903) all sought refuge in London. Pissarro later recalled:

> Monet and I were very enthusiastic over the London landscapes. Monet worked in the parks, whilst I, living at Lower Norwood, at that time a charming suburb, studied the effect of fog, snow, and springtime. We worked from nature ... we also visited the museums. The watercolours and paintings of Turner and of Constable, the canvases of Old Crome, have certainly had influence upon us. We admired Gainsborough, Lawrence, Reynolds, etc., but we were struck chiefly by the landscape painters, who shared more in our aim with regard to *plein air*, light, and fugitive effects. Watts, Rossetti, strongly interested us among the modern men.

Monet also painted his first tentative view of the Houses of Parliament, a theme which was thirty years later to inspire a major series of works, while Pissarro worked with great industry at the landscape of suburbia at Norwood and the Crystal Palace. Yet both were eager to return to Paris, partly because London was not a good place to sell their paintings, which were predictably rejected by the Royal Academy. As Pissarro wrote to the politician and journalist Théodore Duret, 'I count on returning to France as soon as possible ... Here there is no art; everything is a question of business.' When Duret too visited London, he agreed, and wrote to Manet in 1871: 'the English, with regard to French art, like only Gérôme [the Academic Orientalist], Rosa Bonheur, etc. Corot and the other great painters don't exist for them as yet. Things here are the way they were twenty-five years ago in Paris.' Duret wrote just before leaving for America, where he found the modern French school much more appreciated. The great American love affair with Impressionism had begun.

Fortunately for Monet, he was introduced by his friend Daubigny to the dealer Paul Durand-Ruel, who had also fled to London. He bought several Monet paintings and two by Pissarro. This proved an important contact both for Monet and for the spread of knowledge of Impressionism to England; for in the early 1870s Durand-Ruel organized ten exhibitions over a four-year period in London at which works by Impressionist painters were shown. Both Pissarro and Monet would later visit England on several occasions, but in 1871, just as they returned to Paris, James Tissot fled to London. He had remained in Paris following the outbreak of the Franco-Prussian War and stayed there during the siege of Paris and the horrors of the Commune, when the city was torn in two jagged halves and fought itself to a bloody standstill, leaving violent animosities between suburbs which, over a century later, are still vivid in folk memory. To escape the savage retaliation inflicted on the Communards, Tissot settled in London, where he was to remain from 1871 to 1882. There he produced some of his finest work, 'living like a King', as Berthe Morisot remarked, on the proceeds from the sale of ambitious social conversation pieces. Berthe Morisot visited Tissot in London in 1874, after staying on the Isle of Wight, where at Cowes she had painted one of her liveliest compositions, *Isle of Wight* (Pl. 582), full of the ebb and flow of yachts in movement, and very different from Tissot's glamorous yatching scene, *The Ball on Shipboard* (Pl. 332), an eloquent testimony to the artist's powers of captivating the public by an inspired use of the fashion plates and engraved illustrations of society functions which appeared in ladies' journals of the day.

Tissot's conversation pieces, such as *Hush! The Concert* (Pl. 333), provide striking evidence of the sophistication of the artistic circles in which he moved. Society

582
Berthe Morisot
Isle of Wight
1875
oil on canvas, 36 × 48cm
(14¼ × 18⅞in)
Private collection

583
Alfred Sisley
Regattas at Molesey
1874
oil on canvas, 66 × 91.5cm
(26 × 36in)
Musée d'Orsay, Paris

certainly beat its way to Tissot's door, as Edmond de Goncourt scornfully described in 1874, after visiting Tissot's studio in St John's Wood, which was provided: 'with a waiting room where, at all times, there is iced champagne at the disposal of visitors, and around the studio a garden, where, all day long, one can see a footman in silk stockings brushing and shining the shrubbery leaves'.

Yet for all his enjoyment of high society, Tissot could reveal an unexpected earthiness. Once, after a meeting with the artist, Edmond de Goncourt recorded a statement which could be by Zola: 'He tells me he likes England, London, and the odour of coal because it smells of the battle of life.' This quality in Tissot explains why Degas attempted to persuade him to participate in the first Impressionist exhibition of 1874, in part motivated by a wish to rehabilitate his friend. Degas wrote: 'See here, my dear Tissot, don't hesitate or try to avoid the issue. You just have to exhibit ... It'll do you good (it is a way for you to show yourself in Paris, which people say you are evading) and it will be good for us too ... The realist movement no

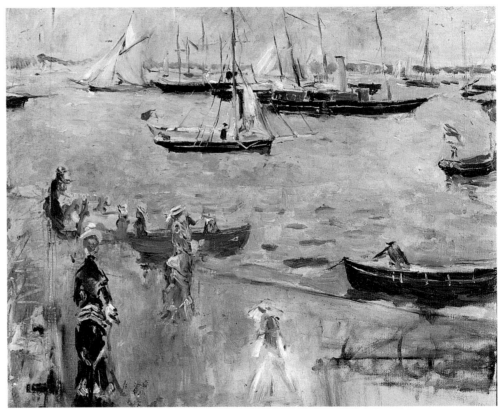

582

longer needs to fight with others. It *is*, it *exists*, it has to *show itself separately*. There has to *be a realist salon* ... Exhibit. Stay with your country and your friends.' Although Tissot was never to exhibit with the Impressionists, his elegant but ambiguous art fuses the best qualities of Victorian and Impressionist painting and still possesses the power to puzzle and enchant us today.

Some of the most successful of all Impressionist paintings of the Thames were by Alfred Sisley (1839–99), the Cinderella of the Impressionist movement. Paradoxically, although he was born and died in France, Sisley was of British parentage and therefore British by birth, never gaining French nationality. This explains why, when in 1897 he finally married his mistress Eugénie Lescouezec, after thirty years together and just a year before they both died of cancer, he did so in Cardiff and not in France. Sisley's first visit to England had been from 1857 to 1859, nominally to study in London for a business career, although actually he took the opportunity to absorb the

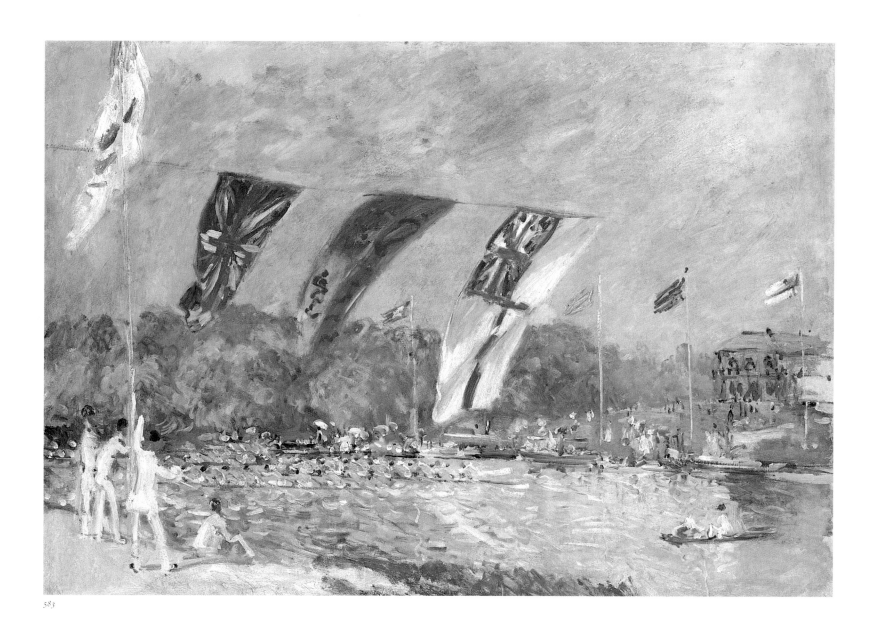

584
Alfred Sisley
Cardiff Roadsteads
1897
oil on canvas, 54.5 × 65.5cm
(21½ × 25¾in)
Musée des Beaux-Arts, Rheims

585
James Abbott McNeill Whistler
**Nocturne in Black and
Gold: The Falling Rocket**
1875
oil on wood, 60.3 × 46.6cm
(23¾ × 18⅜in)
Detroit Institute of Art

work of British landscape painters in museums and art galleries, particularly that of John Constable, with which he felt a deep affinity. Back in Paris he entered the studio of Gleyre in 1862, there meeting Renoir, Bazille and Monet, with whom he became close friends. In 1874 his friend and patron, the opera singer Jean-Baptiste Faure, invited Sisley to visit London with him, and in four months he painted 17 paintings of the Thames at Hampton Court (Pl. 583), some of his freest, most untrammelled work, described by Kenneth Clark as 'a perfect moment of Impressionism'.

Sisley's later career was dogged by lack of money, robbing us of similar paintings of the Isle of Wight where he went on holiday in 1881, but without sufficient cash to buy materials to paint Alum Bay. But he did paint some of his last moving canvases, of the Roadsteads of Cardiff (Pl. 584), Langland Bay, Lady's Cove and Starr Rock, in the spring of 1897 while staying in Penarth.

Although French Impressionism itself made a great impact in the last twenty years of the Victorian age, Whistler's stormy career created even more controversy

584

and upheaval. The *Peacock Room* incident (see above, p. 60) embodies the central tenet of Whistler's aesthetic credo – the supremacy of the artist's opinion over that of collectors or patrons. The theme recurs in the dispute between Whistler and Ruskin over the latter's criticism of Whistler's *Nocturne in Black and Gold: The Falling Rocket* (Pl. 585), which culminated in the notorious libel case of 1878. The first shot in this famous battle occurred in 1873, when John Ruskin, then Slade Professor of Art, delivered his third lecture on Tuscan art. Always prone to digression, he alluded to a painting by Whistler exhibited in 1872, entitled *Harmony in Grey*, saying:

> I never saw anything so impudent on the walls of any exhibition in any country
> as last year in London. It was a daub, professing to be 'a harmony in pink and
> white' (or some such nonsense); absolute rubbish, and which had taken about a
> quarter of an hour to scrawl or daub – it had no pretence to be called painting.
> The price asked was two hundred and fifty guineas.

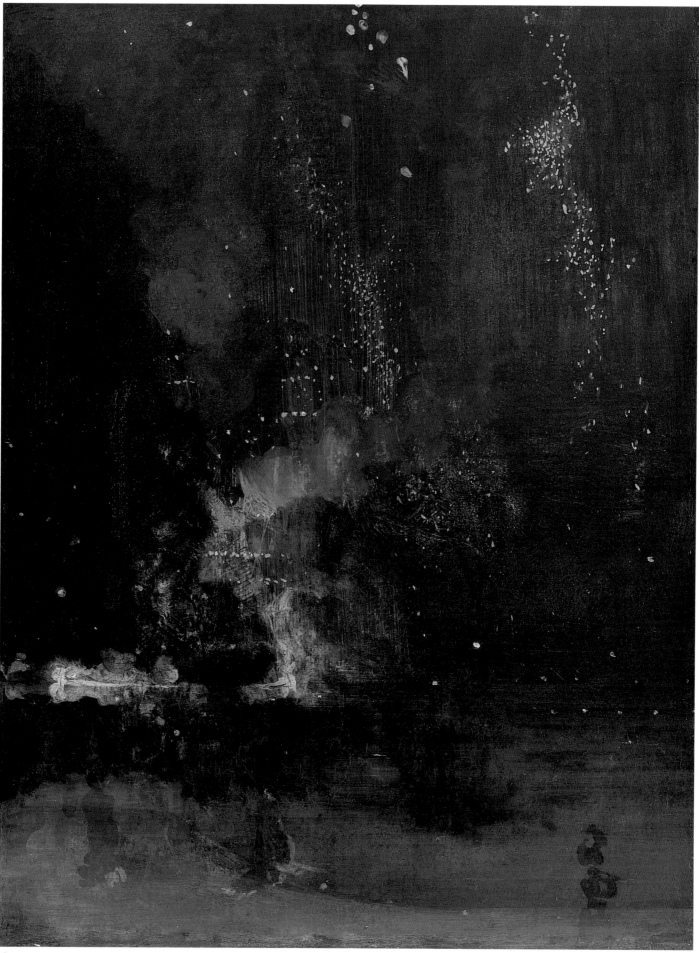

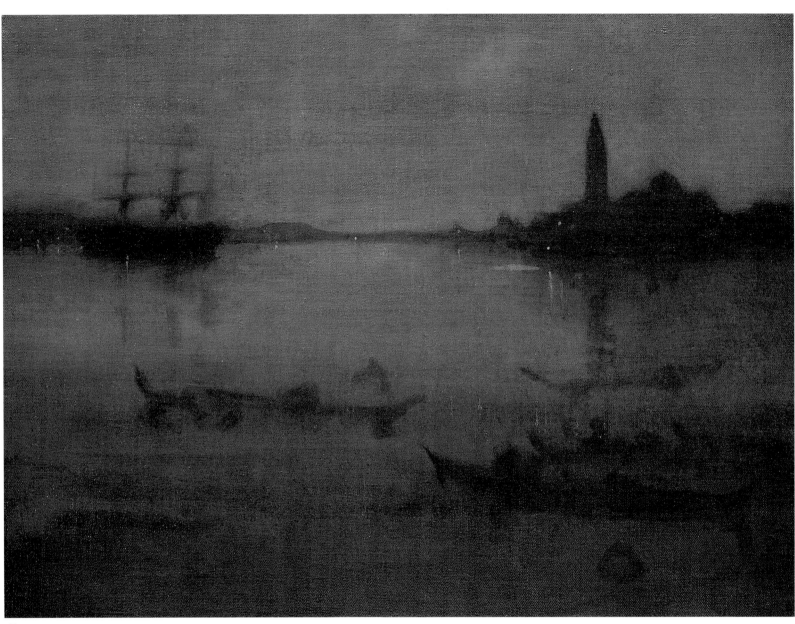

586
James Abbott McNeill Whistler
**Nocturne in Blue and Silver:
The Lagoon, Venice**
1879–80
oil on canvas, 51 × 66cm
(20 × 26in)
Museum of Fine Arts, Boston

Whistler did not immediately learn of this critical tirade. But when Ruskin four years later returned to the attack, directing his ire upon another painting, a pyrotechnic display of awesome power was to be ignited. The exploding fireworks of the trial would burn both artist and critic.

For thirty years Ruskin had dominated art criticism. The artists he supported all conformed to his own highly personal interpretation of the rule of 'truth to Nature'. This enabled him to accept both the minute painstaking detail of Millais and the subjective abstraction of Turner. Ruskin's opinions could make or break the reputation of an artist. In Letter 79 of his personal periodical *Fors Clavigera*, published in July 1877, he wrote an extensive critique of the opening exhibition at the Grosvenor Gallery in June 1877. Tissot was chided for his 'mere coloured photographs of society', but Whistler's *Nocturne in Black and Gold* was described in words which have become renowned for their offensiveness:

> For Mr Whistler's own sake, no less for the protection of the purchaser, Sir
> Coutts Lindsay ought not to have admitted works into the gallery in which the
> ill-educated conceit of the artist so nearly approached the aspect of wilful impos-
> ture. I have seen, and heard, much of cockney impudence before now, but never
> expected to hear a coxcomb ask two hundred guineas for flinging a pot of paint
> in the public's face.

Whistler sued Ruskin for libel, and the date of the trial was set for November 1878. The case proved an important turning point in the history of art, for it marked the beginning of aspects of art as various as conceptualism and abstraction.

Artistic controversies provide ideal opportunities for satire. Public interest in the case led to the rapid adaption of a French farce, *La Cigale*, by Offenbach's librettists Meilac and Halévy; it had satirized Degas and the Impressionists, and now its target was changed to Whistler. Entitled *The Grasshopper*, it was staged in December 1877 at the Gaiety Theatre.

The plot involves an 'artist of the future' named Pygmalion Flippit, who names Whistler as his master, and produces a painting entitled *Dual Harmony*, representing a blue ocean beneath a burning sky. When hung upside down it showed a vast sandy desert under a blue and cloudless sky. Flippit observes: 'Like my great master, Whistler, I see things in a peculiar way, and I paint them as I see them. For instance, I see you as a violet colour, and if I painted your portrait now I should paint it violet.' Surprisingly, the victim Whistler seems to have quite enjoyed the piece, which was put on with his co-operation. It was, after all, as his friend Alan Cole remarked, 'a tremendous puff for Whistler', during the months when he needed all the public support he could muster before the case came to trial.

In the two days of legal argument at the trial itself, an atmosphere of Gilbertian farce prevailed. Pictures were unceremoniously passed from hand to hand in the heavy fog which deepened the gloom of the candle-lit court. One painting hit the head of a balding gentleman, and appeared liable to fall out of its frame, before it reached the witness box. Whistler, on being asked whether the painting was his, inserted his monocle, and paused theatrically before responding: 'Well, it was once. But it won't be much longer if it goes on in this way.' The inevitable jokes about paintings being upside down or the right way up were made, notably concerning *Nocturne in Blue and Silver* (1872–3).

Ruskin, not present owing to a nervous breakdown, was, significantly, represented by the establishment figure of the Attorney General, Sir John Holker. The cut and thrust of cross-examination brings the case vividly to life:

> Holker: Did it take you much time to paint the *Nocturne in Black and Gold*? ...
> How long do you take to knock off one of your pictures?

> Whistler: Oh, I 'knock one off' possibly in a couple of days – (*laughter*) – one day
> to do the work and another to finish it.
>
> Holker: The labour of two days is that for which you ask two hundred guineas?
>
> Whistler: No, I ask it for the knowledge I have gained in the work of a lifetime
> (*applause*).

Whistler won his case but was awarded the derisory sum of one farthing and no costs. It ruined him financially and he was declared bankrupt for the sum of £3,000, which forced him to sell the White House, his studio in Chelsea, designed by his friend the architect E.W. Godwin. Indeed, both plaintiff and defendant suffered as the result of the case. Although his popularity was so great that his costs were paid by a public subscription organized by the Fine Art Society, Ruskin endured much mental distress even before the case came to trial, retiring to Coniston where in February 1878 he sank into his first major attack of insanity.

It was, however, impossible to depress Whistler for long, and soon after his bankruptcy his fortunes improved. The Fine Art Society, with remarkable even-handedness, advanced him the £150 necessary to take him to Venice for three months to produce a set of twelve etchings, with the option of buying the plates for £700 on his return. While in Venice Whistler also painted some relatively little-known Nocturnes in oils, of which *The Lagoon, Venice: Nocturne in Blue and Silver* (Pl. 586) is a fine example. His pupil Sickert recorded Whistler using large housepainter's brushes (favoured by twentieth-century action painters) for the large sweeps of colour in such works.

Whistler returned to London in November 1880, and the Venice set was exhibited at the Fine Art Society the following month in one of the carefully orchestrated settings which Whistler loved, followed by a Venetian pastels show in which white and yellow were the dominant notes. The wall was white with yellow hangings, the floor covered with pale yellow matting, the couches pale yellow serge, and the cane-bottomed chairs were painted yellow. There were yellow flowers in yellow pots and a white and yellow livery for the attendants, who at the private view wore yellow socks and yellow neckties. Whistler distributed yellow favours, 'wonderful little butterflies', to his friends.

His Venetian exile was a turning point for Whistler. It had cut him off from England but renewed his links with France. During the 1880s he was in correspondence with both Degas and Monet, the latter introducing him to Mallarmé who became a close friend. But England remained the stage upon which Whistler could appear most effectively, and he still hoped to influence the future of British art. This he was to accomplish by his influence over young artists who admired his independent stance and who read his polemical *Ten O'Clock Lecture*, delivered in February 1885, which contains a moving and famous declaration of his beliefs:

> Nature contains the elements, in colour and form, of all pictures, as the keyboard
> contains the notes of all music. But the artist is born to pick and choose, and
> group with science, these elements, that the result may be beautiful – as the musi-
> cian gathers his notes, and forms his chords until he brings forth from chaos glori-
> ous harmony ... the story of the beautiful is already complete – hewn in the mar-
> bles of the Parthenon – and broidered with birds, upon the fan of Hokusai – at
> the foot of Fujiyama.

After Whistler's return in 1880 from his productive year of etching in Venice, it became a point of honour for any young artist worth his salt to declare his personal challenge to orthodoxy by being seen to believe in Whistlerian principles. They followed the 'master' both in their choice of subject and their allegiance to his demanding standards in exhibiting their works. But it could often be a bumpy ride.

In November 1884 Whistler was asked to join a rather staid body, the Society of British Artists. Attendances were falling at their exhibitions, and their members hoped that Whistler's controversial work and charismatic personality would attract public notice. He was loyally joined by many of his pupils, led by William Stott of Oldham (1857–1900), who had trained in Paris and passed several summers at Grez-sur-Loing while painting *The Ferry* and *The Bathers*, works which gained him French critical recognition. Stott's *A Summer's Day* (Pl. 587), a carefully composed study of nude boys on a sandy beach under a cloudless sky, anticipated Tuke's later variations on a similar theme (Pl. 362).

In 1886 Whistler's followers staunchly voted him in as President of the Society of British Artists, just in time for him to host a visit from the Prince of Wales to one of the group's exhibitions. This led to the Society being awarded a Royal Charter as part of the Golden Jubilee celebrating fifty years of Queen Victoria's reign. Whistler himself, aged fifty-two, was delighted with his new establishment role. He persuaded Alfred Stevens, the Belgian painter, and Claude Monet to accept honorary membership. Monet became a good friend of Whistler, staying with him when he visited London in 1887; his paintings filled the winter exhibition of the Society in 1888.

But some of Whistler's innovations and controversial new ideas were extremely unpopular. He designed a velarium for use in the exhibitions, to ensure a subtle, diffused light, and declared: 'We want clean spaces round our pictures. We want

587
William Stott of Oldham
A Summer's Day
1886
oil on canvas, 132.9 × 189.3cm
(52¼ × 74¾in)
Manchester City Art Gallery

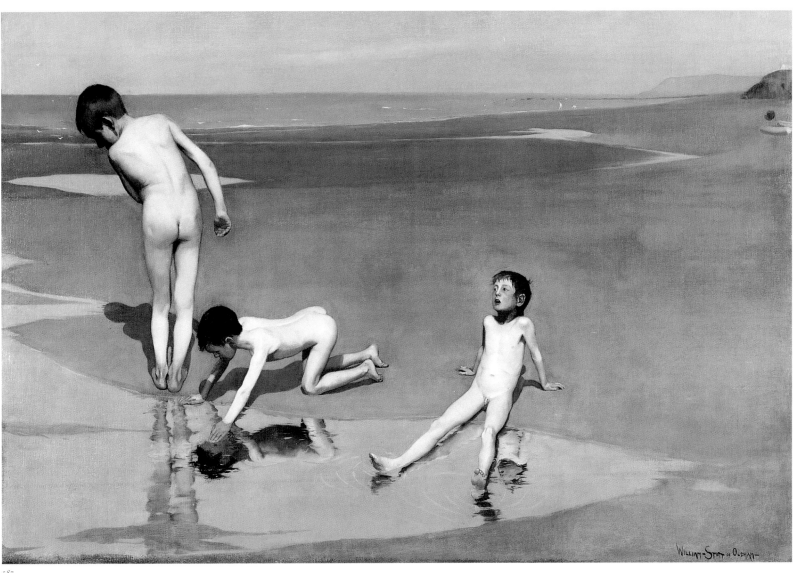

587

588
Walter Richard Sickert
**Gatti's Hungerford Palace
of Varieties: Second Turn
of Katie Lawrence**
*c.*1887–8
oil on canvas mounted
on board, 84.4 × 99.3cm
(33¼ × 39⅛in)
Art Gallery of New South
Wales, Sydney

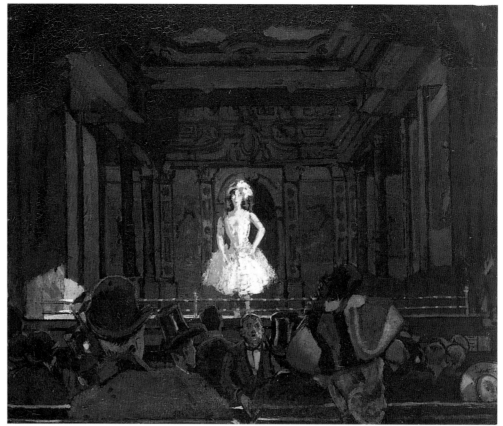

588

them to be seen. The British Artists must cease to be a shop.' Such ideas upset old members of the society, and one of them wrote a poem complaining that:

> ... no sooner was he seated in the Presidential chair,
> Than he changed our exaltations into wailings of despair
> For he broke up our traditions and went in for foreign schools
> Turning out the work we're noted for and making us look fools.

Eventually the older members, whose paintings Whistler had banished, rebelled, and as a direct result of this row in 1888, Whistler and some twenty of his close associates walked out of the society, leaving it £2,000 in debt. Inevitably, Whistler could not resist the ironic comment: 'The Artists have come out: only the British remain.'

The incident confirmed the *malaise* Whistler had experienced after the Ruskin case, and he never felt completely at home in London again. Although he joined the New English Art Club, formed in 1886, he always remained rather scornful of its activities. Its founders were largely artists who had worked in France, and had been influenced by the *plein-air* school and Bastien-Lepage. They included George Clausen, Philip Wilson Steer and Sargent. But in 1889 control of the Club passed to a minority group led by the most remarkable of all Whistler's followers, a good-looking young man named Walter Richard Sickert (1860–1942).

Like Whistler, Sickert was a cosmopolitan and charismatic figure. He once remarked, 'no one could be more English than I am – born in Munich in 1860, of pure Danish descent!', omitting to mention the dash of Anglo-Irish blood on his mother's side which gave him a very English wit, present in his eminently readable writings on art. Both his father and grandfather were painters, the family settling in London in 1868. For some years Sickert worked as an actor touring with Henry Irving, and he always retained a theatrical eye for what might be termed 'a strong situation' in his genre subjects. In 1881 he became a student at the Slade, leaving in 1882 to become Whistler's pupil and assistant.

From Whistler Sickert acquired a fastidious approach to the application of oil paint, and developed a fluid, low-toned palette which was to become a highly distinctive feature of his work. He also gained experience of etching techniques when helping to print his master's plates. Like Whistler, he enjoyed the polemics and publicity of the art world. Sickert has left a lively account of what it was like to run errands for Whistler to Paris in the early 1880s, as when he delivered *Arrangement in Grey and Black: The Artist's Mother* (Pl. 90) to the Salon. There Whistler's letter of introduction led him to change one great but extremely touchy master for another – Degas, for whom he worked for two years. Degas's paintings of the performers and audiences at Parisian *café-concerts* deeply impressed Sickert and suggested the theme

589
Théodore Roussel
Blue Thames, End of a Summer Afternoon, Chelsea
1889
oil on canvas, 83.5 × 119.4cm
(33 × 47½ in)
Private collection

589

with which he is particularly associated, the gilt and velvet, smoke-filled music-halls which he loved to frequent, both in Paris and London.

Sickert had the actor's quick ear for a witty lyric, and relished the songs so full of ambiguities and *double-entendres*, and the masterly timing and delivery of the performers, such as the singer depicted in *Gatti's Hungerford Palace of Varieties: Second Turn of Katie Lawrence* (Pl. 588). Over seventy drawings exist for this painting, some very small, for from Degas Sickert had learnt to paint in the studio, building up a composition from many drawings – the exact opposite of Whistler's teaching. When first exhibited this painting caused a critical storm, being dismissed as 'a dirty smear, as vulgar in execution as the choice of subject', while the poor singer was

described as grotesque: 'Her mouth is twisted under her left ear, her hands flap on her short skirt, large and lifeless, her legs are wooden, her feet enormous.'

Another artist susceptible to the charisma of Whistler as mentor and example was Mortimer Menpes (1860–1938), from Adelaide in Australia. He had painted at Pont-Aven in Brittany before meeting Whistler in 1880 or 1881 and becoming his disciple and studio assistant. At a meeting in his home in Fulham, a group of seven other committed followers of Whistler decided to rent a joint studio at Baker Street. A studio stamp was devised showing a steam engine advancing with a red light: 'a danger signal to the Philistines to warn them that reformers were on their track'. Two of the artists also in thrall to Whistler's influence were Sidney Starr (1857–1925), a brilliant pastelist, and Théodore Roussel (1847–1926), one of the most intriguing of Whistler's followers. His *Blue Thames* (Pl. 589) shows him breaking away from the tenets of his mentor, and anticipates his sensitive colour experiments and analytical approach to colour and light, which deserve wider recognition.

When Sickert returned from Paris in 1885 full of enthusiasm for Degas, or 'Digars' as Menpes called him, the group began to renege on their allegiance to Whistler and discuss Impressionism instead. Degas had once remarked to Sickert: 'I

590
Sidney Starr
The City Atlas
1889
oil on canvas, 60.9 × 50.6cm
(24 × 20in)
National Gallery of Canada,
Ottawa

591
Mortimer Menpes
Flower of the Tea
1887–8
oil on wood, 26.7 × 17.1cm
(10½ × 6¾in)
Tate Gallery, London

592
Edward Atkinson Hornel
Kite Flying, Japan
c.1844
oil on canvas, 76.2 × 48.5cm
(30 × 19in)
National Gallery of Scotland,
Edinburgh

591

592

don't like carriages myself. You can't see anyone. That's why I like omnibuses. On them you can see people. Isn't that why we're here – to see each other?' Menpes and his friends enthusiastically followed this advice, travelling around London on omnibuses to record metropolitan life, as a few years later early film makers would do. A particularly effective work to emerge from this discipline is Sidney Starr's *The City Atlas* (Pl. 590) of 1889. The back view of the girl at the front of the bus recalls Degas's belief that a back view should reveal age and social position as much as a portrait.

From the 1860s to the 1890s the 'cult of Japan' infected artists as various as Rossetti, Tissot, Whistler, Manet, Monet, Degas and Van Gogh. Study of Japanese art provided major lessons in dramatic composition, viewpoint and perspective, such as cutting off figures by the picture frame. In the 1880s several young artists, intrigued by such Japanese effects and by Japanese artifacts, actually made the journey to Japan, with rather mixed results. One was Menpes, who visited Japan in 1887 for eight months to learn 'all the methods of Japanese art'. On his return he exhibited 137 oils and 40 prints created in Japan in the Dowdeswell Galleries, New Bond Street, one of which was *Flower of the Tea* (Pl. 591).

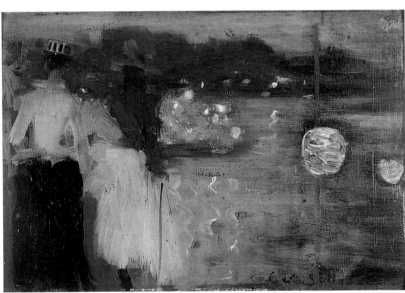

593

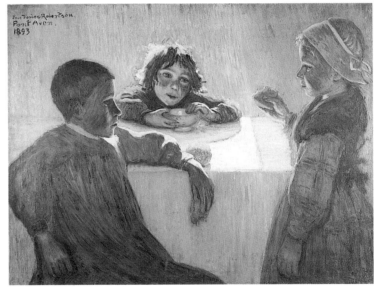

594

The exhibition was visited by Oscar Wilde who, already bored with the cult of Japan, posed the question:

> ... do you really imagine that the Japanese people, as they are presented to us in
> art, have any existence? ... In fact, the whole of Japan is a pure invention. There
> is no such country, there is no such people. One of our most charming painters
> went recently to the Land of the Chrysanthemum in the foolish hope of seeing
> the Japanese. All he saw, all he had the chance of painting, were a few lanterns
> and some fans. He was quite unable to discover the inhabitants, as his delightful
> exhibition ... showed only too well ...

As so often, Wilde is at his most profound when most paradoxical, and it is impossible not to feel sorry for poor Menpes, who characteristically was also abused by Whistler, enraged by his disciple visiting Japan without his permission.

A few years later, from 1893 to 1894, the Scottish painters Edward Atkinson Hornel (1864–1933) and George Henry (1858–1943) visited Japan, staying at Nagasaki, Yokohama and Tokyo, where they were disappointed in an exhibition of works by Japanese artists who had gone to study painting in Paris and Munich, and in so doing, in Hornel's view, 'learned their painting but lost their art!' Henry later

recalled his visit to Japan in less than enthusiastic terms: 'I painted landscapes there, both oils and watercolour, and figures, from the geishas, the most highly refined and educated women in Japan; and in both the same national feeling was visible, the absence of any strong contrast of colour. I had all my life been trying for strong colour, tartan landscape and vivid contrast.' As these anecdotes show, artistic cross-pollination could have its hazards, although a work such as *Kite Flying* by Hornel (Pl. 592) still has great charm.

For most of the members of the New English Art Club, however, foreign influence meant nothing so exotic as Japan. As the *Pall Mall Gazette* put it: 'the desire of the new school ... is to vindicate the soundness of engrafting English feeling and sentiment upon what is known as French technique'. A founder member of the Club was George Clausen, who in the 1870s visited Holland and Paris. In 1881 he saw

595
Henry Herbert La Thangue
In the Orchard
1893
oil on canvas, 83 × 72.5cm
(32¾ × 28½in)
Bradford Art Gallery and
Museums

596
Walter Osborne
**Apple Gathering,
Quimperlé**
1883
oil on canvas, 58 × 46cm
(22¾ × 18½in)
National Gallery of Ireland,
Dublin

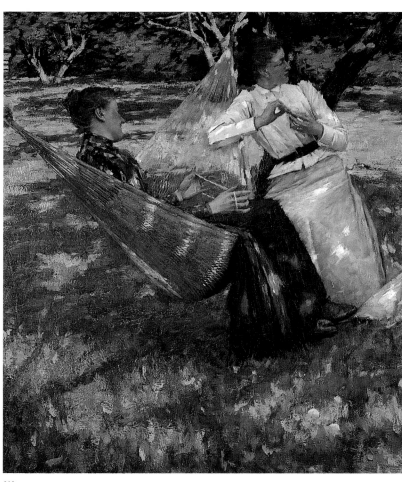

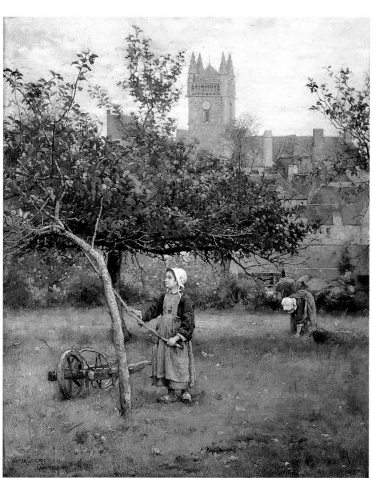

595

596

some Bastien-Lepage works which gave him a lifelong commitment to rural subjects. The influence is clear in *Breton Girl Carrying a Jar* (Pl. 402) but less pronounced in his later, more Impressionist works such as *A Souvenir of Marlow Regatta* (Pl. 593). Another founder member was Henry Herbert La Thangue (1859–1929), whose sun-dappled *In the Orchard* (Pl. 595) is a characteristic painting from the Club's heyday.

The leading artist of the group was Philip Wilson Steer. There is surely something symbolic in the fact that he was one of those unlucky painters forced to return to England in 1884 because of his failure to pass a compulsory French language exam at the Ecole des Beaux-Arts. The traditional British inability to learn a foreign language has always led to fashions in both British and French art suffering a sea change during their short Channel crossing, and Impressionism is no exception. Paradoxically, Wilson Steer's beach scenes in Suffolk and Boulogne, such as *Children*

597
John Lavery
The Bridge at Grez
1883–4
oil on canvas, 76.2 × 183.5cm
(30 × 72¼in)
Private collection

598
William McTaggart
The Storm
1890
oil on canvas, 121.9 × 183cm
(48 × 72in)
National Gallery of Scotland,
Edinburgh

599
John Singer Sargent
**Paul Helleu Sketching with
his Wife**
1889
oil on canvas, 66.3 × 81.5cm
(26 × 32in)
Brooklyn Museum of Art, New York

Paddling, Walberswick (Pl. 228) are some of the most successful 'Impressionist' paintings by an Englishman.

By 1888 the Club included not only Whistler himself, but others who had left the Royal Society of British Artists. Among them were Sickert, who however ceased to exhibit as 'a pupil of Whistler'. From Cornwall, Stanhope Forbes, Henry Tuke and other members of the Newlyn school submitted pictures. *Apple Gathering, Quimperlé* (Pl. 596) by the Irish painter Walter Osborne (1859–1903) shows the appeal of the little town in Brittany, where George Clausen also loved to paint. Nearby was Pont-Aven where in the 1890s Gauguin settled with his disciples the Nabis, as did some young English artists, among them Eric Forbes-Robertson, a member of the distinguished theatrical family. His fascinating sketch books, and paintings such as *Breton Children, Pont Aven* (Pl. 594), show the influence of Gauguin.

North of the border a group known as the Glasgow Boys (including Hornel and Henry) also proclaimed Impressonist beliefs. From Glasgow, via training in Paris under Gérôme and Bonnat and several summers at Grez-sur-Loing, came the Belfast-born John Lavery. His painting *The Bridge at Grez* (Pl. 597) shows a scene which par-

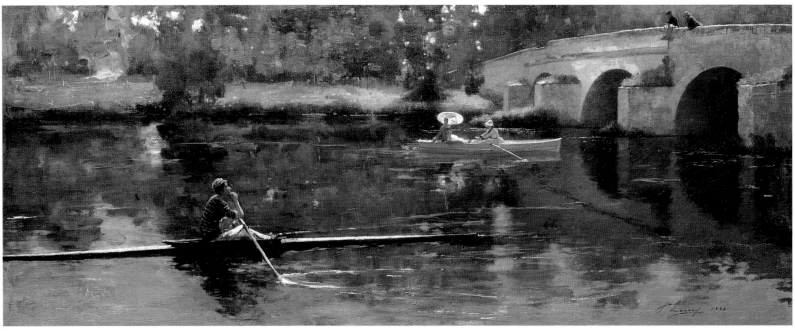

597

allels the mood of musical compositions such as *Summer Night on the River* by the composer Frederick Delius, who also made his home at Grez. The group also included James Guthrie, *aficionado* of the 'goose girl' theme (Pl. 401).

Scotland also produced the highly individual figure of William McTaggart (1835–1910), the leading landscape artist of his time, who has been called 'the Scottish Impressionist'. During his long career he painted in a range of styles varying from Pre-Raphaelitism to Abstract Expressionism. *The Storm* (Pl. 598), an impressive example of his work, recalls descriptions of the painter on the beach struggling to paint at an easel weighed down with rocks in a howling gale, the *plein-air* artist personified.

Whistler ceased to exhibit at the New English Art Club in 1889, and in the early 1890s began to withdraw from the London scene, causing a vacuum which was filled by John Singer Sargent. Sargent had settled in London in 1886, bringing with him the *plein-air* techniques which he shared with his Impressionist friend Claude Monet. Although based in England, he kept up his connections with France, often returning to holiday and work with friends. Two such visits are commemorated in the paintings

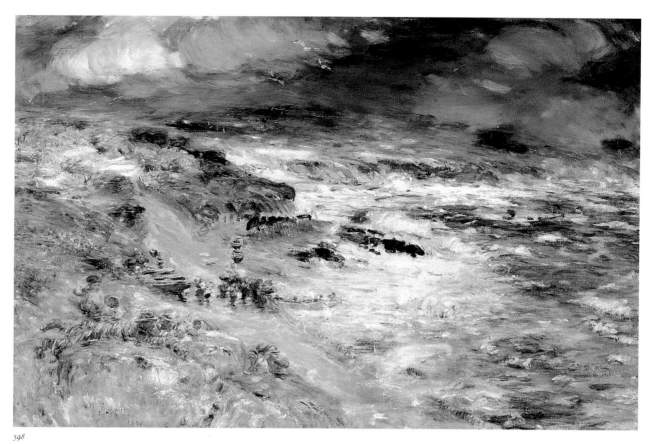

598

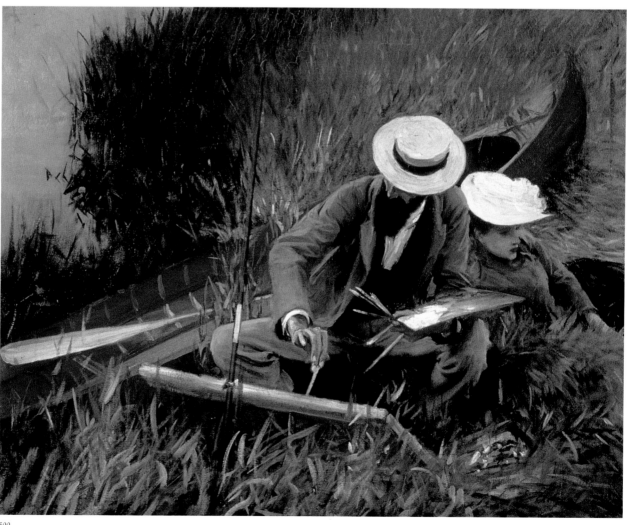

599

600

Claude Monet Painting at the Edge of a Wood (c.1887) and *Paul Helleu Sketching with his Wife* (Pl. 599). The focus on Helleu's hand, brush and palette are almost an affirmation of the primacy of the art of painting in the open air.

Yet Whistler's presence was still felt by many, including Sickert who wrote to his friend Jacques-Emile Blanche that he felt increasingly ill at ease with the Bastien-Lepage faction at the New English Art Club, 'whose touch is square and who all paint alike'. Sickert had met Blanche at Dieppe where he passed his summers from 1895 in company with Degas and Monet, and these meetings were to become the main link between the French avant-garde and progressive English art.

Exciting news of activities in the French capital was also provided by the young Irishman, George Moore, in his *Confessions of a Young Man*, published in 1888. Stylistically an exotic cocktail of Pater and Flaubert, it first brought Verlaine, Rimbaud, Mallarmé and the great artists of the Impressionist movement to notice in Britain. Moore was a friend of Manet, whose vivid portrait sketch dating from around 1879 captures the great raconteur in his favourite setting of the café-bar. In December 1889 Sickert and a group of friends sympathetic to Impressionism, including Wilson Steer, Sidney Starr and Théodore Roussel, nailed their colours to the mast and opened an independent exhibition at the Goupil Gallery called *The London Impressionists*. Many of the works on view were of London themes, a choice vigorously defended by Sickert, who was 'strong in the belief that for those who live in the most wonderful and complex city in the world, the most fruitful course of study lies in a persistent effort to render the magic and poetry which they daily see around them'.

During the 1890s the Channel packet boats continued to thrive on the comings and going of artists and writers. Whistler moved permanently back to Paris in 1892, only returning to Chelsea in 1901 to die. While Whistler went back to Paris Camille Pissarro stayed with his son Lucien (1863–1944) at Bedford Park, and painted the charms of Kew Gardens. Amazingly for a Frenchman, he even enjoyed the excitement of watching cricket matches, painting that theme on no fewer than five separate occasions. During his visit in the spring of 1890 he painted Hyde Park, Kensington Gardens, Charing Cross Bridge and Old Chelsea Bridge.

Monet also returned again to London. In 1899, 1900 and 1901, now a wealthy man, he stayed at the Savoy Hotel. There on the sixth floor, for six weeks, he looked at: 'What I like most in London ... the fog. Without the fog, London would not be a beautiful city. It's the fog that gives it its magnificent breadth.' Monet finished nearly a dozen views of Charing Cross Bridge (Pl. 600) and Waterloo Bridge (eighty remained unfinished!) and many views of the Houses of Parliament as seen across the river from the terrace of St Thomas's Hospital.

The Impressionists were not the only foreign artists with radical ideas to visit Britain. The Macchiaioli were a group of Italian artists from Florence active in the mid-nineteenth century in revolt against academic conventions, who emphasized their painterly freshness by the use of blots or patches (*macchie*) of colour. One artist of the group was Telemacho Signorini (1835–1901), whose extraordinary painting of *Leith* (Pl. 601), dominated by a positively psychedelic poster for Rob Roy cigarettes, is surely one of the most remarkable landscapes painted in Britain during a decade of innovations.

In 1917 the landscape *Lavacourt under Snow* by Claude Monet was left to the National Gallery as part of the bequest of Sir Hugh Lane, much to many of the trustees' reluctance. One of their number was Lord Redesdale, who declared: 'I should as soon expect to hear of a Mormon service being conducted in St Paul's Cathedral as to see the works of the modern French art-rebels in the sacred precincts of Trafalgar Square.'

Old attitudes were slow to change ...

600
Claude Monet
Charing Cross Bridge
1900
oil on canvas,
60·6 × 91·5cm (23⅞ × 36in)
Museum of Fine Arts, Boston

601
Telemacho Signorini
Leith
1881
oil on canvas, 45.6 × 41.8cm
(18 × 16½in)
Palazzo Pitti, Florence

601

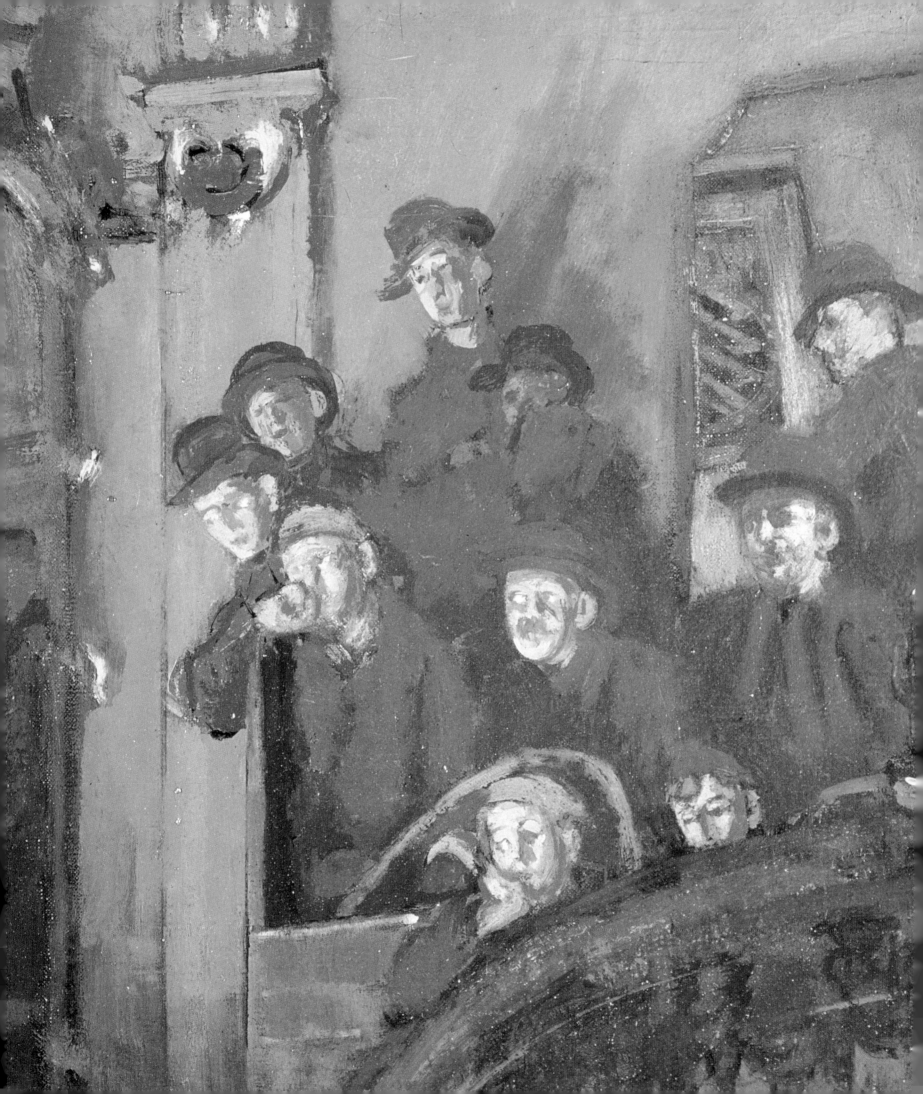

'**T**here came a sudden clamour outside, the door burst open and another well-known artist rushed in dancing and frantically waving an evening paper. "Ruskin's dead! Ruskin's dead!" he cried; then sinking into a chair. "Thank God, Ruskin's dead! Give me a cigarette!"' The silversmith and jeweller Henry Wilson (1864–1934), describing the reaction in a London club to the news of Ruskin's death in 1900, pungently conveys the universal sense at the turn of the century in the art world of an old order ending and a new era beginning.

Ruskin's death came mercifully after a period of mental breakdown which is movingly portrayed in a painting of the old man in his study by William Gershom Collingwood (1854–1932) (Pl. 603). With Queen Victoria's own demise in 1901, both the nineteenth century and the Victorian era were consigned to the museum. But for many, Ruskin's death

602 Walter Richard Sickert, **The Gallery of the Old Bedford** (detail of Pl. 608)

marked the key turning point, among them the American architect Frank Lloyd Wright, who in 1901 lectured and wrote upon *The Art and Craft of the Machine* in repudiation of Ruskin's dogmatic insistence on the absolute supremacy of hand craftsmanship. The sense of change was also reflected in the fine arts. During the 1890s one after another of the great names of Victorian art and letters had died: Alfred, Lord Tennyson in 1892, Madox Brown and Albert Moore in 1893, William Morris and Lord Leighton in 1896 (whose last words were 'Give my love to the Academy'). In February 1896 Millais was elected President of the Royal Academy, and on hearing the news Holman Hunt wrote to congratulate his old friend, quoting an affectionate pun made years earlier by Edward Lear: 'Ah! Now the Millais-nium has come!'

Sadly Millais's tenure of the post only lasted seven months, before his death from cancer also in 1896. There was a feeling of the last grains of sand slipping through the hourglass as the century drew to a close. Reading all these obituaries no doubt contributed to the fact that the 1890s were the point at which the Victorians first thought of themselves historically as an epoch. This was the aim of a Victorian Exhibition

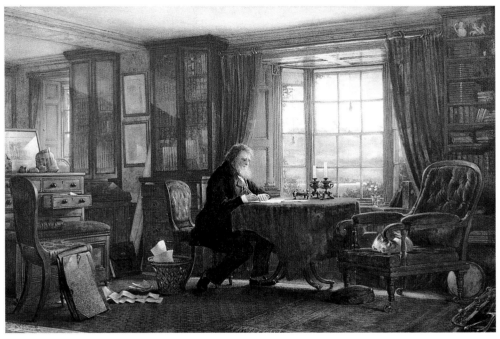

603

held in 1891 at the New Gallery, which had succeeded to the role of the most important private gallery after the closure of the Grosvenor in 1890. Subsequent exhibitions held there included a memorial exhibition of Burne-Jones in 1898 and one-man shows of Watts in 1896 and Rossetti in 1898. Watts increasingly saw his role as being that of one chosen to commemorate the great figures of his age. In this spirit he elected 'to paint the portraits of men who might hereafter be considered to have made or marred their country', remarking to Cecil Rhodes during a sitting, 'I'm not sure myself *which* you are doing.' Both artist and sitter were men of dreams and vision, reflected in Watts's *Physical Energy*, the great bronze figure which stands as the Rhodes Memorial in Bulawayo, while another cast can be seen in Kensington Gardens in London.

The first four years of the New English Art Club, founded in 1886, succeeded in fundamentally changing the course of painting in England. When the 1890s dawned the Royal Academy was no longer the supreme arbiter of taste, and began to experience difficult times as the old guard continued to die off, and relatively few new

artists arose to take their place. These concerns were voiced in an entry in Lord Leverhulme's diary after he had visited the private view of the 1892 summer exhibition. He grumbled about the general level of work shown, but 'bought a picture for the works called *Wedding Morning* by Bacon [Pl. 457]. It is only a moderate picture but very suitable for a soap advertisement'. Lord Leverhulme built up a collection of works of this type, which can still be seen at the Lady Lever Art Gallery, Port Sunlight. One of the most amusing is Louise Jopling's study of two aesthetic ladies washing a collection of blue and white china (Pl. 373).

The Honours roll of deceased artists continued with Burne-Jones in 1898, whose art and attitudes began to seem distinctly old-fashioned in some quarters very soon after his death, particularly his hatred of the Impressionists, whose subjects he had denounced as 'landscapes and whores'. Opinion abroad was divided on Burne-Jones's own works. The Norwegian sculptor Gustav Vigeland, for example, commented disapprovingly on their emasculated qualties in 1901: 'You won't find a single painting by Burne-Jones that could not be displayed at a Sunday School.' This view was not shared, however, by the young Pablo Picasso in Barcelona, whose admiration for Burne-Jones and the Pre-Raphaelites is reflected in some of his own early works, and who declared that his first visit to Paris in 1901 was meant to be only a stop on his way to England.

The knowledge of British art displayed in these comments by Vigeland and Picasso was gained from the widespread global dissemination of articles on the subject by the new art magazines which were founded all over Europe during the late 1890s. They ranged from Diaghilev's *Mir Iskusstva* in St Petersburg to *Simplicissimus* in Germany, the Austrian *Ver Sacrum*, and *Joventut* in Barcelona. One of the first and most influential of all these journals was the *Studio*, founded in 1893. Under its influence British art became more cosmopolitan than at any other time in the century. It carried notices of important art exhibitions all over Europe, and articles by artists such as Frank Brangwyn on good foreign locations for sketching holidays. It was always in the vanguard of advanced taste from its very first number which made the reputation of Aubrey Beardsley, the most important British artist of the decade (see below). Beardsley became art editor of both the *Yellow Book* and the *Savoy*, two short-lived journals which between them encapsulated the heady years which Max Beerbohm categorized as 'the Beardsley Period'.

The *Studio* also publicized the emergence of other exceptional new British talents from north of the border. In 1890 the Grosvenor Gallery had housed an important exhibition of the Glasgow School, or Glasgow Boys as they preferred to be called. Their members included Joseph Crawhall and Arthur Melville (1855–1904), who both evolved highly individual watercolour styles and produced work of dazzling virtuosity. Melville's Spanish bull-fighting scenes drenched in the hot southern sun (Pl. 605), painted on dampened paper in splotches of colour, and Crawhall's wonderful birds and mammals (Pl. 273) are astonishing technical feats. Another article in the *Studio* on Japanese flower painting may well have led the designer Charles Rennie Mackintosh (1868–1928), architect of the revolutionary Glasgow School of Art, to begin a brief experiment with Symbolism. He painted a series of botanical watercolours of highly stylized plant forms, in which transparent watercolour washes are freely applied over underlying pencil drawings. *The Harvest Moon* (Pl. 604) is the earliest known imaginative drawing by Mackintosh – a prelude to the so-called 'Spook School'. The unmistakably Art Nouveau winged figure and the cloud upon which she stands contrast with spikey plant forms to form an intensely personal statement.

Although generally remembered as a draughtsman, Henry Tonks (1862–1937) was a fine colourist. His painting *The Hat Shop* (Pl. 606) is his most famous work,

604

605
Arthur Melville
The Little Bullfight:
'Bravo Toro'
*c.*1888–9
watercolour, 55.9 × 77.5cm
(22 × 30⅛in)
Victoria and Albert Museum,
London

606
Henry Tonks
The Hat Shop
1892
oil on canvas, 67.7 × 92.7cm
(26¼ × 36½in)
Birmingham City Museum
and Art Gallery

605

reminiscent of similar scenes by Degas and Tissot. Tonks first trained as a doctor and became Senior Medical Officer at the Royal Free Hospital and Demonstrator in Anatomy at the London Medical School. This practical experience combined with his great skill as a draughtsman led to his appointment in 1892 as Assistant Professor at the Slade School. There he succeeded two major masters, Alphonse Legros and Fred Brown, and himself became a great but intimidating teacher.

This is to anticipate, however, and we must turn back to the beginning of the decade often nostalgically dubbed as the 'naughty nineties', partly in remembrance of the popular art form of the music halls. These establishments in the late Victorian era were dominated by the chairman who kept order with a gavel and an endless stream of jokes, and by such stars as Marie Lloyd, arguably the most famous Victorian woman after the Queen herself and Florence Nightingale. Her songs 'A little of what you fancy does you good' and 'My old man says follow the van', full of sexual innuendo or describing moonlight flits to avoid paying the rent, are still remembered today, and have outlived the gaudy but delightful theatres where they were sung with such gusto. Fortunately, Sickert in a number of paintings recorded the packed stalls, footlights, mirrors and crowded galleries of several music halls (Pl. 588). Such scenes also appealed to the American Social Realist artist Everett Shinn (1876–1953), later a member of the Ashcan School, who painted a memorable interior of the London Hippodrome in 1902 (Pl. 607), which is one of the most thrilling treatments of the art of the trapeze since Degas.

Sickert's own favourite theatre was at Camden Town where he painted *The Gallery of the Old Bedford* (Pl. 608). When it was exhibited, his friend George Augustus Moore (1853–1933) wrote in a review:

> I like it, because of its beauty; it has a beauty of tone, colour, and composition … that grey space of ceiling with its coloured panel, and that space of grey blue beneath the gallery with just sufficient pillar to explain, are they not admirably balanced? … the shadow too that floats over the gold ornaments is in its right place: it is transparent as a real shadow, and therefore redeems the vulgar painting and gilding … The great mirror in which vague shadows are reflected, is it not a triumph?

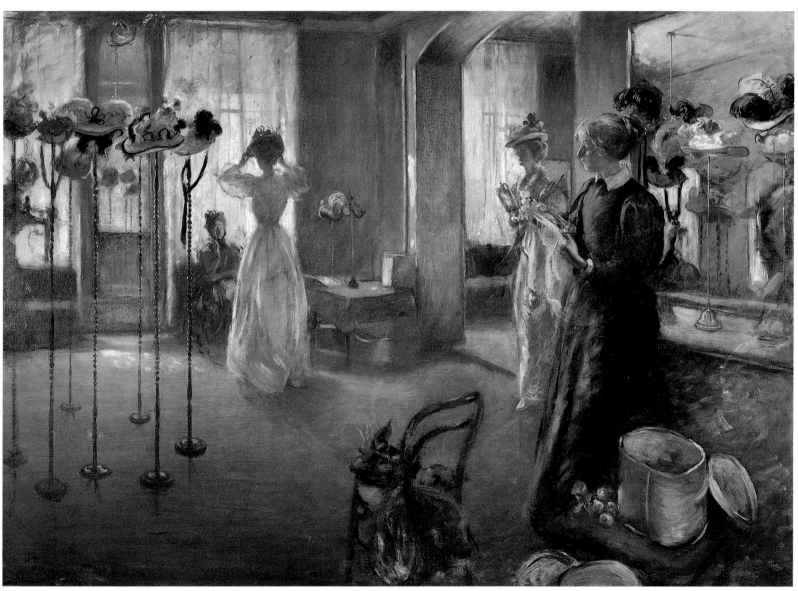

607
Everett Shinn
The London Hippodrome
1902
oil on canvas, 67 × 89.5cm
(26¼ × 35¼in)
The Art Institute of Chicago

608
Walter Richard Sickert
**The Gallery of the Old
Bedford (The Boy I Love
is up in the Gallery)**
1895
oil on canvas, 76.2 × 59.7cm
(30 × 23½in)
Walker Art Gallery, Liverpool

609
William Rothenstein
Coster Girls
1894
oil on canvas, 100.6 × 75.8cm
(39½ × 30in)
Sheffield Museum and Mappin
Art Gallery

610
Charles Conder
**Fan design: Preparations
for a Fancy-Dress Ball**
watercolour, 23.2 × 53.3cm
(9¼ × 21in)
Victoria and Albert Museum,
London

In both literary and artistic fields, Moore, who was an intimate friend of Manet and the Impressionists, played a major role in British art. He studied painting in Paris and there gained a knowledge of French writing which stood him in good stead on his return to England in 1880, where he was to revitalize the Victorian novel with realistic techniques borrowed from Zola, Maupassant and the Goncourts. In his novel *Esther Waters* (1894) the main scene, like Frith's painting *Derby Day*, is set against the background of the race, without the actual event itself intruding. The book began a fashion for 'realist' literary works, notable examples being W. Somerset Maugham's *Liza of Lambeth* (1897) and Arthur Morrison's *A Child of the Jago* (1896). In the same vein the American writer Jack London, after a few weeks in the slums of the East End of London, wrote *The People of the Abyss* (1903), which gives a bitterly ironic account of a degrading night in the workhouse, contrasted with an exhibition of Japanese art at the opening of the Whitechapel Art Gallery.

This was also the world portrayed by William Rothenstein (1872–1945) in his painting *Coster Girls* (Pl. 609) and in the graphic pen and ink drawings of Phil

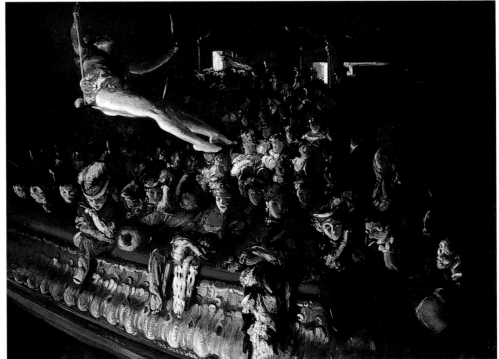

607

May which were much admired by both Lord Leighton and Whistler. May's book *Guttersnipes* (1896) brilliantly captures the atmosphere of the city streets on which the young Charlie Chaplin was growing up, a child very reminiscent of May's ragamuffins.

In the early 1890s Phil May and Charles Conder (who had met each other in Sydney) shared a studio in Paris with Rothenstein. Conder and Rothenstein held a joint exhibition in Paris before the latter left for England. They were on friendly terms with Henri de Toulouse-Lautrec, accompanying him to the Moulin Rouge, where Conder painted a vivid study, *The Moulin Rouge* (1890), of the music hall so associated with Lautrec's great poster. They also visited Le Chat Noir, immortalized by Théophile-Alexandre Steinlen. Conder frequently posed for Lautrec, and his distinctive features can be seen in the paintings *Aux Ambassadeurs: Gens Chic* and *Elles*, and in the poster *Reine de Joie*.

Conder was indeed more at home in Paris than London following his return

608

609

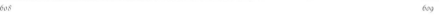

610

from Australia (see above, pp. 425–7). His sensitive watercolours on silk are subtle but extremely fragile. He loved to work at night, and descriptions abound of him taking a roll of silk in one hand, a bottle of absinthe in the other and disappearing to his studio to paint the fan-shaped compositions of which he was particularly fond (Pl. 610). He was not a good salesman, prompting Oscar Wilde to remark: 'Dear Conder! always trying to persuade one to buy a fan for 10 guineas for which one would be very happy to pay 20!' Conder was a dandy, who affected the costume of the 1840s and Murger's *La Vie de Bohème.* For the contemporary critic D.S. MacColl, 'Conder reduced nature to the music of colours and evoked perfumed and poetic moods … and the aestheticism of the "Yellow Nineties".'

During the 1890s the art of painting began increasingly to be challenged by a new form of graphic art – street murals and posters, which possessed a sophistication and universal appeal that led to them being dubbed 'Pictures of the Year in the People's Academy'. The boldness of the new discipline, an art form in its own right, led to it becoming a major formative influence on the arts of the twentieth century.

611

612

In the days before pictorial posters only typographical advertisements could inform the public of such events as the departure times of boats or stage coaches, and theatrical performances. A fascinating picture by John Parry (1810–79) shows us a bill-poster in action in the 1830s putting up posters for such attractions as a flea show and an advertisement for shaving cream (Pl. 611). The only pictorial images are crude woodcuts. It was Frederick Walker to whom the honour of creating the first pictorial poster goes, for his striking design for Wilkie Collins's novel *The Woman in White* (Pl. 612).

But the real 'father' of the poster was Jules Chéret (1836–1932), who after studying the processes of lithography in England in the 1870s, effected the changeover from the typographical to the pictorial poster by producing from four stones a rainbow palette of colour. Chéret's posters earned him the praise of Manet, who described him as the 'Watteau of the streets', and of Degas, who dubbed him 'the Tiepolo of the boulevards'. Indeed, in an interview with the English critic Charles

Hiatt, Chéret maintained that for him posters were not necessarily a good form of advertising but they made excellent murals! It was his great achievement to take the visual language of popular folk art, add the delicate colours of the butterfly wings he kept by him as he worked, and produce a new art form. Some of his posters, like his advertisement for Vin Mariani tonic wine (Pl. 613), were issued in both France and England.

This was also true of the posters designed by Chéret's distinguished pupil Henri de Toulouse-Lautrec (1864–1901), who was on close terms with the English poster enthusiast Edward Bella, the organizer of two big international shows of posters in London in 1894 and 1896 in the Westminster Aquarium. The French section was selected and accompanied by Toulouse-Lautrec. For Bella, who manufactured confetti, Lautrec created a poster which beautifully interpreted the subject, using a technique taught to him by Chéret, called 'spatter', in which the colours are literally

613
Jules Chéret
Vin Mariani Popular French Tonic Wine
1894
poster, 120 × 85cm (47⅛ × 33½in)
Private collection

614
James Pryde and
William Nicholson
(the Beggarstaff Brothers)
Don Quixote
1895
design for a poster, black and
brown paper cut-out pasted on
to white paper, 193 × 196.2cm
(76 × 77¼in)
Victoria and Albert Museum,
London

613

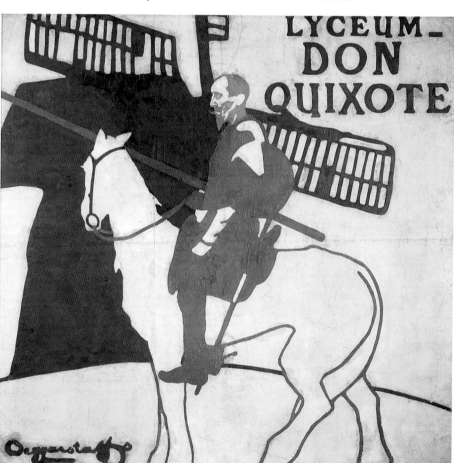

614

spattered upon the surface of the stone by rubbing them through a comb.

Among the most original posters by British artists in the London exhibitions were those by the Beggarstaff Brothers, the *nom de plume* of the painters James Pryde (1866–1941) and William Nicholson (1872–1949). Years later Pryde recalled how:

> a friend told us he had heard there was going to be an exhibition of posters at the
> Westminster Aquarium, and we thought we would like to do some for it … we
> did some five or six large designs, not for any particular firm's commodity, but
> merely for a given article to which the firm's name could be applied … Thus we
> did a design for pianos, cocoa, and so on … We made them fairly large, for some
> were twelve feet high … We decided that a silhouette treatment was the best,
> and it had this advantage, that it had not been done before. Moreover, it was a
> very economical way of reproducing a poster for reproduction, for the tones

615

616

were all flat … to get this flat effect, we cut out the designs in coloured paper
and pasted them on flat boards …

One of the Beggarstaff Brothers' most famous poster designs was created for the great
actor-manager Sir Henry Irving, for a one-act play entitled *Don Quixote* (Pl. 614), but
never used.

The most exciting artist of the decade also designed some unusual posters but did
not exhibit at the Academy, and indeed painted virtually no pictures in the usual
sense of the term. Aubrey Beardsley (1872–98), self-trained, famous by his early
twenties and dead at 26, was once described by Roger Fry as the 'Fra Angelico of
Satanism'. His amazing drawings were attacked at the time as being 'the mere
glorification of a hideous and putrescent aspect of modern life', but he is now regard-
ed as both a great artist and a founder of the Art Nouveau style. Sickert offered to
teach him oil painting and laid out some colours on a palette, but nothing much ever
came of it, for Beardsley left only one canvas, *A Caprice* (Pl. 615), in which a dwarf,
dressed in red, gestures to a lady dressed in black relieved by a white muff and white
plume in her hat. On the back of the canvas is painted a masked woman in black
with a white mouse upon the table before her.

Both Sickert and the major French portrait painter and writer Jacques-Emile
Blanche (1861–1942) painted portraits of Beardsley. Blanche also painted a double-
portrait (Pl. 616) of the two aesthetes, the designer Charles Ricketts and his life-long
companion Charles Hazelwood Shannon, dubbed by Oscar Wilde 'Orchid' and
'Marigold', whose lives were completely devoted to art. In 1896 Ricketts, who was
trained as an illustrator, founded a private printing press – the Vale Press – for which
he designed borders, initials and illustrations. These were much admired, by among
others Lord Leighton, who found his designs 'full of imagination and a weird charm'.
Shannon practised the use of lithography with rare sensitivity and was a fine painter
of the nude, as demonstrated by such works as *Pearl Fishers* (Pl. 617).

In the 1890s one of the magnetic crossroads of Europe for many disparate artists
was the port of Dieppe, not only convenient for access to both London and Paris,
but also a delightful seaside resort. There from 1895 to 1898 Conder painted enchant-
ing small sketches such as *Beach Scene, Dieppe* (Pl. 618). In 1897 he saw much of
Beardsley, who was then in the last stages of consumption, but still working franti-
cally on subjects varying from Gautier's *Mademoiselle de Maupin* to a cover for a new
magazine to be called the *Peacock*. Other visitors included Oscar Wilde (after his
release from prison in May 1897) and his immediate circle, such figures as the poet
Ernest Dowson, the artists Rothenstein, Ricketts and Shannon, and the witty cari-
caturist Max Beerbohm. Sickert's art also came to its full maturity in his paintings of
Dieppe, which capture so memorably the subdued tonality of the port, and also
record the excitement of mixed bathing (still unheard of in England) in *Bathers,
Dieppe* (Pl. 620).

While other artists strove to capture the charms of Dieppe, and the Impressionists
recorded the boulevards of Paris, William Logsdail chose to paint a series of views of
London, which after languishing unregarded for many years are now once more
appreciated. In 1887, after a long visit to Egypt and Venice, where he painted a large
picture of St Mark's Square, he settled at Primrose Hill and began to paint *St Martin-
in-the-Fields* (Pl. 621). He hired a removal van with a tarpaulin roof, parked it out-
side Morley's Hotel, and for several cold winter months worked on the composition,
his feet kept warm by bales of straw. Other works in the series included *The Bank of
England*, *Sunday in the City* and *The 9th of November: The Lord Mayor's Procession
Leaving the Mansion House*. Of these subjects Logsdail wrote: 'I had always thought
that London of all places in the world, ought to be painted but it appeared too

615
Aubrey Beardsley
A Caprice
c.1894
oil on canvas, 76.1 × 63.4cm
(30 × 25in)
Tate Gallery, London

616
Jacques-Emile Blanche
**Charles Ricketts
and Charles Shannon**
1904
oil on canvas, 92.1 × 73cm
(36¼ × 28¾in)
Tate Gallery, London

617
Charles Hazelwood Shannon
Pearl Fishers
1896
oil on canvas, 93.9 × 68.5cm
(37 × 27in)
Fine Art Society, London

617

618
Charles Conder
Beach Scene, Dieppe
c.1895–9
oil on wood, 33 × 44.5cm
(13 × 17½in)
Sheffield Museum and Mappin
Art Gallery

619
Alfred Munnings
**The Norwich School of Art
Painting Room**
1897
watercolour, 71.1 × 45.7cm
(26 × 18in)
Norwich School of Art

620
Walter Richard Sickert
The Bathers, Dieppe
1902
oil on canvas, 131.5 × 104.4cm
(51¼ × 41⅛in)
Walker Art Gallery, Liverpool

618

formidable, too unassailable … I do not wonder that so few have even dared to touch it. However, I did take courage to try and leave a few records of it, only after a very few years to acknowledge myself beaten.'

In May 1898 at the Prince's Skating Rink in Knightsbridge, the International Society of Sculptors, Painters and Gravers opened their first exhibition. Their President was Whistler, and the four leading Impressionists, Manet, Degas, Monet and Renoir, as well as Cézanne, were included in a show which formed a fitting climax to the century. Yet it would be three years before a Degas entered a British national collection, via the bequest by Constantine Alexander Ionides of his collection to the Victoria and Albert Museum. Ionides, a Manchester businessman, was encouraged by Legros to buy such works through the agency of the great dealer Durand Ruel. Ionides was unusual in taking such advice, for most British collectors at this time fought shy of buying any controversial foreign works.

The influence of both the poster discipline and Beardsley's astonishing linear powers led to the emergence of what might be described as a 'turn of the century line' – bold, dynamic and closely related to the emergent decorative art style known as Art Nouveau. This stylistic phenomenon can be found in both commercial artists and poster designers, whose graphic prowess was initially developed by the teaching methods then in vogue, firmly based on drawing from antique casts. We gain a vivid impression of art teaching in these days from a spirited study of his surroundings in the painting room of the Norwich School of Art by Alfred Munnings (Pl. 619). The sketch won him a National Bronze Medal the following year, which also saw his debut in the Royal Academy with his delightful painting *Stranded* (Pl. 623). This painting already gave witness to the singular flair for colour that was to find later expression in his life-long commitment to painting racing and sporting subjects, the bright colours of jockeys' silks and the glossy coats of thoroughbred race horses.

In the fullness of time in the 1950s, Munnings would become a controversial President of the Royal Academy, expressing ferociously Victorian views on the non-representational art of Picasso and Braque. As a result his name became an emotive button to press for critics anxious to trigger a reaction against stuffy and conservative

619

views. This has led to the public becoming blinded to the real merits of his early work.

When selecting a painting redolent of the warm sunlit days of the last decade of the Victorian age one needs look no further than *Boulter's Lock: Sunday Afternoon* (Pl. 622) by Edward John Gregory (1850–1909), a colourful kaleidoscope of a fashionably dressed crowd enjoying the pleasures of a day on the river. Boulter's Lock near Maidenhead on the Thames was built in 1830 with a six-foot fall – the main river goes over a weir. This part of the Thames was particularly popular during the Thames boating craze chronicled by Jerome K. Jerome in his minor classic *Three Men in a Boat* (1889). On Ascot Sunday in 1888, 72 steam launches and 800 boats passed through Boulter's Lock; Henley Regatta week was equally popular.

A tradition exists that the man seated in the skiff to the extreme right looking back over his shoulder is the artist himself, and his friends served as models for the other figures in the painting. Forty-six careful pencil studies for details of the painting survive. The critics were pleased with Gregory's painting, which was begun in 1882 but was first exhibited in 1897. The *Art Journal* waxed lyrical: 'It is the kind of picture which foreign critics recognise as national; it is in fact the three-volume novel in art, the guide book and encyclopaedia of the manners and customs of the English people.'

It was works of this type which most roused the ire of the prophet of the new intellectual forces which would shape the course of British art in the new century.

621
William Logsdail
St Martin-in-the-Fields
1888
oil on canvas, 143.5 × 118.1cm
(56½ × 46½in)
Tate Gallery, London

622
Edward John Gregory
Boulter's Lock – Sunday Afternoon
1897
oil on canvas, 214.5 × 143cm
(84½ × 56½in)
Lady Lever Art Gallery,
Port Sunlight, Liverpool

623
Alfred Munnings
Stranded
1898
oil on canvas, 45.7 × 35.6cm
(18 × 14in)
Bristol Museum and Art
Gallery

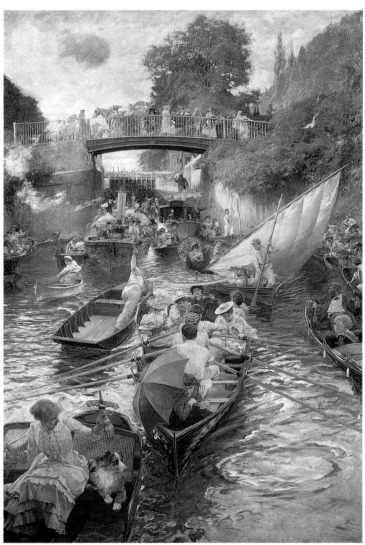

622

623

624

625

Roger Fry (1866–1934), who more than anyone would change the public taste for art in the new twentieth century, observed of such literal transcripts of life:

> So long as representation was regarded as the end of art, the skill of the artist and his proficiency in this particular feat of representation was regarded with an admiration which was in fact mainly non-aesthetic. With the new indifference to representation we have become much less interested in skill and not at all interested in knowledge. We are thus no longer cut off from a great deal of barbaric and primitive art …

Thus Fry wrote in 1917 for a lecture given to the Fabian Society on Picasso.

In England, however, a delight in representational skills was to continue. Three paintings created a decade after the Victorian age came to an end close the era for us and point forward into the twentieth century. Spencer Gore's *Gauguins and Connoisseurs at the Stafford Gallery* (Pl. 624) shows Sickert on the extreme left, and below him Augustus John. On the right without a hat is Wilson Steer, and in the middle, with his finger to his nose, is the nervous gallery owner John Neville. The painting vividly captures not only changing attitudes to the sensual art of Gauguin's Tahiti nudes but a vital new direction in British art. This had begun after an epoch-making New Grafton Gallery exhibition of 1910 that created the term Post-Impressionist. It would be consolidated with later exhibitions featuring the works of Picasso and the doctrines of 'significant form' espoused by Roger Fry.

Despite Fry's strictures the old narrative tradition lived on in such works as *Bank Holiday* (Pl. 625) by Alphonse Legros's main pupil, William Strang (1859–1921). When we look at this young couple, and particularly the young man, it is hard, with hindsight, not to hear a premonition of 'the monstrous anger of the guns' of the first great war two years away which would finally end the self-confidence of the

Victorian and Edwardian eras. Another painting of the time looks still further ahead. Sir William Orpen's painting *A Bloomsbury Family* of 1907 (Pl. 626) shows William Nicholson at the head of a table crowded with children. Opposite him with arms outstretched on the table is his son Ben, destined to become one of the most important abstract painters of the twentieth century.

Looking back at the Victorian era today we can find much to admire, much to censure and much to amuse us. Most of us at some time have played the enjoyable if facetious game of inventing new titles for the more extraordinary Victorian paintings, such as the long lines of frustrated lightly clad ladies passionately in love with knights in armour but without tin openers, from Millais's *The Knight Errant* (1870) to *Hellilil and Hildebrandt: Meeting on the Turret Stair* (1864) by Frederick W. Burton (1816–1900) and Waterhouse's *Lamia* (1905).

In behaving so facetiously we are much nearer to the Victorians than might be supposed, for all the great critical figures, from Thackeray to Wilde, Ruskin to Pater, and Haydon to Fry used irony, satire and humour to make their points, admittedly sometimes with savagery. That is why the vituperative anti-Victorian diatribes of several distinguished late twentieth-century critics when reviewing major retrospective exhibitions of artists such as Burne-Jones or Sargent possess a strangely familiar, old-world Victorian quality, reminding us that the art of the Victorian era never loses its capacity to amaze, surprise and delight, but also to shock us and make us laugh.

624
Spencer Gore
**Gauguins and Connoisseurs
at the Stafford Gallery**
1911
oil on canvas, 83.8 × 71.7cm
(33 × 28¼in)
Private collection

625
William Strang
Bank Holiday
1912
oil on canvas, 152.7 × 122.6cm
(60¼ × 48¼in)
Tate Gallery, London

626
William Orpen
A Bloomsbury Family
1907
oil on canvas, 85 × 88.8cm
(33¼ × 35in)
Scottish National Gallery
of Modern Art, Edinburgh

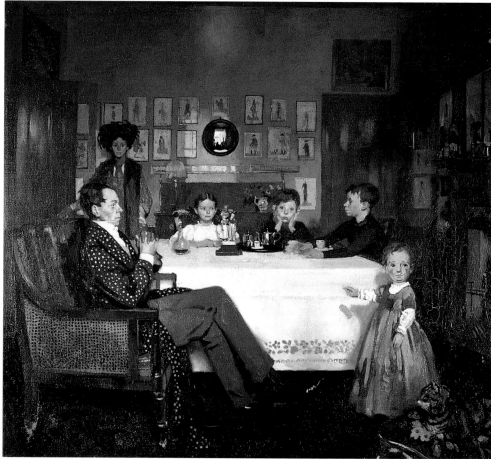

626

SELECT BIBLIOGRAPHY

After visiting the Tate Gallery, the Victoria and Albert Museum and Leighton House in London, by far the best introduction to Victorian painting is to make an extensive tour of the great regional galleries of the Midlands and North of England: Birmingham, Sheffield, Leeds, Manchester, Liverpool and Preston. Several university collections are also most rewarding, notably the Barber Institute in Birmingham, the Fitzwilliam in Cambridge, the Hunterian in Glasgow and the Ashmolean at Oxford. North of the border, Edinburgh's National Gallery and Glasgow's Kelvingrove all contain notable paintings, as do the collections at Aberdeen, Dundee and Perth.

Local 'schools of art' can be studied in their respective town collections: the Norwich School at Norwich Castle, the Bristol School at Bristol City Art Gallery and in the West of England the Newlyn School at Penzance. In the south of England, Tunbridge Wells, Brighton, Bournemouth, Southampton and the Royal Holloway College, Egham, have rewarding collections, the last named being of particular interest. Ruskin scholars should visit the extensive collections of his work at Sheffield, at Lancaster University, and the Pre-Raphaelite collections at Carlisle. American readers should visit the Bancroft Foundation at Wilmington, Delaware, the largest collection of Rossetti's works in the United States.

The most enjoyable method of learning about the Victorian age is to read primary sources – the words of the painters themselves, or those of contemporary writers. Several artists discussed in these pages left extensive autobiographies, notably W.P. Frith, whose *My Autobiography and Reminiscences* (2 vols., London, 1887) and *Further Reminiscences* (London, 1888), although gossipy and full of irrelevant digressions, still provide a vivid introduction to Frith's great paintings of daily life in the Victorian age.

C.R. Leslie's *Autobiographical Recollections* (London, 1860) reveal the charm which made him so liked a figure, and throw much light upon his contemporaries and the workings of the Royal Academy. Both the novelist Wilkie Collins and C.H. Cope left interesting biographies of their fathers, respectively *William Collins, R.A.* (London, 1848) and *Reminiscences of C.W. Cope R.A.* (London, 1891). Another document of great human interest is provided by Ernestine Mills, *The Life and Letters of Frederick Shields 1833–1911* (London, 1912).

Equally important, and an invaluable general survey of nearly all the early Victorian artists discussed in this book, is Samuel and Richard Redgrave's *A Century of British Painters* (London, 1866), with a good later edition edited by Ruthven Todd (London, 1947). Another early work of scholarship which is still an excellent reference book is Algernon Graves, *The Royal Academy of Arts: A Complete Dictionary of Contributors and their Works* (8 vols., London, 1905–6) which quotes in full the often lengthy titles of exhibited works, and gives artists' addresses, thus providing invaluable leads to the identification of artists and works of art.

Works by the great critical minds of the Victorian era include:

COOK, E.T., and WEDDERBURN, A. (eds.), *The Complete Works of John Ruskin* (39 vols., London, 1903–12)
PATER, Walter, *Works of Walter Pater* (8 vols., London and New York, 1900–1)
ROSENBERG. J.D. (ed.), *The Genius of John Ruskin: Selections from his Writing* (London, 1979)
THACKERAY, W.M., *The Roundabout Papers*, in the complete library edition of his work (Oxford, 1899)

Among the wealth of secondary sources the best introduction is still the trilogy of books by the great interpreter of the Victorian age, William Gaunt, who in 1942 published *The Pre-Raphaelite Tragedy*, followed by *The Aesthetic Adventure* (London, 1945) and *Victorian Olympus* (London, 1949). Other surveys include:

CHAPEL, Jeannie, *Victorian Taste: The Complete Catalogue of Paintings at the Royal Holloway College* (London, 1982)
GERE, Josephine, *Masters or Servants?* (London and New York, 1977)
HUBBARD, Hesketh, *A Hundred Years of British Painting, 1851–1951* (London, 1951).
MAAS, Jeremy, *Victorian Painters* (London, 1969). A benchmark for all subsequent works on the subject
REYNOLDS, Graham, *Painters of the Victorian Scene* (London, 1953)
REYNOLDS, Graham, *Victorian Painting* (London, 1966)
TREBLE, Rosemary, *Great Victorian Pictures: their Paths to Fame* (London, 1978)
TREUHERZ, Julian, *Victorian Painting* (London, 1993)
WARNER, Malcolm, *The Victorians: British Painting 1837–1901* (exhibition catalogue, National Gallery of Art, Washington DC, 1997)
WOOD, Christopher, *Dictionary of Victorian Painters* (Woodbridge, 1971)
WOOD, Christopher, *Victorian Panorama: Paintings of Victorian Life* (London, 1976)
WRAIGHT, Robert, *Hip! Hip! Hip! R.A.* (London, 1968)

Works used in individual chapters are referred to below.

PREFACE

LONGFORD, Elizabeth, *Victoria R.I.* (London, 1964)
WARNER, Marina, *Queen Victoria's Sketchbooks* (London, 1979)

CHAPTER 1
INTRODUCTION

ERRINGTON, L., *Tribute to Wilkie* (exhibition catalogue, National Gallery of Scotland, Edinburgh, 1985)
HAYDON, Benjamin Robert, *The Autobiography and Journal of Benjamin Robert Haydon* (London, 1853)
LESLIE, C.R., *Memoirs of the Life of John Constable* (London, 1843)
LISTER, Raymond, *Samuel Palmer: A Biography* (London, 1974)
ORMOND, R., *Sir Edwin Landseer* (exhibition catalogue, Tate Gallery, London, 1982)
REYNOLDS, Sir Joshua, *Discourses on Art* (London, 1778)

CHAPTER 2
THE VICTORIAN ART ESTABLISHMENT

DEARDEN, J.S., *John Ruskin: An Illustrated Life 1819–1900* (Princes Risborough, 1973)
GIBBS-SMITH, C.H., *The Crystal Palace, 1851* (London, 1951)
HERRMANN, Frank, *The English as Collectors* (London, 1972)
JAMES, W., *The Order of Release: The Story of John Ruskin, Effie Gray and John Everett Millais* (London, 1947)
John Ruskin (exhibition catalogue, Arts Council of Great Britain, 1983)
LEON, D., *Ruskin: The Great Victorian* (London, 1949)
MACLEOD, Dianne Sachko, *Art and the Victorian Middle Class* (Cambridge, 1996)
PETERS, Robert L., *The Crowns of Apollo: Swinburne's Principles of Literature and Art* (Detroit, 1965)
ROSENBERG, J.D., *The Darkening Glass* (London, 1963)
Ruskin and his Circle (exhibition catalogue, Arts Council of Great Britain, 1964)
SMILES, Samuel, *Self Help* (London, 1859)

CHAPTER 3
THE FRESCO REVIVAL: MURAL PAINTING

GIROUARD, Mark, *The Return to Camelot: Chivalry and the English Gentleman* (New Haven and London, 1981)
GREENE, John, *Brightening the Long Days: Hospital Tile Pictures* (Leeds, 1987)
HAY, Malcolm, and RIDING, Jacqueline, *Art in Parliament* (London, 1996)
MERRILL, Linda, *The Peacock Room: A Cultural Biography* (New Haven and London, 1998)
NEWMAN, Theresa and WATKINSON, Ray, *Ford Madox Brown and the Pre-Raphaelite Circle* (London, 1991)
POINTON, Marcia, *William Dyce 1806–1864: A Critical Biography* (Oxford, 1979)

CHAPTER 4
THE GOOD AND THE GREAT: PORTRAIT PAINTING

BLUNT, Wilfred, *England's Michelangelo: G.F. Watts* (London, 1975)
COOMBS, Katherine, *The Portrait Miniature in England* (London, 1998)
DU MAURIER, Daphne (ed.), *The Young George Du Maurier: Letters 1860–1867* (London, 1951)
FOSKETT, Daphne, *British Portrait Miniatures* (London, 1963)
FOSKETT, Daphne, *A Dictionary of British Miniature Painters* (2 vols., London, 1972)
LAMBOURNE, Lionel, *An Introduction to Caricature* (London, 1983)
ORMOND, Richard, *John Singer Sargent* (exhibition catalogue, Tate Gallery, London, 1998)
PIPER, David *The English Face* (London, 1957)
RATCLIFF, Carter, *John Singer Sargent* (Oxford, 1983)
REYNOLDS, Graham, *English Portrait Miniatures* (London, 1952)
ROBERTSON, W. Graham, *Time Was: The Reminiscences of W. Graham Robertson* (London, 1931). A minor classic which remains one of the best books on late Victorian painting.

CHAPTER 5
OILS VERSUS WATERCOLOURS: LANDSCAPE PAINTING

BECKETT, R.B. (ed.), *John Constable's Correspondence* (6 vols., Suffolk Records Society, 1962–8)
BUTLIN, Martin, and JOLL, Evelyn, *The Paintings of J.M.W. Turner* (2 vols., Newhaven and London, 1984)
HARDIE, Martin, *Watercolour Painting in Britain* (3 vols., Oxford, 1968)
NEWALL, Christopher, *Victorian Watercolours* (London, 1987)
REYNOLDS, Graham, *Constable, the Natural Painter* (London, 1965)
STEWART, Brian, *The Shayer Family of Painters* (London, 1981)
SUMNER, Ann, *Ruskin and the English Watercolour From Turner to the Pre-Raphaelites* (exhibition catalogue, Whitworth Art Gallery, Manchester, 1989)
WILCOX, Scott, and NEWALL, Christopher, *Victorian Landscape Watercolours* (New York, 1992)
WILTON, Andrew, *The Great Age of British Watercolours 1750–1880* (exhibition catalogue, Royal Academy, London, 1993)

CHAPTER 6
THE NARRATIVE IMPULSE: GENRE PAINTING

BECK, Hilary, *Victorian Engravings* (Victoria and Albert Museum, London, 1973)
HELENIAK, Katherine Moore, *William Mulready* (New Haven and London, 1980)
JOHNSON, E.D.H., *Paintings of the British Social Scene: From Hogarth to Sickert* (London, 1986)
LAMBOURNE, Lionel, *An Introduction to Victorian Genre Painting* (London, 1982)
PARKINSON, Ronald, *Victoria and Albert Museum. Catalogue of British Oil Painting 1820–1860* (London, 1990)
POYNTON, Marcia, *William Mulready* (exhibition catalogue, Victoria and Albert Museum, London, 1986)
SITWELL, Sacheverel, *Conversation Pieces* (London, 1936)
SITWELL, Sacheverel, *Narrative Pictures* (London, 1937)

CHAPTER 7
VIRTUAL REALITY: THE PANORAMA

ALTICK, Richard, *The Shows of London: A History of Exhibitions, 1600–1862* (Cambridge, Mass., 1978)
FEAVER, William, *The Art of John Martin* (Oxford, 1975)
GERNSHEIM, Helmut and Alison, *L.J.M. Daguerre: The History of the Diorama and the Daguerreotype* (London, 1956)
GREENACRE, F., *Francis Danby* (exhibition catalogue, Tate Gallery, London, 1989)
GUITERMAN, H., *David Roberts, R.A., 1796–1864* (London, 1978)
GUITERMAN, H., and LLEWELLYN, B., *David Roberts* (exhibition catalogue, Barbican Art Gallery, London, 1985)
HYDE, Ralph, *The Regent's Park Colosseum* (London, 1982)
HYDE, Ralph and WILCOX, Scott, *Panoramania! The Art and Entertainment of the 'All-Embracing View'* (exhibition catalogue, Barbican Art Gallery, London, 1988)
PLESSEN, Marie-Louise von, *Sehsucht: Das Panorama ... des 19 Jahrhunderts* (exhibition catalogue, Bonn, 1993)

VAN DER MERWE, P., *Clarkson Stanfield* (exhibition catalogue, Sunderland Museum and Art Gallery, 1979)

CHAPTER 8
CHILDHOOD AND SENTIMENT
ASLIN, Elizabeth, *Children and their Toys in English Art* (exhibition catalogue, Bethnal Green Museum, London, 1974)
ASLIN, Elizabeth, *Childhood* (exhibition catalogue, Sotheby's, 1988)
GREG, Andrew, *The Cranbrook Colony* (exhibition catalogue, Wolverhampton Art Gallery, 1977)
HOGARTH, Paul, *Arthur Boyd Houghton* (exhibition catalogue, Victoria and Albert Museum, London, 1975)
HOLDSWORTH, Sara, and CROSSLEY, Joan, *Innocence and Experience: Images of Childhood in British Art from 1600 to the Present* (exhibition catalogue, Manchester City Art Gallery, 1992)
HOWELL, Sarah, *The Seaside* (London, 1974)
MORRIS, Edward, and MILNER, Frank, *And When Did You Last See Your Father?* (exhibition catalogue, Walker Art Gallery, Liverpool, 1992)

CHAPTER 9
FAIRY PAINTING
ALLDERIDGE, Patricia, *The Late Richard Dadd, 1817–1886* (exhibition catalogue, Tate Gallery, London, 1974)
BAKER, Michael, *The Doyle Diary … the Strange and Curious Case of Charles Altamont Doyle* (New York and London, 1978)
Fairies (exhibition catalogue, Brighton, 1980)
Fantastic Illustration and Design in Britain 1850–1930 (exhibition catalogue, Rhode Island School of Design, 1979)
LAMBOURNE, Lionel, *Richard Doyle and his Family* (exhibition catalogue, Victoria and Albert Museum, London, 1983)
LAMBOURNE, Lionel, *A Regency Lady's Fairy Bower: Amelia Jane Murray* (London, 1985)
Victorian Fairy Paintings (exhibition catalogue, Royal Academy, London, 1997–8)

CHAPTER 10
SPORTING AND ANIMAL PAINTING
EGERTON, Judy, and SNELGROVE, Dudley, *British Sporting and Animal Paintings 1655–1867*. The Paul Mellon Collection (London, 1981)
LAMBOURNE, Lionel, and CONNER, Patricia, *Derby Day 200* (exhibition catalogue, Royal Academy, London, 1978)
LAMBOURNE, Lionel, and WEBSTER, Mary, *British Sporting Painting 1650–1850* (exhibition catalogue, Arts Council of Great Britain, 1974)
MILLER, Delia, *Queen Victoria's Life in the Scottish Highlands depicted by her Watercolour Artists* (London, 1985)
ORMOND, Richard, *Sir Edwin Landseer* (exhibition catalogue, Philadelphia Museum of Art and Tate Gallery, London, 1981)
PAGET, Major G.D.L., *The Melton Mowbray of John Ferneley 1782–1860* (Leicester, 1938)
SELWAY, N.C., *The Regency Road* (London, 1957)
TAYLOR, B., *Animal Painting in England from Barlow to Landseer* (London, 1958)
WALKER, Stella, *Sporting Art: England 1700–1900* (London, 1972)

CHAPTER 11
THE PRE-RAPHAELITES
AMOR, A.C., *William Holman Hunt: The True Pre-Raphaelite* (London, 1989)
FAXON, A.C., *Dante Gabriel Rossetti* (New York and Oxford, 1989)
FLEMING, G.H., *John Everett Millais: A Biography* (London, 1998)
GERE, John, and IRONSIDE, Robin, *Pre-Raphaelite Painters* (London, 1948)
HARES-STRYKER (ed.), *An Anthology of Pre-Raphaelite Writings* (Sheffield, 1997)
HILTON, Timothy, *The Pre-Raphaelites* (London, 1970)
MARSH, J. and GERRISH NUNN, P., *Women Artists and the Pre-Raphaelite Movement* (London, 1989)
NEWMAN, T. and WATKINSON, R., *Ford Madox Brown and the Pre-Raphaelite Circle* (London, 1991)
The Pre-Raphaelites (exhibition catalogue, Tate Gallery, London, 1984)
ROBERTS, Leonard, *Arthur Hughes: His Life and Work* (Woodbridge, 1997)
STALEY, Alan, *The Pre-Raphaelite Landscape* (Oxford, 1973)
SURTEES, Virginia, *Dante Gabriel Rossetti: The Paintings and Drawings* (2 vols., Oxford, 1971)
SURTEES, Virginia, *Dante Gabriel Rossetti: Painter and Poet* (exhibition catalogue, Royal Academy, London, 1973)
SURTEES, Virginia (ed.), *The Diary of Ford Madox Brown* (New Haven and London, 1981)

CHAPTER 12
'ALL HUMAN LIFE IS HERE': CROSS-SECTIONS OF SOCIETY
ALLWOOD, Rosamund, *G.E. Hicks, Painter of Victorian Life* (exhibition catalogue, Geffrye Museum, London, 1982–3)
COWLING, Mary, *The Artist as Anthropologist: The Representation of Type and Character in Victorian Art* (Cambridge, 1989)
FRITH, William Powell, *My Autobiography and Reminiscences* (3 vols., London, 1887–8)
MATYJASZKIEWICZ, Krystyna (ed.), *James Tissot* (Oxford, 1984)
WOOD, Christopher, *Victorian Panorama. Paintings of Victorian Life* (London, 1976)

CHAPTER 13
THE NUDE AND CLASSICISM
ANDERSON, G.N., and WRIGHT, Joanne, *Heaven on Earth: The Religion of Beauty in Late Victorian Art* (exhibition catalogue, Djanogly Art Gallery, Nottingham University, 1994)
BALDRY, A.L., *Albert Moore, His Life and Work* (London, 1894)
BECKER, Edwin, et al. (eds.), *Sir Lawrence Alma-Tadema* (New York, 1997)
FARR, Dennis, *William Etty* (London, 1958)
ORMOND, Richard and Leonée, *Lord Leighton* (New Haven and London, 1975)
WOOD, Christopher, *Olympian Dreamers: Victorian Classical Painters 1860–1914* (London, 1983)

CHAPTER 14
WOMEN ARTISTS
BUTLER, Lady Elizabeth, *An Autobiography* (London, 1922)
CLAYTON, Ellen, *English Female Artists* (London, 1876)
GERRISH NUNN, Pamela, *Victorian Women Artists* (London, 1987)
JOPLING, Louise, *Twenty Years of my Life* (London, 1925)

MAAS, Jeremy, *Gambart, Prince of the Victorian Art World* (London, 1975)
MARSH, J., *Elizabeth Siddal 1829–1862: Pre-Raphaelite Artist* (exhibition catalogue, Ruskin Gallery, Sheffield, 1991)
TAYLOR, Ina, *The Art Of Kate Greenaway* (Exeter, 1991)
USHERWOOD, Paul, and SPENCER-SMITH, Jenny, *Lady Butler, Battle Artist 1846–1933* (exhibition catalogue, National Army Museum, London, 1987–8)

CHAPTER 15
SOMBRE SCHOOLS OF ART: SOCIAL REALISM
DORÉ, Gustave, and JERROLD, Blanchard, *London: A Pilgrimage* (London, 1872)
FREE, Renée, *Victorian Social Conscience* (exhibition catalogue, Art Gallery of New South Wales, 1976)
McCONKEY, Kenneth, *Pleasantries* (exhibition catalogue, Newcastle upon Tyne, 1981)
TREUHERZ, Julian, *Hard Times: Social Realism in Victorian Art* (exhibition catalogue, Manchester City Art Gallery, 1987–8)

CHAPTER 16
PARTING: EMIGRATION AND WAR
COLEMAN, Terry, *Passage to America* (1972)
DANIEL, Jeffrey, et al., *Solomon: A Family of Painters* (exhibition catalogue, Geffrye Museum, London, 1985)

CHAPTER 17
THE FRAILER SEX AND THE FALLEN WOMAN
CASTERAS, Susan P., *Images of Victorian Womanhood in English Art* (Rutherford, New Jersey, 1987)
CASTERAS, Susan P., and PARKINSON, Ronald, *Richard Redgrave* (exhibition catalogue, Victoria and Albert Museum, London, 1988)
MILLS, Ernestine, *Frederick Shields* (London, 1912)

CHAPTER 18
A TRANSATLANTIC EXCHANGE
CIKOVSKY, Nicolai Jr., and KELLY, Franklin, *Winslow Homer* (exhibition catalogue, National Gallery of Art, Washington DC, 1996)
HUGHES, Robert, *American Visions: The Epic History of Art in America* (London, 1997)
WEINBERG, Barbara, BOLGER, Doreen, and CURRY, David Park, *American Impressionism and Realism. The Painting of Modern Life 1885–1915* (exhibition catalogue, Metropolitan Museum of Art, New York, 1994)

CHAPTER 19
COLONIAL TIES: ARTISTS IN A WIDER WORLD
David Livingstone and the Victorian Encounter with Africa (exhibition catalogue, National Portrait Gallery, London, 1996)
NICHOLAS, F.W. and J.M., *Charles Darwin in Australia* (Cambridge, 1989)
NOAKES, Vivien, *Edward Lear 1812–88* (exhibition catalogue, Royal Academy, London, 1985)
REID, Dennis, *A Concise History of Canadian Painting* (Toronto, 1988)
SMITH, Bernard and Terry, *Australian Painting 1788–1990* (Melbourne and Oxford, 1991)

CHAPTER 20
AESTHETES AND SYMBOLISTS: THE LAST ROMANTICS
BURNE-JONES, Lady Georgiana, *Memorials of Edward Burne-Jones* (2 vols., London, 1904)
Burne-Jones (exhibition catalogue, Metropolitan Museum of Art, New York, 1998)
CASTERAS, Susan P., and DENNY, Colleen, *The Grosvenor Gallery: A Palace of Art in Victorian England* (exhibition catalogue, Yale Center for British Art, New Haven, 1996)
Frederic Leighton 1830–1896 (exhibition catalogue, Royal Academy, London, 1996)
HOBSON, Anthony, *J.W. Waterhouse* (Oxford, 1989)
LAMBOURNE, Lionel, *The Aesthetic Movement* (London, 1996)
NEWALL, Christopher, *The Art of Lord Leighton* (Oxford, 1990)
NEWALL, Christopher, *The Grosvenor Gallery Exhibitions* (Cambridge, 1995)
WHISTLER, J.A.M., *The Gentle Art of Making Enemies* (London, 1890)
WILTON, Andrew, and UPSTONE, Robert, *The Age of Rossetti, Burne-Jones and Watts: Symbolism in Britain 1860–1910* (exhibition catalogue, Tate Gallery, London, 1997)
WOOD, Christopher, *Burne-Jones* (London, 1998)

CHAPTER 21
IMPRESSIONISM IN BRITAIN
DORMENT, R., and MacDONALD, M.F., *James McNeill Whistler* (exhibition catalogue, Tate Gallery, London, 1994)
ERRINGTON, Lindsay, *Master Class: Robert Scott Lauder and his Pupils* (exhibition catalogue, National Gallery of Scotland, Edinburgh, 1983)
FOX, Caroline, and GREENACRE, Francis, *Painting in Newlyn 1880–1930* (exhibition catalogue, Barbican Art Gallery, London, 1985)
HARDIE, William, *Sir William Quiller Orchardson R.A.* (exhibition catalogue, Scottish Arts Council, 1972)
McCONKEY, Kenneth, *British Impressionism* (Oxford, 1989)
McCONKEY, Kenneth, *Impressionism in Britain* (exhibition catalogue, Barbican Art Gallery, London, 1995)
MERRILL, Linda, *A Pot of Paint: Aesthetics on Trial in Whistler v. Ruskin* (Washington DC, 1992)
PICKVANCE, Ronald, *English Influences on Vincent Van Gogh* (exhibition catalogue, Arts Council of Great Britain, 1974–5)

CHAPTER 22
THE END OF AN ERA
BARON, Wendy, *Sickert* (London, 1973)
DESLANDES, Gerald, *Arthur Melville 1855–1904* (exhibition catalogue, Dundee Museum and Art Gallery, 1977–8)
HAMILTON, Vivienne, *Joseph Crawhall 1861–1913* (exhibition catalogue, Glasgow City Art Gallery and Museums, 1990)
HILLIER, Bevis, *Posters* (London, 1969)

INDEX

Numbers in **bold** refer to the illustrations

A

Abbey, Edwin Austin (1852–1911) 62; *Scenes from 'The Quest for the Holy Grail'* 63, **59**
Abbott, Samuel 63
Aberdare, Lord 431–2
advertising 147–8, 180
Aestheticism 299, 405, 440, 445, 463, 464
Africa 435–7
Agnew, William (1825–1910) 40
Agnews 40, 228, 361
Albert, Prince Consort (1819–61) 7, 29–30, 31, 32, 44, 45, 49, 51, 53, 67, 71, 119, 161, 194, 209, 212–15, 265, 282, 338, 362, 371, 415, **71**
Alexandra, Princess of Wales (1844–1925) 370, 451
Alice, Princess 371
Allingham, Helen (1848–1926) 316–19; *A Cottage at Chiddingfold, Surrey* 319, **383**
Allingham, William 205–6, 316
Allnut, John (1773–1863) 27
Alma-Tadema, Lawrence (1836–1912) 291–4, 297, 308; *In the Tepidarium* 291–4, 334, **352**; *The Roses of Heliogabalus* 294, **353**; *The Sculptor's Model* 294, **350**
Alps 116
Aman-Jean, Edmond 447
American artists 391–411
American Civil War 400, 402
American War of Independence 400
Ancients 74
Anderson, Sophie (1823–1903), 306, 319; *Elaine* 319, **384**; *Foundling Girls in their School Dresses at Prayer in the Chapel* 182, **219**
Angas, George French (1822–88) 421–3; *Maori Head* **529**
Angeli, Helen Rossetti 382
Angerstein, John Julius 26, **21**
Anglican Church 237
animal paintings 209–26, 319–20
Ansdell, Richard (1815–85) 212; *A Shooting Party in the Highlands* 212, **257**
Appleyard, Fred (1874–1963), *Spring Driving Out Winter* 60
Archer, James (1823–1904), *Summertime, Gloucestershire* 174, **206**
Archer, Janet (*fl.*1873–93), *Girls Skipping* 186, **224**
architectural studies 119
Armitage, Edward (1817–96), *Caesar's Invasion of Britain* 47
Armstrong, Elizabeth (1859–1912) 325, 371; *School is Out* 345, **424**
Armstrong, Thomas 288,

405, 464
Arnold, Dr 177
Arnold, Matthew (1822–88) 301
Art Nouveau 456, 489, 497, 498
art schools 33, 37–8, 311
Art Treasures Exhibition, Manchester (1857) 31
Arts and Crafts movement 443
Ashcan School 403, 490
Atkinson, W.A. (*fl.*1849–67), *The First Public Drinking Fountain* 135, **160**
Audubon, John James (1785–1851) 398; *Golden Eagle* 398, **490**
Austen, Jane (1775–1817) 305, 306
Australia 163, 416–21, 423–7

B

Bacon, John H.F. (1868–1914), *The Wedding Morning* 371, 489, **457**
Bainbridge, Beryl 323
Baines, Thomas (1822–75), *Elephant in the Shallows of the Shire River* 435, **547**; *Herd of Buffalo opposite Garden Island, Victoria Falls* 435–7, **548**
Ballantyne, John (1815–97) 33; *William Powell Frith Painting the Princess of Wales* **27**
Balzac, Honoré de (1799–1850) 374
Bancroft, Samuel 407
Banks, Sir Joseph (1743–1820) 414, **515**
Bannister, Jack 129
Banvard, John 165
Barbizon School 328
Baring, Sir Thomas 26
Barker, Robert (1739–1806) 151, 152, 153, 163, 167; *Edinburgh from Calton Hill* 151, **180**
Barker, Thomas Jones (1815–82) 322; *The Secret of England's Greatness* 415, **514**
Barnard, Frederick 188
Barnum, Phineas T. 154
Barratt, Thomas 180
Barrau, Loreano 424
Barret, George 35
Barrett, Jerry (1824–1906) 362; *The Mission of Mercy* 362, **441**
Barrie, James (1860–1937) 207
Barry, Sir Charles (1795–1860) 44
Bartholdi, Frédéric Auguste (1834–1904) 351, 400
Bastien-Lepage, Jules (1848–84) 331–5, 423, 424, 476, 481, 485; *The London Bootblack* 332–5, **404**; *La Pauvre Fauvette* 331–4, **400**
Bateman, Robert (1842–1922) 443; *Three Women Plucking Mandrakes* 443, **556**
Baudelaire, Charles

(1821–67) 219, 330, 331, 384, 445, 465
Baxter, George 437
Bazille, Frédéric (1841–70) 470
Beardsley, Aubrey (1872–98) 63, 89, 91, 489, 497, 498, **99**; *A Caprice* 497, **615**
Beaumont, Sir George 20, 173
Bedford, Georgiana, Duchess of 173
Beerbohm, Max (1872–1956) 51, 489, 497
Beeton, Mrs (1836–65) 261, 368
Beggarstaff Brothers 495–7; *Don Quixote* 497, **614**
Bell, Jacob 264, 265
Bella, Edward 495
Bellows, George 403, 410
Bentley, Robert 411
Berlioz, Hector (1803–69) 192
Best, Mary Ellen (1809–91), *The Artist in her Painting Room, York* 306, **371**
Biard, François-Auguste (1798/9–1882), *The Slave Trade* 435
Bierstadt, Albert (1830–1902) 152, 399; *Emigrants Crossing the Plains* 399, **484**, **491**
Bigg, William Redmore (1755–1828) 26
Bingham, George Caleb (1811–79) 399–400; *Fur Traders Descending the Missouri* 400, **495**; *The Verdict of the People* 400, **494**
Birmingham Art Gallery 40–1
Bishop & Sons 166
Blackburn, Henry 297
Blackwood's Magazine 174
Blake, Peter 207
Blake, William 66, 74, 192
Blanche, Jacques-Emile (1861–1942) 485, 497; *Charles Ricketts and Charles Shannon* 497, **616**
Board of Trade 37
Boccaccio, Giovanni (1313–75) 249, 315
Böcklin, Arnold (1827–1901), *Isle of the Dead* 448
Boldini, Giovanni (1845–1931), *Lady Colin Campbell* 89, **96**
Bonheur, Rosa (1822–99) 319–22, 467; *Changing Pastures* 320, **387**; *The Horse Fair* 319–20, **386**
Bonnat 482
Bosch, Hieronymus (*c.*1460–1516) 197–8
Boston Public Library 62–3
Botticelli, Sandro (1444–1510) 39; *Primavera* 315
Boughton, George Henry (1833–1905), *God Speed!* 343
Bouguereau, Adolphe William (1825–1905) 285
Boyce, George Price (1826–97) 122, 383, **474**; *The Great Sphinx of Gizeh*

122; *Night Sketch of the Thames near Hungerford Bridge* 122, 383, **142**
Boydell, John (1719–1804) 192
Braddon, Mary Elizabeth 374
Brady, Matthew (1823–96) 54, 400
Bramley, Frank (1857–1915); *For of Such is the Kingdom of Heaven* 345, **423**; *A Hopeless Dawn* 345, **395**, **421**
Brandard, John (1812–63) 193
Brangwyn, Frank (1867–1956) 489
Braque, Georges (1882–1963) 498
Brees, S. 163
Brett, James 266
Brett, John (1831–1902) 20, 100–2, 106; *The Glacier of Rosenlaui* 100; *The Stonebreaker* 102, 251–3, **112**; *Val d'Aosta* 102, **111**
Britannia Theatre, Hoxton 182
British Diorama 157, 160
British Empire 413–37
British Institution 25–6
Brontë, Anne (1820–49) 305, 306–7
Brontë, Charlotte (1816–55) 74, 305, 329, 378
Brouwer, Adriaen (*c.*1605–38) 10, 128
Brown, Ford Madox (1821–93) 58–9, 62, 122, 232, 238, 313, 382, 488; *Chaucer at the Court of Edward III* 238–41, **290**; *An English Autumn Afternoon, Hampstead* 106, 407, **118**; *The English Boy* 182, **216**; *The Expulsion of the Danes from Manchester, 910 AD* **52**; *Girl at a Lattice* 249; *The Last of England* 355–9, **434**; *Walton-on-the-Naze* 106, **119**; *William Michael Rossetti* 77, **81**; *Work* 241, **291**
Brown, Fred 490
Brown, John 400
Brown, William (1788–1859), *View of Louth* 154, **183**
Browning, Elizabeth Barrett (1806–61) 250
Browning, Robert (1812–89) 78, 277, 367
Brueghel, Pieter (1525/30–69) 197
Brunel, Isambard Kingdom (1806–59) 160, 194–7, 266
Bruneri, François 144
Buchanan, Robert 39, 382, 445
Buckingham Palace 45–6
Bullen, William 226
Bulwer-Lytton, Edward (1803–73) 235
Bunce, Kate Elizabeth (1858–1927) 315; *Melody* 315, **379**
Bunce, Myra 315
Burchett, Richard (1815–75) 51–3; *View across Sandown Bay, Isle of Wight* 109, **121**
Burford, Robert 163

Burges, William (1827–81) 59–60; *Cardiff Castle* **53**; *Scenes from Aesop's Fables* 60, **54**
Burnaby, Colonel Frederick Gustavus 84–6, 89
Burne-Jones, Edward (1833–98) 38–9, 51, 62, 78, 253, 313, 315, 383, 405, 408, 441, 442, 443, 448, 450, 451, 453–9, 488, 489, 503; *The Briar Rose* series 407, **456**; *The Car of Love* 456, **572**; *Cupid Delivering Psyche* 442; *The Godhead Fires* 284, **345**; *The Golden Stairs* 454, **570**; *The Hand Refrains* 284; *The Heart Desires* 284; *King Cophetua and the Beggar Maid* 454–6, **571**; *Laus Veneris* 454, **569**; *Phyllis and Demophoön* 442, **555**; *Sidonia von Bork* 254, **315**; *The Sleep of King Arthur in Avalon* 456–9, **574**; *The Soul Attains* 284; *Sponsa de Libano* 456
Burnet, John 251
Burns, Robert (1759–96) 12, 20, 129
Burr, Alexander Hohenlohe (1835–99), *The Night Stall* 173–4, **204**
Burr, John (1843–94), *The Peepshow* 137, **161**
Burton, Decimus (1800–81) 154
Burton, Frederick W., *Hellilil and Hildebrandt: Meeting on the Turret Stair* 503
Buss, Robert William (1804–75), *Dickens's Dream* 73, 337, **73**
Butler, Lady (Elizabeth Thompson, 1846–1933) 322–3; *Evicted* 323, 349–51, **426**; *The Roll Call* 322, 362, 367, **388**; *Scotland Forever* 322–3, **389**
Butler, Samuel (1835–1902), *Mr Heatherley's Holiday* 33, **28**
Butler, Major General Sir William 349
Buvelot, Abram Louis (1814–88) 423
Buxton, Sir Thomas 435
Byron, Lord (1788–1824) 198, 199, 280, 330

C

Cabanel, Alexandre (1823–89) 285, 400; *Birth of Venus* 288
Caiva, Antonia 454
Calcott, Sir Augustus Wall 194
Calderon, Philip Hermogenes (1833–98) 146; *Broken Vows* 370, **452**; *Her Most High, Noble and Puissant Grace* 146, **174**
Cameron, Julia Margaret (1815–79) 77–8, 91, 313; *Alfred, Lord Tennyson* **82**

Campbell, Lady Colin 89, **96**
Canada 427–31
Cardiff Castle 59–60, **53–4**
caricatures 73
Carlyle, Thomas (1795–1881) 78, 241, 251, 329
Carolus Duran (1838–1917) 89
Carpenter, Margaret Sarah (1793–1872) 307; *H.B.W. Milner* **370**
Carpenter, William Hookham 307
Carr, Emily 431
Carraciolo, Lodovico, *Rome* 167
Carroll, Lewis (1832–98) 7, 49, 205
Cary, Joyce (1888–1957) 50
Casas, Ramon 424
Cassatt, Mary (1844–1926) 188, 409–10; *The Loge* 410, **511**
Castel Coch 60
Catlin, George (1796–1872) 396, 427; *Comanche Indians Chasing Buffalo with Lances and Bows* 396, **489**
Cerrito, Fanny 194
Cervantes, Miguel de (1547–1616) 129
Cézanne, Paul (1839–1906) 498
Chadwick, Mr 311
Chalon, Alfred Edouard (1780–1860) 66, 193, 308; *Mrs De Wint* 66, **64**; *Standing on the Window Ledge* 193, **231**
Chantrey, Sir Francis (1781–1841) 41
Chaplin, Charlie (1889–1977) 137, 186, 492
Charlotte, Queen (1744–1818) 152
Chartists 232, 235
Chase, William Merritt (1849–1916) 410–11; *At the Seaside* 411, **512**
Chassériau, Théodore (1819–56), *Tepidarium* 291
Chatterton, Thomas (1752–70) 251, 308
Chaucer, Geoffrey (*c.*1345–1400) 251, 253
Chekhov, Anton (1860–1904) 360
Chéret, Jules (1836–1932) 494–5; *Vin Mariani Popular French Tonic Wine* 495, **613**
childhood, paintings of 169–89
Chinnery, George (1774–1852) 432–5; *Chinese Street Scene at Macao* 435, **545**
'chocolate box' art 147–8
Church, Frederic Edwin (1826–1900) 152, 395–6, 399, 432; *Niagara Falls, from the American Side* 395, **488**
Clare, John (1793–1864) 119
Clark, Thomas 423
classicism 279–94, 299, 328
Claude Lorrain (1600–82) 419
Clausen, George (1852–1944) 332, 476, 481, 482; *Breton Girl Carrying a Jar* 332, 481,

402; *A Souvenir of Marlow Regatta* 481, **593**

Claxton, Florence Anne (*fl.*1860), *The Choice of Paris* 311, **374**

'The Clique' 198–9, 202

Cole, Alan 473

Cole, George Vicat (1833–93), *Winter Scene* 109–11, **122**

Cole, Sir Henry (1808–82) 30, 37, 51

Cole, Thomas (1801–48) 152, 392–5, 398, 404; *The Dream of the Architect* 160, 395, **487**; *The Course of Empire* 395; *Departure and Return* 395; *The Oxbow* 152, 395, **486**; *The Voyage of Life* 395

Coleman, W.S. 299

Coleridge, Samuel Taylor (1772–1834) 173

Collingwood, William Gershom (1854–1932), *John Ruskin in his Study at Brantwood, Cumbria* 487, **603**

Collins, Charles (1828–73) 243; *Convent Thoughts* 238, **288**

Collins, Wilkie (1824–89) 308, 374, 494

Collins, William (1788–1847) 26, 173; *Rustic Civility* 173, **202**

Collinson, James (1825–81) 232, 249, 355; *Answering the Emigrant's Letter* 355; *The Emigration Scheme* 355, **433**; *For Sale* 249, **304**; *Italian Image Makers at a Roadside Alehouse* 249; *The Renunciation of Queen Elizabeth of Hungary* 249, **303**; *To Let* 249

Collmann, Mary Ann 74, **76**

Colnaghi and Son 361

colonial paintings 413–37

Combe, Thomas 238

Conder, Charles (1868–1909) 423, 425–7, 492–4; *Beach Scene, Dieppe* 497, **618**; *Departure of the SS Orient from Circular Quay* 425, **534**; *Fan design: Preparations for a Fancy-Dress Ball* 494, **610**; *A Holiday at Mentone* 425, **535**; *The Moulin Rouge* 492

Constable, Isabel 37

Constable, John (1776–1837) 20–3, 25, 37, 94, 96, 111, 129, 153–4, 410, 416, 429, 467, 470; *The Cenotaph to the Memory of Sir Joshua Reynolds* 20, **16**; *Stonehenge* 23, **17**

Cook, James (1728–79) 414

Cook, Thomas 31

Cooke, Edward William (1811–80) 97; *Scheveningen Beach* 97, **106**

Cooke, Grace 323

Cook's Tours 269

Cooper, Abraham (1787–1868) 215–16; *The Day Family* 215–16, **260**

Cooper Henderson, Charles (1803–77) 219, 221; *The Edinburgh Mail Coach and*

Other Coaches in a Lamplit Street 219, **264**

Cooper, Thomas Sidney (1803–1902) 96, 222–4, 259; *Bull* 222; *The Victoria Jersey Cow* 224, **269**

Cope, Charles West (1811–90) 194; *The Council of the Royal Academy Selecting Pictures for the Exhibition* 33–4, 35, **29**; *The Embarkation of the Pilgrim Fathers for New England, 1620* 47, **37**; *The First Trial by Jury* 47; *Palpitation* 137–9, **164**; *The Young Mother* 371, **453**

Copley, John Singleton (1738–1815), *The Death of the Earl of Chatham* 11, 392, **5**; *Death of Major Peirson* 392

Coram, Captain Thomas (*c.*1668–1751) 128, 182

Cornelius, Peter von (1783–1867) 44, 238

Cornforth, Fanny 76, 249, 254, 382–3, **474**

Corot, Jean Baptiste Camille (1796–1875) 467

Corvo, Baron (Frederick Rolfe, 1860–1913) 300–1

Cotman, Frederick George (1850–1920), *One of the Family* 342, **415**

Courbet, Gustave (1819–77) 20, 282, 327–8, 405, 464, 465; *La Belle Irlandaise* 465; *Burial at Ornans* 327; *The Painter's Studio* 464; *The Stonebreakers* 253, 327, **396**; *The Studio* 328

Couture, Thomas (1815–79) 285

Cox, David (1783–1859) 35, 40–1, 96, 111, 116; *The Challenge* 116; *The Night Train* 116, **134**; *Rhyl Sands* 116, **133**

Craig, Gordon 277

Cranbrook Colony 174, 177

Crane, Walter (1845–1915) 32–53, 442, 443–5, 451; *The Chariot of the Hours* 445; *Diana and Endymion* 443; **558**; *The Laidly Worm of Spindleston Heugh* 445; *Love's Altar* 445; *Neptune's Horses* 445, **559**; *The Renaissance of Venus* 299–300, 443, **361**; *The Sleeping Beauty in the Wood* 456; *The Triumph of Spring* 443

Crawhall, Joseph (1861–1913) 224, 489; *The Aviary, Clifton* 224, **273**

Creswick, Thomas (1811–69) 194; *Land's End, Cornwall* 97, **107**

Crimean War 53–4, 361–2

Cristall, Joshua (1767–1847) 137; *A Scottish Peasant Girl Embroidering Muslin at Luss, Loch Lomond* 137, **162**

Crivelli, Carlo (*c.*1430–95) 454

Crofts, Ernest (1847–1911), *Whitehall: January 30th, 1649* 146, **177**

Croker, Crofton 194

Crome, John (1768–1821) 467

Crowe, Eyre (1824–1910), *The Dinner Hour: Wigan* 384, **477**

Cruikshank, George (1792–1878) 131, 193, 329; *The Bottle* 329; *Cold, Misery and Want Destroy their Youngest Child* 135, 329, **397**; *The Worship of Bacchus* 329

Cumming, Sir William 272

Curtis, Ralph 89

Cuyp, Albert (1620–91) 222–4

D

Dadd, Richard (1817–86) 198–203, 205, 264; *Come unto these Yellow Sands* 199, **241**; *Contradiction: Oberon and Titania* 202, **242**; *The Fairy Feller's Master-Stroke* 202–3, **243**; *Saint George after the Death of the Dragon* 46

Daguerre, Louis (1789–1851) 155–6, 157; *The Ruins of Holyrood Chapel, Edinburgh, Effect of Moonlight* 156, **185**

daguerreotypes, 330

Daley, Victor 423

Danby, Francis (1793–1861) 156, 161; *The Deluge* 161–3, **189**; *A Midsummer Night's Dream* 194, **233**

Daniell family 431

Dante Alighieri (1265–1321) 315, 441

Darnley, Lord 281

Darwin, Charles (1809–82) 78, 99, 211, 325, 415–16

Daubigny, Charles-François (1817–78) 467

Daumier, Honoré (1809–79) 267, 288

David, Jacques-Louis (1748–1825) 398

Davies, John Scarlett, *The Library of Benjamin Godfrey Windus* 27, **22**

Day, John 216

De Mille, Cecil B. 156

De Morgan, Evelyn (1855–1919) 315; *Flora* 315, **378**

De Morgan, William (1839–1917) 315

De Nittis, Giuseppe (1846–84) 277

De Vere, Aubrey 351

De Wint, Peter (1784–1849) 119; *Harvest Field* 119, 135

De Wint, Mrs Peter 66, **64**

dealers 40

Decadents 440, 445

Degas, Edgar (1834–1917) 91, 170, 267, 274, 409, 468, 473, 474, 477, 479–80, 485, 490, 494, 498

Delacroix, Eugène (1798–1863) 11, 246, 281, 282, 285

Delaroche, Paul (1797–1856) 420

Delius, Frederick

Delville, Jean 447

Deverell, William Howell (1827–54) 249–50; *The Grey Parrot* 250, 313, **306**; *Twelfth Night* 250

Dewing, Thomas Wilmer (1851–1938) 408; *Morning Glories* 408, **506**

di Marco, Alessandro 300

Diaghilev, Sergei (1872–1929) 489

Dickens, Charles (1812–70) 17, 31, 67, 71, 73, 129, 131, 159, 177, 182, 186, 198, 237, 258, 264, 269, 277, 329, 330, 337, 342, 343–4, 360, 368, 375, 378, 380, 383, **72–3**

Dicksee, Sir Frank (1853–1928) 41; *The Confession* 388, **483**

Diderot, Denis (1713–84) 26

Dieppe 497

dioramas 155–9

Disney, Walt 207

Disraeli, Benjamin (1804–81) 71, 74, 76, 207, 329

divisionism 301

Dixon, Annie (1817–1901) 306; *Princess Helena* 306, **369**

Dollman, John Charles (1851–1934), *Les Misérables (A London Cab Stand)* 224, **270**

Doré, Gustave (1833–83) 330–1, 384; *The Exercise Yard at Newgate* 331, **399**; *'Glad to death's mystery…'* 380, **468**; *Over London by Rail* 331

Dorling, Henry 261

Dostoevsky, Fyodor (1821–81) 384

Dowling, Robert (1827–86) 419; *Aborigines of Tasmania* 419, **522**

Dowson, Ernest (1867–1900) 497

Doyle, Sir Arthur Conan (1859–1930) 206

Doyle, Charles Altamont (1832–93) 206; *Self-Portrait: A Meditation* 206, **248**

Doyle, Richard (Dicky, 1824–83) 193, 205–6, 453; *'Do Not Touch'* 31, **25**; *The Fairy Tree* 205, **246**; *Under the Dock Leaves* 206, **250**

Drury Lane Theatre, London 157–9

Du Maurier, George (1834–96) 77, 78, 183, 277, 288, 298, 440, 442, 464, 465; 14/–8

Dudley Gallery 36, 441–2

Dudley, Alexandre 387

Durand, Asher Brown (1796–1886) 395, 404

Durand-Ruel, Paul 410, 467, 498

Duranty, Edmond 410

Dürer, Albrecht (1471–1528) 204, 238

Duret, Théodore 467

Duterrau, Benjamin (1767–1851) 419; *The Conciliation* 419, **521**

Dyce, William (1806–64) 44–5, 46, 49, 238; *The Baptism of King Ethelbert* 47, **36**; *Hospitality: The Admission of Sir Tristram to the Fellowship of the Round Table* 49, **39**; *Jacob and Laban* 45; *The Madonna* 45; *Neptune Resigning to Britannia the Empire of the Sea* 45, **34**; *Pegwell Bay: A Recollection of October 5th, 1858* 99–100, **108**; *Religion: The Vision of Sir Galahad and his Company* 49; *Titian's First Experiments with Colour* 143, **167**

E

Eakins, Thomas (1844–1916) 402, 403–4; *The Biglin Brothers Racing* 403, **501**; *The Gross Clinic* 403, **502**

Earle, Augustus (1793–1838) 163, 416, 421; *A Bivouac of Travellers in Australia* 416, **516**; *Panorama of Hobart* 163, **192**

Earle, George (*fl.*1857–1901), *Coming South* 269; *Going North* 269, **325**

Eastlake, Sir Charles (1793–1865) 29, 44, 46, 218, 235; *The Salutation to the Aged Friar* 143, **170**

Eastlake, Lady 28–9

Edinburgh Trustee's Academy 37

Edward, Prince of Wales (1841–1910) 20, 33, 84, 86, 207, 272–3, 274, 322, 370–1, 451, 475

Egg, Augustus (1816–63) 194, 198, 258, 261, 380, 388; *Past and Present* 238, 367–8, 374–5, **462–4**

Egley, William Maw (1826–1916) 131; *Florence Dombey in Captain Cuttle's Parlour* 131, **153**; *Omnibus Life in London* 267, **322**

Egypt 102–3

Elgin Marbles 280, 291, 459

Eliot, George (1819–80) 74, 127–8, 147–8, 306, 329, 368

Ellison, Rev. Richard 36

Elmore, Alfred (1815–81) 198; *On the Brink* 375, **447**, **460**

Elsley, Arthur J. (1860–1952) 14/–8

Emerson, Ralph Waldo (1803–82) 398

emigration 349–61

engravings 139–43, 183, 211, 267, 336

Etruscan School 111–12

Etty, William (1787–1849) 46, 194, 280–4; *The Combat* 281; *The Judgement of Paris* 281, 336

Eugénie, Empress (1826–1920) 319

exhibitions 26–7, 30–2, 33–5, 36–7, 40–1

F

Faed, Thomas (1826–1900) 33, 34; *The Last of the Clan* 351, **427**

fairy paintings 191–207

Fantin-Latour, Henri (1836–1904) 331, 405, 464–5; *Homage to Delacroix* 465

Farmer, Mrs Alexander (*fl.*1855–67), *An Anxious Hour* 371–4, **454**

Farrar, Dean 177

Faure, Jean-Baptiste 470

Fenton, Roger (1819–69) 53–4, 106, 361

Ferneley, John (1782–1860) 216; *The Council of Horses* 216, **261**; *John, Henry and Francis Grant at Melton* 218, **262**

Feure, Georges de 447

Fielding, Anthony Vandyke Copley (1787–1855) 93, 115, 416; *Ben Lomond* 115, **128**

Fielding, Henry (1707–54) 129

Fildes, Luke (1844–1927) 86, 143, 336–8; *Applicants for Admission to a Casual Ward* 337, **407**; *The Doctor* 338, **408**; *The Empty Chair* 337, 343–4, **418**; *Houseless and Hungry* 336–7; *The Widower* 338

Fine Art Society 40, 474

First World War 323, 406, 502–3

Fitz-Roy, Blanche 451

Fitzgerald, John Anster 197–8; *Alice in Wonderland* 207; *The Captive Robin* 197, 237; *Fairies in a Bird's Nest* 198, **240**

Fitzroy, Captain 415, 416

Flatow, Louis Victor (1820–67) 266–7

Flaubert, Gustave (1821–80) 485

Flaxman, John (1755–1826) 50, 280

Forain, Jean-Louis (1852–1931) 91

Forbes, Stanhope (1857–1947) 325, 332, 345, 482; *Fish Sale on a Cornish Beach* 345, **422**; *The Health of the Bride* 345, 371, **458**; *A Street in Brittany (Cancale)* 332, **403**; *The Village Philharmonic* 345

Forbes-Robertson, Eric (1865–1935) 482; *Breton Children, Pont Aven* 344, 482, **594**

Ford, Florrie 299

Forster, John 73

Fortescue-Brickdale, Eleanor (1872–1945) 315; *In the Springtime* 315, **380**; *Such Stuff as Dreams are Made of* 315

Foster, Myles Birket (1825–99) 120, 186; *Children Running down a Hill* 186, **221**; *The Milkmaid* 137, **159**; *San Giorgio*

Maggiore 119, **140**
Foundling Hospital 182
Fouqué, Friedrich Heinrich Karl de la Motte 194
France, Impressionism 463–4, 467
Franklin, Lady 419
Fremiet, Emmanuel (1824–1910) 224
frescos 43–63
Friedrich, Caspar David (1774–1840) 395
Fripp, Charles Edwin, *The Battle of Isandhlwana, 22 January 1879* 437, **550**
Frith, William Powell (1819–1909) 17, 28, 33, 73, 131, 198, 199, 202, 257–67, 269, 272–4, 308, 322, 400, **27**; *Derby Day* 12, 260–5, 272, 363, 492, **320**; *Many Happy Returns of the Day* 173, **201**; *The Marriage of the Prince of Wales* 370–1, **455**; *Private View of the Royal Academy, 1881* 39–40, 277, 450, **20**, **32**; *The Race for Wealth* 273; *The Railway Station* 266–7, **316**, **321**; *Ramsgate Sands* 186, 258, 259–60, 261, 370, **317**; *Retribution* 273, **330**; *The Road to Ruin* 273; *The Salon d'Or, Homburg* 272–3, **329**; *A Scene from Sterne's 'A Sentimental Journey'* 131, **152**
Frost, William Edward (1810–77) 46, 282–4; *Diana and her Nymphs Surprised by Actaeon* 282, **339**
Fry, Roger (1866–1934) 291, 497, 502, 503
Fry, Samuel 266
Fuseli, Henry (1741–1825) 192, 211, 280; *Titania's Awakening* 192, **230**

G

Gainsborough, Thomas (1727–88) 26, 182, 467
Galsworthy, John (1867–1933) 147, 388
Gambart, Ernest 265, 267, 272, 320
Gambier-Parry, Thomas (1816–88) 59
Garland, Henry (*fl.*1854–90), *The Winner of the Match* 226, **275**
Gaskell, Mrs (1810–65) 306, 329
Gauguin, Paul (1848–1903) 344, 482, 502
Gautier, Théophile (1811–72) 193, 280, 497
Gautreau, Madame 89, 407, **93**
Gay, John 216
genre painting 12–15, 20, 127–48, 399–400
George III, King (1738–1820) 152, 392
George IV, King (1762–1830) 12, 17, 26, 221
George V, King (1865–1936) 86

Gérard, François (1770–1837) 11
Gere, Charles March (1869–1957), *The Tennis Party* 228, **277**
Géricault, Théodore (1791–1824) 221, 330; *Epsom Derby* 215
Germany 192
Gérôme, Jean-Léon (1824–1904) 224, 291, 403, 424, 467, 482
Ghirlandaio, Domenico (1449–94) 315
Gibson, John (1790–1866), *The Tinted Venus* 284, **341**
Gilbert, Alfred (1854–1934) 335
Gilbert, Sir William Schwenck (1836–1911) 274
Gill, Samuel Thomas (1818–80) 420–1; *Digger's Wedding in Melbourne* 421, **524**
Gilpin, Sawrey (1733–1807) 216
Giorgione (1477–1510), *Fête Champêtre* 288
Girtin, Thomas (1775–1802) 35, 152–3; *Eidometropolis* 152
Gissing, George (1857–1903) 133, 342
Glackens, William (1870–1938), *Hammerstein's Roof Garden* 410, **509**
Gladstone, W.E. (1809–98) 76, 277
Glasgow Boys 482, 489
Gleyre, Charles (1806–74) 288, 291, 470
Gloeden, Baron von (1856–1931) 300
Glover, John (1767–1849) 416–19; *The Bath of Diana, Van Diemen's Land, 1837* 419, **520**; *My Harvest Home* 419, **519**
Godwin, E.W. (1833–86) 40, 474
Goldsmith, Oliver (1728–74) 129, 131, 258, 359
Goncourt, Edmond de (1822–96) 468, 492
Goncourt, Jules de (1830–70) 492
Goodall, Edward Alfred (1819–1908) 361
Goodall, Frederick (1822–1904) 146; *Jessie's Dream* 363, **444**; *Puritan and Cavalier* 146, **175**
Goodwin, Albert (1845–1932) 122–5; *Ponte Vecchio, Florence* 125, **145**
Gordon, General (1833–85) 437, **549**
Gordon, George Gordon, 5th Duke of **6**
Gordon, W.J. 224
Gore, Spencer (1878–1914), *Gauguins and Connoisseurs at the Stafford Gallery* 502, **624**
Gosse, Edmund (1845–1928) 99, 188, 316
Gotch, Thomas Cooper (1854–1913) 189; *The Child Enthroned* 189, **227**
Gothic Revival 59, 395

gouache 114
Gould, Elizabeth 419–20
Gould, John (1804–81) 135, 313, 419–20; *Great Brown Kingfisher* 420, **523**
Goupil & Co. 342, 485
Gozzoli, Benozzo (*c.*1420–97) 44, 232, 315
Graeme, Poppy 407
Graham, Peter (1836–1921) 224
Graham, Thomas (1840–1906), *Alone in London* 380, **469**
Grand Tour 152
Grant, Baron Albert 273
Grant, Sir Francis (1803–78) 33, 34, 71–3, 216–19, **262**; *Queen Victoria Riding out with her Gentlemen* 71, 218, **69**
The Graphic 180–2, 183, 336–7, 338–43, 345, 423
Graves, Henry 267
Great Exhibition (1851) 30–1, 37, 71, 147, 220, 284, 335, **24**
Greaves, Walter (1846–1930) 272; *Hammersmith Bridge on Boat Race Day* 228, **278**
Greeley, Horace (1811–72) 399
Green, Charles (1840–98), *Her First Bouquet* 180–2, **215**
Greenaway, Kate (1846–1901) 38, 316, 319; *The Garden Seat* 316, **382**
Gregory, Edward John (1850–1909), *Boulter's Lock – Sunday Afternoon* 501, **622**
Greuze, Jean-Baptiste (1725–1805) 129, 313; *Father Reading the Bible to his Children* 26
Grieve, Thomas (1799–1882) 155; *A Grand Moving Panorama of London in the Time of Elizabeth I* 155, **184**
Griffith, D.W. (1875–1948) 156
Grigson, Geoffrey (1905–85) 211
Grimaldi, Joseph (1779–1837) 154–5
Grimm Brothers 192–3
Grimshaw, John Atkinson (1836–93) 112–14, 206–7; *Iris* 207, **249**; *Nightfall down the Thames* 112, **126**; *Tree Shadows on the Park Wall* 112–14, **127**
Gros, Antoine-Jean (1771–1835) 11, 219
Grosvenor Gallery 39, 40, 111, 442, 450–4, 488, 489
Group of Seven 431
Gurney, Samuel 135
Guthrie, James (1859–1930) 332, 482; *To Pastures New* 332, **401**
Guys, Constantin (1802–92) 330, 384; *Study of Prostitutes in the Haymarket* 384, **475**

H

Haag, Carl (1820–1915) 212; *Morning in the Highlands* 212–15, **258**
Hague School 328
Haig, Axel, *The Great Indian Peninsula Railway Terminus and Administrative Offices, Bombay* 432, **544**; *View of the Winter Smoking Room in Cardiff Castle with Medieval Figures* 60, **53**
Halévy, Daniel (1872–1962) 473
Halkerston, Charles, *The Rotunda on the Mound, Edinburgh* 165, **194**
Hals, Frans (*c.*1580–1666) 89
Hamerton, P.G. 288
Hamilton, Lady 76
Handel, George Frederick (1685–1759) 182
Hardwick, Philip Charles (1792–1870), *The Booking Hall, Euston Station* 50, **42**
Hardy, Frederick Daniel (1826–1911) 177–8; *Playing at Doctors* 177–8, **209**; *The Young Photographers* 177
Hardy, Thomas (1840–1928) 132, 166, 316, 342
Hassam, Childe (1859–1935) 410; *Washington Arch, Spring* 410, **510**
Havell, Edmund (1819–94), *Weston Sands in 1864* 186, 260, **319**
Hawarden, Lady 448
Haydon, Benjamin Robert (1786–1846) 15–19, 46–7, 273, 279–80, 503; *The Assassination of Dentatus* 280; *The Banishment of Aristides* 46; *The Black Prince Entering London* 46; *The Curse of Adam* 46; *The Hero and his Horse on the Field of Waterloo* 17; *Marcus Curtius Leaping into the Gulf* 46; *The Meeting of the Unions on Newhall Hill, Birmingham* 17; *The Mock Election* 17, 400, **10**; *Napoleon on St Helena* 17; *Punch, or May Day* 17, **11**; *The Reform Banquet* 17; *Wellington Musing on the Field of Waterloo* 17; *Wordsworth on Helvellyn* 17, **12**
Haydon, Michael 266
Hayllar, Edith (1860–1948), *A Summer Shower* 228, **279**
Hayter, Sir George (1792–1871), *Queen Victoria* 66–7, **65**
Hazlitt, William (1778–1830) 17, 220
Heade, Martin Johnson (1819–1904), *Approaching Thunderstorm* 400, **498**
Heatherley's School of Art 33, **28**
Heavy, Charles 421
Heber, Bishop 414–15
Heidelberg School 423–5
Heilbuth, Ferdinand 277
Heine, Heinrich (1797–1856) 193
Helena, Princess 306
Helleu, Paul (1859–1927) 485, **580**, **599**
Henry, George (1858–1943)

212–15, **258**
Hague School 328
480–1, 482
Henshall, John Henry (1856–1928), *Behind the Bar* 137, **158**
Henty, George (1832–1902) 144
Herbert, John Rogers (1810–90) 50
Herbert, Ruth 76
Herkomer, Hubert von (1849–1914) 86, 323, 336, 340–2, 343, 360–1; *Cecil Gordon Lawson* 86, **91**; *Eventide – A Scene in the Westminster Union* 340, **414**; *Hard Times* 342; *The Last Muster* 340, 364, **445**; *Pressing to the West* 360–1, **438**; *On Strike* 342, **416**
Herodotus 297
Herring, Benjamin 222
Herring, John Frederick (1795–1865) 221–2, 264; *Harvest Time* 222; *Seed Time* 222, **268**; *The Start of the 'Dirty' Derby* 221, **251**, **267**
Hertford, Marquis of 31
Hiatt, Charles 494–5
Hicks, George Elgar (1824–1914) 269–72, 380; *Billingsgate Fish Market* 270–2, **326**; *Changing Homes* 371, **456**; *Dividend Day at the Bank of England* 269; *The General Post Office, One Minute to Six* 269–70, **327**; *Woman's Mission* 375–7, **461**
Hiffernan, Joanna 405, 465
Hill, Emma 356
Hind, William George Richardson (1833–89) 429; *The Game of Bones* 429, **537**
History painting 10–11, 54, 143, 144–6, 400, 419, 427
Hogarth, William (1697–1764) 10, 17, 31, 128–9, 182, 273, 382, **148**; *Election* series 400; *The Four Times of Day* 272; *The Harlot's Progress* 129, 380; *The Idle and Industrious Apprentices* 129; *Marriage à la Mode* 129, 380, 388; *The Rake's Progress* 129, 380
Hogarth Club 380
Hokusai 116
Holbein, Hans (1497–1543) 238
Holker, Sir John 473–4
Holl, Frank (1845–88) 86, 336, 338–40; *Her First Born* 338, **411**; *Hush!* 338; *Hushed* 338; *I am the Resurrection and the Life* 338; *John Everett Millais* 86, **92**; *The Lord Giveth and the Lord hath Taken Away* 338; *Newgate – Committed for Trial* 340, **412**; *No Tidings from the Sea* 338, **410**
Holland, James (1800–70), *The Hospital of the Pietà* 119, **139**
Hollar, Wenceslaus (1707–77) 155
Holloway, Thomas (1800–83) 28, 228, 267, 298
Holyoake, William

(1834–94), *In the Front Row at the Opera* 387–8, **480**
Homer 279
Homer, Winslow (1836–1910) 7, 226, 402–3, 404; *Croquet Scene* 226, **274**; *Early Evening* 402, **499**; *The Wreck of the Iron Crown* 403, **500**
Hooch, Pieter de (1629–84) 127
Hood, Thomas 377–8
Hooker, Sir William 325
Hope, Thomas 26
Hopkins, William H. (*fl.*1853–92), *Weston Sands in 1864* 186, 260, **319**
Hopley, Edward William John (1816–69), *A Primrose from England* 421, **527**
Horace 280
Hornel, Edward Atkinson (1864–1933) 480, 482; *Kite Flying, Japan* 481, **592**
Hornor, Thomas (1785–1844), *London from the Summit of St Paul's Cathedral* 154, **182**
Horsley, John Calcott (1817–1903) 178, 298; *The Contrast: Youth and Age* 178, **208**
Horton, Priscilla 193, **232**
Houghton, Arthur Boyd (1836–75) 133, 183, 344, 371; *Interior with Children at Play* 183, **220**; *Volunteers Marching Out* 133, **156**
Houses of Parliament 23, 44, 45, 46–9, 51, 63, 400, 467, 485, **18**
Hovenden, Thomas (1840–95) 400, 403; *Breaking Home Ties* 400; *The Last Moments of John Brown* 400, **496**
Howlett, Robert 264, 266
Hudson, George 131
Hudson River School 152, 392–5
Huggins, William (1820–84) 211–12; *A Lion Resting in the Midday Sun* 212, **255**
Hughes, Arthur (1832–1915) 51, 122, 250, 313; *April Love* 250, 369, **308**; *Aurora Leigh's Dismissal of Romney (The Tryst)* 250; *Home from Sea* 364, **446**; *The Long Engagement* 251, 369, **309**
Hughes, Thomas 177
Hugo, Victor (1802–85) 224, 409
Humboldt, Baron von 395–6
Hunt, Alfred William (1830–96) 120–2; *A November Rainbow – Dolwyddelan Valley* 120, **141**
Hunt, Charles (*fl.*1870–96), *A Coffee Stall, Westminster* 133, **157**
Hunt, William Henry (1790–1864) 115, 192, 325; *The Attack* 178; *The Defeat* 178; *The First Cigar, the Aspirant* 178; *The First Cigar, Used Up* 178; *Primroses and Bird's Nests* 115, **129**

Hunt, William Holman (1827–1910) 33, 232, 235, 238, 246–7, 250, 388, 440, 451, 488; *The Awakening Conscience* 238, 247, 249, 383, 387, **476**; *Claudio and Isabella* 238, **289**; *A Converted British Family Sheltering a Christian Missionary from the Druids* 238; *Dante Gabriel Rossetti* 76, **79**; *The Hireling Shepherd* 241–3, **292**; *The Light of the World* 243, **295**; *Little Nell and her Grandfather* 131; *Our English Coasts, 1852 (Strayed Sheep)* 246, **296**; *The Plain of Esdraelon from the Heights above Nazareth* 105–6, **117**; *Rienzi Vowing to Obtain Justice* 235, **284**; *The Scapegoat* 105, 232, 247, **297**; *Valentine Rescuing Sylvia from Proteus* 238

Huskisson, Robert (1819–61) 194; *The Midsummer Night's Fairies* 194, **236**

Huxley, Thomas (1825–95) 277

Huysmans, J.-K. (1848–1907) 84, 453

I

Ibsen, Henrik (1828–1906) 389

Idyllic School 125

Illustrated London News 148, 197, 330, 361, 384

illustrations 131–2, 183

Impressionism 186, 188, 267, 301, 325, 404, 405, 409–10, 411, 423, 424, 463–85, 489

Inchbold, John William (1830–88) 100; *The Lake of Lucerne, Mont Pilatus in the Distance* 100, **110**

India 415, 431–2

Indian Mutiny 362–3, 432

Industrial Revolution 329

Ingres, Jean Auguste Dominique (1780–1867) 11, 71, 291, 420; *Odalisque and the Slave* 285

Institute of Painters in Water Colours 35–6

International Exhibition (1862) 253, 284, 291

International Society of Sculptors, Painters and Gravers 498

Ionides, Constantine Alexander 498

Ireland 349–51, 359

Irving, Sir Henry (1838–1905) 497

Irving, Washington (1783–1859) 132

Israels, Jozef (1824–1911) 328, 338

Italy 143

J

Jackson, John 308

Japanese art 480–1

Jefferson, Thomas (1743–1826) 392

Jerome, Jerome K. (1859–1927) 501

Jerrold, Blanchard 330–1

John, Augustus (1878–1961) 502

John, Gwen (1876–1939), *Self-Portrait* 325, **394**

Jones, George (1786–1869) 322

Jopling, Louise (1843–1916) 308–11; *Blue and White* 311, 489, **373**

journals 183, 330, 336–7, 489

Jowett, Benjamin 51

Joy, George William (1844–1925), *The Death of General Gordon* 437, **549**

Joy, Thomas (1812–66) 198

Jullian, Philippe 447

K

Kane, Paul (1810–71) 427; *Portrait of Kee-A-Kee-Ka-Sa-Coo-Way* 427, **536**

Kauffmann, Angelica (1741–1807) 9, 307

Kean, Charles (1811–68) 155, 198

Keats, John (1795–1821) 17, 91, 232, 280, 459

Keightley, Thomas 193

Kemble, John Philip (1757–1823) 198

Kemp-Welch, Lucy (1868–1958) 323; *Colt Hunting in the New Forest* 323, **390**; *The Gypsy Drovers* 323

Kenrick, Sir William 41

Kettle, Tilly 431

Khnopff, Fernand (1858–1921) 408, 448

King, Emma Brownlow (1832–1905) 306; *The Foundling Restored to its Mother* 182, **218**

Kingsley, Charles (1819–75) 177, 203–4, 345

Kirk, John 435

Koehler, Robert (1850–1917), *The Strike* 342, **417**

Krieghoff, Cornelius (David, 1815–72) 54, 427–9; *Merrymaking* 427, **538**; *The Officer's Trophy Room* 429, **539**

L

La Thangue, Henry Herbert (1859–1929), *In the Orchard* 481, **595**

Laclos, Pierre Choderlos de (1741–1803) 137

Lamb, Charles (1775–1834) 17

Lamb, John I and II, *London to Hong Kong in Two Hours* 165, **193**

Lami, Eugène (1900–90), *A Hunting Breakfast in England* 219, **263**

Lamont, Thomas Reynolds 288

Landini, Andrea 144

landscapes 93–125

Landseer, Sir Edwin (1802–73) 12, 17–20, 28, 31, 33, 38, 46, 148, 194, 209–12, 215, 218, 222, 224, 228, 308, 320; *Dignity and Impudence* 211; *Highland Music* 147; *The Hunting of Chevy Chase* 19, 215, **13**; *A Jack in Office* 211; *Laying Down the Law* 211, **253**; *A Midsummer Night's Dream* 197, 238, **238**; *The Monarch of the Glen* 211, **252**; *A Naughty Child* 170–3, **200**; *The Old Shepherd's Chief Mourner* 211, **254**; *Queen Victoria and Prince Albert at the Bal Costumé of 12 May 1842* 71, **71**; *The Stonebreaker and his Daughter* 19–20, 251–3, **14**; *Windsor Castle in Modern Times* 67, 212, **67**

Lane, Sir Hugh (1875–1915) 485

Langley, Walter (1852–1922) 345; *But Men Must Work and Women Must Weep* 345, **420**; *Disaster* 345; *...Never Morning Wore to Evening but some Heart did Break* 345

Langtry, Lily (1853–1929) 277

Lauder, Robert Scott (1803–69) 37

Lavery, Sir John (1856–1941) 89; *The Bridge at Grez* 482, **597**; *The Rocking Chair* 89, **97**; *The Tennis Party* 228, **276**

Lawrence, Sir Thomas (1769–1830) 11, 65, 159, 281, 307, 467; *George Gordon, 5th Duke of Gordon* **6**

Lawson, Cecil Gordon (1851–82) 86, 111, 451, **91**; *The Hop Gardens of England* 111, **124**; *A Hymn to Spring* 111

Lazarus, Emma 351–2

Le Sage, Alain René (1668–1747) 129

Leader, Benjamin Williams (1831–1923), *February Fill Dyke* 111, **123**

Lear, Edward (1812–88) 67, 105, 325, 431–2, 488; *Mount Kangchenjunga* 431–2, **543**; *The Temple of Bassae* 105, 116

Lee, Frederick Richard (?1798–1879) 96

Leech, John (1817–64) 46, 131, 220, 259, 261, 264, 421

Leefe, Agnes 207

Legros, Alphonse (1837–1911) 37, 331, 405, 451, 453, 490, 498; *The Angelus* 331; *A Garden of Misery* 331; *The Tinker* 331, **398**

Leibl, Wilhelm (1844–1900) 410, 411

Leighton, Frederic (1830–96) 33, 34, 51, 53, 58, 59, 83, 112, 133, 224, 277, 284, 285–8, 291, 300, 335, 459, 488, 492, 497; *Actaea, the Nymph of the Shore* 288, **347**; *The Arts of Industry as Applied to Peace* 53, **47**; *The Arts of Industry as Applied to War* 53; *Clytie* 459, **578**; *Daedalus and Icarus* 285–8, **346**; *Death of Brunelleschi* 143; *Elijah in the Wilderness* 448, **561**; *Flaming June* 448, **563**; *May Sartoris* 83, **86**

L'Enfant, Pierre-Charles (1754–1825) 392

Leonardo da Vinci (1452–1519) 39, 76

Leslie, Charles Robert (1794–1859) 12, 46, 129, 154, 197, 308, 392; *A Garden Scene* 182, **213**; *Molière, 'Le Bourgeois Gentilhomme'* 131, **150**; *My Uncle Toby and the Widow Wadman* 129, 147, **149**; *Queen Victoria in her Coronation Robes* 67, 369, **449**

Leutze, Emanuel (1816–68) 54; *Washington Crossing the Delaware* 54, 400, **497**; *Westward the Course of Empire Takes its Way (Westward Ho!)* 54, **48**

Leverhulme, Lord 311, 489

Levin, Phoebus (1836–1908), *Covent Garden Market from James Street* 272; *The Dancing Platform at Cremorne Gardens* 272, **328**

Lévy-Dhurmer, Lucien 447

Lewis, John Frederick (1805–76) 102, 103–5, 116; *A Frank Encampment in the Desert of Mount Sinai, 1842* 103, **114**

Leyland, Frederick 60, 112, 442

Leys, Baron 59

Lhotsky, Dr John 421

Lind, Jenny (1820–87) 361, 378

Lindsay, Sir Coutts (1824–1913) 111, 451–3, 473

Linnell, John (1792–1882) 66, 119, 423; *George Rennie* 66, **63**

Liverpool Academy 38

Liverpool Exhibition 169–70

Livingstone, David (1813–73) 415, 435–7

Lloyd, Marie (1870–1922) 490

Logsdail, William (1859–1944) 497–8; *Piazza of St Mark's, Venice* 143–4, **171**; *St Martin-in-the-Fields* 144, 497, **621**

London, Jack (1876–1916) 492

London Art Union 260

London International Exhibition (1862) 31–2

London School 37

Long, Edwin (1829–91) 28, 297–8; *The Babylonian Marriage Market* 297–8, **358**

Lord's Day Observance Society 36

Loudon, J.C. (1783–1843) 154

Louis, Prince of Hesse 371

Louis Philippe, King of France (1773–1850) 66

Luard, John Dalbiac (1830–60), *The Welcome Arrival* 361–2, **440**

Luks, George 410

M

Maas, Jeremy 266–7

McAdam, John (1756–1836) 19, 219

Macchiaioli 408, 485

MacColl, Dugald Sutherland 41, 494

McConnell, William 270

McCubbin, Frederick (1855–1917) 423, 424; *Bush Burial* 423; *Down on his Luck* 423, **513**, **530**; *The Lost Child* 423

MacDuff, William (fl.1844–66), *Shaftesbury, or Lost and Found* 335, **405**

Mackenzie, Frederick (1787–1854), *The National Gallery when at Mr J.J. Angerstein's House, Pall Mall* 26, **21**

McKim, Charles 63

Mackintosh, Charles Rennie (1868–1928) 489; *The Harvest Moon* 489, **604**

Maclise, Daniel (1806–70) 33, 46, 71, 197, 205, 264; *Charles Dickens* 73, **72**; *The Death of Nelson at Trafalgar* 49; *The Meeting of Wellington and Blücher at Waterloo* 49, **33**, **40**; *Priscilla Horton as Ariel* 193–4, **232**; *Sir Francis Sykes and Family* 71, **70**; *Undine and the Wood Demon* 194, **235**

Macready, William (1793–1873) 159, 193, 198, 282

McTaggart, William (1835–1910) 37, 482; *The Storm* 482, **598**

magazines 183, 330, 336–7, 489

Mallarmé, Stéphane (1842–98) 474, 485

Malory, Sir Thomas (d.1471) 50, 51, 63

Manchester 31

Manchester Town Hall 58–9

Mancini, Antonio (1850–1930) 89

Manet, Edouard (1832–83) 91, 226, 274, 402, 464, 465, 480, 485, 494, 498; *Déjeuner sur l'herbe* 288

Manning, Cardinal (1808–92) 78, **84**

Mantegna, Andrea (1431–1506), *Madonna della Vittoria* 454–6

Mantell, Dr Gideon 160

Mappin Art Gallery, Sheffield 36

marine landscapes 97–9

Marks, Henry Stacy (1829–98) 224; *A Select Committee* 224, **271**

Marryat, Captain

Louis, Prince of Hesse 371

(1792–1848) 144

Marshall, Ben (1768–1835) 212, 215, 216, 260; *Anti-Gallican* 212, **256**

Martens, Conrad (1801–78) 416; *Sydney Harbour Looking towards the North End* 416, **517**

Martin, Albin (1813–88) 423; *Maoris Returning from Fishing* 423, **528**

Martin, John (1789–1854) 156, 157, 159–60, 281, 331, 395; *The Assuaging of the Waters* 161, **190**; *Belshazzar's Feast* 159, 160, **179**, **188**; *The Coronation of Queen Victoria* 160; *The Country of the Iguanodon* 160; *The Deluge* 161; *The Eve of the Deluge* 161; *The Fall of Nineveh* 159

Martineau, Robert Braithwaite (1826–69), *Kit's First Writing Lesson* 131, 250, **307**; *The Last Chapter* 374, **459**; *The Last Day in the Old Home* 250, 360, **436**

Mason, George Heming (1818–72) 111–12; *Harvest Moon* 112, **125**; *Ploughing in the Campagna* 111–12

Maugham, W. Somerset (1874–1965) 492

May, Phil (1864–1903) 89, 492

Mayhew, Henry (1812–87) 132, 137, 329–30

Meilhac, Henri (1831–97) 473

Meinhold, Wilhelm 254

Melbourne, Lord (1779–1848) 66, 218

Melville, Arthur (1855–1904) 489; *The Little Bullfight: 'Bravo Toro'* 489, **605**

Melville, Harden S. (fl.1837–79) *News from the Diggings* 355; *The Squatter's Hut* 355, **432**

Menpes, Mortimer (1860–1938) 479, 480; *Flower of the Tea* 480, **591**

Merritt, Anna Lea (1844–1930) 319; *Love Locked Out* 319, **385**

Merritt, Henry 319

'Merry Cardinal' pictures 144

Mesdag, Hendrik (1831–1915), *Panorama of Scheveningen* 166

Metropolitan Drinking Fountain and Cattle Trough Association 135

Meux, Lady 84, **88**

Micas, Nathalie (1824–89) 319–20; *The Horse Fair* 320, **386**

Michelangelo (1475–1564) 20, 38

Middle East 102–5

Middlemore, Sir John 41

military paintings 322–3

Mill, John Stuart (1806–73) 378

Millais, Effie 74–6, 232, 247, 248

Millais, Sir John Everett

(1829–96) 34, 38, 71, 74–6, 86, 133, 178–80, 203, 204–5, 228, 232, 235, 237–8, 243, 247–8, 249, 277, 308, 311, 313, 335, 337, 440, 465, 473, 488, **92**; *Autumn Leaves* 248; *The Blind Girl* 132, 139, 247–8, **299**; *The Boyhood of Raleigh* 180, **212**; *Bubbles* 180, 269, **214**; *Cherry Ripe* 180; *Christ in the House of His Parents* 67, 237–8, **286**; *Ferdinand Lured by Ariel* 205, **247**; *Isabella* 235, **283**; *John Ruskin* 74, **31**; *The Knight Errant* 503; *Mrs James Wyatt Jnr and her Daughter* 76, **77**; *My First Sermon* 178, 210; *My Second Sermon* 178–80, **211**; *Ophelia* 243, 369, 447, 459, **281**, **293**; *The Order of Release* 247; *The Princes in the Tower* 180, 154; *The Return of the Dove to the Ark* 238, 313, **287**; *A Waterfall in Glenfinlas* 247
Miller, Annie 249
Millet, Jean-François (1814–75) 328; *The Angelus* 331
Milton, John (1608–74) 47
miniatures 66
Mitchell, Robert, *Section of the Rotunda, Leicester Square* 152, **181**
Molière (1622–73) 12, 129, 131, 258
Monet, Claude (1840–1926) 423, 464, 467, 470, 474, 475, 480, 482–5, 498; *Charing Cross Bridge* 485, **600**; *Lavacourt under Snow* 485
Moore, Albert (1841–93) 58, 284, 294–7, 408, 442, 453, 488; *Azaleas* 297, **354**; *Dreamers* 448, **565**; *The Loves of the Winds and the Seasons* 294, 450, **566**; *Midsummer* 448, **564**; *A Venus* 297, **356**; *A Wardrobe* 297, **355**
Moore, George Augustus (1853–1933) 89, 91, 170, 188, 485, 490–2, **98**
Moreau, Gustave (1826–98), *L'Apparition* 453
Morgan, John (1822–85), *A Winter Landscape with Boys Snowballing* 186, **222**
Morisot, Berthe (1841–95) 467; *Isle of Wight* 467, **582**
Morland, George (1762/3–1804) 26, 96, 173, 308, 384
Morris, Jane 76, 253, 254, 441, 445–7
Morris, May 76–8
Morris, William (1834–96) 51, 78, 250, 253, 299, 407, 441, 488; *Queen Guenevere* 253, **312**; *St George's Cabinet* 253, **314**
Morris and Company 456
Morrison, Arthur 492
Morton, W. Scott 266
Moser, Mary (1744–1819) 9, 307

Mount, William Sidney (1807–68), *Cider Making* 399, **493**
Müller, William James (1812–45) 102; *The Ramesseum at Thebes, Sunset* 102, **113**
Mulready, Augustus Edwin (1843–1904), *Remembering Joys that are Passed Away* 186, **223**
Mulready, William (1786–1863) 12, 173, 178, 282, 329; *The Bathers* 282; *Bathers Surprised* 282, **337**; *Choosing the Wedding Gown* 131, **151**; *An Interior Including a Portrait of John Sheepshanks* 23; *The Last In* 147; *The Lesson* 173; *The Sailing Match* 173, **203**; *The Sonnet* 369, **451**
Munnings, Alfred (1878–1959) 498–501; *The Norwich School of Art Painting Room* 498, **619**; *Stranded* 189, 498, **623**
mural painting 43–63
Murger, Henri (1822–61) 464, 494
museums 41
music halls 490
Muybridge, Eadweard (1830–1904) 222

N

Nabis 344, 482
Napoleon III, Emperor (1808–73) 246, 288
Nash, Joseph (1808–78) 119; *The Porch at Montacute House, Somerset* 119, **136**
National Gallery 25, 26–7, 29, 37
National Portrait Gallery 37, 77
National Sunday League 36
Nazarenes 44–5, 232, 238
Nelson, Admiral (1758–1805) 153
Neoclassicism 392, 395
Nettlefold, J.H. 41
Neville, John 502
New English Art Club 301, 476, 481–2, 485, 488
New Gallery 488
New Grafton Gallery 502
New Society of Painters in Water Colours 35–6, 114 441–2, **30**
New Zealand 416, 420, 421–3
Newlyn School 325, 332, 338, 344–5, 482
Newman, Cardinal (1801–90) 76
News of the World 257
Newton, Kathleen 84, 359, 387
Nicholson, Ben (1894–1982) 503
Nicholson, William (1872–1949) 495–7, 503; *Don Quixote* 497, **614**
Nicol, Erskine (1825–1904), *The Emigrants* 352, **430**

Nightingale, Florence (1820–1910) 362, **441**
'Nimrod' (C.J. Apperley) 218
9 x 5 exhibition group 425–7
North, John William (1842–1924), *A Gypsy Encampment* 125, 336, **146**
North, Marianne (1830–84) 325, **392**
Northbrook, Lord 431
Norton, Caroline 374
nudes 280–301, 311

O

O'Brien, Lucius (1832–99), *A British Columbian Forest* 431, **542**
oil paintings 93–114
Old Bond Street Gallery 445
Old Water Colour Society *see* Society of Painters in Water Colours
O'Neil, Henry Nelson (1817–80), *Eastward Ho! August, 1857* 362–3, **425**, **442**; *Home Again* 363–4; *The Last Moments of Raphael* 143, **168**
O'Neill, George Bernard (1828–1917), *Public Opinion* 32, **26**
Orchardson, Sir William Quiller (1832–1910) 37, 388; *The First Cloud* 388; *Mariage de Convenance* 388, 481; *Mariage de Convenance – After!* 388, **482**; *Master Baby* 170, **199**; *On Board HMS Bellerophon* 147, **178**
Orpen, Sir William (1878–1931) 301; *A Bloomsbury Family* 503, **626**
Orwell, George (1903–50) 216
Osborne, Walter (1859–1903), *Apple Gathering, Quimperlé* 482, **596**
Ostade, Adriaen van (1610–84) 10, 12, 128
Otway, Thomas (1652–85) 159
Overbeck, Johann Friedrich (1789–1869) 238
Ovid 285
Oxford Movement 237
Oxford Union 50–1, 246, 253, **44**

P

Palgrave, Francis (1788–1861) 132
Palmer, Samuel (1805–81) 20, 66, 74, 119, 419, 423; *Ancient Rome* 119; *Coming from Evening Church* 20, **15**; *Going to Sea* 119, **137**; *Modern Rome* 119
Palmer, T.A. 374
Palmerston, Lord (1784–1865) 77, 218, 415
panoramas 151–67
Paris 464–5
Paris Salon 288
Parnell, Charles Stewart (1846–91) 349
Parrott, William (1813–89)

23; *J.M.W. Turner at the Royal Academy, Varnishing Day* **19**
Parry, John, *London Street Scene (Billposting)* 494, **611**
Pater, Walter (1839–94) 39, 299, 442, 485, 503
Patmore, Coventry (1823–96) 238, 377
Paton, Sir Joseph Noel (1821–1901) 33, 203–4, 205; *The Fairy Raid* 203–4, 205, **229**, **245**; *The Man with the Muck Rake* 204; *The Quarrel of Oberon and Titania* 203; *The Reconciliation of Oberon and Titania* 203, **244**
patrons 27–9
Pattle sisters 77
Payne, Henry Arthur (1868–1940), *Plucking the Red and White Roses in the Old Temple Garden* 63, **58**
Pears Annual 148
Pears Soap 180
Peel, Sir Robert (1788–1850) 26, 29
Pellegrini, Carlo (1839–89) 73
Penny, Edward (1714–91) 26
Pepys, Samuel (1633–1703) 129
Perrault, Charles (1628–1703) 456
Pettie, John (1839–93) 146–7; *Peveril of the Peak* 146; *Two Strings to her Bow* 147, **176**
Philippoteaux, Félix, *La Charge des Cuirassiers Français à Waterloo* 322
Philippoteaux, Paul, *Battle of Atlanta* 166; *The Battle of Gettysburg* 165–6, **196**; *Niagara Falls* 166; *The Siege of Paris* 166
Phillip, John (1817–67) 198, 199, 222
'Phiz' (Hablot K. Browne, 1815–82) 131
photography 53–4, 58, 66, 77–8, 147–8, 222, 226, 264, 266, 361, 400, 448
Picasso, Pablo (1881–1973) 311–13, 489, 498, 502
Pinero, Sir Arthur Wing (1855–1934) 388
Pinwell, George John (1842–75) 125; *King Pippin* 125, **144**
Piombo, Sebastiano del (1485–1547), *The Raising of Lazarus* 62
Pissarro, Camille (1830–1903) 226, 424, 463, 467, 485
Pissarro, Lucien (1863–1944) 485
plein-air painting 186, 411, 423, 465, 476, 482
Poe, Edgar Allan (1809–49) 395
Pollard, James (1792–1867) 220, 221; *The Royal Mail Coaches for the North Leaving the Angel, Islington* 220, **265**; *A Street Scene with Two Omnibuses* 220, **266**
Pont-Aven 482
Poole, Paul Falconer

(1807–79) 378; *The Emigrant's Departure* 352, **431**
portrait painting 11–12, 65–91, 407
Post-Impressionism 404, 502
posters 494–7, 498
pot lids 147–8
Potter, Beatrix (1866–1943) 325; *Fly Agaric* 325, **391**
Potter, Paulus (1625–54) 222
Poussin, Nicolas (1594–1665) 163
Powers, Hiram (1805–73), *Greek Slave* 284, **340**
Poynter, Sir Edward (1836–1919) 37, 41, 51, 53, 58, 59, 133, 288–91, 297, 464; *The Catapult* 291, **349**; *The Cave of the Storm Nymphs* 291, **351**; *Faithful unto Death* 291; *The Four Quarters of the Globe Bringing Offerings to Britain* 53; *Israel in Egypt* 291; *Peacock Frieze* 53, **45**; *A Visit to Aesculapius* 288, **348**
Pratt, Messrs F. & R. 147
Pratt, Samuel 71
Pre-Raphaelite Brotherhood 39, 44, 50, 76, 109, 120, 132, 182, 192, 203, 231–54, 311–13, 364, 380–3, 407–8, 439–59, 489
Price, William Lake 119
Prinsep, Sara 77
Prinsep, Val (1838–1904) 51
prints 147–8
'problem pictures' 375
Proudhon, Pierre Joseph (1809–65) 327
Prout, John Skinner (1805–76) 419, 420; *Ancanthe, Lady Franklin's Museum, Van Diemen's Land* 419, **525**; *A Voyage to Australia* 163, 419
Prout, Samuel (1783–1852) 115, 120, 219; *C'a d'Oro, Venice* 115, **131**
Pryde, James (1866–1941) 495–7; *Don Quixote* 497, **614**
Puccini, Giacomo (1858–1924) 464
Pugin, A.C. 156
Pugin, Augustus Welby Northmore (1812–52) 44, 395
Punch 49, 154, 193, 330
Puvis de Chavannes, Pierre (1824–98) 62
Pyne, James Baker (1800–70) 96; *Isola Bella, Lago Maggiore* 96, **104**

R

Rackham, Arthur (1867–1939) 207
Ragged School Union 335
railway travel 266–9
Raimondi, Marcantonio (c.1488–1534) 288
Raphael 20, 29, 44, 45, 76, 232, 280, **168**; *Judgement of Paris* 288
Realism *see* Social Realism

Redesdale, Lord 485
Redgrave, Richard (1804–88) 37, 51, 106–9, 129, 281, 282, 284, 328, 378–80; *Donatello* **46**; *The Emigrant's Last Sight of Home* 359, **435**; *Going into Service* 380, **467**; *The Governess* 378, **466**; *The Outcast* 378; *The Poor Teacher* 378; *The Sempstress* 329, 378, **465**; *The Valleys also Stand Thick with Corn: Psalm LXV* 109, **120**
Redgrave, Samuel 129, 282
Reform Bill (1832) 23, 27
Regent's Park Colosseum 154, **182**
Reid, George (1860–1947) 56; *Hail to the Pioneers* **49**
Reinhart, Benjamin Franklin (1829–85) 399
Rembrandt (1606–69) 193; *The Anatomy Lesson of Doctor Tulp* 403
Remington, Frederick (1861–1909) 399; *A Dash for the Timber* 399, **492**
Rennie, George 66, **63**
Renoir, Pierre Auguste (1841–1919) 188, 470, 498
Retzsch, Moritz (1779–1857) 193
Reynolds, Sir Joshua 9–10, 11, 15, 20, 26, 192, 232, 392, 467, **16**; *Portrait of the Artist* **3**
Reynolds-Stephens, William (1862–1943), *Summer* 62
Rhodes, Cecil (1853–1902) 413, 488
Ribera, Jusepe de (1588–1656) 403
Richardson, H.H. (1838–86) 342
Richardson, Samuel (1689–1761) 137
Richardson, Thomas Miles Jnr (1813–90) 119–20; *Ben Muich-Dhui* 119; *The Entrance to the Pass of the Awe, Argyllshire* 119; *The Pass of Glencoe from Rannoch Moor* 119, **138**
Richmond, George (1808–96) 74, 294; *Lord Salisbury* 74, **75**
Richmond, William Blake 58
Richter, H.C. 420
Richter, Ludwig (1803–84) 193
Ricketts, Charles 497, **616**
Ridley, Matthew 343
Rimbaud, Arthur (1854–91) 485
Ritchie, John (fl.1855–75), *A Border Fair* 269; *A Summer Day in Hyde Park* 269; *A Winter's Day in St James's Park* 186, 269, **324**
Rivière, Briton (1840–1920) 28, 148; *Sympathy* 228, **280**
Rizzoni, Alexandre 144
Roberts, David (1796–1864) 102, 103, 115, 116, 156–7, 194, 197, 199; *The Gate of Metwaley, Cairo* 103, **115**; *The Israelites Leaving Egypt* 157, 159–60, **186**

Roberts, Tom (1856–1931) 423–4, 425–7; *Allegro con brio: Bourke Street* 424, **531**; *A Breakaway!* 424, **532**; *Shearing the Rams* 424

Robertson, Walford Graham (1866–1948) 89, 443, 453, **95**

Roman Catholic Church 237

Romantic movement 192, 215, 328

Romney, George (1734–1802) 192

Rosa, Salvator (1615–73) 416, 421

Ross, Sir William Charles (1794–1860) 46, 66; *Prince Ernest and Prince Edward of Leiningen* 66, **62**

Rossetti, Christina 206, 235, 248, 249, 355

Rossetti, Dante Gabriel (1828–82) 38–9, 49, 50–1, 76–8, 122, 232, 238–41, 243–6, 248–9, 253, 254, 284–5, 311–13, 315, 335, 380–2, 383, 407, 440–1, 442, 445, 450, 451–3, 464, 467, 480, 488, **79**; *Beata Beatrix* 254, 441, **313**; *Bocca Baciata* 249, **300**; *Dante's Dream at the Time of the Death of Beatrice* 441, **553**; *The Day Dream* 445–7, **561**; *Ecce Ancilla Domini* 237, 243, **285**; *The First Anniversary of the Death of Beatrice* 248; *Found* 238, 382, 383, **471**; *The Gate of Memory* 382, **472**; *G.F. Boyce and Fanny Cornforth* **474**; *La Ghirlandata* 76–8, **80**; *The Girlhood of Mary Virgin* 235, **282**; *Helen of Troy* 249, **302**; *How They Met Themselves* 243, **294**; *Ligea Siren* 285; *La Pia de' Tolomei* 441, **552**; *Regina Cordium* 249, 254, **301**; *Scenes from Malory's 'Morte d'Arthur'* 51, **44**; *Venus Verticordia* 285, **344**

Rossetti, William Michael (1829–1919) 77, 231, 232, 407, **81**

Rossiter, Charles (1827–after 1890), *To Brighton and Back for 3s. 6d.* 269, **323**

Rothenstein, William (1872–1945) 497; *Coster Girls* 492, **609**

Rousseau, Le Douanier (1844–1910) 228

Rousseau, Jean-Jacques (1712–78) 26, 427

Rousseau, Théodore (1812–67) 328

Roussel, Théodore (1847–1926) 479, 485; *Blue Thames, End of a Summer Afternoon, Chelsea* 479, **589**

Rowe, William, *Puss in Boots* **43**

Rowlandson, Thomas (1756–1827) 421

Royal Academy 7, 9, 12, 20, 26, 27, 32–5, 38, 39–40, 41, 60–2, 114, 143, 147, 161, 194, 218–19, 258–9, 277, 307, 405, 441, 442, 450, 488–9, **20**, **29**, **32**

Royal Academy Schools 38, 291, 298, 311

Royal Exchange 62

Royal Holloway College 28, 267, 298

Royal Institute of Oil Painters 315

Royal London Panorama 165

Royal Manchester Institute 38

Royal Watercolour Society 315

Rubens, Peter Paul (1577–1640) 111, 215, 456

Ruland, Dr Carl 29

Ruskin, John (1819–1900) 23, 27, 37, 38–9, 50, 51, 56, 74, 86, 93–4, 97–9, 100, 102, 103–5, 106, 111, 114–16, 119–20, 122, 125, 139, 159, 163, 173, 193, 228, 232, 235, 238, 243, 247, 250, 253, 261, 282, 285, 297, 300, 305, 313, 315, 316, 322, 329, 361, 377, 378, 382, 383, 405, 407, 453, 470–4, 487–8, 503, **31**, **603**; *Coast Scene near Dunbar* 115, **130**; *Self-Portrait* 74, **78**; *Study of Gneiss Rock at Glenfinlas* 247, **298**

Ruskin, John James (1785–1864) 27, 115

Russell, John (1858–1930) 423, 424

Russell, Lord John 218, 415

Russell, William Howard 361, 362

Rutland, Duke of 216

Ruxton, Captain Augustus 407

Ryder, Albert Pinkham (1847–1917) 409; *Toilers of the Sea* 409, **508**

S

Sadler, Walter Dendy (1854–1923), *Friday* 144, **172**; *Thursday* 144

St-Gaudens, Augustus (1848–1907) 62

St Ives 344

St John's Wood Clique 144–6, 182

Sala, George Augustus (1828–96) 269–70

Salisbury, Lord 74, 349–51, **75**

Salviati, Antonio (1816–90) 51

Sandys, Frederick (1829–1904) 299, 442–3; *Medea* 443, **557**

Sargent, John Singer (1856–1925) 62–3, 86–9, 404, 406–7, 476, 482–5, 503; *Carnation, Lily, Lily, Rose* 89, 186–8, **225**; *Claude Monet Painting at the Edge of a Wood* 485; *Ellen Terry as Lady Macbeth* 89, **60**, **94**; *Garden Study of the Vickers Children* 186–8, **226**; *Gassed* 406; *El Jaleo* 406, **504**;

Madame Gautreau 89, 407, **93**; *Paul Helleu Sketching with his Wife* 485, **580**, **599**; *Walford Graham Robertson* 89, **95**

Sartoris, May 83, **86**

Sass's Academy 33

Savage Club 198

Scharf, George (1788–1860), *Interior of the Gallery of the New Society of Painters in Water Colours, Old Bond Street* 35, **30**

Scheffer, Ary (1795–1858) 285

Schlegel, August Wilhelm von (1767–1845) 192

Schwindt, Moritz von (1804–71) 193

Scotland 119, 351, 482

Scott, David (1806–49) 56; *Puck Fleeing before the Dawn* 194, **234**

Scott, Sir Walter (1771–1832) 19, 23, 71, 119, 129, 131, 146, 192

Scott, William Bell (1811–90) 56, 235, 382, 440; *The Death of the Venerable Bede* 56; *A Descent of the Danes* 56; *The Free North Britons Surprising the Roman Wall between the Tyne and Solway* 56; *Grace Darling and her Father Saving the Shipwrecked Crew* 56; *Iron and Coal* 56–8, **51**; *The Romans Cause a Wall to be Built for the Protection of the South* 56, **50**

Scottish Academy 38

seaside paintings 258–60

Seddon, Thomas (1821–56) 246

Selous, Henry Courtnay, *The Opening Ceremony of the Great Exhibition, 1 May 1851* 30, **24**

Sewell, Anna (1820–78) 224, 342

Shaftesbury, 7th Earl of (1801–85) 177, 335

Shakespeare, William (1564–1616) 12, 46, 47, 111, 129, 155, 159, 192, 193–7, 198, 205, 232, 238, 241

Shakespeare Gallery 192

Shannon, Charles Hazelwood 497, **616**; *Pearl Fishers* 497, **617**

Sharples, Rolinda (1793–1838) 306; *The Artist and her Mother* 306, **368**

Shaw, George Bernard (1856–1950) 389

Shayer, William (1788–1865) 96–7; *The Village Festival* 97, **105**

Shee, Sir Martin Archer (1770–1850) 11, 65

Sheepshanks, John (1787–1863) 29, 37, 131, 132, 378, **23**

Shepherd, Thomas Hosmer (fl.1813–58), *The Regent Street Panorama* 163, **191**

Shields, Frederic James (1833–1911) 58; *Factory Girls at the Old Clothes Fair,*

Knott Mill, Manchester 384–7, **478**

Shillibeer, George 220

Shinn, Everett (1876–1953), *The London Hippodrome* 490, **607**

Shoe Black Brigade 335

Sickert, Walter Richard (1860–1942) 89–91, 170, 188, 291, 301, 474, 476–80, 482, 485, 497, 502; *Aubrey Beardsley* 91, **99**; *Bathers, Dieppe* 497, **620**; *The Gallery of the Old Bedford* 490, **602**, **608**; *Gatti's Hungerford Palace of Varieties* 477–9, 490, **588**; *George Moore* 91, **98**

Siddal, Elizabeth (1829–62) 76, 232, 238, 243, 248, 249, 250, 253, 254, 313, 380; *A Lady Affixing a Pennant to a Knight's Spear* 313, **375**; *Pippa Passing Close to Loose Women* 367, **448**

Signorini, Telemacho (1835–1901), *Leith* 485, **601**

Simmons, John (1823–76) 194; *Titania* **238**

Simpson, W.B. and Sons 51

Simpson, William (1823–99) 361; *Commissariat in Difficulties* 361, **439**

Sisley, Alfred (1839–99) 423, 468–70; *Cardiff Roadsteads* 470, **584**; *Regattas at Molesey* **583**

Sitwell, Sir Osbert (1892–1969) 86

Sketching Society 143

Slade, Felix (1790–1868) 37

Slade School of Fine Art 37–8, 311, 490

'The Slashing School' 89

sleep, paintings of 447, 448–50

Sloane, John 410

Small, William (1843–1929) 343; *The Good Samaritan* 338, **409**

Smallfield, Frederick (1829–1915), *Early Lovers* 369, **450**

Smart, Jon 431

Smiles, Samuel (1812–1904) 27

Smirke, Sir Robert (1781–1867) 269

Smith, Albert, *Overland Mail* 165, **195**

Smollett, Tobias (1721–71) 129

Snyders, Frans (1579–1657) 19, 215

Soane, Sir John (1753–1837) 27

Social Realism 137, 327–45, 404

Society of Arts 282

Society of British Artists 475–6, 482

Society of Painters in Water Colours (Old Water Colour Society) 35–6, 43, 114–16, 122, 416, 441–2

Society for the Sons of St George 391

Society of Women Artists 38

Soden, John 34–5

Solomon, Abraham (1823–62) 313; *Acquitted* 139; *Brighton Front* 260, **318**; *Drowned! Drowned!* 380; *First Class – The Meeting* 139, **165**; *The Flight from Lucknow* 363, **443**; *Second Class – The Parting* 139, 352, **429**; *Waiting for the Verdict* 139, **166**

Solomon, Rebecca (1832–86) 313; *The Wounded Dove* 313, 368, **377**

Solomon, Simeon (1840–1905) 39, 133, 288, 299, 313, 408, 439, 440–1, 442, 445, 447; *Bacchus* (oil) 442, **554**; *Bacchus* (watercolour) 299, **359**; *Love in Autumn* 299, **360**; *Sacramentum Amoris* 442

Spear, Ruskin (1911–90) 91

Speed, Harold (1872–1957), *Autumn* 62, **55**

Spenser, Edmund (c.1552–99) 207

sporting paintings 209–11, 215–22, 226–8

sporting prints 147–8

'Spy' (Leslie Ward 1851–1922) 73, 308; *Anthony Trollope* 73, **74**

Stanfield, Clarkson (1793–1867) 33, 46, 97–9, 116, 156, 157–9, 194, 199; *The City of York with the Cathedral on Fire* 157; *The Military Pass of the Simplon* 157; *On the Dogger Bank* 97–9, **100**, **109**; *Venice: The Dogana and Salute* 159, **187**; *Venice and its Adjacent Islands* 157–9

Stanford, Leland (1824–93) 221

Stanhope, John Roddam Spencer (1829–1908) 51, 315, 451, 454; *Thoughts of the Past* 383, **473**; *The Waters of Lethe by the Plains of Elysium* 447–8, **560**

Stanley, H.M. (1841–1904) 437

Starr, Sidney (1857–1925) 479, 485; *The City Atlas* 480, **590**

Steen, Jan (1626–79) 127

Steer, Philip Wilson (1860–1942) 188, 476, 481–2, 485, 502; *Children Paddling, Walberswick* 188, 481–2, **228**; *A Summer's Evening* 301, **365**

Steinle, Baron 285

Steinlen, Théophile-Alexandre (1859–1923) 492

Stephanoff, James, *The Virtuoso* 280, **335**

Stephens, Frederick George (1828–1907) 232, 246, 249, 250; *Morte d'Arthur* 250; *Mother and Child* 250, **305**

Stephenson, Robert 58

Sterne, Laurence (1713–68) 12, 129, 131, 258

Stevens, Alfred (1818–75) 74, 475; *Mrs Mary Ann Collmann* 74, **76**

Stevens, Frederick William 432

Stillman, Marie (1844–1927) 313–15; *Cloister Lilies* 313; *Messer Ansaldo Showing Madonna Dianova his Enchanted Garden* 313, **376**

Stillman, W.J. 313

Stokes, Marianne (1855–1927) 325; *The Passing Train* 325, **393**

Stone, Frank, *Cross Purposes* 383

Storey, George Adolphus (1834–1919), *Orphans* 182, **217**

Stott, William, of Oldham (1857–1900), *The Bathers* 475; *The Ferry* 475; *A Summer's Day* 475, **587**

Strang, William (1859–1921), *Bank Holiday* 502, **625**

Street, G.E. (1824–81) 59

Streeton, Sir Arthur (1867–1943) 423, 424–7; *Fire's On* 425, **533**

Strudwick, John Melhuish (1849–1937) 454; *Isabella* 454, **568**

Strutt, William (1825–1915) 420; *Black Thursday* 420, **526**; *Bushrangers on the St Kilda Road* 420

Stuart, Gilbert 391

Stubbs, George (1724–1806) 221, 222

Studio magazine 345, 489

Sullivan, Sir Arthur (1842–1900) 274

Sully, Thomas (1783–1872) 391–2; *Queen Victoria* 391–2, **485**

Surtees, R.S. (1803–64) 219–20

Swan, John Macallan (1847–1910) 224–6, 300, 301; *Orpheus* 226, 301, **364**

Swayne, George C. 297

Swift, Jonathan (1667–1745) 192, 216

Swinburne, Algernon Charles (1837–1909) 39, 284–5, 288, 297, 325, 383, 440, 443, 445

Sykes, Sir Francis 71, **70**

Symbolism 254, 325, 405, 408–9, 440, 447, 448, 489

T

Taglioni, Maria (1804–86) 66, 193, 194, 368, **231**

Taine, Hippolyte (1828–93) 261

Tasmania 416–19

Tate, Sir Henry (1819–99) 40, 41, 338

Tate Gallery 29, 41

Telford, Thomas (1757–1834) 19, 219

temperance movement 135–7

Teniers, David (1610–90) 10, 12, 127

Tenniel, John (1820–1914) 47–9, 51; *A Song for Saint Cecilia's Day* 49, **38**

Tennyson, Alfred, Lord (1809–92) 50, 63, 78–83, 232, 246, 250, 319, 362,

456–9, 488, **82–3**
Terry, Ellen (1848–1928) 78, 89, 277, **60**, **85**, **94**
Thackeray, William Makepeace (1811–63) 38, 102, 129, 131, 163, 282, 503
Thayer, Abbott Handerson (1849–1921) 408–9; *Angel Seated on a Rock* 409, **507**
Thomas, William Luson 336
Thompson, Francis (1859–1907) 331
Thompson, Margaret, *Puss in Boots* **43**
Thurtell, John 264
Tiffany, Louis Comfort (1848–1933) 408
The Times 237–8, 291, 362
Tissot, James (1836–1902) 84–6, 274–7, 359–60, 453, 464, 467–8, 473, 480, 490; *The Ball on Shipboard* 274, 467, **332**; *Colonel Burnaby* 84–6, **89**; *The Convalescent* 387; *Good-bye – On the Mersey* 359, **437**; *Hush (The Concert)* 274–7, 467, **333**; *The Last Evening* 387; *October* 387, **479**
Titian (c.1488–1576) **167**
Tolstoy, Leo (1828–1910) 74
Tonks, Henry (1862–1937) 38, 489; *The Hat Shop* 489–90, **606**
Toorop, Jan (1858–1928) 447
Toulouse-Lautrec, Henri de (1864–1901) 492, 495
Traquair, Phoebe (1852–1936) 62; *Suffer the Little Children* 62, 319, **57**
travel 266–9
Trevelyan, G.M. 226
Trevelyan, Lady Pauline 56
Trevelyan, Sir Walter 56
Trollope, Anthony (1815–82) 73, 251, 273, 277, **74**
Tuke, Henry Scott (1858–1929) 300–1, 475, 482; *Ruby, Gold and Malachite* 300, **362**
Turner, Joseph Mallord William (1775–1851) 23, 35, 38, 44, 94–6, 97, 115–16, 119, 125, 163, 313, 395, 410, 463, 467, 473, **19**; *The Burning of the Houses of Parliament* 23, **18**; *The Dark Rigi* 116, **132**; *The Fighting Temeraire Tugged to her Last Berth to be Broken up* 94, **101**; *Rain, Steam and Speed* 96, **103**; *Snowstorm – Steam Boat off a Harbour's Mouth* 94, **102**
Tusser, Thomas (c.1520–c.1580) 111
Twain, Mark (1835–1910) 400

U

United States of America 391–411
Uwins, Thomas (1782–1857) 27, 46, 143; *Brigands Capturing English Travellers* 143; *Haymakers at Dinner* 137, **163**; *An Italian Mother Teaching her Child the Tarantella* 143, **169**; *A Neapolitan Boy Decorating the Head of his Inamorata* 143; *A Neapolitan Saint Manufactory* 143; *Nuns Taking the Veil* 143

V

Van Gogh, Vincent (1853–90) 7, 125, 331, 342–4, 423, 480; *At Eternity's Gate* 344; *Gauguin's Chair* 344, **419**; *The Potato Eaters* 343
Vanderlyn, John (1775–1852), *Panorama of Versailles* 167, **197**
Vanity Fair 73
Varley, John (1778–1842) 66, 116
Vedder, Elihu (1836–1923) 408; *The Sphinx of the Seashore* 408, **505**
Velázquez, Diego de Silva y (1599–1660) 12, 71, 89, 403, 465
Venice 119
Verdi, Giuseppe (1813–1901) 387
Verlaine, Paul (1844–96) 485
Vernet, Horace (1789–1863) 219, 322, 420
Vernon, Robert (1774–1849) 27
Vibert, Jean-François (1840–1907) 144
Victoria, Queen (1819–1901) 7, 17, 29, 32, 65–71, 119, 155, 193, 194, 197, 204, 207, 212–15, 218, 221, 224, 259–60, 265, 272, 282, 320, 322, 338, 362, 368, 369, 370–1, 391–2, 413, 415, 431, 475, 487, **1**, **65**, **67–9**, **71**, **449**, **485**; *The Royal Family at Osborne House* 66
Victoria and Albert Museum 36, 37, 53
Vigeland, Gustav (1869–1943) 489
Virgil 279, 280

W

Waagen, Gustav Friedrich (1794–1868) 31, 159
Wagner, Richard (1813–83) 63, 86
Wainewright, Thomas Griffiths (1796–1847) 416; *The Cutmear Twins: Jane and Lucy* 416, **518**
Walker, Frederick (1840–75) 125, 300, 442; *The Bathers* 300, **363**; *The Harbour of Refuge* 340, **413**; *Spring* 125, **143**; *The Vagrants* 336, **406**; *The Woman in White* 494, **612**
Wallace Collection 31
Wallington House, Northumberland 56–8
Wallis, Henry (1830–1916) 20; *Chatterton* 251, **310**; *The Stonebreaker* 251–3, **311**

Walton, Frank (1840–1928), *The Lawn at Goodwood* 274, **331**
Ward, Edward Matthew (1816–79) 47, 198, 258, 308; *Hogarth's Studio in 1739* 128–9, 182, **148**
Ward, Henrietta (1832–1923) 38, 308; *Palissy the Potter* 308, **372**
Ward, James (1769–1859) 215, 308; *Napoleon's Horse, Marengo, at Waterloo* 215, **259**
Ward, Dr Nathaniel (1791–1868) 421
wars 361–4, 437
watercolours 35–6, 93–4, 114–25
Waterford, Lady Louisa Stuart (1811–91) 315; *Christ among the Doctors* 315; *Suffer the Little Children to Come unto Me* 315, **381**
Waterhouse, Alfred (1830–1905) 58
Waterhouse, John William (1849–1917) 459; *La Belle Dame sans Merci* 459, **576**; *Hylas and the Nymphs* 459, **577**; *The Lady of Shalott* 369, 447, 459, **551**, **575**; *Lamia* 503; *The Mermaid* 301, **366**; *Nymphs Finding the Head of Orpheus* 459; *The Siren* 301
Watson, Homer (1855–1936) 429; *Before the Storm* 429, **540**
Watteau, Antoine (1684–1721) 10
Watts, Frederick Waters 96
Watts, George Frederic (1817–1904) 41, 49–50, 51, 58, 77, 78–83, 91, 226, 284, 315, 451, 459, 453, 467, 488; *Alfred Inciting the Saxons to Encounter the Danes at Sea* 47, **35**; *Alfred, Lord Tennyson* 78, **83**; *Caractacus Led in Triumph through the Streets of Rome* 47; *Cardinal Manning* 78, **84**; *Choosing (Ellen Terry)* 78, **85**; *Found Drowned* 380, **470**; *Hope* 459, **579**; *The Irish Famine* 351, **428**; *The Judgement of Paris* 284; *Love and Death* 453, **567**; *Orlando Pursuing the Fata Morgana* 284, **342**; *Physical Energy* 488; *The School of Lawgivers* 49, **41**; *Under a Dry Arch* 380; *The Wife of Pygmalion* 284, **343**
Webb, Sir Aston (1849–1930) 41
Webb, Philip (1831–1915) 253; St George's Cabinet 253, **314**
Webster, Thomas (1800–86) 12, 26, 132, 174, 258, 259, 329; *Football Match* 226; *The Frown* 178; *Going to the Fair* 178; *Returning from the Fair* 178; *Sickness and Health* 174–7, **198**, **207**; *The Smile* 178; *The Truant* 147; *A Village Choir* 132, **155**
weddings 370–1

Wellington, Duke of (1769–1852) 12, 23, 26, 49, 71, **33**, **68**
West, Benjamin (1738–1820) 10–11, 280, 391, 392, 404; *Agrippina Landing at Brundisium with the Ashes of Germanicus* 10–11; *The Death of General Wolfe* 11, 392, **4**; *Sir Joseph Banks* 414, **515**
Westall, Richard (1765–1836) 7; *Queen Victoria as a Girl* 7, **1**
Whale, Robert (1805–87), *The Canada Southern Railway at Niagara* 429–31, **541**
Wheatley, Francis (1747–1801) 384; *The Cries of London* 26
Whistler, James Abbot McNeill (1834–1903) 38, 39, 40, 60, 62, 63, 83–4, 94, 112, 122, 169–70, 188, 228, 272, 274, 288, 297, 298, 311, 404–6, 411, 424, 429, 450–1, 453, 464, 465, 470–7, 479, 480, 482, 485, 492, 498; *Arrangement in Black No. 5: Lady Meux* 84, **88**; *Arrangement in Grey: Portrait of the Painter* 83, **87**; *Arrangement in Grey and Black No. 1: The Artist's Mother* 84, 477, **90**; *At the Piano* 465; *The Coast of Brittany: Alone with the Tide* 465; *Dancing Girl* 297, **357**; *Harmony in Grey* 470; *The Lagoon, Venice: Nocturne in Blue and Silver* 405, 473, 474, **586**; *A Nocturne in Black and Gold: The Falling Rocket* 405, 470–3, **585**; *The Peacock Room* 60, 470, **56**; *Rose and Silver* 60; *Six Projects* 297; *The Three Girls* 60; *Wapping* 331, 405, **503**; *The White Girl (Symphony in White No. 1)* 465, **581**
Whitman, Walt (1819–91) 399
Wilde, Oscar (1854–1900) 39, 40, 273, 277, 389, 416, 429, 463–4, 480, 494, 497, 503
Wilding, Alexa 76
Wilhelm II, Kaiser (1859–1941) 86
Wilkie, Sir David (1785–1841) 12, 143, 159, 261, 322, 388; *The Blind Fiddler* 147; *Blind Man's Buff* 12, **7**; *Chelsea Pensioners Reading the Gazette of the Battle of Waterloo* 12, 265, **2**, **9**; *The Penny Wedding* 12; *Pitlessie Fair* 12; *The Refusal from Burns's Song of 'Duncan Gray'* 12, 139, **8**; *Village Politicians* 12; *William IV* 65, **61**
Wilkins, William 26
William IV, King (1765–1837) 20, 65, 221, **61**
Wilson, Henry (1864–1934) 487
Wilson, Thomas Walter (fl.1870–1903), *The Lawn at*

Goodwood 274, **331**
Winchelsea, Lord 226
Windus, Benjamin Godfrey (1790–1867) 27–8, **22**
Wingfield, Major John 228
Winterhalter, Franz Xaver (1805–73) 67–71, 212, 319; *The First of May, 1851* 71, **68**; *Florinda* 282, **338**
Witherington, William Frederick (1785–1865), *The Hop Garland* 174, **205**
Wodehouse, P.G. (1881–1975) 43
Wolf, Joseph (1820–99) 224; *Greenland Falcons* 224, **272**
women: artists 305–25; depictions of 367–89
Wood, Christopher 32
Wood, Mrs Henry 374
wood engravings 183, 336, 343
Woodham-Smith, Cecil 351
Woodward, Benjamin 50
Woolner, Thomas (1825–92) 76, 232, 355–6
Wordsworth, William (1770–1850) 17, 20, 173, 419, **12**
Wright, Frank Lloyd (1867–1959) 488
Wyatt, Matthew Digby (1820–77) 266

Y

Yeames, William Frederick (1835–1918) 144; *And When Did You Last See Your Father?* 144, **147**, **173**

Z

Zambaco, Maria 442, 456
Zoffany, Johan (1733–1810) 431
Zola, Emile (1840–1902) 288, 331, 468, 492
Zorn, Anders (1860–1920) 344